VISUAL

CULTURE

Edited by Norman Bryson,
Michael Ann Holly,
and Keith Moxey

Images

VISUAL

and

CULTURE

Interpretations

Wesleyan University Press

Published by University Press of New England

Hanover and London

Wesleyan University Press

University Press of New England, Hanover, NH 03755

© 1994 by Wesleyan University
Printed in the United States of America

5 4 3 2 1

CIP data appear at the end of the book

Acknowledgments for previously published chapters
appear at the beginning of the Notes section for each
chapter; acknowledgments for illustrations appear in
the captions.

CONTENTS

List of Illustrations vii

Preface xiii

Introduction xv

GRISELDA POLLOCK I
Feminism/Foucault—Surveillance/Sexuality

LISA TICKNER 42
Men's Work? Masculinity and Modernism

JOHN TAGG 83
The Discontinuous City: Picturing and the Discursive Field

KEITH MOXEY 104
Hieronymus Bosch and the "World Upside Down": The
Case of *The Garden of Earthly Delights*

THOMAS CROW 141
Observations on Style and History in French Painting of the
Male Nude, 1785–1794

WHITNEY DAVIS 168
The Renunciation of Reaction in Girodet's *Sleep of
Endymion*

WOLFGANG KEMP 202
The Theater of Revolution: A New Interpretation of
Jacques-Louis David's *Tennis Court Oath*

NORMAN BRYSON 228
Géricault and "Masculinity"

ERNST VAN ALPHEN 260
Strategies of Identification

KAJA SILVERMAN 272
Fassbinder and Lacan: A Reconsideration of Gaze, Look,
and Image

CONSTANCE PENLEY 302
Feminism, Psychoanalysis, and the Study of Popular
Culture

ANDREW ROSS 325
The Ecology of Images

MICHAEL ANN HOLLY 347
Wölfflin and the Imagining of the Baroque

MIEKE BAL 365
Dead Flesh, or the Smell of Painting

DAVID SUMMERS 384
Form and Gender

List of Contributors 413

Index 417

ILLUSTRATIONS

Feminism/Foucault

1. Vincent van Gogh, *Miners* 11
2. Constantin Meunier, *Miner of the Borinage* 12
3. Cécile Douard, *Hercheuses (Hauliers) Waiting to Descend* 13
4. Constantin Meunier, *Hercheuse (Haulier) of the Borinage at the Pit* 14
5. Cécile Douard, *Hercheuse (Haulier) Pushing Her Wagon* 18
6. Illustration to First Report of the Commissioners on the Employment of Children in the Mines 19
7. Robert Little, *Lancashire Pitbrow Worker*; T. G. Dugdale, *Jane Horton, Pitbrow Worker*; John Cooper, *Pitbrow Worker, Wigan* 21
8. John Cooper, *Lancashire Pitbrow Woman in Sunday Dress* 22
9. Robert Little, *Ellen Grounds in Working Costume* (1866); Robert Little, *Ellen Grounds in Sunday Costume* (1866); Unknown, *Ellen Grounds with Arthur Munby 11 September 1873* 27
10. John Cooper, *Jane Brown*; John Cooper, *Jane Brown* 30
11. Chart indicating a way of mapping the bourgeois semiotics of class and gender 34

Men's Work?

1. *Augustus John and family with gypsy caravan.* 51
2. Augustus John, *Lyric Fantasy* 52
3. Wyndham Lewis, *Self Portrait as a Tyro* 53
4. Henri Gaudier-Brzeska, *Head of Ezra Pound* 54
5. Gwen John, *The Student* 58
6. Augustus John, *The Smiling Woman* 58
7. Vanessa Bell, *Frederick and Jessie Etchells Painting in the Studio at Asheham* 62
8. *Kate Lechmere sewing curtains at the Rebel Art Centre* 64

9. Helen Saunders, *Untitled* (Female Figures Imprisoned) 66
10. Helen Saunders, *Abstract Composition in Blue and Yellow* 68

Hieronymus Bosch and the "World Upside Down"

1. Hieronymus Bosch, *The Garden of Earthly Delights* 108
2. Jan Gossaert, *Hercules and Dejaneira* 109
3. Hieronymus Bosch, *The Cure of Folly* 110
4. Jan Gossaert, *Neptune and Amphitrite* 112
5. Anonymous, *Ventricles of the Brain* 115
6. Leonardo da Vinci, *Ventricles of the Brain* 115
7. Albrecht Dürer, *Self-Portrait* 116
8. Jan van Eyck (copy), *Holy Face of Christ* 116
9. Master of the Die, *Grotesque Ornament* 119
10. Anonymous, "Men Defending Castle against Hares" 121
11. Anonymous, "Battle for the Pants" 122
12. Anonymous, "Man Hunted by Hare" 123
13. Anonymous, "Double-headed Monster Fighting" 123
14. Hieronymus Bosch, *The Garden of Earthly Delights* (detail) 125
15. Master of the Power of Women, *Allegory of the Power of Women* 126
16. Hieronymus Bosch, *The Garden of Earthly Delights* (detail) 127
17. Hieronymus Bosch, *The Garden of Earthly Delights* (detail) 128
18. The Housebook Master, *Parodic Coat of Arms* 129
19. Hieronymus Bosch, *The Garden of Earthly Delights* (detail) 131

Observations on Style and History in French Painting of the Male Nude

1. Anne-Louis Girodet, *The Sleep of Endymion* 142
2. François Gérard, *Cupid and Psyche* 142
3. Pierre-Narcisse Guérin, *Aurora and Cephalus* 144

4. Anne-Louis Girodet, *Hippocrates Refusing the Gifts of Artaxerxes* 144
5. Studio of Jacques-Louis David, after David, *The Death of Socrates* 145
6. Anne-Louis Girodet, after Jacques-Louis David, *The Oath of the Horatii* 145
7. Jacques-Louis David, *Lictors Returning to Brutus the Bodies of his Sons* 146
8. Jean-Germain Drouais, *Marius at Minturnae* 150
9. Jean-Germain Drouais, *The Dying Athlete* (or *Wounded Soldier*) 152
10. Jacques-Louis David, *Marat at his Last Breath* 157
11. Anne-Louis Girodet, *Pietà* 157
12. Jacques-Louis David, *The Death of Bara* 157
13. *Hermaphrodite* 160

The Theater of Revolution

1. David, *Tennis Court Oath* 204
2. Helman after Monnet, *Tennis Court Oath* 205
3. David, *Tennis Court Oath* 206
4. David, *Tennis Court Oath* 206
5. David, *Tennis Court Oath* 207
6. Ledoux, *Theatre at Besançon* (section) 210
7. Ledoux, *Theatre at Besançon* (groundplan) 210
8. Legrand-Molinos, *Plan for a Parliament* (section) 212
9. Legrand-Molinos, *Plan for a Parliament* (groundplan) 212
10. Legrand-Molinos, *Plan for a Parliament* (section) 213
11. Helman after Monnet, *I. Prairial de l'an III* 215
12. Ledoux, *Symbolic representation of the auditorium [of the theatre in Besançon] through the pupil of an eye* 217
13. *The Great Seal of the United States* (from the one-dollar bill) 218
14. *Vignette of the Assemblée Constituante* (until 1791) 220
15. *Vignette of the Convention Nationale* (until 1795) 220
16. Lebarbier-Laurent, *The Rights of Man*, Version of 1793 220
17. *Membership card of the Cordeliers* (after February 1791) 222
18. *Vignette of the Comité de Salut Public* (1793–1794) 222

Géricault and "Masculinity"

1. Photograph of Arnold Schwarzenegger — 228
2. After Polykleitos, *Doryphoros* — 234
3. Théodore Géricault, *Charging Chasseur* — 237
4. Jean-Antoine Gros, *Battle of Aboukir* (detail) — 238
5. *Cuirassier of the 2nd regiment*, plate from *Troupes Françaises* — 240
6. Géricault, *Wounded Cuirassier* — 241
7. Géricault, *Seated Hussar Trumpeter* — 241
8. Géricault, *Portrait of a Carabinier* — 242
9. Géricault, *Cart with Wounded Soldiers* — 249
10. Géricault, *The Return from Russia* — 250
11. Géricault, *Start of the Barberi Race* — 251
12. Géricault, *Start of the Barberi Race* — 251
13. Géricault, *Start of the Barberi Race* — 252
14. Géricault, *Four Youths Holding a Running Horse* — 252
15. Géricault, *The Raft of the Medusa* — 253
16. Géricault, *Severed Heads* — 254
17. Géricault, *Man with Delusions of Military Command* — 255

Fassbinder and Lacan

1. Fassbinder, from *Gods of the Plague* — 280
2. Fassbinder, from *The American Soldier* — 280
3. Fassbinder, from *Gods of the Plague* — 280
4. Fassbinder, from *Gods of the Plague* — 280
5. Fassbinder, from *Gods of the Plague* — 280
6. Fassbinder, from *Gods of the Plague* — 280
7. Fassbinder, from *Gods of the Plague* — 280
8. Fassbinder, from *Gods of the Plague* — 280
9. Fassbinder, from *Ali: Fear Eats the Soul* — 285
10. Fassbinder, from *Ali: Fear Eats the Soul* — 285
11. Fassbinder, from *Ali: Fear Eats the Soul* — 285
12. Fassbinder, from *Ali: Fear Eats the Soul* — 285
13. Fassbinder, from *Ali: Fear Eats the Soul* — 285
14. Fassbinder, from *Ali: Fear Eats the Soul* — 285

Feminism, Psychoanalysis, and the Study of Popular Culture

1. Copy of a page from *Datazine* listing fan publications
 for sale 305
2. K/S Illustration 306
3. K/S Illustration 307

Wölfflin and the Imagining of the Baroque

1. Leonardo da Vinci, *The Last Supper* 348
2. Tintoretto, *The Last Supper* 348
3. Tiepolo, *The Last Supper* 349
4. Raphael, *The School of Athens* 355
5. Rubens, *The Raising of the Cross* 357
6. Giovanni Battista Gaulli (Baciccio), *Adoration of the
 Name of Jesus* 358
7. Raphael, *The Expulsion of Heliodorus* 359

Dead Flesh, or the Smell of Painting

1. Rembrandt, *The Levite Finds His Wife in the Morning* 366
2. Rembrandt, *A Woman Hanging from the Gallows* 370
3. Rembrandt, *A Woman Hanging from the Gallows* 370
4. Rembrandt, *Slaughtered Ox* 372
5. Rembrandt, *Slaughtered Ox* 372
6. Rembrandt, *Entombment* 374
7. Rembrandt, *The Anatomy Lesson of Dr. Nicolaes Tulp* 376
8. Rembrandt, *The Anatomy Lesson of Dr. Jan Deyman* 377

Form and Gender

1. School of Fontainebleau (Master L.D.?), *The Young
 Michelangelo Asleep at a Window* 387
2. Michelangelo, *Night* 388
3. Paolo Veronese, *Vision of St. Helen* 389
4. Copy after Michelangelo, *Leda and the Swan* 391

PREFACE

T H I S anthology collects the work of fifteen lecturers who contributed to a National Endowment for the Humanities Summer Institute entitled "Theory and Interpretation in the Visual Arts," held at the University of Rochester during July and August 1989. Lecturers, organizers, participants, and visitors met daily for six weeks to chart, discuss, and argue over the impact of contemporary theory on the discipline of art history. We came together from an assortment of academic departments (art history, studio arts, philosophy, history, film studies, classics, theater, anthropology, psychology, and literary studies) and from a variety of educational institutions, from technical schools to graduate programs. Especially important to the organizers of the institute was the mix of geographical areas and of international perspectives, for we were concerned about the potential isolation of American art history from European cultural studies.

This was the second time such an institute was held, and the second time the editors collected the lectures given for the occasion. *Visual Theory: Painting and Interpretation* (edited by Norman Bryson, Michael Ann Holly, and Keith Moxey) was published in 1991 by Polity Press in Britain and Harper Collins in the United States as a result of the first symposium, held at Hobart and William Smith Colleges in 1987. All of the essays anthologized in that volume were "theoretical"; most concentrated on questions arising from debates in analytic philosophy and phenomenology. In this second anthology, we focus on the impact of recent post-structuralist thinking on traditional art historical analysis.

Both institutes were designed to encourage discussion of theoretical perspectives in art history. The organizers of the two symposia felt that not many other forums existed for debating the issues that have enlivened so many other fields in the humanities and social sciences, from history, philosophy, and anthropology to literary studies. We simply wanted to see what would happen to the conception of the discipline as a discipline if theoretical issues were brought to the fore.

INTRODUCTION

T H E academy is visibly changing. Other humanities have not suffered as much as the history of art from institutional inertia. Literary studies, for example, has welcomed the unsettling that the expanded rhetoric of theory has generated. In his survey of the impact of interpretation and criticism on literature departments in *Framing the Sign*, Jonathan Culler offers the hope that essays in the new "genre" of theory will challenge and help reorient thinking in other fields "than those to which they ostensibly belong because their analyses of language, or mind, or history, or culture offer novel and persuasive accounts of signification."[1] The growing awareness of theoretical horizons shaped, for example, by class, ethnicity, nationality, sexual orientation, and gender, have compelled art historians to acknowledge our discipline's inseparability from a larger cultural and ideological world. During the past fifteen years or so, the ideas about which we think and write have seemed at odds with the traditional canon in which many of us were schooled. Within the academy itself, there has arisen a questioning of all the values it once safeguarded. As scholars of art history, we can no longer see, much less teach, transhistorical truths, timeless works of art, and unchanging critical criteria without a highly developed sense of irony about the grand narratives of the past.

In this larger political arena, wranglings over visual imagery from the sixteenth to the late twentieth century may seem somewhat insignificant; but those of us involved in the debates see the larger issue of representation itself at stake and note the ways in which works of art have always engendered rather than merely reflected political, social, and cultural meanings. The essays collected here span a wide array of historical and contemporary topics, but it seems fair to say that they are all involved in the ideological rethinking that should be an inescapable activity of all interdisciplinary and disciplinary activity in the last decade of the twentieth century. To quote Culler again: "Indeed, theory should be understood not as a prescription of methods of interpretation but as the discourse that results when conceptions of the nature and meaning of texts and their relations to other discourses, social practices and human subjects become the object of general reflection."[2]

History of Images, History of Art

The essays in this collection could be understood as contributions to a history of images rather than to a history of art. They represent a general tendency to move away from the history of art as a record of the creation of aesthetic masterpieces, which constitute the canon of artistic excellence in the West, towards a broader understanding of their cultural significance for the historical circumstances in which they were produced, as well as their potential meaning within the context of our own historical situation.

The focus on the cultural meaning of the work, rather than on its aesthetic value, can mean many things. Most obviously, it means that works that have traditionally been excluded from the canon of great works, images produced for film or television, for example, are now capable of receiving the same careful consideration that was once lavished upon works that made up the canon. It also means that it is possible to approach canonical works, those said to be invested with inherent aesthetic value, with different eyes. Instead of seeking to promote and sustain the value of "great" art by limiting discussion to the circumstances of the work's production and to speculation about the extraordinary impulses that may have characterized the intentions of its makers, these contributors examine the work performed by the image in the life of culture. Far from excluding a consideration of aesthetic value, the essays collected here offer a new and different definition of aesthetics. Instead of applying a Kantian aesthetic, according to which value is an intrinsic characteristic of the work of art, one capable of being perceived by all human beings regardless of their location in time and place—a recognition that depends only upon one's status as a human being—these writers betray an awareness that the aesthetic value of a work depends on the prevailing cultural conditions. They invest the work with value by means of their appreciation of its meaning both in the cultural horizon of its production and its reception.

The importance of the shift from the history of art to the history of images cannot be overestimated. On the one hand, it means that art historians can no longer rely on a naturalized conception of aesthetic value to establish the parameters of their discipline. Once it is recognized that there is nothing intrinsic about such value, that it depends on what a culture brings to the work rather than on what the culture finds in it, then it becomes necessary to find other means for defining what is a part of art history and what is not.

On the other hand, it means that, rather than being shaped by tradition, the discipline will consist of those interpretations of images that are most effective in exploring the potential meaning of the cultural creations of the past for the circumstances in which we find ourselves today. In some sense, this commitment corresponds with past practice, if not past theory. Despite its insistence on the value of an established canon, the shape of art historical interpretation was always determined by those authors whose interpretations most effectively captured the imagination of a contemporary audience.

The transformation of the history of art into a history of images may be seen as one of the consequences of the theoretical and methodological developments that have affected other disciplines in the humanities. These transformations mean that the cultural work of the history of art will more closely resemble that of other fields than has been the case in the past. It offers the prospect of an interdisciplinary dialogue, one that is more concerned with the relevance of contemporary values for academic study than with the myth of the pursuit of knowledge for its own sake. The move from the history of art to a history of images is intimately related to the realization that full and final knowledge of the world is a utopian dream of nineteenth-century idealism and twentieth-century positivism. It depends on a conception of knowledge as something that is necessarily compromised by the attitudes and values of those engaged in its production.

The Social History of Art

Among the identifiable writing genres that currently constitute the history of art, one that has actively contributed to its conception and history of images is the social history of art. Despite the efforts of those who pioneered the project of accounting for art in terms of social history, there has always existed the risk of its dilution into a procedure that merely adds on to artistic masterpieces a supplementary backdrop of "context." In practice, and at its least enlightening, the procedure consists of locating works of art against a "background" constituted by economic and social history, with little or no investigation of the ways in which the latter intersect with the former. It is assumed that the point of the juxtaposition is obvious, that the work, which is still accounted for in terms of the formal conventions that determined its structure, somehow synthesizes or mirrors the social and cultural cir-

cumstances in which it was produced. Such an approach characterizes the work as the end product of cultural activity. Art is the place in which historical developments culminate and are given their highest cultural form. Art history's allegiance to an eighteenth-century aesthetic is thus maintained: It is the work that prompts universal approbation or disapprobation in the mind of the "disinterested" and passive observer. Since aesthetic value resides in the work, and all spectators react to it in the same way, the theory depends upon the posited existence of a distance between work and viewer. It is, in fact, art history's continuing adherence to a theory of immanent aesthetic value that has prevented historians from fully examining the ways in which the work is related to all the other institutions and practices that constitute social life.

Several of the papers included in this volume seek to revise this notion of the social history of art by abandoning the traditional concern with the work's aesthetic status in order to show how it plays an active cultural role, one that is just as important to the historical process as any other social agency. To do so, these authors, Griselda Pollock, Lisa Tickner, John Tagg, Wolfgang Kemp, Thomas Crow, and Keith Moxey, call upon a variety of different theoretical sources.

1. Each of the authors invokes a semiotic notion of representation. By defining the work of art as a semiotic representation, that is as a system of signs, they break art history's allegiance to an account of artistic creation that is based on the concept of resemblance or mimesis. Far from duplicating some referent in the real world, as the mimetic tradition would insist, these authors claim that what is most interesting about representational works is the way in which they exhibit the cultural values of the historical moment to which the artist belonged. They are reluctant, in other words, to abandon to transparency what they regard as the richly textured semiotic discourse of the image. The fact that, after centuries of artistic production inspired by the principle of mimesis, the Western tradition is characterized by a pictorial history notable for its variety rather than its homogeneity has been used as evidence to suggest that the theory of representation as committed to the search for the "essential copy" is implausible. Rather than invoke notions of quality, such as "primitive" or "sophisticated," they insist that the work of representation is not as simple as the traditional account would have it. The variety of pictorial discourses is instead related to the ways in which the work actively engaged in organizing and structuring the social and cultural environment in which it was located.

2. In turning to a semiotic definition of the work as a "representation," these writers also seek to escape from the difficulties encountered by traditional social history inspired by the Marxist definition of society as divided into a base and a superstructure. According to the Marxist tradition of cultural analysis, social life consists of an economic base, which includes the circumstances of economic production and the organization of labor, and a superstructure that includes religious, philosophical, and artistic activity. This theory reinforced traditional aesthetic attitudes towards the work as a cultural synthesis imbued with immanent value by suggesting that the work was a reflection of what were regarded as the determining historical events of the period, namely those occurring in the economic base. Semiotic theory can be used as a way of collapsing this distinction. By claiming that all aspects of social life, those involving the economic activities of the base as much as the cultural activities of the superstructure, consist of signifying systems composed of signs, these social historians abandon the possibility of seeing through one level of culture to another. If both economic and cultural activities are regarded as representations, then they both are equally infused with social value, social value that must be read as different kinds of discourse rather than as the manifestation of developments taking place elsewhere in the social fabric.

3. Pollock, Tickner, and Tagg also wish to escape traditional social history's preoccupation with the notion of class as the dominant factor in interpretation. They claim that the dependence on the Marxist base/superstructure model has accorded a privileged status to the class struggle as the most important dimension of art historical narratives. In doing so, these narratives have been blind to the ways in which works of art are involved in defining and structuring differences of gender, as well as those of class. Griselda Pollock and John Tagg are especially interested in using the work of Michel Foucault as the basis for a social history that would be sensitive to both of these issues. In the work of Foucault, Tagg finds an account of social power as constituted by discursive practices that respond to a variety of different kinds of interests. In his discussion of photography, he points out that the photograph was capable of being made part of signifying systems that controlled and manipulated the lives of the insane, the criminal, and the poor, that fetishized the female body for consumption by a patriarchal society, and that (by means of portraiture) worked to constitute a notion of selfhood. All these systems were colored by the power relations they served to articulate; that is, they manifested the values of a repressive state,

a patriarchal family structure, and a humanist conception of the self. Tagg's point is that Foucault's notion of culture as constituted by discursive practices that are informed by the notion of power affords us the means by which social history can be made sensitive to issues other than those of social class. In fact, he ends his essay on a polemical note by calling for a "cultural" rather than a "social" history.

Griselda Pollock's essay explores Foucault's notion of discursive practice to expose the power relations that course through cultural representations dealing with the life of late nineteenth-century miners in the Borinage. In each case, she traces the ways in which notions of class and gender work together to construct social difference. For her, Foucault offers the means by which to explore cultural representations that cannot be related exclusively to the class system or to patriarchy and to study the ways in which these social values intersect and collude in the control and manipulation of the bodies of the female proletariat.

Lisa Tickner's contribution differs from the other two by including an analysis of the misogyny of British modernism and by applying the notion of gender as cultural construct to an examination of male sexuality. Her account picks up on the work of American scholars such as Carol Duncan, whose pioneering essay on the misogyny of European modernism from cubism to expressionism set the model for this type of enterprise.[3] Tickner's exploration of the way in which male modernists sought to define the movement as a masculine one is enlivened by an analysis of the way in which they divorced themselves from their privileged middle and upper class backgrounds by acquiring the social habits and manners of dress of members of the proletariat.

Moxey's paper examines what he claims is an early instance of the elaboration of the myth of the artist as genius by means of an examination of The Garden of Earthly Delights by Hieronymus Bosch. He is concerned to demonstrate the ways in which Bosch self-consciously manipulated the pictorial sign systems of his day to insure that they would be understood as self-referential gestures. To achieve his purposes, Bosch turned to the grotesque secular imagery found in the margins of the religious art of the Middle Ages. By placing the peripheral images of popular culture at the center of his princely commission and by calling attention to the process by which the work was achieved, Bosch also placed the personality of the artist at the center of the attention of his patron and his audience. In doing so, he effectively turned the tables on the conventional artist/patron relationship of his day by

subordinating the subject matter and cultural function of the commi-sioned work to a celebration of the inventive imagination of the artist as an exceptionally gifted individual.

Thomas Crow's contribution to this volume, an analysis of Girodet's painting, *The Sleep of Endymion*, shows clearly how questions of visual style are not ignored or bracketed by the social historian of art but are, instead, complicated and deepened. If the history of artistic style is thought of, narrowly, as a succession of visual formats and types, then the *Endymion* (1791) breaks with the style of Girodet's teacher, David, and inaugurates a new, eroticizing classicism that is continued in works such as Gérard's *Cupid and Psyche* (1799) or Broc's *Death of Hyacinth* (1802). What is then considered important about the *Endymion* is its swerve away from representation of the male figure in terms of civic virtue and self-sacrifice and towards a new kind of figure, characterized by sensuality and private pleasure. Crow, however, finds this interpre-tation inadequate once the painting is placed within the complex social circumstances of its production. Instead of marking a "romantic" break with Davidian precedent, the work should be seen, Crow argues, as emerging from the contradictory ethos of dependency and emulation that is so pronounced in David's studio. Girodet's painting is depen-dent on previous models (by Drouais and David), but at the same time, it shows its independent talent by deliberately inverting aspects of the predecessors' work. Though the sensuality and hedonism of the picture may seem to connote an apolitical vision of privacy and pleasure, in the context of the Revolution, athletic male beauty is able to connote civic virtue (which is why David was able to absorb elements of the *Endy-mion* into his painting of the youthful political martyr, Bara). If we look at the record of Girodet's involvement with Republican politics during his stay in Rome, what we find is not a reactionary figure who turns his back on the political arena but a Jacobin activist whose paintings are continuous with Republican ideals. The limitations of formalism are clear: If we attend to matters of style in separation from context, we will miss the meanings that *Endymion* circulated in its own historical moment and milieu. What is needed is a framework of analysis sensitive both to style and to context and thus able to "read" the nuanced codings of style in terms of their complex historical meanings.

Wolfgang Kemp's paper both articulates a theoretical position and offers us a practical model of historical interpretation. His account of David's painting, *The Tennis Court Oath*, not only relates it to the cir-cumstances of its production but describes the way in which it was

meant to function in its original location. Analyzing the way in which the pictorial convention of one-point perspective on which the painting is based was deliberately intended to intersect with the architectural setting in which the work was meant to be placed, Kemp sees the work as a means by which the Revolution's legitimacy could be continually enacted by those entering the Assembly. The same structure of interpellation is also associated with the surveillance enforced by the Revolution's "Committee on Public Safety" during the very years the painting was being executed. The painting was left unfinished because revolutionary struggles purged so many of the members of the legislature that once took part in the event, including the figure of Bailly, on whose head the organizing lines of the perspective system converge. Revolutionary action, in other words, cut the ground from under an elaborate pictorial structure aimed at manifesting the rationality of the new order.

Gender Studies

Though neither Kemp nor Crow addresses the gendered character of the works they discuss, this issue is central to the arguments of many other papers. One of the unexpected developments within the institute's debates concerned the issue of the visual representation of masculinity. No less than five of the contributions (the essays by Lisa Tickner, Norman Bryson, and Kaja Silverman, along with those by Whitney Davis and Ernst van Alphen) deal directly with works of art in which the construction of masculinity assumes a central importance. That so many essays on topics unrelated by period or medium should focus on questions of masculinity should not, perhaps, have surprised us as much as it did. In the long term, the waning of patriarchy's self-confidence and the fatigue of its stereotypes could perhaps be expected to focus attention on aspects of masculinity in which lack and inadequacy, hollowness and contradiction, become central features; while the emergence of gay studies as a dynamic and theoretically informed area of research and discussion has made the analysis of gay, lesbian, bisexual, and heterosexual sexualities an urgent and crucial undertaking throughout cultural studies.

Evident in all the papers directly concerned with masculinity and visual representation is a break with inherited critical languages in which art is associated with the celebration of phallic power. For Tickner, Augustus John's or Wyndham Lewis' characterization of modern-

ism as "rough and masculine work" is clearly a response to the threat to male privilege posed, in British society at large, by the growing claims of women to "educational and professional opportunity, social mobility, and democratic citizenship," and posed specifically to the community of male artists by the ever-growing presence of female producers and patrons. John's pursuit of imaginary self-identity as a gypsy patriarch, or Lewis' disdain for Roger Fry and his associates at Omega as "strayed and dissenting aesthetes" and his fantasies of hypermasculinity ("it is a pity that there are not men so strong that they can lift a house up, and fling it across a river") are, in Tickner's view, transparently defensive reactions to what was felt as the weakening of male hegemony.

For Bryson, Géricault's portrayals of wounded or inadequate avatars of masculine heroism are to be understood as critical dissections of the cult of martial valor and masculine triumph with which the Napoleonic adventure had commenced. What Géricault describes is not the self-sufficiency of male heroism but the latter's fundamental impossibility and contradiction. In his reference to Bryson's essay, Ernst van Alphen explores further the nature of this conflict within representations of patriarchal authority. Van Alphen argues that the denial or disavowal of the sexual dimension of masculine power in an image can be understood not only, as Bryson suggests, as a way of resolving the contradictory imperatives of Oedipal law (to be like the father and yet *not* like the father with respect to his phallic privilege and power), but that the anxieties and taboos surrounding masculine sexuality can also be seen as the result of the contradiction between the manifestation of power that the phallus is supposed to embody in patriarchal society and the inadequate actuality of the penis as the signifier of that power. The threat posed by genitality is that what is seen will not be, as van Alphen puts it, "a proud penis as a motivated sign of patriarchal privilege, but a shriveled shrimp." The danger posed here to patriarchy is that, in the gap opened up between symbolic power (the phallus) and the signifier of that power (the penis), the patriarchal order itself may be revealed as an artificial construction of signs that are only arbitrarily connected to (projected onto, and naturalized by) the male body.

Whitney Davis, in his response to Thomas Crow's essay on Girodet's *Endymion*, is also concerned with the iconography of masculinity. Crow describes Girodet's painting in terms of Republican politics and as a statement of affiliation and disaffiliation with the style of David, Girodet's teacher. Davis, however, sees the representation of Endymion as portraying a masculinity that in its passivity and sensuality goes directly

against the heroism and severity portrayed by David in such works as *The Oath of the Horatii, The Death of Socrates,* and *Brutus.* Once again, it is the association between art and the celebration of masculine heroism that is at issue, with the discussion deliberately moving away from the equation of art with virility—the equation that Augustus John, Wyndham Lewis, and, arguably, David were seeking and that for many feminist art historians remains a hidden wish of the discipline. In place of the masculine as stable and heroic, in these essays masculinity is described in terms of conflict and contradiction, structural contradiction for Bryson and van Alphen, and contradiction between colliding definitions of the masculine for Davis (*Socrates* versus *Endymion*).

In Kaja Silverman's essay on Fassbinder and Lacan, contradiction and conflict within constructions of the masculine are again at the center of the argument. Silverman focuses on Fassbinder's refusal to provide "affirmative" images, even to marginal and socially repressed figures, and his insistence instead on the dependency of the ego—male as well as female—on an array of external images. In her analysis, Fassbinder's male characters are constructed through the gaze of others, and in such a way as to expose their own inability to survive and function without this perpetual play with images and masks. Behind the masks stands nothing—the images through which Fassbinder's subjects live in the world are not versions or refractions of some essence or core of selfhood that they possess, but fundamental psychosocial architecture. The characters exist as the movement towards and between the images they try to internalize and project—a movement that can never finally arrive at or merge with the external theater. The specularity that much recent film analysis, like the films it analyzed, located among female characters is now found to inhabit the heartland of masculinity.

Of the many concepts that psychoanalysis can supply to visual studies, the Lacanian model of the Imaginary seems the most fruitful in these papers. Interestingly, the concept is not discussed in a vacuum, as a timeless truth of the psyche, but in each analysis is linked to history and to class. More accurately, the imaginary is theorized as a site in which sexual and class identity are produced inseparably and within precise historical coordinates. Tickner shows that, in their pursuit of a modernism full of "rough and masculine work," the British avant-gardists turned away from the repertoire of masculine identities provided by their own class and sought their images of virility among romanticized underprivileged groups—"costers, navvies, gypsies, 'savages.'" The process of manipulating masculine "image" is at the same

time a complex play with the terms of class; sexual identity and class identity are negotiated together. In Bryson's reading of Géricault's military portraits, the contradiction between phallic presence and phallic lack is lived out through the experience of rank in Napoleonic military society: Superiority and inferiority, power and powerlessness, are at the same time psychic and social or class terms. In Silverman's discussion of Fassbinder's socially marginal characters, social oppression and phallic insufficiency are articulated together ("the male body [is] the point at which economic, social, and sexual oppression are registered"). Striking in these essays is their commitment to a synthesis between social and psychoanalytic modes of discussion; neither form of analysis on its own is evidently held to be sufficient, and whatever difficulties it may entail, the central project here is to incorporate sexual subjectivity within the general analysis of domination. What is new is that male, as well as female, subjectivity now features prominently within the analytic framework.

Although Althusser and Lacan provide the larger framework for the essays by Bryson, van Alphen, Silverman, and Penley, a more immediate and perhaps more determining background is that of film studies, and particularly the highly influential work of Laura Mulvey. In her essay, "Visual Pleasure and Narrative Cinema,"[4] Mulvey argued that the dominant forms of cinema operate a visual regime characterized by strict separation between active (=male) and passive (=female) roles in looking, constructing spectatorship around an opposition between woman as image and man as bearer of the look. Vital though Mulvey's thesis has been to the development of the theory of spectatorship in film studies, above all in its use of psychoanalysis as a means of understanding the nature of the viewing subject, Bryson, Silverman, and Penley argue in different ways for a major modification to Mulvey's model. For Bryson and Silverman, the idea of "woman as image, man as bearer of the look" now needs to be supplemented by a reverse inquiry into the ways in which male subjectivity no less than female subjectivity is constructed around the image and specularity. In Penley's examination of "slash" literature, the work of fantasy is found to involve a greater mobility of subject positions that can be accounted for by the model of strict gender separation. As Penley has said elsewhere, "the structure of fantasy . . . is far more complex and flexible in its disposition of masculine and feminine roles, active and passive drives" than can be understood through "the model of voyeurism and fetishism which dominated both film theory and earlier feminist analyses of film."[5] In the "fanzines" that

Penley discusses, the mobility made available through the operation of fantasy permits the identification of female spectators and readers with male protagonists, with gay sexuality, and even with the setting of the fantasy itself (the ritualized *Star Trek* universe). What is apparent is the fluidity and plurality of the subject's self-positioning and the subject's capacity, at least in fantasy, to cross the normal thresholds of sexual difference and sexual orientation.

While most art historical writing has remained generally indifferent to the inquiry into spectatorship carried out within film studies, by the 1980s it was clear that feminist art history, at any rate, was becoming responsive to and energized by the ideas coming out of the work on cinema. Voyeurism and fetishism, for example, became key concepts in the analysis of the kind of viewing proposed and assumed by important categories of Western painting. When film studies itself moves beyond the model of voyeurism, fetishism, and the strict division of gender roles in viewing, such a development may prove crucial to those ranges of art historical writing that set out to investigate the nature of spectatorship. A new range of questions opens up when the complexity of the process of identification, for men as well as for women, is acknowledged. For example, can one speak of cross-gender identification, for male and female spectators, in relation to painting? What is the role of masochism in relation to male (and not only female) spectators? Has the time arrived to begin openly to discuss and to analyze gay, lesbian, and bisexual spectatorship? Such questions point towards a possible range of future debates over spectatorship in art history, as well as in film studies.

Academic Distance

Penley's paper is remarkable not only for its presentation of cultural material in which the mobility of the subject in fantasy is undeniably present; one of its most notable features is its refusal to enact the familiar kind of distance between inquirer and object of inquiry that is normally expected of scholarship in the humanities. As Penley puts it, "I don't feel so much as if I'm *analyzing* the women in this fandom as thinking along with them." To some, this collapsing of the professionally instituted interval between a scholar and her material may seem the central gesture of this essay, a gesture with implications that extend well beyond the essay's immediate topic. If a cardinal principle of the academy has traditionally been the separation of intellectual subject and intel-

lectual object and the creation of a gap between analyst and what is analyzed—a gap believed to be the enabling space of disinterested inquiry—Penley's essay goes against one of the basic rules of discourse in the university.

It cannot be accidental that this gesture occurs in an essay on popular culture, since the very term "popular culture" harbors a profound contradiction; those who use and enjoy "popular" culture would never normally refer to this culture or its practices in this way. The word itself proposes an apartness, a distinction, that is at the same time a condescension, a survey *de haut en bas*. What can be at stake in categorizing a disciplinary field in this way, if not the privilege of a superior class or caste as it looks down on the life of those whom its own discursive strategies propose as inferior to itself? What may be troubling to some readers about Penley's refusal to condescend is that it threatens to expose the ways in which the academy's production of knowledge is, at the same time, the production of a social power through which it claims authority over other social groups. The refusal to condescend comes close to revealing the academy's own machinery of domination, for, by implication, it names any plea for more objectivity, more distance between scholar and material, as a defense of caste privilege.

Michael Holly's essay on Wölfflin expresses another position in the debate on "appropriate distance," namely that the historian's implication in the object of his inquiry can itself become an important object of knowledge. In her view, Wölfflin's *Principles*, a text elaborately built upon an opposition between the terms "Renaissance" and "baroque," is itself an exercise in baroque historiography: The principles that Wölfflin ascribes to the baroque (conflict, dissonance, asymmetry) are the expressions of Wölfflin's own outlook and his own understanding of historical process, so that in the end what motivates the *Principles* is a fundamental circularity, a profound implication of the historian in the materials he discusses. Works of art are read as rhetorically shaping their subsequent historiographic accounts. For Keith Moxey, such implication by no means renders a historical account any less "historical": "The sign-systems of the past are invested with meaning by those of the present," and to deny that historical interpretations created in the present are the products of the present would be to mystify the nature of historiography.

Perhaps the most extreme statement in the collection—of the view that the interpretation of works of art has its origins in the contemporary circumstances of the interpretation—is Mieke Bal's paper on Rembrandt. Here the critical concerns are emphatically those of the

xxviii I N T R O D U C T I O N

contemporary viewer: The representation of the unrepresentable, the relationship between sadism and voyeurism, the plotting of the intricate subject-positions implied by the works of Rembrandt that she examines, these are topics pursued in the essay outside of those customary narrative conventions of art history that require the viewpointing of all interpretive statements to a clearly established locus in the past. While Bal's alternative narrative mode receives institutional sanction in other disciplines in the humanities, notably in literary studies, in art history the assertive declaration of the place of interpretation as existing in the present runs counter to some of the deepest conventions of the discipline. At the same time, Bal's explicit foregrounding of the present historical and critical horizon challenges traditional art history to justify those of its customary procedures that assume, but rarely examine theoretically, such apparently given ideas as context, the linearity of history, and historiographic "objectivity."

The last essay by David Summers indirectly continues this concern with the artificial neutrality of "historical distance" in its focus on the languages of art. Recognizing that all visual studies require an element of formal discussion, since no art historian can avoid discussing objects, he worries over the task of accommodating the vocabulary of art history to the force of recent sociohistorical and psychoanalytic criticism. Engaging in this labor for the "simple reason" that the "working language no longer worked," Summers traces the roots of the gendered idea of form back to Aristotle and Plato, who wrote of form as that principle of perfect masculine activity that shapes the passive feminine potentiality of matter. A far-ranging intellectual history that attempts to cover most of the important aestheticians from the Greeks to Heidegger, this essay persuasively argues that the form/matter polarity that has pervaded Western thinking for twenty-five hundred years has come to be taken as the natural order of things. If the primary metaphorical language in which we discuss artistic accomplishment is rooted in biological and sexual distinctions, we can only rethink the history of formalist art criticism by coming to terms with the exclusions such classifications have engendered. Clearly an indictment rather than a remedy, the essay leaves to others the task of finding a language of description that will elicit the contributions of those erased by the imprecision and ideological weight of the Aristotelian tradition.

One of the most original contributions to this volume, and one that allows us to return to the theme of history of images/history of art, is Andrew Ross' essay on "The Ecology of Images." About as far from a

critical appreciation of Raphael, for example, as is imaginable, Ross' essay is concerned with the images of popular culture, those images that are manufactured and disseminated for the largest possible audience. Being televised, they are also fleeting and impermanent visions, rarely being preserved on film, and then not for very long. The point of discussing them cannot be justified by invoking some notion of inherent aesthetic value. Ross has no intention of analyzing the intention of their makers in order to assess the intangible values with which they may have been invested in the process of their creation. He is concerned rather with the cultural work performed by these images after they have been launched into a social context: the types of meaning they create in the process of their reception. Analyzing the vast variety of representations of nature that pervade the popular culture of our society, he argues that these images have many different ecologies of their own. Some portrayals of the degradation of nature, for example, are shown in contexts that effectively counter their capacity to elicit an activist response, whereas others serve as a naturalized background to dystopian visions of the future that are animated by ecologically neutral or antiecological narratives. The value of his contribution lies in bringing a whole range of neglected imagery to the forefront of intellectual debate. These images are invested with cultural value not because of the discovery of inherent characteristics whose neglect has prevented them from assuming their proper place in the canon, but because of the way in which they intersect with the intellectual and political preoccupations of the world to which their interpreters belong.

NOTES

1. Jonathan Culler, *Framing the Sign: Criticism and Its Institutions* (Norman, Okla., 1988), 15.

2. Ibid., 22.

3. Carol Duncan, "Virility and Domination in Early Twentieth Century Vanguard Painting," *Art Forum* (December 1973): 30–39.

4. Laura Mulvey, "Visual Pleasure and Narrative Cinema," *Screen* 16, no. 3 (Autumn 1975).

5. Constance Penley, "Introduction" to *Feminism and Film Theory*, ed. C. Penley (New York and London, 1988), 22.

VISUAL

CULTURE

Feminism/Foucault—Surveillance/Sexuality

Classing the Body

THE phrase, classing the body, invokes two related but distinct meanings. The general usage of class is as a synonym for group, set, or species. Processes of selection and comparison produce categorizations or *class*ifications. In the wake of the vast historical changes that came with capitalism, however, the term class acquired specific, political meanings. In the discourse of historical materialism, a critical anatomy of that system, it refers to sets of *relationships* within which we are caught during the process of social production—the ways in which we produce our means of subsistence.

In his magisterial *The Making of the English Working Class*, the social historian, E. P. Thompson states the matter thus:

> By class I understand a historical phenomenon. . . . I do not see class as a "structure," nor even as a "category," but as something which in fact happens . . . in human relationships. More than this the notion of class entails the notion of a historical relationship. . . . The relationship must always be embodied in real people and in a real context. Moreover we cannot have two distinct classes, each with an independent being, and then bring them into relationship with each other. We cannot have love without lovers, nor deference without squires and laborers.[1]

Class is therefore a form of exchange that produces difference and, according to Marx, antagonistic positions between the groups who are differentiated in a system of production. While producing commodities, the system also necessarily produces agents, subjecting them to relations of difference vis-à-vis not only economic means of subsistence but social and ideological power at all levels. This is class.

In Marx's most sustained writing about class and class relations—a historical narrative and anatomy of France during 1848–1851, *The Eighteenth Brumaire of Louis Bonaparte* (1852)—a theatrical metaphor is repeatedly employed to make us understand that class, while constituted materially in actual social relations of production, effectively functions through representation. The "political" sphere in a bourgeois state is a

representation of class forces and relations in struggle. In common parlance, we recognize this representation when we think of parliaments and congresses as the place where the people's representatives gather, debate, and make laws. The political is also a composite of institutions, discourses, personnel, rituals, effects that can be best understood as a kind of staging of the social relations that create the necessity for this sphere of representation and discourse. The political is a space for the realization or performance of class by means of a specific script and using quite distinct costumes, a performance of those relations according to a logic specific to the stage—the political realm, the sphere of political representation. As Stuart Hall has noted when commenting upon the formulation of political versus economic class in the *Eighteenth Brumaire*,

> And once the class struggle is subject to the process of "representation" in the theatre of political class struggle, that articulation is permanent: it obeys, as well as the determinations upon it, its own internal dynamic; it respects its own, distinctive and specific conditions of existence. It cannot be reversed. . . . And the political results and conclusions won or secured at the level of the political not only serve to articulate "the political" as a permanent practice in any social formation, . . . they react, retrospectively, upon that which constitutes them.[2]

The Marxist problematic is, then, to think about the productive specificity of representation as a displaced rather than corresponding articulation of the forces that shape it yet to which it alone gives a shape. Whatever we understand as class effectively exists through practices of representation. Marx tries to explain this situation in the *Brumaire* in relation to the two major factions of the Legitimists, landed property, and the Orleanists, finance capital.

> Upon the different forms of property, upon the social conditions of existence, rises an entire superstructure of distinct and peculiarly formed sentiments, illusions, modes of thought and views of life. The entire class creates and forms them out of their material foundations and out of corresponding social relations. The single individual who derives them through tradition and upbringing, may imagine that they form the real motives and starting point of his activity.[3]

Those of us concerned with cultural histories and the realm of visual representations have found these observations about the representative

character of the political very suggestive. While investigating the possible ways to theorize about the inevitable relations that exist between the social formation and specific representations that are our domain of study in art history, for instance, we could do well to consider the "cultural" as a space of representation, shaped by social forces that are specifically articulated in modes peculiar to the cultural sphere. Instead, therefore, of deriving meaning for culture from some other source— from the social or the economic—we attend to the ways such forces are enacted, performed, staged, and articulated in these specific practices of representation, to how these forces effectively constitute the relations they articulate. There is thus no prior place in which the meanings of cultural forms are made, which art then expresses, replicates, defers to. The cultural is actively producing meaning by its own social, semiotic, and symbolic procedures and imperatives. These meanings are materially constituted in discourses and practices—the technologies of class, to borrow a phrase from Michel Foucault.

Such a line of argument is in line with certain developments in Western Marxism. The empiricism of English Marxist social history, represented by E. P. Thompson, has been displaced by a Marxism revised by the revolutions associated with French structuralism and post-structuralism. Since the later 1950s, we have seen massive changes in the theories and methods of scholarship in the humanities. From conceptualizations of history or literature or art in terms of a social or scientific (empirical) paradigm, we have been catapulted into ways of thinking governed by a linguistic and philosophical paradigm. Paramount is the emphasis on the all-pervasive mediation of language—there is nothing outside of text, discourse, and language. The danger of a total abandonment of history and the social is ever present.

Nonetheless, French theorists responsible for such reorientations have been schooled within an intellectual tradition in which the writings of Marx and the assumptions of Marxism were inevitable, if questioned, components. It is in this context of both the shift in interpretation within Marxism and the impact of what we collectively classify as post-structuralism that I want to introduce the writings of Michel Foucault.

Foucault's writings alternate between stringently refusing a foundationalist account of social forms, that is, that class domination is all a conspiracy by the ruling class, and relying on Marxist narratives to provide a motivating force for power in its capillary and local networks. I want to reconsider Foucault's relation to Marxism and its theorization

of class as a way to approach analysis of the body and class, the body and gender, and gender and class across the body.

It has been suggested that Foucault's whole program was concerned with class—though not at first sight in the clearly Marxist sense.[4] He has attended to processes of classification that constitute and are constituted by discourses, which are always operative in institutionalized practices. It would be easy to set Foucault's interest in discourses on madness and reason, on criminality and lawfulness, on illness and health, on sexuality and deviancy, into my first definition of class and fail to see how he has pursued the construction of these categories. His review of the ways in which power is deployed in relationships institutionalized by categories actually lies close to the second definition of class, and even to Thompson's concern that class be embodied in real people in real contexts. Foucault's work addresses the social process of "classing" by attending to its existence and practice in discursive formations and in their institutional supports. These formations are the specific representations of the relations between power differentials and self-determination.

The classic Marxist model of society is composed of economic and political levels with a subsidiary of the ideological. Revised Marxism gave greater consideration to the specific effectivity of the ideological. That reconsideration was then reshaped and questioned by viewing the ideological through textuality—text or discourse. But no sooner had the structuralist discovery of rule, system, and textuality performed its emancipatory effects than it, too, was contested. Though ideology or discourse may be understood to be a system, ruled by codes and conventions independent of the user's intentions or expression, it could not be accepted that there were no subjects in this system. E. P. Thompson's sense of experience and direct agency of real people in real contexts has been displaced by a structuralist stress on system, but a system that operates through its subjects, people called upon and positioned by the system to enact it, to be its subjects—in both the grammatical sense of agent (subject of a verb who does something) and in the legal sense of being under an authority (subject to the law). A subject is an effect of a system as a character in a play is the effect of the script and its enactment on stage in relation to the other actors, all of whom are speaking their prescribed parts while animating them to create a convincing and effective illusion of identity with the roles the script calls upon them to perform.

There are several theories about the construction of subjectivity, and none has been so influential as those derived from psychoanalysis.

Lacan's theories in particular have had some impact on Marxism, in the form of Louis Althusser's writings on ideology, which he defined in terms of subjects living an imaginary relation to their conditions of existence.[5] Furthermore, he insisted that there is no ideology without a subject. Indeed, ideology is precisely about the calling up, the *interpellation* of subjects. But Althusser's attempts were generally felt to fall too easily into a blunt mechanistic functionalism, making notions of subjectification through ideology an instrument of class domination.[6] In a sense, he lost the ground Hall claims Marx himself had already gained in *The Eighteenth Brumaire*, the notion that once a realm of representation comes into concrete social, institutional, and, we could add, discursive existence, it begins to exercise its own effects as it follows its own internal dynamic. To remain a materialist does not involve returning to a crude form of determination by some untheorized notion of the real, the economic, or whatever. It involves thinking of the social as exchanges within discourse through which subjects are constituted and operated.

Foucault's work, diverse and discontinuous as it undoubtedly is, is symptomatic of this trajectory. What makes his analyses specifically relevant is that he was trying in his many studies to comprehend the plays of power in the discourses and practices which constitute the modern subject in its concrete social relations and actual historical incidence.

In his introduction to *The Foucault Reader*, Paul Rabinow delineates the problematic of Foucault's work as a whole. He suggests that Foucault provides an anatomy of the modes of objectification of the subject. Foucault himself wrote:

> The goal of my work during the last twenty years has not been to analyze the phenomenona of power, nor to elaborate the foundations of such an analysis. My objective instead, has been to create a history of the different modes by which, in our culture, human beings are made subjects.[7]

First of all, Foucault has made the very concept of the subject, epitomized by the figure of speech *man*, historical and therefore contingent. *Man* is of recent invention and subject to imminent displacement. To show this, he has examined a number of different sites for the invention of the subject. He studied discourses on madness, on illness, on criminality, on sexuality that produced, and existed through, institutions— asylums, hospitals, prisons, families, and schools. These are the major institutions of modern society. He also considered the site of invention

of an abstracted version of the subject: in the disciplines still with us in the form of the humanities and social sciences. Foucault traced the invention of the "speaking" subject of grammar and linguistics, the "producing and laboring" subject of political economy, the "living" subject of the life sciences. Here, most clearly, the subject becomes the object of discourse, the object of analytical and classificatory surveillance and definition, the figure in the landscape by which are defined the critical domains of modern life—the economic, the medical, the familial, the disciplinary.

Finally Foucault addressed those areas of social practice and discourse in which the subject was invented as a "self"—a site or subject of pleasure and pain, of conscience and self-regulation. The self internalizes a disciplinary gaze and a set of normalizing standards yet also generates excess and deviation. The formation of the human subject is an effect of discourses that 1) divide the population, sick and healthy, mad and sane, and so forth; 2) classify scientifically by abstracted categories, the speaking subject of grammar, the producing subject of political economy, the living subject of the natural sciences; and, 3) subjectify, that is, produce the category of a self.

The first two practices imply some kind of dominating relationship between those who divide or classify and those who are segregated and classified by discourses of which they are not in charge. Yet no one holds the power; the discursive practices simultaneously produce the surveillant and the surveyed—both are involved in the process of subjectification. The third practice involves active participation of the subject in the process of manufacturing him or herself. "It takes place through a variety of 'operations on people's own bodies, on their own souls, on their own thoughts, on their own conduct.'"[8]

I am interested in considering visual representations, and the discursive formations of which they are a distinct but interdependent element, as sites of transaction between the subjects they form. Rather than as representations of something formed elsewhere, visual images may better be understood in metaphors derived from the theatre. On the one hand, within the discrete realm of the visual image, there is a kind of staging for someone, and on the other, the viewer is part of a performance of meaning. The body of the viewer is organized to participate and perform a series of operations—looking at art, deciphering its codes, enjoying it simultaneously at social, aesthetic, and psychic levels. Within the image, bodies are organized and operated upon by determinants that are also simultaneously social, aesthetic, and psychic. Indeed,

the term body is far too precise and monolithic for the chains of bodily images, the traces of bodies seen, fantasized, imagined, dreaded, looked for, and disavowed, that emerge in any representation of a body, an embodied subject in visual discourse.

Moreover, however heterogeneous the bodies of representation may be, we are committing a crucial omission if we continue to speak indifferently of the body, for one of the fundamental insights of feminism is the differentiation of bodies. Feminists argue that subjectification is synonymous with the production of sexual difference, figured by and inscribed upon our bodies. Subjectivity is indissoluble from the representation/figuration of the body. By that I do not mean that the anatomical, biological, or essential differences of men's and women's bodies are the foundation for sexually differentiated subjectivities; rather, I want to stress the opposite, namely, that subjectivity is invented by means of a sexual differentiation that represents itself by a figuration of the body (indicated by the symptomatic insistence on the phallus, or on penis envy, in Lacan and Freud respectively). This figuration is written onto our bodies, which are then disciplined to perform historically, culturally, and socially specific regimes of sexual difference. Introducing her feminist reading of Lacanian concepts of the human subject as the sexed and speaking subject, Jacqueline Rose writes:

> Sexual difference is then assigned according to whether individual subjects do or do not possess the phallus, which means not that anatomical difference *is* sexual difference (the one strictly reducible from the other), but that anatomical difference comes to *figure* sexual difference, that is, becomes the sole representative of what that difference is allowed to be.[9]

Although psychoanalysis itself remains symptomatically bound to a body—hence its central theses hinge around bits of certain bodies and who has or has not got them (Freud) or has or has not a possibility of an imaginary relation with their symbolic form (Lacan on a good day)—the feminist re-readings themselves are trapped with the body. The feminist insistence on sexual difference figured by symbolically differentiated bodies of man and woman is a progressive move within a discursive struggle (against indifference) but has difficulties in relation to other discourses. Is man/woman the difference, the only difference, the primary difference? Teresa de Lauretis raises this issue.

> To continue to pose the question of gender [in terms of sexual difference], once the critique of patriarchy has been fully outlined, keeps feminist

thinking bound to the terms of Western patriarchy itself, contained within a conceptual opposition that is "always already" inscribed in what Frederic Jameson would call the "political unconscious" of dominant cultural discourses and their underlying "master narratives." [10]

Under a universal sex opposition, woman as difference from man, it becomes difficult to articulate the differences of women from Woman and the differences within the collectivity of women in terms of age, race, class, gender, sexuality, ability/disability, and so forth. Furthermore, de Lauretis argues that there is radical potential in feminist thinking that goes well beyond sexual difference when it conceives of the social subject and the relations of subjectivity to sociality in another way:

> a subject constituted in gender to be sure, though not by sexual difference alone, but rather across languages and cultural representations; a subject en-gendered in the experiencing of race and class, as well as sexual relations: a subject, therefore not unified but rather multiple and not so much divided as contradicted. [11]

De Lauretis wants to deconstruct and unravel the mutual containment of gender and sexual difference by proposing, via Foucault, a technology of gender: "Gender, too, both as representation and self-representation, is the product of various social technologies, such as cinema, and of institutionalised discourses, and critical practices as well as of practices of daily life." [12] Gender, she argues, is not the property of bodies but, again quoting Foucault, of "the set of effects produced in bodies, behaviours and social relations." [13]

Although this position seems both more historically maneuverable and politically sensitive by defining the issue of difference as a social difference, institutionally and semiotically forged, and by locating gender as one of many social effects that collectively constitute contradicted and multiple identities, there is a significant theoretical loss in the move from the divided or split to the contradicted subject. Constance Penley has examined the preference for the latter against the split subject theorized by psychoanalysis, suggesting that, in particular, American feminism has been politically uncomfortable with the implications of psychoanalysis, which offers little "positivity."

> What does it mean that theories of sexual difference lack "positivity"? Perhaps it could be put this way: theories of sexual difference concern themselves with the construction of subjectivity but not in a way that is seen

as constructive. In other words, such theories do not always contribute to the *reconstruction* of a new feminine or feminist subject. It is true that psychoanalytically based theories of sexual difference lack "positivity" in that they offer neither instructions nor prescriptions for educating the psyche along more progressive lines. This is because these theories take as their primary focus the role of the unconscious in the constitution of sexual difference.[14]

It is precisely at the point where the mechanism and processes associated with the unconscious interact with the discursive and representational practices within Foucault's technologies of the subject that the images I want to analyze necessarily fall. The will to know and the resultant relations of power are furrowed by the more unpredictable and destabilizing plays of fascination, curiosity, dread, desire, and horror. At least two stages or scenes of representation interface with the complex interactions of class, gender, and sexuality, which are the conditions in which bourgeois men visualize working women.

The work I am engaged in presently concerns relations in representation between bourgeois men and working women. I am looking at the conditions under which working class women became the object of fascinated looking and of a disciplinary investigation in the nineteenth century. Biddy Martin's question is, therefore, highly appropriate: What is at stake when woman—or the body of woman—is made the object of knowledge?

> If women have been marginal in the constitution of meaning and power in Western culture, the question of woman has been central, crucial to the discourse of man, situated as she is within the literary text, the critical text, the psychoanalytic situation and social texts of all kinds as the riddle, the problem to be solved, the question to be answered. Foucault has not acknowledged the specificity of women's situation with regard to secrecy and truth; his analysis of the power struggles at stake in the humanist's pretense at truth makes it possible, however, to go beyond simply substituting new and more correct answers to the problem of woman by insisting that we ask what is at stake in the question, what is involved in the articulation of the problem of sexual difference, how are discipline and power constituted at the moment at which woman is made the object of knowledge?[15]

Yet, we can legitimately ask if there are *women* to become the object of knowledge. Is not the category—"women" as much as "woman"— a product of both the technologies that engender the subject and those

psychic operations that inscribe upon us sexual difference? How much is the process of "engendering," creating the relations of power between men and women, linked (precisely, in the nineteenth century) to the deployments of sexuality, both the technologies of sex and the pressures of sexualization? Why were these processes, which Foucault himself so frequently poses in terms of the familial model of active adult man and woman with legitimate and dependent offspring, so keenly endorsed by a corollary desire to ensure and police a regime of sexual difference? What were the pleasures of looking at representations of bodies that escaped or deviated from the bourgeois semiotics of the gendered and sexualized bodies of man and woman? These representations circulated both as part of the bourgeois deployment of sexuality amongst the proletariat and as an exciting defiance of it. They thus momentarily inched across the field of desire and law to proffer pornographic pleasure in the most unlikely fields—the fields of knowledge and power, where sexuality and surveillance mutually constructed each other in the interests of bourgeois men.

The Pleasures and Displeasures of Looking at Labor

I shall start with a drawing, dating from 1880 and produced in the Borinage, a mining district in southern Belgium. About to launch himself upon a professional art career, the Dutchman Vincent van Gogh began a drawing of a straggle of miners making their weary way to work in a wintry dawn (fig. 1). The setting is a drab landscape dominated by the industrial installation, which dwarfs the human figures shuffling along beside a leafless hedge. The miners are a motley bunch. There are some women in this group, dressed in jackets and skirts with shawls. There are others, not so easy to discern at first, who wear short breeches and jackets, with headscarves or uncovered hair bound into a bun at the back.

Why was this drawing made? What does it represent? How did it come to exist? Why did it occur to Van Gogh to select this topic, with these working women, as one of his first essays in art?

There are several different ways these issues can be posed and answered. The humanist discourse in art history asks itself this question: Why did Van Gogh make this work? It would answer thus: The drawing exists because the artist decided to draw these "figures" in this "landscape" as a response to what he saw in the world around him. By select-

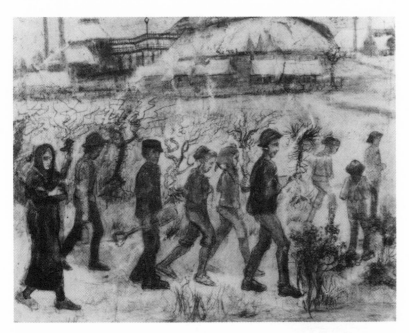

1. Vincent van Gogh, *Miners*, 1880 (F831). Otterlo, courtesy Rijksmuseum Kroeller-Mueller.

ing it and defining it in an idiosyncratic style, his look and hand remake the world as "art."

A social history of art, drawing on semiotics and historical materialism to produce "ideology critique," would ignore such individualistic emphases. To answer its questions, What is this drawing of? and, then, What is the drawing about? a social history of art would excavate the world to which the drawing makes coded reference—the history of Belgian industrialization and mining in particular and the formation and conditions of the Belgian proletariat, both of which developed, significantly, in the decades after the 1860s. The socioeconomic canvas provides the basis for a series of representations of labor and industry, such as those by Constantin Meunier, which, in turn, provide a context for the Van Gogh drawing as an image of labor and class (fig. 2). Van Gogh's relation to this historical situation would be questioned in terms of his position as a class subject in ideology. An analysis of how the miners and their context are specifically figured by this arrangement would then permit a puzzling out of the ideological effects of the image in both

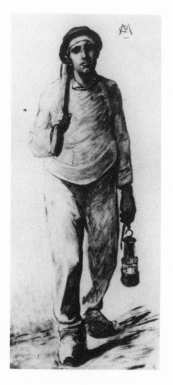

2. Constantin Meunier, *Miner of the Borinage*. Charleroi, courtesy Musée Communal des Beaux Arts.

its socioeconomic and cultural contexts. The result would be to specify the ideological character of Van Gogh's art. It would be just as easy to produce a socialist or a liberal humanitarian as a reactionary bourgeois "Van Gogh" from such a strategy of ideological analysis; but it would not address the issue of gender, either in terms of the gender ideology of the artist or the significance of the representation of *female* labor.

A feminist extension of the social history of art might compare and contrast representations of working women by Van Gogh and by women artists. The French painter, working in Belgium, Cecile Douard (1866–1941), produced many drawings and paintings of women miners in their short breeches and jackets, and there is no doubt that there are different kinds of bodies in representation here than in images of mining women by Van Gogh or Meunier (figs. 3 and 4).[16] The job of a feminist social history of art would be to define the way in which gender difference does or does not correspond with class identifications (all works are by bourgeois artists), but, whatever the outcome, the focus of analysis would

3. Cécile Douard, *Hercheuses (Hauliers) Waiting to Descend*, 1892. Brussels, courtesy Cabinet des Estampes Bibliothèque Albert 1er.

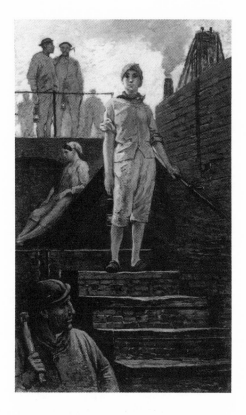

still be the artist as author of the particular meanings for the image. Gender merely inflects "art."

What I want to propose is a quite different feminist strategy that neither abandons social history nor gendered authorship but locates both within the contested field of discursive formations. Here the historical context and the impact of gender is not displaced but reformulated. Both exist only in specifiable discursive formations and strategies of representation. The latter refers to the conditions of visibility, that is, How do certain people, places, things enter into spaces of representation, which spaces do they enter, and why? This leads to a related question: Who is looking, at whom, with what political effects in terms of power and also in terms of its perpetual partner, resistance. Fundamentally, we find ourselves dealing with questions of 1) figured bodies in fictive spaces, and 2) imaginary relations between putative viewers and these bodies figured in fictive spaces.

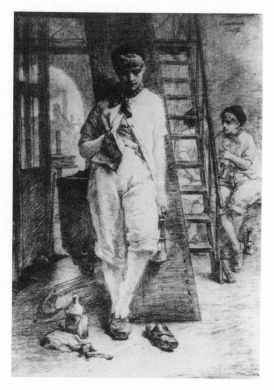

4. Constantin Meunier, *Hercheuse (Haulier) of the Borinage at the Pit*. Charleroi, courtesy Musée Communal des Beaux Arts.

Representation is not just a fancy new word for picturing, depicting imaging, drawing, or painting. Representation is to be understood as a social relation enacted and performed via specific appeals to vision, specific managements of imaginary spaces and bodies for a gaze. The efficacy of representation, furthermore, relies on a ceaseless exchange with other representations.[17] Across the social formation there are diverse assemblages of representations, called discourses, some of which are specifically but never exclusively visual. These combinations interact and cross refer with other discourses, accumulating around certain points to create so dense a texture of mutual reference that some statements, and some visions, acquire the authority of the obvious. At this point, the very fact of representation is occluded and what Foucault has

named a régime of truth is established by the constant play and produc-
tivity of this relay of signs. What is at stake in representation is not so
much a matter of what is shown as it is who is authorized to look at
whom with what effects.

Such a frankly Foucauldian account, however, locates representation
exclusively on the side of power. Precisely because it operates in the field
of power, however, representation as a process is flawed, balked, dis-
rupted, and often overwhelmed by the material it attempts to manage.
While representation is an attempt to manage social forces, it induces
and then is shaped by resistance.[18] Insofar as representation constructs
relations, these relations are social. Finally, insofar as it makes any
appeal to vision, and operates upon the domain of the visual, repre-
sentation becomes prey to complex issues of fascination and anxiety,
curiosity and dread, not theorized by Foucault in his analysis of surveil-
lance. The domain of the visual is an important territory of sexuality, of
the psycho-symbolic theorized by psychoanalysis.

In order to explore this, let us move from the domain of high art
to a more extended discursive field wherein the relations between a
Van Gogh drawing and its social materials can be mapped onto these
relations between vision, knowledge, sexuality, and surveillance.

An Edwardian novelist and travel writer, Clive Holland, published a
guidebook to Belgium in 1911—*The Belgians at Home*. The itinerary
includes a trip to the Mons region of the Borinage. This is a mundane
text. It rehearses, however, what had become a standard pattern of ideas
and beliefs, what T. J. Clark would name ideology, a body of ideas
that have acquired a certain inertness in discourse.[19] It shares with sev-
eral other texts an order, a way of constituting its object and estab-
lishing a "truth" about labor, the body, and sexuality. To its suburban
bourgeois readers, it offered a vicarious tourism, a guarded vision of
an area of Belgium that was "other" and therefore interesting but that
could be also "other" and dangerously unregulated. The threat needs to
be both mastered through adequate information and managed by ap-
propriate interpretation of the supposed facts. These procedures ensure
the authority of the gaze of the bourgeois tourist/reader when put into
potentially disturbing contact with proletarian communities and sites.

Clive Holland's text works by knitting together several distinct dis-
courses: First comes a socioeconomic discourse. Under this rubric, the
text discusses industrialization as unfettered economic growth that ex-
ploits its work force. But we are assured that social conditions have
improved, making it safe to examine. The effects of exploitation are

transferred from the system to the genetic pool of the workers, whose physical appearance records that historical period of "hard times."

Holland proceeds with an anthropological/touristic discourse. From the socioeconomic system, we are transposed to the local physiognomic type, or race:

> The effect of this almost unremitting, arduous and unhealthy toil has been the production of a race dwarf-like in stature. . . . This strange and weird type, which chiefly comes of the third and fourth generation of miners, is particularly noticeable. . . . [20]

Thus social relations and labor are represented through the categorization of a body as a racial type.

A sociological discourse follows the racial categorization. The racial characteristics of this community, "othered" rather than presented as people like the bourgeoisie and positioned disadvantageously in the capitalist system, have given rise to distinctive social patterns and habits. The miners are represented as illiterate, and their marital and sexual arrangements are defined as deviant, not specific but deficient.

Holland ends with a discourse on morality. Customs and habitations can now be condemned:

> It is the habits and customs to which we have referred which make Hainault a dark blot upon the map of Belgium, a district notorious for its immorality, crime and brutalized population.[21]

The specific kinship arrangements, such as early marriage or no marriage at all—it is unclear—are represented as deviations from a norm, unstated in the text, which structures the sense the text produces for its non-Belgian, non-mining readers. Early marriage and non-legalized partnerships do not inevitably brutalize, demoralize, or criminalize a population. The implicit assumption of the text is the bourgeois ideology's demand for female chastity, legal, contractual heterosexuality, and marital exclusivity.

The fictive landscape of work and degradation the text has been sketching through the play of several discourses is finally populated with its most lucid sign—the bodies of women.

> As one cycles along the roads on the way to Mons, roads from which the grey-whiteness of those we have up to the present traversed have gradually become black, one meets at sundown the stunted generation of miners

flowing in their hundreds and thousands out of the colliery gates, dull with
fatigue and often bemused with the effects of the *schnick* they have been
drinking all day. Nor are the women and girls more pleasant figures; per-
haps even less so. One passes hundreds of them, low of stature, with bare
arms grimed with the dust of the coal they have been hauling or tipping out
of huge wicker baskets upon railway sidings into the awaiting trucks, faces
hard with the degradation of unfitting toil, arms and figures like those of
prize-fighters—masses of muscle, almost denuded of any curve or softness.
At first one may mistake them for gangs of boys or lads. . . . Often their
muscular legs are bare, and their feet merely thrust into wooden sabots.
Often their feet are shoeless. Beings which those gifted with the kindliest
charity can scarcely look on save with disgust.[22]

The text here tries to negotiate what is clearly a problem—the con-
junction of labor and sexuality figured by the bodies of women (fig. 5).
Labor and woman are antagonistic terms in the system underlying Hol-
land's text. "Faces hard with the degradation of unfitting toil" can only
hold meaning in relation to a semantic chain whose opposite end leads
to the elevated and fitting, to idle bodies and softened faces. The struc-
turing absence of the text is a bourgeois feminine body, not muscled,
soft, curvaceous, which has its meaning in, and is a sign of, a hierarchy
of relations between the sexes. The text represents the Belgian mining
women as transgressions of a femininity that is, therefore, class and
race specific, the idle white lady who does not labor because she is the
domestic dependent of a man. Rigidly gendered, the lady is economi-
cally excluded from labor, money, and power. The proletarian women's
transgression of so complex a formation is, however, there to be seen, in
their trousered bodies, with exposed ankles and bared feet, walking to
work in public. The bodies of women were required—in bourgeois ide-
ology—to perform and display femininity to signify the bourgeois order
of power. Proletarian women's bodies did not confirm their difference
and thus their deference. By bearing the signs of work and exploitation
on a body that should signal gender through the very absence of such
signs, the field of vision was troubled with issues of class. Having insis-
tently made the reader "look" and see the evidence, Clive Holland's text
then recoils from what it labels almost unbearable sights. Transgression,
discovered through such intense scrutiny, is meant to evoke anxiety and
abjection in the visual field.

This excerpt from Clive Holland's book is a text casually discov-
ered, but it suggests a shared terrain with the Van Gogh drawing, with
Douard, with Meunier, and with Zola's famous novel of mining life,

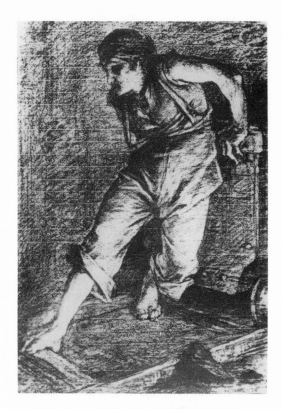

5. Cécile Douard, *Hercheuse (Haulier) Pushing her Wagon*, 1897. Brussels, courtesy Cabinet des Estampes Bibliothèque Albert 1er.

Germinal (1884). It exposes a fascination with and horror at the transpositions between gender, race, and class, signified in the specific configuration of sexuality and labor, labor and morality, femininity and the working body.

Another text takes us to the year 1842 and a British parliamentary commission on the employment of children. When certain men from the elite socioeconomic groups in government visited the coal mining communities of Great Britain, they "discovered" women as well as children being employed in Britain's pits. Women, dressed only in a kind of trouser garment, wore a leather belt around their waists, to which was attached a chain. It passed between their legs to connect with a

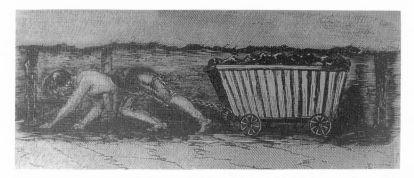

6. Illustration to First Report of the Commissioners on the Employment of Children in the Mines, *Parliamentary Papers*, 1842.

coal-filled truck. The women, crawling on all fours, dragged the truck from the pit face to the nearest collection point. In one of the first instances of illustration accompanying a parliamentary report, this figure was made visible to those who had not witnessed it firsthand (fig. 6). The visual shock added weight to the verbal report. The horror expressed by the middle classes at this "revelation" did not focus on the conditions of such backbreaking labor, its ill effects on health, the wages, or so on; rather, the elite men worried about the opportunities for immorality in the mines resulting from the sight of half-clothed women in the proximity of men. Bourgeois men's sexuality, their excitement at seeing women thus, is disavowed by their projection of a degraded sexuality onto working men, making it impossible to imagine other ways that the fathers, brothers, and sweethearts of these women might have viewed the plight of the women in their communities—in terms of pain, discomfort, and exploitation, for instance.

In 1842 Lord Ashley introduced into Parliament an act that was duly passed. Its first provision was to prohibit women's underground employment in the coal mines. Once the light of knowledge had penetrated the darkened caverns of the mines with their hidden ills, women had to be removed without any consultation, of course, with those thus suddenly deprived of a means of earning their living. Women continued to work underground disguised as men, dressed in their fathers' and brothers' clothes. Others were employed on the pitbanks as surface workers. The most famous of such mining women in Britain were those in the area of the Lancashire town of Wigan. Their notoriety resulted from the fact that they wore breeches.

In 1863 the House of Commons received a petition from the major union of miners: "That the practice of employing females on or about the pitbanks of mines and collieries is degrading to the sex and leads to gross immorality, and stands as a foul blot on the civilization and humanity of the kingdom." [23] One of the key items was the working costume of some surface workers around Wigan. They wore trousers: "a man's dress, and I believe in some cases it drowns all sense of decency betwixt men and women, they resemble each other so much." [24] Evidence for the "peculiarity of dress" was provided by an album of photographs that were submitted to the committee (fig. 7a, b, c). The presentation indicates many important developments taking place around notions of truth and vision in which photography was becoming implicated. [25] But I am interested in the assumption that degradation and immorality would be visible in the physical appearance of the photographed body—a mental, moral, and spiritual condition written upon the body, there for all to see. The photograph not only presents the costume of deviance; it codes the body through the rhetorics of posture, gesture, position in space, and in relation to a viewer. It positions the body in representation, which is to say that it produces a body for representation.

Representatives of the mine owners who wished to defend their access to cheap female labor arranged for the committee to see another set of photographs (fig. 8). These pictures were to show that the working clothes were just that, a costume put on what was essentially a feminine body. This idea was communicated by photographs of the mining women posed in their Sunday dresses. We are supposed to understand that these dresses are not costume but the outward and visible signs of inward and, when in trousers, momentarily invisible femininity.

We need to examine these different sets of photographs in detail. [26] If we look at a series of these photographs of women in working clothes (fig. 7), we can identify a standardized rhetoric by which the sitters are positioned and presented to the viewer. Women stand or sit, posed to face the camera, legs firmly planted apart, holding studio props such as shovel or riddle. Arms are on hips, hands are resting on shovel hilt, the body is opened out to the viewer, and the body acquires a certain solidity. Yet it is difficult to sex this body according to available signs or codes.

How do we read this recurring gesture of hands on hips? Is it the women's stance, assumed when resting after strenuous work or when a stranger interrupts them at their labor? Is it authored by the photographer as a knowing foil to the feminine body language in his formal,

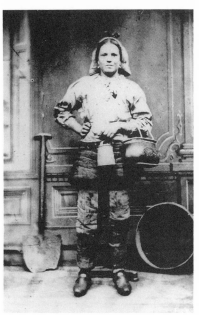

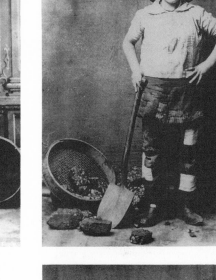

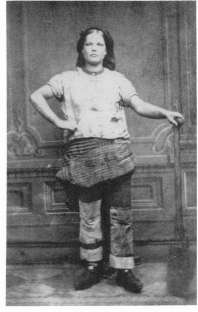

7. *Top left* (a), Robert Little, *Lancashire Pitbrow Worker*, 1867; *top right* (b), T. G. Dugdale, *Jane Horton, Pitbrow Worker*, 1863; *right* (c), John Cooper, *Pitbrow Worker, Wigan*. All reproduced courtesy of the Master and Fellows of Trinity College Cambridge.

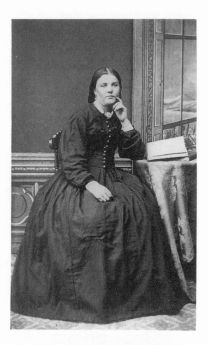

8. John Cooper, *Lancashire Pitbrow Woman in Sunday Dress*. Reproduced courtesy of the Master and Fellows of Trinity College Cambridge.

bourgeois portraits? Do these images then circulate as deviant in relation to femininity, excitingly offering cross-dressers who function as masculinized women, perverting the natural order, yet confirming it through such blatant disorder? Is there in addition an erotic subtext, inscribed through the open display of the body with its evident lack of corsetry, with its invitation to speak of legs firmly planted apart, shoulders back, hands on hips?

The mining women were paid by Mr. Gilroy, principal manager of the Ince Hall Coal and Cannell Company near Wigan, to be photographed in their Sunday dresses (fig. 8; see also figs. 9b and 10b later in this chapter). In these images, the women sit in quite a different fashion, legs erased in the sweep of the skirt, hands carefully resting in their laps or their elbows elegantly placed on a table, body turned slightly off-center with heads and hands forming part of a flowing line with softened contours, which make it superfluous to talk of bodies, presence, directness. These are the codes of femininity. The terms in which we might describe this imaged body are quite different from those solicited by the photographs of the same women in working costume. This comparison reveals

that the body is defined through its clothing, the body is displaced onto cut of fabric and costume.

Part of the pleasure generated by photography is its power to construct such different bodies. In one group, difference is seemingly suspended by bodies that are known to be women's but that masquerade as men's. They have bodies but no signs to sex them, to make them signify difference. In the other set, difference is confirmed, paradoxically through evasion of the body and the proliferation of coded signs of difference embodied by the dress, the posture, the gesture, the overall harmonious effect, which coalesce into the naturalism that photography seduces us into accepting as the world—here is woman. It is a paradoxical visibility, for it offers woman as visibly different by means of veiling everything that might indicate anatomy as the basis of difference. The photographs thus vividly signify that difference is an inscription upon a body, a play of signs, and not a revelation of a given set of facts or biological identities.

Feminists using psychoanalysis have argued that femininity can in fact be defined precisely as a masquerade, a signification of difference for men within a phallic economy of signs and bodies.[27] But such economies are not transhistorical. Given the radical shift in the last century within sign systems of difference, especially around women and fashion, it will be hard for us today to comprehend why a couple of hundred women wearing breeches to work could be the focus of such repeated and varied attentions as was attracted through the nineteenth century to the pitbrow women of Wigan. Can we view these photographs of women miners in breeches as exciting and shocking transgressions of order and meaning? Is it not impossible to register what comes to us as documentary images of nineteenth-century labor as erotic or even pornographic readings, a charge for their viewers that, if never purely sexual, is inescapably bound up with the production and effects of sexuality?[28] (Here sexuality is understood as positionality, subjectivity, fantasy, and desire in negotiation with the law.) I would stress that I use the term sexuality in a Foucauldian sense—not referring to sexual appetites and pleasures but to the social regimes that organize and subordinate women's sexual body to the institutions of the family, to class power, and to social regulation.

This field of meanings and anxieties can be tracked through the text of the Select Committee on Mines in 1865–1867. The final report is defined within the parameters of nineteenth-century liberal ideology.

Fundamentally upholding the interests of coal owners who prefer to use the cheaper labor of women in the pit banks and expressing the liberal ideology of non-interference in the so-called freedom of labor, the committee concluded that allegations of indecency or immorality were not established by the evidence and that no legislative prohibition or interference was required in women's employment. In *Parliamentary Papers*, however, the draft report presented to the committee on 25 July 1867 is printed, and it reads somewhat differently.

> And your committee, therefore, while they admit such employment of women to be unseemly and unsuitable, and while they give full credit to the better sort of miners for their desire to raise the social and moral condition of their whole class, by raising the character and refining the habits of their women, have thought it best to leave whatever improvement may be desired in this respect, to be worked out by the men themselves in the exercise of their power as fathers or husbands, assisted as your committee hope they will be, by the good feeling of the owners of mines.[29]

This is a dense passage. It makes no direct reference to immorality or sexuality, which was repeatedly figured in the questions and evidence to the committee; yet it is written from within an ideological universe in which both are indirectly referred to in terms such as raising moral and social conditions, refining, improving. These terms imply a condition in need of being elevated from a current baseness to a known level of order and purity—to that of the bourgeoisie itself, to the morals (apparently) embodied in the bourgeois family with its chaste and asexual wife at home functioning as mother and servant to the man's needs. According to the parliamentary text, the instrument of power is not the state but the individual authority invested in men as fathers and husbands.

This statement acknowledges the family as one of the sociopolitical, regulative apparatuses of the bourgeois ideological power, even while liberal ideology appears to present the state and the family as two separated domains—the public and the private. The bourgeois version of patriarchy inscribes its hierarchies in the subordination of wives and daughters to their male relatives; it also functions by binding economically and socially disparate groups into alliances as *men*. Bourgeois patriarchy furthermore involves a notion of woman—her body and its products—as the property of such male relatives.[30] Chastity is required in the protection of that property and its passage from one generation to the next. This produces our familiar picture of the asexual lady con-

fined in the private domain, without power, money, mobility, and, with almost no body at all.[31]

During the midnineteenth century, the bourgeoisie increasingly demonstrated an interest in the body of the proletariat and began to define a sexuality for it.[32] The bourgeoisie sent its agents into the territory of the industrial working class, its antagonistic but complementary "other." Through their reports and representations, the bourgeoisie was shocked to "discover," in these proletarian communities, radically different arrangements of sexual relations, ways of handling and dealing with conception, marriage, child-rearing, contacts between men and women, and between generations.[33] Premarital sex was not frowned upon there, and women bore children to their sweethearts, lived at home, and married only when money and housing permitted.

In the discourses of the surveilling bourgeoisie, as it belatedly concerned itself with the sexually healthy and socially productive body of the working class by extending the sway of its regimes of "sexuality" (in Foucault's term), those variations were represented or expressed as "immorality." Bourgeois men discovered another kind of female "body" which appeared to control its own sexualities and its own productivity rather than being exchanged between fathers and husbands. At that point, the apparently deregulated sexuality of working women appeared the most vivid and visible expression of the deviance of the working class as a whole from bourgeois norms. It was threatening to the sex-gender system by which the bourgeoisie defined its class identity at its most vulnerable and therefore most urgently defended point—defended through the codification of the feminine and the absolute regulation of female sexuality and productivity. Domesticity was the bourgeois ideology through which female sexuality was regulated within the bourgeoisie for exclusively heterosexual reproductive uses.

That is why I think it is necessary to see the terms "immorality" and "sensuality"—which arise in discussion of the women miners—not as descriptions of sexual behavior, but as terms generated by a purely bourgeois system of meaning. The effect of such a system, however, was to *sexualize* all women who worked, to make all working women suspect as sexual and immoral.

It would be easy to follow Foucault here. The photographic images function within a bourgeois regime of sense, forming a pattern of discursive elements utterly "naturalized" by the time Clive Holland deployed them. But these photographs are, I suggest, a much less stable visual

field. They are fractured by other exigencies, precisely because of their specificity as images in the field of vision, which is at once a psychic and a social domain.

The final text that elaborates this discursive field exposes the sexuality that cohabits with surveillance. One of the major collectors of photographs of the Wigan mining women and a regular tourist to that area was the minor civil servant and amateur investigative journalist Arthur Munby. He first visited Wigan in 1853 and made regular trips thereafter, documenting his encounters with individual women in his diaries.[34] Although a private activity not undertaken as part of a professional occupation, parliamentary investigation, or research for a statistical society, Munby's amateur activity accords well with the mode of professional masculinity that such occupations serviced even while they created it. I want to examine two extracts from Munby's record of his trips to Wigan. These are pseudo-sociological investigations, but, as representations in a private diary, they constantly use honesty, truthful, or factual reportage as a means to generate a more exciting text—rather in the manner of pornography's typical fictional fabrications of real-life scenarios.

Extract One: Wednesday 10 September 1873 A Visit to Ellen Grounds (fig. 9a, b, c).

I reached Wigan . . . and walked up Scholes, the main street of the colliers' quarter of Wigan, to call on Ellen Grounds, the nearest of my friends, and learn from her the news of the pits. . . . Close by St. Catherine's church, on Mount Pleasant, a vast open space which lies waste because of the pits beneath it, in Scholefield Lane, a row of little redbrick dwellings. In the window of No. 108, the passing child observes inviting comfits, brandyballs, and penny whistles. Here I knocked; and opening the door, whom should I see but Miss Ellen Grounds, wiping of the deal table in the middle of the brick floor. Miss Ellen, who is now four and twenty, was in woman's clothes, this time; a decent brown stuff frock with sleeves, and a white apron; and her light brown hair was knotted up simply behind, and brushed smooth against her comely cheerful face. She looked up, with a puzzled smile. "What, Ellen, dun yo know ma?" "Yea, Ah do—why, yo was here better than three year sin!" she answered; and gave me her hand, which was clean, and in spite of her manly work was neither coarse nor very hard. A fire was blazing in the grate, of course; on one side of it sat Ellen's father the brooman, who was fresh from work and was black; on the other, her handsome old mother, in a blue striped kirtle and a close

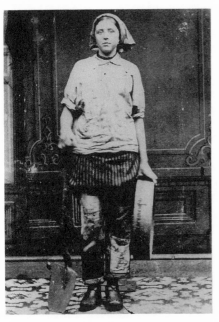

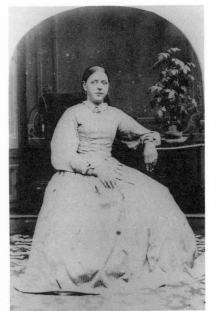

9. *Top left* (a), Robert Little, *Ellen Grounds in Working Costume*, 1866; *top right* (b), *Ellen Grounds in Sunday Costume*, 1866; *right* (c), Unknown, *Ellen Grounds with Arthur Munby 11 September 1873*. All reproduced courtesy of the Master and Fellows of Trinity College Cambridge.

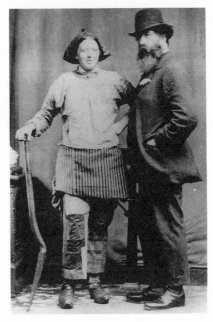

frilled cap. And by the window, with his feet on the settle, sat her young brother, a collier; who never spoke a word the whole time I was there, except Yes or No—in answer to me. "Sit yo doon!" said the damsel, handing me a woodenseated chair; and the old couple added "Aye, sit yo doon!" But why did Ellen wear this effeminate dress? Why was she so exasperatingly clean, and the coaldust gone from her hands? Because she has been "playing" all the week, stopping away from the pit, to attend to her mother, who is unwell. Ellen has left Rose Bridge pits; she now works at Pearson & Knowles's Arley Mine pit, a mile off across the canal. . . . Mrs Grounds had already said that many a mon likes to wed a pit-wench, because she can keep him, or nearly so. And has Ellen got a sweetheart? "Naa, Ah lost him," said Ellen, calmly enough. "He died o' smallpox," said her father; "but he's left her summat to remember him by." What, that two year old child on the floor? "Yah!" said Ellen, taking up the lad and fondling him, which indeed she had done before: and added, in reply to what I said, "But Ah never had a chance to marry him, yo know!" Neither she nor her parents were ashamed of the matter, though they are all decent folk. Her father was evidently fond and proud of the child. Ellen, who has been a factorygirl and a maid of all work, and has now worked 9 years at broo, said she means to work at pit "as long as the Lord'll gie me strength," and added "an t'lad'll work an' all."

Then we talked about being "drawed aht." Ellen said she had been "drawed aht" twice "i' my pit claes," and has seen her own picture hanging up for sale. It is not good however; and I asked if she could not come tomorrow, as she is "playing." Her father and mother both concurred; and Ellen never thought of objecting to walk through the town in her pit dress; which indeed dozens of pit girls do daily, and go of their own accord to be drawed aht in that attire, in order that they may send the picture to absent friends. So Ellen promised to come tomorrow in her pit clothes to Wigan marketplace and Clarence Yard. The only question was, whether she should come with a black face or a clean one. She observed that one often looks just as well with a black face; and I left the point to her discretion; but asked to see her working dress. "Here's t'bonnet," she said bringing out of the scullery a pitgirl's wadded hood bonnet, sound and fairly clean; "and here's mah bedgoon"; which was of pink cotton, patched with bits of blue. And the breeches? "Naa" said Ellen, with creditable shamefastness, "mah breeches is oopstairs, Ah cannot fotch 'em dahn!" Her father and mother, however, both counselled her to bring them; and I was glad of the opportunity of examining this unique garment. So Ellen went upstairs, and came down again with her trousers over her arm. "Them's mah breeches," she said; "they're patched that Ah connot tell t'maan piece on 'em; they was a pair o'men's owd breeches when Ah gat 'em, and Ah've wore em t'nahn year at Ah've worked at pits!" And they were still good; a pair of trousers

made up of patches of cloth and cotton and linen of various colours, but toned down by coaldust to a blackish brown. They were warmly lined and wadded, especially at the knees, to protect them when kneeling among coals or crawling up the shoot; a garment well fitted to keep warm the legs of a woman doing outdoor work. And (which spoke well for the fair wearer) the *inside* of the trousers was clean. They had button holes round the top. How do you keep them on? I asked. "Well" said Ellen, in mere simplicity and not in coarseness, "there's a mony wenches ties string round their waasts; but Ah've getten a good backsahd, at keeps me breeches oop!" She who made this dreadful speech is a fair and comely English girl; homekeeping, industrious, and virtuous according to her lights.

Munby visits Ellen Grounds's parental home and finds Ellen, in a dress and working at housework. He is disappointed at her cleanliness and calls the dress "effeminate," indicating a curious transposition—the working dress was condemned by the miners' unions for being masculine, whereas Munby inverts the issue as if the masculine condition is the norm and women's clothing is deviant.

What Clive Holland's text reports as signs of moral depravity also occur in Munby's accounts. Ellen has had a sweetheart and now has a child, living acceptably with Ellen and its grandparents. Remarking on their lack of shame, Munby none the less creates the possibility of such a fact occasioning shame—not for Ellen and her family, but in the eyes of the bourgeoisie whose sexual systems are thus surreptitiously laid before us as the norm from which this otherwise cheerful woman deviates.

The examination of the clothes exemplifies the manner in which professional observation—in the interests of sociological accuracy (we know what they are made from, how they have worn, etc.)—services an unacknowledged erotic agenda. The discourse on cleanliness—remember Munby's initial disappointment in finding Ellen clean and not begrimed with work dirt—issues in another sexual reading when we are forced to imagine his peering at the crotch of the trousers for signs of "dirt," namely, of her sexuality. The fact that the trousers are "clean," without evident signs of sexuality or other bodily functions, registers as a prosaic relief following the excitement and danger of having dared indirectly to look at a woman's sex. "Nothing to see" is paradoxically comforting.

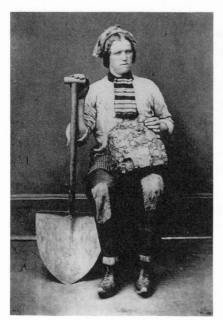

10. *Left* (a), John Cooper, *Jane Brown*; *right* (b), John Cooper, *Jane Brown*. Both reproduced courtesy of the Master and Fellows of Trinity College Cambridge.

Extract Two: Saturday, 29 September 1960,
Visit to Jane Brown (fig. 10a, b)

I went to a neat row of stone cottages just beyond Frank Holme's [a public house at Springs Bridge, near Wigan] and knocked at the door, which stood open, of the centre one. I went in, and found a room comfortable in a rough way, but untidy, it being cleaning night. Before the blazing fire sat a boy, grimy and in pit clothes, resting after his work; and a bony sallow girl from a factory was eating her supper at the dresser. These were Jane's brother and sister. Her mother came in directly; a stout loud-voiced woman, hot tempered evidently, but good-humoured and kindly in a blunt fashion; comely also, and neat enough. She asked me to sit down; I explained about the picture [he had come to buy a photograph of Jane in her trousers] and she was going to produce it, when shouts and trampling of clog shoon were heard outside, the door was driven open, and in burst the two wenches, Ellen Meggison and Jane, shouting and tumbling over one another like lads at a fair. They were both of course in their pitclothes, and as black as ever; and their grimy faces were bathed in sweat, for they

had been running home all the way. The mother instantly began to rate Jane soundly for staying at the alehouse and being out so late (it was now 7:30): "is that the way for a respectable young woman?" thundered she—evidently not merely because *I* was present. The girls shouted in reply that they had had to do overwork and to wait for their wages: and the hubbub subsided, and Ellen flung herself into a chair, and Jane leaned against the drawers, panting, and wiping the beaded sweat—and with it some of the blackness—from her red face, with the end of her neckchief. It was a singular group—the quiet coaly boy by the fire, the sallow pale sister and stout clean mother, and then those two young women in men's clothes, as black and grim as fiends and as rough and uncouth in manners as a bargee, and yet, to those who looked deep enough, not unwomanly nor degraded. They soon became quiet, after the first burst: and their talk had nothing flippant or immodest in it. Jane sat down to her supper of Irish stew; scooping the potatoes out of the bowl with a leaden spoon, and holding the meat in her black fingers while she tore it from the bone with her teeth. Her mother and I meanwhile stood and looked at her—she eating away unconcerned and hungry—and remarked what a fine healthy wench she was, and how she was not seventeen till next month, and so on. And yet this colliergirl of seventeen is ten times more robust and womanly than her elder sister the factory girl. . . . At last I had the picture (which was not a good one) produced, gave Jane the shilling for it, and sixpence to Ellen for "a gill o'yal" [ale] and said goodnight. . . . Here I am sorry to admit that as I left the cottage, Ellen started up and ran after me, dragging Jane with her, to beg that I would come into Frank Holme's and treat them to some *gin*. When I flatly refused, however, they both retired quietly, saying goodnight; Ellen going home to her grandmother's cottage further on.

In this cottage, Munby sets up an opposition between the two kinds of working-class women, the sisters who work in mill and mine. Both are, none the less, set apart from him by class as much as by gender. The appeal of these encounters with working women, often mediated via visits to the photographer's studio, was part of a game in which fantasy played a major part. The play is located around a loosening of the rigid order of sexual difference. Thus the Wigan pitbrow women were tall, strong, healthy, and robust; at times Munby calls them manlike or masculinized. He drew or had them photographed standing with a man for comparison and contrast (fig. 9c). They were robust and healthy, "health" becoming a displaced representation of a good, wholesome, clean femininity. The Wigan mining women defy ordinary categories of difference but are, despite all, a comfortable site of it. Their similarity to men in appearance suspends the dangers and threats of difference—sexuality—and

seemingly disorders the regime of the sexes upon which man's superiority relies. But the masculine professional observer can always manage to discern, beyond mere outward appearances, the necessary signs of women's subordination to his gaze and his naming. Class privilege protected Munby who was nicknamed by the women " 't inspector." But what he finds comfortable in the pitbrow women he befriended is that they seemed not to display the stereotypical signs of their class, which is projected onto the mill women who are represented as pallid and sickly, and as sexual. It is the factory workers who bear this characterization for Munby, while the pitbrow women, for all their physical masculinities, can be retrieved for bourgeois conceptions of femininity because they seem so nonsexual, so respectable. Jane's sister, a mill girl, is Jane's antithesis, sallow, bony, unhealthy, and therefore less "womanly"—that is, more troublesome to men. In a postface to his poem called *Dorothy* (1880) about a wholesome, pure, working class country maidservant, Munby wrote bitterly of the factory girls and their delight in fine clothes and good times: "Ugly hats, their tawdry ribbons and sham flowers, their ill-made impudent frocks, limp white-faced weaklings, they are potential mothers of shame." [35]

The body, the costume, and the slippage between the two defy any sense of fixity and nature. Sexual difference is a constant problem. Its deviations and instabilities must be monitored, explored, and tracked down by those with the competence to examine, assess, investigate, that is to subject these other populations to a surveilling and disciplining gaze. There are pleasures and threats to men of a different class seeking to secure and establish their dominance and control over women's sexuality, which is registered as an insistence, a pressure on their precarious hold on power. It solicits and fascinates but must be controlled. It must be kept clean or be condemned for its sickness and dirt. The working woman's body is the troubled sign of this masculine ordeal.

Foundations and Conditions

"There are obvious convergences between Foucault's work and the interests of feminists in terms of focus and methodology," Biddy Martin writes in her important reflection, "Feminism, Criticism and Foucault." [36] But there are also important tensions and conflicts that have attracted strong feminist critiques of Foucault. [37] These have focused on his indifference to the differential way that power, surveillance, and

sexuality (his three major themes) solicit and subjectify male and female subjects.

By way of indicating the convergence between feminism and Foucault, Biddy Martin quotes Foucault's *History of Sexuality*, in which it is argued that in nineteenth-century discourses on sexuality the female body was hysterisized, that is, seen as saturated with sexuality and inherently pathological. "It is worth remembering that the first figure to be 'sexualized' was the 'idle' woman." [38] Martin's statement would appear to contradict what I have established above about the sexualization of the bodies of laboring women, always negatively opposed to the idle or leisured "lady." I shall try to show how this is not a contradiction.

Foucault identifies a technology of sex operating as much through its desired norms, the Malthusian couple, as through its deviants—all who defy exclusively heterosexual reproduction as the only end of sex—the hysterical woman, the masturbating child, the perverse adult. Bourgeois sexuality is a systematic formation of compulsory heterosexuality, a highly regulated and intensely conflicted system of rules of exchange and bodily behaviors that should ensure a healthy, active, adult reproductive heterosexuality upholding social power and cultural leadership. At the same time, the bourgeoisie have formulated sexualities that will always exceed this socially legitimated systematizing. Drawing on an anthropological discourse on kinship and alliance, Foucault argues that every society produces its systems of marriage for the reproduction of bodies and the transmission of property. The rules constitute the system of *alliance*. For bourgeois society, Foucault identifies a shift to the deployment of sexuality: "The deployment of sexuality has its reasons for being not in reproducing itself [like alliance] but in proliferating, innovating, annexing, creating and penetrating bodies in an increasingly detailed way, and in controlling populations in an increasingly comprehensive way." [39]

It is on this basis that Foucault makes his claims that sexuality is tied to the emerging devices of power, that the intensification of the body is linked with its exploitation as an object of knowledge and an element in relations of power.

The site of the sexuality/power nexus is the body; but there are several bodies defined in Foucault's grid of the four strategic unities of bourgeois power-knowledge centered on sex: hysterization of women's bodies, pedagogization of children's bodies, socialization of procreative bodies, psychiatrization of perverse pleasures. While indicating how densely the weight of this regime pressed on women's bodies, Foucault does not see beyond the inevitability of man/woman difference, which he takes as

PUBLIC	PRIVATE
STREET	HOME
ARTIFICIAL	NATURAL
IMMORAL	MORAL
PROMISCUOUS	RESTRAINED
VICE	VIRTUE
DANGER	SAFETY
DIRTY	CLEAN
DISEASED	HEALTHY
PROSTITUTION	FEMININITY

MALE/BOURGEOIS	FEMALE/BOURGEOIS
SEXUAL	ASEXUAL
VICE	VIRTUE
IMMORALITY	MORALITY
LICENCE/FREEDOM	DISCIPLINE/RESTRAINT
NATURAL LUST	MORAL SUPERIORITY
RATIONALITY	ANIMALITY GOVERNED BY UTERUS
SELF CONTROL	HYSTERIA/PATHOLOGY
MIND OVER BODY	SPIRITUALITY DECORPOREALISED; MIND AND BODY SATURATED BY BIOLOGY CAN ONLY BE TRANSCENDED BY SPIRITUALITY
HEALTHY	SICK
CLEAN	UNCLEAN
IMPURE	PURE

PROLETARIAN	BOURGEOIS
SEXUAL	ASEXUAL/SEXUALLY CONTROLLED
IMMORAL	MORAL
BESTIAL	SPIRITUAL
BODY	SOUL
DISEASED	HEALTHY
DISORDERLY	ORDERLY
UNCLEAN	CLEAN
CORRUPTING	PURIFYING

11. Chart indicating a way of mapping the bourgeois semiotics of class and gender.

given rather than as an effect of the bourgeois system. In a critical reply to Frank Mort's use of Foucault in a historical anatomy of the "domain of the sexual," Lucy Bland exposed some important distinctions that have to be made by those working from Foucault's theses on the deployment of sexuality.[40] Mort had argued that the domain of the sexual was constituted through a series of oppositions, some already familiar to us from the preceding section: healthy/sick, clean/dirty, male/female. But by presenting male and female as opposition, this formulation fails to register the differential production of sexualities for male and female persons and to register the antimonies around which female sexualities are construed, which touch upon issues of class and race. The virgin/ whore axis is written upon a social division of lady/working woman. A chart can be drawn up to map the social and gender spaces across which the significations of bourgeois regimes of sexuality were formed and formulated (fig. 11). Not stemming from an innate difference, these shift-

ing and overlapping antimonies collectively secure, across divisions of class and race, the opposition—man/woman as the apparent source and guarantee of the entire semiotic system. Thus the apparently founding opposition is shown to be a cumulative effect of a historically specific, bourgeois politics of the body.[41]

Foucault argues that sexuality was historically bourgeois.

> We must return, therefore, to formulations that have long been disparaged; we must say that there is a bourgeois sexuality, and that there are class sexualities. Or rather, that sexuality is originally, historically bourgeois, and that, in its successive shifts and transpositions, it induces specific class effects.[42]

The sexing of the body became a site for the classing of the body and vice versa. He argues that a specific form of class consciousness was articulated for the bourgeoisie through its eugenically sexualized body, in contrast to the dynastic bodies of the aristocracies that the bourgeoisie displaced. In place of obsessive preoccupations with genealogy and ancestry, that is, the past, the bourgeoisie focused on the health and procreativity of its recent past, its present, and its future progeny. The proliferation of manuals on health, long life, and how to produce and raise large families are indicative of the kind of concern with the productive/reproductive body, which amounted to a specific form of racism, present negatively in Clive Holland's writings on the mining proletariat as a stunted and demoralized "race."

Preoccupied with its own body, the bourgeoisie was initially indifferent to the physical condition and lifestyles of the exploited classes. Their life, death, or reproduction did not matter, until these threatened the health or wealth of the bourgeoisie. Fear of contamination through epidemics of contagious diseases incited early forays into workers' housing conditions, while many a sanitary report insisted that it was economic folly to waste well-trained bodies to premature morbidity and death.[43] The proletariat was granted a body and a sex only when these demanded regulation in order to safeguard *the body and the sex*, that is, the bourgeoisie's.

The proletariat's body was thus invented as an effect of discipline and surveillance. But this invention opened up the landscape for other bodies, which were invested with bourgeois fantasies that were shaped by the internal conflicts of bourgeois sociopsychic formations. Bourgeois deployment of sexuality within the proletariat had several foci—

housing, procreation, health. Since sexuality involves incitement, intensification, and stimulation, it could only emerge when a technology of control already existed to keep the sexualized body of the proletariat under discipline and surveillance. But the point is that the purely disciplinary attention did not succeed.

At this point, Foucault's arguments become too functionalist, suggesting a more systematic state apparatus than actually existed for these purposes and again failing to register the differential ways in which the deployment worked on men's and women's bodies and lives.

The proletariat was granted a body and a sex through fear of its difference, which was construed for its management as disease, immorality, insubordination, disorder, and deviance.[44] The antagonistic relations that we call class are discursively represented as difference vis-à-vis the stable norm. Bourgeois deployment of sexuality across class lines involves an imposition of a grid of meanings onto the heterogeneous social and sexual relations of nonbourgeois communities, which can then be policed. Sexuality—or rather its class effects—becomes in part synonymous with surveillance and discipline enacted upon the bodies of working people, but it threatens in the same moment to undo the power that disciplinary regulation should create by engaging the surveillant in something more akin to voyeurism, turning documentary evidence into a quite different practice related to pornography.

The Spaces of Power

These are the foundations, the conditions for the emergence of working-class women's bodies into the spaces of bourgeois representation—as the site of bourgeois discipline, the contested places of bourgeois male class power and the sign of a conflicted sexuality. My original question was, Under what conditions did working class women enter bourgeois representation? The question is carefully phrased. To be in representation was, at one time, according to Foucault, part of the rituals of power, reserved for the divine, the heroic, the saintly, and those who rule. This nexus of power and representation functioned through the conjoining of both a representation of a gaze and a representation to a look.[45] In the nineteenth century, a quantitative and qualitative shift occurs around who is represented and how the represented is related to the gaze and to looking. John Tagg has proposed that we understand this shift in terms of a move from the privilege of representation to the burden of

scrutiny.[46] Far from heralding a simple democracy of the image, the expansion of representation subjected large sections of the population to surveillance. As Foucault writes:

> For a long time the ordinary individuality—the everyday individuality of everybody—remained below the threshold of description. To be looked at, observed, described in detail, followed from day to day by an uninterrupted writing was a privilege. The chronicle of a man, the account of his life, his historiography, was written as he lived out his life as part of the rituals of his power. The disciplinary methods reversed this relation, lowered the threshold of describable individuality and made of this description a means of control and a method of domination. . . . The turning of real lives into writing [representation] is no longer a procedure of heroization; it functions as a procedure of objectification and subjection.[47]

The metaphor with which Foucault distilled his argument about the disciplinary society's use of observation was Jeremy Bentham's model prison, the Panopticon. A circular structure around a central tower, its inhabitants were each allotted a cell with a window at the back, illuminating them in their singular spaces for the central observer—watching all and watched by them all. The gaze is dispersed and generalized, disembodied and internalized. Each subject is individuated, packaged, and learns to incorporate the gaze of others as a gaze enacted upon oneself. Foucault was drawn to his work on prisons, however, by earlier work on medicine and another social space, the hospital.

> I wanted to know how medical observation, the observing gaze of the clinician (le regard medical) became institutionalised; how it was effectively inscribed within social space; how the hospital structure was at one and the same time the effect of a new type of look and its support. I came to realize . . . to what extent the total visibility of bodies, of individuals and things, before a centralised look, had been one of the most constant guiding principles.[48]

This passage moves from the gaze of the clinician to the social organization of the space in which it is realized and authorized. I would like to suggest that the proliferating spaces of representation in the nineteenth century are no less social and are no less a major institution of the emerging disciplinary society. The photograph itself replicates the cellular structure, individuating the body as it is displayed not only for the camera's momentary blink but for the fixed scrutiny of the collector, of the police, and of prisons, hospitals, doctors, and social scientists. The

expanded networks of representation in the nineteenth century, capturing and defining, searching out and peering at more and more bodies, enact the new form of social gaze and lend it a more dispersed support. But this scrutiny is not the product of a centralized conspiracy, a planned act of class domination. Foucault argues:

> These tactics were invented and organised according to local conditions, and particular urgencies. They were designed piece by piece before a class strategy solidified them into vast and coherent totalities. It must also be noticed that these totalities do not consist in a homogenization but rather in a complex interplay of support among different mechanisms of power, which are themselves, nevertheless, quite specific.[49]

Thus Foucault suggests that the effects he names the disciplinary society are a result of interaction, often casual, between different agencies, "creating connections, referrals, complementarities and determinations that presuppose that each one of them maintains its own modalities."[50]

From this analysis come my four examples—each indicate a shared domain created through a web of referrals and connections, which never quite constitute the identities that ideological analysis of a Marxist or feminist tendency might seek. Each has its own social and semiotic specificity—art, travel literature, government enquiry, private diary, and amateur social investigation. There is no common cause, the patriarchy, the class system, to which all may be referred. There are, however, accumulating effects across the interconnecting discursive fields. These constitute relations of power that have concrete and material effects. But they are also sites of resistance around key players in the social drama and its spaces of representation—working women and bourgeois men—precisely at the point where sexuality both collaborates with and disrupts the technologies and discourses of disciplinary surveillance.[51]

NOTES

1. E. P. Thompson, *The Making of the English Working Class* (1963; reprint, London, 1968), 9.

2. S. Hall, "The 'Political' and the 'Economic' in Marx's Theory of Classes," in *Class and Class Structure*, ed. A. Hunt (London, 1977), 47.

3. K. Marx, *The Eighteenth Brumaire of Louis Bonaparte* (1852), in *Marx and Engels: Selected Works in One Volume* (London, 1970), 117.

4. See Paul Rabinow, "Introduction," *The Foucault Reader*, ed. P. Rabinow (London, 1984).

5. L. Althusser, "Ideology and Ideological State Apparatuses," in L. Althusser, *Lenin and Philosophy and Other Essays*, trans. B. Brewster (London, 1977).

6. See Paul Hirst, "Althusser and the Theory of Ideology," *Economy and Society* 4, no. 5 (1976).

7. M. Foucault, "The Subject and Power," in *Michel Foucault: Beyond Structuralism and Hermeneutics*, ed. H. Dreyfus and P. Rabinow (Chicago, 1982), 208.

8. P. Rabinow, quoting M. Foucault, "Howison Lectures," Berkeley, 20 October 1980, 11.

9. J. Rose, "Introduction II," in *Feminine Sexuality: Jacques Lacan and the École Freudienne*, ed. J. Mitchell and J. Rose (London, 1982), 42.

10. T. de Lauretis, *Technologies of Gender* (London, 1987), 110.

11. Ibid, 2.

12. Ibid.

13. Ibid.

14. C. Penley, *The Future of an Illusion: Film, Feminism, and Psychoanalysis* (Minneapolis, 1989), xiii–xiv.

15. Biddy Martin, "Feminism, Criticism and Foucault," *New German Critique* 27 (1982): 13; also reprinted in *Feminism and Foucault: Reflections on Resistance*, ed. Irene Diamond and Lee Quinby (Boston, 1988).

16. See *Art et Société en Belgique 1848–1914* (Charlerois, 1980) for details of the work of Douard and Meunier on the theme of mining women.

17. John Tagg, "Power and Photography," *Screen Education* 36 (1980); reprinted in *The Burden of Representation* (London, 1989).

18. Foucault himself admitted this in *History of Sexuality*, vol. 1, *An Introduction*, trans. Robert Hurley (London, 1978), 95; but his failure to grasp its full implications is mordantly criticized in Frances Bartkowski, "Epistemic Drift in Foucault," in *Feminism and Foucault*, Diamond and Quinby, 43–60.

19. T. J. Clark, *The Painting of Modern Life: Paris in the Art of Manet and His Followers* (New York and London, 1984).

20. Clive Holland, *The Belgiums at Home* (London, 1911), 124.

21. Ibid., 125.

22. Ibid., 126.

23. *British Parliamentary Papers*, vol. 13 (1867).

24. *British Parliamentary Papers*, vol. 14 (1866): [20] 36, item 651.

25. See J. Tagg, *The Burden of Representation*, for fuller discussion of this point.

26. The actual album submitted to the select committee has not been traced, but photographs from the same photographers in Wigan were collected by

Arthur Munby and are now kept in the special collection he donated to Trinity College Library, Cambridge. I am grateful to the Master and Fellows of the college for access to this archive and for permission to reproduce the photographs used here.

27. Claire Johnston, "Femininity and the Masquerade: *Anne of the Indies*," in *Edinburgh Film Festival 1975*, ed. Claire Johnston and Paul Willemen; Mary Ann Doane "Film and the Masquerade—Theorising the Female Spectator," *Screen* 23, no. 3–4 (September–October 1982); John Fletcher "Versions of Masquerade," *Screen* 29, no. 3 (Summer 1988).

28. This leads into another discussion of sexuality and the classed body, which is the topic of yet another work in progress.

29. *British Parliamentary Papers*, vol. 13 (1867): [29] 31.

30. See R. E. Dobash and R. Dobash, *Violence against Wives—The Case Against Patriarchy* (London, 1979) on this in relation to wife beating and woman as a thing of men, a property.

31. See Nancy Armstrong, "The Rise of the Domestic Woman," in *The Ideology of Conduct: Essays in Literature and the History of Sexuality*, ed. Nancy Armstrong and Leonard Tennenhouse (London, 1987): "On grounds that her sexual identity has been suppressed by a class that valued her chiefly for material reasons rather than for herself, the rhetoric of the conduct books produced a subject who in fact had no material body at all. This rhetoric replaced this material body with a metaphysical body made largely of words, albeit words constituting a material form of power in their own right" (136).

32. Michel Foucault, *The History of Sexuality*, vol. 1, *An Introduction* (London, 1979), 122–27.

33. Jane Humphries, "Protective Legislation, the Capitalist State and Working Class Men: The Case of the 1842 Mines Regulation Act," *Feminist Review* 7 (Spring 1981): 1–34.

34. Derek Hudson, *Munby: Man of Two Worlds* (London, 1972); Michael Hiley, *Victorian Working Women: Portraits from Life* (London, 1979); Angela John, *By the Sweat of Their Brow: Women Workers at Victorian Coalmines* (London, 1984).

35. A. J. Munby, *Dorothy: A Country Story in Elegiac Verse* (Boston, 1882), 216; the poem was based apparently on stories his wife, Hannah, told him of her mother.

36. Biddy Martin, in *Feminism and Foucault*, Diamond and Quinby, 10.

37. See Frances Bartkowski, "Epistemic Drift," in ibid., n. 18.

38. Foucault, *History of Sexuality*, 1:121.

39. Ibid., 107.

40. Lucy Bland, "The Domain of the Sexual: A Response," *Screen Education* 39 (Summer 1981); Frank Mort, "The Domain of the Sexual," *Screen Education* 36 (Autumn 1980).

41. For further discussion of this point, see P. Stallybrass and A. White, *The Politics and Poetics of Transgression* (London, 1986).

42. Foucault, *History of Sexuality*, 1:127.

43. See Edwin Chadwick, *Report on the Sanitary Condition of the Laboring Population of Great Britain* (London, 1842). This fear finds literary expression in Charles Dickens's Chadwickian novel of the dangers of physical contamination by those of the working class who live in most noxious environments and spread the "miasma" associated with infectious diseases such as typhoid. *Bleak House* (1852–1853).

44. Giovanna Procacci, "Social Economy and the Government of Poverty," *Ideology and Consciousness* 4 (Autumn 1978): 55–72.

45. Michel Foucault, "Introduction: On *Las Meninas*," in *The Order of Things* (London, 1970). See also Michel Foucault, "The Eye of Power," in *Power/Knowledge, Selected Interviews and Other Writings 1972–1977*, ed. Colin Gordon (New York, 1980).

46. John Tagg, "Portraits, Power and Production," *Ten:8* 13 (1984); reprinted in Tagg, *The Burden of Representation*.

47. Michel Foucault, *Discipline and Punish* (London, 1977), 191–92.

48. Michel Foucault, "The Eye of Power," 146; the work referred to is Michel Foucault, *The Birth of the Clinic* (1973; reprint, London, 1976).

49. Foucault, "The Eye of Power," 159.

50. Ibid.

51. A more extended analysis of the issues of sexuality structuring the Munby archive will appear as "The Dangers of Proximity: The Spaces of Sexuality and Surveillance in Word and Image," in a volume edited by Patrice Petro, *Visual Culture* (Bloomington, Ind., 1993).

Men's Work? Masculinity and Modernism

I W A N T here to sketch some of the tangled relations between mod-
ernism and sexual difference in the decade between 1905 and 1915.[1]
In art history, these were the formative years of the British avant-
garde: in 1905 Augustus John was establishing his reputation, in 1910
Roger Fry organized the first "Post-Impressionist Exhibition," in 1915
Wyndham Lewis brought out the second issue of *Blast*. In broader terms,
these were "some of the most immoderate years in English history,"[2]
marked by political tension, industrial unrest, and feminist militancy.
Consider the following quotations:

1. Frank Rutter's dedication to *Revolution in Art*, a defense of post-
impressionism published in 1910: "To Rebels of either sex all the world
over who in any way are fighting for freedom of any kind I dedicate
this study of their painter-comrades."[3] Rutter was an art critic, founder
and secretary of the Allied Artists' Association, director of Leeds City
Art Gallery, and honorary treasurer of the Men's Political Union for
Women's Enfranchisement.

2. The notorious open letter signed by Wyndham Lewis and others
who broke with the Omega Workshops in 1913, which dismissed Roger
Fry and his associates as a "family party of strayed and dissenting Aes-
thetes . . . compelled to call in as much modern talent as they could find
to do the rough and masculine work." ("The Idol is still Prettiness, with
its mid-Victorian languish of the neck . . . despite the Post-What-Not
fashionableness of its draperies.")[4]

3. The *New York Evening Sun*, 13 February 1917 (a quotation I bor-
row from Sandra Gilbert and Susan Gubar's *No Man's Land*): "Some
people think that women are the cause of modernism, whatever that is."[5]

Either rebels and painter-comrades, men and women, fight for a new
social order and a correspondingly modern, emancipated culture, or the
trouble in modernism is women. The artist is a Primitive Mercenary
(*Blast*). Modernism is "rough and masculine work," and the enemy is
effeminacy—perhaps effeminacy in women or men.

I make certain assumptions about modernism and about its relation to categories of sexual difference, which I will now summarize.

Modernism

I assume first of all a set of intimate and mutually determining relations between modernity, modernism, and modernist criticism.

Modernism as a set of cultural practices derives from, and promises expression to, the characteristic beliefs and experiences of modernity, of life in modernized, industrial, urban societies (societies marked by rapid population increase, concentration of manufacture, rapid transport systems and suburbanization, new forms of leisure, commodification, and urban spectacle). Modernism is glossed and evaluated according to the chiefly formalist protocols of modernist art history. One of the consequences of this is that much that was politically challenging, aesthetically contradictory, emancipatory, and interdisciplinary in the culture of modernity has been leached out of our concept of modernism as a collection of objects and a sequence of styles. For its pre-war protagonists, the world was a new place, and modernism was a utopian project. It involved modern painting, modern interiors, modern literature, modern music, modern dancing, modern life, and modern sex: topics embraced indiscriminately and with gusto in the new periodicals like *Rhythm*, which considered itself "a unique attempt . . . to unite within one magazine all the parallel manifestations of modernism in every province of art, education and philosophy." *Rhythm* published Rollo Myers on Debussy, poetry and short stories by Katherine Mansfield, drawings by artists from Picasso to Gaudier-Brzeska, D. H. Lawrence's review of *The Georgian Poets* ("we are awake again, our lungs are full of new air, our eyes of morning"), and Gilbert Cannan on modern marriage ("the majority of marriages are ruined by the absurd masculine theories concerning women, theories to which women, being ill-educated and economically dependent, subscribe").[6]

Each of these terms—modernity, modernism, modernist art history —has particular implications for women. Between, say, 1880 and 1920, significant changes took place in women's professional, sexual, and economic autonomy. You could say that women laid claim to the fruits of modernity—to educational and professional opportunity, social mobility, and democratic citizenship (in spite of Darwinian counterarguments that modernization could not apply to women, that evolution

favored a high degree of specialization between the sexes, and that social progress depended on "womanliness" staying safe and unimpaired). But modernity also laid claim to women who came to embody—for Gordon Selfridge or Le Corbusier—the image and reach of modernity itself.

For a notable artistic engagement with these themes, see Mary Cassatt's mural for the Woman's Building at the World's Columbian Exposition in Chicago (1893), "Young Women Plucking the Fruits of Knowledge and Science." For its mobilization in propaganda, see the work of the Artists' Suffrage League (1907) and the Suffrage Atelier (1909). For its use as subject matter, as part of a movement to modernize literature through the exploration of sexual conflict, see the "New Woman" novels of Thomas Hardy, George Gissing, George Meredith, George Moore, Sarah Grand, and Mona Caird. For its commercial exploitation, see the proliferating advertising and department store imagery of the period, which had its own investments in a new kind of female consumer. (Some of Gwen John's drawings are on notepaper from the Grand Magazin du Louvre. As Rachel Bowlby points out, it wasn't only Freud at this moment who was moved to ask the question, "What do women want?")[7]

The question of women's contribution to modernism as a cultural enterprise has to include all of the patrons, editors, and enablers (Sylvia Beach, Dora Marsden, Harriet Shaw Weaver, Kate Lechmere), as well as the artists and writers. It has *also* to be addressed to the difficulties of feminism and sexuality at the troubled heart of modernist endeavor. The point has been made by Griselda Pollock for late nineteenth-century France ("Why the nude, the brothel, the bar?"), and by Sandra Gilbert and Susan Gubar for Anglo-Saxon literary modernism.[8] It holds, I will claim, for the pictorial modernisms of 1905–1915.

The battle of the sexes (for pro- and antifeminists, especially men) and the exploration of a modern, self-determined identity (particularly by women) is *the* modern subject matter, even where talk of speed, electricity, cars, planes, and war dominates the manifest content of a work. These issues cannot be addressed by a modernist art history which, at its crudest, leaves the women out or which, alternatively, retraces an essential and thus *un*modern femininity in the work. (Even Richard Cork, who pays early and sympathetic attention to the women Vorticists, slips into an account of Helen Saunders that has her "tempering the harsh contours of her abstraction with female waywardness.")[9]

Sexual Difference

The second—and contested—term I want to address is sexual difference. In a very useful résumé of the arguments, Michèle Barrett identifies three concepts of sexual difference: experiential difference, positional difference in discourse, and sexual difference as psychoanalysis accounts for it.[10] Any attempt to combine all three would amount to "a very ambitious theoretical construct indeed"—in Stuart Hall's sceptical phrase— a theory that aimed to account at the same time "for how biological individuals become social subjects, *and* for how those subjects are fixed in positions of knowledge in relation to language and representation, *and* for how they are interpellated in specific historical discourses."[11] Nevertheless, as components of subjectivity, they are only hypothetically distinct.

Experiential difference assumes that the 'definitive assignment of sex roles in history has created fundamental differences between the sexes in their perception, experience, and expectations of the world, differences that cannot help but have been carried over into the creative process'.[12]

If experiential difference emphasizes men and women as distinct sociological categories, *Positional difference* assumes that gender is fixed in part by representations; that gender "is, among other things, a semiotic category."[13] Cultural practices come to be seen as *producing* femininities—"woman" becomes a relational term in a system of difference—rather than as reflecting biological or social femininities produced elsewhere.

In what Peter Wollen describes illuminatingly as "a cascade of antinomies"—functional/ornamental, pictorial/decorative, engineer/leisure class, production/consumption, reality principle/pleasure principle, machine/body, west/east, active/passive, masculine/feminine, "each of which suggests another, step by step"—modernism at a pivotal moment defined itself in each case by disavowing the second term.[14] One way of conceiving modernist theory and practice is thus as a cluster of components that must be constantly defended against encroachment by their "Others." The masculine is threatened by the feminine, the machine by the body, reality by pleasure, abstraction by decoration. Implicit here is the suggestion that there is another trajectory for feminism to investigate, never developed but never entirely repressed, in what Wollen terms "modernism's myth of its own origins": a liminal art of eroticism, exoticism, decoration, and the body.

Barrett locates the origins of her third concept of sexual difference—sexual difference as psychoanalysis understands it—in the impact of Juliet Mitchell's recuperation of Freud in *Psychoanalysis and Feminism* (1974). She acknowledges that it is a fraught and difficult category, overlapping awkwardly with differences one and two, but, at the same time, an indispensable one.

Psychoanalysis brings back the question of sexual difference, not as a story of everyday institutions and discourse (experiential or positional difference), but as a matter of a *fantasy* relation to the body through the Oedipal channeling of desire. With all its difficulties, only the insights of psychoanalysis can answer, in my view, to something like the passionate peculiarities of the Edwardian debates on militant or hysterical femininity;[15] or, on the other hand, the transitions through which Epstein resolved his obsessions with pregnancy and copulation in "The Rock Drill" (1913–1915)—a totem of parthenogenetic *phallic* potency—in his own words, "a machine-like robot, visored, menacing, and carrying within itself its progeny, protectively ensconced."[16] Which brings us back to the "rough and masculine work" of British modernism; to the interplay of "experiential" and "positional" difference that marks its treatment of women artists and the explicitly sexual charge that runs through its squabbles and manifestos; in short, to the historical question of subjectivity.

Artistic Subjectivities: "Masculinity as Masquerade"

During the nineteenth century, "art" and "artist" acquired new resonances. The economic basis for artistic practice shifted decisively from church, state, or private commission to commodity production, and by the early years of the twentieth century (late, in Britain), we find the small coteries of a self-consciously "modernist" avant-garde, if no general agreement on subject or style. The hold of the Royal Academy as the principal educational and exhibiting institution was broken well before 1900.[17] The established art press, with new titles and the appointment of newspaper critics, had begun catering to a general and amateur interest among the cultivated bourgeoisie as well as to specialists and professionals.[18] Combative artists (like Whistler) made good copy. The *kunstlerroman* or artist-novel reached the zenith of its popularity between about 1885 and the First World War, and large numbers of fictional and semi-documentary accounts of the artist and artistic life

were avidly consumed by an expanding public.[19] In the same period, a concern with sexuality and sexual identity emerged as the mark of the modern in art, literature, and social behavior. Feminism and the social and literary phenomenon of the "new woman" helped throw femininity into crisis.[20] The influx of women artists trained in the new public art schools of the Victorian period and in ateliers abroad led to anxieties about the "feminization" of art, that it would be swamped by "a flood of mediocrity."[21] These fears were compounded by the social and economic insecurity of the avant-garde and by a sense of British impotence in the face of European, and specifically Parisian, creativity. Artistic masculinity—at least in some quarters—was also in crisis, and new kinds of harsh, procreative, and virile masculinities were appropriated in response to what was perceived as the depleted and effeminate influence of women, the Royal Academy, and what Gaudier-Brzeska called the disgusting softness of modern life.[22]

If we are to account for the formation and effects of gendered artistic subjects—which is different from tracing the work back to gender, insistently and unproblematically, and only in the case of women—we have to find a place for historical agency.[23] We need a concept of the active subject as both structured and structuring, neither the dupe of history nor the "possessor of her own soul who has hewn out her individual path to well-deserved fame—as an admitted Genius."[24] (Thus Ethel Ducat's praise of Anne Estelle Rice in *Votes for Women*: an unconscious parody of the language of avant-garde heroism as it was informed by the discourse of possessive individualism.) This research is not biography, but it needs the biographer's materials—letters, diaries, memoirs, notebooks—if we are to glimpse something of how men and women aspired to new and modern artistic identities that left their traces on the work.

To become an artist at the turn of the century was not only a social matter of training and opportunity, it was also a question of aspiration, of *imagining* oneself an artist. Fact and fiction, history and biography, psychology and journalism, merged and overlapped in the mapping of an artistic "type" and, hence, in the provision of raw material for new identities.[25] There is little to be gained by insisting on the common sense distinction between "real people" and discursive fictions. Identification, the founding process of subjectivity, assimilates aspects, attributes, or properties of "others" who may just as well be fictional as not. Mythological components inhabit and determine biographical narratives, which in turn effect not only how artists are perceived (the "additional configurations of responses" linked with them as a socially

delimited group) but also how artists understand and produce their *own* identities (in what Ernst Kris and Otto Kurz refer to as the psychology of "enacted biography").[26] The enormous popularity of the artist as a character in fiction, biography, and journalism at the turn of the century meant that no one setting out on an artistic career did so as innocently as they might have taken up bookkeeping or architecture or medicine. The artist was a special kind of being with a special kind of life rather than an ordinary being with particular kinds of skills.

Such questions are increasingly discussed as a problem for women, who could have the skills but not the specialness and were doomed to the category of "lady artist." But I want to suggest that masculinity was also in crisis in the years after 1900 or, to put it more locally, that a combination of factors made the assertion of a virile and creative masculinity both imperative and problematic. Some of these originated in the art world itself and other pressed upon it from outside.

The humiliations of the Boer War (1899–1902), the *Report of the Inter-Departmental Committee on Physical Deterioration* of 1904 (though it refuted rumors that 60 percent of Englishmen were unfit for active service), an apparent increase in the number of mentally defective persons discussed in the *Report of the Royal Commission on the Care and Control of the Feeble-Minded* of 1908, a drop in the birthrate of almost 30 percent between the mid-1870s and 1910, a concern for the well-being of the empire in the face of German economic strength and military preparedness: all this led to talk of moral, physical, and intellectual decline.[27] Much of the debate was couched in the terms of social Darwinism.[28] Darwin had proposed that nations as well as individuals were subject to the law of the "survival of the fittest" and had himself appeared to lend credence to the Victorian ideology of "separate spheres" by claiming that sexual divergence was part of the evolutionary process: the higher the order of civilization, the more refined and distinct the attributes of masculinity and femininity. Eugenicists, who formed the principal strand within social Darwinism, used this argument to claim that national decline could only be reversed by "manly" men and "womanly" women regenerating the population. Social Darwinism crossed the political spectrum. In the hands of eugenicists, it helped promote widespread anxieties about the "masculinization" of modern women and the "effeminacy" of the men they would mate with and breed.

Many men (and also women) *were* disturbed by the impact of modern life on traditional definitions of sexual identity and by the impact

of feminism. The measure of this concern is popular antisuffrage propaganda, which can only be called hysterical. It depicts, graphically, the oppression of men by domineering viragoes or, more frequently, the preemptive strike: the symbolic rape or "castration" of presumptuous women.[29] It has its gentler modes, but what recurs insistently is the fear of what women's emancipation will do to men. It is as though masculinity and femininity are mutually exclusive and mutually damaging. The bottom line is castration or—and it amounts to the same thing perhaps—the feminizing of the virile institutions of civic life: "everywhere," as Almroth Wright put it, "one epicene institution, one cock-and-hen show."[30] It was not clear in 1910 that women would win the vote, but they had several times come close to it. What was clear was that, with the vote or without it, the processes of modernization were irreversible, and they brought women more fully into the fabric of daily public life.[31]

The impact of these changes on men's sense of their masculinity is harder to gauge and impossible to generalize. We might speculate, however, that the encroachment by women on hitherto masculine arenas (clerical work, local politics, medicine, the universities, certain kinds of sport)—however tentative—together with the spectacle of ferocious industrial muscle made for some uncertainty as to the nature of a *modern* masculinity.[32] A womanly woman was a woman with all the maternal and domestic virtues, but manliness was more obviously complicated by class and by the unresolved question of how the defining drives of masculinity (such as lust and aggression) were properly sublimated in civilized life.

Such issues had their local and "artistic" application. The social standing and economic security of the artist had declined since the middle of the nineteenth century. Women were becoming artists with a new sense of organization and self-consciousness, perceiving themselves as a group that suffered from certain difficulties but to which new possibilities were opening. Societies of women artists were becoming less defensive and more vocal. The Women's International Art Club, open to all women who had studied in Paris and did "strong work," had more than one hundred members from seventeen different countries by 1900, when its first London exhibition was held in the Grafton Galleries.[33] In 1910 the exhibition included work by women artists of the past. There is a real sense of women exploring their capacities and their heritage at this moment, in the face of those critical discourses that secured their work as "feminine" and hence deficient. The numbers of

women artists, their invasion of the art schools, their raised profile in the periodicals (first as "surplus" women needing a discreet alternative to governessing, but then as "new" women determined on independence and a career), their role as consumers of the new "art" furnishings, "art" needlework, "art" everything: All this contributed to an uneasy sense that art as a predominantly masculine activity was being feminized and domesticated.

The note of self-conscious virility in the rebellion of an Augustus John or a Wyndham Lewis was intended to distance them from any of this bourgeois "artiness"; from the senility of the *arrière garde*; and from the 1890s dandyism of Beardsley or Whistler.[34] As an aesthetic stance, dandyism was compromised by the backlash from the Oscar Wilde trial of 1895 and by what Wyndham Lewis almost called the bourgeoisification of bohemia.[35] The exquisite pose and rapier wit of the "Butterfly"[36] would no longer serve. A new, blunter, more modern, more brutal (more *masculine*) combatant was required to do battle against twentieth-century philistinism and the dead weight of tradition. (Ezra Pound complained that he was always having to tell young men to square their shoulders, wipe their feet, and *remember the date on the calendar*.)[37]

John became a gypsy patriarch complete with Romany caravan to the outspoken envy of Wyndham Lewis, who wrote to his mother that John was "going to camp on Dartmoor, with a numerous retinue, or a formidable staff, . . . or any polite phrase that occurs to you that might include his patriarchal menage" (fig. 1), and later that "John will end by building a city, and being worshipped as the sole man therein—the deity of Masculinity."[38] John's two portraits of Lewis invite us to mark the transition from the Rugby schoolboy and Slade art student (c. 1903) to the bohemian aesthete and "incarnate loki" of Montparnasse (c. 1905).[39] Cloaked and hatted like a Spanish grandee, the silk bookmarks fluttering from slender, leather-bound volumes of poetry, Lewis prowled the streets of Paris before 1909, harrassing the seamstresses. But he outgrew his apprenticeship to John's persona and adopted something more Nietzschean: the herdsman, the crowdmaster, the Tyro, the primitive mercenary, the Enemy.[40] Henri Gaudier-Brzeska found his sculptural inspiration in the preclassical and tribal collections of the British museum, as well as his creative, sexual, antibourgeois identity, first as "the modern Cellini" and then as "the savage messiah."[41]

John, as the "image of Jove turned gypsy,"[42] adopted a carelessly lyrical style, an expressive brushstroke, and Italianate allusions in the

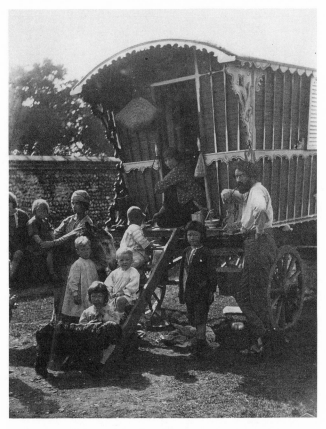

1. *Augustus John and family with gypsy caravan*, c. 1909.
London, courtesy National Portrait Gallery.

struggle to find a visual medium for the essentially conservative and
inchoate myth of a fecund Arcadia in the present. (*Lyric Fantasy*, 1910–
1911, one of the only large works, was never completed (fig. 2). Neither
his painting conditions nor his pastoral figure subjects were appropriate
to modernism as that was conceived after 1910, and certainly after 1914.)
Lewis sketched out his overlapping personae in the *Blast* manifestoes, in
his autobiographical novel *Tarr* (1918, revised 1928), and in short stories
and self-portraits such as *Self Portrait as a Tyro* (1920–1921) (fig. 3). His
pre-war work is marked by an obsession with the crowd—the crowd
his hero Cantleman opposes is both "feminine" and "blind"—and by

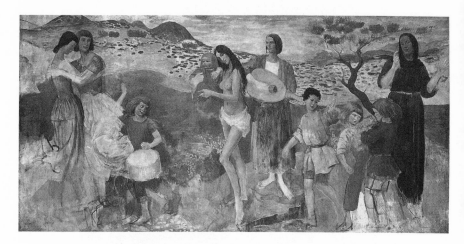

2. Augustus John, *Lyric Fantasy*, 1910–1911. London, courtesy Tate Gallery.

the use of a vocabulary of geometric (that is, as for Worringer, "mas-
culine")[43] forms to invoke both the structure of the industrial city and
the alienating tenor of modern urban life. The "square bluntness"[44] so
valued in Gaudier's work by Ezra Pound is modern by virtue of its dis-
tance both from the smooth transitions of classical carving and from
the expressive modeling of the Rodinesque. But it is also construed as
modern—by Pound and others—because it is phallic, most phallic, in
fact, in the "hieratic head" of Pound himself (fig. 4). There is an easy
traffic between this idea of the modern necessity for a "virile art" and
Gaudier's role as the savage messiah.

The irony is that this free-ranging masculinity required emanci-
pated women to support it. John, Lewis, and Gaudier-Brzeska *expected*
women to be emancipated enough to sleep with them, to forgo fidelity,
in the case of John and Lewis to bear their children out of wedlock, and
in the case of Lewis and Gaudier to help support their art financially.[45]
None of these men was wedded to traditional ideas of womanliness.
All of them believed women could be talented and independent. But an
imperious and often promiscuous, heterosexual masculine egoism ran
through their relations with women nevertheless. And the women them-
selves were often divided or insecure. Few had Gwen John's presence of
mind and passionate selfishness. Nina Hamnett was distracted by *la vie
de boheme* and ignored Sickert's advice to keep callers to their settled
hours.[46] Carrington felt she was "not strong enough to live in this world

3. Wyndham Lewis, *Self Portrait as a Tyro*, 1920–
1921. Kingston upon Hull, courtesy Ferens Art
Gallery.

of people and paint."[47] Sophie Brzeska's trilogy failed to emerge from
her several hundred pages of autobiographical notes. Life drained tal-
ent, often enough in the interests of men and with women's blessing.
Bloomsbury was an exception, at least for Vanessa Bell.[48] Its homosexual
component ironized hearty masculinity, and, for all the intricacies of
its sexual relationships, sexual conquest and a sense of virility did not
permeate its work (which was, of course, precisely Lewis' complaint).

I think there is evident here such a thing as "masculinity as masquer-
ade," not in any sense that would directly complement Joan Riviere's
analysis of "Womanliness as Masquerade" (1929)[49] but in three related

4. Henri Gaudier-Brzeska, *Head of Ezra Pound*, 1914. London, Private Collection, Photograph courtesy Tate Gallery.

ones. First, we can speak generally of identification as the means by which the personality is constituted and specified: "All the world's a stage / and all the men and women merely players." [50] There is a powerful sense of charades about John's imagery and behavior, but the point is that he chose to produce himself as an artistic subject through a series of identifications with the attributes of a nomadic, liminal, and acapitalist group. The process is particularly vivid with John because it is relatively transparent and impinges so directly on his work. But it illuminates the ways in which younger artists played with the appropriation of other, more mythic, and—mythically—more potent masculinities, out of context, as part of their opposition to the conventional codes of middle class masculinity.

Second, we might deepen this first sense of masquerade as a kind of fantasy identification by exploring the operations of masquerade as a form of defense. This notion of defense is the crux of Riviere's case study. She opens with a reference to Sandor Ferenczi's claim that homosexual men may exaggerate their heterosexuality as a defense. She proceeds by stating that "women who wish for masculinity" (her case study is of an intellectual woman who usurps the masculine position of public speaker) "may put on a mask of womanliness to avert anxiety and the retribution feared from men." [51] We can adapt the structure of her

(and Ferenczi's) argument metaphorically. Men moving into art—an area identified with "feminine" sensibility and increasingly occupied by women art students—might feel the need with Nevinson and Marinetti to distinguish *Vital English Art* from the pastimes of women and schoolgirls and to adopt the mask of a heightened and aggressively heterosexual masculinity.[52]

Riviere oscillates in her paper between seeing the masquerade as a travesty—a defense and disguise—and as womanliness itself (womanliness *is* the masquerade). This latter position is the one taken by later commentators, including Stephen Heath who goes on to suggest that there is a corresponding male term for the woman's masquerade—male display or, in Lacan's term, *parade*. He quotes from Virginia Woolf's *Three Guineas*, observing that "all the trappings of authority, hierarchy, order, position make the man, his phallic identity," and then from Eugenie Lemoine Luccione: "If the penis was the phallus, men would have no need of feathers or ties or medals. . . . Just like the masquerade, [parade] betrays a flaw: no one has the phallus."[53] The difficulty here—apart from that of theorizing the asymmetry of "masquerade" to "parade"—is that once we generalize either concept to illuminate a whole gendered identity, we lose its usefulness as a term for a particular symptom and strategy. I want to retain as a backdrop the general association between femininity and masquerade, on the one hand, and masculinity and parade, on the other. But I also argue that the concept of masquerade as a negotiated strategy for gendered survival offers some purchase on the specific, contradictory, and idiosyncratic masculinities of my artist-protagonists.

Augustus John and Wyndham Lewis (who partly learned it from John) were very good at parade: not the civic display of "feathers or ties or medals," but its bohemian antidote. Bohemian parade conjured a masculinity even more phallic in its flamboyance, its sexuality, and its studied neglect of the sartorial niceties that connoted in turn the constraints of duty, decency, and social decorum. As early as 1858, a character in Mary Jackson's novel *Maud Skillicorne's Penance* complains that young artists are "gross in their habits and tastes, snobbish in their appearance aping foreigners in wearing dirty moustaches and antediluvian cloaks."[54] This was not a bad description of Wyndham Lewis in Paris almost half a century later. Bohemian clothing had become a cliché, the garb of minor artists and the merely arty. John retreated further into gypsydom. Lewis made the knight's move and adopted an ironic black suit. Nevinson and the rest of the "Slade coster gang" went for "black

jerseys, scarlet mufflers and black caps or hats." ("We were the terror of Soho and violent participants, for the mere love of a row, at such places as the anti-vivisectionist demonstrations at the 'Little Brown Dog' at Battersea.") [55]

The appropriation of bits of working class clothing into a rougher masculinity than their families had fitted them for is characteristic of the attempt to modernize the tired particularities of artistic identity. It is also, paradoxically, characteristic of parade. The infusion of virility, which is the staple metaphor distinguishing modernity from 1890s aestheticism, comes not from the hierarchical trappings of the desk-bound bourgeoisie but from an invocation of what are perceived as the uncultivated and, hence, unfettered masculinities of the manual and the marginal: costers, navvies, gypsies, "savages." [56] My point is that this is of more than incidental or biographical interest. The proper study of womankind is not always or necessarily woman: masculinity is a problem for feminism (as well as for women and, arguably, men), and both feminism and art history, in focusing on these emergent and provisional masculinities, can illuminate something of modernism's "myth of its own origins" and interests.

I want now to touch on some work of Augustus John's from 1905 and 1909, on what Roger Fry first termed "post-impressionism" in the context of the 1910 and 1912 exhibitions, and on Vorticism, particularly as exemplified in *Blast*. What interests me is the assumption of masculinity, the inscription of sexual difference, and the opportunities afforded by particular groups and practices for women's participation.

Augustus John

John's love of the open road had first been stimulated by Walt Whitman's *Leaves of Grass*. But as professor of painting at Liverpool between 1901 and 1904, he came into contact with the Romany cult through John Sampson, a noted Rai (or non-blood brother), folklorist, and librarian of Liverpool University College. From this point, John aimed to inhabit as far as possible the gypsy life while making it—and here was the rub—compatible with the needs of his family and his subject matter as an artist. In 1905 he acquired a gypsy caravan on the "never-never" from Michel Salaman, taking it to Dartmoor in the early summer and on a more extended trip north in 1909.

The gypsy travelers of the nineteenth century were both oppressed

and romanticized. Their nomadic and acapitalist way of life was increasingly at odds with the structures and values of an industrializing, sedentary, labor-market economy. Various attempts were made by evangelical missionaries and local authorities to educate their children and restrict their movements. At the same time, ethnographers and enthusiasts were studying the Romany dialects, developing the subject of gypsy lore, and compiling the profile of a distinct community within the category of vagrants and casual laborers. (This profile—of a community with its own language, social codes, and transnational European identity—has been strongly challenged by modern scholars.)

The romantic and ethnographic interest in gypsies overlapped with two other concerns: with the advocacy of outdoor leisure pursuits for jaded businessmen, on the one hand, and with a literary fascination for the "open road" exemplified by writers like George Borrow and W. H. Hudson, on the other. Both assumed that the undoubted virtues of modern civilization were inseparable from its debilitating effect upon masculinity, its customs "so polite and graceful as to be at times a positive tax upon a man's time and person." [57] The cult of the open road seemed to offer a last resistance to timetables, frontiers, passports, by-laws, and bourgeois domesticity. It joined with artistic and literary concerns in the pastoralism of the Georgian poets, in magazines like Douglas Goldring's *Tramp* (the first to publish the Futurist Manifesto in English in 1910, along with short stories by Wyndham Lewis and detailed instructions for caravans and tents),[58] and in the pre-war paintings of Augustus John, upon which his reputation chiefly rests.

John's gypsy paintings (unlike Laura Knight's) work his wife and mistress into Romany muses. ("How would you like yourself as a Romany lady?" [59] he asked Dorelia in 1903, and he sent her love letters in the Romany dialect with word lists to learn.) The actual inhabiting of this exotic mythology left Dorelia giving birth in the caravan on a bleak stretch of Dartmoor in the early summer of 1905, and Ida, John's wife, who came to help, washing the family linen in the stream. *Caravan at Dusk* (1905) depicts a gypsy tent of traditional hazel rod construction (instructions were later available in *Tramp*) and clothing drying on the grass. The striped tent appears again, framing the sunlit scene, in *Gypsy Encampment* (1905).[60] John, bearded, leans over the half-door smoking a clay pipe. Ida nurses Robin. Dorelia appears twice, standing in a hat and on the extreme left in the tent with the new baby, Pyramus.

Two years earlier, soon after John had met Dorelia and at a critical stage in their relationship, his sister Gwen John had suggested that

5. Gwen John, *The Student*, 1903–1904. Manchester, courtesy City Art Gallery.

6. Augustus John, *The Smiling Woman*, 1908–1909. London, courtesy Tate Gallery.

Dorelia and she should walk to Rome. Augustus was incensed. He was concerned for their safety but also, perhaps, because vagabonding was to be done under his wing and on his terms. In the autumn of 1903, Gwen and Dorelia took a steamer down the Thames, landed at Bordeaux, and began working their way up the Garonne Valley from village to village. They slept mostly under haystacks or in stables, lived on grapes, bread, lemonade, and a little beer, and earned a few francs from singing or drawing portraits in local inns. The going was hard, not least because their appearance was sometimes misconstrued and the village men would "want to know where we are going to sleep and follow us." At the end of November, they paused in Toulouse, where Gwen painted several portraits of Dorelia. In February 1904—abandoning the idea of

Rome—they returned to Paris, where both earned a living by modeling and Gwen returned to work.[61]

Gwen John's painting of Dorelia as *The Student* was finally exhibited at the New English Art Club in 1909 (fig. 5).[62] In 1908 Augustus painted Dorelia as *The Smiling Woman*[63]—a painting that made his name—and the portrait was included in the International Society's exhibition of "Fair Women" at the New Gallery in 1909 (fig. 6). The comparison is instructive. Reviewing the exhibition for the *Burlington Magazine*, Roger Fry noted that the "vitality of this gypsy Gioconda is fierce, disquieting, emphatic," and enhanced by "the summary strokes with which the swift play of the features and the defiant poise of the hands are suggested."[64] Michael Holroyd and Malcolm Easton suggest that he could be forgiven for failing to recognize in the model "a Miss Dorothy McNeill of respectable urban origins." Between them, John and Dorelia had effected "an ethnic change of the most startling order,"[65] as well as a shift of femininities from the almost demure and concentrated pose of *The Student* to something exotic, extravagant, and seductive. (*The Smiling Woman* prefigures the gypsy heroines of *Tramp* short stories: "a black-eyed Egyptian minx; a rinkeno, ruzlo lass with black hair parted down the middle, . . . gold ear-rings, . . . [and] the mafada, flirtatious glint in her radiantly dark eyes."[66] We cannot measure the paintings against the "truth" of Dorelia; that is not in the nature of picture-making, and Dorelia was in any case adept in a variety of picturesque roles. Augustus goes for bravura and Hals; Gwen for something more *intimiste* with hints of Ingres. There is nothing in *The Student* to tell us that this woman and the artist had just walked from Bordeaux to Toulouse, and much in *The Smiling Woman* to invoke the myth of an exotic vagabond. Both figures are "staged," and staged in relation to concerns shared intimately with the artist; but the staginess of *The Smiling Woman*, its summary vivacity and complicit grin, hint at the role it plays in the artist's sense of his own identity. (We are reminded of Virginia Woolf's comment that a man needs a woman to reflect himself back to himself at twice his normal size.)

Roger Fry, Post-Impressionism and "Omega"

"On or about December 1910, human character changed,"[67] as Virginia Woolf famously put it, meaning life in general but significantly

choosing as her benchmark the public impact of "Manet and the Post-Impressionists." In the two exhibitions of 1910 and 1912, Fry introduced the British public to avant-garde French painting of the previous thirty-five years, enjoyed an enormous *succès de scandale*, and provided the impetus for new forms of modernism before World War I.

This was emancipation for Vanessa Bell, who said of the 1910 exhibition that "it was as if one might say things one had always felt instead of trying to say things that other people told one to feel."[68] The liberation she responded to as an artist was that of strong color, rhythmic line, and a spirited rejection of narrative and naturalistic subject matter. That this was *the* way to paint, and to respond to paintings, was a fundamental tenet of Fry and Clive Bell's modernist aesthetic. That there were no women artists in the 1910 exhibition (Vanessa Bell and six others contributed in 1912),[69] and that its representations of femininity were conventional in all but a strictly pictorial sense, would have been considered a philistine observation not only by Fry and Bell but probably by Vanessa Bell as well.

A measure of institutional opportunity and social emancipation had produced a contradictory situation for women artists in the Edwardian period. Thousands of women were trying to make a living as artists by the turn of the century (3,699 as against 10,250 men in the census of 1901),[70] but the *idea* of the woman artist, if more familiar, was still contested and uncomfortable: They threatened "to become a veritable plague, a fearful confusion, and a terrifying stream of mediocrity."[71] Reviewers condescended to women and called, at the same time, for a specifically feminine art, one that would reproduce the values inscribed to women in the dominant discourses on femininity. Women, in flight from the newly insistent but inferior category of the female artist, conceded the wisdom that "Art has no sex."[72]

The 1910 "Post-Impressionist" exhibition[73] concentrated on work by Cezanne. Gauguin, and van Gogh, with Manet posited as a point of origin, together with work by younger artists including Matisse, Vlaminck, Derain, and pre-cubist Picasso. Some were very well known works, and others cannot now be identified. It is nevertheless possible to hazard from the titles that, in a show containing a large number of landscapes and still lifes, between a quarter and a third of the paintings were paintings of women and almost all the sculptures were of women. They ranged from Manet's *Bar at the Folies Begère* to nudes by Matisse, Picasso, Vallotton, and Maillol. They included Cezanne's *Les Ondines* and *La Toilette*; Redon's *Femme d'Orient*; Gauguin's *Mater-*

nité, *Negrèsses*, and *Tahitiènnes*; and van Gogh's *Madone* and *Jeune Fille* (the mad girl from Zola's *Germinal*). For the British public, these were not conventional paintings, and not until 1912 would Fry find—having promoted—British work to hang in their company. What limited the radicalism of Fry's choice—however outrageous it seemed at the time—was not just the exclusion of cubism or futurism but the extent to which French modernism was premised on the modernizing—the pictorial fragmentation, intensification, or primitivizing—of humanist themes.

The 1910 exhibition attracted adverse publicity, but its extent has been greatly exaggerated; what needs explaining is not so much a scandal (that seductive trope of the embattled avant-garde), but a success. Stella Tillyard (*The Impact of Modernism*) points out that several newspapers implied that the majority of visitors were women. This was partly a way of "striking a triple blow" against women, fads, and modern art—the wife in the *Westminster Gazette*'s fictional dialogue sandwiches the post-impressionists between a suffrage meeting and a Bernard Shaw play.[74] But Tillyard suggests it is likely there *were* more women present than critics expected at exhibitions of modern art, partly as a result of the modicum of social independence but partly because Fry's and Bell's defense of post-impressionism drew on the language and aesthetic of the arts and crafts movement. When Fry—and Desmond MacCarthy, who wrote the catalogue essay from Fry's notes while well fortified with champagne—used words like harmony and rhythm, decoration and design, women "were put in a position to participate in the reception of the new art in a way that they had never been before."[75] The collapse of the arts and crafts movement "left two important groups of consumers without an aesthetic cause consonant with their beliefs": wealthy upper middle and upper class patrons who bought expensive objects and commissioned decorative schemes, and the liberal educated classes who went to exhibitions, bought reproductions, and provided the intellectual backup for the new painting.[76] The critics who wrote about post-impressionism were men (there were no regular women art critics in the national press in 1910). The consumers who bought it, at least as it was translated into applied arts ventures such as the Omega Workshops or, subsequently, Lewis' Rebel Art Centre, were principally (upper class) women. By 1914, Fry and Lewis numbered among their patrons Lady Ottoline Morrell, Countess Drogheda, Lady Tree, the Duchess of Rutland, Lady Cunard, Lady Diana, Lady Margery Manners, and the wives of the Belgian and German ambassadors.[77]

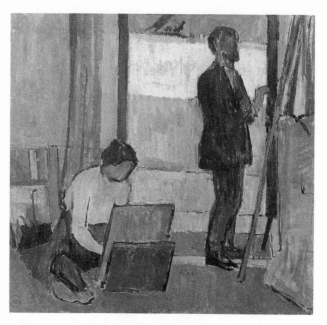

7. Vanessa Bell, *Frederick and Jessie Etchells Painting in the Studio at Asheham*, 1912. London, courtesy Tate Gallery.

Fry founded the Omega Workshops in May 1913.[78] "Omega" was a shop and workshop in Fitzroy Square that sold pottery, rugs, hand-painted furniture, clothes, bags, necklaces, and fabrics (including brightly patterned cloth printed in Manchester for the African market). Omega was intended not only to introduce post-impressionism and "the spirit of fun" into modern interiors but to help support artists who couldn't make a living without a market for modern art. (The artists were paid five shillings per half day for a maximum of thirty shillings per week.) The division of labor favored the men as independent creators (and Vanessa Bell as a co-director) and a bevy of "Cropheads," including Nina Hamnett, Gladys Hynes, Jessie Etchells, and Winifred Gill, as interpretants (fig. 7). Some of the artists seem, like Frederick Etchells, to have been "emancipated" into abstraction by the experience of working on abstract designs for rugs and textiles. Much of the tedious work such as stringing beads and translating rug designs onto graph paper fell to the women. Winifred Gill remembered a lot of time spent painting table legs, trays, "and endless candlesticks for electric lights."[79]

Wyndham Lewis, Vorticism, and Blast

Wyndham Lewis walked out of Omega in October 1913, less than six months after it opened, after a bitter but obscure quarrel now known as the "Ideal Home Rumpus." [80] He and his fellow secessionists accused Fry of manipulating the *Daily Mail*'s commission of a room for the Ideal Home Exhibition, and in an open letter to the *Observer*, they distanced themselves from Fry's "party of strayed and dissenting aesthetes" as the boys who would do "the rough masculine work" of British modernism. To do this they had to make their double rebellion clear—against academic conservatism and, simultaneously, against post-impressionism, which occupied the high ground of the avant-garde. They damned Fry's "curtain and pincushion factory in Fitzroy Square" [81] as effeminacy-by-association while reserving the right, as it transpired, to set up in business for themselves.

Kate Lechmere was the inspiration and backer for the Rebel Art Centre, set up in 1914. (William Roberts later recalled the Lewis/Fry debacle not as a debate over aesthetics but as "a clash between rivals for profits of the English interior-decorating market.") [82] She was prepared to pay the rent, make the curtains, and hand around the tea on Saturday afternoons (fig. 8). (Lewis insisted that "organising tea-parties was a job for women, not artists.") [83] The Rebel Art Centre was something of a disappointment. Plans for an art school and concerts by Schoenberg and Scriabin failed to materialize. Its only group project was its stand at the Allied Artists' Exhibition in June 1914. Gaudier reviewed its "great strength and manliness in decoration" in the *Egoist* at the expense of Omega "prettiness"; [84] but it seems likely that the manly decoration was dependent on a subaltern role for the women, just as in the Omega Workshops.

Eventually the rent came due, and the artists failed to chip in. Lewis was disorganized and distracted by *Blast*. Kate Lechmere's affections strayed to T. E. Hulme, who later proposed to her in an ABC teashop. [85] The Rebel Art Centre closed. Kate Lechmere was blessed in *Blast* but her one hundred pound printing loan was never repaid.

Marinetti and Nevinson in their manifesto of *Vital English Art* (which scooped *Blast* by a month in 1914) damned "the effeminacy of [English] art" and the "English notion that Art is a useless pastime, only fit for women and schoolgirls." [86] The Vorticists argued that "the artist of the modern movement is a savage" and declared themselves "Primitive Mercenaries" in the "iron Jungle [of] the great modern city." Lewis de-

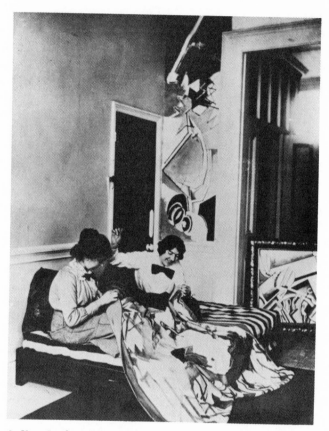

8. *Kate Lechmere sewing curtains at the Rebel Art Centre,*
1914. Norwich, courtesy University of East Anglia Archives.

spised Romantic "Marinetteism"—"We don't want to go about making
a hullo-bulloo about motor cars"—but he envied the electric crane ("It
is a pity that there are not men so strong that they can lift a house up,
and fling it across a river.")[87]

This cult of rough masculinity and Nietzschean egoism has a lot to
do with women, with the fear of effeminacy, feminism, and the chang-
ing world of art. Lewis loathed artiness and amateurs and probably
associated women with both. He hated "taste" and was one of the
first modernists to speak of the invigorating influence of the cheap and
the tawdry. But there is a class inflection, too, that is easily missed. The

vorticists were scholars, not gentlemen. Many had been to grammar schools, Bomberg and Roberts had commenced apprenticeships; they were the children of working men, shopkeepers, foreigners, or the nouveau riche.[88] The gruffer they were the more they asserted an identity. Hulme carried a set of knuckledusters (by Gaudier). Etchells—who liked Lewis—called him "a tremendous bully who wanted to be top dog all the time." He also repeats a nasty little anecdote about Lewis intimidating seamstresses in the Paris streets, which Lewis called "doing a Stendhal" but that we would call sexual harrassment.[89]

These attitudes seem very unpromising, but it is worth noting that there were two women who signed the vorticist manifesto: Jessica Dismorr and Helen Saunders.[90] Both had studied at the Slade, and Dismorr had also studied in Paris, where she had been absorbed into the British Fauve circle associated with *Rhythm* magazine—John Fergusson, Samuel Peploe, and Anne Estelle Rice.[91] Dismorr's *Rhythm* drawing of Isadora Duncan (1911) is already more *angular* than the other illustrations in the magazine (particularly Fergusson's silly curvaceous Eve on its cover).[92] Saunders (spelled "Sanders" in *Blast* in deference to her respectable home background)[93] moved from a Cezannesque post-impressionism c. 1912 towards something more awkward and harshly expressive in gouaches like *The Rock Driller* and *Female Figures Imprisoned* (c. 1913) (fig. 9).[94] Their position in Vorticism is clearly ambivalent. William Roberts' much later painting of *The Vorticists at the Restaurant de la Tour Eiffel: Spring 1915* suggests they were eager but marginal. Lechmere remembered them (spitefully?) as "little lap-dogs who wanted to be Lewis's slaves and do everything for him." [95] Goldring recalled Dismorr leaping up to make the tea when bidden at the inaugural *Blast* tea party.[96] Making the tea seems to have been a regular rite of feminine subservience. But it is worth noting two things. First, that in a work like *Female Figures Imprisoned* Saunders probably comes closer than anyone else in the pre-war avant-garde to producing an overtly feminist painting; and second, that Dismorr and Saunders' literary contributions to *Blast* 2 in 1915—stranger and more vivid than their competent abstractions—are remarkable for the attempt to harness elements of vorticist enthusiasm and vocabulary to "feminine" themes.[97]

What might have encouraged Saunders and Dismorr to identify their interests with those of vorticism and its apparent contempt for femininity, particularly since Dismorr had moved from the orbit of *Rhythm* magazine and the British fauves, which should have proved more congenial?

9. Helen Saunders, *Untitled* (Female Figures Imprisoned), c. 1913. Courtesy of
Private Collection.

Although vorticism is notorious now for the bully-boy style of its
polemics, this should not blind us to the fact that, in its rejection of sen-
timent, narrative, moralizing, and passivity, it also rejected much that
was feeble and titillating in images of women. The futurists ordered "no
nudes for ten years." [98] Fry drew the wrath of the art establishment on
his head in 1913 for asking how long it would take "to disinfect the
Order of Merit of Tadema's scented soap." [99] Pornographic sudsiness
was anathema to Lewis, too. So were John's endless gypsies and Sickert's
Camden Town "low-life" art, "with its cheap washing-stands and im-
modest artist's models squatting blankly and listlessly on beds." [100] In
Blast he asserted that "the actual human body becomes of less impor-
tance every day." [101] Hulme, discussing Lewis' work, said that "the art-
ist's only interest in the human body was in a few abstract mechanical
relations perceived in it, the arm as lever and so on. The interest in living
flesh . . . is entirely absent." [102] Women are displaced by machines in
Blast as the proper subject and inspiration of modern art: "We hunt

machines they are our favourite game. / We invent them and then hunt them down." [103]

Blast blasted effeminacy, in women or men. It damned the Britannic aesthete, but it blessed the suffragettes.[104] (More specifically, it blessed Lilian Lenton, a convicted arsonist, and Freda Graham, who slashed five paintings in the National Gallery.) It blasted Oscar Weininger,[105] whose 1903 book on *Sex and Character* identified masculinity with genius and women with childbearing and the unconscious life. It departed from futurism on the question of women—though even Marinetti extolled the suffragette in an address to the Lyceum Club in 1910, exempting her from the futurist "contempt for woman," whose "snake-like coils" had ever "choked the noblest ideals of manhood." [106] The play of sexual difference across the rhetoric of British modernism suggests that the rising Turks consolidated their position by identifying their opponents as dilettante or effete. But it also, if surprisingly, offered opportunities for a *feminist* repudiation of femininity, if at the cost of swapping feminist content for geometric form (Helen Saunders' *Female Figures Imprisoned* of 1913 for *Abstract Composition* of 1915 (fig. 10). Perhaps, though, the opportunities for women in this aesthetically radical milieu were actually *less* than they had been for Mary Cassatt, Suzanne Valadon, or Paula Modersohn-Becker. Women, too, wanted out of effeminacy. If the suffrage campaign shifted from arguments based on equality to those based on difference around the turn of the century (from "justice" to "expediency"), women artists did the reverse. They needed to escape the debilitating attributes of femininity and chose "art has no sex." The opportunity for a contribution to "the painting of modern life" that was *at the same time* womanly, implicitly feminist, and stylistically avant-garde had probably passed. The contributions of artists as different as Valadon and Gwen John lay in the *refusal* of the radical modernisms of the 1910s and 1920s. We have to look outside Britain and not to Helen Saunders for something that smacks of a *feminist modernism*, to the work of Natalia Goncharova, for instance, more concerned in establishing her identity as a Russian and a modernist than as a woman.[107] Nevertheless, witty and ironic feminine references intrude into such vigorously avant-garde imagery as the Tate Gallery's *Linen* of 1912.

Vorticism ended with the war, cut down in its prime like Gaudier and Hulme. Most of the Bloomsburyites were pacifists and conscientious objectors. Most of the vorticists were volunteers or willing conscripts. Those that survived did not resume where they left off. The experi-

10. Helen Saunders, *Abstract Composition in Blue and Yellow*,
c. 1915. London, courtesy Tate Gallery.

ments of what Lewis called "that little segment of time on the far side
of world war i" [108] had lost their relevance. Women had gained the vote
and the removal of the Sex Disqualification Act. Well over 600,000 men
had been killed, about 9 percent of the male population under fifty-five.
The vocabulary of *Blast* had been blasted by the war. But the desire

for, and fear of, femininity remained at the heart of the transformed modernisms of the 1920s and 1930s. In one corner stood Henry Moore, champion of humanist abstraction, whose sculptures of the interwar years are almost exclusively of the maternal or reclining female figure: the Primeval Mother, as the analyst Erich Neumann discusses them in *The Archetypal World of Henry Moore* [109] (a book Moore found too uncomfortable to finish). In the other corner stood André Breton, author of the 1924 "Manifesto of Surrealism," in which he describes his dream of a castle "in a rustic setting, not far from Paris." He would live there and work with a few of his friends as permanent guests: Louis Aragon, Robert Desnos, Artaud and Paul Eluard, "and so many others besides, and gorgeous women I might add. . . . Isn't what matters that we be the masters of ourselves, the masters of women, and of love too?" [110]

One of the *un*modern things about Western modernism is that the answer to this question—the question of *The Magic Flute*,[111] one of the oldest questions in the world—is, despite the modernizing impact of feminism and of women's entry into public life, still invoked as a resounding "Yes." [112]

NOTES

1. I say "sketch" advisedly; my paper consists of a series of exploratory forays onto the territory of pre-war British modernism. It forms part of a larger work-in-progress.

2. George Dangerfield refers to the years between 1910 and 1914 as "four of the most immoderate years in English history . . . hysterical, violent and inconclusive" (*The Strange Death of Liberal England* [1935; reprint, London, 1970], 18). I want to extend his description to the period between 1905 and 1915; that is, to the years between the outbreak of feminist militancy and the publication of *Blast* 2.

3. Frank Rutter, *Revolution in Art* (London, 1910).

4. The "round-robin" letter is quoted in full in W. K. Rose, ed., *The Letters of Wyndham Lewis* (London, 1963), 47–50.

5. *New York Evening Sun*, 13 February 1917. Quoted in Sandra Gilbert and Susan Gubar, *The War of the Words*, vol. 1 of *No Man's Land: The Place of the Woman Writer in the Twentieth Century* (New Haven, 1988), vii.

6. See *Rhythm*, 2 vols., nos. 1–14 (1911–1913), prospectus for June 1912, bound in with vol. 1: "*Rhythm* will aim at securing its position as the *Organ of*

Living Art and Living Thought." D. H. Lawrence, "The Georgian Renaissance," *Rhythm*, Literary Supplement (March 1913); Gilbert Cannan, "Observations and Opinions IV: Marriage," *Rhythm* 2, no. 10 (November 1912). See also Sheila McGregor, "J. D. Fergusson and the Periodical 'Rhythm,'" in *Colour Rhythm and Dance: Paintings & Drawings by J. D. Fergusson and His Circle in Paris* (Scottish Arts Council, 1985).

7. Rachel Bowlby, *Just Looking: Consumer Culture in Dreiser, Gissing and Zola* (New York and London, 1985). See particularly chap. 2, "Commerce and Femininity."

8. Griselda Pollock, "Modernity and the Spaces of Femininity," in her *Vision and Difference* (London, 1988), 54. Gilbert and Gubar, *War of the Words*.

9. Richard Cork, *Vorticism and Abstract Art in the First Machine Age*, 2 vols. (London, 1976), 424.

10. Michèle Barrett, "The Concept of Difference," *Feminist Review* 26 (Summer 1987). I discuss this article and its implications for art history in "Feminism, Art History, and Sexual Difference," *Genders* 3 (Fall 1988).

11. Stuart Hall, "Theories of Language and Ideology," in *Culture, Media, Language* (London, 1980), 159.

12. Mary Garrard, "Artemisia and Susanna," in *Feminism and Art History: Questioning the Litany*, ed. Norma Broude and Mary Garrard (New York, 1982), 161.

13. I borrow this formulation from Norman Bryson's introduction to the College Art Association panel on "What Use Is Deconstruction, Anyway?" (Houston, 1988).

14. Peter Wollen, "Fashion/orientalism/the body," *New Formations* 1 (Spring 1987), 29.

15. I discuss this in *The Spectacle of Women: Imagery of the Suffrage Campaign 1907–1914* (Chicago, 1988).

16. Jacob Epstein, *Let There Be Sculpture: The Autobiography of Jacob Epstein* (London, 1942), 56. See also Richard Cork's discussion of Epstein in *Vorticism and Abstract Art*, 456ff.

17. The impact of the Slade (opened 1871), the New English Art Club (from 1886), and the Academy Reform Movement (1886–1887) all took their toll.

18. See *The Art Press: Two Centuries of Art Magazines* (London, 1976; *Studio International* 193, no. 983 (September/October 1976) (special issue on art magazines), particularly John Tagg, "Movements and Periodicals: The Magazines of Art." *The Studio*, founded in 1893, offered feature articles, art criticism, and instruction in various arts and crafts techniques; its readership included professionals, students, amateurs, and the cultivated middle class in general, to which *The Studio* offered itself as "the recognised vehicle of modern art knowledge."

19. The genre of the artist-novel stretches from the late eighteenth century and Goethe's *Werther and Wilhelm Meister*, to Joyce's *Stephen Dadelus* and

beyond. It embraces a host of minor and forgotten authors (Ouida, Gertrude Jewsbury, Gilbert Cannan), and some of the canonical fiction of the period (Balzac, James, Proust, Joyce). Henri Murger's immensely influential *Scenes de la vie de bohème* (1845) was first translated as *The Bohemians of the Latin Quarter* in 1887 and reappeared with different titles in 1901, 1908 and 1920. George du Maurier's *Trilby* was published in 1894, reputedly selling 100,000 copies in the first three months. Directly and through stage adaptations (including Puccini's *La Bohème*, dramatic versions of *Trilby*, and a whole host of Trilbyana), Murger and du Maurier represent the furthest reach of the artist-novel in terms of sales, public popularity, and innumerable citations in memoirs and other works of fiction. But scores of artist-novels were published between about 1885 and 1920, many of them, like *Trilby*, which first appeared in *Harper's Bazaar*, reaching an expanding public in serial form. The best-known avant-garde *kunstlerroman* is Joyce's *Portrait of the Artist as a Young Man* (1914), but Wyndham Lewis's *Tarr* (1918; rev. ed. 1928) is comparably innovatory.

On the *kunstlerroman* see Bo Jeffares, *The Artist in Nineteenth Century English Fiction* (Gerrards Cross, 1979); Maurice Beebe, *Ivory Towers and Sacred Founts: The Artist as Hero in Fiction from Goethe to Joyce* (New York, 1964); Lee T. Lemon, *Portraits of the Artist in Contemporary Fiction* (Lincoln and London, 1985); Grace Stewart, *A New Mythos: The Novel of the Artist as Heroine 1877–1977* (St. Alban's, VT., 1979). (Beebe adds further references on p. 5, note 4; there is, however, more to be said about the *kunstlerroman*, women artists, and sexual difference.)

20. On the "new woman," see A. R. Cunningham, "The 'New Woman' Fiction of the 1890s," *Victorian Studies* (December 1973); Elaine Showalter, *A Literature of Their Own: British Women Novelists from Brontë to Lessing* (1977; reprint, London, 1978), chapter 7; Gail Cunningham, *The New Woman and the Victorian Novel* (London, 1978); and Rosalind Rosenberg, *Beyond Separate Spheres: The Intellectual Roots of Modern Feminism* (New Haven, 1982), chapter 3, all of which cite further sources.

21. Octave Uzanne, *The Modern Parisienne* (London, 1907), 129–30.

22. Ezra Pound recalled Gaudier-Brzeska's conversation as a flow of remarks jabbing the air: "it might be exogamy, or the habits of primitive tribes, or the training of African warriors, or Chinese ideographs, or the disgusting 'mollesse' of metropolitan civilization . . ." (Ezra Pound, *Gaudier-Brzeska: A Memoir* [1916; reprint, Hessle, Yorkshire, 1960], 39–40). The identification of the "virile" with the "primitive," the laudatory use of "phallic," and the appeal to a mythically potent masculinity—one unenfeebled by urban life—recur in writings by Lewis, Pound, Gaudier-Brzeska, and others. "The artist of the modern movement is a savage," proclaimed the *Blast* "Manifesto II" (20 June 1914). These claims reverse, if they do not improve, the common, casual, and racist evaluation of tribal cultures as either primitive or degenerate.

23. Two recent articles illuminate the problems of subjectivity and author-

ship in art historical analysis: J. R. R. Christie and Fred Orton, "Writing on a Text of the Life," *Art History* 11 (December 1988); and Griselda Pollock, "Agency and the Avant-Garde," *Block* 15 (Spring 1989).

24. Ethel Ducat, *Votes for Women*, 26 May 1911.

25. See Rudolph and Margot Wittkower, *Born Under Saturn: The Character and Conduct of Artists: A Documented History from Antiquity to the French Revolution* (London, 1963). The Wittkowers dismiss the idea of a specifically artistic "type" but point to the efficacy of nineteenth-century psychologists such as Cesare Lombroso in helping to produce one. Lombroso and others lent scientific authority to a loose conglomerate of popular beliefs, philosophical thought, and literary convention. The Wittkowers conclude (p. 294) that, while psychology failed to solve the enigma of the creative personality, it nevertheless helped *shape* "the generic personality and character of modern artists."

26. Ernst Kris and Otto Kurz, *Legend, Myth, and Magic in the Image of the Artist: A Historical Experiment* (New Haven, 1979), 2 n. 1 (citing R. Linton [1943] on "additional configurations of responses"), and 132 ("enacted biography").

27. The analogy with Roman decadence was made in *The Decline and Fall of the British Empire*, published anonymously by the Tory pamphleteer Elliott Mills in 1905, and was subsequently taken up in Baden-Powell's *Scouting for Boys* (1908), Balfour's 1908 address on "Decadence," and elsewhere. I am indebted to Samuel Hynes, who discusses these and related sources in "The Decline and Fall of Tory England," chap. 2 of *The Edwardian Turn of Mind* (Princeton, 1968). The concern with *moral* decline was enhanced by the trial of Oscar Wilde in 1895 and by the publication in the same year of the English translation of Max Nordau's *Degeneration*. Nordau argued that all characteristically modern art showed evidence of the decadence threatening the human race. He was widely cited or echoed in conservative criticism of the post-impressionists in 1910 and by opponents of futurism, vorticism, and other manifestations of pre-war modernism.

28. "Social Darwinism" is a convenient term for a variety of applications of evolutionary theory to social theory between the 1870s and 1914. Darwin's cousin, Francis Galton, coined the term "eugenics" in 1883, but eugenic theories were also influenced by the social philosopher Herbert Spencer, who had first used the expression "the survival of the fittest" in 1864. There is an extensive literature, but see Raymond Williams' chapter, "Social Darwinism," in *Problems in Materialism and Culture* (London, 1980); Jeffrey Weeks, *Sex, Politics and Society: The Regulation of Sexuality since 1900* (London and New York, 1981), chapter 7; Jane Lewis, *Women in England 1870–1920*, (Oxford, 1984); David Green, "Veins of Resemblance: Photography and Eugenics," *Oxford Art Journal* 7, no. 2 (1984).

29. On pro- and antisuffrage imagery, see Tickner, *The Spectacle of Women*. Feminism, femininity, and evolutionary theory are discussed on pp. 185–92.

30. Sir Almroth Wright, *The Unexpurgated Case Against Women's Suffrage* (London, 1913), 60.

31. See among others Patricia Hollis, ed., *Women in Public 1850–1900* (London, 1979); and Lee Holcombe, *Victorian Ladies at Work: Middle Class Working Women in England and Wales 1850–1914* (Newton Abbot, 1973).

32. As Elsie Clews Parsons commented in 1916: "Womanliness must never be out of mind, if masculine rule is to be kept intact" (*Social Rule: A Study of the Will to Power* [New York, 1916], 54). On the argument that fears of women's "masculinization" (by work, higher education, or the vote) masked fears of men's concomitant feminization, see Peter Gabriel Filene, *Him/Her/Self: Sex Roles in Modern America* (1974; reprint, New York, 1976), 72–77.

33. See Charlotte Yeldham, *Women Artists in Nineteenth-Century England and France* (London, 1984), chapter 2, part 3 ("Societies of Women Artists"). Germaine Greer, *The Obstacle Race: The Fortunes of Women Painters and Their Work* (London, 1979), also lists women's exhibitions at this period (pp. 321–23).

34. *Rhythm*, invoking Watts and (indirectly) Burne Jones, painted a picture of the Victorian idealist as "an artist such as the *Girl's Own Paper* would be charmed with"; a "slim man of gentle manners . . . [who] paints the soul." Dan Phaër, "Types of Artists 1. The Victorian Idealist," *Rhythm* 2, no. 5 (June 1912).

35. Part 3 of Wyndham Lewis' *Tarr* is devoted to the "Bourgeois-Bohemians". Lewis at one point considered this as a title for the whole novel. The essential edition is now *Tarr. The 1918 Version*, ed. Paul O'Keeffe (Santa Rosa, 1990); scrupulous and illuminating.

36. Whistler's monogram was the butterfly (with a sting in its tail).

37. See for example Pound's letter to Margaret Anderson (September 1917) in which he referred to writing articles that can be reduced to "Joyce is a writer, GODDAMN your eyes, Joyce is a writer, I tell you Joyce etc etc. Lewis can paint, Gaudier knows a stone from a milk-pudding. WIPE your feet!!!!!!" *The Letters of Ezra Pound 1907–1941*, ed. D. D. Paige (London, 1951), 179. Note also his letter (ibid., 80) to Harriet Monroe, 30 September 1914, regarding T. S. Eliot: "He has actually trained himself *and* modernised himself *on his own*. The rest of the *promising* young have done one or the other but never both (most of the swine have done neither). It is such a comfort to meet a man and not have to tell him to wash his face, wipe his feet, and remember the date (1914) on the calendar."

38. Wyndham Lewis (in Paris, having seen Gwen John) to his mother, c. 1904, and again, c. 1907: *The Letters of Wyndham Lewis*, ed. W. K. Rose (London, 1963), 11–12, 31.

39. See Augustus John on Lewis as "our new Machiavelli" in *Chiaroscuro: Fragments of Autobiography* (London, 1952), 73: "In the cosmopolitan world of Montparnasse, P. Wyndham Lewis played the part of an incarnate loki, bearing the news and sowing discord with it. He conceived the world as an arena,

where various insurrectionary forces struggled to outwit each other in the game of artistic power politics." (Lewis left Rugby School by December 1897 and the Slade in 1901.) See Rose, *Letters of Windham Lewis*, 2, n. 38, on Lewis' years in Paris c. 1902–1909.

40. Lewis' Nietzschean manifesto is "The Code of a Herdsman," first published in *The Little Review* 4, no. 3 (July 1917) as "Imaginary Letters, III": "Above all this sad commerce with the herd, let something veritably remain 'un peu sur la montagne.' "The Crowd Master" appears in *Blast* 2 (1915) 98. Tyros (satires, "forbidding and harsh") first appeared in Lewis' *Tyros and Portraits* exhibition at the Leicester Galleries, April 1921, which included his *Self Portrait as a Tyro* (1920–1921). In 1921 and 1922, Lewis edited two issues of *The Tyro, a Review of the Arts of Painting, Sculpture and Design* (Egoist Press). The first section of the *Blast* "Manifesto" (20 June 1914) announces, "We are Primitive Mercenaries in the Modern World." Two of Lewis' biographers borrow their titles from his self-characterization as the Enemy: Geoffrey Wagner, *Wyndham Lewis: A Portrait of the Artist as the Enemy* (London, 1957), 22ff.; and Jeffrey Meyers, *The Enemy: A Biography of Wyndham Lewis* (London, 1980), 107–8.

41. See Pound's monograph on Gaudier-Brzeska, 47, n. 22: "He accepted himself as 'a sort of modern Cellini.' He did not *claim* it, but when it was put to him one day, he accepted it mildly, quite simply, after mature deliberation." And H. S. Ede, *Savage Messiah* (1931; reprint, London, 1972), 136: In Brodkzy's presence Gaudier-Brzeska "seemed to be thrown into a vivid energy. . . . Brodzky . . . [called him] 'Savage' and 'Redskin.' It pleased Pik [Gaudier] to be thought elemental, and Brodzky and Zosik [Sophie] would call him 'Savage Messiah,' a name deliciously apropos." Horace Brodzky himself recalled that Gaudier-Brzeska was "continually talking 'savage,' and 'barbaric' and gloated over the free and erotic life of the South Seas" (*Henri Gaudier-Brzeska 1891–1915* [London, 1933], 56).

42. Laurence Housman (alluding to John's presence in William Orpen's painting of *The Café Royal*), *Manchester Guardian*, 25 May 1912.

43. See "Cantleman's Spring-Mate," *Blast* 1 (20 June 1914): 94. Lewis' interest in Worringer is discussed by Geoffrey Wagner, *Wyndham Lewis*, 110, 153–55.

44. Pound (*Gaudier-Brzeska*) cites with approval Lewis' description of the "peculiar soft bluntness" in works such as Gaudier-Brzeska's *Stags* and *Boy with a Coney* (p. 26); and holds out for the "squarish and bluntish work" (including *Birds Erect*) as examples of the artist's "personal combinations of forms" (pp. 78–79). Brodzky (*Henri Gaudier-Brzeska*) quotes Pound—"Yes, Brzeska is immortalising me in a phallic column"—and stresses the phallic qualities of the head as intended from the beginning by sculptor and sitter (p. 62). Lewis described the finished work as "Ezra in the form of a marble phallus" (quoted by Cork, *Vorticism and Abstract Art*, 182).

45. John's numerous and complex liaisons and their progeny are dealt with

by Michael Holroyd, *Augustus John: A Biography*, rev. ed. (Harmondsworth, 1976). Lewis had three illegitimate children and conducted a range of concurrent relationships before, and during, his marriage (see Meyers, *The Enemy*). Kate Lechmere (for *Blast*) and then, in the 1920s, Anne Estelle Rice and Jessica Dismorr, among others, lent him money. In the case of Lechmere and Dismorr, this soured their relations. The diary of Gaudier's mistress Sophie Brzeska, whose name he took, is in Cambridge University Library. It is fraught with arguments about money and sex. Before we thank John Quinn and Ezra Pound as enlightened patrons of Gaudier-Brzeska, we should recall Sophie's dwindling savings and the washing, cleaning, cooking, and mending at which Gaudier sneered but of which he was the beneficiary. ("At least," Sophie remarked sarcastically, "I have saved a genius for humanity.")

46. "You are young and can stand a lot but you won't always be. Save your precious nerves. You must not be perpetually in a state of purposeless excitement. The grounds must be allowed to settle and the coffee to clear. . . . Don't stand any nonsense from your men friends and lovers. Keep them *tyrannically* to their settled hours—like a dentist—the hours that suit you—and them so far as possible. Don't give anyone any rights. Exact an absolute obedience to time *as the price of any intercourse at all.* Don't be a tin kettle to any dog's tail, however long." Walter Sickert to Nina Hamnett, 1918, quoted by Denise Hooker, *Nina Hamnett: Queen of Bohemia* (London, 1986), 114.

47. Quoted by Paul Levy, "The Colours of Carrington," *Times Literary Supplement*, 17 February 1978, p. 200. (Dora Carrington used only her second—ungendered—name.) There is a new biography: Gretchen Gerzina, *Carrington: A Biography* (London, 1989).

48. Vanessa Bell was tied into Bloomsbury aesthetics by an intricate network of kinship and love, as sister of Virginia Woolf, wife to Clive Bell, and lover first of Roger Fry and subsequently Duncan Grant. Curiously, both Bell and Carrington devoted their lives to men who were chiefly homosexual. But Grant, as a painter himself, was, unlike Lytton Strachey, able to demonstrate an active interest in his partner's work. And Bell took the practical step of founding her own exhibition society in the Friday Club. She was thus in a better position than the women excluded or marginalized by rival avant-garde coteries. See Richard Shone, "The Friday Club," *The Burlington Magazine* 117 (May 1975); and Frances Spalding, *Vanessa Bell* (London, 1983).

49. Joan Riviere, "Womanliness as a Masquerade," *The International Journal of Psychoanalysis* 10 (1929); reprinted with an article by Stephen Heath, "Joan Riviere and the Masquerade," in *Formations of Fantasy*, ed. Victor Burgin, James Donald, and Cora Kaplan (London, 1986). I am grateful to Whitney Davis and Claire Pajaczkowska for comments on the "masquerade," though I have no space to develop them here.

50. Jacques speaks the lines of William Shakespeare's *As You Like It*, but "Totus mundus facit histrionem" was a commonplace written on the wall of Shakespeare's theater, The Globe.

51. Riviere, from Burgin, Donald, and Kaplan, eds., *Formations of Fantasy*, 35.

52. Nevinson and Marinetti's futurist manifesto *Vital English Art* (1914), which damned effeminacy and called for an art that was "strong, virile and anti-sentimental," was published in full in the *Observer* (7 June 1914). It is reproduced in C. R. W. Nevinson, *Paint and Prejudice* (London, 1937), 58–60. Masculinity and femininity are assymetrically placed, of course, in relation to the masquerade as symptom or strategy. The defense of an aggressively heterosexual masculinity would be a defense against narcissism and the fantasized retribution of more virile men, there being no symmetrical economy of masculinity in which women would be the source of retribution.

53. Virginia Woolf, *Three Guineas* (1938; reprint, Harmondsworth, 1977), 23; Eugenie Lemoine-Luccioni, *La Robe* (Paris, 1983), 34; both quoted by Stephen Heath in *Formations of Fantasy*, 56.

54. Mary Jackson, *Maud Skillicorne's Penance*, vol. 1 (1858), 89, quoted in Bo Jeffares, *Artist in Nineteenth Century Fiction*, 67.

55. C. R. W. Nevinson, *Paint and Prejudice*, 26. He lists Wadsworth, Allinson, Claus, Ihlee, Lightfoot, Curry, and Spencer as fellow members of the "gang." There is no space here to go into the fascinating question of women's bohemian dress, but, Dorelia's gypsy finery aside, there is some suggestion (particularly with Nina Hamnett and Dora Carrington) that it veered towards bobbed hair, colored stockings or socks, and children's shoes: a carefully cultivated modern artist-ness that combined the New Womanly with the prepubertal. Like another of Riviere's patients, they treated the whole thing with levity and parody. Perhaps that was the form of their masquerade.

56. Augustus John's biographer speaks of his "inverted dandyism." He had, as Wyndham Lewis recalled, "a carriage of the utmost arrogance"; and Edward Thomas reported that "with his long red beard, ear-rings, jersey, check-suit and standing six feet high, . . . a cabman was once too nervous to drive him" (quoted in Holroyd, *Augustus John: A Biography*, 359. On John and gypsies, see ibid., (especially pp. 45, 356–60, 397, 401, 408–9); Malcolm Easton and Michael Holroyd, *The Art of Augustus John* (London, 1974), 12–13; and Malcolm Easton, *Augustus John: Portraits of the Artist's Family* (Hull, 1970). The 1909 caravan trip was photographed by Charles Slade, whose brother Loben married Dorelia's sister Jessie. There are prints in the National Portrait Gallery archives.

57. Henry Taunt, *A New Map of the River Thames . . . combined with guides giving every information required by the tourist, the oarsman, and the angler* (Oxford [undated but c. 1890]), 207–8:

To labour for hours in a foul atmosphere, as many mercantile men in London do, is an excess that damages many of them. . . . To strain every nerve of the brain in getting off orders and merchandise in the shortest space of time possible, and without the ommission of the slightest detail; or to be perched at a desk wading through accounts day after day, with scarcely

the slightest change of posture—all these are excesses that every City man more or less meets with, and which make the health of the body more delicate. . . . Gentlemen too, who have no business, still find excesses growing on their time and selves.

Camping out is the corrective for those who would leave behind "those cares of business, those endless accounts, those toils of pleasure that turn night into day."

58. *The Tramp: An Open Air Magazine*, designed to appeal "to the open-air man, the artist, the literary man, and the general reader." Edited by Douglas Goldring, vol. 1 (1910); vol. 2 (1910–1911). Contents include Harry Roberts, "The Art of Vagabondage"; L. C. Cameron, "A New Kind of Caravan"; Scudamore Jarvis, "The Caravan" ("how the gipsy life can be indulged in for the least possible outlay"); translations from Chekov; short stories by Wyndham Lewis, W. H. Davies, and Jack London; a review of the 1910 post-impressionist exhibition and extracts from the futurist manifesto; T. W. Thompson, "Gipsies. An Account of Their Character, Mode of Life, Folk-lore, and Language"; and William Kirby, "Francesca Furens," a mockingly antifeminist novella in six parts.

59. Quoted in Holroyd, *Augustus John: A Biography*, 186.

60. These paintings are reproduced in Holroyd and Easton, *Art of Augustus John*.

61. On the trip to Toulouse, see Holroyd, *Augustus John: A Biography*, 191–93; Cecily Langdale, *Gwen John* (New Haven, 1987), 24–25; and letters from Gwen John to Ursula Tyrwhitt (Gwen John papers, National Library of Wales, Aberystwyth). The quotation is from a letter to Tyrwhitt (1903), quoted by Langdale, p. 24. In Paris in 1904, both women modeled for artists, Dorelia to John's fury and jealousy. Gwen John posed chiefly for English women but also for Rodin, with whom she began an affair. (Rodin's *The Muse*, commissioned as a monument to Whistler but rejected in 1919, is a curiously coarse, disturbing, and amputated treatment of what Rodin called her "corps admirable.")

62. See Langdale, ibid., which includes a catalogue raisonné. She illustrates all four paintings for which Dorelia posed in Toulouse.

63. *The Smiling Woman* was the first picture purchased by the Contemporary Art Society and is now in the Tate Gallery.

64. Roger Fry, "The Exhibition of Fair Women," *Burlington Magazine* 15 (1909): 17.

65. Holroyd and Easton, *Art of Augustus John*, 15.

66. Harwood Brierley, "At the Shooting Gallery. The Gypsy Girl and Her Patrons," *The Tramp* 1 (August 1910): 460–62.

There is the mafada, flirtatious glint in her radiantly dark eyes, and on all counts she is a likely girl to draw custom. Alike at the beer bar, at the shooting saloon or gallery, at the board-walk of the pennygaff, and on the proscenium of the music-hall it is not so much a question as to what actual

value is given for money as to what kind of a girl serves, attends, or exhibits. Worldling patrons want a well-knit figure, sparkling eyes, more *chic* than cheek, and an easy chatsome manner. . . . A superficial familiarity, jaunty airs, and saucy manner suit her well. She knows her business, and the trick of the trade, which is naughty enough to please "buskins" and real swells alike, . . . [but] she holds aloof from men who attempt to chuck her under the chin for a "loobni" or harlot.

67. Virginia Woolf, "Mr Bennett and Mrs Brown," in *Collected Essays by Virginia Woolf*, vol. 1 (London, 1975), 320.
68. Quoted in Frances Spalding, *Vanessa Bell* (London, 1983), 92.
69. The 1912 Post-Impressionist Exhibition included work by Mme. Marval, Mme. Hassenberg, Mlle. Lewitzka, Mlle. Joukova, and Mlle. Natalia Goncharova (her paintings arrived late, at the beginning of 1913), and in the British section, Jessie Etchells as well as Vanessa Bell.
70. *The Census of England and Wales* for 1911 (vol. 10, Occupations and Industries, Part II) gives 4,202 females and 7,417 males in the category "Painters, Sculptors, Artists."
71. Octave Uzanne, *The Modern Parisienne* (London, 1907), 129–30.
72. Women gained entry to the academic curriculum as its influence waned and were often no better placed in the new avant-garde coteries than in the academy itself. Vanessa Bell complained of the New English Art Club that its members "seemed somehow to have the secret of the art universe within their grasp, a secret one was not worthy to learn, especially if one was that terrible low creature, a female painter" (Frances Spalding, *Vanessa Bell*, 36–37). Walter Sickert welcomed Ethel Sands and Nan Hudson into the Fitzroy Society in 1907 because he wanted "to create a Salon d'Automne milieu in London and you could both help me very much" (and in Nan's case, pour the tea). But when Fitzroy transformed itself into the Camden Town Group in 1911, women were excluded: "The Camden Town Group is a male club, and women are not eligible. There are lots of two sex clubs and several one sex clubs, and this is one of them" (Wendy Baron, *Ethel Sands and Her Circle* [London, 1977], 65 and 81). Women figured as signatories to the vorticist manifesto and contributors to *Blast*, but their position was marginal. Nina Hamnett's talent was swallowed by bohemia; she ended up the ravaged referent of Gaudier's *Torso*: "You know me," she would remark to acquaintances, "I'm in the V & A [Victoria and Albert Museum] with me left tit knocked off" (quoted from Ruthven Todd by Denise Hooker, *Nina Hamnett: Queen of Bohemia* [London, 1986], 213).
73. "Manet and the Post-Impressionists" took place at the Grafton Galleries, 8 November 1910–15 January 1911, and the Second Post-Impressionist Exhibition, also at the Grafton Galleries, was 5 October 1912 to (with a rearrangement at the beginning of January) 31 January 1913. See J. B. Bullen, ed., *Post Impressionists in England* (London, 1988); also Benedict Nicolson, "Roger Fry and Post-Impressionism," *Burlington Magazine* 93 (January 1951).

74. S. K. Tillyard, *The Impact of Modernism 1900–1920: Early Modernism and the Arts and Crafts Movement in Edwardian England* (London, 1988). I am indebted to her account. Tillyard cites the *Westminster Gazette* ("E.S.," "Post-Impressionism," 21 November 1910, p. 3) on p. 102.

75. Tillyard, ibid., 103.

76. Ibid., 39.

77. On the fashionability of the avant-garde, see also Nevinson, *Paint and Prejudice*, 58. As a young but well-publicized futurist acolyte, he heard Frank Rutter lecture on modern art in the evenings at the Doré Gallery and there met "Lady Muriel Paget, Lady Grosvenor, Lady Lavery, and through them pre-War Society," and at Lady Cunard's, "Eddie Marsh, Lady Diana Manners, and one hundred and one Guardees and Guinnesses."

78. On the Omega Workshops see Judith Collins, *The Omega Workshops* (London, 1984); Isabelle Anscombe, *Omega and After: Bloomsbury and the Decorative Arts* (London, 1981); Cork, *Vorticism and Abstract Art*, chap. 4; Richard Cork, *Art Beyond the Gallery in Early 20th Century England* (New Haven, 1985), chap. 3. Roger Fry's comment about "the spirit of fun" is quoted in these sources from Virginia Woolf, *Roger Fry: A Biography* (London, 1940), 194.

79. Winifred Gill, from an unpublished letter to Duncan Grant (4 July 1966, Victoria and Albert Museum Library); quoted in Hooker, *Nina Hamnett*, 63.

80. See Quentin Bell and Stephen Chaplin, "The Ideal Home Rumpus," *Apollo* 80 (October 1964); William C. Lipke, "The Omega Workshops and Vorticism," *Apollo* 91 (March 1970); W. Michel, *Wyndham Lewis: Paintings and Drawings* (London, 1971); Cork, *Vorticism and Abstract Art*, chap. 4; Jeffrey Meyers, *The Enemy: A Biography of Wyndham Lewis* (London, 1980), 41ff. Bell and Chaplin give the full text of the "strayed and dissenting aesthetes" letter, as does Rose in *Letters of Wyndham Lewis*.

81. Lewis' dismissive phrase from *Blast* 2 (July 1915).

82. On the Rebel Art Centre, see Cork, *Vorticism and Abstract Art*, 146ff; Cork, *Art Beyond the Gallery*, chap. 4. The decor was startling, with pale lemon walls and doors "of lawless scarlet [which] amicably agreed to differ with decorous carpets of dreamy blue." Lechmere lived in a flat above the centre, celebrated in a *Vanity Fair* article on "The Futurist Note in Interior Decoration" (25 June 1914). See also William Roberts' later pamphlet, *Some Early Abstract and Cubist Work 1913–1920* (London, 1957): "This was not a dispute of two erudites over a subtle point of aesthetics, but a clash between rivals for the profits of the English interior-decorating market."

83. Kate Lechmere, interviewed by Richard Cork, *Vorticism and Abstract Art*, 148.

84. Gaudier-Brzeska's review (the *Egoist*, 15 June 1914), is reprinted in Ezra Pound's *A Memoir*, 34.

85. See Cork, *Vorticism and Abstract Art*, 160f., on Lechmere's relations with Hulme (who proposed to her in an ABC teashop). Lewis tried unsuccess-

fully to revenge himself on Hulme, who hung him upside down by his trouser cuffs on the railings of Soho Square for his pains.

86. *Vital English Art* is reproduced in Nevinson, *Paint and Prejudice*, 58–60. It demands: "That English artists strengthen their Art by a recuperative optimism, a fearless desire of adventure, a heroic instinct of discovery, a worship of strength and a physical and moral courage, all sturdy virtues of the English race" (p. 59).

87. The first three quotations are from Manifesto 2, *Blast* 1 (20 June 1914). "It is a pity that there are not men so strong" is from Lewis' "A Review of Contemporary Art," in *Blast* 2 (July 1915), section C, statement 31.

88. This is Charles Harrison's point, *English Art and Modernism 1900–1939* (London and Bloomington, 1981), 89.

89. According to Frederick Etchells (interviewed by Richard Cork), Lewis would walk alongside a woman in the street, then move ahead of her, swinging round to block her path and pushing against her with his body. See Cork, *Vorticism and Abstract Art*, 111.

90. Cork, ibid., reproduces work by Jessica Dismorr (1885–1939) and Helen Saunders (1885–1963) and discusses their contribution to Vorticism (pp 148ff.). He was helped by Helen Peppin, a long-standing friend of Helen Saunders'. Her daughter Biddy Peppin has now completed an MA thesis on Saunders and Dismorr for Birkbeck College, University of London. I am very grateful to both Helen and Biddy Peppin for discussing the paintings with me. Saunders reverted to figurative painting after World War I. Dismorr exhibited abstract works with the Seven and Five Society in the 1920s. Since writing this essay my attention has been drawn to Jane Beckett and Deborah Cherry's article "Women under the Banner of Vorticism," *Cahier* 8/9 (1988) of the International Centrum voor Structuúranalyse en Constructivisme, Belgium.

91. On the *Rhythm* circle see note 6; also Malcolm Easton, *Anne Estelle Rice (1879–1959): Paintings* (Hull, 1969).

92. Dismorr's *Izidora* and Fergusson's *Rhythm* cover are reproduced in *Colour, Rhythm and Dance*, 14, 15. The *Rhythm* image is a stylized version of Fergusson's painting with the same title (1911), University of Stirling.

93. Letter from Helen Saunders to William Wees, 1 September 1962, quoted in Wees, *Vorticism and the English Avant-Garde* (Manchester, 1972). Or the name may have been misspelled mistakenly, from its family pronunciation as "Sanders."

94. All these paintings are actually untitled, but I have kept the titles given them by their owner—as Cork does—partly to distinguish them and partly because the titles do reference something strained, intense, and disturbing in the work.

95. Kate Lechmere, interviewed by Richard Cork, in Cork, *Vorticism and Abstract Art*, 150.

96. Douglas Goldring, *South Lodge: Reminiscences of Violet Hunt, Ford*

Madox Ford and the English Review Circle (London, 1943), 68. Quoted in Cork, *Vorticism and Abstract Art*, 414.

97. In Dismorr's arch "June Night," the narrator speeds with her Latin lover through the interminable suburbs to the red glare of the city; once there, she leaves him on the 43 bus ("I have lost my taste for your period"). Even more extraordinary is Saunders' war poem "Mud," or Dismorr's "Monologue":

> My niche in nonentity still grins—
> I lay knees, elbows pinioned, my sleep mutterings blunted against a wall.
> Pushing my hard head through the hole of birth
> I squeezed out with intact body . . .
> Details of equipment delight me.
> I admire my arrogant spiked tresses, the disposition of my perpetually
> forshortened limbs,
> Also the new machinery that wields the chains of muscles fitted beneath
> my close coat of skin.

98. See *The Technical Manifesto*, published as a leaflet by *Poesia* (Milan), 11 April 1910, and in English from the catalogue to the Sackville Gallery "Exhibition of Works by the Italian Futurist Painters," March 1912. "We demand, for ten years, the total suppression of the nude in painting." Reprinted in Umbro Apollonio, ed., *Futurist Manifestos*, trans. from the Italian by Robert Brain and others (London, 1973), 31.

99. Roger Fry, *Nation* (18 January 1913).

100. See W. Lewis, "History of the Largest Independent Society in England," quoted in Walter Michel and C. J. Fox, *Wyndham Lewis on Art: Collected Writings 1913–1956* (London, 1969), 90 (on Sickert) and 92 (on John's "tribes after tribes of archaic and romantic Gitanos and Gitanas"). "I resent Mr John's stage-gypsies emptying their properties over his severe and often splendid painter's gift."

101. "The New Egos," *Blast* 1 (20 June 1914): Vortices and Notes.

102. T. E. Hulme, "Modern Art and Its Philosophy," reprinted in *Speculations: Essays on Humanism and the Philosophy of Art*, ed. Herbert Read (London, 1924), 106; also quoted in Wees, *Vorticism and English Avant-Garde*, 83.

103. "Our Vortex," *Blast* 1 (20 June 1914): Vortices and Notes. The echoes of Tennyson are presumably intended: "Man is the hunter; woman is his game. / The sleek and shining creatures of the chase, / We hunt them for the beauty of their skins; / They love us for it, and we ride them down" (Lord Alfred Tennyson, *The Princess: A Medley*, 1851).

104. *Blast* 1 (20 June 1914): 151–52. "You and Artists are the only things (you don't mind being called things?) left in England with a little life in them. . . . We make you a present of our votes, so long as you leave works of art alone."

105. Oscar Weininger's influential *Sex and Character* (1903) tried to dis-

tinguish male and female characteristics by according to men the capacities for domination, thought, and self-control, and to women those for intercourse and childbearing. The poles of "male" and "female" were identified with those of subject and object, the conscious and the unconscious, God and Matter. Weininger committed suicide in 1903. Helen Saunders read Weininger (apparently on Lewis' recommendation), but persisted in the belief that as a woman she had a soul.

106. See Margaret Nevinson, "Futurism and Woman," *Vote* (31 December 1910). The suffragist Margaret Nevinson was Christopher Nevinson's mother.

107. In Clive Bell's "The Debt to Cezanne" (1914), Goncharova's is the only woman's name among the more than twenty modernists he recognizes. We can only speculate on the interest and influence that paintings like *Linen* and *The Electric Lamp* might have inspired had they been available to Boris Anrep, who was responsible for the Russian section at the second post-impressionist exhibition of 1912. Linda Nochlin comments on these works in *Women Artists 1550–1950*, ed. Ann Sutherland Harris and Linda Nochlin (New York, 1976), 63.

108. Lewis quoted in Wees, *Vorticism and English Avant-Garde*, 6.

109. Erich Neumann, *The Archetypal World of Henry Moore*, trans. from the German by R. C. F. Hull (London, 1959).

110. André Breton, "Manifesto of Surrealism" (1924), reprinted in *Manifestos of Surealism*, trans. from the French by Richard Seaver and Helen Lane (Ann Arbor, 1969), 17.

111. The libretto for Mozart's *The Magic Flute* (1791) is generally attributed to Emanuel Schikaneder. (It has a number of eighteenth-century sources including the novel *Sethos, Histoire ou Vie Tirée des Monumens, Anecdotes de l'ancienne Egypte* by the Abbé Jean Terrasson [1731]; "On the Mysteries of the Egyptians," by Ignaz von Born, an essay published in the first volume of the *Journal für Freymaurer* [1784]; and the collection of fairy stories, *Dschinnistan*, edited and published in three volumes by Wieland between 1786 and 1789.) It has been argued that Pamina's trials and priestly initiation with her lover, Tamino, elevate her to a level of equality and enlightenment without precedent in the opera's sources or in the masonic rituals to which it refers. But the structure of the narrative follows a (feminine) Oedipal trajectory by which Pamina must break from her mother, the tyrannical Queen of the Night, and find her place in the symbolic order: in Sarastro's realm of Nature, Reason, and Wisdom, and in a new family with Tamino, "united in wisdom and selfless love."

112. Russian modernism is an exception here. Jo-Anna Isaak has pointed out that we, too, often generalize from what is in fact "Western European or MOMA's modernism." See her "Representation and Its (Dis)contents," a review of Griselda Pollock's *Vision and Difference* (London, 1988), in *Art History* 12, no. 3 (September 1989).

The Discontinuous City:
Picturing and the Discursive Field

T H I S essay is concerned with orders of sense, régimes of visual meaning, and the discursive formations and practices of power in which they are constituted. It operates, therefore, at a particular level of specificity and does so with some point. It sets out to map an analysis of one type of formation—the formation of disciplinary knowledge and representations, as it emerges in mid-nineteenth-century Europe and North America—into a wider field; engaging not only recent accounts of representation as bound up with the processes of spectacle and commodification, but also questions of the structures and relations of capitalist cultural production. In placing its emphasis on the effects of the institutionalization of certain systems of discursive constraints, it is relatively silent on the issue of resistance. But, as I make clear, this is not at all to suggest that the fixities of meaning, whose general effects I trace, are ever coherent, accomplished, stable or secured.

Insistence on the return of the openness and indeterminacy of discourse also has consequences for more general questions of theory and methodology in the social history of art that remain implicit, rather than explicit, here. In rehearsing some of the themes that have interested me in my recent work, I shall, however, begin by addressing an important area of exchange between social histories and feminist histories of art. And in conclusion, I shall try to draw out more pointedly what I see as a central theoretical difficulty for such social histories, whether dependent on the expressive model of Marx's *German Ideology*, as with Antal, or developing out of the theories of ideology of Althusser and Macherey, as with the approaches that emerged most particularly in Britain in the 1970s.[1]

The City of Spectacle

In an essay on "Modernity and the Spaces of Femininity", in the collection *Vision and Difference*,[2] Griselda Pollock has argued that we cannot

grasp those processes of social restructuring which we associate with the construction of modern social orders, or their articulation in notions of *modernity* and new protocols of artistic practice that represent themselves as *modernist*, unless we also see them as centrally involving crucial historical shifts in the political, economic and cultural production of positions for femininity. It is not, however, just a question of adding a feminist account of women's art production to what she sees as the formidable but "flawed" analyses of social historians of art such as T. J. Clark or Thomas Crow.[3] Rather, modernism and modernity have to be seen as constituted in and through an emergent discursive order, both organizing and organized by a new economy of sexual difference. The privileged terrain of this emergence remains, however, the metropolitan city: paradigmatically, Paris in the second half of the nineteenth century.

The presence of this city has saturated the argument and has, in turn, been saturated by its terms. On the one hand, the city's spaces have provided a way to locate, describe and metaphorize the field of discourse. On the other, the logic of discourse has provided a way of construing the city as a system of closures, overflowed by the fluctuations of difference. The city was ground for modernist representation because, for this analysis, it was already text.[4] Perhaps it would be more accurate to say, it was already a compendium of texts; one construction impacting on another, in a process of accumulation and condensation that replicated the cultural, political and economic concentration on which the power of the modern city was founded.

The connecting links of the argument have become familiar now. At the level of urban planning and the built environment, the productive, commercial, governmental, residential and recreational functions of the nineteenth century metropolis were systematized and demarcated, in a separation that controlled circulation and traced a pattern of dominance, but also orchestrated sights and opened up vistas that marked out a distinct function of the city as spectacle. Through an immense accumulation of capital, this city took form not only as the site, but also the *object*, of an emphatically visual consumption, articulating and articulated in new subjective experiences of exhilaration and alienation, pleasure and fear, mobility and confinement, expansiveness and fragmentation. And nowhere were these more intense than at those spaces of intersection, especially in places of commercial leisure, where emergent codifications of identity and desire were set in flux, opening the way to new excitements and anxieties that, in the headiest accounts, seemed capable of transcending or rupturing the entire structure.[5]

Such a city was, therefore, both a complex of representations and the place of circulation of representations; the effects of the one always articulating into and reworking the other, and constituting the working material for a range of ambivalent modernisms. What Pollock is insistent upon is that such spaces of representation, logged by a revisionist social history of art, cannot be plotted solely along the axis of consumption, spectacle and class; they have also to be seen as tracing and constructing a difference that is, at once and inseparably, a demarcation of gender. The shift from predominant household production to metropolitan industrialization involved a transformation of all those arrangements and representations of work, sexuality, parental responsibilities, psychological life, assigned social traits and internalized emotions through which men and women are positioned in sexual difference. It was a restructuring mapped onto and by the city, so that a passage across its spatial plan was a passage across a geography of gender power, in which men and women were inscribed in relations of asymmetry (and supposed complementarity) that marked out spaces of subjection and, crucially here, structured the subject's relation to desire, pleasure and power in looking.[6]

The effects of this production and fixing of difference are pursued by Pollock across a number of mutually investing spatial planes that overdetermined modernist painting practice in Paris, in the late nineteenth century. At the level of spatial zoning, the city itself—at least, the respectable city of middle class life—was structured around the differentiation of a feminized private and domestic sphere from a masculinized public domain. It was a division that a woman could cross only at the risk of falling from the elevated social space of "femininity." Even in the permissible public spaces of the theatre, the park or the promenade, the lady was seen as dangerously exposed to the predatory public gaze of the male and in consequent peril of confusion with that other, unspeakable, order of womanhood, which entered the public arena only as the brazen object of an exchange and desire that were decently repressed in the closeted spaces of domesticity. So within this divided space was already another: the space of a look, conflated with a gaze: the eroticized, mobile, free and avaricious gaze of the middle-class, male flâneur, dandy or blood—that " 'I' with an insatiable appetite for the 'non-I'," as Baudelaire described him, that "mirror as vast as the crowd itself"[7]— which was never a habitable space for a woman. Insistent, surreptitious, and self-possessed, the assertive presence of this gaze set "Woman"— "object of keenest admiration and curiosity"[8]—apart, overruling the

hidden, downcast and interiorized look of the "respectable woman" and the open, searching stare of the woman "on the town" who was knowingly part of the spectacle of what Baudelaire saw as a City of Women.[9] Finally, we have the space of pictorial representation itself: an active space in which, in modernism, these other spaces of exclusion intersected and were reworked. It was a cultural terrain that proved equally uninhabitable to women; not essentially, but as an effect of the régimes of sense and pleasure in which the feminine was, by definition, excluded from the privileged institutions, locations, languages, subject-positions and statuses of a modernism for which "Woman" was the sign but never the speaker.

Across such levels of representation, therefore, we see a new régime of femininity emerging, which served men as a means of regulating and accessing female sexuality, and in which the practices of modernism were implicated. Yet, this order was never monolithic. It was overflowed by the very difference it constructed and, as Pollock points out, by its active rearticulation in the work of artists like Mary Cassatt, which exposed the presumption of the masculine gaze, displaced the look as privileged sense, and affirmed the private sphere as, equally, a "modern" space.[10] In a sense, this paralleled the way that middle class women, at the price of accepting the confinements of domesticity, could then exercise from that place a moral authority over the home and even the community. It says nothing, however, about those troublesome working women whose demeanor and very existence as impoverished female workers violated some of the dearest held genteel precepts of "woman's nature" and "woman's place".

As Christine Stansell has brilliantly pointed out,[11] while metropolitan industrialization strengthened women's economic dependence on men, the very precariousness of this dependency in a casualized labour market compelled women to seek other means of support within an economy to which their labour was increasingly central. Of itself, this both disturbed any settled or complacent notions of the place and control of women, and opened opportunities for working class women to turn certain conditions of subordination into new initiatives, outrunning the limits of family households and imposing their presence on the wider municipal field of economic, political and cultural conflicts. Already in the 1850s in New York, for example, young working women, whose wage earnings allowed them some degree of distance from familial authority, had played an acknowledged, if ancillary, role in reworking the materials of urban, commercial leisure into the new, and defiantly

working class, subculture of the Bowery Boys and Gals, which flaunted middle class codes of dress and status, reterritorialized the working class city, and challenged the dichotomous and patriarchal representations of both a moralizing middle class domesticity and a misogynistic popular culture.[12] What we have here is something quite distinct from the autonomous "female subculture" Judith Walkowitz claims to have been a distinguishing feature of nineteenth century prostitution.[13] These Bowery Gals were not ladies, but neither were they fallen women or archetypal victims, caught in a fatalistic structure of bondage, determinism, silence and passivity. As Stansell remarks, "the dialectic of female vice and female virtue was volatile;" at times, sufficiently so to break apart the binary logic of sexual difference, as "in the ebb and flow of large oppressions and small freedoms, poor women traced out unforeseen possibilities for their sex."[14]

The City of Others

In this way, perhaps, we might begin to go beyond the difficulty Pollock seems to have in talking about working class female subjects, other than as the prostitutes and servants they were represented as having to be. It is a silence that might also be linked to another, which follows from her exclusive concentration in this essay on femininity and the city in relation to spectacle, consumption and the fetishizing gaze. The modern city was also, at the same time, a place of production, servicing and exchange, dependent on the immigration and congregation of large masses of working people whose very presence and proximity to the core of the spectacle of capital posed real and imagined threats. The conflict was inseparable from the dynamic of the capital city in which the drive to break down every spatial barrier to the "healthy" circulation of capital and goods simultaneously divorced the city from its imaginary organic past and inflamed the phobia of contagion and pollution at every level of its social life.[15] The containment of this conflict demanded constant efforts of negotiation and propelled the development of new apparatuses and techniques that were codified in proliferating practices of social discipline—policing, education, health, housing, and moral welfare—whose effectivity was bound up with their *political strategy of representation*.

The very separation of spheres—which is the structural principle of democratic order, inscribed in condensed and overdetermined patterns

of spatial zoning and the very structure of instrumental representation—provided the impetus to new and intrusive forms of social regulation and surveillance. Industrialized production and urban living were geared to the colonization and development of techniques of power that were continuous and diffuse, rather than sporadic and exemplary, productive rather than interdictive, internalized rather than spectacular, paternal rather than adversarial, professionalized rather than politicized. Taken over principally from the church, the military and the schools, such techniques entailed new agencies, apparatuses and instruments: new types of expert, new institutional structures, new disciplined forces, new architectural orders, and new languages and technologies of documentation, data storage and information handling. Deploying these new technologies of observation, representation and regulation, modern apparatuses of social control—the police, hospitals, schools, insane asylums, prisons, departments of immigration, public health and sanitation—bore down, literally, on the alien within the social body and its environment. In the process, they not only exerted effects of domination and subordination that integrated social regulation in an unprecedented manner, but also created the conditions for a new disciplinary framework of knowledge in which the social was constituted as the multiple object and target of novel supervisory practices and technical discourses.[16]

What we have to deal with in the nineteenth century urban, industrial complex, therefore, is the imagination of a new mode of governance that is, at once, a disciplinary régime and a field of science—the field of anthropology, comparative anatomy, criminology, medicine, psychiatry, public health, and sociology. It is a formation that aspires, at all levels, to an unmatched systematicity. Its strategy is to change the ground of struggle over the production and control of meaning, as part of the struggle to dominate and exploit the social body and its space. Yet, it is a strategy that seeks to elide the struggle it wages, gathering power to its expert discourses, while displacing its motivation onto its other and representing its incursions into an objectified space and populace as disinterested, technical and benign.

It is within this dismal landscape that we have to locate that other nineteenth century textualization of the city and its inhabitants: the archive of documentation. The very notion of *documentation* was locked into a history of disciplinary practice and knowledge that emerged, piecemeal, across the workings of the apparatuses I have described. It belonged to a paranoid formation for which the social was always dangerously alive with potential pathologies that threatened to overrun the

social body, if not constantly monitored, interpreted and subdued. This was the dream of the social reformatory: that scientific and humane establishment. Surveillance was its apparatus of restraint; the record, its cell; the index, its carceral architecture. It readily appropriated the latest technologies—photography prominent among them—though it was as suspicious of their productivity as it was of the social itself. It sought to make them servile instruments of its compulsive knowledge, driven by a separation, isolation and subjugation of its still troubling object, but eliding the erotic character of its curiosity, denying desire and the exchange of pleasure.

In such knowledge, the intransigent social field was to be dominated by its transformation into a series of "case studies". Set at a distance, outside any mutual exchange, such "cases" were to be stripped of all interiority and scrutinized, without shame, as fields of natural signs: signs of lack, signs of guilt; evident signs that could be read exhaustively; signs that could be transcribed without distortion and fixed in the transparent languages of evidence and documentation. In the fantasy of the subject of this knowledge, the other of this singular and overpowering encounter could be totally and immediately known; reduced to a difference the system of discipline produced, pathologized, desired and controlled. The fixing of this difference constituted the questionable alibi and unstable power of social discipline. It worked—in so far as it did [17]—by arresting the proliferation of frames of differentiation, by reducing difference to duality, and by holding in place a rigid and irreversible polarization of the positions of subject and object. But it also needed to enforce the immediate presence of that object to that subject, and this was produced by imposing a transparency on experience and representation, as the instruments of an overwhelming truth. The production of knowledge was, at one and the same time, the exertion of power: the appropriation of the social by the fixing of identities in relations of domination and subordination. But this process itself turned on the fixing in place of certain new technologies of representation as purely *instrumental* modes.[18]

Powers and Photographies

The separation of subject from object. The fixing of difference, the immediacy of experience. The transparency of representation. The instrumental mode. What was described here was a discursive space in

which a particular photography could be made to operate and in which
a particularized photography was already prepared, by then, to find its
place. Construed as impartial, objective, clean, compelling and mod-
ern, instrumental photography transmitted the power of the disciplinary
structure, but also returned to it powers of its own: the power of a
technology of representation already constructed to reproduce the con-
ventional conditions of western optical realism; the power of an order
of meaning generated by an already elaborated system of discursive
constraints; the power of a machine of subjection built to recruit iden-
tification and structure pleasure and power in looking. But, if the field
of view of this camera came to coincide with the gaze of disciplinary
power, we must remember that this was not the easy conjunction of
eye with eye. The look of the camera and the look of social surveil-
lance and science—though looks, nonetheless—were not physiological
but complex discursive events. As such, they had their histories: histo-
ries of institutional negotiation, technical elaboration, and productive
interaction. If the instrumental camera was to operate as a controlled
extension to the expert or supervisory eye, then the structured possibili-
ties of its representational system had to be invested in the drives and
desires of a constellation of apparatuses of power. If the photographs
such a camera produced were to claim the status of technical documen-
tation, then they had to be differentiated from a field of photographic
representations. They had to shun the picturesque and sensational, dis-
dain the moralism of philanthropic reformism, affect a systematicness
beyond commercial views, and relinquish the privilege of Art for the
power of Truth. If these photographic documents were subsequently to
"speak for themselves" and wield the power of proof, then the mean-
ings supposedly inherent in the images, and even in their omissions and
silences, had to be produced from a most careful rendition, by restricted
agencies whose status, competence and reading would be institutionally
guaranteed.[19]

Instrumental photography was operative, then, when two discursive
structures were coupled and bolted together. The point is that this could
only take place through a process of institutional negotiation whose his-
tory has to be traced. The notion of evidentiality, on which nineteenth
century practices of documentation traded, could never be taken as
already and unproblematically in place. Photographic documents had to
have their status as truth produced and reproduced, and institutionally
sanctioned. Their meanings were closed and exerted a force only within
the frame of the more extensive arguments and social interventions that

constituted the photographs' conditions of existence and infused their production and reading. If photographs seemed to bring to this process certain powers—the power of a new and intrusive look; the power of a new means of representation and mode of accumulation of knowledge; the power to structure belief and recruit consent; the power of conviction and the power to convict—then the powers they wielded were only rhetorically their own. In practice, they belonged to the agents and agencies that mobilized them and interpreted them, and to the discursive, institutional and political strategies that constituted them, supported them, and validated them.

This is not at all to suggest that "photography" was the transparent reflection of a power outside itself.[20] It is, rather, to insist that the photograph's compelling weight was never phenomenological, but always discursive, and that the power effects of photographic evidence were *produced* by the articulation of two discursive formations. If this is to grant that the photographic always exceeded its colonization, investment and specification in institutional frameworks of use, it is not to concede any intrinsicness of "the medium." It is not to equate a discursive structure with a technology. Nor is it to posit any unity or closure to photography's discursive field. It is precisely in this sense, therefore, that I have denied that photography as such has any identity.

What I was arguing, against any totalizing or teleological view, was that the meaning and value of photographic practices could not be adjudicated outside specific, historical language games.[21] Photography is neither a unique technology nor an autonomous semiotic system. Photographs do not carry their meanings in themselves, nor can a single range of technical devices guarantee the unity of the field of photographic meanings. A technology has no inherent value, outside its mobilizations in specific discourses, practices, institutions and relations of power. Images can signify meanings only in more or less defined frameworks of usage and social practice. Their import and status have to be produced and effectively institutionalized, and such institutionalizations do not describe a unified field or the working out of some essence of the medium. Even where they interlink in more or less extended chains, they are negotiated locally and discontinuously and are productive of meaning and value. The issue, however, is not the imposition of limits as such on the productivity of discourse, for without these the endless play of meaning could never be specified. The question is, rather, that of the specific political effects of particular historical structures of discursive constraints and the histories of struggles to impose or resist them.

If we look, in these terms, at the proliferation of photographic tech-
nologies, techniques, and practices in the nineteenth century, we can
see that, for all the projections of criticism, the new means of significa-
tion did not constitute a closed or unified medium, or contain within
themselves a preordained historical function. A plurality of particular
photographies were deployed in a whole range of differently directed
practices. Their effects and legitimations were not given in advance, but
derived from specific discursive economies. They were institutionalized
under markedly different terms, discussed and evaluated by different
agents, in very different frameworks of reference, and accorded quite
different statuses. In this way, the potential field of photographic prac-
tices and meanings was divided up, pragmatically, without regard to
consistency or uniformity. And across this variegated terrain, the unity,
essence and integrity of "photography" was only ever locally and dis-
continuously invoked and defined.

For example, while almost ninety percent of photographic production
in the mid nineteenth century was bound up with a portrait industry
governed, like any other arena of capitalist enterprise, by concerns of
profitability, market development and cost effectiveness, this fully com-
mercial field of production was itself layered according to what could
be sustained by different consumerships. As the industry developed, it
was a point of some heated debate whether a continuous sense of pho-
tography could be said to operate across the entire field, or even whether
it was bound by a "family resemblance". Different pricing mechanisms,
different organizations of production, and different styles of promo-
tion supported very different kinds of practice, different expectations,
and very different ways of *handling* the image—in every sense of that
term. Understanding these differences was integral to the varieties of
the ritual, whose social absorption was overwritten by the gradually
accepted attribution of different cultural statuses and degrees of com-
mercial protection to the products of the various suppliers. It was not
an undisputed process, but the hierarchical definition of levels in the
photographic commodity market was, paradoxically, one of the con-
texts in which distinctions between a mutually exclusive art and com-
merce were instigated and deployed to divide one photographic practice
from another.

To the side of the demands of the market place (at least, initially), cer-
tain committed amateur groups, across Europe and North America, also
laboured at a comparable division. Yet, for all the claims of Symbolist
theory, nothing could be guaranteed at the level of the image or by ethi-

cal assertion alone. Thus, while insisting that their distinction resided in their photographs themselves, such groupings worked assiduously at setting up the institutional structures and frameworks of discourse— independent galleries, salons, journals, forms of patronage, and modes of criticism—capable of negotiating the sought for status of Art for their aspiring, individuated work.[22] Only across such structures could the *difference* of their photography have been produced and secured. Its constitution was, therefore, necessarily located and localized. What was pertinent to the discussion of photographicness here in the new galleries of photographic art, did not at all pertain to, or impinge upon, the equally earnest assessment of photographicness in those other late nineteenth century galleries—the "rogues" galleries I earlier located in the discursive formation of the disciplinary system. And, if the real subject of an emergent art photography was the imaginary force of presence of the creative author, in these lowly archives, authorship was less than nothing. To serve as evidence and record, the image—as we saw—had to be *unsigned* and said to speak for itself, though only qualified experts could read its lips.

In each case, then, a special domain of photography, that claimed basis in the ontology of the image itself, had to be produced, in a process interlocking with special domains of writing and speaking and regulated by institutional controls over literacy and practice. In the appropriation of photography to art, as in its appropriation to documentation, we see the same double relation. On the one hand, the constitution of a "purely photographic space"—whether as art or evidence—was inseparable from the empowering of a discursive and institutional order that annexed the productivity of photography to its structure. On the other hand, the fixing of meaning *in* the image—whether as expression or index—empowered the speech of that order, by eliding the materiality of the photograph as sign, its problematic nature as discursive event, and the power and desire structured into and by it. In art as in police work, this was not just a matter of overcoming conservative resistance to new technology, but rather of a struggle over new languages and techniques and claims to control them. Yet, as I have said elsewhere: the artist's proof was not the police officer's. There was no general or purely photographic system. And, if the *nature* of "photography" was repeatedly invoked, it was always *local* conditions that determined the production of its "universal" identity.

As a final example, we may take the emergence of a broadly based, economically significant and aesthetically troubling sphere of amateur

practice, following the vast expansion of the photographic economy in the 1880s and the growth of fully corporate dry-plate, camera and photofinishing industries. To acknowledge this industrial momentum is not, however, to grant that we could ever derive the categories, constraints and motivations, or the cultural subordination, of amateur photographies from the technological and economic shifts themselves. To talk about the emergence of amateur photographies is to talk of the tracing out of new levels of meaning and practice, new hierarchies of cultural institutions, and new structures and codes of subjectivity: processes unquestionably bound up with technological innovation and the restructuring of production and marketing, but equally caught in the impetus of a reconstitution of the family, sexuality, consumption and leisure that plots a new economy of desire and domination. And if we can follow this overdetermined development across a radiating cultural geography, it is never as a simple unified, unrolling, economically and technologically driven process. The formation of amateur photographies had always to be negotiated in and across the fields of specific national structures, cultural conventions, languages, practices, constructed traditions and institutions. So far from expressing the necessity of a purely economic or even ideological process, amateur practices constituted a discursive formation in the fullest sense: decentred and differentiated; saturated with relations of power, structuring new effects of pleasure, and generating new forms of subjectivity that have then to be seen as determinant conditions of capitalist growth in themselves.

Totalizations and the Discursive Field

There is still, however, a larger question here, that overspills the negotiation of local statuses for specific photographies. In a wider frame, what was happening with this institutional subdivision of photography was that specific tensions and conflicts within capitalist cultures were being contained and even negotiated away. Thus, while photographic technologies promoted a vast proliferation of image production in industrialized countries, their effects were never as total as commentators hoped or feared.[23] Caught up in attempts to define the essential and intrinsic nature of "the medium," what these commentators failed to grasp was the dissemination of new institutional and discursive formations, across which—I have argued—the potentiality and productivity of this outpouring of images was organized and constrained. As a result, the

transformation of cultural structures by mechanical production and the emergence of mass consumer markets did not automatically erode the authority of a more or less officially sanctified Culture, whose increasingly marked institutional isolation was the condition of its continued privilege to question and affirm social values. Through the same process, the attribution of exemplary status to certain modes and works of photographic Art did not inhibit a burgeoning photographic industry, or conflict with the power of instrumental photographies. And by the same token, the vastly expanded accessibility of photography to amateurs did not democratize corporate industrial structures, or erode the status of professional artists, technicians, or expert interpreters. An honorific museum culture coexisted with the family album and the police file.

From the point of view of cultural history and theory, such stratification must have consequences for notions of an inherent trend in capitalist formations toward ever greater homogenization at the economic, political and discursive levels. The drives of the market and the quickening pace of commodification do not encompass the totality of image production. Mass participation does not undo the structures of cultural authority, the control of knowledge, or an adaptive, professionalized division of labour. Panoptic techniques of discipline and surveillance do not entirely displace the power of spectacle and effect a total reversal of the political axis of representation. The deployment of instrumental technologies by the state goes along with its protection of capitalist cultural industries and its support of a privileged post-market cultural arena.[24] The marking out of these discursive and institutional spaces may be defensive or aggressive, negative or assertive. What they stake out, however, is a new and resilient order; though this order must not be confused with the state, even if the state may, in part, annex it, invest it, and be called on to adjudicate upon it. It is an order without coherence, coordination or centre. That is precisely how it functions; how its conflicts are kept from becoming ruptural. We must be skeptical, therefore, of all attempts to treat the cultures of capitalist societies as totalities or unities. If the proliferation of photographic technologies and images exploded anything, it was not art, privilege, or reality, but this entrenched organicist conception—as dear to a certain critical left as to a certain critical right.

This brings us back to what was implicitly at stake in Griselda Pollock's critique of current social historical accounts of modernism, spectacle, the city and sexuality: to questions of representation, identity,

class and gender and, specifically, to the tendency in Marxist theori-
zations of culture to foreclose the issues involved in their relation. A
whole territory of debate opens up here, going back to Marx's various
treatments of the concept of representation or articulation.[25] It would
be beyond my brief, and my time, to pursue this. However, in relation
to the project of the Social History of Art, I might underline the follow-
ing awkward points about the consequences of the kind of discursive
analysis I have been developing here.

In the first place, if it is in the material processes of discourse that
interests and identities are differentiated and defined, then "class analy-
sis" cannot survive in the form of a theory of ideology, a return to
origins, or a mechanism of expression. There can be no given and essen-
tial "class interests" from which cultural representations can be derived.
Indeed, to reverse the terms of the analysis, class identity can only de-
note the heterogeneous, dispersed and contingent outcome of a play of
discourses and articulations, overdetermined by other relations of dif-
ference.[26] Secondly, once one allows an effectivity to discursive practices
in constituting meaning and identity and generating effects of power,
then there is no longer any way of invoking another, determinant and
external tier of "social" explanation. It becomes a contradiction to con-
ceive of discursive structures in exteriority to a social domain they,
in effect, contain and define. Yet, conceptions of cultural practices as
reflections, expressions, superstructures, ideologies or functional appa-
ratuses of social reproduction have to deny that the discourses, practices
and institutions that constitute the cultural can accomplish anything in
themselves, other than the *re-presentation* of what is already in place, at
some more "basic" level.[27] Thirdly, and finally, once one confronts the
openness and indeterminacy of the relational and differential logic of the
discursive field, then the notion of social totality itself has to be radically
displaced. As Ernesto Laclau and Chantal Mouffe have argued:

> The incomplete character of every totality necessarily leads us to aban-
> don, as a terrain of analysis, the premise of *"society"* as a sutured and
> self-defined totality. "Society" is not a valid object of discourse. There is
> no single underlying principle fixing—and hence constituting—the whole
> field of differences.[28]

If the "social" exists, it is only "as an effort to construct that impos-
sible object,"[29] by a temporary and unstable domination of the field of
discursivity, imposing a partial fixity that will be overflowed by the ar-

ticulation of new differences. There is no end to this history. We find ourselves without the guarantees of an immanent, objective process or a last instance, but analysis and intervention do not need a lost cause. That very lack opens the way to the multiplication of forms of subversion and the imagination of new identities, in which cultural strategies can no longer be contained in a secondary role. In the same play, it invades and transforms the very object, ground and field of possibilities of the social history of art.

NOTES

This essay is reprinted from John Tagg, *Grounds of Dispute: Art History, Cultural Politics and the Discursive Field* (London, 1992; Minneapolis, 1992), by permission of the publishers.

1. Karl Marx and Frederick Engels, "The German Ideology," *Collected Works*, vol. 5 (London, 1976), 19–539, especially vol. 1, sec. 1: "Feuerbach: Opposition of the Materialist and Idealist Outlooks," 27–93.
 For the concept of an "expressive" structure, see: Louis Althusser, "From *Capital* to Marx's Philosophy," "Marxism is not a Historicism," and "Marx's Immense Theoretical Revolution," in Louis Althusser and Étienne Balibar, *Reading Capital*, trans. Ben Brewster (London, 1970). For the seminal discussion of "Hegelian" and "Marxist" concepts of totality, see: Louis Althusser, "Contradiction and Overdetermination," and "On the Materialist Dialectic," in *For Marx*, trans. Ben Brewster (Harmondsworth, 1969). For Althusser's later theory of ideology, see especially: "Ideology and Ideological State Apparatuses (Notes towards an Investigation)," in *Lenin and Philosophy and Other Essays*, trans. Ben Brewster (London, 1971). See also: Pierre Macherey, *A Theory of Literary Production*, trans. Geoffrey Wall (London, 1978).
 Examples of social histories of art structured around a concept of art as the expression of economically determined class outlooks might include, Frederick Antal, *Florentine Painting and Its Social Background; The Bourgeois Republic Before Cosimo de'Medicis's Advent to Power: XIV and Early XV Centuries* (London, 1947); Arnold Hauser, *The Social History of Art*, 2 vols. trans. Stanley Godman (New York, 1951); Max Raphael, "Picasso," in *Proudhon, Marx, Picasso: Three Studies in the Sociology of Art*, ed. John Tagg, trans. Inge Marcuse (New Jersey, 1980; London, 1980); and Nicos Hadjinicolaou, *Art History and Class Struggle*, trans. Louise Asmal (London, 1978). For approaches to the social history of art influenced by Althusser's and Macherey's theories

of ideology, see: T. J. Clark, *Image of the People: Gustave Courbet and the 1848 Revolution* (London, 1973), and "The Conditions of Artistic Creation," *Times Literary Supplement*, no. 3768 (24 May 1974): 561–62; Griselda Pollock, "Vision, Voice and Power: Feminist Art History and Marxism," *Block* 6 (1982): 2–21; and John Tagg, "The Currency of the Photograph," *Screen Education* 28 (Autumn 1978): 45–67.

2. Griselda Pollock, "Modernity and the Spaces of Femininity," *Vision and Difference: Femininity, Feminism and Histories of Art* (London, 1988), 50–90. For a discussion of the representation of the city in relation to the discourses of discipline, not focusing, however, on gender difference and not included in the above collection, see: Griselda Pollock, "Vicarious Excitements: *London: A Pilgrimage* by Gustave Doré and Blanchard Jerrold, 1872," *New Formations* 4 (Spring 1988): 25–50.

3. Pollock has in mind, specifically, T. J. Clark, *The Painting of Modern Life: Paris in the Art of Manet and His Followers* (New York, 1984). Her comments might apply equally to Thomas Crow, "Modernism and Mass Culture in the Visual Arts," in *Modernism and Modernity*, ed. Benjamin Buchloh, Serge Guilbaut, and David Solkin (Halifax, Nova Scotia, 1983), 215–164; Robert Herbert, *Impressionis: Art, Leisure and Parisian Society* (New Haven, 1988); and Theodore Reff, *Manet and Modern Paris* (Chicago, 1982).

4. See for example: Clark, *The Painting of Modern Life*, especially "Introduction" and "The View from Notre-Dame;" and Pollock, "Modernity and the Spaces of Femininity." For other discussions, see: Marshall Berman, *All That Is Solid Melts Into Air: The Experience of Modernity* (New York, 1982); David Harvey, "Paris, 1850–1870," in *Consciousness and the Urban Experience: Studies in the History and Theory of Capitalist Urbanization* (Baltimore, 1985), 63–220, and "The Representation of Urban Life," *Journal of Historical Geography* 13, no. 3 (1987): 317–21; Kristin Ross, *The Emergence of Social Space: Rimbaud and the Paris Commune* (Minneapolis, 1988).

5. See the earlier version of "A Bar at the Folies-Bergère," chap. 4 of Clark, *The Painting of Modern Life*: "The Bar at the Folies-Bergère," in *The Wolf and the Lamb: Popular Culture in France, from the Old Regime to the Twentieth Century*, ed. Jacques Beauroy, Marc Bertrand, and Edward T. Gargan (Saratoga, Calif., 1977).

6. Pollock, "Modernity and the Spaces of Femininity." See also: Abigail Solomon-Godeau, "The Legs of the Countess," *October* 39 (Winter 1986): 65–108; and Janet Wolff, "The Invisible Flâneuse; Women and the Literature of Modernity," *Theory, Culture and Society* 2, no. 3 (1985): 37–48.

7. Charles Baudelaire, "The Painter of Modern Life," in *The Painter of Modern Life and Other Essays*, trans. Jonathan Mayne (Oxford, 1964), 9.

8. Ibid., 30.

9. Cf. sections "X. Woman," ibid., 29–31, and "XII. Women and Prostitutes," ibid., 34–38.

10. Pollock, "Modernity and the Spaces of Femininity," 79–85.

11. Christine Stansell, *City of Women: Sex and Class in New York, 1789–1860* (Urbana and Chicago, 1987).

12. For discussion of the Bowery Boys and Gals, see ibid., 89–101. See also: Alvin F. Harlow, *Old Bowery Days: The Chronicles of a Famous Street* (New York, 1931); and Lloyd Morris, *Incredible New York: High Life and Low Life of the Last Hundred Years* (New York, 1951). Contemporary accounts and journalism include: George C. Foster, *New York by Gas-Light* (New York, 1850); Abram C. Dayton, *Last Days of Knickerbocker Life in New York* (New York, 1882); and George Ellington, *The Women of New York, Or the Underworld of the Great City* (New York, 1869).
For comparison with the dress of prostitutes in England and the transgressive imitation of middle-class codes, see Judith R. Walkowitz, *Prostitution and Victorian Society: Women, Class, and the State* (Cambridge, 1980), 26.

13. Walkowitz uses the term "female subculture" but does not effectively define it; ibid., 5, 15, 25, 131, 201.

14. Stansell, *City of Women*, 221.

15. See: M. Christine Boyer, *Dreaming the Rational City: The Myth of American City Planning* (Cambridge, Mass., 1983); Didier Gille, "Maceration and Purification," in *Zone*, nos. 1/2, ed. Michel Feher and Sanford Kwinter (New York, n.d.), 227–81; and John Tagg, "God's Sanitary Law: Slum Clearance and Photography in Late Nineteenth Century Leeds," chap. 5 of *The Burden of Representation: Essays on Photographies and Histories* (London, 1988), 117–52, and "The Proof of the Picture," *Afterimage* 15, no. 6 (January 1988): 11–13.

16. See: Michel Foucault, *Discipline and Punish: The Birth of the Prison*, trans. Alan Sheridan (Harmondsworth, 1977); *Power, Truth, Strategy*, ed. Meaghan Morris and Paul Patton (Sydney, 1979); *Power/Knowledge*, ed. Colin Gordon (Brighton, 1980); and *Foucault Live (Interviews, 1966–84)*, ed. Sylvère Lotringer, trans. John Johnston (New York, 1989). Also: Gilles Deleuze, *Foucault*, trans. Seán Hand (Minneapolis, 1988), especially "A New Cartographer," 23–44; Jacques Donzelot, *The Policing of Families* (London, 1979); Michel de Certeau, *Heterologies: Discourse on the Other*, trans. Brian Massumi (Minneapolis, 1986), especially chap. 13, "Micro-techniques and Panoptic Discourse: A Quid pro Quo," 185–92; Pasquale Pasquino, "The Genealogy of Capital—Police and the State of Prosperity," *Ideology & Consciousness*, 4 (Autumn 1978), and "Criminology—The Birth of a Special Savoir," *Ideology & Consciousness* 7 (Autumn 1980): 17–32; and Giovanna Procacci, "Social Economy and the Government of Poverty," *Ideology & Consciousness* 4 (Autumn 1978).

17. The gaze of spectacle and the gaze of power are visual agencies that, as Kaja Silverman reminds us, can never be owned by anyone's eye, outside all specularity. (Cf. Kaja Silverman, "Fassbinder and Lacan: A Reconsideration of Gaze, Look and Image," *Camera Obscura* 19 [January 1989]: 55–84). It is only

through specific cultural representations that particular looks—here, the look of the flâneur, the look of the policeman, the look of the record photographer—come to be conflated with the authority of the gaze. And it is only in the struggles to impose and institutionalize such cultural representations that these looks, and the practices, protocols and discourses in which they are inscribed, come to be legitimized as distinct and discrete regimes and, simultaneously, assigned the status of "universal" law: the universality of Art and pleasure, or evidence and truth.

Yet, such legitimations, and the conflations on which they rest, cannot be secured or even long sustained, not only because their institutionalization is resisted and never finally accomplished, but also because they are internally conflicted. The look of that secular detective, the flâneur, "mirror as vast as the crowd itself," which would see everything, from every angle, at once and un-seen, is both lost to the lure of its own lonely desire and inescapably part of the intoxicating spectacle it would command. The look of surveillance and discipline cannot erase the desire that implicates it in the lack it disburdens on the other, or the pleasure that scandalously threatens to change the meaning of the power relations of domination and submission it imposes.

What is also put in question, here, is the very separation of looks that the discursive régime instates. The historical forms of this separation described here—the popular catalogue of sights and the professionalized archive of documentation—only come to exclude each other through a constant process of negotiation and struggle. Yet, the institutional closures that give them their pleasurability and force can never be held in place. The images fall out of the catalogue and the archive. The rules of their games are never finalized or clear. They intersect and interplay in hybrid or uncertain spaces: in the Photographic Survey Records of antiquarian societies in metropolitan centres like London and Paris and provincial cities like Manchester; in the homiletic narrative lantern slide sets of "Slum Life in Our Great Cities Photographed Direct from Life," sold extensively to temperance and missionary groups by individual entrepreneurs and commercial companies such as Banforth's of Holmfirth, West Riding; and in civic collections that appropriated the products of a range of photographic discourses to the constitution of a notion of local or national history and cultural heritage. In March 1898, in Paris, for example, Boleslaw Matuszewski, a Polish photographer and cinématograph operator, published *Une nouvelle source de l'histoire (création d'un dépot de cinématographie historique)*, in which he proposed the creation of "un *Musé ou Dépot cinématographique*". Here, material of a "documentary interest . . . slices of public and national life . . . the changing face of the cities" would be gathered in a national historical archive capable of furnishing incontrovertible evidence, for use in legal contexts, the arts, medicine, military affairs, science and education. (See also Boleslaw Matuszewski, *La Photographie animée* [Paris, 1898].) It was in such repositories that the institutional specificity of documentation and the particularism of social reform and

antiquarian records began to be reworked into more generalized and emotive discourses. Across the territories of evidence and spectacle, a new Historical Section opens, governed by a social democratic political project of managing consent through the new means of communication, in the context of modernizing, rationalizing, and professionalizing the social domain. This was the space of emergence of *documentary* in its historically specific sense.

See: Tagg, *The Burden of Representation*, 5–15, 139–42; H. D. Gower, L. Stanley Jast and W. W. Topley, *The Camera as Historian: A Handbook to Photographic Record Work* (London, 1916); Harry Milligan, "The Manchester Photographic Survey Record," *The Manchester Review* 7 (Autumn 1958): 193–204; G. H. Martin and David Francis, "The Camera's Eye," in *The Victorian City: Images and Realities*, vol. 2, ed. H. J. Dyos and Michael Wolff (London, 1973), 227–46.

18. This may be the point to comment on a noticeable loss in the passage of the argument from urban spectacle to urban discipline: the loss of the focus of sexual difference.

The pathologizing and hystericizing of female bodies in the discourses of medicine, psychiatry and criminology, like the gendering of urban space, the discursive projection of "Woman" and the positioning of women in the city as spectacle, were structural to the reorganization of the economy of masculinity and femininity in the nineteenth century and to a new formation of identity and difference. From this point of view, the emphasis should remain the same: as with the concepts and practices of modernity and modernism, the discourses of disciplinary knowledge were crucially articulated on a new régime of sexual difference. Yet, stress on this strategic centrality carries the danger of re-essentializing difference, not only in the reduction of sexual difference to duality, as we find in Pollock's essay, but in the (spatial) isolation of a centralized sexual difference from the simultaneous field of differentiations.

The object of disciplinary knowledge—constituted in a relation of engendered otherness—was always, simultaneously, the vanishing point of condensed and conflicting frames of difference, in which multiple differentiations of sexuality, race, class, regionality, age and culture were compounded on the ground of anatomy. Similarly, the economy of spectacle, as it was written across the *internal* and *external* space of the nineteenth century city, determined not only a political economy of gender difference, or even of gender and class, but also and inseparably a network of divisions of race, ethnicity, regionality and culture, overdetermined by shifts in the division of labour, the distribution of skills and the condition of labour markets. The differences, which are presented as singular and essential, multiply, divide within themselves, and recombine, re-implicating defining term and differed in the discursive fields from which they have emerged, but which cannot provide the last word: gender, race, class. . . .

19. For further, though differently theorized, discussions of instrumental photography see: David Green, "Classified Subjects," *Ten:8* 14 (1984): 30–37,

and "A Map of Depravity," *Ten:8* 18 (1985): 37–43; Roberta McGrath, "Medical Police," *Ten:8* 14 (1984): 13–18; André Rouillé, *L'Empire de la photographie: Photographie et pouvoir bourgeois 1839–1870* (Paris, 1982); and Alan Sekula, "The Body and the Archive," *October* 39 (Winter 1986): 3–64.

20. This can also be read as the beginnings of a response to Geoffrey Batchen's critique of *The Burden of Representation* ("Photography, Power, and Representation," *Afterimage* 16, no. 4 [November 1988]: 7–9), which—if I may paraphrase—seeks to convict me of holding an instrumental view of writing and photography as passive, inert and compliant "ideological" tools, entirely external and transparent to the negative power of repressive juridical institutions. Even allowing for inaccuracies of reading and confusions over significant and recognized differences between articles written across a ten year period and the pointed, but largely ignored, auto-critique that introduces the collection, I find this disconcerting. For whatever purposes, it seems that what has to be attributed to me is, *in every particular*, the view that my writings have from the first set out to dispute.

21. The term "language games" obviously refers both to Ludwig Wittgenstein, *Philosophical Investigations*, trans. G. E. M. Anscombe (Oxford, 1958); and to its renewed currency in Jean-François Lyotard, *The Postmodern Condition: A Report on Knowledge*, trans. Geoff Bennington and Brian Massumi (Minneapolis, 1984); *The Differend: Phrases in Dispute*, trans. Georges Van Den Abbeele (Minneapolis, 1988); and, with Jean-Loup Thébaud, *Just Gaming*, trans. Wlad Godzich (Minneapolis, 1985).

22. Cf. Ulrich Keller, "The Myth of Art Photography: A Sociological Analysis," *History of Photography* 8, no. 4 (October–December 1984): 249–75.

23. For a discussion of the critical inflation of the threat or promise of photographic technologies, see John Tagg, "Totalled Machines: Criticism, Photography and Technological Change," *New Formations* 7 (Spring 1989): 21–34.

24. See Raymond Williams, *The Sociology of Culture* (New York, 1982), chap. 2, "Institutions," 33–56.

25. The classical points of departure in Marx would be: "The Eighteenth Brumaire of Louis Bonaparte," in Karl Marx and Frederick Engels, *Collected Works*, vol. 11 (London, 1979), 99–197; *Grundrisse: Foundations of the Critique of Political Economy (Rough Draft)*, trans. Martin Nicolaus (Harmondsworth, 1973); and *Capital*, vol. 1, chap. 1, "The Commodity," trans. Ben Fowkes (New York, 1977), 125–77.

For discussion of the problems involved in Marx's uses of the concepts of representation, articulation and fetishism, see: Althusser, "Marx's Immense Theoretical Revolution," in *Reading Capital*; Jean Baudrillard, *The Mirror of Production*, trans. Mark Poster (St. Louis, 1975); and *For A Critique of the Political Economy of the Sign*, trans. Charles Levin (St. Louis, 1981), especially "Fetishism and Ideology: The Semiological Reduction," 88–101, and "Towards a Critique of the Political Economy of the Sign," 143–63; Ben Brewster, "Fetish-

ism in *Capital* and *Reading Capital*," *Economy and Society* 5, no. 3 (August 1976): 344–51; Norman Geras, "Marx and the Critique of Political Economy," in *Ideology in Social Science: Readings in Critical Social Theory*, ed. Robin Blackburn (Glasgow, 1972), 284–305; Stuart Hall, "Marx's Notes on Method: A Reading of the 1857 *Introduction*," *Working Papers in Cultural Studies*, no. 6 (Birmingham, 1974); "Re-Thinking the 'Base-and-Superstructure' Metaphor," in *Class, Hegemony and Party*, ed. Jon Bloomfield (London, 1977), 43–72; "The 'Political' and the 'Economic' in Marx's Theory of Classes," in *Class and Class Structure*, ed. Alan Hunt (London, 1977), 15–60; and "The Problem of Ideology—Marxism without Guarantees," in *Marx: A Hundred Years On*, ed. Betty Matthews (London, 1983), 57–85; Barry Hindess and Paul Hirst, *Mode of Production and Social Formation* (London, 1977); Paul Hirst, "Althusser and the Theory of Ideology," in *On Law and Ideology* (London, 1979), 40–74; Ernesto Laclau and Chantal Mouffe, *Hegemony and Socialist Strategy: Towards a Radical Democratic Politics* (London, 1985), especially chap. 3, "Beyond the Positivity of the Social: Antagonisms and Hegemony," 93–148; Gayatri Chakravorty Spivak, "Scattered Speculations on the Question of Value," in *In Other Worlds: Essays in Cultural Politics* (New York and London, 1987), 154–75.

26. Cf. Hall, "The 'Political' and the 'Economic' in Marx's Theory of Classes;" Paul Hirst, "Economic Classes and Politics," in Hunt, ed., *Class and Class Structure*, 125–54; and Tagg, "Introduction" to *The Burden of Representation*.

27. Cf. Hirst, "Althusser and the Theory of Ideology;" and Tagg, ibid.

28. Laclau and Mouffe, *Hegemony and Socialist Strategy*, 111.

29. Ibid., 112.

Hieronymus Bosch and the "World Upside Down": The Case of *The Garden of Earthly Delights*

THE writing of art history is often regarded as if it were a self-evident enterprise in which historians share common assumptions and common goals. What matters, it is thought, are not the theoretical assumptions and methodological procedures that animate the work so much as the empirical "evidence" the study brings to bear on the interpretation in question. The lack of articulated assumptions implies that such theoretical considerations are unnecessary because all practitioners share the same point of view. As a consequence, it is possible for the discipline to operate on the basis of a hidden agenda, one that is difficult to challenge because it is not supposed to exist. This essay, however, is as much concerned with the ways in which we have tried to make sense of the work of Hieronymus Bosch as it is with the construction of a new interpretation of its significance; that is, it is especially interested in what the historian brings to the work of interpretation. As a consequence, I shall try to define some of the most important presuppositions underlying current scholarship on Bosch, as well as the perspective from which my own proposal is made.

A superficial acquaintance with the scholarly literature on Bosch reveals that, while the artist's work has been almost universally acknowledged to be enigmatic, one author after another has approached it as if it were a puzzle that needed solving or a code that should be broken. Erwin Panofsky epitomized this attitude when he wrote in *Early Netherlandish Painting*:

> In spite of all the ingenious, erudite and in part extremely useful research devoted to the task of "decoding Jerome Bosch," I cannot help feeling that the real secret of his magnificent nightmares and daydreams has still to be disclosed. We have bored a few holes through the door of the locked room; but somehow we do not seem to have discovered the key.[1]

Many competing interpretations suggest that Bosch's visual forms are symbols that can be explained through recourse to esoteric knowledge, which was part of Bosch's historical horizon but which is unknown to us today. As a consequence, the literature is characterized by attempts to explain his imagery in terms of astrology, alchemy, rare forms of heresy, illustrated puns, and so forth.[2]

There are, of course, notable exceptions to this rule. Interestingly enough, such approaches tend to favor a broader understanding of the cultural significance and social function of his art.[3] Paul Vandenbroeck, for example, has recently provided us with an analysis of the social values manifested in Bosch's subject matter, thus affording us insight into his role as a member of a new, humanistically educated elite.[4] He shows that such paintings as *The Ship of Fools*, *The Cure of Folly*, *The Death of the Miser*, and *The Haywain Triptych* not only manifest the secular morality of this group, but that these moral values were used to distinguish their own from the cultures of other classes. Another of Vandenbroeck's contributions is his discussion of Renaissance art theory in relation to Bosch's visual imagery. He argues, however, that while Bosch made use of concepts such as invention, fantasy, and genius in the elaboration of an apparently hermetic art, his work was nevertheless capable of being deciphered by a humanistically trained elite. The hermetic quality of Bosch's work is thus interpreted as a device by which meaning could be hidden from those who were regarded as socially (and morally) inferior. Vandenbroeck writes:

> His work may be accounted for down to the smallest detail, as Bax has demonstrated and maintained against all other interpreters. Bosch is a pseudo-visionary (a concept which we have used without pejorative connotations), who sought the greatest possible control over the thought, that is to say the subject-like *inventio* which was the basis for his visual imagery.[5]

This interpretation is confirmed in his most recent essay on *The Garden of Earthly Delights*, in which meaning is ascribed to every aspect of the pictorial fabric.[6]

In what follows, I will suggest that while the function of Bosch's paintings may very well have served the moral and social purposes ascribed to them by Vandenbroeck, his visual motifs did not possess the specific meanings that he and others have attributed to them. In other words, I will argue that, far from being "accounted for down to the smallest detail," Bosch's imagery was to a large extent incapable of

being read and that it was this very quality that enhanced its appeal for a humanistically educated audience. In place of the pictorial *symbol*, I would substitute the pictorial *sign*. Rather than attempt to ascribe to Bosch's pictorial motifs symbolic or allegorical status, that is, to claim that the work's material substance refers to an ideal substructure that is fixed, separate, and distinct, I will think of them as signs in which both material and ideal qualities are indissolubly united. In doing so, I want to draw attention not to the depths of meaning that are said to lie behind Bosch's forms but to the surfaces they animate. Rather than look through the work, I suggest we examine the way in which it resists our gaze. Instead of valuing transparence, the way in which many interpreters have claimed that the paintings afford us access to an intellectual realm behind the surface, I should like to emphasize their opacity—the way in which his paintings insist that the interpreter create meaning before them. As a contrast to Panofsky's model of historical scholarship as an enterprise dedicated to the discovery of secrets and the penetration of sealed chambers, I should like to quote Michel Foucault:

> The contemporary critic is abandoning the great myth of interiority: . . . He finds himself totally displaced from the old themes of locked enclosures, of the treasure in the box that he habitually sought in the depths of the work's container. Placing himself at the exterior of the text, he constitutes a new exterior for it, writing texts out of texts.[7]

By using the notion of the sign, I wish not only to draw attention to the way in which the signifying systems of the past can only be interpreted in light of the signifying systems of the present, but also to suggest that both those of the past and those of the present are ideologically informed. Rather than define the sign as something that draws its meaning from all the other units that constitute the system of which it is a part, as for example, in Saussure's definition of the word's relation to language[8]—a strategy that serves to abstract signification from its cultural and social circumstances—I wish to use a notion of the sign developed in the Soviet reaction to Saussure, namely that used by Valentin Volosinov and Mikhail Bakhtin.[9] According to this view, signs are not part of an abstract, timeless system but are conceived of as engaged in specific social and cultural transactions. Instead of defining their significance by means of their relation to all the other elements of the system to which they belong, as in the structural semiotics of Saussure, signs obtain their meaning from the specificity of the circumstances of their use.

To suggest that signs can be ascribed specific meaning is not, of course, to suggest that they are univocal. Far from implying that the interpreter can ever arrive at the "true" significance of the sign systems of the past, a recognition that signs are defined by their social and historical location implies that every interpretation is itself constituted by sign systems that have their own social and historical specificity. In other words, an understanding of the signifying processes of the past involves a recognition that the work of the interpreter is also a signifying process and that both the signs of the past and the signs of the present are colored and compromised by the circumstances of their production.[10]

If Bosch's visual imagery is to be understood in terms of signs as defined above, then it will be important to locate them within the other signifying systems that constituted the culture in which he worked. Insofar as this analysis is indebted to the historicist assumption that events are shaped by the historical context in which they take place, then it will be important to ascertain the ways in which the signs that articulate his work intersected with the rest of the sign systems that organized the social and historical circumstances of their creation. That is, like those interpretations that depend upon astrology, alchemy, heresy, or the identification of puns, this interpretation will have to move beyond the boundaries of the picture plane into the culture that surrounded it. Rather than penetrating the image so as to see through its forms to intellectual traditions they allegedly symbolized or embodied, this analysis will attempt to move across their surfaces to examine the conventional and thus social sign systems with which they are both contiguous and continuous. Instead of regarding the image as a finished product, that is, as a reflection of intellectual activity taking place in another sphere, the image will be regarded as part of a social process. Instead of occupying a passive place in the life of culture, it will be regarded as an active participant.

Norman Bryson has pointed out that there is nothing self-evident about the choice of circumstances the historian adduces in an attempt to build a causal narrative about his or her subject.[11] Bosch's imagery must have served a variety of different functions for those who originally experienced it. Since matters relating to class will figure prominently in the narrative I propose to tell, however, the context I have deemed relevant is concerned with the role played by Bosch's works in the artistic collections of the Burgundian nobility of his time. What little information we have concerning the early patronage of Bosch's art suggests that his paintings were collected by members of the aristocracy, espe-

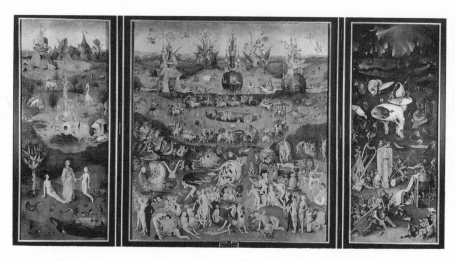

1. Hieronymus Bosch, *The Garden of Earthly Delights*. Madrid, courtesy Museo del Prado.

cially by those who had been most affected by the introduction of humanist culture. Bosch's painting *The Garden of Earthly Delights* (fig. 1), for example, was almost certainly commissioned by Henry III of Nassau, advisor and chamberlain to the reigning duke Phillip the Handsome.[12] According to Antonio de Beatis, an Italian who traveled in the Netherlands in 1516–1517, the *Garden* hung in the Brussels palace of the counts of Nassau in the company of a painting representing Hercules and Dejaneira, in which the figures were depicted nude. Gombrich has plausibly suggested that this painting may be identified with a work by Jan Gossaert, which is now in the Barber Institute in Birmingham (fig. 2). Bosch's work was thus included in a collection that had been decisively marked by the humanist taste of the Italian Renaissance.[13] The pictorial conventions or signs with which Gossaert has constructed this cultural representation are deeply indebted to the Italianizing art of Albrecht Dürer. It was through Dürer's absorption of the canon of anatomical proportions codified in antiquity by Vitruvius and revived in the Renaissance by artists such as Leonardo that Gossaert could present his figures as representative of the pictorial ideals of humanist culture.[14] On the other hand, the erotic intimacy that characterizes the mythological couple is typical of the way in which such subjects were handled by Netherlandish artists in the early years of the sixteenth century.[15]

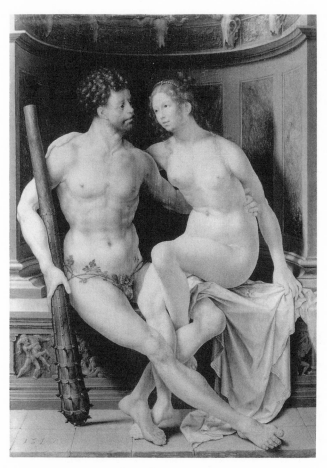

2. Jan Gossaert, *Hercules and Dejaneira*. Birmingham, courtesy The Barber Institute, University of Birmingham.

The collection of paintings assembled by Henry III's third wife, the Spanish princess Mencia de Mendoza, after Henry's death, was consistent with the taste I have just described. That is, she included works by Bosch in a group of works executed largely by Italianizing artists. Shortly before her departure for Spain in 1539, she instructed her agents to buy at least one work by Bosch, a version of one of his best-known paintings, *The Haywain Triptych*.[16] Inventories of her collection taken in 1548 and after her death in 1554 reveal that there were several other

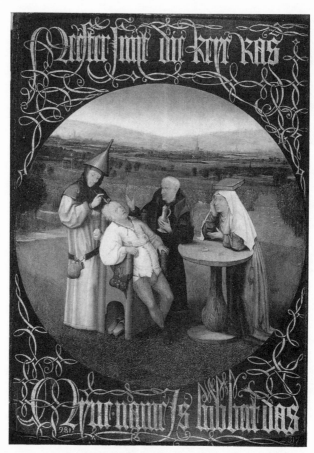

3. Hieronymus Bosch, *The Cure of Folly*. Madrid, courtesy Museo del Prado.

works ascribed to Bosch in her possession. Bosch's paintings would thus have formed part of a collection that included Jan Gossaert, Bernard van Orley, Jan Vermeyen, Jan van Scorel, and Maarten van Heemskerck, all leading exponents of the Italianizing tendency in Netherlandish painting during this period.[17]

Henry III and Mencia de Mendoza appear to have been the rule rather than the exception among those who first collected works by Bosch. A version of *The Cure of Folly* (fig. 3) once hung in the dining room of Phillip of Burgundy's palace at Duurstede in 1524. Like *The Garden of*

Earthly Delights, it shared the walls with three large paintings of nudes, probably representing mythological subjects. J. J. Sterk has proposed that one of these paintings may have been a lost work by Jan Gossaert representing Hercules and Antaeus, which is known from a copy now in a private collection in Germany.[18] Phillip of Burgundy, an illegitimate son of Phillip the Good, Duke of Burgundy, had filled important positions of state before becoming bishop of Utrecht in 1517. His humanist interests are well documented. His court poet, Gerrit Geldenhauer, who wrote a biography of Phillip, tells us that his patron studied painting and goldsmiths' work as a youth and that his conversation revealed an intimate knowledge of the work of the ancient theorist Vitruvius. Philip was also the patron of the artist Jan Gossaert, whom he took with him on a diplomatic mission to Rome in 1508. He employed both Gossaert and Jacopo de Barbari, a Venetian painter and theorist, in the decoration of his palace at Souburg. The interest of both of these artists in Italian Renaissance art theory is evident in Gossaert's painting of Neptune and Amphitrite (fig. 4), in which the figures are constructed in accordance with the Vitruvian canon of human proportions.[19]

What was it that made Bosch's visual imagery so attractive to a humanist audience? How did the sign systems that constitute the surface of his works intersect with the sign systems that organized and structured the humanist culture of an aristocratic elite? What access do we have to the taste that enabled this class to appreciate representations of ideal nudes and the world of imagination that we appear to find in the works of Bosch? This point in our narrative marks a shift from the analysis of Bosch's patronage to an analysis of the intellectual culture to which that patronage subscribed. One of the means of obtaining access to the aesthetic values of Bosch's original audience is to examine their ideas about the nature and function of artistic products. Many of their ideas on such matters must have been shaped by what they knew about the theory of art, in this case the humanist theory of the Italian Renaissance. A way into our topic is afforded by a piece of art criticism by Antonio de Beatis, whom we have mentioned earlier. Beatis included the following in his description of his visit to the palace of Henry III of Nassau:

And then there are some panels on which bizarre things have been painted. Here seas, skies, woods, meadows and many other things are represented, such as those [figures] that emerge from a shell, others that defecate cranes, men and women, whites and blacks in different activities and poses. Birds,

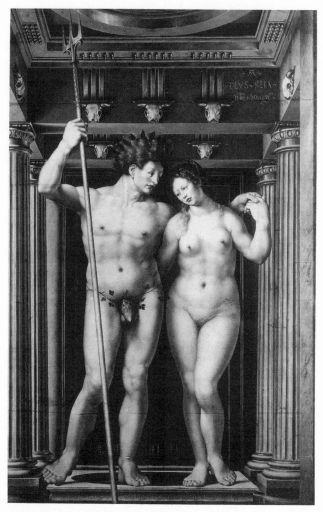

4. Jan Gossaert, *Neptune and Amphitrite*. Berlin, courtesy
Staatliche Museen.

animals of all kinds, executed very naturally, things that are so delightful and fantastic that it is impossible to describe them properly to those who have not seen them.[20]

It is remarkable that Beatis should have focused not on the way in which Bosch's visual motifs carried symbolic meaning, nor even on the allegorical significance of the work, but that he should have emphasized the way in which these motifs drew attention to the artist's powers of invention and fantasy. Most telling of all is his admission that he cannot find words to describe the painting adequately to those who have not seen it themselves. By remarking on the way in which visual and linguistic signification differ, Beatis suggests the way in which Bosch's pictorial signs establish the singularity of their author.

The notion of fantasy, already present in Beatis's account, becomes central in that written by a Spanish scholar at the beginning of the seventeenth century. Drawing an elaborate analogy between poetic and artistic creation based on Horace's dictum *ut pictura poesis* (as in painting, so in poetry), Jose de Siguenza argued that Bosch sought to distinguish himself from his great contemporaries, Dürer, Michelangelo, and Raphael by means of the strategy adopted by Teofilo Folengo, the "macaronic" (or satiric) poet of the Italian Renaissance.[21] According to Siguenza, Folengo had created a highly personal, idiosyncratic style in order to set himself apart from his great predecessors Virgil, Terence, Seneca, and Horace.

> Hieronymus Bosch certainly wished to resemble this poet, not because he knew him (for, as I believe, he painted his fantasies before him), but because the same thinking and the same motive impelled him: he knew that he had great gifts for painting and that in regard to a large part of his works he had been considered a painter who ranked below Durer, Michelangelo, Raphael (Urbino) and others, and so he struck out on a new road, on which he left all others behind him, and turned his eye on everything: a style of painting satirical and macaronic, devoting much skill and many curiosities to his fantasies, both in innovation and execution and often proved how able he was in his art . . . when he spoke seriously.[22]

The value attached to fantasy in the criticism of Beatis and Siguenza, together with its justification by the latter using the notion of *ut pictura poesis*, is a characteristic of Italian Renaissance art theory of the fifteenth and sixteenth centuries. Beginning with Cennino Cennini's *Libro dell'arte* of about 1400, Italian art theorists had extolled the values of

fantasy and artistic license as a means of claiming a more exalted status for the artist. Cennini claims that painting

> . . . deserves to be placed in the next rank to science and to be crowned with poetry. The justice lies in this: that the poet is free to compose and bind together or not as he pleases, according to his will. In the same way the painter is given freedom to compose a figure standing, sitting, half man, half horse, as it pleases him, following his *fantasia*.[23]

Undoubtedly the greatest claims for the importance of fantasy in artistic creation were made by Leonardo da Vinci. An aspect of his thinking on the subject is found in his equation of fantasy and reason in a personal adaptation of Aristotelian faculty psychology. According to Aristotle, whose views had dominated psychological theory during the Middle Ages, fantasy was located in the foremost ventricle of the brain and thus separated from the operations of reason, which were thought to be located in the central ventricle. Aristotle's theory is clearly illustrated in a woodcut from Georg Reisch's encyclopedia, the *Margarita philosophica* (*The Philosophical Pearl*), which appeared in Freiburg in 1503 (fig. 5).[24] According to the woodcut, fantasy is found in the foremost ventricle, reason in the central one, and memory in the third ventricle at the back of the brain. Leonardo, on the other hand, in a drawing of about 1489 (fig. 6), which Kemp identified as an illustration of psychological theory rather than an anatomical study of the skull, placed fantasy in the central ventricle so that it was linked to reason. In doing so, he associated fantasy with what had traditionally been regarded as the most privileged activity of the brain. Leonardo's view of the importance of fantasy was accompanied by extraordinary claims to artistic license, claims that had profound implications for the social status of the artist. He wrote, for example, "The divinity which is in the science of painting transmutes itself into a resemblance of the divine mind in such a manner that it discourses with free power concerning the generation of the diverse essences of various plants, animals and so on."[25]

The importance ascribed to fantasy as the basis for artistic license by humanist art theory was not confined to Italy. Both patrons and artists north of the Alps appear to have recognized that its implications had the potential to transform their relationship. The importance of fantasy can also be demonstrated in the career of Bosch's contemporary, Albrecht Dürer. Dürer, whose theoretical writings and artistic practice are both deeply indebted to Leonardo, seems to have been aware of the

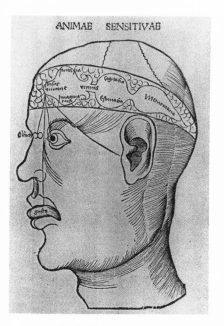

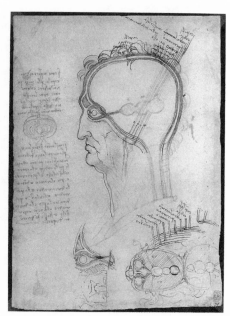

5. *Left*, Anonymous, *Ventricles of the Brain*, woodcut. From Georg Reisch, *Margarita philosophica*, Freiburg, 1503. Photo from Martin Kemp, "From 'Mimesis' to 'Fantasia': The Quattrocento Vocabulary of Creation, Inspiration and Genius in the Visual Arts," *Viator* 8 (1977): 347–98, fig. 4. Reprinted with permission of the Regents of the University of California.

6. *Right*, Leonardo da Vinci, *Ventricles of the Brain*, Windsor, courtesy of the Royal Library, Windsor Castle.

latter's claims concerning the divine nature of artistic creation. Though his *Self-Portrait* of 1500 (fig. 7), whose format is thought to have been derived from fifteenth-century representations of the "Holy Face" of Christ (fig. 8), may have made reference to the notion of the *imitatio Christi* (imitation of Christ), it can also be regarded as a self-conscious assertion of the analogy between divine and artistic creation.[26] In a draft to the introduction of his treatise on painting, written in 1512, Dürer wrote:

> Many centuries ago the great art of painting was held in high honour by mighty kings, and they made excellent artists rich and held them worthy,

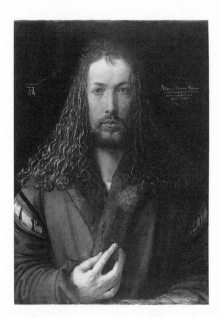

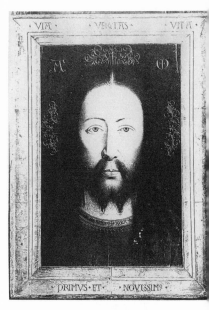

7. Albrecht Dürer, *Self-Portrait*. Munich, courtesy Bayerische Staatsgemälde- sammlungen.

8. Jan van Eyck (copy), *Holy Face of Christ*. Munich, courtesy Bayerische Staatsgemäldesammlungen.

> accounting such inventiveness a creating power like God's. For the imagi- nation of the good painter is full of figures, and were it possible for him to live forever he would always have from his inward "ideas," whereof Plato speaks, something new to set forth by the work of his hand.[27]

In this passage Dürer explicitly equates the divine-like quality of artistic creation with the need for social recognition. The situation that existed in the past, the honor paid to artists by royalty, is clearly invoked as a model for the present.

Another artist working in Germany (prior to his journey to the Netherlands), the Venetian, Jacopo de Barbari, composed an appeal to his patron Frederick the Wise of Saxony for the recognition of painting as the eighth liberal art.[28] Barbari argued that, far from being a mechani- cal art, painting presupposed a knowledge of all the other liberal arts. In addition, the artist not only imitated nature but had the capacity to reproduce nature, a creative activity without parallel among the rest of the arts.[29] He concludes:

... from which most illustrious prince, elector of the Roman Empire, you can contemplate in these few precepts the excellence of painting which, in an inanimate nature, makes visible that which nature creates as palpable and visible. And one can deservedly seat painting among the liberal arts, as the most important of them. For when men have investigated the nature of things in their number and in their character, they still have not been able to create them. It is to this creation that painting is so suited that it deserves its freedom.[30]

It would appear that such views were expressed by Barbari wherever he went. After leaving Germany, Barbari worked first for Phillip of Burgundy (1509) and later for Margaret of Austria, regentess of the Netherlands. J. J. Sterk has discerned Barbari's teaching in a poem by Phillip's court poet and biographer, Gerrit Geldenhauer. In a Latin poem in praise of painting written in 1515, Geldenhauer praises the painter for his ability to reproduce nature as well as to create naturalistic depictions of historical and mythological narratives. Like Barbari, Geldenhauer suggests that these qualities deserve the recognition of rulers.[31] The career of Jacopo de Barbari thus enables us to reconstruct at least one avenue by which the new humanist ideas concerning artistic license and its implications for the status of the artist, which were first developed in fifteenth-century Italy, were disseminated among artists and patrons living in the Netherlands.

The realization that notions of fantasy and artistic license played a role in the aesthetic values of the humanistic elite for which Bosch worked does not immediately help us understand the significance his art had for them. After all, the rising importance of the notion of fantasy in Renaissance art theory was not directly related to the development of non-mimetic imagery of the kind we associate with Hieronymus Bosch. The role of fantasy in artistic creation as envisioned by Leonardo and Dürer, for example, had nothing to do with departing from the principles of mimesis. Fantasy enabled the artist to depart from nature, in the sense of reproducing or creating nature, rather than to neglect or defy it. However, while fantasy and mimesis were regarded as completely congruent concepts, fantasy could also be invoked as a means of accounting for imagery that deliberately broke the rules of resemblance.[32] Interestingly enough, such justifications of non-mimetic imagery were also undertaken in terms of *ut pictura poesis*. For example, the popularity in Renaissance Italy of the non-mimetic decorative ornaments known as "grotesques," a type of ornament based on Roman wall decorations

discovered during the excavation of the Golden House of Nero in the late fifteenth century, was justified in terms of artistic license.[33] An engraving by the anonymous Italian Master of the Die (fig. 9), dating from the early sixteenth century, is accompanied by the following text:

> Poet and Painter as companions meet
> Because their strivings have a common passion
> As you can see expressed in this sheet
> Adorned with friezes in this skilful fashion.
>
> Of this, Rome can the best examples give
> Rome toward which all subtle minds are leading
> When now from grottoes where no people live
> So much new light of this fine art is spreading.[34]

When the subject of the new fashion for "grotesques" was raised during Francisco de Holanda's discussions with Michelangelo, Michelangelo is said to have defended them by expressly quoting Horace:

> In this sentence he [Horace] does in no way blame painters but praises and favours them since he says that poets and painters have license to dare to do, I say to dare . . . what they choose. And this insight and power they have always had; for whenever (as rarely happens) a painter makes a work that seems false and deceitful . . . , this falseness is truth; and greater truth in that place would be a lie. For he will not paint a man's hand with ten fingers, nor paint a horse with the ears of a bull or a camel's hump; nor will he paint the foot of an elephant with the same feeling as the foot of a horse, nor the arm or face of a child like those of an old man; nor an eye nor an ear even half an inch out of its proper place; nor even the hidden vein of an arm may he place where he will; for all such things are false. But if, in order to observe what is proper to a time and place . . . , he change the parts of limbs (as in grotesque work . . . , which would otherwise be without grace and most false) and convert a griffin or a deer downward into a dolphin or upward into any shape he may choose, putting wings in the place of arms, and cutting away the arms as if wings are better, this converted limb, of lion or horse or bird will be most perfect according to its kind . . . ; and this may seem false but can really only be called well invented or monstrous. . . . And sometimes it is more in accordance with reason to paint a monstrosity (for the variation and relaxation of the sense and in respect of mortal eyes, that sometimes desire to see that which they never see and think cannot exist) rather than the accustomed figure (admirable though it be) of men and animals.[35]

9. Master of the Die, *Grotesque Ornament*, engraving. New York, courtesy The Metropolitan Museum of Art, Harris Brisbane Dick Fund, 1953 (53.600.62).

What is important in this discussion of the justification of the fashion for grotesques in terms of *ut pictura poesis*, is not the grotesques themselves, since there is little likelihood that Bosch could have known them and they bear no resemblance to his own pictorial forms. It lies rather in the way in which a non-mimetic tradition of representation was justified

in terms of the artist's license, his right to the untrammeled exercise of his fantasy.

The inspiration for Bosch's own non-mimetic vocabulary would appear to lie in the fantastic forms traditionally used in the decoration of ecclesiastical architecture and furniture, objects of decorative art, and the margins of illuminated manuscripts. Before suggesting some of the ways in which Bosch may have used these forms to his own ends, we must first of all examine their original function and significance within the cultural and social context in which they were produced. The apparently frivolous quality of these imaginative forms, which appear to bear no relation to the religious function of the buildings, objects, and books in which they are so often found, proved deeply offensive to medieval moralists. The well-known letter of St. Bernard of Clairvaux, written in the twelfth century, affords us an account of their "beautiful depravity," while condemning them as useless fancies:

> But in the cloister, before the eyes of penitent brethren, what is that ridiculous pageant of monstrosities, that beauty of ugliness doing? What place is there for dirty monkeys, for ferocious lions, for monstrous centaurs, for half-men, for spotted tigers, for fighting soldiers, for huntsmen winding their horns? You may see there a number of bodies with a single head, or again many heads upon a single body. Here a four footed beast is seen with a serpent's tail, there the head of a quadruped upon a fish. Here a beast whose forepart is a horse and it drags half a goat after it: there is a horned creature with the hind quarters of a horse. So copious, in short, and so strange a variety of diverse forms is to be seen that it is more attractive to peruse the marbles than the books, and to spend the whole day gazing at them rather than meditating on the Law of God. In God's name! if men are not ashamed of the folly of it, why do they not at least smart at the thought of the cost? [36]

Scholars of illuminated manuscripts, the art form from which, as we shall see, it is most likely that Bosch derived his ideas, have proposed that these motifs often constituted a satirical and/or entertaining form of humor.[37] Many of the themes depend upon the notion of the "world upside down"; that is, they satirize classes, occupations, and the sexes by inverting the relationships in which they usually stand in society. Among the favorite targets of the illuminators are the aristocracy and the clergy. For example, chivalric ideals are disparaged when knights are shown attacked by hares (fig. 10), and the clergy is mocked when its ecclesiastical activities are performed by apes. Alternatively, knights are

10. Anonymous, "Men Defending Castle against Hares," *Metz Pontifical*, mss. 298, f. 41. Photo copyright Fitzwilliam Museum, University of Cambridge.

defeated by women in jousts, and clerics are seduced by nuns. Dominant women are frequently satirized in representations of marital strife; one of the favorite themes being the "battle for the pants," which, then as now, seemed to metaphorize the issue of sexual control in marriage (fig. 11). Other images are more entertaining then satiric and depend on the inversion of relationships in nature. In such scenes, rabbits execute dogs or hunt human beings (fig. 12).[38] An important dimension of this marginal imagery is made up of monsters or hybrids composed of various combinations of human and animal forms.[39] Such monsters engage in improbable activities that mimic forms of human activity or demonstrate the limitations of their own curious forms (fig. 13).

Bosch's knowledge of the fantastic imagery of the manuscript margins was, in all likelihood, a personal one. Not only have direct borrowings from manuscripts been documented in his work, but recent scholarship suggests that he was trained as a manuscript illuminator rather than as a panel painter.[40] Far from suggesting that Bosch used the images of the manuscript margins as a source from which he borrowed to create his

a paine ke ien trai de desir enforchie
T rop mes ꞇ plus souent si me font grãt aie
U i penser amourous a la belle emuoisie
ꝗ plus me font de bie qnt ie mi estudie
k e de li regaider en la fache polie
ꝗ si a bñ raison sil est ki le ws die
ar dieu dist li baudrais mse wlentiers saroie
La raison de chesti car p dieu ie cudoie
k en j tout seul regart estoit mil tãs de ioie
k en trestous les pensers ke ie peser poroie
S ire ce dist li rois bie giet vos otroie
O mes ke ws ames bie ams nest pas moie
O ꞓ ws en est ensi ꞇ moi en autre voie
ꝗ ais tant dirai ie bñ puis ke dire le doie
Q iit ie ui a loisir la gorge li blanchoie
I e vis ꞇ le mentõ des cheueaus tresꝑ ꞇ bloie
D e la belle ꝑ cui fine amours mi mantroie
J e sin si tres nues ke nest riens ke ie voie
R ien ne ui rien ne sene ne riés ne sentiroie
S en tel point deuãt li tot mon uiuãt estoie
ꝗ ꝑ cheste raison de tant i entendoie
k en regart esbahi nus amãt nen a ioie
ꝗ aisasir ie sui tous seus en cãbre clere ꞇ coie
ꝗ li dous souenirs a penser me tanoie
D e chels kai ueu se iamais le veoie
ꝗ ieust plʼ noblemẽt ws li mi mantenroie
ꝗ mes biens ꞇ mes mans coiemẽt li diroie
I ors pens ꞇ outrepes regart ꞇ estudie
ꝺ les ter de mon cuer en pensant li enuoie

11. Anonymous, "Battle for the Pants," *Voeux du Paon*, ms. 24, f. 6v. New York, Glazier Collection, courtesy Pierpont Morgan Library.

grant ioie cheuauchent les puis de uai garni

12. Anonymous, "Man Hunted by Hare," *Romance of Alexander*, ms. 264, f. 81v. Oxford, Bodleian Library. Reproduced from Lillian Randall, *Images in the Margins of Illuminated Manuscripts*, Berkeley, University of California Press, 1966, fig. 356. Reprinted with permission of the Regents of the University of California.

13. Anonymous, "Double-headed Monster Fighting," *Luttrell Psalter*, ms. Add 42130, f. 211. London, British Museum. Reproduced from Eric Millar, *The Luttrell Psalter*, London, British Museum, 1932, fig. 151b.

own images, as has previously been claimed, I would argue that Bosch transformed the earlier tradition by means of an imaginative rework-ing of its principles on the basis of *ut pictura poesis*. It is my argument that Bosch used the satirical and entertainment value of the notion of the "world upside down," as well as of fabricated monsters, in order to demonstrate the humanist artist's new claim to artistic freedom.[41]

An example of his use of the principle of inversion, in this case one that is well known in the manuscript margins, is his reversal of natural relations of scale. In the landscape of the central panel of *The Garden of Earthly Delights*, humans are often dwarfed by birds and animals as well as by fruits and other vegetation. The magnificent, brilliantly hued birds in the pool in the middle distance are many times the size of the humans who ride on their backs.[42] Not only are the birds larger than human beings but the inversion of the usual relationship is dramatized in that, here, birds feed humans rather than vice versa. The intense natu-ralism that characterizes Bosch's depiction of these birds may also have its sources in the manuscript margins. During the course of the fifteenth century, the satiric and humorous non-mimetic world of the manuscript margins was transformed by the introduction of *trompe l'oeil* borders, in which the manuscript text was surrounded by meticulously described objects from the real world.[43] While the earlier traditions did not entirely die out, the borders were increasingly filled with illusionistic represen-tations of flowers, jewels, peacock feathers, and other precious objects. Fruits, like birds, also find their relation to humans dramatically altered. The fruits of the central panel are described with a marked attention to their luscious shapes and glossy surfaces. The scene contains giant rasp-berries and strawberries and cherries, from which many human beings can eat at the same time. The delectable quality of the fruits and their effect on the people that animate the landscape, many of whom feed off them voraciously, adds to the air of sensual enjoyment that characterizes the scene.

Apparently, Bosch's appreciation of the subversive potential of these "world upside down" reversals, the way in which, for example, inver-sions of scale might be used to marginalize the activities of humans by centralizing the presence of birds and fruit, thus suggesting that the former are captive to their sensual desires, enabled him to extend the principle so as to organize certain sections of the composition and even to plan the central panel as a whole. For example, Walter Gibson has proposed that the beautiful, nude young women who occupy the pool in the center of the central panel (fig. 14), and who seem to have attracted

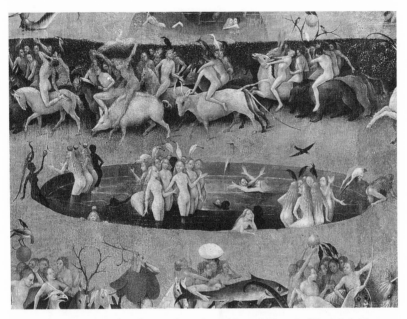

14. Hieronymus Bosch, *The Garden of Earthly Delights* (detail). Madrid, courtesy Museo del Prado.

the attention of a cavalcade of gesticulating male riders, might be a reference to the misogynist idea of the "power of women"—according to which women were held responsible for male lust.[44]

This popular idea is more clearly enunciated in an allegory by an anonymous German engraver dating from the middle of the fifteenth century (fig. 15). A banderole above the woman's head reads,

> I ride a donkey whenever I want
> A cuckoo is my lure
> With it I catch many fools and monkeys.[45]

The sense of the image depends on the equation of lust and folly, for the German words *esel* for donkey, *gauch* for cuckoo, and *affe* for ape all carried the secondary connotation "fool." The significance of this equation carried special moral opprobrium in an age when the concept of folly was closely linked with that of sin. The "power of women" idea may also be contained in one of the most striking images of the central panel, the couple encased in a bubble (fig. 16). The woman is the most

15. Master of the Power of Women, *Allegory of the Power of Women*, engraving. Munich, courtesy Bayerische Staatsbibliothek.

prominent of the nude pair, not only because of her placement and size but because of the pallor of her skin. She appears as the lure that has attracted the attentions of the man beside her. While comment on the transitory and evanescent nature of sexual pleasure may be found in the fragility of the bubble in which the scene unfolds, it also seems to be implied by the nude figure standing on his head immediately to the right. This figure, whose gesture serves to display rather than to hide his genitals, may, as we have seen, constitute a reference to the idea of the "world upside down."

Gibson also drew attention to the way in which the springtime loveliness of the central panel echoes literary and pictorial representations of the "Garden of Love"—a theme whose inspiration lay in the literary tradition initiated by the *Roman de la Rose*.[46] The characterization of this garden as one of sensual delectation contrasts markedly with the sober mood of the garden of Paradise in the left wing with which it bears a striking similarity. Both landscapes, for example, have a fountain at the center from which four channels of water flow. Their structural similarity appears deliberately ironic, for the significance of the biblical story in one directly contradicts the sensual abandon of the other. In one, the

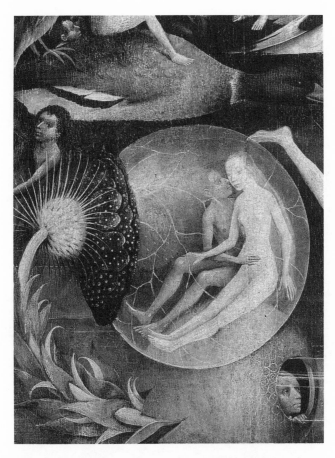

16. Hieronymus Bosch, *The Garden of Earthly Delights* (detail). Madrid, courtesy Museo del Prado.

marriage of Adam and Eve is enacted for the sole purpose of human procreation; in the other, sexual ecstasy takes place in the absence of children.[47] This interpretation gains strength when it is associated with an incident taking place at the center of the fountain in the central panel (fig. 17), in which a man touches a woman suggestively while another woman bends down so as to present her buttocks to the spectator. This scene takes place in the vicinity of a nude man standing on his head. The use of such a figure to convey the idea of the "world upside down" is not unknown in this period. A German engraver known as the Housebook

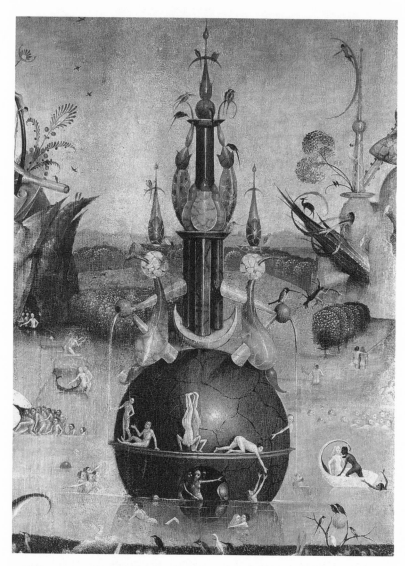

17. Hieronymus Bosch, *The Garden of Earthly Delights* (detail). Madrid, courtesy Museo del Prado.

18. The Housebook Master, *Parodic Coat of Arms*,
engraving. Amsterdam, courtesy Rijksprentenkabinet.

Master, who worked on the Middle Rhine in the third quarter of the
fifteenth century, used just such a figure at the center of a parodic coat
of arms (fig. 18).[48] The crest of this coat of arms illustrates the theme
of the henpecked husband, a peasant who is forced to carry his wife on
his back. Such themes, a commonplace of late medieval art, constitute
a satire of sexual relations in which the "natural" hierarchy of male
domination was not observed. The juxtaposition of this figure with the

sexually explicit group at the center of the fountain suggests that such activities are to be condemned and rejected.

The right wing and its Hell scene offer us another series of inversions. Here, musical instruments, usually a source of entertainment and sensual enjoyment, are transformed into instruments of torture (fig. 19). One figure is stretched across the strings of an enormous harp, while others are forced into choral singing led by a monster who reads music that has been tattooed onto the behind of one of the unfortunates in his power. Another figure, imprisoned in a drum, is deafened by the monster who beats it, while a third, tied to a flute, has had another flute inserted in his anus. In the foreground, a pretty young woman is offered an image of herself in a mirror supported on a monster's behind, the vain satisfaction she may have taken from her reflection being sabotaged not only by its source but by the amorous attentions of a hideous black monster who fulfills the role of a male lover. Finally, a scene that not only manifests the principle of inversion but almost quotes the imagery of the manuscript margins: Striding across the foreground is a hare blowing a hunting horn, who carries a human being on the spear he carries over his shoulder.[49]

What are the implications of Bosch's choice of the manuscript margins and the inversions of the world upside down for the cultural context in which he worked? By making use of the traditions of manuscript illumination, Bosch turned to an art form that had been traditionally associated with the aristocracy. There was, in the Middle Ages, no other social group that could undertake the enormous expense involved in the production of these sumptuous objects of display. It is perhaps not irrelevant to our discussion that Engelbert II of Nassau, father of Henry III who, as we have seen, was in all likelihood the first owner of *The Garden of Earthly Delights*, collected these precious books and commissioned one of the most spectacular examples produced in the fifteenth century.[50] It is significant that the satirical humor of the "world upside down" flourished in an aristocratic milieu. As anthropologists and historians have so often pointed out, the social function of rituals and other expressions of this idea is to demonstrate the need for order.[51] The satire of chivalric attitudes or of the role of the clergy could only take place in a context within which such questioning did not constitute a real challenge to the status quo. Indeed, it could be argued that the importance of the manuscript margins in books that include chivalric romance, on the one hand, and missals, psalters, and prayerbooks, on the other, lies

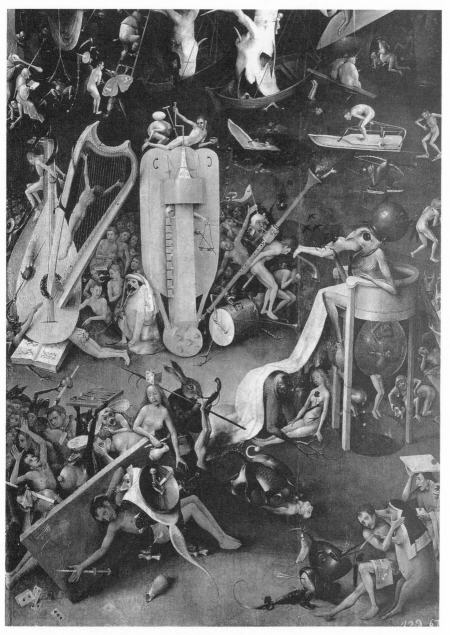

19. Hieronymus Bosch, *The Garden of Earthly Delights* (detail). Madrid, courtesy Museo del Prado.

in the way in which they supported and reinforced the assumptions of the classes and occupations of those who commissioned them.[52]

The significance of Bosch's use of the theme of the "world upside down" may be expanded if we recognize it as a manifestation of the way in which a culture affirms and sustains its values by distinguishing itself from a realm of chaos or nonculture. According to the cultural theory developed by Boris Uspenskii, Juri Lotman, and others of the Tartu of Soviet semiotics in the 1960s, culture and nonculture stand in a structural relation to one another:

> The mechanism of culture is a system which transforms the outer sphere into the inner one: disorganization into organization. . . . By virtue of the fact that culture lives not only by the opposition of the outer and inner spheres but also by moving from one sphere to the other, it does not only struggle against the outer "chaos" but has need of it as well; it does not only destroy it but it continually creates it.[53]

The mechanism of turning the world upside down, of moving the culturally repressed into a position of cultural dominance, can also serve as a way in which cultural boundaries are redefined. In Bosch's case, this translation of the topsy-turvy world of the manuscript margins into the center of the image, the elevation of visual themes and motifs whose subversive potential relegated them to the periphery, represented a dramatic expansion of the high culture of his time. The movement from the margins to the center may thus be viewed as not only a momentary aberration whose anomaly serves to reinforce the values of the status quo, but also as a means by which high culture could realign its boundaries so as to include within its parameters motifs that had previously been excluded.

This perspective on Bosch's art seems particularly relevant in light of the long-lasting impact of his work on Netherlandish painting.[54] It has, for example, been possible to trace a series of artists working in a Boschian vein until well into the third quarter of the sixteenth century, a series that includes some of the best-known artists of the period, including Pieter Bruegel the Elder. In the field of twentieth-century art, the appropriation of elements considered beyond the realm of official culture has been interpreted as one of the most important strategies of the avant garde.[55] Thomas Crow has argued that the avant garde has repeatedly turned to the world of popular culture in search of artistic inspiration. He claims that it is by means of these appropriations, these

transformations of nonculture into culture, that the avant garde has legitimated its status and function as a source of cultural production. The analogy between the artistic practice of the avant garde and those of Hieronymous Bosch is a striking one. In Bosch's case, it seems that the transformation of nonculture into culture was the means by which he could establish himself as a unique and distinctive talent. The appropriation of the "world upside down" was thus part of the process of "making genius."

In moving the "world upside down" from the margins to the center, Bosch did more than make use of a cultural trope that was well known to his audience. By making these inversions the focus of his work, Bosch transformed nonculture into culture and turned the tables on received notions of the work of art. Although vestiges of the age-old format of the "Last Judgment" inform the organization of *The Garden of Earthly Delights*—that is, its panels offer us a central scene that represents the earth and the world of human beings between scenes that represent Paradise and Hell—its moralizing message about the need to repent and prepare for the life to come is scrambled by the imposition of another system, another order, for which there was no precedent. By replacing the Resurrection with a scene of human beings indulging in their sensual appetites, Bosch not only transformed a theological statement into a moral commentary on sensuality and sexuality, but he called attention to the creative power of the individual artist. The new function of the work is not just to instruct, for, animated by the concept of artistic license, it draws attention to its facture as a manifestation of an unusual and exceptional artistic talent. Bosch's use of the notion of the "world upside down" thus serves as a metaphor for the rising status aspired to and accorded the artist in the Renaissance. By moving the author of the image from a marginal to a central position, from one who carried out the instructions of others to one who was directly involved in the creation of pictorial meaning, Bosch found a means of suggesting that the artist could no longer be regarded as a mere craftsman.

The history of the way in which the values of Renaissance humanism, the class values of a narrow social elite, transformed the social function of artistic production is not unrelated to the cultural circumstances of our own time. The historicist ideology created by nineteenth-century idealist philosophy, which invested the transcendence ascribed to aesthetic value with purpose and meaning, no longer dominates the circumstances of artistic production. The Hegelian claim that artistic changes

pursue a necessary development, a claim born of a teleological view of history, has largely been abandoned. As a consequence, the modernist myth that attributed stylistic change to a historical imperative has been decisively challenged.

The collapse of a motivated history of immanent aesthetic value has led to a questioning of the definition of aesthetic value itself. In this context, the self-referential gestures of the art of Hieronymus Bosch, gestures that have been institutionalized as the means by which aesthetic value may be asserted, have become suspect, and artists increasingly seek ways to integrate their work with broader cultural and social functions. The goal of some of the most progressive tendencies of postmodernism is not to draw attention to the artists so much as to articulate political messages of social importance.[56] Whether or not the artist can escape commodification in an art market organized on capitalist principles remains uncertain. It is difficult for artists to market their work in a way that does not call attention to their role as individual creators in a cultural climate that still subscribes to the notion of the artist as genius. Nevertheless, the assertion of the autonomous power of the artist has increasingly been called into question as a legitimate ambition for artistic production. Considerations of this nature enable us to see how the sign systems of the present intersect with those of the past in the creation of new meaning. A historical moment concerned with the dissolution of transcendent notions of creativity enables us to appreciate the way in which this idea was first inscribed into the work of art in the Renaissance.

What are the stakes in interpreting *The Garden of Earthly Delights* as a manifestation of the rising aspirations of the Renaissance artist as opposed to an allegory of the astrological, alchemical, heretical, or folklore ideas of Bosch's own time? The latter purport to explain the significance of his pictorial forms through an account of Bosch's unknowable intentions, that is, they regard the surface of the work as the result of a complex process of symbolization in which Bosch encrypted his meaning behind a layer of baffling pictorial forms. I have argued, instead, that his enigmatic forms were the product of fantasy and a means by which the artist could call attention to his own role in the process of interpretation. Instead of taking for granted that *The Garden of Earthly Delights* is a work of "genius," I have tried to show the means by which "genius" is a socially constructed category. I have attempted to look around the edges of the Boschian enigma in order to see it as part of a broader set of historical issues. Rather than account for its mystery, I

have argued that this mystery is a deliberate creation of the artist. The stakes of this interpretation thus lie in the fact that Bosch's "genius" is not a precondition to the work of interpretation. Indeed, it is only by appreciating the pictorial gestures by which Bosch ensured himself a place in the canon of great artists admired by the Burgundian aristocracy and the humanistically educated upper classes that we gain insight into the quality and texture of his intelligence, ambition, and imagination, thus ensuring him a place in the canon of "great" artists we admire today.

NOTES

1. Erwin Panofsky, *Early Netherlandish Painting. Its Origins and Character*, 2 vols. (Cambridge, Mass., 1966), 357–58.

2. It would be impossible to represent the entire interpretive spectrum here. The following are examples of some of the alternatives that still command scholarly interest. Astrology: Andrew Pigler, "Astrology and Jerome Bosch," *Burlington Magazine* 92 (1950): 132–36; Lotte Brand Philip, "*The Peddler* by Hieronymus Bosch, a Study in Detection," *Nederlands Kunsthistorisch Jaarboek* 9 (1958): 1–81; Anna Spychalska-Boczkowska, "Materials for the Iconography of Hieronymus Bosch's Triptych of *The Garden of Earthly Delights*," *Studia Muzeale Poznan* 5 (1966): 49–95. Alchemy: Jacques van Lennep, *Art et alchimie: Étude de l'iconographie hermetique et de ses influences* (Brussels, 1966); Madeleine Bergman, *Hieronymus Bosch and Alchemy*, trans. Donald Bergman (Stockholm, 1979); Laurinda Dixon, *Alchemical Imagery in Bosch's "Garden of Earthly Delights"* (Ann Arbor, 1981). Heresy: Wilhelm Fraenger, *The Millennium of Hieronymus Bosch. Outlines of a New Interpretation*, trans. Eithne Williams and Ernst Kaiser (Chicago, 1951; first German ed., Coburg, 1947); idem, *Die Hochzeit zu Kana: Ein Dokument semitischer Gnosis bei Hieronymus Bosch* (Berlin, 1950); Patrik Reutersward, *Hieronymous Bosch* (Uppsala, 1970). Illustrated puns: Dirk Bax, *Hieronymus Bosch: His Picture Writing Deciphered*, trans. M. Bax-Botha (Rotterdam, 1979); idem, *Beschrijving en poging tot verklaring van het Tuin der Onkuisheiddrieluik van Jeroen Bosch, gevolgd door kritiek op Fraenger* (Amsterdam, 1956). For an introduction to the Bosch literature, see Walter Gibson, *Hieronymus Bosch. An Annotated Bibliography* (Boston, 1983).

3. See Pater Gerlach, *Jheronimus Bosch. Opstellen over Leven en Werk*, ed. P. M. le Blanc (The Hague, 1988); J. K. Steppe, "Jheronimus Bosch. Bijdrage tot de historische en ikonographische studie van zijn werk," in *Jheronimus Bosch. Bijdragen bij gelegenheid van de herdenkingstentoonstelling te*

's-Hertogenbosch ('s-Hertogenbosch, 1967), 5–41; Walter Gibson, *Hieronymus Bosch* (New York, 1973).

4. Paul Vandenbroeck, *Jheronimus Bosch. Tussen Volksleven en Stadscultuur* (Berchem, 1987). Vandenbroeck's identification of Bosch's values with those of a humanist bourgeoisie anxious to define itself as distinct both from those who were less well off and from the aristocracy must now be considered in the light of the discovery of tax records that identify Bosch as one of the wealthiest citizens of his native city of Hertogenbosch. See Bruno Blonde and Hans Vlieghe, "The Social Status of Hieronymus Bosch," *Burlington Magazine* 131 (1989): 699–700.

5. Vandenbroeck, *Jheronimus Bosch*, 178, my translation.

6. P. Vandenbroeck, "Jheronimus Bosch' zogenaamde Tuin der Lusten," *Jaarboek van het Koninklijk Museum voor schone Kunsten, Antwerpen* (1989): 9–210.

7. Michel Foucault, *Foucault Live (Interviews, 1966–84)*, ed. Sylvère Lotringer, trans. John Johnston (New York, 1989).

8. Ferdinand de Saussure, *Course in General Linguistics*, ed. Charles Bally and Albert Sechehaye, trans. Roy Harris (La Salle, Il., 1986).

9. Mikhail Bakhtin, *The Dialogic Imagination*, ed. Michael Holquist, trans. Caryl Emerson and Michael Holquist (Austin, 1981); Valentin Volosinov, *Marxism and the Philosophy of Language*, trans. Ladislav Matejka and I. R. Titunik (Cambridge, Mass., 1986; first ed., Moscow, 1929).

10. For an expanded treatment of these ideas, see my article, "Semiotics and the Social History of Art," *New Literary History* 22 (1991): 985–99. Mine is not the first attempt to approach Bosch's visual forms from a semiotic perspective; see Albert Cook, *Changing the Signs. The Fifteenth-Century Breakthrough* (Lincoln, Neb., 1985). Cook made use of the arbitrariness of the Saussurean definition of the sign, the fact that it draws its meaning solely from its relation to all the other words in the language rather than from its relation to its referent, to argue that it was involved in an endless proliferation of meaning. His interpretation suggests that Bosch's forms can both mean anything or everything his interpreters have claimed them to mean. By relativizing the act of interpretation to this extent, Cook fails to acknowledge the ideological freight and political commitment that is a feature of the use of signs both in the past and the present.

11. Norman Bryson, "Art in Context," in *Studies in Historical Change*, ed. Ralph Cohen (Charlottesville, 1992), 18–42.

12. See Sir Ernst Gombrich, "The Earliest Description of Bosch's 'Garden of Delights,' " *Journal of the Warburg and Courtauld Institutes* 30 (1967): 403–6; also Steppe, "Jheronimus Bosch"; and P. Gerlach, "De Nassauers van Breda en Jeroen Bosch' 'Tuin der Lusten,' " in *Jheronimus Bosch*, 171–86. The following account of Bosch's humanist patrons is by no means complete. Among those with documented humanist interests are such patrons as Margaret of Austria, regentess of the Netherlands, Cardinal Domenico Grimani, and Damiao da Gois, the Antwerp agent of John III of Portugal.

13. For other aspects of Henry III's interest in the artistic forms of the Italian Renaissance, see R. van Luttervelt, "Renaissance Kunst te Breda. Vijf Studies," *Nederlands Kunsthistorisch Jaarboek* 13 (1962): 55–104, and 14 (1963): 31–60; and Nicole Dacos, "Tommaso Vincidor. Un élève de Raphael aux Pays-Bas," in *Relations artistiques entre les Pays-Bas et l'Italie à la renaissance. Études dédiées à Suzanne Sulzberger*, ed. N. Dacos (Brussels, 1980): 61–90.

14. For Gossaert's dependence on Dürer, see Sadja Herzog, "Tradition and Innovation in Gossaert's *Neptune and Amphitrite* and *Danae*," *Bulletin van het Boymans van Beuningen Museum* 19 (1968): 25–41.

15. For the use of mythological subjects in the production of erotic imagery, see G. Denhaene, "Les collections de Philipe de Clèves, le goût pour le nu et la renaissance aux Pays-Bas," *Bulletin de l'Institut Historique Belge de Rome* 45 (1975): 309–42; Larry Silver and Susan Smith, "Carnal Knowledge: The Late Engravings of Lucas van Leyden," *Nederlands Kunsthistorisch Jaarboek* 29 (1978): 239–98; Larry Silver, "*Figure nude, historie e poesie*: Jan Gossaert and the Renaissance Nude in the Netherlands," *Nederlands Kunsthistorisch Jaarboek* 37 (1986): 1–40.

16. J. K. Steppe, "Mencia de Mendoza et ses relations avec Erasme, Gilles de Busleyden et Jean-Louis Vives," in *Scrinium erasmianum. Mélanges historiques publiés sous le patronage de l'Université de Louvain à l'occasion du cinquième centenaire de la naissance d'Érasme*, 2 vols., ed. J. Coppens (Leiden, 1969), 1:449–506.

17. Mencia's art collection is not the only record of her humanist interests. Her library contained a number of works by ancient authors as well as by the leading humanist intellectual of her own time, Desiderius Erasmus. Mencia was, in addition, a patron of Erasmus' friend, the Spanish humanist Juan Luis Vives. Vives lived in the Nassau palace at Breda from 1537 until his death in 1540. After her return to Spain, Mencia provided two professorships at the University of Valencia, and her will contains instructions for the foundation of a secondary school in Toledo, in which there were to be professors of Latin, Greek, and Hebrew. See Th. M. Roest van Limburg, *Een Spaansche gravin van Nassau. Mencia de Mendoza, markiezin van Zenete, gravin van Nassau* (Leiden, 1908).

18. J. J. Sterk, *Filips van Bourgondie* (Zutphen, 1980), 137.

19. See Herzog, "Tradition and Innovation"; also, J. Duverger, "Jacopo de Barbari en Jan Gossaert bij Filips van Burgondie te Souburg (1516)," in *Melanges Hulin de Loo*, ed. P. Bergmans (Brussels, 1931), 142–53.

20. Gombrich, "Earliest Description," 404; my translation.

21. For Folengo and his poetry, see William Schupbach, "Doctor Parma's Medicinal Macaronic: Poem by Bartolotti, Pictures by Giorgione and Titian," *Journal of the Warburg and Courtauld Institutes* 41 (1978): 147–91.

22. Jose de Siguenza, *Tercera Parte de la Historia de la Orden de S. Geronimo* (Madrid, 1605), quoted by Charles de Tolnay, *Hieronymus Bosch* (Baden-Baden, 1966), 402.

23. Martin Kemp, "From 'Mimesis' to 'Fantasia': The Quattrocento Vocabu-

lary of Creation, Inspiration and Genius in the Visual Arts," *Viator* 8 (1977): 347–98, quotation on 368; also Jean Hagstrum, *The Sister Arts. The Tradition of Literary Pictorialism in English Poetry from Dryden to Gray* (Chicago, 1958), 55; and David Summers, *Michelangelo and the Language of Art* (Princeton, 1981), 133. For the role of art theory in the establishment of the "autonomy" of art, see Michael Muller, "Kunstlerische und materielle Produktion. Zur Autonomie der Kunst in der italienischen Renaissance," in *Autonomie der Kunst. Zur Genese und Kritik einer burgerlichen Kategorie,* ed. Gunther Busch (1972), 9–87.

24. Kemp, ibid., 379; Martin Kemp, " 'Il Concetto dell'Anima' in Leonardo's Early Skull Studies," *Journal of the Warburg and Courtauld Institutes* 34 (1971): 115–34; and Martin Kemp, *Leonardo da Vinci. The Marvellous Works of Nature and Man* (Cambridge, Mass., 1981), 125–27.

25. Kemp, "From 'Mimesis' to 'Fantasia,' " 383.

26. Erwin Panofsky, *The Life and Art of Albrecht Dürer* (Princeton, 1955), 43; also, Milton Nahm, "The Theological Background of the Theory of the Artist as Creator," *Journal of the History of Ideas* 8 (1947): 362–72; Joseph Koerner, "Albrecht Dürer and the Moment of Self-Portraiture," *Daphnis* 15 (1986): 409–39.

27. William Martin Conway, *The Writings of Albrecht Dürer* (London, 1958), 177.

28. Paul Stirn, "Friedrich die Weise und Jacopo de Barbari," in *Jahrbuch der preussischen Kunstsammlungen Berlin* (1925): 130–34. For Barbari's restless career, see André de Hevesy, *Jacopo de Barbari. Le maitre au caducée* (Paris and Brussels, 1925); and Luigi Servolini, *Jacopo de Barbari* (Padua, 1944).

29. For the history of the idea of *natura naturans* in the Renaissance, see Jan Bialostocki, "The Renaissance Concept of Nature and Antiquity," *Acts of the Twentieth International Congress of the History of Art,* 2 vols. (Princeton, 1963), 19–30.

30. Quoted in Sterk, *Filips van Bourgondie,* 180 n. 40; my translation.

31. Ibid., 111.

32. See Murray W. Bundy, *The Theory of the Imagination in Classical and Medieval Thought* (Urbana, 1927), 114–16.

33. For the history of this fad, see Nicole Dacos, *La Découverte de la Domus Aurea et la formation des grotesques a la renaissance* (London, 1969).

34. Translated from the Italian by E. H. Gombrich, *The Sense of Order. A Study of the Psychology of Decorative Art* (Ithaca, 1979), 280.

35. Quoted in Summers, *Michelangelo and Language of Art,* 135–36. I have eliminated his citations of the original Portuguese.

36. M. R. James, " 'Pictor in Carmine,' " *Archaeologia or Miscellaneous Tracts Relating to Antiquity* 94 (1951): 141–66, quotation on 145. See also Meyer Schapiro, "On the Aesthetic Attitude in Romanesque Art," in *Romanesque Art* (New York, 1977), 1–27.

37. See H. W. Janson, *Apes and Ape Lore in the Middle Ages and the Renaissance* (London, 1952); Rosy Schilling, "Drolerie," in Otto Schmidt, ed., *Reallexicon zur deutschen Kunstgeschichte*, vol. 4 (Stuttgart, 1959), cols. 567–88; Jurgis Baltrusaitis, *Reveils et prodigues. Le Gothique fantastique* (Paris, 1960); Lillian Randall, *Images in the Margins of Gothic Manuscripts* (Berkeley, 1966); Gerhard Schmidt, " 'Belehrender' und 'befreiender' Humor. Ein Versuch uber die Funktionen des Komischen in der bildende Kunst des Mittelalters," in *Worüber Lacht das Publikum im Theater? Spass und Betroffenheit—Eins und Heute. Festschrift zum 90. Geburtstag von Heinz Kindermann*, ed. Margret Dietrich (Vienna, 1984), 9–39. For an opposing point of view, one that argues that marginal illustrations are usually related to the texts with which they are associated in some didactically meaningful way, see D. K. Davenport, "Illustrations Direct and Oblique in the Margins of an Alexander Romance at Oxford," *Journal of the Warburg and Courtauld Institutes* 34 (1971): 83–95. Like Davenport, Michael Camille has recently approached marginal imagery on the assumption that it is related to the texts. However, this relation is conceived of as multifaceted and not confined to moral comment. See *Images on the Edge. The Margins of Medieval Art* (Cambridge, Mass., 1992). I am grateful to Jonathan Alexander and Lucy Sandler for useful suggestions and help with bibliography.

38. For an interpretation of this scene as a reference to a passage in the "life" of Alexander the Great, recounted in the manuscript it illustrates, see Davenport, ibid., 90–91.

39. See Lucy Freeman Sandler, "Reflections on the Construction of Hybrids in English Gothic Marginal Illustration," in *Art, the Ape of Nature. Studies in Honor of H. W. Janson*, ed. Moshe Barasch and Lucy Freedman Sandler (New York, 1981), 51–65.

40. Frederic Lyna, "De Jean Pucelle à Jérôme Bosch," *Scriptorium* 17 (1963): 310–13; Suzanne Sulzberger, "Jérome Bôsch et les maîtres de l'enluminure," *Scriptorium* 16 (1962): 46–49; Walter Gibson, "Hieronymus Bosch and the Dutch Tradition," in *Album Amicorum J. G. van Gelder*, ed. J. Bruyn, et al. (The Hague, 1973), 128–31.

41. The connection between the "world upside down" of the manuscript margins and Bosch's *The Garden of Earthly Delights* has been noted by Gloria Vallese, "Follia e Mondo alla Rovescia nel 'Giardino delle Delizie' di Bosch," *Paragone*, n.s. 38 (1987): 3–22. The author does not link Bosch's use of the principle to *ut pictura poesis*. I thank Christopher Johns for this reference.

42. Vallese, ibid., 13, has called attention to the fact that Bosch's birds are in the water while the sky is filled with flying fish.

43. See John Plummer, *The Hours of Catherine of Cleves* (New York, 1966).

44. Gibson, *Hieronymus Bosch*, 85. For the "power of women" theme, see Friedrich Maurer, "Der *Topos* von den Minnesklaven: Zur Geschichte eine thematischen Gemeinschaft zwischen bildende Kunst und Dichtung im Mittelalter," *Deutsche Vierteljahrschrift fur Literatur-wissenschaft und Geistesge-*

schichte 27 (1953): 182–206; Susan Smith, "To Woman's Wiles I Fell: The Power of Women *Topos* and the Development of Medieval Secular Art," (Ph.D. diss., University of Pennsylvania, 1978).

45. This translation is from A. Hyatt Mayor, ed., *Late Gothic Engravings of Germany and the Netherlands. 682 Copperplates from the "Kritischer Katalog" of Max Lehrs* (New York, 1969), 343 n. 30.

46. Walter Gibson, "*The Garden of Earthly Delights* by Hieronymus Bosch: The Iconography of the Central Panel," *Nederlands Kunsthistorisch Jaarboek* 24 (1973): 1–26, 9.

47. Ibid., 16–18.

48. See Jan Piet Filedt Kok, ed., *Livelier than Life. The Master of the Amsterdam Cabinet or the Housebook Master*, exhibition catalogue, Amsterdam, 1985, cat. no. 89.

49. See Isabel Mateo Gomez, "El conejo cazador del 'Jardin de las delicias' de Bosco en una miniatura del siglo XIV," *Archivo español de arte* 45 (1972): 166–67.

50. J. J. Alexander, *The Master of Mary of Burgundy. A Book of Hours for Engelbert of Nassau* (New York, 1970). For the house of Nassau's collection of illuminated manuscripts, see Anne Korteweg, "De bibliotheek van Willem van Oranje: De handschriften," in *Boeken van en Rond Willem van Oranje* (exhibition catalogue), (The Hague, 1984), 9–39.

51. Victor Turner, *The Ritual Process. Structure and Anti-Structure* (Ithaca, 1969); Natalie Zemon Davis, *Society and Culture in Early Modern France* (Stanford, 1965).

52. For an example, see Michael Camille "Labouring for the Lord: The Ploughman and the Social Order in the Luttrell Psalter," *Art History* 10 (1987): 423–54.

53. Boris Uspenskii, Juri Lotman, et al., "Theses on the Semiotic Study of Cultures (as applied to Slavic texts)," in *Structure of Text and Semiotics of Culture*, ed. Jan van der Eng and Mojmir Grygar (The Hague, 1973), 1–28.

54. See Gerd Unverfehrt, *Hieronymus Bosch: Die Rezeption seiner Kunst im frühen 16. Jahrhundert* (Berlin, 1980).

55. Thomas Crow, "Modernism and Mass Culture in the Visual Arts," in *Modernism and Modernity: The Vancouver Conference Papers*, ed. Benjamin Buchloh, Serge Guilbaut, and David Solkin (Halifax, 1983), 215–64.

56. This is a theme of several essays in Hal Foster, *Recodings. Art, Spectacle, Cultural Politics* (Seattle, 1985).

Observations on Style and History in French Painting of the Male Nude, 1785–1794

W H E N might a drastic change in artistic style be a form of continuity? A necessary corollary to this question is to ask whether art-historical explanation requires at this moment a reinvigorated capacity for stylistic analysis, but one that would not be predicated on the traditional search for visual resemblances between works of art. A painting that poses the first question and dictates a positive answer to the second is *The Sleep of Endymion* (fig. 1), painted in Rome by the French artist Anne-Louis Girodet in 1791 when he was just twenty-four years old.

Girodet's *Endymion* is classicizing, to be sure, and he was at the time one of David's most able and trusted students, but its version of classicism—ethereal, timeless, unreal—is a world away from the engaged and worldly variety of the other Davidians. The subject was the beautiful boy with whom the moon goddess Selene fell into desperate infatuation; in some accounts, she put him into perpetual sleep so that he would always be available for her nocturnal visits.[1] Girodet chose this version of the story and rendered the goddess as immaterial moonlight, whose passage is facilitated by the smiling Eros.

It was a reactive piece of art, and its maker says so repeatedly in his letters—this was to be a work owing absolutely nothing to David's example, and he would spare no work necessary to achieve this independence.[2] I cannot, in fact, cite a prior instance in which that very modern form of youthful rebellion is expressed so vividly and insistently by an artist. As a stylistic shift, it seems to be the opening to an increasingly dominant mode of the later Directory, Consulate, and Empire, represented in Gérard's or Guérin's efforts in a similar iconographic vein (figs. 2 and 3). Its great success and prestige provided the French with a way of taking in the international linear style for which Flaxman's Homeric drawings served as the most influential example.

To say, then, that *Endymion* belongs with that stylistic sequence would be true not only to the evidence of "the eye" but to the artist's own testimony. Girodet's individual reaction against David—con-

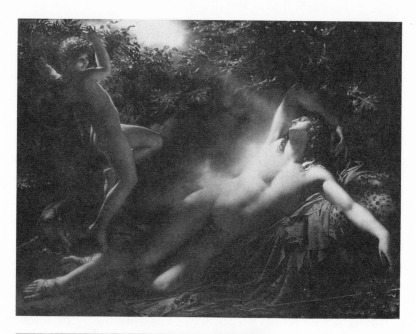

1. Anne-Louis Girodet, *The Sleep of Endymion*, 1791. Paris, courtesy Musée du Louvre.

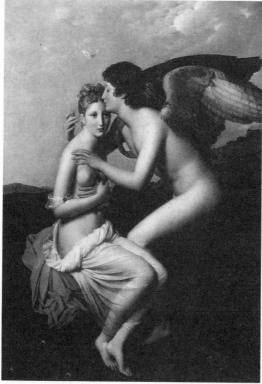

2. François Gérard, *Cupid and Psyche*, 1798. Paris, courtesy Musée du Louvre.

sistent, some have said, with his aristocratic family connections—is a breakthrough painting that stimulates a collective stylistic reaction.[3] This collective style of abstract and polished classicism, oriented to myth and an eroticism beyond time rather than to the virtue and choices of historical heroes, was one vehicle for depoliticizing the revolutionary return to the antique.

That effect of timelessness is a particularly arresting achievement of the *Endymion*, and again it was a matter of hyperconscious intention. It led Girodet to one spectacularly failed experiment: So that the painting would look forever as if it had just left the easel of its youthful maker, he mixed a large measure of olive oil in with the surface layer of pigment. The painting was to go on show in the student exhibition beginning August 25; in July he wrote despairingly to Gérard that the surface was never going to dry. He had to scrape it off and, in a few weeks, produce the astonishingly seamless skin to which the other worldly effect of the painting owes so much.[4]

Everything fits; yet at the same time it does not. The affinities between the *Endymion* and the likes of Guérin has to reach across Girodet's other major effort of the Roman period, *Hippocrates Refusing the Gifts of Artaxerxes* (fig. 4), which was done later and which seems to put into reverse any reaction present in its immediate predecessor. Along with the large amount of labor concentrated into a fairly small area of canvas, what is most striking about the painting is its effort to be "correct," that is, correct according to the standards of Davidian moral narrative. The conception and arrangement is obviously dependent on David's *Socrates* of 1787; and, in this story as well, loyal disciples witness an act of exemplary patriotism by a Greek sage. Girodet has painted his self-portrait into the story, but that tentative profile—at the extreme lefthand margin of the composition—is far from the confident rebel evoked in the *Endymion* correspondence.

There is an understandable logic to this dependency if, as I believe to be the case, Girodet is responsible for the finished portions of this replica of the *Socrates* now in the Princeton Museum of Art (fig. 5). The level of skill on display is remarkable, and it is evidence for a deep internalization of the master's project. Nothing is known at present about the painting's purpose or destination—or why it was left in this state.[5] But an attribution to Girodet is consistent with the well-documented replica of the *Horatii* (fig. 6) done in 1786, for which Girodet is almost entirely responsible.[6] There is a document, largely ignored in the art historical literature, that presents a remarkable picture of the collective

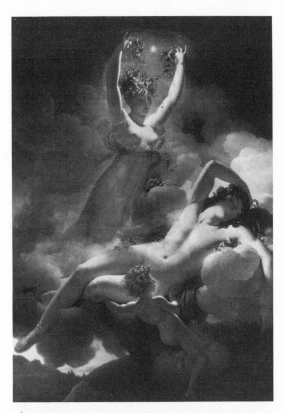

3. Pierre-Narcisse
Guérin, *Aurora and
Cephalus*, 1811. St.
Petersburg, courtesy
of the Hermitage.

4. Anne-Louis Giro-
det, *Hippocrates
Refusing the Gifts
of Artaxerxes*, 1792.
Paris, courtesy
Faculté de Médecine.

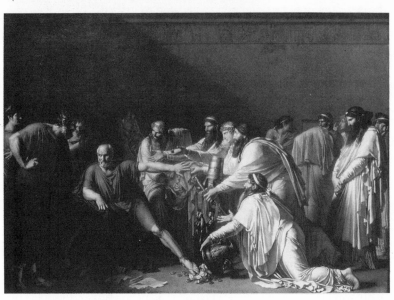

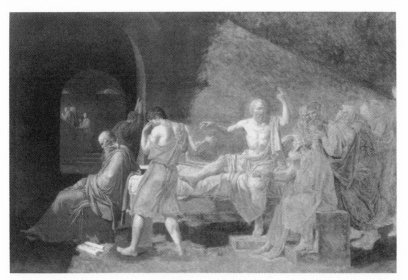

5. Studio of Jacques-Louis David, after David, *The Death of Socrates*, 1787–1790? Princeton, courtesy Princeton University Museum of Art.

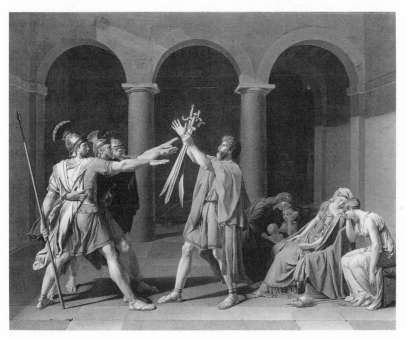

6. Anne-Louis Girodet, after Jacques-Louis David, *The Oath of the Horatii*, 1786. Toledo, Ohio, courtesy Toledo Museum of Art.

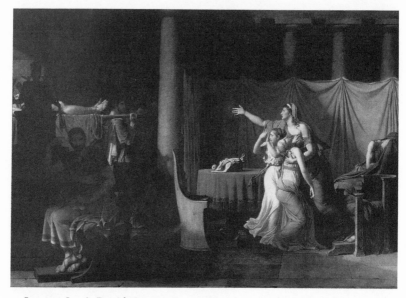

7. Jacques-Louis David, *Lictors Returning to Brutus the Bodies of his Sons*, 1789. Paris, courtesy Musée du Louvre.

distribution of responsibilities that characterized David's studio practice during these years. This account, published in 1827, was meant to sum up the various contributions by students to his autograph paintings over the entire span of his career. It gives Girodet credit for crucial sections of David's *Brutus* of 1789 (fig. 7).[7] He is credited with finishing the face, left arm, and foot of Brutus' wife—and indeed these are among the sections of the painting brought up to a closed finish more consistent with Girodet's way of working than with David's rougher treatment of glazes. He went on, we are told, to intervene in a passage of maximum subtlety and importance to the picture's narrative and emotional effect. François Gérard, his close companion in these years, had finished the shadowy background behind the head of Brutus. David found himself unable to adjust the treatment of the head to bring it sufficiently forward; so he called on his student to complete the work because "Girodet truly understood chiaroscuro better than he did." (At the same time, Gérard was asked to paint the entire figure of the grieving nurse at the far right: Isolated at the edge of the composition in her own private world of sorrow, she is the chief formal and thematic counterweight to Brutus himself.)[8]

This account is consistent with the pattern of intense professional and emotional interchange within the studio that had been set almost from the beginning of David's career as a teacher. That pattern was characterized by a self-reinforcing dialectic of precocious responsibility, on the one hand, and regressive dependency, on the other. Favored pupils were encouraged, in a way that was consistent with a progressive political stance, to think of themselves as peers of the master.[9] Yet their exercise of that franchise only bound them closer and closer to his example, more thoroughly than the most old-fashioned, authoritarian methods would have done. Already in the *Socrates* replica, it appears to have been the master who assumed the maximum freedom to improvise, the pupil who was constrained to an exacting standard of technical correctness. In the work on the *Brutus*, the master's freedom extended to a license to confess—or feign—incompetence. Such license was denied the pupils, and their conspicuously brilliant efforts were so many signs of David's power over them, the power to orchestrate the elements of his new syntax from above.

Even after the *Endymion*, this bond was far from being surpassed in Girodet's construction of his artistic project. Not only did he return to filial territory in the *Hippocrates*, he threw himself into committed revolutionary political action in Rome in a way that paralleled David's contemporaneous involvements in Paris. And his commitment brought with it far greater physical risk than any run by his master before the fall of Robespierre. It would lead to a forcible and catastrophic interruption of his work as an artist, but would also cause the *Endymion* to glow with an even more remarkable aura in 1793 and early 1794, the years of Jacobin ascendancy.

This chain of events followed directly from the declaration of the French Republic in September 1792.[10] The Vatican withdrew diplomatic recognition from the French mission in Rome; only a caretaker consular presence was allowed to remain. Harrassment against French citizens in Rome by Swiss soldiers and Catholic zealots increased, all tacitly or not so tacitly encouraged by the Church authorities. In September, two young artists who were living and working independently of the Academy, Chinard and Ratter, were arrested and their work confiscated. One of Chinard's sculptures in particular, which he called *Reason Subduing Superstition* (Musée Carnavalet), was construed as an attack on religion. Cardinal Bernis, the former ambassador, secured their release, but the arrest was used as a pretext for military threats against the papal states on the part of the National Convention in France. In October,

rumors reached the French artists in Rome that the Swiss Guards were planning an armed attack on the students of the Academy in retaliation for the murders of royal Swiss soldiers in the September massacres in Paris. (Girodet understood that he had been singled out in particular, and his authorship of a students' patriotic petition to the Convention bespeaks a visible role of political leadership.[11]) At that point, an irregular French agent named Hugou de Bassville arrived from Naples, where the French fleet held the port. Though without formal status, he soon assumed control of French diplomacy, insisting on an assertive republican presence and making repeated preemptory demands for concessions from the papacy. The director of the Academy had by this time resigned, and in his absence, Bassville made the Academy his virtual headquarters. Late in that autumn, the Convention in Paris was still reacting to the arrests in September. David took the opportunity to demand a removal—more than that, an "auto-da-fé"—of all royalist symbols and insignia in the Rome Academy, and the order was given to hang the arms of the Republic at the entrance in place of the fleur-de-lys.[12] David's insistence on this point may have come out of ignorance, but what he was proposing was a reckless endangerment of the lives of the pupils; for the issue of gracing the Academy with the arms of the Republic was precisely what brought the wrath of the papacy down on their heads.

Symbols were much on the mind of the Pope. He had been burned in effigy in the Palais Royal, and the Church was waiting for a chance to revenge that outrageous sacrilege. The impertinent Bassville had been tolerated as long as he had the fleet at his back, but in December the fleet was surprised by a storm while leaving port and largely disabled. After that, violent retaliation in Rome became almost inevitable; there was no longer any restraint on the black clergy and the growing antirepublican mobs. Bassville, by January, had taken the precaution of removing most of the pupils of the Academy to Florence or Naples, both still friendly to France. He still remained, at grave and growing personal risk, intent on showing the Republican arms; and Girodet was one of only four artists who stayed behind. Bassville, on 13 January, paid with his life for that project when a mob attacked his carriage in the street and murdered him. At almost the same moment, Girodet, with the others, were inside the Academy painting the Republican arms. They never got the chance to put them up. While still at work, they were surprised by a mob, which was now filling the courtyard and street outside and being incited to more pillage by the priests who led it. This is the account of events given by Girodet himself:

We still had brushes in hand when the furious rabble burst in, and instantly reduced the doors, windows, and panes to rubble. They had only twenty steps to mount in order to assassinate us; [barely escaping and] reaching the street, we found ourselves abandoned and without aid in the midst of this rabble thirsty for our blood. . . .

The tortuous streets and our cool heads saved us for the moment. Escaping this danger and believing that I was taking all necessary precautions, I proceeded to hurl myself into further peril. I ran to the house of Bassville at the very moment of his murder. . . . I ducked into an Italian house two steps from there and stayed inside until nightfall. I was foolhardy enough to return to the Academy, which had become the Palace of Priam. The mob was ready to put it to the torch. There I was recognized by one of our old models, . . . and together we made our escape.[13]

He eventually found a temporary haven in Naples, after days of travel on foot and encounters with torrential storms and brigands in the Pontine marshes. That forced retreat led to an arduous, malaria-plagued return to France that took two years. When he was able personally to show the *Endymion*, he put it on display with a portrait of the black Jacobin Jean-Baptiste Belley, representative to the French National Assembly from the colony of Saint-Domingue (present-day Haiti).[14] It would be better to say that this painting is a double portrait contrasting the living and the dead, the African and the European, the force of action and the force of ideas. Belley leans against a splendid commemorative bust of the Abbé Raynal, the great Enlightenment advocate of political reform, which the artist has imaginatively erected on a hilltop of the Caribbean island. Raynal's liberationist ideas and his arguments against colonial exploitation had prepared the ground for Belley's decisive intervention in the Assembly in 1794, when he won approval for the abolition of slavery in the colonies and full citizenship for blacks. The Belley painting celebrates a heroic triumph of Enlightenment ideas and the principle of equality. For Girodet, there was no inconsistency between the two paintings. And if a classicism of reaction found important cues in the *Endymion*, that would have to be counted a failure of Girodet's larger project in the 1790s.

To grasp that project in all of its dimensions, a mediating figure must be introduced between Girodet and David: Jean-Germain Drouais, David's first *and* most-favored pupil, who had died in Rome of smallpox in 1788.[15] The relationship between the two had been exceptionally close; when Drouais won the Rome Prize in 1784, David went to Rome as

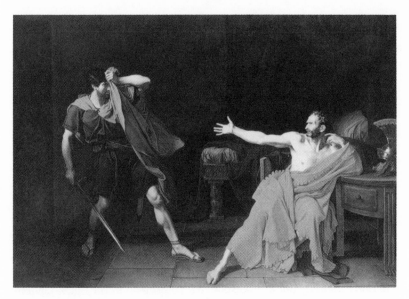

8. Jean-Germain Drouais, *Marius at Minturnae*, 1786. Paris, courtesy Musée du Louvre.

well, as much to prolong their collaboration as to paint the *Horaces* in the stimulating surroundings of antiquity. Drouais did a good deal of work on the painting, including some finished parts.[16] When he died, David's anguish was deep and prolonged: "I have lost my emulation," is his famous eulogy, and the letters he had received from Drouais were encased inside a shrine he had built in his garden.[17]

Given the competitive atmosphere inside the studio, Drouais would be the premier rival for them all, yet his death—and the nature of David's grief—meant that he could never be replaced. Girodet's insistent rejection of David's example was one way to deny the situation, yet the *Hippocrates* demonstrates that it would return nonetheless; not only was Girodet unable to evade a comprehensive dependence on David, but the specific prior success of Drouais in emulating the master also becomes an issue in the painting.

That success was Drouais' precociously large-scale *Marius at Minturnae* (fig. 8), which celebrates a particularly unsavory Roman general and adventurer who turned away an executioner through the sheer force of his domineering personality. It is self-evidently an act of homage to *The Oath of the Horatii* and an artifact of the mutual identification—with

all of its tensions—that existed between master and pupil. The figure of Marius becomes, with a few transformations, Girodet's figure of Hippocrates. The emblem of that unattainable relationship is installed at the center of Girodet's only multi-figured composition of his Roman period.

The pathos of that gesture, however, goes alongside a more positive effect of Drouais' example. During his time in Rome, the pupil had outdone the master in defying the authority of the Academy, refusing in every way open to him the hierarchy of control and discipline to which the students were required to submit. Drouais had been determined, as David had been on his behalf, to function as an independent creator obedient only to his own inner virtue, talent, and civic responsibility.[18] In this, Girodet was ready and able to match his predecessor. The fact that he possessed a larger politics in which to locate and deepen that oppositional stance meant that this was terrain on which he could surpass Drouais, both in life and in art.

On the latter ground, the kind of painting in question would not be the kind for which David had established the model but one specific to the Roman academic context. There was one genre of art in which all students had to demonstrate competence: the painted study of the single male nude, the so-called *académie peinte*. These were sent on to Paris for evaluation by a committee of the Academy's elders. In the hands of most artists, the study was constructed from a sitting or reclining studio pose, the identity of the model minimally transformed by a few classical props or sometimes only by the name of a classical hero as a title. In keeping with the stably horizontal poses, heroes known particularly for their deaths were frequent names of convenience, though the bodies tended to be unmarked and without signs of pain or distress.

Neither Drouais nor Girodet, for all of their ambitions to complete independence, were able to evade the requirement of the nude *académie*. In compensation, both sought to elevate the task (and eclipse their rivals at the annual student exhibition) by transforming the nude male figure into a kind of history painting. The aggressive transformation of these norms begins in 1785 in the work of Drouais, whose *Dying Athlete* (fig. 9) betrays nothing of that complacency. He reaches instead to invest a single body with complexity and inner differentiation characteristic of multi-figured narrative. His work transforms the balanced studio pose on which it is based into a moment of tense concentration. The vacant upward stare of the model becomes a gaze of focused inward and outward concentration. The effort it costs the warrior is registered in the

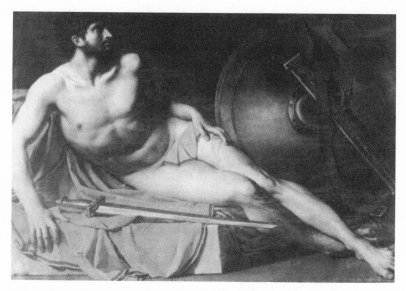

9. Jean-Germain Drouais, *The Dying Athlete* (or *Wounded Soldier*), 1786.
Paris, courtesy Musée du Louvre.

contrast of the supporting right hand with the left. What had been no
more than the model's fatiguing effort to maintain the pose becomes
an inner determination to hold the body upright to the end, to refuse
collapse into unconsciousness.

The alertness of the figure, first of all, distinguishes it from the un-
consciousness typical of the academic nude. This he extends to forge
a link between that alertness and physical pain. Unlike the Hellenistic
Dying Gaul, which would have been a touchstone for this kind of sub-
ject, the warrior does not attend to his wound. As depicted, it is all but
invisible, but the entire body is organized to mark the spasm of pain
that energizes the figure. Though the body as a whole seems fully drawn
out along its continuous lower contour, it is in fact twisted unnaturally
at the center along a harshly incised transition. Its languid extension is
violated at the center of the torso in a contraction that reads as an in-
voluntary contraction of pain. The raking light further throws that area
into shadow so that the body is divided by zones of light and dark as well
as by its disposition in space. The light is the zone of control; despite
the wrenching pain, the warrior's reaction to it is limited to the dark
zone. He resists and contains it so thoroughly that the overall beauty

of his figure is undisturbed. The relaxed left hand of the gladiator has become one of unconscious elegance, and the legs cross with a grace we take to be innate in a noble character. That Praxitelian elegance, when maintained in the face of mortal suffering, is the source of the painting's drama and pathos—the pain alone would not suffice.

In the early 1790s, Girodet's independent behavior in Rome and expressions of contempt for the Academy and its teaching were fully consistent with the behavior of his predecessor. The most acute problem that he faced was how to imitate Drouais' example of independence and his transformation of the academic nude into an emblem of that independence without falling into a dependent imitation of his predecessor. The negative transformation of Drouais' prototype was his solution. The startling "originality" and apparently non-Davidian character of the *Endymion* should, I think, be understood as a move in the same game begun by Drouais, with every encouragement from their common master.

To grasp the degree to which the markedly original overall character of the *Endymion* can be generated through a systematic reversal of the *Athlete*'s distinctive features, we could even create a comparative table:

Where the *Athlete* is:	The *Endymion* is:
suffused with muscular tension	drained of tension
disfigured	physically flawless
suffering	in a state of bliss
resists an unyielding environment	yields to pliant, enveloping environment
left without human aid	embraced by divine devotion
ready with his weapons	has discarded weapons
hyper-conscious	never conscious
described with unnatural clarity	described with a diffuse but natural obscurity

Girodet's negative transformations seem to generate a body that is utterly sealed, closed, and beyond time, a body that gives back to narcissistic desire its primitive dream of bliss in death. But it is precisely Girodet's determination to produce what he called a "purely ideal effect," one sequestered from the worldly empiricism of David, that opens his figure to a thoroughly differential play of meaning.

To begin to see this at the level of technical and formal choices, one need only attend to the way in which the outline of the figure, while firm and complete at first glance, in fact refuses wholeness as we follow its

linear course. The integration of the body with its surrounding atmosphere is an effect dependent on a continuously shifting play between clarity or obscurity of outline; the harder, highlighted areas are just hard enough to prevent the body submerging itself in the haze; the soft, shadowed ones just sufficient to prevent the body's coming free from its surrounding matrix. The body is legible as a whole, and so is the entire painted surface, because of this oscillating, unfixed play of difference.

Accompanying this play of line are unexpected reversals in the normal scale and relative presence of the body's parts: the features of the face are hardly present; they offer not so much a profile as a compression of the face into a narrow illuminated zone, contrasted with the large, almost grotesque area of neck in emphatic shadow, the pure, formalized play of presence and absence given unnatural stress through these unnatural transformations. This insistence on reversal extends to the accompanying eros figure, which is rendered so that the edges of his body are drawn with light rather than dark tones that normally indicate the recession and disappearance of three-dimensional form; shadow moves from the edge of the body to its center. And then there is the largest division of light and shade, the one that divides the body into its upper and lower zones. The desire of the goddess, reduced to moonlight and removed from any obvious gender location of its own, is displaced from the privileged phallic location of male desire, allowing the question of Endymion's sexual identity to be suspended. The sharp line of shadow cuts in a horizontal line directly across the swelling curve of the hip and just above the genital zone. The male eros, who stands in for the absent woman, opens the way to the moonlight with a look of malicious pleasure.

His simultaneous provision and denial of light is the largest display of pure difference in the painting. It generates less a castration of the male body than a perpetual displacement of its stability of gender. It is that which organizes the separate qualities of the figure—the elongated and tapering legs, the ringlets of hair, the compressed Greek profile, the abandonment of consciousness—into its pervasive effect of androgyny. To call those aspects of the image "feminine" in and of themselves is, I think, no longer possible, theoretically or politically; nor is it necessary, as long as we stay close to the complex of meanings actually in circulation with the picture in 1793–1794. To see this "androgyny" as primarily about sexual desire—its confusion, multiplication, or cancellation—is to impose a present-day limitation on reading the body. It is to fail to see the other boundary crossings that are simultaneously at work in the

painting: youth and age; inexperience and maturity; the timeless and the instantaneously immediate. It is a body that is removed from life yet never decays; that is subject to perpetual repetitions of sensual plea- sure yet is never exhausted by them; that is trained like an athlete of antiquity for war yet remains forever untouched by violence, knowing death only in the midst of ecstatic animation of the nerves, muscles, blood, and skin. These are the components of its human ideal, which is then situated between two poles of observable, nonhuman nature: the impalpable energy of light and the substantial, tactile presence of botanical and entymological specimens.

If the *Endymion* was indeed an effort to contain and surpass the agonis- tic, Davidian conception of Drouais' *Dying Athlete*, David's response to the painting would take that process one step further. To understand the erstwhile master's response, it is important to recognize that his de- pendence on his star pupil had not stopped with Girodet's departure for Rome. The famous portrait of revolutionary martyrdom, *Marat at His Last Breath* (fig. 10), was an assignment that put David's powers of invention and rapid execution to a demanding test. Here we know of no direct contribution by any assistant,[19] but David did manage to enlist the absent Girodet through a painting his pupil had left behind. The last work done by the younger artist before his departure for Rome had been an enormous canvas depicting the Virgin with the dead Christ (fig. 11), painted for an obscure provincial monastery (two of his aunts had re- tired to a neighboring convent and seem to have been the intermediaries for the commission).[20] At some 3.5 meters in height, it was precociously ambitious in scale and represented, in its bare simplicity and gloomy tenebrosity, a new kind of picture for the Davidian group. David, we are told, registered his approval of the painting before Girodet left Paris with it, and the *Marat* registers a very tangible memory of his pupil's work.[21] In general terms, the pose of Girodet's Christ, the drastic reduc- tion of accessories, the proportional division of the format effected by the horizontal sarcophagus, the angle of the light, and the obscure upper zone created by the shadowy wall of the cave all provided David with clear cues in his conception of Marat's moment of martyrdom. Another feature the paintings have in common is the use of a fictive inscription that enters the name of the painter into the commemoration of grief. And the most obvious sign of David's reliance on his pupil's *Pietà* is the tracing of the contour along the head and shoulders of the Virgin into the line of the sarcophagus: In a startling transposition, this has become

almost precisely the line of Marat's head and body as it emerges above the bath.

For the third of his revolutionary martyr portraits (fig. 12), David was handed a markedly different brief, but he continued in his implicit reliance on Girodet's example. Joseph Bara, a boy-victim of counter-revolutionary forces in the west of France, appears as an unblemished, eerily beautiful ephebe, suffering but without visible wounds, dreaming more than dying, near to but not within the fury of combat.[22] Where, it has often been asked, might the artist have gotten the idea that a vision so insubstantial and erotically charged could be any kind of persuasive representation of revolutionary virtue? The regard of the artist, with which we are invited to identify, appears to have scandalously little to do with civic virtue or battlefield heroism. The sensuality of the body goes beyond a beauty appropriate to its age and innocence. Commentators have assumed with near unanimity that the painting suffers from an overbalancing from the public to the private; that the nudity, especially this kind of nudity, could carry anything but an inappropriate or unseemly private significance has, until very recently, been an impossible thought.[23]

Although Girodet had left no other convenient images of martyrdom behind, he had in the meantime come to be represented in Paris in two vivid substitutes. The first was a breathless written account, published that summer, of Girodet's heroism in the January riots. The young painter's identity was even more vividly inscribed in the text since it was written in his voice, taking the form of a fictional letter by him to none other than David.[24] In the light of this publicity, the younger painter became the closest thing to an artist hero available during the first year of the Republic. The second representation was, of course, the painting that made his reputation and that, in many ways, came to take over his identity: *The Sleep of Endymion*.

Circumstantially, a situation of noncontradiction between the dream-figure of Endymion and actual political commitment and self-sacrifice was temporarily in force. But more profoundly, its inspired interplay of conceptual opposites would have corresponded to the difficult combination of ideas and conditions bound up for David in the Bara commission. How was he to move from the celebration of mature martyrs like Lepeletier and Marat, significant historical actors whom he knew personally, to the heroization of an unknown boy? How was he to ennoble what was at best a trivially unlucky act of bravado—one that may, in fact, have had no actual revolutionary motivation? How was he to find unstereo-

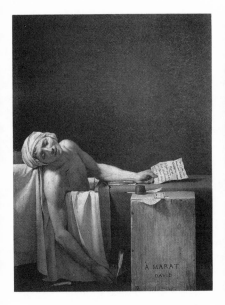 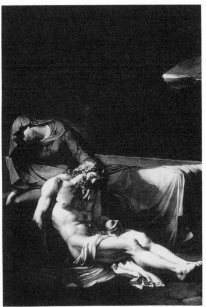

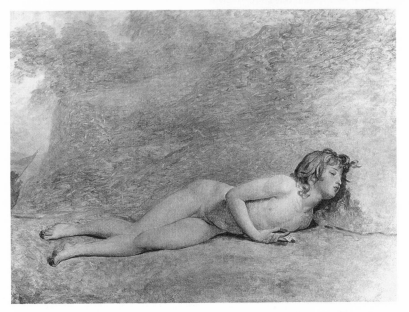

10. *Top left*, Jacques-Louis David, *Marat at His Last Breath*, 1793. Brussels, courtesy Musées Royaux des Beaux-Arts.

11. *Top right*, Anne-Louis Girodet, *Pietà*, 1790. Haute-Garonne, courtesy Church of Montesquieu-Volvestre.

12. *Above*, Jacques-Louis David, *The Death of Bara*, 1794. Avignon, courtesy Musée Calvet.

typical form for the propagandistic stereotypes of outraged innocence and the sacrifice of youth with which he was forced to work?

Recent scholarship has begun to uncover the significance of the ideal nude body in the painting as both an emblem of uncorrupted virtue and a guarantee of the painting's universal—not anecdotal—significance.[25] As an erudite point of departure, congenial to David and his circle, Plato's *Symposium* describes the contemplation of the beautiful ephebe (the *ermonenos*, to adopt K. J. Dover's now standard terminology)[26] by the mature citizen (*erastes*) as a potential means for leading the mind upward from the realm of the sensual to an understanding of universal good.[27] There is also a key document of the period that assumes a connection between the public representation of political virtue and the male body conceived as a beautiful object of delectation by the male artist. It comes from the proceedings of the Popular and Republican Society of Arts, the quasi-official Jacobin artists' club, which published its journal, *To Arms and to Arts!*, during the first half of 1794—precisely when David was at work on the Bara. In its pages, a pitiless hostility toward the enemies of Revolution, indeed toward anyone not zealously partisan, went hand in hand with exhortations to preserve and display the classical canon of male beauty as a privileged symbolic embodiment of civic virtue.

Its editor, Athanase Détournelle, inserted into one number an obvious pastiche of Winckelmann's famously rhapsodic description of the Belvedere Apollo. He then went on to counsel young artists, fired by the revolutionary cause, to substitute this sort of contemplative erotics even for the study of the model: "I am persuaded that . . . a lesson taken before the beautiful figures that I have just described would contribute more to their progress than their slavishly copying the school model during an entire season; in that in drawing one merely teaches the hand to trace, but in resting in a contemplation attached to contours, forms and expressions, one gives to one's genius the sublime Élan that leads to immortality."[28]

These lines reverse our normal expectation concerning imitation and invention, and they seem far from the expected purposes of artists committed to a regime of violently enforced civic virtue. But in the watchful atmosphere of early 1794, there would be nothing printed in a journal such as this one that was not deemed appropriate to that regime.[29] Girodet's ephebe was the most visible emblem of this aesthetic available from the hand of a suitably committed contemporary artist. David, however, could no more appropriate the *Endymion* prototype directly

than Girodet could have done with Drouais' *Athlete*. Questions of original stylistic signature aside, the story of Bara's death had to be depicted with an immediacy and total visibility that made the frozen stillness and obscurity of *Endymion*'s nocturnal bower unusable. The nervous scumbling with which the body and its setting alike are rendered amounts to an appropriation of the atmospheric unity of figure and ground achieved by Girodet. The reversal of technique, from sealed to porous one might say, allows the master to make the pupil's innovation his own. But when it came to the suppression of the genitals—doubly imperative in light of the mandate that David represent outraged innocence and the special object of a mother's love—the overall illumination and blond light deprived him of the device of veiling shadow. David's response was to take the boy's body and break it in two, simultaneously to figure its suffering and to downplay its sex.

And it is here that the trouble with the image begins. The body of Bara is twisted unnaturally at its center; that, along with the shadowed abdomen, is the mark of the body's violation, the bayonet wound to the midsection that killed the boy (this device directly recalls Drouais' *Athlete*). Part of what produces the body's unnatural twist is the curious position of the legs, the upper one behind the lower. Since the boy seems to be rolling over onto his chest, the expected position of the legs would be the reverse. The logic for the anomalous arrangement comes from an identifiable substitution of a direct classical analog to the *Endymion*: For this area, David has borrowed the hips and legs of the Borghese *Hermaphrodite* (fig. 13), but as seen from the rear, not from the front. The derivation of the design of the *Marat* from the contour of the virgin in Girodet's *Pietá* showed a tendency on David's part to abstract and displace patterns of line from other works of art. Here the entire upper contour of Bara's body, particularly the raised hip, is determined by a superimposition of the two-dimensional contour of another figure, while the strangely effaced treatment of the genitals follows the pattern of lines created by the lower buttocks and inner thighs of the antique statue. This borrowed indeterminacy of gender, overlaying the representation of an unseen but mortal wound, leads to an eerie undecidability of point of view: a simultaneous transparency and reversal at the primary locus of erotic sensation.

Much of the strangeness of the image is derived from this clash of two incompatible bodies in one. Wound, absent genitalia, and anus become conflated in a way that leaves the painting indeterminably positioned between public and private interest, between the sayable and the un-

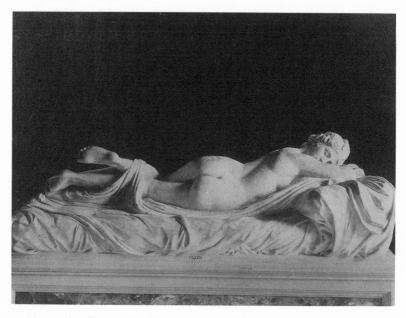

13. *Hermaphrodite*, marble. Rome, courtesy Galleria Borghese.

sayable.[30] Girodet's *Endymion* had been the result of an adroit set of moves within the established codings of the hero's body, motivated by an intense wish to construct a self distinct from the luminous Drouais and therefore attain maximum distance from the latter's approach to the nude figure. David struggles here to retain his mastery by taking possession of both at once, to accommodate the heroic endurance of pain within the erotically replete conflation of *Endymion* and Hellenistic *Hermaphrodite*. But this condensation of their distinct positions within the visual codes of the nude hero generates dissonance, even cacophony, smoothed into a provisional consistency by a thousand touches of the hand.

If the resulting image can be seen only as unpleasantly perverse, even pederastic, this is because the observer's ability to read ambiguity in the body has declined to a narrowly sexual register. But the logic of substitution and reversal that guided David's handling of Girodet's ephebic prototype, while comprehensible, was no guarantee of legibility even for the artist's contemporaries. The *Endymion*, itself the product of substitution and reversal of the distinctive features of a previous prototype,

could be said ultimately to have suffered a similar fate, but for different reasons. The painting had evolved along a course that was engaged and politicized in its motivation, but the logic of that course meant that the painting was more and more invested in the realm of art, to the negation of the overt effects—if not the inner logic—of David's and Drouais' challenging precedents. In the atmosphere of political amnesia fostered under the Directory, those precedents lost their force, lost their ability to activate the differential meanings operating in the *Endymion*. Girodet's community had stopped speaking the language in which the painting had been conceived.

The interpretation offered here does not pretend that the private and subjective meanings we see as naturally inhering in the painting are not present. His antagonism toward David, his jealous resentment of Drouais' priority, were powerfully overdetermined. But between 1790 and 1793, he had a public context available in which they could make another kind of sense. In a way, the less attractive, private component of his practice is factored out following the fall of Robespierre. In his *Cupid and Psyche* of 1799 (Paris, Louvre), Girodet's old studio companion Gérard led the way in capturing the *Endymion*'s sealed envelope of flesh and delivering it to a strain of precious eroticism that sought a place beyond the vicissitudes of political orthodoxy. In the wake of Gérard's initiative came a chain of languishing androgynes openly dependent on Girodet's example, which included Broc's *Death of Hyacinth* in 1802 (Poitiers, Musée Sainte-Croix) and the *Iris and Morpheus* and *Aurora and Cephalus* (both Leningrad, Hermitage) of the inevitable Guérin, the artist who most faithfully attended to the prevailing winds. When the languages of the Revolution broke down, the painting could be used as a token of the refusal of public meanings altogether. The Guérins take over, but at the cost to art of taking the *Endymion* as a frozen unity rather than as a fabric of differences.

I think the *Endymion* is, even to viewers unsympathetic to this kind of art, more powerful, more arresting than the paintings it helped inspire; it is not saccharine, not trivially recherché, in the way they are. When we intuit that distinction in quality, we are sensing its far greater complexity of motivation, its struggle for meaning. We are sensing too that it belongs, in formal terms, to a sequence of paintings other than the one suggested by its immediate visual similarities to other works of art. Rather than asking what the painting "looks like," one needs to ask where it came from. There is far more explanatory power in identifying what a painting has visibly been made of (in this case a complex mixture

of career imperatives, emotional affiliations and antagonisms, philo-
sophical commitments, accidents of biography, and much else besides)
than in intuiting what else it might resemble. An historical stylistics will
capture the former; too much of current theorizing in art history com-
pounds the errors of traditional analysis of style by continuing along the
latter path.

NOTES

This essay overlaps substantially with two previously published discussions of
this material: one in the Proceedings of the 1989 colloquium, "David contre
David," edited by Régis Michel, held at the Louvre; the other in the collec-
tion, *Fictions of the French Revolution*, edited by Bernadette Fort (Evanston,
Ill., 1991). I want to thank both of those editors for their remarkable energy,
erudition, and exactitude.

1. The myth has a number of variants; in some the hero is a grand and
mature figure, son of Zeus and king of Elis; his eternal sleep comes either as
punishment for his love of Hera or as a gift from Zeus because Endymion could
not bear the prospect of growing old. In another his connection to the moon
begins in astronomical observations. (Later in life Girodet would contribute
an entry to a mythological dictionary discussing the multiple aspects of the
myth: François Noël, *Dictionnaire de la fable* [Paris, 1803], 1:475–76). In 1791,
however, Girodet chose as a primary source a text of later antiquity that both
flattered his erudition and allowed him the greatest freedom of interpretation.
It comes from Lucian's *Dialogues of the Gods*, the satire of mythology by the
skeptical Greek writer of the second century A.D. (*Loeb Classical Library* [Cam-
bridge, Mass.], 7:328–31). The source was first identified by George Levitine
(*Girodet-Trioson: An Iconographical Study*, [Ph.D. diss., Harvard University,
1953; published New York, 1974], 126–27). In one short passage, Aphrodite
mockingly chides Selene for her uncharacteristic infatuation with the mortal
boy, describing her as the victim of her mischievous son Eros:

 What's this I hear you're up to, Mistress Moon? They say that every time
 you get over Caria, you stop your team and gaze at Endymion sleeping out
 of doors in hunter's fashion, and sometimes even leave your course and go
 down to him.

Girodet renders the obsessive Selene as a fall of immaterial moonlight, whose

passage is facilitated by the smilingly malign Eros disguised as Zephyr the wind. His treatment of her beloved follows directly from the description Lucian renders in her voice:

> I think he's good-looking, Aphrodite, especially when he sleeps with his cloak under him on the rock, with his javelins just slipping out of his left hand as he holds them, and his right hand bent upwards round his head, and framing his face makes a charming picture, while he's relaxed in sleep and breathing in the sweetest way imaginable. Then I creep down quietly on tip-toe, so as not to waken him and give him a fright, and then—but you can guess; there's no need to tell you what happens next. You must remember I'm dying of love.

2. Girodet, "Correspondance," *Oeuvres posthumes*, ed. P.-A. Coupin (Paris, 1829), 2:392, 396.

3. In the modern literature, this view originates with Frederick Antal, "Reflections on Classicism and Romanticism II," *Burlington Magazine* 67 (April 1936): 132; it has been repeated by Albert Boime, *Art in the Age of Revolution* (Chicago, 1987), 448–51.

4. See *Lettres addressées au Baron François Gérard, peintre d'histoire . . . 2e édition publiée par le baron Gérard son neveu* (Paris, 1886), 1:177–78.

5. For a reproduction and discussion of this replica, see the author's "Une manière de travailler in the Studio of David," *Parachute* 56 (October–November 1989): 48–50. See also the illustration and entry on the Princeton canvas by Alan Wintermute in *1789: French Art during the Revolution* (New York, 1989), 113–19. J. L. J. David, *Le Peintre Louis David, 1748–1825. Souvenirs et documents inédits* (Paris, 1880), 59, refers to Girodet having painted some of the background figures in the original *Socrates*.

6. On the contested previous attribution to David, see the exchange between then director O. Wittman and R. Rosenblum, *Burlington Magazine* 107 (June 1965): 323–24; (September 1965): 473–75; (December 1965): 623; and 108 (February 1966): 90. For a documentary confirmation of Rosenblum's judgment in favor of Girodet on stylistic grounds, see the following note.

7. P.-A. Coupin, *Essai sur J.-L. David* (Paris, 1827), 61–64 (copy in Bibliothèque Nationale, Paris). The first mention of this list, to my knowledge, was made in Stephanie Brown, "Girodet: A Contradictory Career" (unpublished Ph.D. diss., University of London, 1980), 41ff. Coupin emphatically gives the Toledo *Horatii* to Girodet (p. 61) and publicly objected on two occasions in *La Revue encyclopédique* to the owners of the copy, the Didot family printing firm, exhibiting it as a David (30:578; 33 [January 1827]: "réclamations").

8. Coupin, *Essai*, 62–63.

9. The principal figures here are P.-A. Hennequin, J.-B. Wicar, J.-G. Drouais. This intimacy could produce strong tensions. Hennequin, in his post-

humously published memoirs (*Un peintre sous la Révolution et l'Empire: Mémoires de Ph.-A. Hennequin écrits par lui-même* [Paris, 1933], 57ff.), speaks of the jealousy of Wicar toward him that led to his early expulsion from the studio. On Wicar, see the thorough biography by F. Beaucamp, *Le peintre lillois Jean-Baptiste Wicar, son oeuvre et son temps* (Lille, 1939), 1:27ff. On Drouais, the most up-to-date source is P. Ramade and R. Michel, *Jean-Germain Drouais, 1763–1788* (Rennes, 1985), 13–63. The most eloquent testimony to the intimacy between David and Drouais are the latter's surviving contributions to their correspondence, reproduced in David, *Le Peintre Louis David*, 34–51.

10. The two existing accounts, one written from the French perspective, the other from the Vatican's, are F. Masson, *Les diplomates de la révolution* (Paris, 1882), 15–145; and L. Vicchi, *Les français à Rome pendant la Convention (1792–1795)* (Fusignano, 1892), 87–137, with extensive documents, 8–91.

11. See "Adresse des pensionnaires de l'Académie de France à la Convention," in *Correspondance des Directeurs de l'Académie de France à Rome avec les Surintendants des Bétiments, publiée d'après les manuscrits des Archives Nationales*, ed. A. de Montaiglon and J. Guiffrey (Paris, 1887–1912), 16:251, which reads in part:

> We citizen-pupils will forever honor the happy day that will return them to the nourishing breast of their country; guided by their love of her, would they ever forget for a single moment that their duty is to pass on from age to age the memory of virtuous deeds? Happy indeed that they can help awaken in the hearts of their countrymen the sentiments with which they themselves are inspired; happier still, after having paid to their country the homage of their talents, to spill their blood in her defense.

12. See extract from the procès-verbaux of the Convention (25 November 1792), in *Correspondance des directeurs*, 16:167; also letter of 24 December 1792 to Topino-Lebrun, in David, *Le Peintre Louis David*, 120–22.

13. "Correspondance," letter to Trioson, 19 January 1793.

14. See *Girodet 1767–1824*, (Montargis, 1967), nos. 13, 20.

15. For an early compendium of recollections of the younger Drouais' life, see J.-B.-A. Suard, "Eloge de M. Drouais, élève de l'Académie royale de peinture," *Mélanges de la littérature* (Paris, 1806), 3:273–84.

16. See A. Péron's résumé of the recollections of David's pupil J. B. Debret, who accompanied his master to Rome, *Examen du Tableau du Serment des Horaces peint par David, suivi d'une Notice historique du tableau, lus à la Société des Beaux-Arts* (Paris, 1838), 33ff.

17. See *Mercure de France* (7 June 1788), 40; on the shrine, see T. C. Bruun-Neergaard, *Sur la Situation des Beaux-Arts en France ou Lettres d'un Danois à son ami*, (Paris, 1801), 104–105.

18. On his petition to be exempted from the normal required copies and

studies—and the angry response of the Director-General d'Angiviller—see *Correspondance des directeurs*, 15:100–106. For further discussion of Drouais' behavior in this period and official reactions to it, see the author's "The Decline of State Authority in the Direction of French Painting as Seen in the Career of One Exemplary Theme, 1777–1789," in *The Consumption of Culture 1600–1800: Image, Object, Text*, ed. John Brewer and Ann Bermingham (London, Berkeley and Los Angeles, 1993).

19. Again, according to Coupin, *Essai* (p. 63), Gérard's assistance was crucial in David's rapid completion of the now lost martyr portrait of the regicide deputy Lepeletier de Saint-Fargeau. We can never confirm this statement from physical evidence, but Coupin, inviting his readers to test his claim, states that it was obvious from the appearance of the surface that Gérard had completed the entire body of the murdered Republican aristocrat.

20. The best discussion of this painting is in Brown, "Girodet," 55ff.

21. See M. Pérignon, *Catalogue des tableaux, dessins et croquis de M. Girodet-Trioson* (Paris, 2 April 1825), 10.

22. The most comprehensive treatment of the painting, with relevant documents, is now to be found in the catalogue of the exhibition at the Musée Calvet, Avignon: M. P. Foissy-Aufrère et al., *La mort de Bara: de l'événement au myth, autour du tableau de Jacques-Louis David* (Avignon, 1989); see especially the challenging interpretation of its iconography, facture, and degree of "finish" by Régis Michel, 41–77.

23. For a representative discussion, see Joseph C. Sloane, "David, Robespierre, and the 'Death of Bara,'" *Gazette des Beaux-Arts*, 6ᵉ per., 74 (September 1969): 153–55.

24. "Dorat-Cubiáres [Michel Cubières-Palméyzeau]," *La mort de Basseville ou la conspiration de Pie VI dévoilée* (Paris, 1793). The text begins with the words, "You know, my dear master . . . ," at which point an asterisk directs the reader to this explanatory note:

> This is not the author who is speaking, but a young French artist, a pupil of David, a resident of Rome at the time of Bassville's murder, and an eye-witness to the facts that he will relate. The author believed it appropriate to render the account in the first person, in his voice, in order to lend to the narration greater fluency, vividness, and fire.

25. See William Olander, "Pour transmettre à la postérité: French Painting and Revolution 1774–1795" (unpublished Ph.D. diss., New York University, 1983), 293–302, who writes (298, 302):

> David's painting, though unfinished, is complete enough to suggest that its nudity, ambiguous sex and swooning, near eroticism were not merely aspects of a preparatory study but intended as the final image in order to

convey the components of a universal myth and not reality. . . . Bara, as conceived by Robespierre and David, was the mystic [androgynous] Adam before the fall, recomposing itself throughout all civilizations, endowed with a single mind and pursuing a single destiny throughout all history, to emerge in 1794 as this singularly frail boy-girl child. . . . For the men of Year 2, fanatical in their devotion and vision, Bara was a symbol of a universal mankind as created by the Revolution, of a paradise regained, of sublime virtue and beauty, before the fall.

R. Michel ("Bara," in *La mort de Bara*, 67) has argued not only that the nudity represents David's considered final intention but that the handling of paint represents an extension into a total pictorial vocabulary of the nervous scumbling with which David surrounded the subjects of his portrait subjects of 1793. He sees the technique, first, in terms of popular oratory, on the Aristotelian model, which must imitate the painter of the sketch who avoids superfluous, distracting details and fineness of effect. Further, it evokes on its own the disorder of battle without falling into the inferior genre of battle painting, and, finally, "le dynamisme de la touche sature la toile d'une sorte d'immédiateté elle rend l'Histoire vivante, où la fige d'ordinaire la froideur du glacis. En d'autres termes, l'Histoire conjugue au présent: elle devient visuelle et tactile, où la finition lisse l'emprisonne dans l'immobilité du passé révolu."

26. See Dover, *Greek Homosexuality* (Cambridge, Mass., 1989), 16, 156ff.

27. For an excellent recent discussion, see David Halperin, "Platonic Eros and What Men Call Love," *Ancient Philosophy* 5:161–204. The Platonism of David's *Death of Socrates* (1787, New York, Metropolitan Museum of Art) has as much to do with the *Symposium* as it does with the *Phaedo*, a subject discussed further in the author's "A Masculine Republic: Bonds between Men in the Art and Life of Jacques-Louis David," in *The Delicate Taste*, ed. Gillian Perry and Michael Rossington (Manchester, 1994).

28. *Aux Armes et aux Arts! Peinture, sculpture, architecture, gravure. Journal de la Société républicaine populaire et des arts* (1794): 169–70. J. B. Wicar, a loyal ex-student of David's and zealous Jacobin supporter, was enjoined to visit the superior collection of first-generation casts owned by the sculptor J. B. Giraud to see if better reproductions could be made from his. Détournelle inserts an extended counterpoint on the works to accompany the report on the negotiations. On the Belvedere Apollo he writes, "His youth is the flower of an eternal springtime, but it is simultaneously a perfect flower, . . . complete, tender, and sweet. . . . This statue seems to come alive like the beautiful beloved of Pygmalion and to take on life and movement the more attentively it is contemplated" (pp. 163–65). At the end, he confesses the obvious, that his descriptions were all cribbed from Winckelmann.

29. On 29 Nivôse (18 January 1794), Wicar presented a petition to the society, reported at length in the journal. It contains an exhortation to artists, above all,

to consecrate their energies to commemorating those who have sacrificed their lives to the Revolution: "The people call again for their friend," he declared with reference to Marat. "They want to see again his bloodstained features that again strike terror into the villainous criminal; our children will demand from us faithful images of the fathers of Equality" (p. 106). This task required a purification of the body of artists, and Wicar's speech represents a savage enlistment of the principles and language of the Terror. First, there had to be revenge on those artists who had stayed in Italy, thereby taking the side of the hostile papacy and royalist French émigrés: "Legislators, if we direct your vision to the children faithful to their country, to good Republicans, we appeal to all of your severity: we invoke national vengeance against the traitors, vile, debased, and prostituted artists, monsters who have taken the unspeakable oath to Louis XVII, to this phantom, the rallying sign of all the assassins of our country." Among these outlaws, he counted in particular his old studio-mate Fabre. If their bodies remained out of reach, their works should be immolated in their stead: "Let the products of their infamous hands, the works that have gained them the favors of despotism, no longer afflict our republican vision; let everything that might remind us of these traitors to their country be offered in a burnt offering to the dead souls of our Brothers!" (104).

30. The unconscious response of the painter to this condensation of erotic loci may be responsible for the unsettling trace of red paint along the crease that marks the disappearance of the genitals, one that echoes a similar trace across the lower lip.

The Renunciation of Reaction in Girodet's
Sleep of Endymion

> And how will you enquire, Socrates,
> into that which you do not know? What
> will you put forth as the subject of
> enquiry? And if you find what you
> want, how will you ever know that this
> is what you did not know?
> —Plato, *Meno* (trans. Jowett)

AT one time art critics and historians aligned Girodet's remarkable painting *Endymion, effet de lune* (*The Sleep of Endymion*), painted in 1791 and exhibited in the Salon of 1793 (see Crow, fig. 1), with considerably later images—produced toward the end of the century and during the empire and Restoration—commonly understood by many commentators to exemplify a "decadent" post-revolutionary "neoclassicism of reaction."[1] Superficially, Girodet's painting does indeed appear contiguous if not identical with such works, or even with the earliest manifestations of what would become romantic art. "As for Guérin and Girodet," Baudelaire wrote in 1855, comparing the two painters to their master David, "it would not be hard to find in them a few slight specks of corruption, one or two amusing and sinister symptoms of future Romanticism—so dedicated were they, like their prophet, to the spirit of melodrama."[2] Perhaps following Baudelaire's lead, for many observers the neoclassical paintings that Girodet's work seems to foreshadow have become the proper context for interpreting it, as if their terms were its terms. But, of course, the later images—like any entries in an evolving, necessarily disjunctive iconography—were at best only selective replications of Girodet's painting, repeating, revising, or even partly refusing it in the light of accrued pictorial developments and novel historical experience. If Girodet's painting displays "one or two"

symptoms of what would later become a widespread "corruption" of French painting, can the fault really be Girodet's—or is it rather to be attributed to those later artists who permitted the disease, whatever it is supposed to have been, to advance so much further? In 1791–1793, Girodet surely did not fully intend to provoke the flood of productions his painting retroactively seemed, along with a few other works, to have released. But what, then, did he intend to accomplish?

In a reinterpretation of Girodet's painting, Thomas Crow—eschewing the blatant anachronism involved in many previous assessments—aligns it with more directly contemporaneous images that he understands to be forms of "prerevolutionary" classicism, with which, superficially, it appears to have little in common.[3] Very broadly speaking, whereas earlier observers interpreted the painting on the basis of an orthodox formal analysis that seemed unequivocally to place it within neoclassical iconography and its field of social and ethical meanings (however these are evaluated), Crow approaches the *Endymion* as a rhetorical statement within the context of an immediate contemporary "politics," artistic, professional, and public. Crow's analysis—more synchronic and "structural" than diachronic and evolutionary—generates valuable formal and historical insights. In some ways, however, the problem of articulating how and especially why Girodet's painting stands between classical and neoclassical art—and between "prerevolutionary" and post-revolutionary practice—persists in Crow's interpretation. Successfully detaching the painting from the supposedly corrupt "reaction" of neoclassical painting, Crow now attaches it to the supposedly more radical ethics of early Davidian classicism; and although he begins to explain the disjunction between the former and the latter in quite particular ways, we are still left wondering exactly how Girodet's neoclassicism replicated—repeated, revised, and refused—its ancestral classicism. This question is due not, I think, to any flaw in the positive results of Crow's formal and historical analysis; rather, it is due to what that analysis cannot recognize in the first place.

Crow's Two Metaphors for the "Political" History of Art

Crow does not deny that Girodet's *Endymion* has a highly individual, perhaps even peculiar, affiliation with Davidian classicism. Indeed, Crow assumes the traditional judgment that there is a palpable contradiction between the formal organization and ethical content of "pre-

revolutionary" Davidian images of history, embodied in works like David's *Oath of the Horatii* (1784–85; Crow, fig. 6) and *Death of Socrates* (1787; Crow, fig. 5), and Girodet's mythological painting of 1791. But for Crow, this contradiction can be transcended—simultaneously recognized and overcome—in two ways.

First, Crow supposes that contemporary "politics"—its institutions, circumstances, and activities from 1785 to 1793—at the time mediated, and for us can now explain, the palpable difference between Davidian classicism and Girodet's replicatory revision of it. Later I will return to the details of Crow's account. His most general conclusion, however, is that the *Endymion* belongs to the same "circulation of meanings" as David's "pre-revolutionary" history paintings—namely, what he identifies as "opposition to despotic authority" in 1785, supporting the "cause of revolutionary social transformation" by 1793. In this essay, although I do suppose that the painting "circulates" the terms of Davidian classicism, I will also suggest that it does not wholly circulate *in* the terms of Davidian classicism. In other words, Crow's conclusion (somewhat hedged and qualified) that the meaning of the *Endymion* lies in its oppositional cause does not, in itself, exhaust the matter.

Underwriting Crow's entire analysis of the "political" dimension of Davidian classicism, including Girodet's idiosyncratic contribution to it, is the notion that politics must be a positive presence, an active force, that can actually have the material effect Crow claims for it. Politics supposedly forges what he calls a "circumstantial noncontradiction" between history and representation, between the actual political-ethical context or motivation of Girodet's pictorial practice and his seemingly nonpolitical—or, at least, non-Davidian—painterly display in *The Sleep of Endymion*. But I would like to question this conception of what Crow, in one of his two fundamental metaphors, describes as "the level of the political." Politics, as such, is neither present, nor active, nor effective, nor located as a "level." Only a particular ideology—a politics of "politics"—makes it so. To the extent that such an ideology can only be constituted in a particular politics, politics must be absent from or, more accurately, always going beyond itself. Not at all a "level," it is a space or, more exactly, a spacing.

At the end of this essay, I will try to suggest where this space might be identified in the supposed affiliation of David and Girodet as belonging to the same "level" of politics. But in the most general sense, as soon as historical criticism recognizes the fault lines within the "level of the political," "politics" loses its supposed status as some objective, inde-

pendent reality—an ontological slice of things upon which other things rest and move—that mediates history and representation. "Politics" is simply the field of contradictions between history and representation, and to invoke the "level of the political" is thus nothing more than one way of describing—certainly not of explaining—the way images are "in" history. Can we salvage something here? Can we produce a "political" analysis of a painting that does not conflate the spaces and spacings of politics with a particular *ideology for* this space and spacings, that is, with an historically specific ideology of politics as an effective "level"? For Crow, an image is constituted in its historical context in the positive playing-out, the progressive stitching-up, of a politics subsisting as a "level" in and of social life. (As we will see momentarily, the "level" requires something like an even, single field of social interaction, a political playing field.) By contrast, I will say that as a politics unravels itself, as its internal spacings are established (or, to use a metaphor alternative to the architectural one Crow adopts, as they are written), the "circumstantial noncontradiction" between an image and its historical context of production and reception momentarily emerges. These perspectives are not mutually contradictory; we are not faced with an either/or choice for historical criticism. Rather, as I will also try to suggest, they are mutually implicated, for political spacing might (although it might not) momentarily create a political "level."

Second, Crow implies that the apparent contradiction between "prerevolutionary" Davidian classicism and Girodet's *Endymion* is a largely formal one. To reveal a "circumstantial noncontradiction" between David and Girodet, he would thus have us reassess the style-formalist's usual argument—it is assumed in the traditional account of Girodet's "reaction"—that formal similarity among images betokens their historical continuity and formal dissimilarity betokens their historical discontinuity, such as a change in technical means or an ideological reorientation among the makers and viewers. To avoid depending on the almost purely visual judgment that Girodet belongs with post-revolutionary neoclassicism, Crow calls for a "systematic" and "historically based" account of form; presumably this account is to be distinguished from a transhistorical lumping of morphological similarities in a single "style." One can hardly disagree with the ambition to be contextually but not transhistorically comparative. But note that in his revised species of formal analysis, Crow wants to see the history of images—in the second crucial metaphor that undergirds his analysis—as a series of "moves" in the "game" of constituting form, a kind of style-competition or style-

debate. According to this view, the history of image makers should be seen, correlatively, as the maneuvers of producers attempting to have a "career," a kind of style-business or style-marketing. If we accept this model, of course, it is *guaranteed in advance* that formal relations among pictorial replications will be determined by Crow's "level of the political"—for by stipulation history *is* the politics and economy of forms: autonomous "political" actors supposedly fashion their formal identity and professional success in public actions of mutual definition, alliance, competition, and resistance.

Rooted in the two metaphors for art historical process that I have just identified, Crow's overall account is partly based on an abstract conception of how history generates forms that he does not scrutinize as such—as a particular historical formation in itself. For my purposes, it is significant that the historical determination of this conception actually lies at least in part in ideologies of masculinity and modes of public effectivity or political virtue quite specific to the era Crow considers, as well as to the larger cultural formations of bourgeois rationalism and their ostensibly radical (but largely predictable) precipitates. Because Girodet's *Endymion*, I will argue, partly renounces this very abstraction about the real history by which its maker could supposedly produce it, Crow's account of its meaning seems both suspiciously seamless and manifestly incomplete.

Girodet's Endymion *and "Pre-Revolutionary" Classicism*

For Crow, Girodet's *Endymion* cannot be grouped easily with the "classicism of reaction," where earlier writers had placed it, because among other things it was made and exhibited at the same time as, and apparently in the general context of, the artist's Jacobin participation in the Revolution. How, then, are we to reconcile Girodet's actual political position and activities with the apparently nonpolitical—or, at least, non-Davidian—formal and thematic order of the painting? In dealing with just this question, one earlier commentator suggested that the painting was Girodet's "escape" from the tensions of political turmoil.[4] Crow, however, rejects a closely parallel possibility that the painting could bespeak the artist's immaturity, his youthful inability completely to encompass his political and aesthetic interests in a unified practice. Because Girodet later exhibited *The Sleep of Endymion* at the Salon of 1798 with his portrait of the former slave and deputy from Santo

Domingo, C. Belley, Crow judges that, for the artist, the painting must have somehow been compatible, "at the time," with images exemplifying rationalist, Enlightenment ideals. (The portrait of Belley depicted the deputy resting against a bust of the early French abolitionist Raynal.) More broadly, the painting must somehow have been consistent with Girodet's position and ambitions in the entire Davidian politico-artistic enterprise.

But quite apart from difficulties in interpreting the exhibition history of the *Endymion*,[5] it is not obvious that in calibrating Girodet's painting and Girodet's professional and public politics one should, with Crow, assume a circumstantial "noncontradiction" between Girodet's figure of Endymion and his personal commitment and self-sacrifice in the revolutionary situation. For one thing, Girodet's earlier religious works have a strong continuity—for example, in their dramatic chiaroscuro—with the *Endymion*. Although we may agree with Crow not to group the painting with the later "classicism of reaction," the possibilities for situating it are not thereby restricted to the one that Crow pursues.[6]

For another thing, the "noncontradiction" Crow hopes to find between Girodet's painting and his politics does not license us, as he acknowledges, to ignore the formal evidence—Crow himself convincingly presents it—that Girodet's identification with his master and his circle was decidedly ambivalent, operating as "reversals" of stylistic and thematic resolutions produced by David and Drouais rather than as direct imitations of them. In other words, the salient "noncontradiction" between Girodet's ostensible politics and his painting could turn out to be nothing more than his openness to palpable, not to say flagrant, contradiction between the painting and his Davidian training, Jacobin public identity, and revolutionary political action. This "contradiction" was— to continue the hypothesis—overtly staged by occasionally displaying the painting in conjunction with images possessing rationalist and Republican connotation. In sum, we might be looking for a "circumstantial noncontradiction" that accounts systematically for a contradictory production—not for a way to show that the production is not contradictory.

The bulk of Crow's demonstration is devoted to explaining the "political" coherence of the *Endymion* with Davidian classicism through a detailed analysis of personal and professional identifications and rivalries within the school of David. According to Crow, it is clear that Girodet partly "internalized" his master's project. Moreover, he

recognized David's first, exemplary student, Drouais, as an ideal to be followed, a competitor to be surpassed, and an example to be circumvented. In 1793, the year he exhibited the *Endymion*, Girodet added his personal contribution to the public dialogue among Davidians; and for Crow, David kept the current flowing in the same circuitry with his *Joseph Bara*, painted in 1794 (Crow, fig. 12), in which Girodet's figure of sleeping Endymion has been replicated as the dying or dead body of the famous boy-martyr of the Revolution. *Bara* is possible evidence that Girodet's *Endymion*, for David, did belong to the field of Davidian "revolutionary" classicism—or, rather, that it could be made to do so by David after the fact, in a highly individual replication of Girodet's work. David, then, was evidently getting some kind of message in the *Endymion*. Later I will suggest exactly what this message might have been; but the nature or status of that message for Girodet in 1791— and his intentions in exhibiting it in the way he did in 1793—cannot necessarily be illuminated one way or the other, without anachronism, by David's painting of 1794. David's replication might be compared with Jean-Baptiste Régnault's *Liberty or Death*, shown in the Salon of 1794.[7] Régnault revised the unheroic, youthfully effeminate figure of Endymion—rendered virtually sexless by David in his image of Bara— in order to depict a beautiful, athletic ephebe making the aggressive gesture of the Davidian public man undertaking decisive action. Régnault's personification of Republican determination is an Endymion endowed with the moral consciousness and public identity of the young Horatii. Just like David's *Bara*, however, this replication does not explain the *Endymion* as politically radical; rather, it was unthinkable without the previous example of the *Endymion*. Régnault seems to be reinserting into public history what Girodet, in ways we will examine, had removed from it. Furthermore, allegories of Republican heroism and virtue were not the only species of replication the *Endymion* engendered or to which it was related as one expression of an available *topos*. Although Crow tends to downplay the importance of these other replications in relation to the public, "political" salience of the painting, as we will see, Girodet probably took them into account as one of the rhetorical contexts without which his own painting was unthinkable.

In all of this, especially in his analysis of the particular formal relations between Drouais and Girodet, Crow convincingly broadens the findings of style-formalism, as I have noted, into a kind of style-structuralism. Formal similarities among works of visual art are not the only evidence

for an historical relationship, a flow of energy through a circuit of personal and professional identifications and rivalries. We must also examine "structural" relations—one image's formal inversion, reversal, or negation of another—above and beyond the relation of similarity, no matter what its own basis in imitation, quotation, allusion, and influence might be. As I have noted, the whole circuitry—this politics and economy of forms—amounts, as Crow puts it, to "moves in a game." Crow's detailed example of this "game" among the Davidians shows that the moves can be quite complex. They accumulate over time in a tradition of image making continuously available for further image making. The difficulty of bridging some of the relations and oppositions created by the game, as it is actually played, leads to the apparent stress or peculiarity of particular images and to the lesser or greater differences among them. Thus there are some textbook plays (such as Drouais' *Marius at Minturnae* of 1786 [Crow, fig. 8] and Girodet's own *Hippocrates Refusing the Gifts of Artaxerxes* of 1792 [Crow, fig. 4] as well as some spectacular, if dangerous, passes (*Endymion* is clearly one of these) and a few awkward fumbles (perhaps *Bara* counts as a malformation of this kind). On this model we can easily explain why the actors apparently expended so much energy on the game. Crow simply has to endow each player with an "inner need" or "intense wish" to "construct a self" distinct from other such selves. This desire for self-identification animates pictorial decisions and professional actions that must lead, by definition, to "political" differentiation among the agents in their public identity. Thus, to complete the argument, apparent contradictions among the agents' actions—for example, the disjunction between David's and Girodet's paintings—make sense. They are noncontradictory actions in the circumstances because they are produced by agents playing a game of imitating, reversing, and negating what other agents are doing, working under stress or threat of failure and with the final goal to emerge preserved, identified, and rewarded as the self-same distinct agent— namely, the public "artist," an "individual" with a "career."

But that difficulty and difference must characterize each player as such—independent of participation in the local, contingent "political" game and sometimes precisely caused by it—and the idea that the rules of the game may be self-defeating or self-consuming seem to have a lesser place in Crow's account.

Endymion's Masculinity

At the very least, Girodet's figure of Endymion exhibits another visu-
alization of the male hero's body, attitudes, and actions than the one
accepted in David's *Oath of the Horatii* (1784–1785) or *The Lictors
Returning to Brutus the Bodies of His Sons* (1789; Crow, fig. 7) or in
Drouais' *Marius at Minturnae* (1786). Endymion absolutely does *not*
embody the kind of stoic dignity, moral alertness, and public effectivity
imagined in Davidian classicism of the mid- and late 1780s. Despite
the purported evidence for Girodet's revolutionary heroism in Italy, we
could plausibly suppose, then, that he did not wholly believe, although
he may have consciously expressed, those "agendas for male public
action" and its mythology promulgated in the Republic by David and
many other partisans.[8] During his years as a student in Italy, Girodet
constantly "philosophized on his fleeting youth, bad health, and brevity
of life"—he was ill and financially strapped—"and was haunted by the
idea of death."[9] If David's images of Stoic heroism, as Dorinda Outram
proposes, enabled "revolutionaries to manage their fear of imminent
death, a death which for many of them had become a totally secu-
lar event,"[10] Girodet's non-Davidian image might have enabled him to
manage anxiety about what the Davidian illusion of male bodily self-
possession and self-sacrifice actually implies for men in public action.

Needless to say, the works of David to which Girodet evidently
responded were subtle and ambiguous in themselves. We should not
ignore, for example, what Crow has interpreted as the "moral indetermi-
nacy" of Brutus in David's rendition of him.[11] Indeed, it is certainly part
of Crow's general account of what he has been the first clearly to see as
"pre-revolutionary" painting in France to investigate the multiple ways
in which David's history paintings of the mid-1780s were produced in
conflict. It is worth noting, however, that although he provides a com-
pelling account of the professional conflicts about picture making and
political representation that determined David's "pre-revolutionary"
productions, he pulls his punches when it comes to other species of con-
flict perhaps related (but certainly not reducible) to this public context.
In his study of David's *Oath of the Horatii*, for example, he suggests that
the image manifests "the overly vivid yet generalized and dissociated
character of hallucination," which he defines in the "clinical, psychoana-
lytic sense: the patient denies the place of an object in his own history . . .
and consequently faces the continual return of his memory of the object

as a 'real' presence."[12] He refers not only to Freud's and Lacan's writings on negation and denial but also to Freud's case history of the "Wolf Man," whose childhood dream and drawing supposedly represented the "primal scene" of his bisexual conflict.[13] However, Crow does not specifically cite the Wolf Man's drawing as an analog of David's painting, nor does he develop the implication that David's painting, if it is a "hallucination" in the "clinical, psychoanalytic sense," must therefore replicate conflicts—the "loss of an object"—long antedating the immediate public and "political" conflicts he dissects in such detail. Here again, we can see how a particular ideology of politics—a conception of politics as a "level" in immediate social intercourse, taken by the historian to be essentially a rationally articulated and managed dispute about conflicting *policies*—elides other senses in which politics might have reality for human agents. Conceived merely as the social space of struggles over artistic, professional, or other institutional "policy," "politics" has little time-depth in an agent's history. It transpires in the "horizontal" dimension of an agent's interaction with other agents with whom he is temporarily confronted, not in the "vertical" dimension of his continual self-projection as an agent with past, present, and future desires. For an historian of traditions of representation, the horizontal analysis on its own has little real explanatory power.[14] For the moment, however, I will assume the immediate "political" lucidity, self-confidence, and public effectivity of David's "pre-revolutionary" works. Later we will see that Girodet probably understood them thoroughly enough to engage them in the space of their own anxiety and magical, defensive idealization.

Some of this complexity is already made explicit in Crow's account. As I have noted, however, Crow aims to transcend the contradiction between Girodet's *Endymion* and Davidian classicism rather than to preserve it. The painting "began," he says, "in a reformulation of the artistic vocation as opposition to despotic authority [in the school and Academic system] that evolved into one of service to the cause of Revolutionary social transformation." Yet he does not quite say why it was specifically the *Endymion* that satisfied the "structural" requirements of the "game" among David, Drouais, and the rest, why it came to serve their larger public cause. To put it another way, why were Girodet's supposed political moves made through the *Endymion* and not some other work, actual or possible? Following Crow's own analysis of the formal generation of the painting, we can readily imagine another painting of the male body fitting the bill, that is, the reversal and inversion of David

and Drouais—an Attis or Adonis, for example, or a Hyacinth, a Hylas, a Ganymede, or a Narcissus, let alone the Christ taken down from the cross already produced by Girodet in the early 1780s.[15]

One element in what Crow calls the "complex of meanings in circulation" concurrently with Girodet's painting must have been the connotations of Endymion, especially (but not only) because Girodet himself was learned in classical literature. (He later collaborated on Noël's *Dictionnaire de la fable*, published in 1803, and probably contributed the description of the painting to be found therein.[16]) Skating lightly over the myth itself and its particular rendition at the hands of Girodet, Crow does not really say what dream is dreamed by the "dream-figure" of Endymion or what dream is dreamed by the *Endymion* for Girodet.

To be specific, although the setting is mythological and the story in part describes Endymion's agelessness and deathlessness, Endymion is not only "timeless," as Crow would have it. Like the Horatii, Brutus, or Marius, Endymion also has a significant history in mortal human time, which leads to the immortal sleep supposedly depicted in the painting. Girodet presents Endymion on the other side of the kind of human action—with its driving passions and painful reasonings—being contemplated or confronted by the Horatii, Brutus, or Marius. In one of the chief sources for the myth, Zeus punishes Endymion with eternal sleep; the ruler of the gods believed that Endymion, hero and king of Elis, committed the crime against the gods and his own mortal nature of loving Zeus' wife, the goddess Hera. According to Greek thinking, Endymion's love exemplified an unreasoning and impious *hubris*. In the other principal source for the myth, equally well known to eighteenth-century readers, the moon goddess Selene observed the beautiful mortal youth hunting with his dogs and lying at rest in a cave. By arranging for him to fall into an immortal sleep, she ensured that he would be forever beautiful and youthful in her eyes; visiting him as he sleeps, she gratifies her desire for his body. Some expressions of this version of the myth emphasized Endymion's active sexuality: he is sometimes said to have impregnated Selene *before* entering his eternal sleep. In mortal human time, then, Endymion defies the gods or provokes the lust of the goddess. (Possibly he satisfies his own desires, although the story is ambiguous. In another version, Endymion could not bear the thought that his beautiful body would grow old. As he was a son or grandson of Zeus, the high god granted his plea to live forever without aging— although he could only do so in a state of sleep.) All versions of the

myth clearly express a specific ethical and narrative relation between Endymion's mortal and his immortal existence.[17]

We should also examine the time and place of pleasure or the erotic in Girodet's image. Both in the painting and in his comments about it, Girodet was quite specific about the moment rendered in the image. Whether or not she caused him to fall into his eternal sleep, Endymion is depicted just about to be used sexually by Selene. According to the myth, this occurred fifty times and brought her fifty sons. The two characters' erotic relation, then, is temporally located as well as repeated—extended in a full duration, but not endless. (As we will see, the painting is actually about a temporal cycle.) In fact, the mythological sources, inconsistent and open-ended as they are, leave the possibility quite open that, although Girodet depicts Endymion sleeping, it is not necessarily *as an immortal*. Selene saw him sleeping in his cave *before* but (at least in the dominant version of the myth) had sexual relations with him *after* he fell into eternal sleep. In Girodet's own later synthesis of the story, written for Noël's 1803 dictionary, he puts Endymion to sleep as a consequence of Zeus' wrath or at his own request; here, Selene comes across him as he sleeps for eternity and has sexual relations with him. We can certainly follow Girodet's later published description as an authoritative text for the painting produced more than a decade earlier. But two points should be clear. First, Girodet knew a full range of sources with their ambiguous placement of active masculine sexuality; the painting does not simply assume but actively reflects on the time and place of a man's sexuality in relation to his mortal historical status and action. And second, the painting itself offers nothing enabling a viewer to decide definitively among the possible narrative versions of the myth—again, one might suppose, provoking questions in the viewer about history, temporality, and the place of sexuality or eroticism. Does the painting depict Selene, in the form of the moonbeam, first encountering the mortal Endymion at rest during a hunting expedition? Does it depict Selene arriving to take her pleasure on the body of the beautiful youth, condemned by Zeus for his earlier erotic transgression? Does it depict the youth, having been granted his plea that his body never age, falling into eternal sleep in his cave, with the passing moonbeam indicating that soon Selene will be introduced to his defenseless body by a sly Eros? The painting does not offer a clear vision of what state of things lies on the other side of Endymion's mortality. Rather, it subsists precisely as a question about his mortal history and its other side: The painter sug-

gests or evokes various possible causes and consequences of the body's dropping out of history, but he does not confirm any single one of them. This bracketing of narrative resolution is consistent with other aspects of the painting.

Girodet evidently depicts Endymion stirring to turn toward the moonbeam as it touches his face. (In resolving the final image, Girodet seems to have focused this narrative possibility as he worked. In an oil sketch for the painting, the moonbeam is not included, and Endymion appears to be resting quietly—only a barely perceptible torsion in his trunk suggesting that he is stirring or turning over to his right.[18]) Perhaps he will have an erotically pleasurable dream to accompany the goddess' visit—a dream, indeed, in which his own passivity and obliviousness would be reversed, reintroducing him to action and temporality as he becomes tumescent, penetrates Selene, and impregnates her. Perhaps he will awake to have intercourse with her. But perhaps he will have "sensual pleasure" (Crow's phrase) without ever knowing it, for, if he is depicted here in the proverbial "sleep of Endymion," then we know that he cannot awake. Although his body is animated by Selene's touch, it is, in Lucian's description, "helpless." His awareness and will are divided from his body and suspended in sleep. Things happen to him, and his body can only passively react; he performs phallic acts without phallic desire.

Indeed, Endymion behaves just like the female body as it was imagined in the traditions of pictorial classicism and in iconography of the earlier decades of the eighteenth century in France. For example, in the Abbé de Favre's poetic retelling of the story, published in 1779, it is the goddess Diana who reclines "sous un berceau de myrtes, dans ce voluptueux abandon que donne la fraîcheur du bain," and it is Endymion, a rustic shepherd, who parts the foliage "et reste en extase à l'aspect de tant de charmes."[19] As Philip Stewart observes, in the engraving to illustrate the text Jacques Sebastien Leclerc depicted the goddess as a "langorous" version of a more common image of the "ferociously *pudique* Diana."[20] Stewart points out that "whether pastoral or contemporary in its accoutrement, the contrived motif of the woman in a wooded area dozing, whom a lover or other admirer chances upon, reappears constantly in the light verse of the period, and its artistic counterpart takes on a life of its own."[21] To illustrate the point, he reproduces a plate for Masson de Pezay's *Nouvelle Zélis au bain*, published in 1768, in which Zélis, reclining in the glade, is discovered by a male stranger.[22] The viewer knows that Zélis is unaware of her predicament,

because she makes the traditional gesture of unconsciousness—head thrown back, with one arm behind it—that Girodet will also use for Endymion. But part of the narrative connotation (and gender stereotype) of the image, of course, is that she is nonetheless sexually seductive, even sexually available: Her white bosom—in some images, the woman's breasts can be much more exposed—is oriented provocatively (but nonetheless as if by accident) to the stranger's gaze. The ambiguity in this replication of the *topos* lies, for the viewer, in knowing what will happen next. Will she bring her arm down from behind her head to adjust her dress, modestly shielding herself before the stranger's eyes? Or will she display herself willingly, even longingly, like Diana responding to the shepherd Endymion in the illustration noted above? The text gives us the general answer:

> Sans les amants, que serviraient l'ombrage
> Et le gazon, que, sous l'épais feuillage
> Au doux printemps, font naître les Zéphirs?
> L'ombrage est fait pour voiler les plaisirs;
> Et le gazon? . . . L'amour en sait l'usage.[23]

Among other things, in the *Endymion* Girodet almost certainly responded to such verse. For example, in describing the painting in Noël's 1803 dictionary and in a later letter, he explicitly noted his decision to depict Eros as Zephyr, personification of the breezes. The choice has no basis in the classical texts of the myth (and Girodet asserted that "cette pensée m'appartient tout entière"),[24] but conforms instead to the contemporary poetic imagination of the pastoral setting of love and its counterpart, the imagination of rape.

As Crow notes, phallic desire must be located in the moonbeam of Selene penetrating the foliage to discover the sleeping hero. In the myth, as Greek artists recognized and as eighteenth-century readers of Greek mythology would have realized, Selene at least in part behaves in conventionally "masculine" fashion, acting as the pursuing lover who is attempting actively to gratify desire for the beautiful but passive boy, the beloved. In Greek vase painting, "when goddesses fall in love with mortal males, as Aphrodite did with Adonis, Dawn with Tithonos or the Moon with Endymion, they react like older males."[25] Nonetheless, in Lucian's version of the myth, Selene specifically lacks the mental control of the lover, the free, rational, adult male citizen of the democracy.[26] Like Endymion, she too is cut off from reason in a frenzy caused by

Eros, the mischievous son of Aphrodite. In the painting, then, we see the alert, sly, willful Eros introducing an unreasoning Selene to reasonless Endymion.

Independent of the mythological allusion, the painting, regarded in strictly literal terms, also suggests an erotic—but possibly nonphallic—connection between Eros and Endymion. Indeed, in the painting it is almost as if Eros discovers Endymion for himself, pulling back the foliage to illuminate the sleeping youth, who turns toward the light in such a way that the hovering Eros will momentarily be directly above or astride him. In the second half of the eighteenth century, any decorous representation of same-sex eroticism—there were, of course, indecent pictures—would likely display "Winckelmann's contradiction," a rhetorical formation perfectly intelligible to literate European society after that scholar's murder in 1768: The modern artist imitates the forms of classical antiquity, its representation of beautiful boys and perfect youths (or perfect youths and physically powerful, dignified men) in sensual association, without publicly acknowledging their content— "Greek love" as such, the sexual activity among boys, youths, and older lovers.[27] In this context we should note, for example, that although the moonbeam directly lights the face of Endymion, it also backlights the figure of Eros and even falls brightly on his rear end, which faces away from the ostensible light source: The compositional logic of the painting requires that there be moonbeams pointed in two different directions, although the *trompe l'oeil* minimizes our impression of any such violation of nature. (In another reading of the painting, the light source must be placed far back in the fictive space, above the illuminated clearing we can just see off to the back of Eros' left side. This logic would equally require a diffused or divided light source.) Along with the ambiguity of narrative roles, this pictorial feature is consistent with one's general sense that the diffuse moonlight depicted in the painting evokes the uncertain, partial attribution of phallic masculinity to all three actors in the story.

More than a decade after Girodet first exhibited his painting, he was treating it "almost like [his] commercial sign."[28] At this time he asserted that the moonbeam in the painting was "Diana," often thought to be a moon goddess of the Greeks. In his own words in a letter written some time during or shortly after 1806, the painting shows Diana, "renowned for her chastity," approaching the sleeping Endymion "in a moment of mere amorous contemplation."[29] But in 1791, while working out the elements of the narrative, Girodet had obviously depended on

the version of the myth portraying the unchaste, sexually aroused Selene. (In Lucian's telling, it is Selene who complains to Aphrodite about the trouble Eros has caused her.) Thus his later restatements may bespeak— in their very "reaction"—the more "revolutionary" aspects of the painting in 1791–1793, namely, the revision of conventional metaphors for gender difference, an opening toward a nonphallic and possibly homo-erotic alternative, that I am briefly pointing toward here.

I have certainly not explored all of the possible metaphorical associations in the way the Girodet's painting narrates its mythological story. But by this point it should be clear, at least, that in the *Endymion* there is a considerable and overt reshuffling of the Davidian—and earlier— gendering of reason, moral acuity, and public effectivity as masculine, and of passion, moral unconsciousness or obliviousness, and sexual passivity as feminine. In the painting's visualization of the story, activity and passivity have been redistributed. Selene seems to occupy the active "masculine" role of pursuing the beautiful young man. But she is female; moreover, a mere moonbeam cannot take sexual pleasure. The goddess, if she is going to appear at all, does not have the full stability of masculinity in reason. Instead, as Lucian puts it, she is "humiliated" by the desire Eros has implanted in her. Although Endymion is the only mortal male in the image and has a supremely beautiful, sexually desirable body, he is "helpless" and passive. Eroticism suffuses the scene, but it is unclear whether Endymion feels any sexual pleasure—even if he is about to have intercourse with the goddess. Indeed, he is depicted to have the body, conventionally, from which one—that is, some active male— *takes* pleasure. But here, unlike the Athenian beloved who chooses and submits to his older lover after a decorous courtship, Endymion cannot make a wise, rational choice in love, thereby proving his fitness to become a fully adult citizen; instead, he is oblivious to his situation. Finally, in the painting it is *Eros* who is the alert, intelligent male subject. He acts toward an end of his own on the two passive, unreasoning or reasonless objects of his schemes, the "helpless" Endymion and the "humiliated" Selene. But quite apart from the fact that he is a mere child, in the moral stature of his reasons he is no Brutus or Marius. He plays a game, an obvious counterpoint to the moral dignity of Stoic heroes whose gravity in political affairs means nothing to him. All three actors, then, partly embody and partly fail to embody an ideal of active, publicly engaged, and virtuous masculinity. Although they might carry out the actions of men, the defining property of such masculinity—namely, reason—has been trivialized or voided throughout.

The Rhetorical Field of the Endymion

The pictorial and metaphorical activity I have briefly identified in the *Endymion* was not the sole invention of Girodet. I am not, I think, burdening the painting with unlikely meanings.

To take one example, we can find a structural relative of the story of Endymion in the ubiquitous eighteenth-century depictions of Cupid and Psyche. Cupid visits Psyche in the darkness of night, but although he gives her great pleasure, when she seeks to set her eyes on him their love is imperiled. Here again, conventional gender identities are redistributed. Although Cupid is an active masculine agent, his deeds are not precisely public; and although Psyche assumes the "masculine" role of pursuing a beautiful youth, she cannot succeed in possessing him without destroying their erotic connection altogether. These connotations of the myth were explored in pictorial art produced both before and after Girodet's *Endymion*. For example, in Marillier's frontispiece engraving for Jean de la Fontaine's *Amours de Psyché et Cupidon*, published in Paris in 1782, Psyche, carrying a lighted lamp, lifts the bedclothes to expose her naked, sleeping husband, depicted—like Endymion—with his head and one arm thrown back. But, as Philip Stewart notes, despite her assumption of the active, inquisitive, desiring "male" role, Psyche is not quite a female equivalent of the typical male character, discovering, gazing upon, and ultimately assaulting the object of his desires. The illustrator depicts her as having dropped her dagger, and thus the reader knows that "unlike the male, who is habitually inspired by such situations to accomplish his designs," she "cannot consummate the act she intends."[30] Rather than merely switching conventional roles, both characters in the story just lose what is proper to them. Not surprisingly, the "androgyny and unisexuality" in Joshua Reynolds' *Cupid and Psyche*, shown at the Royal Academy in 1789, has often been remarked.[31] In Gérard's *Cupid and Psyche* (Crow, fig. 2), exhibited in the Salon of 1798, the year Girodet showed the *Endymion* with the *Portrait of Belley*, Psyche awakes in the hours before dawn at Cupid's presence. She cannot see him and folds her arms beneath her breasts with chaste delicacy, while Cupid lightly brushes the air around her with his lips. Although she cannot see him, she feels him, and although he can see her, he does not touch her. There is enough light in the sky to show that at any moment she might identify the beautiful youth who must then abandon her. Gérard's figure of Cupid is a synthesis of and response to Girodet's Eros, Selene, and

Endymion, at least as specific and nuanced as David's figure of Bara—suggesting that the field of overtly "revolutionary" political meanings into which David attempted to pull Girodet's painting was not the only possible one circulating at the time.

For several recent commentators, "the semiotic instability of these paintings [of the late eighteenth and early nineteenth centuries] has much to do with the fissures and strains that emerged in masculine gender identity during the revolutionary situation when all certainties were under fire."[32] I will not take up this more general argument here, but it is evidence, I think, for my contention that the story of Endymion specifically challenged classical or classicizing conceptions of history and male agency that Keats' *Endymion*, of 1818, was felt by some of its contemporary readers to be decadent, "effeminate," and un-Grecian. One modern critic has suggested that in its "effeminate" language the poem "unveils and interrogates the powerful nostalgia" for the "cool, chaste, and lucidly structured" forms of antiquity by dramatizing the impossibility of attaining the formal harmony of classic art and of creating characters who could embody the moral grandeur of classic gods and heroes.[33]

To take another example, almost a full decade before Girodet's *Endymion* was painted, a "homosexual current began to supplant the exaltation of women in [French] painting," to use the overdramatic words of Dominique Fernandez.[34] As Fernandez recognizes, this development transpired over a thirty-year duration, beginning about 1780 and lasting through the 1810s and 1820s. The *Endymion* can be seen, I think, as one of the most crucial replications in the emergence of an iconography characterized by a constant, intricate repetition, revision, and refusal of available stereotypes for representing the masculine, feminine, homoerotic, pederastic, and sodomitical dimensions or interests of the male body. All of these categories were more or less clearly distinguished from one another in mid- and late eighteenth-century thought; only later were they integrated in what became the mid- to late nineteenth-century unitary concept of "homosexuality."

It is crucial to see the emergence of a "homosexual current" in modern European art as a long-term and highly complex process. Fernandez leaves the distinct impression, however, that what he takes to be the earliest works in the "homosexual current" of French painting fully assumed a unitary concept of homosexuality in the consciousness of painters and viewers. Specifically, he cites Jean-Baptiste Régnault's *Education of Achilles*, painted in 1782 but not exhibited in the Salon until 1791.[35]

The problem is not so much that a "homosexual" reception could not have existed in the 1780s or 1790s. Although the medical-psychiatric concept of "homosexuality" is a mid- to late nineteenth-century construction, homoeroticism and sodomy, at least, had been cross-mapped or conjoined in stable systems of erotic practice and self-identification in various urban settings in Europe since the fifteenth century; they were loosely integrated into the more general libertinage of the Ancien Régime, the court of Frederick the Great, or the Papal Court.[36] Rather, the issue is whether Régnault's painting actually appealed to or (even more dramatically) was produced for homoerotic or sodomitical regard. It seems likely that the painting did not assume this reception as the sole site, at any rate, of its overt address. Although the myth of Chiron and Achilles did have explicitly pederastic and sodomitical elements, Régnault's treatment of them in the painting was very oblique. Although Fernandez apparently does not notice the possibility and refers chiefly to the "beautiful nude youth" in the center of the composition, no doubt a literate viewer could have taken the archery lesson—quite apart from the way Régnault arranges the bodies of the two participants—as a rather witty metaphor for pederastic initiation. Such a viewer might thus have been amused at the deeply shadowed, wooded setting of the scene, a revision of the usual sunny pastoral; for men seeking to make sexual contact with one another were well known "to take themselves out for a walk" (se promener) after dusk—or at certain times during the day, seeking to seduce "les jeunes écoliers"—in the Luxemburg Gardens, the Tuileries, wooded areas of Versailles, and elsewhere to make pick-ups (pour y raccrocher), despite occasional rousts by the garden police (the "archers").[37] But the characters' expressions are hard to interpret, and the narrator's attitude is not wholly clear—for while Chiron may be lusting after his young charge, the noble Achilles (rendered as beloved rather than in his more usual role as womanizer, husband, or lover) appears somewhat tentative and fearful. If "discretion . . . was the price of homosexual freedom,"[38] it is possible that Régnault's painting cautiously adopted it. It is equally possible, however, that Régnault merely hoped both to amuse and to titillate his audience by playing on the widely current stereotype of the licentious educator-pederast cruising in the park.

In 1791, the year Girodet painted the Endymion, Régnault exhibited a more interesting and challenging work, Socrates Tearing Alcibiades from the Bosom of Voluptuousness. In Régnault's rendering, the body of Alcibiades, although muscular, is white, soft, and somewhat flac-

cid, a palpable degeneration of the hard, virile bodies that David had used to depict the Horatii. While pulling his student and favorite from the women's boudoir, Socrates makes a rhetorical gesture—one hand pointed skyward as he makes a speech—that apes the one David gave to him in *The Death of Socrates* (1787). As we will see, this dichotomy between the rational, self-controlled Socrates and other, more sensual men, Alcibiades or Endymion, was also explored by Girodet. In such paintings of the immediately "pre-revolutionary" and revolutionary period, men like Achilles, Alcibiades, and Endymion are, of course, heroic in their own way. But they were understood to have been transformed or brought low by their own desire, pride, or irrationality; ultimately they are punished by their peers or by the gods. To be specific, they did not always comport themselves in conventionally masculine fashion. In fact, in the later eighteenth-century topography of gender, they are much closer to the position traditionally occupied by sexually wanton women in classicizing art than to the more stoic heroes, Brutus or the Horatii, or to exemplars like Socrates; for even though Socrates is more closely identified with pederastic thought or action than Achilles or Alcibiades, his "masculine" rationality is rarely in doubt.

Still, the whole matter warrants more exploration than it tends to receive. For example, feminized masculinity and "homosexualized" masculinity (either pederastic or homoerotic) were pictorially distinguished, even though they could be cross-mapped for specific rhetorical purposes. The specifically *pederastic* male body can be indicated pictorially in the combination of Chiron's or Socrates' overly domineering action (simultaneously lewd and pedantic), unattractive visage, and powerful physique, with an exaggeration of those parts metonymically denoting his sexuality (his bald pate, his hairiness). All of these properties, of course, can be ennobled in portrayals—including several images of Socrates—that imagine the pederast's successful idealization of what is otherwise conceived of as a pointless, even slightly pathetic sexuality precisely because it embodies neither the generativity of fatherhood nor the homoeroticism of male peers. Thus, in Régnault's painting, a hint of foolishness registers in the otherwise dignified mien of Socrates admonishing the errant Alcibiades: The youth's newly grown beard, manly (if underexercised) physique, and impatient response to the old man clearly indicate that he has outgrown the pederastic interest of his teacher and suitor, despite (or even because of) the fact that it is cloaked in rational argument.

Likewise, throughout Davidian classicism and early neoclassicism,

a specifically *homoerotic* revision of the conventional classical stereo-type of masculinity is not the same as the feminizing revisions. Homo-eroticism can be extended into domains that actually contrast with the feminine—such as the image of a powerfully built man who can be simultaneously a father, husband, friend, suitor, and male lover, and, occasionally, a pederastic lover. The usual model here, of course, was not Socrates but the greatest of the gods, Zeus, a great hero, Hercules, or a famous ancient leader (the Republican elders or Hadrian were obviously preferred to the Julio-Claudian emperors). David himself had recog-nized as much as early as 1779, in depicting Achilles as a magnificent, brooding lord in the *Funeral of Patroclus*, a painting he much disliked. In the later *Leonidas at Thermopylae*, finished in 1814, he composed many hypermasculine male bodies in homoerotically sensual groups. The viewer is to understand Leonidas, in David's vision of him, as a moral and intellectual Socrates—one willing to sacrifice his body and accept death unflinchingly—without the pederasty, and, at the same time, as a Brutus or other stoic hero, with homoeroticism added. In both senses, Leonidas could not be further away from the feminine passivity of an Endymion or the decadent masculinity of an Alcibiades.

In yet another relation within the topography of masculinity, the homoerotic male—such as an adult Achilles or a Leonidas—is never imagined as a sodomite, at least within the representation of homoeroti-cism in decorous, widely public discourse. In his fine study of sexual iconography in eighteenth-century French art, Allain Guillerm goes so far as to suggest that "masculine inversion" was actually a "strictly taboo subject."[39] Considering, however, that a flourishing subculture built around male-male sexual relations imagined and identified itself in many ways, one is not surprised to find that inter-male sodomitical relations could be depicted in quasi-pornographic images produced for specialized circulation or covert viewing.[40] For example, in one of the two separate editions of Sade's *Justine* published by Girouard in Paris in 1791, certain copies—evidently they were made to interest a well-defined readership—contain illustrations of baroque sodomitical orgies populated by a large, almost entirely male cast of characters. The images take their cues from Pollaiuolo and other Italian models to depict the sodomitical libertine's taut, athletic body. They often show him to have long, tousled hair escaping its high-class coiffure or bewigging, indicat-ing not so much femininity as licentiousness, and a very large, proudly erect penis. He is as distant, then, from the softness and androgyny or near-sexlessness of "feminized" heroes like the young Achilles or

Endymion as he is from the ugliness of the pederast or the reserve and decorousness of the homoerotic hero. Most important, the sodomite can engage in the fellatio of another male, a sex act that is not even figuratively denoted in the other images we have examined and was widely regarded by general society as disgusting.[41]

In the context of the different conventions I have briefly noted, the highly particular superimposition of homoeroticism and femininity in the male body apparently did not fully occur until the first two decades of the nineteenth century, in works such as Broc's 1801 *Death of Hyacinth*, noted earlier. Combined with a growing tendency to conceive of nonreproductive sexuality as unnatural, this new image of one species of masculinity was to have a profound effect on the later nineteenth-century stereotype of the essence of homosexuality as degenerate effeminacy. In this respect, France appears to have lagged somewhat behind England, where by 1750 the masculine sodomitical libertinage of the "rakes," who would have active anal intercourse with youths, had already been reimagined as the homosexually sodomitical effeminacy of the "mollies," who would happily indulge passive oral intercourse with both boys and men. In the 1780s in France, the "conception of male homosexuals as sexually passive and effeminate individuals" was "relatively new."[42] If the evidence of contemporary pictorial art is any guide, the process of rewriting the eighteenth-century topography of gender was not completed until the first decades of the nineteenth century. Girodet's own drawings of Virgil's story of the Trojan lovers Nisus and Euryalus, made sometime between 1811 and the painter's death in 1824, belong to a stage in this final development. Although Virgil clearly identified Nisus as lover and Euryalus as beloved, in these stiff and uncomfortable works Girodet—playing down the suggestion of pederastic or sodomitical affiliation but nonetheless replicating Italian drawing as much as Greek sculpture—represents them as almost identical in age, physique, and facial appearance and idealizes their homoerotic bond. The two lovers' reason for dying for one another does not derive from political principle and does not display stoic heroism in the public cause (Virgil devotes much of the text to their raging blood-frenzy). Because they die for love, their motives, and thus their bodies, are "feminine." Girodet thus manages to conjoin the feminity of Endymion—and the hint of a pederastic or sodomitical sensuality—with the homoeroticism of masculine heroes like Achilles or Leonidas.[43]

What principally disappears in the long-term process of "homosexualizing" the male body, I think, is any claim it might have to undertake

public action on the basis of rational principle—a status that had even been attributed, in some republican or revolutionary contexts, to the female body.[44] The *philosophes*, writes D. A. Coward, "were inclined to judge the homosexual as a man who denied his civic responsibilities."[45] Even the most radically materialist or libertarian Enlightenment writers on male-male eroticism tended to see it as a distraction from politics. The revolutionary writer Anacharsis Cloots, for example, posed what, for him, was a rhetorical question that could only be answered rationally in the affirmative: "Because Achilles loved Patroclus; Orestes, Pylades; Aristogiton, Harmodius; Socrates, Alcibiades, and so on, were they the less useful to their country?" Nonetheless, speaking for himself, he still insisted that "the Revolution takes up all my leisure time, and we need all our vital spirits for such a beautiful cause."[46] For me, the interest of Girodet's *Endymion* lies precisely in the way it does not decide this point quite so decisively and, indeed, so dangerously. The image explores, without resolving, the tension between public action on the basis of rational principle and the mortality of a beautiful man, a tension forced into an absolute dichotomy by others—from the Davidian radicals to the late nineteenth-century criminologists and psychiatrists who insisted, we might say, that a public man need not be interested in his beauty and a beautiful man could not be interested in the public.[47] Works like the *Leonidas at Thermopylae* and *Nisus and Euryalus* were built upon the revision effected by the *Endymion* itself, even if they only worked, as I have noted, partly against it. The *Endymion* acknowledged that it was possible to renounce the Davidian "pre-revolutionary" image of active masculinity—or, more exactly, to renounce its supposed incompatibility with male beauty, sensuality, and homoeroticism.

Socrates and Endymion

Although the *Endymion* narrates a story about sex, like the myth, it concerns itself much more broadly with the entire bodily and mental integrity and focus of Endymion. In this context, the appropriate counterpoint to the *Endymion* is not only Drouais' classicizing *Dying Athlete* of 1786 (Crow, fig. 9). It must also be David's *Death of Socrates*, painted in 1787. Girodet knew this painting extremely well: He had worked under David's supervision on some of the figures of Socrates' friends.[48] Here Girodet's engagement with a predecessor was not merely formal. Before and during the Revolution, "the image of a 'Socratic'

death," Outram writes, "was in widespread use." Some revolutionaries self-consciously imitated Socrates' stoicism—his self-controlled elaboration of philosophical arguments—in the face of danger and death.[49] In David's painting, the condemned Socrates grasps the cup of hemlock and prepares to drink it down. He pauses in his action, however, to complete his philosophical interrogation: He raises one hand to make a crucial point, perhaps the denouement of the elenchus. Whereas some of his friends attend to his words with a stoic but mournful reserve, others grieve openly with unreserved passion, like the female members of Brutus' family in David's later painting. But for Socrates himself, the hemlock is to be neither hated nor feared. Indeed, it might be welcomed, for the philosopher tries to convince his friends that, although his mortal body will perish, his soul will not. After the death of his body, it will remain intact, ageless, and deathless; it subsists forever in an endless cycle of "living," "dying," and being reborn.

In the story of Socrates' last days as narrated by Plato, the relation between reason and unreason—and their seating in a body—does not reduce to a simple dichotomy between the true philosopher's knowledge and self-control and other people's ignorance and fearfulness, although a crude contrast of this kind did provide David, in the *Brutus* and elsewhere, with a lucid formal order for a narrative painting. Socrates actually claims to have no secure knowledge, a fact that decisively distinguishes him from Protagoras and the other sophists. Instead, he is supposedly led, as if helpless, by the elenchus (its reasons are ostensibly not identified with his own self). The elenchus enables him to overturn the formerly secure reasoning of his interlocutors about the subjects *they* discourse on so confidently—until the Socratic elenchus gradually unreasons them (see especially *Meno*, 80A–B). The impersonal, impartial elenchus wedges apart the bodily genuineness of ordinary people's reasons—their fear, hate, love, and grief—and apparently shows them to be groundless. Only the body of Socrates, it seems, can tolerate the elenchus—and only to the extent that the elenchus establishes certain conclusions "for themselves," as rational conclusions independent of Socrates' bodily reasons.

David's text for the scene of the death of Socrates, the *Phaedo*, relates the "end of our friend[Socrates]—the best man of his time" (118A). In this text, deathless Endymion sleeping forever is Socrates' carefully chosen metaphor (72B–E) for just the condition of endless blankness after bodily death that a rational philosopher cannot accept as a logical possibility. As Socrates argues, if everything were continually to

die without some ongoing "compensation," then "eventually everything would put Endymion in the shade—in fact, he would be nowhere—because *everything* else would do the same as he did, namely, *sleep*." That is to say, if all things took the path of Endymion, then everything would be dead and nothing would be alive. Because this state of affairs is unimaginable, the rational conclusion must be that "there is such a thing as coming to life again; the living are born from the dead; and the souls of the dead have a real existence." [50] In turn, from the point of view of a public man (the adult male citizen), bodily death—the death of his loved ones, as in the story of Brutus, or his own death—can only be regarded as a possible and acceptable price for his public effectivity in pursuing rational ends. It should be approached with calm or even "Stoic heroism." It was even to be sought out deliberately to the extent that "death was practically the only guarantee for the men and women of the French Revolution of [achieving] heroic status"; [51] or so an ideology of the relation between masculine identity, moral virtue, rational clarity, public effectivity, and bodily integrity would have it—an ideology that apparently found its appropriate image in the life and death of Socrates and the salient counterpart, I suggest, in sleeping Endymion.

Rationality, Revolution, and Renunciation

It will not be easy to put together the somewhat disparate observations I have made so far in exploring various dimensions of the rhetorical and "political" fields within which Girodet's *Endymion* might have made sense to the artist and his contemporaries. We cannot expect absolute consistency if we hope to be alive to the way a painting may speak in crosscutting ways; and it would seem that the painting is just as complex, and perhaps as contradictory, as initially suspected. But at this point a possible synthesis of sorts can be sketched.

The Socratic body-in-elenchus—especially the Socratic "death" toward which it tends—is, I believe, the target of Girodet's interrogation in *The Sleep of Endymion*. Perhaps we could even imagine that Girodet's painting continued the dialogue that David and his students, Girodet among them, might have had in 1787 while deciding how to represent Socrates and his students. Their considerations probably ranged both over possible philosophical or textual approaches and over more specifically pictorial questions. For the latter, it is obvious, I think, that, to compose the figure of the sleeper, Girodet drew on the reclining figure

of the so-called *Sleeping Faun* that he probably saw in the Palazzo Bar-
berini in Rome during his student days at the French Academy.[52] Despite
the great fame of the *Faun*, David himself apparently never used it as a
formal source for his major history paintings. The gestures of Socrates
in *The Death of Socrates* and of the men in *The Oath of the Horatii*
can be seen as loose variations on the Roman gesture of *adlocutio*, the
gesture of public address or, more broadly, of projecting oneself into
historically significant action. *Adlocutio* assumes a wakeful, watchful,
reasoning intelligence. By absolute contrast, the Faun's gesture—arm
thrown back behind the reclining head—embodies *athymia*, an "altered
state of consciousness." [53] He has taken himself out of worldly action and
history. I cannot say whether David and Girodet were fully alert to the
subtleties of gestural meaning in classical sculpture, but it is probable
that Girodet specifically selected the gesture of *athymia* for his Endy-
mion; not all classical renditions of the story that were probably known
to him included it.[54] Whether rooted in the classical pictorial tradition
or not, the differences between David and Girodet do seem to derive
in part from a difference carefully observed and stated within classical
philosophy.

Their acceptance of a "Socratic" death represents the logical end point
of the mortal, political attitudes and actions of the various heroes de-
picted in Davidian "pre-revolutionary" history paintings—Socrates, the
Horatii, Brutus, and Marius. In life, these characters are supposedly men
of complete mental self-possession and potent public effectivity precisely
because they accept the possibility of sacrificing the body for reason(s).
As such, they are the historical, mythological, and fictional images, the
"ideal egos," of the real historical actors who depict them—namely, the
artists who are, in Crow's account of them, autonomous agents striv-
ing for a public presence and effectivity, maneuvering through failures
and successes, and rationally making "moves in a game" animated by
professional assessment and "political" principle.

It is therefore something of a puzzle that one of these professional
practitioners, the twenty-four-year-old, aspiring painter Girodet, re-
nounced this image. In *The Sleep of Endymion*, the young hunter, for-
merly hero and king of Elis, does not occupy the masculine public role.
Instead, this position is taken up, in a highly ambiguous and diffuse fash-
ion, by the moon (simultaneously absent goddess and pursuing lover)
and by the amoral, scheming Eros. The beautiful young man himself
exists in a state of complete suspension. He is no longer capable of judg-
ing, deciding, or acting. Endymion, then, is not only the *formal reverse*

of Drouais' dying athlete; he is also the *logical condition for*—because he is the final horizon of—Socrates', Brutus', or Marius' stoic heroism. They must be what they are because an endless Endymionic sleep of body and mind toward which everything might be tending is unthinkable—unthinkable, that is, for the rational public action and dignified acceptance of death that Socrates' "cyclical argument" is intended to underwrite. But in Girodet's image of it, Endymionic sleep is neither unthinkable nor unacceptable. Instead, Girodet narrates its specific historicity and eroticism for a beautiful youth precisely as a possible— a palpable and visible—condition for his body. This condition merely implies the end of a certain kind of "masculinity," phallic desire, and public action, an end to being in male public history as such. This space of public identity and action, of course, was not merely a feature of some given "level of the political" assumed by the modern historian. Rather than being an ahistorically real or transcendentally actual space of social action and interaction, it was being invented—and challenged—at the very time David and Girodet produced their imaginations and counterimaginations of it. Indeed, the Davidian ideology imagines a "level" of politics—a space into which men can project themselves, dispute policy, and transform the world—whereas Girodet imagines another time and place for masculine desire, located on the "other side" of or as a reserve within the Davidian level. This deferral of (and alternative within) action, "history," masculinity, and the "political"—this so-called "timelessness"—does not obliterate but rather guarantees the endless beauty and desirability of the male body, which remains intact, and indeed unchanging, as a body open to both feminine and masculine regard and possibly even to its own sensual pleasures and sexual dreams.

Girodet may have depicted Endymionic sleep as a "move in a game" that had earlier included David's depiction of Socratic death. Girodet's pictorial reference to the argument underlying David's *Death of Socrates* must be seen, I think, as an allusion meant to be publicly palpable to David and the Davidians and probably to any viewers who knew the literature of rationalism and republicanism. (I say this even though, as far as I can tell, no art historian of the period has noted the connection between Girodet and David through Endymion and Socrates.) Whereas David's image of Socratic death is fully consistent with an ideology for the real public action of political painting by which the image itself was ostensibly produced by a political painter, Girodet's painting of Endymionic sleep raises a doubt about the way in which the image

could be determined by the public, political commitment or action of its maker. Either the image is inconsistent with the politics of its maker—his "opposition to despotic authority" in "the cause of Revolutionary social transformation"—or it questions that politics, not necessarily in order to reverse or refute it but rather to maintain the possibility of renouncing it under certain imaginable conditions.

Paradoxically, one of these conditions would be the moment at which the public professional struggle—the politics and economy of style Crow so compellingly documents—takes possession of the "helpless" body of the painter. In its very unreasoning frenzy to imitate, to surpass, and to circumvent his teachers and peers, it "humiliates" his dignity as a reasoning moral agent. At this point, the painter's own politics of autonomous self-possession and effective public presence, of "opposition to despotic authority," must require *resistance to itself*; and so, *The Sleep of Endymion* is created. Although it may well have emerged in opposition to the authority of the school as a structural reversal of an *académie* by Drouais, it proceeded by visualizing what is unthinkable in the ideology animating that *académie*, to renounce *itself* as an *académie*. Thereby it confronts the school of David with a problem: By all "political reason," a painting like the *Endymion* should not exist, but it is nonetheless the very consequence of the school's own most political and public mode of effectivity. It is no surprise—if not quite Crow's "noncontradiction"— that Girodet should have gone on to help paint the Republican arms or that he should have occasionally displayed the finished painting along with explicitly revolutionary images. At the time, *The Sleep of Endymion* was generated not as the gap between revolution and reaction, between two different politics, as traditional commentary must have it, and not only as the gap between one resolution and a reaction to it within the self-same politics of revolution, as Crow's account has it, but also as the gap within the self-same politics itself—the self-renunciatory possibility that sustains revolution ostensibly based on reason, and any reaction to it, as rational.

NOTES

1. For the alleged "decay" of Girodet and other neo-Davidians, see, for example, Hugh Honour, *Neoclassicism* (Harmondsworth, 1968), 186; and Lorenz

Eitner, *An Outline of Nineteenth Century European Painting* (New York, 1987), 1:32–33.

2. Charles Baudelaire, *The Mirror of Art*, trans. Jonathan Mayne (1855), reprinted in Lorenz Eitner, ed., *Neoclassicism and Romanticism 1750–1850* (Englewood Cliffs, N.J., 1970), 141.

3. Crow, this volume. For Crow's concept of "pre-revolutionary" classicism, see his "The 'Oath of the Horatii' in 1785," *Art History* 1 (1978): 424–71. As my essay is partly a reflection on Crow's interpretation, it should be read in conjunction with it. My comments are based on the paper Crow presented at the Summer Institute on Theory and Interpretation in the Visual Arts at the University of Rochester in 1989. Another version of Crow's essay appears as "Revolutionary Activism and the Cult of Male Beauty in the Studio of David," in Bernadette Fort, ed., *Fictions of the French Revolution* (Evanston, Ill., 1991), 55–83. For advice and comments, I am grateful to Norman Bryson, Hollis Clayson, Bernadette Fort, Keith Moxey, Julia Sagraves, Mary Sheriff, Abigail Solomon-Godeau, and Lisa Tickner.

4. George Levitine, *Girodet-Trioson: An Iconographical Study* (Ph.D. diss., Harvard University, 1952; rev. ed., New York, 1978), 132–33.

5. Girodet exhibited the painting in many Salons (Levitine, *Girodet-Trioson*, 118); in 1798, he showed his *Jeune enfant regardant des figures dans un livre* as well as the *Portrait of Belley* (see Helen Toussaint, et al., *French Painting: The Revolutionary Decades 1760–1830* [Sydney/Melbourne, 1980], no. 59 and pl. 9; Jean-Francois Heim, Claire Béraud, and Philippe Heim, *Les salons de peinture de la révolution française 1789–1799* [Paris, 1989], 226).

6. For Girodet's religious paintings preceding the *Endymion*, see Levitine, *Girodet-Trioson*, chap. 3.

7. See *French Painting, 1774–1830: The Age of Revolution* (Detroit, 1975), no. 150; Heim, Béraud, and Heim, *Les salons de peinture*, 320.

8. Dorinda Outram, *The Body and the French Revolution: Sex, Class and Political Culture* (New Haven, 1989), 87.

9. Levitine, *Girodet-Trioson*, 100.

10. Outram, *The Body and the French Revolution*, 88.

11. Thomas Crow, review of P. Bordes, R. Paulson, and N. Bryson, *Art Bulletin* 68 (1986): 502.

12. Crow, "The 'Oath of the Horatii,'" 461.

13. See further Whitney Davis, "Sigmund Freud's Drawing of the Dream of the Wolves," *Oxford Art Journal* 15 (1992): 70–87.

14. To Crow's horizontal analysis of David's politics, one might compare Richard Wollheim's vertical analysis of Ingres' desire (*Painting as an Art* [Princeton, 1987], chap. 5). The two perspectives need to be judiciously integrated to produce realistic history. Unfortunately, recent art history has artificially polarized them—there are both contemporary institutional "politics" and deep art-historical desires at work here—to force a false choice within art histori-

cal practice. The genuine philosophical dispute that might be in question here has hardly been addressed. While the horizontal analysis, for example, seems to assume a Marxian or Sartrean subject who could effectively erase a lifetime of compromise in a single act of revolutionary redemption, projecting himself from the present into a future, the vertical analysis assumes a Freudian subject who cannot escape—although he might forget—his past (for the comparison, see Sebastian Gardner, "Psychoanalysis and the Story of Time," in David Wood, ed., *Writing the Future* [New York, 1990], 81–97).

15. Levitine, *Girodet-Trioson*, fig. 12. For an interesting discussion of a Hyacinth (in a *Death of Hyacinth*) by Jean Broc, painted in 1801 (*French Painting, 1774–1830*, no. 16), see George Levitine, *The Dawn of Bohemianism: The Barbu Rebellion and Primitivism in Neoclassical France* (University Park, Pa., 1978), 116–17. Broc's figure of Hyacinth could easily have been generated oppositionally from David's or Drouais' classicism, following almost exactly the same "structural" principles identified by Crow for Girodet's figure of Endymion. Although I cannot accept Levitine's reduction of the "symptomatic" properties of this work to the question of "any sexual proclivities" on the part of its painter, viewers have often noted and even idealized the apparent homosexuality of the image, "an example, unequaled in the painting of the world, of the celebration of homosexual union" (Dominique Fernandez, *Le rapt de Ganymède* [Paris, 1989], 164). The young god of the breeze, Zephyr, slew Hyacinth in rivalry for Apollo's love; he was portrayed in an extraordinary painting by Pierre-Paul Prud'hon, shown in the Salon of 1814 (*French Painting, 1774–1830*, no. 143). Prud'hon's boyish Zephyr is, I think, a replication belonging to the same rhetorical field as the figure of Eros in Girodet's *Endymion*.

16. Levitine, *Girodet-Trioson*, 104–105, 121–22.

17. The most important sources for the story of Endymion are Pausanias (V.1.3) and Apollodoros' *Library* (I.7.5). Lucian's imagination of the story, which focused on the predicament of Selene (*Dialogues of the Gods*, Book 11; see H. W. Fowler and F. G. Fowler, trans., *Works of Lucian of Samosata* [Oxford, 1905], 1:69–70), is central to Girodet's formal arrangements in the painting. Girodet's various comments on the subject matter of his work are collected by Levitine, *Girodet-Trioson*, 121–22.

18. Heim, Béraud, and Heim, *Les salons de peinture*, 49.

19. L'Abbé de Favre, *Quatres heures de la toilette des dames* (Paris, 1779), 21, quoted by Philip Stewart, *Engraven Desire: Eros, Image and Text in the French Eighteenth Century* (Durham, N.C., 1992), 143.

20. Stewart, *Engraven Desire*, 144 and fig. 5.7.

21. Ibid., 181.

22. Ibid., 182, fig. 6.6. The text was an expanded version of *Zélis au bain* (Geneva, 1763).

23. Alexandre de Masson de Pezay, *La nouvelle Zélis au bain* (Geneva, 1768), 28, quoted by Stewart, *Engraven Desire*, 182.

24. P. A. Coupin, ed., *Oeuvres posthumes de Girodet-Trioson* (Paris, 1829), 2:340; see Levitine, *Girodet-Trioson*, 122–23.

25. Kenneth Dover, *Greek Homosexuality* (Cambridge, Mass., 1977), 172.

26. On the intellectual, ethical, and political ideals supposedly to be observed or embodied by the lover and his beloved, see John J. Winkler, "Laying Down the Law: The Oversight of Men's Sexual Behavior in Classical Athens," *The Constraints of Desire: The Anthropology of Sex and Gender in Ancient Greece* (New York, 1989), 45–70; and David M. Halperin, *One Hundred Years of Homosexuality and Other Essays on Greek Love* (New York, 1990), 29–38.

27. Hans Mayer, "Winckelmann's Death and the Discovery of a Double Life," in *Outsiders: A Study in Life and Letters*, trans. Denis M. Sweet (Cambridge, Mass., 1982), 167–74.

28. Levitine, *Girodet-Trioson*, 118.

29. Coupin, ed., *Oeuvres posthumes*, 2:339. In a drawing made toward the very end of his life (one might see it as a retrospective confirmation of his own revised view of the painting), Girodet did take up the theme of Diana and Endymion (P. A. Coupin, ed., *Les amours des dieux: récueil des compositions dessinées par Girodet* [Paris, 1826], no. 6; see Jacqueline Boutet-Loyer, *Girodet: dessins du Musée [Girodet]* [Montargis, 1983], no. 87 [bottom right]). Here he closely followed the models of the classical sarcophagi depicting the theme (see n. 54); usually Eros leads Diana by the hand to the sleeping Endymion. But at one time he had been insisting that the painting was not a "Diana and Endymion" at all, a fact that he deliberately underscored in the unusual title—*Endymion, effet de lune*—for the Salon of 1793 (see further, Levitine, *Girodet-Trioson*, 123).

30. Stewart, *Engraven Desire*, 194–95, fig. 6.13.

31. I quote Jean H. Hagstrum, *Sex and Sensibility: Ideal and Erotic Love from Milton to Mozart* (Chicago, 1980), 284. I cannot say whether Girodet knew the work.

32. Ewa Lajer-Burchart, review of P. Bordes and R. Michel, *Art in America* (October 1989): 39; Lajer-Burchart specifically designates the *Endymion*.

33. Martin Aske, *Keats and Hellenism* (Cambridge, 1985), 73.

34. *Le rapt de Ganymède*, 161.

35. *Le rapt de Ganymède*, 160; for the painting, see Heim, Béraud, and Heim, *Les salons de peinture*, 320; and Lawrence Gowing, *Paintings in the Louvre* (New York, 1987), 650.

36. A useful overview can be found in Randolph Trumbach, "Sodomitical Subcultures, Sodomitical Roles, and the Gender Revolution of the Eighteenth Century," in Robert P. Maccubbin, ed., *Unauthorized Sexual Behavior during the Enlightenment, Eighteenth Century Life* (special issue) 9 (1985):109–21. In eighteenth-century France, sodomy between adult males was frequently tolerated, but pederasty tended to be vilified and prosecuted; in either case, however, the laws were unevenly applied to men of different social status and family or political connections (see Michel Rey, "Police et sodomie à Paris au XVIIIe siècle: du péché au désordre," *Revue d'histoire moderne et contempo-*

raire 29 [1982]: 113–24; and Jeffrey Merrick, "Sexual Politics and Public Order in Late Eighteenth-Century France: The *Mémoires sécrets* and the *Correspondance sécrete*," *Journal of the History of Sexuality* 1 [1990]: 71–75). Several sodomitical nightclubs (or "sociétés d'amour") could be found (see D. A. Coward, "Attitudes to Homosexuality in Eighteenth-century France," *Journal of European Studies* 10 [1980]: 239); more specialized associations of male sodomites and libertines developed their own elaborate codes and rituals (see Michel Rey, "Parisian Homosexuals Create a Lifestyle, 1700–1750: The Police Archives," in Maccubbin, ed., *Unauthorized Sexual Behavior*, 179–91; Claude Courouve, *Les assemblées de la manchette: Documents sur l'amour masculin au XVIIIe siècle* [Paris, 1987]; Jean-Luc Quoy-Bodin, "Autour de deux sociétés sécretes libertines sous Louis XV: l'Ordre de la Felicité et l'Ordre Hermaphrodite," *Revue Historique* 110 [1986]: 57–66). Those outside the subculture expressed many different opinions about it. Whereas Voltaire regarded male love as a "disgusting abomination," Diderot allowed that male-to-male sexual attractions could not be against nature because they actually occurred (see Michel Delon, "The Priest, the Philosophes, and Homosexuality in Enlightenment France," in Maccubbin, ed., *Unauthorized Sexual Behavior*, 122–31).

37. See Coward, "Attitudes to Homosexuality," 235, 238, 243; Rey, "Parisian Homosexuals," 180. Surveillance, arrests, and some public prosecutions failed to end these practices.

38. Coward, "Attitudes to Homosexuality," 238. Harsh punishment was meted out against "pederasts" who failed to be discreet—like the defrocked monk Jacques-François Pascal, publicly executed in 1783 for violence against a boy who resisted him (Merrick, "Sexual Politics and Public Order," 72).

39. Allain Guillerm, "Le système de l'iconographie galante," *Dix-huitième siècle* 12 (1980): 186.

40. Unfortunately, to my knowledge the material has not been systematically explored in terms of the issues considered in this essay; for orientation, see L. von Brunn and G. Jacobsen, eds., *Ars Erotica: Die erotische Buchillustrationen im Frankreich des 18. Jh.*, 3 vols. (Dortmund, 1983).

41. These copies are difficult to obtain; I am grateful to the Special Collections Department of Northwestern University Library for assistance in my research. Stewart, *Engraven Desire*, fig. 8.58, reproduces an "anonymous illustration of 1797" for Sade's *Juliette* along the same lines. We should not, of course, suppose that Sade's interests—or those of the readers who acquired these copies—were typical. "Sade pushed his vision to an extreme, and the characters who receive such names as Cupidon, Narcisse, Adonis, Hercule, and Antinoüs usually merit them not because of a beautifully proportioned neck or trunk but because of perfectly, if outrageously, proportioned genitals" (Jacob Stockinger, "Homosexuality and the French Enlightenment," in George Stambolian and E. Marks, eds., *Homosexualities and French Literature: Cultural Contexts/Critical Texts* [Ithaca, N.Y., 1978], 179). In his painstaking examination of the "homosexual" subculture of eighteenth-century Paris, Rey ("Parisian

Homosexuals," 185) concluded that fellatio between men was seen as "depraved or very wanton, in any case extreme"—an act that could easily lead to pursuit, reprisals, and prosecution.

42. Merrick, "Sexual Politics and Public Order," 71. For Britain, see especially Randolph Trumbach, "The Birth of the Queen: Sodomy and the Emergence of Gender Equality in Modern Culture, 1600–1750," in Martin Duberman, Martha Vicinus, and George Chauncey, Jr., eds., *Hidden from History: Reclaiming the Gay and Lesbian Past* (New York, 1989), 129–48; Richard Davenport-Hines, *Sex, Death and Punishment: Attitudes toward Sex and Sexuality in Britain since the Renaissance* (London, 1990), 55–104.

43. For the drawings, see Boutet-Loyer, *Girodet*, nos. 79–81. The same tendencies appear in Girodet's drawings for Bion's *Bucolica*, especially in *Apollo and Hyacinth* (Fernandez, *Le rapt de Ganymède*, pl. 9), and seem to have been general ones in the 1820s. Claude-Marie Dubufe's *Apollo and Cyparissus*, for example, shown in the Salon of 1822 (*French Painting, 1774–1830*, no. 53), revises what is represented in one version of the story as the tragic outcome of Apollo's pederastic lust (Cyparissus is turned into a stag while fleeing the god's attentions) by combining it with another version (the sensitive—thus feminized—Cyparissus mourns the accidental death of a pet stag). As Delon puts it, "the scandal of homosexual mating is extenuated by the growing effeminacy of male forms" ("Homosexuality in Enlightenment France," 129). It is worth noting, however, that these works were not, of course, entirely novel inventions of the late eighteenth and early nineteenth century; they could draw on a well-established pictorial tradition in which any species of male erotic irrationality—not necessarily conceived of as specifically pederastic or homoerotic—resides in a feminized or androgynous body. In 1765, for example, Diderot remarked on the "kinds of hermaphrodites" in Fragonard's great *Coresus and Callirhoe*—especially the "undetermined sex" of the high priest, who slays himself rather than sacrifice the woman he loves (Roger Lewinter, ed., *Oeuvres complètes*, 15 vols. [Paris, 1969–1974], 6:198; see further, Mary Sheriff, *Fragonard: Art and Eroticism* [Chicago, 1990], 43).

44. See Darline Gay Levy and Harriet B. Applewhite, *Women in Revolutionary Paris, 1789–1795* (Urbana, Ill., 1980); Dominique Godineau, *Citoyennes tricoteuses: les femmes du peuple à Paris pendant la Révolution française* (Paris, 1988); P. Bordes and R. Michel, eds., *Aux armes et aux arts!: Les arts de la Révolution, 1789–1799* (Paris, 1988). For other parts of Europe, compare Helga Mobius, "Images de femme pour la république," in Dario Gamboni and Georg Germann, eds., *Emblèmes de la liberté: l'image de la république dans l'art du XVIe au XXe siècle* (Bern, 1991), 53–72.

45. Coward, "Attitudes to Homosexuality," 240.

46. Anacharsis Cloots, *Ecrits révolutionnaires, 1790–1794*, ed. Michèle Duval (Paris, 1979), 124–25, quoted by Delon, "Homosexuality in Enlightenment France," 129–30.

47. For the broader context of this deep and insidious modern stereotype of pederastic and homoerotic sexuality, see the superb studies by Victor J. Seidler, *Rediscovering Masculinity: Reason, Language and Sexuality* (London, 1989); and Jonathan Dollimore, *Sexual Dissidence: Augustine to Wilde, Freud to Foucault* (Oxford, 1991).

48. Robert Herbert, *David, Voltaire, "Brutus" and the French Revolution: An Essay in Art and Politics* (London, 1972), 8; for the painting, see *French Painting, 1774–1830*, no. 32. Crow sees Girodet's *Hippocrates Refusing the Gifts of Artaxerxes* (1792) as imitating the David. It is fully consistent with my thesis that *The Death of Socrates* should have been replicated by Girodet in several ways.

49. Outram, *The Body and the French Revolution*, 78, 174 n. 34. See generally R. Trousson, *Socrate devant Voltaire, Diderot, et Rousseau: la conscience en face du mythe* (Paris, 1967).

50. R. S. Bluck, *Plato's Phaedo* (London, 1955), 61–62, 143. What Bluck dubs Socrates' "cyclical argument" is only one of several cases the teacher mounts to establish that bodily death is inconsequential for the philosophical man. See further Ronna Burger, *The Phaedo: A Platonic Labyrinth* (New Haven, 1984), 64–68; and Ann Hartle, *Death and the Disinterested Spectator* (Albany, N.Y., 1986), 11–83.

51. Outram, *The Body and the French Revolution*, 150.

52. For J. J. Whiteley, "Light and Shade in French Neo-Classicism," *Burlington Magazine* (December, 1975), 768–73, the figure of Endymion is the "Barberini Faun viewed by artificial light": He makes the interesting suggestion that modes of lighting ancient sculptures shaped their imitation in neoclassical painting. Light and shade, however, clearly have thematic values as well— for example, in marking distinctions between the sexes. It is not necessary to adopt Whiteley's hypothesis to accept that Girodet had studied the great work, among the most famous in Rome; it had also been copied in marble by French craftsmen in the middle part of the eighteenth century (see Francis Haskell and Nicholas Penny, *Taste and the Antique: The Lure of Classical Sculpture, 1500–1900* [London, 1981], 202–6).

53. Andrew Stewart, *Greek Sculpture: An Exploration* (New Haven, 1990), 1:207.

54. In the surviving classical depictions of Endymion, the hero is depicted with a gesture like that of the *Sleeping Faun* about half of the time. The versions of this kind that might have been seen by Girodet during his studies at the French Academy included two Pompeiian paintings (Lily Kahil et al., eds., *Lexicon Iconographicum Mythologiae Classicae* [*LIMC*], no. 3, pt. 2 [Zurich/ Munich, 1986], nos. 22, 24), four sarcophagus reliefs in Roman collections (*LIMC*, nos. 46, 50, 63, 67), and the only well-preserved sculpture (*LIMC*, no. 94), the last closely parallel to the Barberini Faun and perhaps another very immediate source for Girodet's painting.

The Theater of Revolution: A New Interpretation of Jacques-Louis David's *Tennis Court Oath*

A S artistes manquées, as would-be artists, we art historians feel a strong inclination toward the great unfinished projects. Here we are not only entitled but asked to complete what was left fragmentary. But especially in the case of works that never stood the test of realization, we are tempted to do what we do more often than not to normal works of art: We transfer them to a kind of ideal space, severing their bonds to function, place, and viewer.

In this chapter, I present a new interpretation for a famous fragment, using it to demonstrate the decisiveness of a work's function and place of destination, especially in this case of a bold and failed design.

In the case of David's *Tennis Court Oath*, we find authorization in an argument that David himself put forward some years after he began the painting. He said:

> To be sure, France does not really love the Fine Arts. An affected taste rules. Even if Italy's masterpieces are met in France with great enthusiasm, one regards them in reality as curiosities or treasures. The place a work of art occupies, the distance which you have to overcome in order to see it, these factors contribute in a special way to the work's aesthetic value. In particular the paintings which previously served as church ornament lose much of their attraction and power when they do not remain at the place for which they were made.[1]

I shall give you only a very short summary of the well-known facts about the Tennis Court Oath.[2] On 20 July 1789, the six hundred deputies of the Third Estate met in a tennis court at Versailles, after the king had kept them away from their normal meeting place. There they took an oath to remain in permanent assembly until they had drawn up a constitution for their country: They would "die rather than disperse before France was free." Even the revolutionary events that followed in

rapid succession could not interfere with the primordial importance of this day.

After celebrating the first anniversary on 20 June 1790, deputy Dubois-Crancé entered a threefold motion at the Jacobin club: that the tennis court of Versailles should be preserved as a landmark of national interest, that parliament should assemble there every year and renew the oath, and that "the most energetic brush and the most skillful graving-tool" should "immortalize" the event.[3] The last part of the motion essentially spelled out the fact that Jacques-Louis David was Dubois-Crancé's man.

The first suggested step was to paint a picture of the Tennis Court Oath for the assembly hall of the parliament, a work measuring twenty to thirty feet. This huge painting was then to be reproduced in engravings. The Jacobin club approved this motion, introduced it in parliament, and parliament approved it on 6 November 1790. David went to work. The Salon of 1791, which opened in September, witnessed the first result of his intensive studies: a large, very detailed drawing (fig. 1), which attracted much attention and induced parliament to pass a resolution: "That the painting, which represents the oath at the Tennis Court and was begun by the painter J. L. David, should be executed at public expense, and is to be hung at the location which serves as Parliament's meeting place, in order to remind the lawmakers of the courage, that is necessary for their task."[4] David had received a commission, which was unique in many respects. To begin with, the patron was without precedence. The parliament, the representatives of the people, had taken the initiative, in former times a prerogative of the king or the municipality. The work was to be executed at public expense. It was destined for a building, for a public space, that France never had seen and that was still being planned when David got the commission: the floor of a parliament. Uncommon, even according to feudal standards, was the bold scale of the work, which Dubois-Crancé had estimated at twenty to thirty feet and which was even enlarged by David to twenty-seven to thirty-five feet. To execute a one hundred-square-meter picture not as a wall painting, not as a mosaic, as Dubois had first proposed, but as an easel painting confronted a painter with many technical and artistic problems. Also without precedent was the subject: a revolutionary crowd, six hundred actors figuring in such a large composition. And, finally, a radically new understanding of history painting was at work in choosing an event of the very recent past and enlarging it to monumental scale.

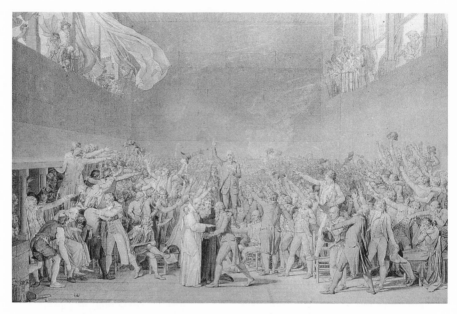

1. David, *Tennis Court Oath*, 1791. Paris, Louvre, Cabinet des Dessins, cour-
tesy Service de Documentation Photographique.

Each of these challenges would have been too great for a painter of
lesser ability. David, however, might have coped with this accumulation
of artistic problems if external difficulties had not interfered. He suc-
ceeded in transferring the outlines of his design to the canvas and real-
izing some of the heads. He then went into politics himself, was elected
deputy, and became the pageant master of the Republic, a sought-after
man. In the same space of time, more and more protagonists of 20 June
1789 had left the political arena, in fact, had left head and life under the
guillotine. Bailly, Mirabeau, Barnave-St. Etienne, Robbespierre—some
of the key figures in the event—either died, were decapitated, or be-
came unpopular in the very years when David was due to complete his
work.[5] Although the bold design remained a fragment, its very success-
ful engravings shaped the sensibilities of both David's contemporaries
and of the following generations. Ultimately, historical event and history
painting became almost identical.

David was neither the first nor the only one to picture this event,
however, and his version perhaps lays the least claim to historical cor-
rectness. A comparison can help clarify its idiosyncrasies. In his engrav-

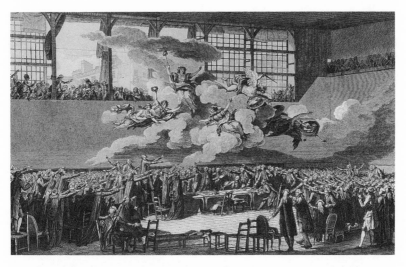

2. Helman after Monnet, *Tennis Court Oath*, 1792–1793, courtesy Bibliothèque Nationale.

ing, Charles Monnet (fig. 2) shows the court from an oblique view; he arranges the deputies in a half circle and locates the central point of interest in the back of the court. There, Bailly, the president of the assembly, pronounces the oath. According to the rules of perspective, the horizon, and with it the viewer's ideal position, is in the center of the cloud.[6] In short, Monnet keeps the event at a distance and allows it to take shape in a relatively unconstrained manner.

 David's final composition is just the opposite of projects of this kind and of Monnet's print. David faces the somewhat cold, sterile construction of the court frontally; he takes a small part of the crowd and arranges it like a frieze, parallel to the picture plane and reaching from one side of the court/of the painting to the other. Behind it, the majority of the deputies appears as a kind of etcetera-formula, as a relatively vague, vibrating mass. The first row is placed close to the viewer, although separated from him by a distinct, small strip of space. Equally near is the only central figure, President Bailly, who stands on a table and stares out of the picture, confronting the viewer directly. Between Bailly's eyes is the point at which the relevant structural lines of the composition meet; it is the crossing-point of the picture's diagonals and the center of both the vertical and horizontal axes. Moreover, this spot marks the vanishing point at which the orthogonals of the image converge. The

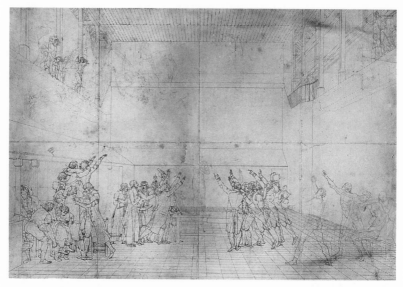

3. David, *Tennis Court Oath*, 1791. Cambridge, courtesy Fogg Art Museum.

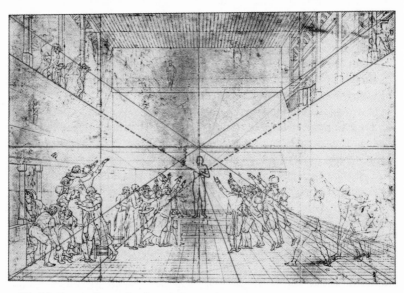

4. David, *Tennis Court Oath* (*vide* fig. 3), diagonals and vanishing point.

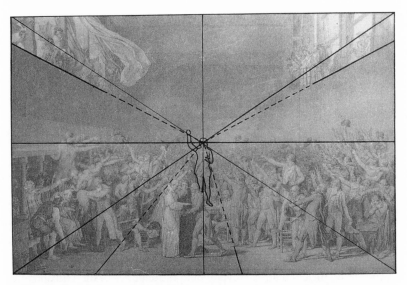

5. David, *Tennis Court Oath* (*vide* fig. 1), diagonals and vanishing point.

viewer is thus there, face to face with Bailly, a little bit above the crowd. More stress couldn't be laid upon this single point; we will have to bear that in mind.

It should be noted here that David, who was not very strong in perspective, is said to have left the geometrical construction of his painting to a specialist, a "perspecteur," in this case probably the architect Charles Moreau. The result of his efforts would then have been the large drawing in the Fogg (fig. 3), which is exactly the same size as the drawing for the Salon.[7] In one respect, the two drawings differ: they have different vanishing points. In the Fogg drawing, the vanishing lines come together where Bailly's hand should be and, in his hand, the paper containing the formula of the oath (fig. 4). In the finished version it is— as we have seen—the point between Bailly's eyes (fig. 5). The difference is a subtle one, but it marks two different conceptions about the central point. The first drawing, the Fogg drawing, is the result of considerations based on the logic of the event. This work concentrates on the symbolic essence of the event, on the document that is holding out the promise of a greater document, the constitution of the bourgeois state. To make the vanishing point coincide with Bailly's eyes would make no sense on this level. Bailly is engaged in taking the oath in many ways:

by having the document, by raising his right arm, by pronouncing the formula—but the look of his eyes matters little in this respect. The transition from the first to the second vanishing point indicates a shift from a conception based on the logic of the event to one that stresses the painting's physical context. The final placement of the vanishing point focuses the composition on the point at which two systems of communication merge: one within the painting and one between the painting and the viewer. This creates a center of exceptionally active radiation, as well as acknowledges the viewer.

Upon consideration, this shift in the central point might only be the logical outcome of prior compositional ideas. One could say that the final placement of the vanishing point is the keystone of a construction that fulfills the needs of an aesthetical reception rather than historical accuracy. The accent on the document would have been only a symbolical compensation for the deficit in the logic of the narrative. After all, the way David pictures the event in both drawings does not meet the claims of historical reality. Never would the deputies of the Third Estate have arranged themselves in this way. They did not stand behind Bailly, and Bailly, when pronouncing the oath, did not turn his back on them. They did not press closely together in one half of the court, in order to leave the other half void. Lacking an authentic depiction of the event, we can assume that all the other versions of the *Tennis Court Oath*— versions that show Bailly in the middle of the crowd, as the center of a, so to speak, natural circle and not as the protagonist of a frieze-like group—get closer to the truth. "He [Bailly] is too far at the front, where only a few stand, while a multitude are behind him; it is not natural that he turns his back on them," as a critic said of the picture in 1791.[8]

To understand David's forced composition we have to deal with problems of its reception. We must ask about its spatial context, the kind of addressees the work was intended for, and how its composition resounded to its external conditions and requirements. The *Tennis Court Oath* is a picture of a provisional parliament, destined for a permanent parliament. The style for a parliament building was not yet realized on the continent before the French Revolution. Even the "Constituante," the parliament that commissioned David, met in a makeshift place; but by the time David started working on his large painting, certain formal and ideological notions concerning the appearance and function of a parliament had arisen. Without knowing the final shape of the new building, David could at least presuppose a basic structure, and, equally

important, he could form an idea of the ideological quality of the space he was to decorate.

Between 1789 and 1793, a broad range of different designs for a parliament was produced, but all of them adhered to the same type of projected floor:

> Nobody came upon the idea to follow the English model with its square ground-plan and its spatial confrontation of the party in power and the opposition, with its placing the president and the speaker at one end of the hall. In every case the floor à la française prevailed, meaning a semicircular or semielliptical ground-plan, which had the king, the president and the speaker in the centre, face to face with the plenum and the public. The model was found, probably stimulated by the latest developments in theater-architecture; the triumph of French parliamentarism resulted in many realizations throughout the world.[9]

Concerning the practical and conceptual affinity of theater and parliament, we have to add that the architectural school of the French theater had found the exchangeable model only right before the Revolution and as a reaction to the same social changes that finally made building a parliament necessary. Think only of Charles Nicolas Ledoux's democratic theater for Besançon, which opened in 1784 and about whose amphitheatrical ground plan its author wrote:

> The halfcircle is the one and only form which allows everything on stage to be seen. It is the task of the artist to establish the frame for his picture in such a way that it obstructs neither the object nor its perception. Morals, combined with political power, will restore the natural ranks. Who pays most, sits at close range; who pays least, sits far away, but by paying the admission all spectators have a claim to sitting comfortably and safely, to having a good, unobstructed view from every angle and to being seen equally well from everywhere (figs. 6, 7).[10]

Ledoux's new approach meant the abolition of two major structural elements of the baroque theater: the parquet and the boxes. He gave to the theater the uniformity and functional structuring that fitted the purposes of a democratic parliament just as well. The basic rights of the theater-goer to a seat and to unobstructed vision and hearing entail the abolition of the boxes: to see well, and to be easily seen, are the two quintessential aspects of Ledoux's program. For overview you have to pay the price of surveillance.

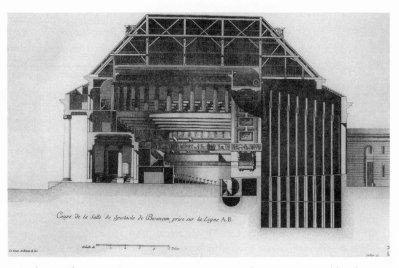

6. Ledoux, *Theatre at Besançon* (section), 1784. Photo courtesy Bildarchiv Foto Marburg.

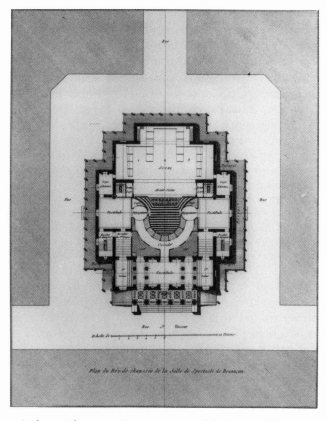

7. Ledoux, *Theatre at Besançon* (groundplan), 1784. Photo courtesy Bildarchiv Foto Marburg.

How close the relations were between the two building types can be seen very clearly from a comparison of Ledoux's theater with the designs for the new parliament, which were published by Jacques Legrand and Jacques Molinos in 1791 (figs. 8, 9). These architects planned to remodel the partly finished church La Madeleine into a "Palais National" in such a manner that the nave could be used as an extended vestibule and the choir (plus transepts) as the amphitheatrical floor. A new building type would never again succeed an old one in such an outspoken manner. "Every place," says the commentary on this project, "where the deputies meet is transformed into a sanctuary. Even that obscure gymnasium, that tennis court, where the National Assembly took upon its oath to live in freedom or to die, . . . instantly became a sacred place and will remain such forever." [11] A "temple" was to be built. But the massive changes that the plans provide for the remodeling of the church are indebted to the model of the theater. The theater designs lent themselves to the transformation of the extant church into the parliament. No doubt Legrand and Molinos worked from a knowledge of Ledoux's building for Besançon. They opted for the pure semicircular ground plan, which was not yet the norm in theater-architecture. Their rationale is Ledoux's: "The representatives of the Nation, arranged on the steps of the amphitheatre, have approximately the same distance from the president of the assembly; their eyes are fixed on him in a very natural way, and from his lectern the speaker can see all his colleagues." [12] Further, Legrand and Molinos refer to the monumental colonnade of the theater of Besançon, with whose help Ledoux made an optical distinction between the gods and the expensive tiers.

But whereas Ledoux uses the space behind the colonnade for more seats, Legrand and Molinos provide seats for the public above the colonnade. And Legrand and Molinos elaborate upon Ledoux's design by substituting the flat ceiling for a half dome, with the result that the floor incorporates three geometrical or stereometrical forms, pure forms according to the philosophy of revolutionary architecture: namely, the half circles of the ground plan and of the upper part of the front wall and the quartersphere of the cupola. But it is not only formalistic purism that dictates the choice of forms; it becomes clear when we read the description of the "voute immense" that they also serve the needs of "architecture parlante," for here the architects wanted to display the flags of France's twenty-four departments to evoke the unity of France, France as a whole. Another symbolic statement was assigned to the half circle of the front wall (fig. 10): Here was to appear the northern

8. Legrand-Molinos, *Plan for a Parliament* (section), 1791. Courtesy Soc. Amis Bibl. Art. Arch.)

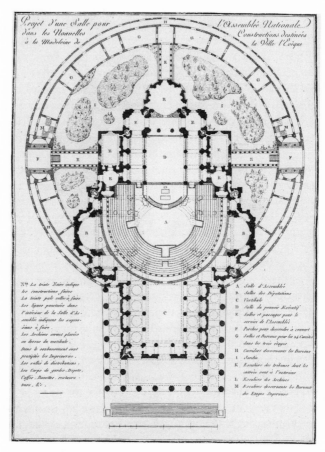

9. Legrand-Molinos, *Plan for a Parliament* (groundplan), 1791. Courtesy Soc. Amis Bibl. Art. Arch.

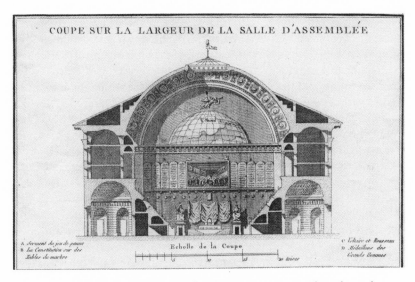

COUPE SUR LA LARGEUR DE LA SALLE D'ASSEMBLÉE

10. Legrand-Molinos, *Plan for a Parliament* (section), 1791. Photo by author.

hemisphere, with France at the center and the genius of liberty above it. What Dubois-Crancé said in his speech in 1790 when he argued for commissioning David with the *Tennis Court Oath* helps us understand this composition. He said: "No sooner had the structure of the French constitution extricated itself from the ruins of old superstitions, than it presented itself to the neighbour-nations in a sublime way. Imitating our example, the whole world [as a matter of fact, he said 'the circle of the world'] will be free."[13] The extension of the visual program to cosmic dimensions has its political sense, but we should not overlook that highest utilization of circular and spheric forms, the analogy with the cosmos itself. Again we are reminded of Ledoux, who placed at the front of his treatise on architecture the image of the planetary system, or of his great rival, Etienne-Louis Boullée, who claimed for himself the introduction of the sphere into architecture and who wrote on behalf of the circular form: "In nature everything is circle: the stone, which falls into a lake, makes numberless circles; centrifugal force expresses itself in circles; the air, the sea circle around endlessly; the satellites revolve around Jupiter and Saturn, and the planets are on their immense orbit."[14]

The circle was provided by nature and is therefore right, good, and beautiful. The circle is the symbol of unity, equality, and infinity; it is practical and proper. For the revolutionary architects all these at-

tributes were interchangeable. On his (never realized) project for a theater, Boullée writes: "I have made the inside of my auditorium in the shape of a semicircle—undoubtedly one of the most beautiful shapes. . . . Moreover this is the only shape suitable for a theater. It is necessary to be able to see and hear perfectly and what shape fulfils these two requirements better than the one whose exactly equal radii give the ear and eye the greatest and most equitably distributed freedom; where no point hides another and where, for this reason, all spectators on the same level can see and hear equally well." [15]

It has escaped the notice of the David scholars that his *Tennis Court Oath* was part of the Legrand and Molinos project. The design of the front wall speaks to where it was to be placed and how its surroundings were planned. The large canvas struggles to stand its ground on the wall, which is forty meters long. It was to be hung in a rather high position— its lower edge on a level with the highest tiers of the deputies. Beneath the canvas were to appear the stands for the president and the speakers, to its sides, marble slabs with the engraved text of the constitution, and above it, the said picture of the northern hemisphere. This design must have been completed after May or September 1791, because it shows in the final version of David's composition. It was submitted at the end of 1791 and published in 1792.

It is hard to tell how much it was the result of a direct cooperation between the painter and the architects. But two facts at least are certain: When David thought about the future location of his painting, he could work on the premise of an amphitheatrical structure of the floor, as it was planned in its purest form by Legrand and Molinos. As a member of the parliamentary committee responsible for the new building, he knew of Legrand's and Molinos' projects. Of all the submitted designs, theirs were the most successful and received the most prominent publication. It may be that David was instrumental in placing his work in, and adjusting to, the parliament to be built. In any case, this design of the floor's front wall represents the one and only interpretation of the *Tennis Court Oath* in its surroundings, so to speak. Neither the painting nor the parliament building according to Molinos' and Legrand's plans were realized. Money and the pressure of time stopped the latter.

The Parliament's decision of September 1792 to remodel for its own purposes not the Madeleine but rather the theater of the Tuileries was a decision supported by David. Behind the change in plans may have stood David's own insight into the impracticability of his painting: for the new structure allowed no place for his huge canvas (fig. 11). He

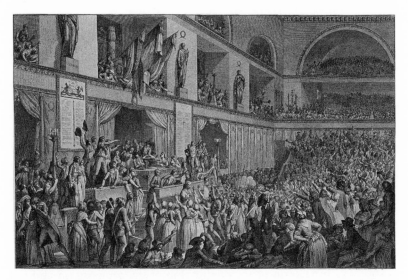

11. Helman after Monnet, I. *Prairial de l'an III*, 1794. Photo courtesy Bibliothèque National, Paris.

was to adorn this place, the wall behind the speaker, with two smaller works: the dead Marat and the dead Lepelletier.[16]

So far we have analyzed the structure of communication within the painting, and we have reconstructed (the structure of) the space it was intended for. We can now relate these two aspects. The model of the theater is appropriate not only for the parliamentary floor but also for the first major commission for picturing a parliament in action. Many writers have mentioned the theatrical effect of David's *Tennis Court Oath*. Here I am interested not in the depicted but in the architecturally defined theatricality.

The plenum of deputies as the auditorium, the general public as the gods, the platform, including the speakers' lectern and the president's seat, as the proscenium, and the *Tennis Court Oath* as decor and stage— these were the elements of the planned parliamentary theater. Putting them together we get a more than functional form; we get an ideologically motivated one that we know well: the circle. When we imagine looking from above on David's arrangement of the crowd, we get a perfect half circle, with Bailly in the center and with the front line as its straight line. This half circle is forced and, according to the logic of the event, unmotivated and asks for completion through the amphitheater

of the floor and the plenum of the deputies. The painted half circle of the provisionary parliament and the real half circle of the true parliament complement each other to form the appeal-structure (*appellstruktur*) of David's composition.

In this case, though, viewers and actors, public and stage, are not brought together by architectural means alone. This interaction of painting and architecture would have been a solution that fits very well into the concept of neoclassical art: close connection between the two sides but protection of their respective autonomy. In this respect, the exposed strip in the foreground speaks a clear language. But David goes one step further to secure the contact between the two halves of the circle. The figure of Bailly, which faces the viewer, which indeed faces all viewers, collects the energy of the crowd, focuses it, and redirects it to the viewer.

This kind of perforation into the closed mechanism of neoclassical painting is not unprecedented in David's work, but what is unprecedented is that a painting of this size comes to one point or head. Through a subtle manipulation of the relationship of the composition and the actant, what is normally the remotest and deepest point in this painting—the vanishing point—has been reversed to form the opposite: Bailly's look, which marks this center, transmits, without intermission, the focused message of the painting into the infinity of his audience like a beacon. The look as the active and activating center, the all-seeing eye, and the "figura cuncta videntis," all point to issues that affect theater and parliament, art and politics, in a similar manner.

First of all, let's look into the most famous eye of the period, provided by an illustration to Ledoux's treatise on architecture (fig. 12). The title, "Symbolic representation of the auditorium through the pupil of an eye," refers to the auditorium of the theater of Besançon, which was opened in 1784 (whereas the book was published only in 1804). Seen "through the pupil of an eye" can be understood, on the one hand, as: We look through the pupil into the eye, into its inner half-circular or, better, concave background, in this case into the amphitheater. The natural disposition of our sight organ is in accordance with the structure of the auditorium: the theater is all eyes. Ledoux devotes a long passage to this thought, parts of which we have already quoted: "Equal sight for all" is his maxim. If we transfer this model to the situation for which David's painting was destined, we get the floor of a parliament that allows equal sight (*rayon égal*) for all the viewers/deputies, as well as equal sight on the stage, that is, on the platform and on the stage set. Such is the case in David's *Tennis Court Oath*. Like the radius of a

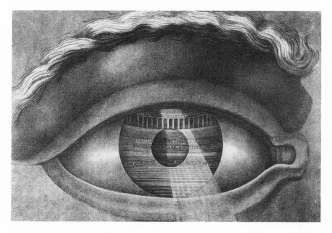

12. Ledoux, *Symbolic representation of the auditorium [of the theatre in Besançon] through the pupil of an eye,* 1804. Photo courtesy Bildarchiv Foto Marburg.

quarter-sphere all the lines of sight were to run up to the center, to the all-captivating eye of Bailly.

If, on the other hand, we understand the symbolic eye as an active organ—and this is the way the words seen "through the pupil of an eye" are normally read—as meaning not into but with the aid of this eye, then we see how the mighty eye receives the image of the auditorium and mirrors it back to us. This eye would have been located where Bailly's eyes are, on the stage, in a rather elevated position and facing the auditorium frontally. A remarkable coincidence between David's and Ledoux's works is that the exact visual center is, in both cases, a rather neutral zone and not a place of specific interest: through the center of Ledoux's pupil runs a relief-frieze; Bailly's line of sight meets the ambulatory and not the deputies or the general public, if we imagine the hanging of the painting according to the plans of Legrand and Molinos. We can fairly safely say that these looks are directed toward nothing special, but see all and everything; and this is the way they are shaped, these staring and totally open eyes. Ledoux's basic law said not only that all should see equally well but also that all should be seen equally well. Our short treatment of theater-architecture has already suggested that this call for a two-way communication had to meet more than just a technical or—so to speak—hygienic demand. How far we stand in

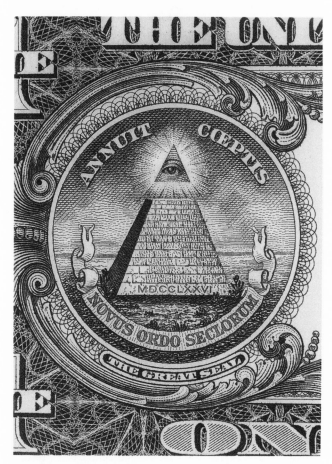

13. *The Great Seal of the United States* (from the one-dollar
bill). Photo courtesy Bildarchiv Foto Marburg.

the arena of politics becomes clear when we consult the eye-symbolism
of the French Revolution.

The basic scheme of David's composition was already prefigured in
the Great Seal of the United States, which everybody can study on the
one-dollar bill (fig. 13) and which dates back to the penultimate de-
cade of the eighteenth century: a pyramid with an eye at its peak.[17] I
have already mentioned that Bailly's eyes mark not only the intersection
of the vanishing lines but also the point where the diagonals intersect.

When we cut up these lines, then, four triangles with eyes at the top result—the formation of a pyramid, as in the seal. Regardless of the many symbolic meanings of the eye and the triangle, we are entitled to state that, in these cases, the social body or basis is finished, or better yet, crowned through an eye. Combined with any form of symbolic light (for example, sunrise, lightning, dissipation of darkness), the eye and the triangle are the most successful emblems of the two great bourgeois revolutions of the eighteenth century and of the Enlightenment in general.[18] It is remarkable that the symbolic triad is completely present in the seal as well as in the *Tennis Court Oath*. David ingeniously exploits the historic circumstances: the lightning and the fierce wind of a thunderstorm about to break provide the proper atmospheric-cosmic accent. We admire the stage manager's skill, for David deflects the lightning and brings its effect down to the scene by using the expressive gestures of people and things.

"Annuit Coeptis," the second inscription on the seal, meaning "He has favored the beginnings," speaks of *Him*, who finds in this combination of triangle, eye, and light his conventional symbolic expression. But in spite of the strong Christian connotations of the symbol, one should not overlook that it competes with strong profane implications: freemasons, atheists, philosophers, people of the Enlightenment used it frequently to designate providence, the light of reason, or, generally, the "Supreme Being" to which most enlightened minds still felt bound. We must suppose, then, that the political symbolism of the French Revolution had to consider carefully Christian, political, and ideological implications when it engaged the "natural sign" of the eye for its own purposes.

The *Constituante*, the parliament that commissioned David's *Tennis Court Oath*, had as the vignette of its resolutions the Bourbonic lilies (fig. 14).[19] We should keep in mind that a vignette is as official as a state seal. The convention, the next parliament, for whose floor the painting was destined and for whom David was a deputy, changed the vignette and replaced the lilies with the eye (fig. 15). The deputies, who did not have to work eye to eye with Bailly, reproduced in every legal publication the all-seeing eye. But even without David's painting and Bailly's eyes, the floor of the new parliament did not remain "blind." The front wall of the remodeled theater of the Tuileries (see fig. 11) displayed two big panels with the text of the human rights statement inscribed on them. The one on the left (fig. 16) had at its top the eye and the triangle, surrounded by an aureole of light. This image goes back to an earlier

14. *Left, Vignette of the Assem-blée Constituante* (until 1791).
Photo by author.

15. *Right, Vignette of the Conve tion Nationale* (until 1795). Pho by author.

16. Lebarbier-Laurent, *The Rights of Man*, Version of 1793.
Photo courtesy Bibliothèque National. Paris.

engraved publication of the human rights statement, which probably followed the political iconography of the American Revolution. The old interpretation has been preserved. According to the preamble of the declaration, which says, "resolved and declared in face of and under the auspices of the Supreme Being," the divine eye shines upon the foundation, the block of human rights, which is flanked by allegories of France and Justice.

Whether the vignette or emblem of the Convention, the single eye, still retains this meaning may be reasonably doubted. After 1789 the symbol was thoroughly reevaluated and indeed intensified; it resurfaced, for example, as the logo of the most radical party in parliament, the Cordeliers (since February 1791; fig. 17), and as the vignette of the Convention's most powerful group, the "Comité de salut public" (fig. 18). Both these cases and many others established the meaning of the eye as a symbol of surveillance. The "public welfare committee" under Robespierre and, before it, the Cordeliers declared the securing of permanent revolution against the inner and outer enemies the highest objective of their politics. The reign of terror, "la terreur," based its power on a close-meshed control and surveillance system: "Activité-Pureté-Surveillance" was the motto of the eye vignette of the "public welfare committee," and a more appropriate device could not be found for the "Great Incorruptible" himself. That David was aware of this shift in meaning and supported it is evident from the decorations that he designed for the "Festival of Unity," 10 August 1793: "Now the pageant proceeds through the boulevards. It is led off by the crowd of the united societies of the people. They carry a banner, on which the stern eye of the law is represented, as it pierces through a thick cloud. The second group is formed by the members of the Convention National; eight of them carry on a handbarrow a chest: it is covered by a veil and contains the tables, in which the human rights and the constitution are inscribed."[20] Again, the combination of the eye and the tables of law.

How does the *Tennis Court Oath* relate to this development of a symbol, of a natural sign? This is not an academic question; it has nothing to do with getting the iconography straight. We are dealing with a time when "a generalized visual paranoia in Paris" reigned. Norman Bryson states:

It was a period when one could be denounced by one's servant for wearing clean linen; when debates could take place in the National Assembly concerning right sumptuary conduct: is it counter-Revolutionary or is it

17. *Membership card of the Cordeliers* (after February 1791).
Photo by author.

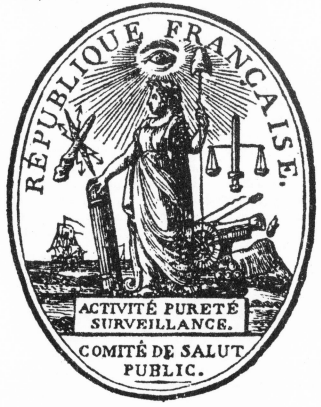

18. *Vignette of the Comité de Salut Public* 1793–1794. Photo
by author.

patriotic for women to wear oak-leaves in their hair? is it an insult to the General Will for a Quaker not to remove his hat before the Bar? is the red cap a true sign of Liberty, or the mask of intrigue? During the Jacobin supremacy, life and death turned on the interpretation of signs: to uproot a tree of Liberty, to sing "O Richard o mon roi," to deface the image of Marat, these were crimes of the utmost seriousness." [21]

Bryson is talking about the *terreur*, but I would contend that this sort of public visual awareness and sensitivity to symbols dates back at least to 1790/1791, when the *Tennis Court Oath* was in the making.

Again, how does this work of art fit into the symbolic discourse? Bailly's gaze works, works very well, as I wanted to show, on the level of reception—but not only on this level. In this point, geometry and politics, past and present, merge as the gaze reaches all, as all gazes become absorbed in it. But as I said, the gaze does not only function as a device for focusing visual energies, it is also a sender. It is a stern gaze, but is it also a gaze that has ultimate authority? Bailly is more elevated than the other deputies around him, elevated by the height of a quickly supplied table. His makeshift position and his gaze really cannot claim what the eye of God and of the king could claim: that they not only see all and everything but give rise to all and everything. The gazes of God and the king have no counterparts that look back: These gazes are directed one-way. In this painting, however, it is crucial that gaze answers gaze and that the half circles unite. More than the combined action of painting and space is at stake here. In my opinion, there are two open questions concerning the status of the bourgeois revolution that are made visible by this active and open composition and that remain open: the question of the permanent revolution, "révolution en permanence," and the question of the legitimation of the *novus ordo*, the new order of society.

The objective of the oath of 1789 was to constitute the bourgeois state. This task was never regarded as finished. The idea was that Parliament would form the general will into new laws and amendments, as the will was laid down in the declaration of human rights in 1789. Substituting the will of the "one" for the "one will" was of paramount importance for the French Revolution. It adhered to a principle that would not allow the Revolution to end in stable institutions but to be carried on as a permanent revolution. "A revolutionary law," says Condorcet, "is a law whose object is to maintain the revolution and to accelerate or regulate its course." [22] And Rousseau, who was responsible for this idea, had already insisted that it would "be absurd for the will to bind itself for

the future."[23] So the unity confirmed over and over again, "la volonté UNE," "la Nation Une et Indivisible," the "multitude . . . united in one body," the closed circle, all these fantasies of unification, were not only the ultimate principle but also the goal permanently to be achieved.

Dubois-Crancé's proposal to renew the Tennis Court Oath every year illustrates this point, and we must put David's painting, which is the permanent *Tennis Court Oath*, in this context. The painting is thus not a fixed document or memorial tablet, like Trumbull's "Declaration of Independence,"[24] for instance (the counterpart for the American Revolution), but a composition that asks for active completion and new reactions. David took it upon himself to make the "*volonté générale*," the electrified action of the crowd, the topic of great painting, but he did not confine himself to the depiction of external aspects like quantity and emotional action. What his accumulation of frozen attitudes does not really achieve is attained through composition as a whole: the indication of the new quality of political dynamics, of dynamics "en permanence," which must transcend the borders of a painting.

"The great problem in politics, which I compare to the problem of squaring the circle in geometry . . . [is]: How to find a form of government which puts the law above man."[25] Commenting on this crucial statement of eighteenth-century political theory, Hannah Arendt writes:

> Theoretically, Rousseau's problem closely resembles Sieyes' vicious circle: those who get together to constitute a new government are themselves unconstitutional, that is, they have no authority to what they have set out to achieve. The vicious circle in legislating is present not in ordinary lawmaking, but in laying down the fundamental law, the law of the land or the constitution which, from then on, is supposed to incarnate the "higher law" from which all laws ultimately derive their authority. . . . The trouble was—to quote Rousseau once more—that to put the law above man and thus to establish the validity of man-made laws, "il faudrait des dieux," "one actually would need gods."[26]

In the *Tennis Court Oath*, however, Bailly is not constituted as the highest source of authority, which does away with all needs of sanction. And no cloud of highest beings descends favorably. In this respect, David does not fool himself and his contemporaries: Bailly, the whole painting, whose energy he collects, transmits the problems, the anxieties, and the hopes of the beginning. Any attempt to close the circle again and again equals squaring the circle. Like the geometrical form of the circle

in nature, architecture and art do not fulfill automatically what the ideology of the time promised—namely, establishing social unity. Unlikely as it is, that unity, however defined and realized, can do away with the deficit of the first and highest sanction. Then establishing unity and permanent revolution can become a goal in itself and seeing and being seen can become the foremost task of the political machinery. Rousseau's theory confronted the Revolution with a terrible alternative: The unity of the nation, he said, only functions when an external enemy threatens; if there is no such enemy, he is to be tracked down in every single citizen as every person's "individual will and self-interest." Can there be no production of unity through appeals, through symbolic alliances in feasts, and in great compositions of painting and architecture, as in our study case? As a matter of fact, the *Tennis Court Oath* was stopped because unity was established by elimination: more and more parliaments relieved one another, more and more deputies dropped out of sight. On 12 November 1793, the head of Jean Silvain Bailly fell under the guillotine; the one head, without which the composition of the *Tennis Court Oath* comes to nothing, is blinded. What was developed after 1791, after the conception of our painting and with the help of David, was the surveillance state, on the one hand, and a helpless attempt, on the other hand, to supply the need for legitimation by the cult of the "Supreme Being." The Bailly of the *Tennis Court Oath* does not entirely belong to either development. But he teaches the viewers, who meet his gaze after 1984, that certain things can start by developing clever techniques of mass communication.

NOTES

A version of this article was first published in *Marburger Jahrbuch für Kunstwissenschaft* 21 (1986).

1. J. L. David, quoted in J.L.D. David, *Le peintre Louis David 1784–1825* (Paris, 1880), 339f.
2. A Schnapper, *David. Témoin de son temps* (Paris, 1983), 102ff.; P. Bordes, *Le Serment du Jeu de Paune de Jacques-Louis David* (Paris, 1983).
3. Dubois-Crancé quoted in Bordes, ibid., 148f.
4. Quoted in ibid., 54.

5. Schnapper, *David*, 118ff.; Bordes, *Le Serment*, 85ff.

6. F. -L. Bruel, *Un siècle d'histoire de France par l'estampe 1770–1871. La Collection Vinck* (Paris, 1909), Nr. 1460.

7. For David's preliminary drawings, see D. Holma, *Son evolution et son style* (Paris, 1940), 58ff., fig. 18ff.; V. Lee, J.-L. David, "The Versailles Sketchbook," *The Burlington Magazine* III (1969): 197ff.; W. Kemp, "Das Bild der Menge (1789–1830)," *Städel-Jahrbuch* 4 (1973): 253ff.; M. -D. de La Patellière, "Rysunki Jana Piotra Norblina przedstawiajace 'Przysiege w Jeu de Paume' w zbiorach amerykanskisch," *Biuletyn Histori Sztuki* (1979): 413ff.; P. Bordes, David, and Norblin, " 'The Oath of the Tennis Court' and two Problems of Attribution," *The Burlington Magazine* 122 (1980): 569ff.; Schnapper, *David*, 105ff.; Bordes *Le Serment*, 39ff.

8. Quoted in Bordes, *Le Serment*, 72.

9. F. Boyer, "Projets de salles pour les assemblées revolutionaires à Paris (1789–92)," *Bulletin de la société de l'histoire de l'art francais* (1933): 183. For the building and planning history of the revolutionary parliaments, see A. Brette, *Histoire des edifices où ont siége les assemblées parlementaires sous la révolution*, vol. 1 (Paris, 1902); F. Boyer, "Les Tuileries sous la convention," *Bulletin de la société de l'historie de l'art français* (1934): 197ff.; J. -M. Pérouse de Montclos, E. -L. Boullée 1728–1799 (Paris, 1969), 181f. The notion of "parliament as theater" has been treated splendidly by M. -H. Huet, *Rehearsing the Revolution. The Staging of Marat's Death 1793–1797* (Berkeley, Los Angeles, London, 1982).

10. C. -N. Ledoux, *L'architecture considérée sous le rapport de l'art, des moeurs et de la legislation* (Paris, 1804), 223. See also J. Rittaud-Hutinet, *La vision d'un futur: Ledoux et ses theatres* (Lyon, 1983).

11. A. -G. Kersaint, *Discours sur les monuments publics* (Paris, 1792), 56.

12. Ibid., 63f.

13. Dubois-Crancé, quoted in David, *Le peintre Louis David*, 89.

14. H. Rosenau, *Boullée and Visionary Architecture* (London, New York, 1976), 147.

15. Ibid.

16. *Archives parlementaires de 1787 à 1860* (Paris, 1862ff.), 49: 652.

17. F. H. Sommer, "Emblem and Device. The Origin of the Great Seal of the United States," *Art Quarterly* 24 (1961): 57ff.

18. Werner Hoffmann, ed., *Luther und die Folgen für die Kunst* (München, 1983), 430f.

19. A. Boppe, *Les vignettes emblématiques sous la Revolution* (Paris, 1911), passim.

20. Quoted in K. Scheinfuss, ed., *Von Brutus zu Marat. Kunst im Nationalkonvent 1789–1795* (Dresden, 1973), 98.

21. N. Bryson, *Tradition and Desire, From David to Delacroix* (Cambridge 1984), 96.

22. Quoted in H. Arendt, *Über die Revolution* (München, 1974), 237.
23. Ibid., 97.
24. I. B. Jaffé, *Trumbull, The Declaration of Independence* (New York, 1976).
25. Rousseau quoted in Arendt, *Über die Revolution*, 238.
26. Ibid.

NORMAN BRYSON

Géricault and "Masculinity"

I N this paper, I bring together two distinct inquiries: the first, an inquiry into some aspects of the cultural construction of masculinity; and the second, an inquiry into certain works by the French nineteenth-century painter Théodore Géricault (1791–1824). But first, I should explain what lies behind this juxtaposition. My claim is that, in some sense, the two inquiries are one and the same: that you can view Géricault's work as itself an inquiry into the construction of masculine identity or identities in the specific context of his class and period. His class would be the aristocratic and upper bourgeois milieu to which Géricault belonged, and the period is the years of Géricault's output as a painter—from the late Napoleonic context of his first military subjects (after 1810) to the post-Restoration context of his last paintings (1822–1823). If Géricault's work is itself a series of explorations of masculinity and masculine identity, then to talk about his painting in our own time would be a strange enterprise if we were not to take into account current discourses that explore masculinity. These are necessarily diverse and contradictory; selection is essential, and here my selection has been guided by the questions raised in film studies (though entirely pertinent to art history) concerning the gendered nature of the gaze.

A classic objection to the juxtaposition of works of visual art with discourses on sexual difference is that inevitably the work of art ends up merely repeating and confirming the themes and terms of the discourse on sexuality, that Géricault's paintings are sure to end up as allegories of that discourse, that painting is bound to be demoted and relegated to a secondary and illustrative status. This charge has particular force when the discourse on sexuality does not of itself address the visual. Then one is dealing far more with two independent fields, where the reality of painting as a visual construction is lost in, or becomes secondary to, the verbal discourse on sexuality. But what is interesting about the way the present period theorizes sexual difference is that questions of the visual are of primary importance in the discourse on sexuality: What is visual or "figural" about painting—as opposed to whatever discursive or iconographic content it may possess—is no longer outside or

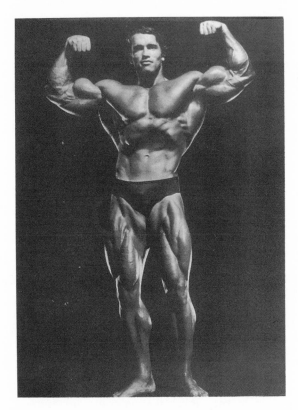

1. Photograph of Arnold Schwarzenegger, from
Encyclopedia of Modern Body Building (New
York, 1987).

lost to the discussion but has moved almost to center stage. Crucial to the discussion of the image has been the analysis of the gaze; in particular, that kernel of the analysis that describes a dominant "heterosexual" optic in which visual activity is culturally constructed across a split between active (= male) and passive (= female) roles—where the man is bearer of the look, and the woman is the object for that looking, is image. Perhaps I should explain that I have no particular quarrel with this analysis, which seems to me to conform to the facts not only of current constructions of visuality but of important phases and formations within Western European painting. In this paper, I want to follow the recent work of others, including Kaja Silverman, Steve Neale, and Mary Ann Doane, in adding to that model with the intention of extending its explanatory power and also, perhaps, its political effectiveness.[1]

My principal modification to the model ("Woman as Image, Man as Bearer of the Look") concerns what may appear as an anomaly within it: that while the model probes issues to do with the male's perspective on the female, as preordained object of looking, it may be relatively underdeveloped in dealing with what is at stake in the male gaze upon another male. The model establishes voyeurism as the central process in the male spectator's relation to the image of the female, and identification as the central process in the male spectator's positioning with regard to the image of the male. For example, Laura Mulvey's initial analysis of the relation of the male spectator to the male character in the films she cites, stresses how the male viewer steps into the male character's shoes, aligns his viewpoint with that of the character, projects himself into the landscape of the narrative, and sees from within that diegetic space.[2] Mulvey suggests that this process is easy for the male spectator, especially in those cases where such filmic codes as the view-pointing of shot/reverse shot establish the camera as seeing from the point of view of the male character or intra-diegetic hero. But the ease with which such codes invite the male spectator into the space and landscape within the film should not, I think, be taken at face value. Rather, ease of identification here might be thought of as portraying an "enchanted" relationship between male spectator and male character, a streamlining into an easy conveyance and projection of identifications that, for the male spectator, may involve crucial difficulties. One might suggest here that the streamlined ease of projection that invites the male spectator to align himself with the perspective of the male hero in fact exists to simplify and to pacify the mechanism of intermale identifica-

tion—which I suggest is a much thornier business than the enchanted fiction of identificatory ease proposes.

I begin with one of the first lessons that men might take to heart from feminism and learn to apply to their own situations: that gender is primarily a cultural construction, and for all, for men and women alike. Which at once locates masculinity not as naturally given, but as construction, and as a continuous construction that has to go until the subject's dying day. To be a subject constructed as a male involves a necessary masquerade, the masquerade of the masculine. Although the mechanisms for producing the gender masquerade are necessarily different for each gender position (which I will elucidate on later) what is held in common is the strain of that continuous production. The masquerade is interminable, not least because of the sanctions against those who would try to escape it. By a system of "cross-censorship," [3] the same codes of masculine identity that the subject introjects into his own case he projects outward onto all other males as a continuous injunction to maintain the codes. Deviation or failure to obey that constant injunction risks instant and severe penalties. This censorship already points to ways in which the masculine masquerade is directed not only towards women but towards other males. It points, thereby, to the anomaly in the model that I mentioned just now: that the male is not only bearer of the male gaze but is also object of that gaze. Those analyses of male identification that posit ease of access on the part of the male viewer (of films, of paintings) omit precisely this coercive aspect of identification. And this can block the way to getting at what lies behind that coercion: the fears, anxieties, and strains of producing the masculine (as one might produce a play in which the actors constantly risk forgetting their lines).

The issue of the masquerade implies at the least some common ground of experience across the genders, for the male subject no less than the female is constructed in the field of vision by a split between "I see myself" and "I see myself seeing myself"; or, more simply, between being at the same time the subject of the male gaze and its object. The latter position, that of object, is a matter of intermale surveillance, constant monitoring, patrolling, and inspection. The policing here ranges from actual encounters with the law to introjection of the Law as interpellation. Yet what one thinks of as soon as the masquerade is named is the asymmetry of the sexes with regard to the masquerade of gender and the particular intensity with which the mechanisms of identification must bite into the male subject.

In Genesis 9:20, one reads of the drunkenness of Noah:

[Noah] planted a vineyard; and he drank of the wine, and became drunk, and lay uncovered in his tent. And Ham, the father of Canaan, saw the nakedness of his father, and told his two brothers outside. Then Shem and Japheth took a garment, laid it upon both their shoulders, and walked backward and covered the nakedness of their father; their faces were turned away, and they did not see their father's nakedness.

Why is it that the sight of the father's nakedness provokes such disturbance in the sons that they must walk backwards to avoid it? There is no question here of recognizing and experiencing the trauma of sexual difference; if there is trauma here, it cannot be of the same kind as the disturbance that centers on genital difference. If the father's genitals are the same and yet are disturbing, then the issue must be that, in fact, they are not the same: Between the father's genitals and his own, the son recognizes a difference of another order, where the stakes are not the same as those in sexual difference, though perhaps no less high.

Freud's texts have the advantage of being able to approach this traumatic terrain better than most others, and one can invoke certain of his texts here for the clarity of their exposition. What they establish is the Oedipus as the structure to think through the difficulty in the intermale relation of identification. The locus of the trouble is, of course, the physical and affective relation of the child to its parents, which the Oedipus model resolves differently for each sex. Here we might recall, following Kaja Silverman's account, Freud's use of the concepts of the "positive" and the "negative" Oedipus.[4] For the girl, the "positive" resolution of the Oedipus lies in breaking the direct libidinal ties to the father by identifying with the relay of the mother. This is the dominant resolution, yet the "positive" Oedipus is accompanied by a "negative" version where the reverse occurs: in the negative version, the girl deals with libidinal ties to her mother by identification with the father, in other words, by identifying with the masculine position. It goes without saying that only one of these versions, the "positive" Oedipus, goes according to cultural plan and eclipses the other. Now consider the same problem, of the child's relation to its parents, as it affects the male child. For the boy, the positive Oedipus requires that libidinal ties to his mother be structured through the relay of identification with the father; at the same time, the accompanying negative Oedipus structures the libidinal field the other way round, breaking the direct libidinal ties to the father by identifying

with the mother. The subject, male or female, goes through the filter of the Oedipus towards two quite different resolutions and sets of identifications: one with the imago of the mother, the other with the imago of the father. Again it goes without saying that, given the polymorphousness of infantile sexuality, one would not expect otherwise; and given the cultural valorization that establishes only one of these modes as correct, one obviously will emerge much more strongly and hide the other from view.

To stay now with the male's situation, the passage through the Oedipus brings quite particular contradictions and vicissitudes in its wake. The primary difficulty is the libidinal attachment to the father, which I take to be where the story of Noah's sons seeing their father's nakedness comes close to a locus of anxiety. The positive Oedipus eclipses the negative by making the male child identify with the father and renounce the libidinal ties of what might be called the father/son romance; yet, in so far as the positive resolution remains unable fully to eclipse the negative, there remain those libidinal residues that can no longer find their object. The libidinal currents that had formerly centered on the father are proscribed and unaccounted for; now that they are deprived, and permanently so, of their object, they must enter a state of constant quest.[5] One is dealing here with an excess, that which cannot take part in identification and lies outside identification with the father and adjacent to it. One might note that the same situation occurs for the girl, for the residues of the negative Oedipus persist in enjoining identification with the imago of the father, against the cultural pressures that proscribe this. Yet a second disturbance now occurs that is specific to the male: that while he is enjoined to *be like the father*, he cannot and must not be like the father *in one crucial respect*, namely that he cannot possess the father's sexual privilege and power. There issues forth an impossible double command: to be like the father, but not to be like the father with respect to his sexual power. Just when the male assumes the male position, he cannot assume it fully; which is to say that the male must produce masculinity and yet not produce it—a play in which the actor is not so much in danger of forgetting his lines as of being struck dumb in the first act.

I opened this essay with a photograph of Arnold Schwarzenegger pumping iron, and I meant it to designate the effort, the sweat, of producing the masculine masquerade (fig. 1). I now want to comment on a Greek sculpture, the *Doryphoros* of Polykleitos (fig. 2), examining both its idealization of the male body and what I take to be Schwarzenegger's

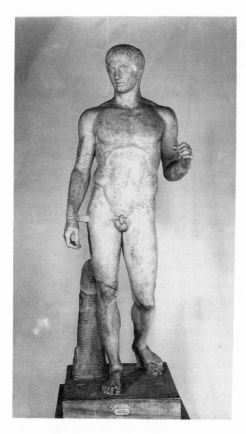

2. After Polykleitos, *Doryphoros*; Roman copy in marble of bronze original from fifth century BCE. Naples, Archeological Museum; photo courtesy Soprintendenza Archeologica delle Province di Napoli e Caserta.

efforts at the same. Idealization might be defined here as the gap between the actual body and that higher imago of the body that constitutes the masculine ideal, the identification to which the male subject aspires and is also prevented from attaining, at the point of sexual power. Of course, such discrepancy between the sense of the body as actually inhabited by its owner and the sense of the body as also existing in some ideal form is a primary component in the foundation of the Imaginary, at least if we follow Lacan's early paper here. Its troubled relation to the ego-image is one that both sexes share.[6]

What is striking in both these visual examples is the extraordinary disavowal of libidinal investment present in the representations. In the case of the sculpture, one could speak of its mathematical purity, its construction according to a canon of perfect proportions, its classicism: here I will mention only the diminished size of its genitals. It is the

Greek tendency in this period to limit life-sized or enlarged genitals to comic and bacchic scenes, to the realm of the satyrical; the Polykleitos regards underplaying and diminution of the genitals as essential for its higher purposes.[7] The convention is so familiar that it is still possible to overlook its aspect of the bizarre; for idealization here entails that the discrepancy between the viewer's sense of his own sex and the ideal, as well as the accompanying anxiety, be resolved by so diminishing the genitalia that no anxiety concerning discrepancy will arise. The gap between actuality and the imago is dealt with by reversing it so that the idealized genitalia do not compete with the real thing; or, more precisely, they are made to compete—gap and disparity are presented—but the spectator wins. In this case, the anxious gap between the male spectator and the imago of masculinity can be precisely measured as a ratio: as the sculpture's genitals are diminished relative to actual genitals, so the sense of the male's genital self-possession and sexual power stands in relation to the masculine imago. What is feared and cannot be assumed by the male subject is the sexuality of the imago, a fear that in the case of the sculpture is defused by the strategy of diminution and sublimation.

The Schwarzenegger example achieves a similar effect through intense fetishization of the muscular. The first point I wished to make through this image was the sweat of the masculine masquerade, the Herculean effort required if the body is to achieve the masculine ideal. My second point is, once more, to do with genital presentation. First, genital concealment is essential within this visual aesthetic: to expose fully the bodybuilder's genitals is to leave behind the visual arena in which the activity is supposed to take place for an altogether different visual genre. Second, the body outline that results from this particular cultivation of musculature is such that enlargement is present in every bodily zone except the area concealed. The result is the sense that the body can be inflated to a quite surprising degree—it is capable of pneumatically pumping itself up until a remarkably altered silhouette results—yet the concealed area remains outside the process of inflation, absolutely out of play (in many older photographs of this type, one finds traces of airbrushing, effacing the area completely). Again, this strategy allows the "magnificent" imago to achieve a visible appearance before others and before the self, but leaves out the question of sexuality. Third, an actually fetishistic strategy seems to be followed: Attention passes, according to the classical model of fetishism,[8] away from the primary zone of sex to secondary displacements. The whole body is phallicized, from marks of

inflation, to removal of body hair, to exaggerated dilation of the veins. The masculine imago is contemplated, in other words, by crossing out the actual genital area and passing its characteristics to the body image as a whole via a trope of metonymy: the whole is made to stand for the part (as in the grammatical example of "Your Majesty," used to address the king).

Such examples might seem simply to point to the homoerotic, and perhaps they do, but what is of no less interest is the installation of a certain libidinal structure within masculinities that are not perceived as deviating from orthodox masculine coding. On the contrary, the Greek ideal became culturally central for all systems of visual representation touched by classicism and neo-classicism, in the many periods of its appearance. The cult of bodybuilding may be culturally marginal, yet it is by no means proscribed, and its influence is currently closer to middle-class culture than in many earlier periods. In other words, within culturally valorized constructions of codes for masculinity, one finds striking evidence of the proximity of the negative Oedipus to its more successful and positive partner. The image of masculinity is charged with libidinal currents that are consistent with formations that are regarded as nondeviant and non-"pathological."

Perhaps I may mention in passing two stories, one from Woody Allen and the other a personal recollection. At one point in (I think) *Zelig*, Woody Allen plays a psychoanalytic rebel who breaks with Freud over a point of doctrine. The dispute concerns the concept of "penis envy," which he complains, Freud wanted to confine to women. The second is a personal experience. For reasons I now hardly recall, in the early 1970s I was visiting the Esalen Institute at Big Sur at the same time that an experimental drug rehabilitation program for Vietnam veterans was in progress. The program was shrouded in secrecy—the area where it was taking place was surrounded by military police—and the vets and the visitors to Esalen only met at the showers (Esalen being famous for its waters). Apparently the participants in the program showered together in the large outhouse for this purpose, supervized by their commanding officer. What I found interesting was the following detail: that although the men were showering naked, the officer wore swimming trunks. But to return to art.

Géricault's career begins amidst the crisis of militarism provoked by the early success and eventual failure of the Napoleonic project. His first Salon painting, the *Charging Chasseur* of 1812 (fig. 3), is already remarkable for its alteration of the image of the warrior when compared with

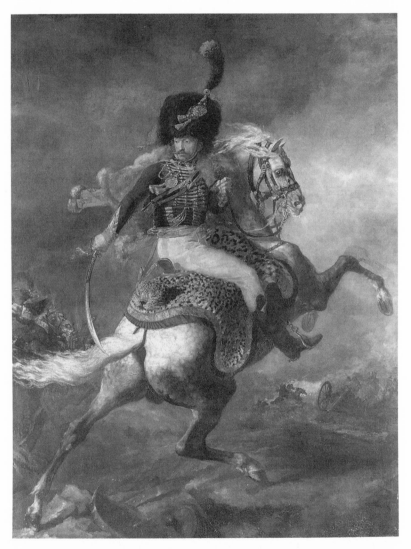

3. Théodore Géricault, *Charging Chasseur*. Paris, courtesy Musée du Louvre;
photo © Réunion des Musées Nationaux.

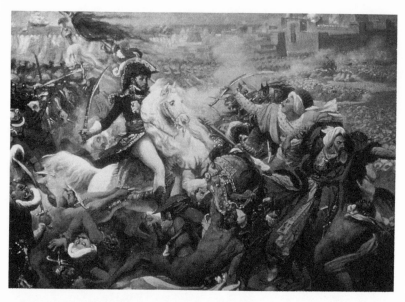

4. Jean-Antoine Gros, *Battle of Aboukir* (detail). Detroit, courtesy Institute of Fine Arts.

earlier Napoleonic battle scenes, such as Gros' depiction of Murat in the *Battle of Aboukir* (1806; fig. 4).[9] In the latter, the figure of the warrior is surrounded by a narrative of battle with which the figure is entirely coherent. The sword, for example, is related to the advance of horse and rider and to its imminent victims, notably the Egyptian who lies already crushed beneath Murat's onslaught. Géricault's representation of the Chasseur is quite otherwise. Horse and rider have been spirited away from the battlefield; one sees no surrounding military action that might explain the rider's action or pose. Instead, the narrative order is comparatively obscure: Horse and rider are stranded somewhere away from the fray, and the furious turning of the horse lacks rationale. One notes, too, the irrational placement of the sword, no longer held aloft to crash down on the enemy but turned inward toward the horse. And the costume is subtly disarrayed when compared with that of Murat. Here the clues are more like nuances one might overlook. Once seen, though, they are hard to deny. The Chasseur's right leg flings blindly out into space, its profile appearing narrow and weak; his bearskin hat is seemingly too large and somewhat askew, and the panache that crowns it is,

again, off center (it produces no sense of apex to a firm pyramidal composition). Also telling is the disposition of the horse's limbs, which splay out in all directions. No stability comes to the rider from his mount; he sits on a charger whose footing is precarious. Spatially there is more torsion, more spiraling of lines, and more sudden turning than makes sense. The horse charges forward, but the rider looks back as though the enemy had been missed; in a sense he is traveling backward in space.

The details I want particularly to emphasize, though, concern military fashion. The rise of Napoleon coincides with a fantastic elaboration of military costume in France.[10] The army of the *ancien régime* had been one of mercenaries, but the *grande armée* is made up of citizens; the political break is dramatized by the invention of entirely new forms of battle dress. The new creations involve tremendous intensification of the macho spectacle. At enormous expense, the light cavalry are given elaborate *shako* headgear, with Hungarian-style boots or riding breeches buttoned at the side. Cuirassiers are given epaulettes, breastplates of hammered steel over a thick cuirass bordered with scarlet, helmets augmented with thick horsehair crests and the tall, scarlet plumes known as *houpettes*, with breeches of buckskin or chamois, and boots to the knee (fig. 5). The dragoons have coats of green cloth, helmets with copper crests, and for their mounts sealskin (for the troops) or panther skin (for the officers).[11] On Prince Murat this sort of paraphernalia sits rather well.[12] But on the *Charging Chasseur*, it somehow misses: the lines are "out," the bravura image of the male emerges but is also in some sense botched. From the beginning Géricault stresses the distance between an actual image and the imago that cannot quite be attained.

The *Wounded Cuirassier* widens the gap still further (fig. 6). Here the battlefield is almost invisible: All we see of it is some smoke, flames, and the suggestion of a rout at a great distance. Removal from action takes away the narrative context needed to explain the figure's action (one wonders whether there is an intimation of desertion). Essentially, the figure of the male here, and throughout Géricault's military paintings, is of an armor-plated being whose vulnerable interior body lies enclosed behind thick protective layers (boots, gauntlets, helmet, cape), just as the sword lies enclosed in its thick scabbard. There are also signs that, besides sealing the body off from the dangerous outer world, the costume is intended to produce an image of bravura: The helmet rises to a tall crest, the waist is girdled by a buckled belt and metal bands, the trousers are piped, and the boots spurred. Yet this image of masculine power and panache is at the same time unable to produce, or live up to,

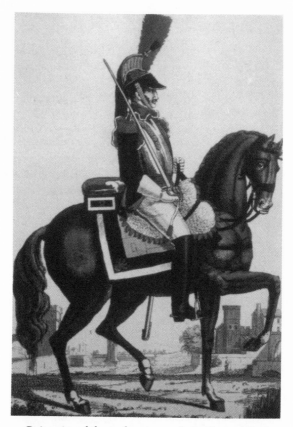

5. *Cuirassier of the 2nd regiment*, from *Troupes Fran-
çaises*. Martinet, Paris, courtesy Musée de L'Empire,
Salon-de-Provence.

its own signs of strength. The position of each leg conveys instability;
the sword, sign of aggression, is now used as a staff, simply for physical
support. And the figure is wounded, at least in the painting's title. But
wounded where? The eye, guided by the title, finds no actual wound,
only perhaps wounded*ness*, a general sense of hurt and fear. What re-
mains unstated in the figure is projected through the mount, with its
burning-ember eyes and expression of panic.

Later images of the warrior in Géricault move these themes of

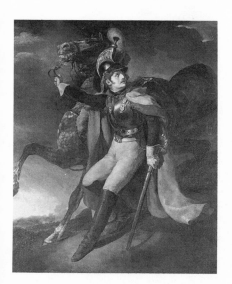

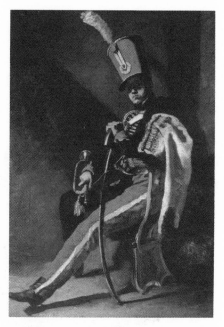

6. Géricault, *Wounded Cuirassier*. Paris, courtesy Musée du Louvre; photo © Réunion des Musées Nationaux.

7. Géricault, *Seated Hussar Trumpeter*. Vienna, courtesy Kunsthistorisches Museum.

wounded or failed masculinity into a register of half-statement and implication; their interest lies in the way they understate the intimations of failure to the point where the viewer detects them almost as atmospheres. The *Seated Hussar Trumpeter*, for example, so removes the figure from actual battle conditions that he seems now without occupation, dressed and ready to sound the alarm, but seated and settled in a way that suggests long waiting through empty hours (fig. 7). One suggestion of the pose is that of sitting patiently to have one's portrait painted; the implication is one of preparedness to fight but actual inactivity and exclusion from battle (connotations of rest border here on those of convalescence). Consider the shadow cast by the figure's right leg: Here the strength of the leg, which the piping and close fit of the fabric emphasize, disappears into the suggestion of a stick, almost of a crutch. The arm of the cape hangs slack and empty; helmet and plume

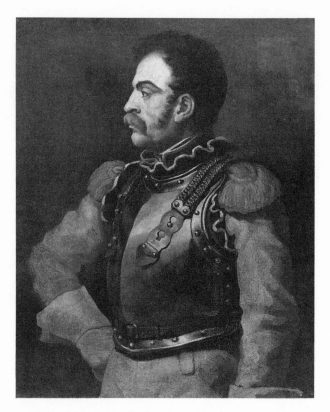

8. Géricault, *Portrait of a Carabinier*. Paris, courtesy Musée
du Louvre; photo © Réunion des Musées Nationaux.

nod toward sleep. What is stated here is the cessation of vigilance, alert-
ness, command; the emptying out, in fact, of the imago of strength,
which at once deflates, unbacked by force or power.

With the *Portrait of a Carabinier*, the issues are less, I think, to do
with loss of strength than with the whole relation of the body to military
costume and to the markers of virility (fig. 8). A continuity is estab-
lished between fetishism *on* the body and fetishism *of* the body. On the
body are found layer upon layer of protective encasements, beginning
with the cuirass and continuing through at least four further integu-
ments: the scalloped jerkin, the square-collared coat, the dark under-
coat, and the white shirt beneath. To these are added the straps over
the cuirass, the scarlet epaulettes, the broad-sleeved gauntlets. In this

painting, the multiplication of these signs of male invulnerability and, therefore, strength are made subtly continuous with facial details: The moustaches are exaggerated, as are the side-whiskers and black eyebrows. A secondary sexual characteristic of the male, facial hair, is elaborated across a cultural code of masculinity to produce and build up the signs of "virility," which extend back into the body in the flared nostril, and stern lower lip. At the same time this profusion of macho signals is interestingly undermined. This subversion is almost entirely accomplished by the use of black. The portrait is offset by blacks so unremitting that over the imago of strength a pall is cast. Across the color code, the blacks yield a semantic charge of the lugubrious, of an inwardness filled with melancholia. In the face, an activation of red and white pigments creates temples so pallid that the face looks drained. The livid eyelids suggest exhaustion. Over the cheeks, red and white used in bands (following a sort of "stage makeup" principle) imply haggardness and perhaps encroaching age.

In subjects of this kind (they are Géricault's principal subjects from 1812–1815), one is presented with a certain paradox of the masculine. The masculine *must* be produced: The signs of masculinity are multiplied to cover the entire body and to code the body itself so that from the male body will be projected an imago of strength that is not simply personal but national, that of the citizen militia collectively orchestrating the production of masculine image. At the same time, the whole process is shown in a state of strain and fatigue: Despite the massive exertion with which the masculine is produced, and perhaps because of that exertion, the image topples and fails. Now, a certain way of reading these images regards Géricault as simply reflecting, in personal terms, the national trauma of the failure of the Napoleonic adventure, particularly as it affected Géricault's own class—the aristocracy and upper bourgeoisie that led the campaign. I would not argue with that view, but I would like to ask for more precision concerning the *links* here between the political (Waterloo, Elba, the Restoration) and the personal (expressed through images of the warrior wounded, stranded, mournful), for these links may hold the greatest theoretical interest. One is dealing with an "outer-world" phenomenon—the collapse of Napoleonic militarism— and an "inner-world" phenomenon—Géricault's investigation of a certain masculinity, in its crisis of simultaneous exacerbation and failure. Critical here is the connection between the outer and inner worlds, which I think in this case can be located—the particular usefulness of Géricault as a case for study—in the nature of military command.

Perhaps I can touch again on those stories: Woody Allen's joke about the way Freud wanted to confine the concept of penis envy to women, and the Esalen anecdote, which concerned the way the superior in the chain of command felt obliged, or was under orders, not to appear naked before the men. The reason I mention these stories is to get at this question: Why do structures of hierarchy bite so deeply into the male subject? Or, restated, what imaginable mechanism might account for the way in which the political order is registered in or entered into the psychic order of the male? How does political (patriarchal) power get its deeper purchase inside male subjectivity?

Obviously I am unable to answer these questions, but a start might be made if one recalls the contradictory position that the male subject inhabits with regard to the identification with the father. On the one hand, the positive resolution of the Oedipus requires the male subject to identify with the father; on the other hand, the incest taboo requires the male not to identify with, not to introject or incorporate, the father's sexual privilege, in particular that of sexual access to the mother's body. Freud names as the superego the agency that carries out the identification, the introjection of the father; but this introjection is unable to incorporate the sexual aspect of the father, his phallic power and privilege. These remain perpetually outside the male subject: The male is enjoined to assume the phallic rôle, but the power of the phallus can never be his. The crucial result is the experience of inauthenticity within the production of the masculine, that the male can never fully achieve phallic power, however great the exertion toward that end. However much the markers of the masculine proliferate, what subtends that proliferation is lack within the position of the masculine, the deficit at its very center. The structure thus reveals an impossibility, an impassable contradiction, within the formation of the masculine. The male subject must never know, or introject, the father's phallic strength, which remains therefore always outside. Here Woody Allen's story is of moment. If we grant that, *pace* Freud, there is a penis envy among men, then the locus of phallic strength is never inside but only in other men: It is the other males who have it.

In Géricault's military paintings the social form that deals with the inferiority of the male subject concerning his identification with what cannot be assumed and therefore remains "higher" and "outside" is *rank*. In each of Géricault's military paintings, the figure occupies a precise place in the hierarchy. Although for us the sense of where they all

stand is hazy, nothing is more precise than the punctilio of rank in military societies, and particularly those of the nineteenth century. Then, simply by glancing at the medals on a man's chest an informed eye could read off his entire career in detail, as clearly as reading a *curriculum vitae*. Géricault's figures are subjects *in* rank, subjects *of* rank. Liaison between the political and subjective spheres is achieved by entering the positions of the social hierarchy (here, the military hierarchy) across the lack that inhabits the male subject—the vacant center of masculinity. In rank, the subject is always below (let us set to one side the exceptional position of Napoleon); and what cements the social ranking, what gets the political structure to bite as deeply as it does into the subjective order of the masculine, is the permanent inferiority that results from lack of phallic power. Which in a sense resolves the Oedipus in the social rather than in the family domain: By entering into the field of inter-male ranking, the inner lack within the masculine, its ineradicable sense of inferiority, is linked to hierarchies that structure, order, and also use and depend on the sense of the inadequate masculine. Géricault's paintings show how, at least for the military culture of his time, rank, which invariably positions each figure in the chain of military command, and the sense of masculinity as lack, absence, and failure, go hand in hand across the ligature binding the sexual and political orders.

One is dealing here, in other words, with a set of specific historical constructions of the masculine, current and widespread in Napoleonic military society, in which masculinity is presented as an array of imagos, compellingly impressive to the male subjects to whom they are addressed, and at the same time drawing their power to excite by generating a glamor to which the subject *aspires* but which he does not yet, and perhaps never can, possess. The heroic body exists in the permanent place of the superior masculine to which the subject is attracted from a place down below, of inferiority, adoration, even abjection. A letter by Carl Schehl from 1806, recording the entry of Napoleonic troops into his city, describes precisely the impact of such images of the super-virile or the super-strong:

> Troops crossed the city almost every day. I liked to admire the handsome drum-major and the bearded sappers with their high bearskin hats and white leather aprons who always marched in the lead. My joy was even greater when the cavalry arrived; I would show a squad of light cavalrymen or hussars the way to their quarters and never missed a chance to ask them to mount their horses.

At about this time, in the fall of 1811, we saw the arrival of the chiefs
of staff of the 2nd regiment of carabiniers, which was coming to billet.
This was the most beautiful regiment I had ever seen. Yes, I think that with
their uniform and equipment they were really the most beautful soldiers
in existence. All of the men were as tall as grenadiers and the horses were
almost of all of vigorous Norman stock.

The regiment had two uniforms: a sky-blue one for everyday wear and
white uniform for dress parades, with sky-blue collar and facing. One had
tight, gray cloth breeches, with a *basane* (or bronze-lace) stripe, and the
other white breeches. The riding boots were high, shiny, and had jingling
spurs; and finally they wore a very large and heavy coat made of thick
white cloth, which virtually covered rider and horse. . . . The helmets and
armor of the officers were dazzling with their gilding, and there was a silver
star on the breastplate.[13]

Unmistakable in this passage is the mixture of excitement at the display
of the male body in military splendor, with the abjection of its worshipper, who casts himself in the rôle of this masculinity's servant or groom.
In relation to the bravura display, Schehl presents himself as a humble
voyeur at the margins of the scene, who never misses a chance "to ask
them to mount their horses," and who fetishizes the glamorous body
images of his heroes into a series of fascinated glimpses of breeches,
boots, armor, spurs. Of his own dress and appearance Schehl says nothing; visually he himself does not seem to exist in the same dimension as
his heroes, or rather his involvement with their body imagery is as the
internal space across which the images pass, a space of yearning for the
command and magnificence they alone possess.

Schehl's reaction is perhaps an extreme case, from the edges of the
military campaigns. But in important ways it is continuous with the behavior and attitude of the troops themselves in their daily life and in
their ordinary routines. Another memoir records what must have been
a familiar enough situation:

I had been in the company for five months when, one Sunday, my chief
squadron sergeant major, passing in review the preparations for inspection, stopped in front of me and, after looking me over from head to foot,
said: "Parquin, you may have a handsome uniform, but you are not a soldier! Your gaze should be assured, look me squarely in the whites of the
eyes; make me tremble if you can! You are in the army now!" This was in
the Twentieth regiment of chasseurs, and even though this was a relatively
new branch of the cavalry, their esprit de corps was very high.[14]

Drilling here is not only an objective process, a training of the body that will make it compliant with orders and commands coming from the outside and on high; it is the internalization of the "outside" and "on high," the systematic means of placing the subject in the position of inferiority with regard to the imago of strength that the body is supposed to emit. That imago is to be reproduced not only by external means— falling into line at drill—but by internal work, the creation of a subjective attitude ("Parquin You are in the army now!") that comes from taking the imago into the self and fashioning the self in accordance with its normative styling and protocols. At the same time the process is always incomplete: the squadron sergeant major is not *yet* impressed, not yet "trembling" before Parquin's gaze, and Parquin is not yet the full embodiment of the magnificent imago that exerts its pressure from the higher point in the chain of command.

The ability of the *grande armée* to capture the hearts and minds of its troops can be seen, in terms of military history, as a factor hardly less important to the success of the army than any other strategic innovation in the domains of tactics, troop movements, or weaponry. Under the *ancien régime* the army could be thought of as separate from the greater society, as a specialized group performing specific functions, as a profession. It might include mercenaries, paid to take orders, who had leased their bodies to the state in return for soldiers' pay. But in the *grand armée*, with its basis in national conscription, the military are no longer a group over there, and military service is no longer exactly a profession: The army in principle consists of every able-bodied male, everyone who counts fully as a citizen. The body is no longer leased to the state, it *is* the state; the state emerges as a new kind of biopolitical entity, and by virtue of gender the male body belongs to the state, as state property. Hence the need to glorify that body: In post-Revolutionary France the state is no longer figured in the king, but in the male body itself, and the body's destiny for glory or defeat is that of the nation as a whole. What binds the military state together and what holds in union its disparate interests, classes, and groups, is a *corps glorieux* with which the citizen militia must identify to the whites of their eyes. The military fashion plates of the period (for example, fig. 5) give only the outward version of that imago in its various forms; what they cannot show is the internalization of those forms, their introjection into the innermost layers of subjectivity. Once the imago bites deep into the male subject it produces a force as formidable as—more more formidable than—the force gen-

erated by modernized equipment or ballistics or strategy. Each officer must build himself in relation to that image:

> One must be born for it. No other condition requires more natural predispositions, an innate flair for war, than that of the light trooper. He must have all of the qualities of the superior man: intelligence, will, and strength. Constantly left to fend for himself, frequently exposed to combat, accountable not only to the troops that he commands but to those he protects and guides, he must keep his mental and physical faculties focused at all times. His task is a hard one, but there are opportunities for distinction every day.[15]

In the case of Géricault, perhaps the most fascinating phase of his work commences with the breakup of this *corps glorieux*, and the dismantling of the Napoleonic military machine in 1815. The defeat of the *grande armée* is arguably different from previous military defeats in French history in that what had been at stake in the Napoleonic era was the masculine body itself, its strength and charisma, its capacity to generate from the body the imago of the super-masculine or the superstrong. 1815 means the obliteration of that imago. Its breakdown and fragmentation are a trauma in the literal sense, a destruction of body image that is experienced subjectively, by Géricault, as utter annihilation. The images Géricault creates of wounded and defeated soldiers turn on the wholesale disintegration of that collective orchestration of the masculine image of bravura (figs. 9 and 10). Now that the superior term in the chain of command is gone, and Napoloeon, Murat, and the officers whose uniforms had made Schehl breathless with excitement in 1811, are written out of history, the body loses altogether its reference to that heroic image from above and on high. Géricault records its mutilation and agony, a destruction that is at the same time military, political, and psycho-sexual. After 1815, he is left with basically two choices: to continue the pursuit of the magnificent imago outside the now derelict military arena—a prolongation of the yearning for psycho-physical magnificence that slowly takes on visual form as *The Race of Riderless Horses* (figs. 11 through 14); or to stay with the experience of 1815, to explore as far as humanly possible the breakup of the image as a psychosexual system—the theater of the dismantled Imaginary that Géricault portrays in the *Raft* (fig. 15) and its accompanying studies (fig. 16), and in the portraits of the insane (fig. 17).

With *The Race of Riderless Horses* the imago of male strength is pro-

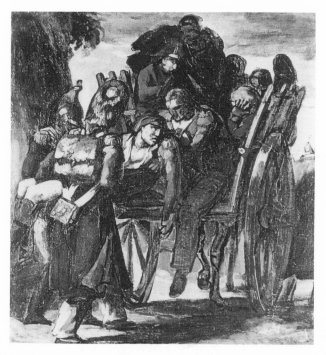

9. Géricault, *Cart with Wounded Soldiers*. Cambridge, photo
courtesy Fitzwilliam Museum.

duced across two terms, rider and horse, and the runners quickly assume
the air of macho allure that the series as a whole exists to recapture and
recreate (the process is perhaps at its most intense in the Louvre picture,
fig. 13). One should say something of the material reality of the race
itself:

> At the close of the [Roman] Carnival of 1817, in mid-February, Géricault
> witnessed the race of the Barberi horses in the Corso, the stampede of
> riderless horses, run traditionally in the city's central thoroughfare on the
> last five days of the Carnival. . . . On the approach of evening a cannon
> shot signalled the clearing of the Corso. A troop of dragoons, clatter-
> ing down the street's length from the Palazzo Venezia to the Piazza del
> Popolo, swept it of the last carriages. Spectators meanwhile filled the win-
> dows overlooking the course and crowded into the wooden stands at the
> obelisk in the Piazza. Preceded by senatorial guards in purple and yellow
> livery, the Barberi horses made their entrance, led to the starting posi-

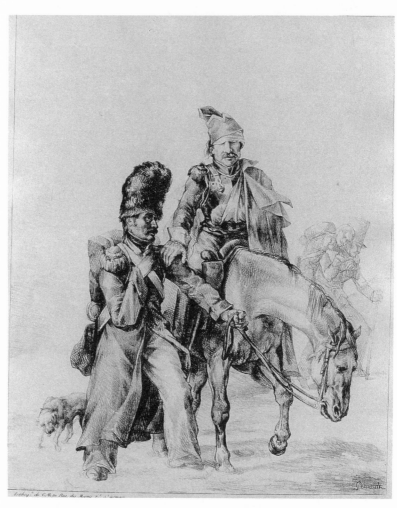

10. Géricault, *The Return from Russia*. Rouen, photo courtesy Musée des Beaux-Arts.

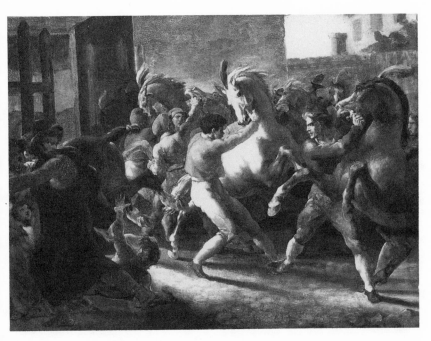

11. Géricault, *Start of the Barberi Race*. Lille, photo courtesy Musée des Beaux-Arts.

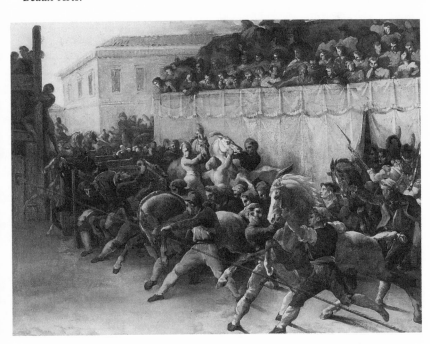

12. Géricault, *Start of the Barberi Race*. Baltimore, photo courtesy Walters Art Gallery.

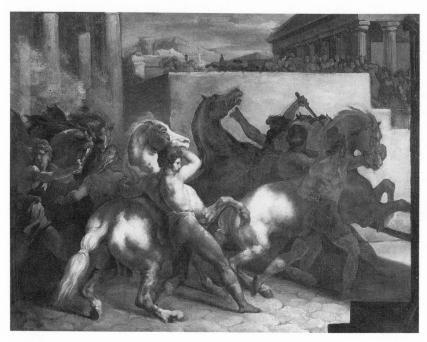

13. Géricault, *Start of the Barberi Race*. Paris, courtesy Musée du Louvre; photo © Réunion des Musées Nationaux.

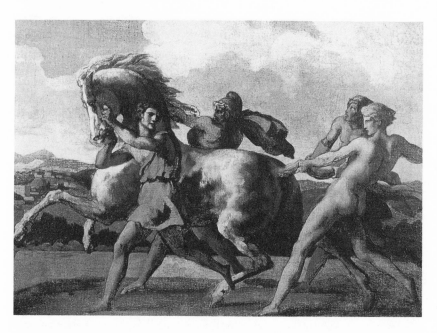

14. Géricault, *Four Youths Holding a Running Horse*. Rouen, photo courtesy Musée des Beaux-Arts.

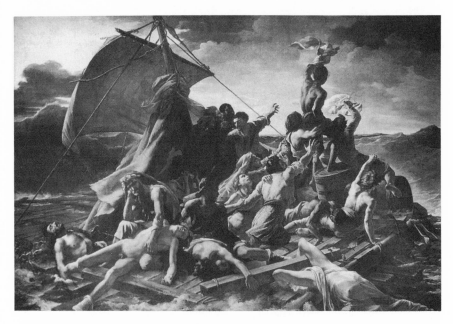

15. Géricault, *The Raft of the Medusa*. Paris, courtesy Musée du Louvre; photo © Réunion des Musées Nationaux.

tion beneath the stands by costumed grooms who strained to keep them from breaking away. Everything had been done to irritate and frighten the animals; plumes nodded from their heads, firecrackers spluttered at their tails, spikes dangled against their flanks. In their panic to escape across the starting rope into the empty street before them, they viciously kicked and reared, bit one another, and trampled the grooms holding them by the head and tail. The crowd waited in tense anticipation, all eyes on the struggling men and horses penned in at the start, where fearful manglings were likely to happen.[16]

Géricault presents the grooms in much the same way that he had presented the military figures of 1812–1814, through exaggeration of the markers of masculinity. For example, the groom with the green tunic, to the right in the Lille version of the subject (fig. 11), exhibits the same preoccupation with the profile of virility that informs the *Portrait of a Carabinier* (fig. 8): the beetling brow, aquiline nose, square jaw, and broad neck. The legs are subjected to a muscular inflation that makes them seem far stronger and more robust than those of the rearing horse,

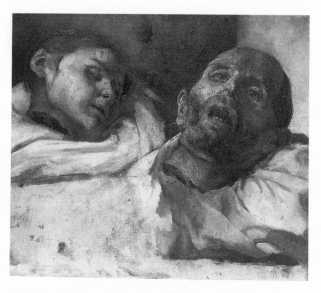

16. Géricault, *Severed Heads*. Stockholm, photo courtesy of
the National Museum.

whose form connotes, by contrast, a kind of animal delicacy. In the
Baltimore version of the *Race*, the grooms are given poses wherein the
legs are conspicuously spread out (fig. 12). Across a cultural code that is
perhaps still current, such a stance expresses (for both genders) a height-
ened statement of sexual identity; here the pose is pushed almost toward
the "splits" in a heightening that borders on the physically impossible
(the exaggeration of "masculinity" here falls just short of toppling and
collapsing). The fabric of tunic and hose models itself so closely to thigh
and calf (the fabric seems to have almost no thickness at all) that, even
more so than with the military costumes, the body shows through the
clothes.

In what sense are these images of masculinity rather than of, say, Itali-
anness, sport, or carnival? First, the activity they represent is entirely
confined to males. Second, the possession of the qualities that are thus
made exclusive to the male is under challenge: It is not the horses' mettle
that is being tested (here lies the difference from ordinary races) as much
as that of the grooms. And third, the images involve the whole process of
idealization and identification that I have tried to locate as particularly
intense within this period's formations of masculinity. Though Géri-

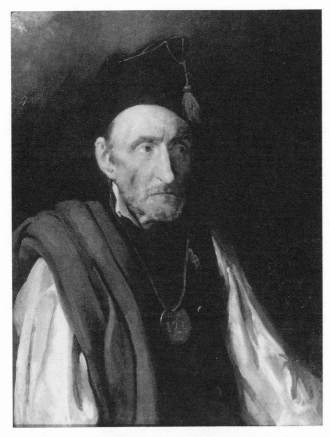

17. Géricault, *Man with Delusions of Military Command*.
Winterthur, photo courtesy Museum Stiftung Oskar Reinhart.

cault's early portrayals of the scene (for example, the Baltimore picture, fig. 12) are still anecdotal, with much picturesque detail of the course, grandstand, and spectators, what the series seeks is greater and greater idealization: The picturesque scene is refracted across, and corrected by, such obvious prototypes as Michelangelo and the Parthenon friezes (fig. 13). "Idealization" here is not only a matter of pictorial style but of a whole social and subjective economy of machistic yearning that measures the actual and real against the higher imago: The real Roman grooms, with their local costume and somewhat servant-like status, turn into athletes from classical Athens, or from Arcadia (in the version at

Rouen, fig. 14, their bonnets become antique Phrygian caps, they acquire Greek costume, or Greek nudity, and the horses they tame lose all connection with carnival, becoming steeds like Pegasus, manes rhyming with the clouds).

If *The Race of Riderless Horses* centers on the persistence of the quest for glamorized or glorified images of masculine identity, with *The Raft of the Medusa* (fig. 15) and its concomitant studies we are shown the negative side of that quest, a set of images circulating between idealization and abjection. In terms of its narrative, the *Raft* portrays a community from which all signs of the heroic have been removed and within which all remnants of the system of rank have broken down. In a reverse of the classic mutiny plot, where the lower ranks turn on the officers and captain, here the higher-ups in the chain of command have turned on their inferiors and have cast them onto the pathetically inadequate craft, leaving them to their fate. After the horrible experiences on the raft, the survivors exist in a space absolutely outside the civilized society of rank and position; they are human beings for whom the terms superior and inferior no longer have meaning. In the Salon picture (fig. 15) Géricault reworks this grim material in such a way that, even though the narrative speaks of a total loss of social order, at the level of its composition the image is re-ordered as an evident hierarchy, a pyramid at whose apex stands the figure whose gesture of signaling to the rescue ship literally returns the company to the civilized world. That is, perhaps, the deep contradiction in the *Raft*, between its narrative and its composition, so that a story of cruelty, murder, cannibalism, and complete loss of the social is reconfigured visually as the ordered and ideally functioning system that has now precisely broken down. Just as *The Race of Riderless Horses* continues to pursue the magnificent imago beyond the social conditions of its destruction in 1815, the *Raft* reorganizes the tale of aberration in terms of the formal conventions of the Salon history painting and a persistent idealization of the body that at times comes into open conflict with the narrative itself (a tale of starvation, with nevertheless idealized and aestheticized actors).

Yet accompanying this retroactive re-ordering or secondary revision are the *Raft*'s parallel studies, where the masculine body is contemplated in the light of the complete destruction of its coherent form (fig. 16). The male body is no longer able to produce any kind of phallic command or even any kind of ego-image, in Lacan's sense. The capacity of the Imaginary to lay the foundations of the subject in the form of a jubilant, heroic image ceases to exist, and the work of the Imaginary itself

grinds to a halt. What surfaces is the unconscious, which the magnificent imago had repressed in order to exist; the body sensed as incapable of generating any image at all, with that inadequacy presented now as the central feature of subjectivity—as its principal fact. The military portraits, like their surrounding culture, had used bodily magnificence as a prize so seductive that it might be worth sacrificing to it one's actual flesh. The glamor of the *corps glorieux*, with its promise of full phallic power, could override and outdazzle any rival sense of the body as fundamentally unable to live up to, or incorporate, the image's imperious demands. With that imago now politically as well as psychically ruined and obliterated, all that remains is flesh, mutilation, the carnage of the Napoleonic battlefield resurfacing in the Restoration as a historical memory that can no longer be warded off or held at bay by the constructed fiction of male *superbia*.

And finally, the portraits of the insane. To a great degree they remain a contradiction in terms. Typically, a portrait works to place the sitter's body in its proper persona—its exact place in the hierarchies of rank, wealth, and prestige, its precise location on the social map. But the insane are those who are off the social map, who have no place in the structure of rank, whose portraits in a sense cannot be painted. Normally portraiture builds on the subject's own creation of social "face," the façade the subject presents to the world, the image round which self structures its identity. But the insane of Géricault's portraits lack this capacity; they have lost the power to project image of any kind, or to build their subjectivity on its foundations. They lack "face" altogether, just as the severed heads and limbs lack "body." Or they produce face parodically, as in the picture known as *Man with Delusions of Military Command* (fig. 17), where one sees faciality that runs on automatic and cannot be stopped—perhaps Géricault's last word on the nature and the limits of the rôle of the image in the production of military identity.

We are now used to the idea of the male gaze as it positions the female as object for that gaze. What these images of Géricault suggest is the need to complicate that prevailing model. One is forced by the paintings themselves to account for the process of identification that, in the case of the male subject, is so fraught with disturbance. Male subjectivity cannot be considered as simply voyeuristic in its visual expressions, and we need to recognize the process of assuming male identification and subject position as an extremely complex negotiation, and one that opens, like all such negotiations, directly onto the field of history. The problem of identification that lies at the base of "masculine" formations of

the subject is vital territory for visual theory to explore, not only in its psychoanalytic but in its historical and visual constructions. In the linkage between the male subject, the male image, and the social hierarchy, one of the key components of the political order of patriarchy may, perhaps, be found.

NOTES

1. See Kaja Silverman, "Fassbinder and Lacan: A Reconsideration of Gaze, Look and Image," *Camera Obscura* 19: 55ff., reprinted in the present volume. Steve Neale, "Masculinity as Spectacle," *Screen* 24, 6; 2ff.; Mary Ann Doane, *The Desire to Desire: The Women's Film of the 1940s* (Bloomington, 1987).

2. Laura Mulvey, "Visual Pleasure and Narrative Cinema," *Screen* 16.

3. See Pierre Bourdieu, *Outline of a Theory of Practice*, trans. Richard Nice (Cambridge, England, and New York, 1977), 196.

4. See Kaja Silverman, *The Acoustic Mirror: the Female Voice in Psychoanalysis and Cinema* (Bloomington and Indianapolis, 1977), esp. chap. 4.

5. See Kaja Silverman, "Masochism and Male Subjectivity," *Camera Obscura* 17: 31ff.

6. Jacques Lacan, "The Mirror Stage as Formative of the Function of the 'I,'" in *Ecrits: A Selection*, ed. and trans. A. Sheridan (New York, 1977).

7. See J. Winkler, "Phallos Politikos," *Differences* 2, no. 1 (1990): 20–45.

8. Sigmund Freud, "Fetishism," in *The Standard Edition of the Complete Psychological Works of Sigmund Freud*, ed. James Strachey (London, 1953–73, 21: 311ff.

9. On Gros and Géricault, see L. Eitner, *Géricault: His Life and Work* (London, 1983), 30–33, figs. 2–5, and pl. 22.

10. See *The Age of Napoleon: Costume from Revolution to Empire: 1789–1815* (New York, 1989).

11. See R. Brunon, "Uniforms of the Napoleonic Era," in *The Age of Napoleon,* 179–201.

12. The bravura appearance of Prince Murat is described by an officer of the hussars who sketched him in 1811:

The king of Naples was tall and well-built, affable and genteel with everyone who approached him; his manners were polite and sometimes he talked in rapid, imperious bursts. His gait was brisk. He always wore pompous and flamboyant uniforms, something between a Pole and a Moslem, rich fabrics, contrasting colors, furs, embroidery, pearls, and diamonds; his

hair fell in wavy locks on his broad shoulders; he had black sideburns and shining eyes; all of this created an effect of surprise and made one think of a charlatan. But for all of his quirks, he had great qualities; his bravery defied belief; when he went into battle, it was like seeing one of those paladins of antiquity. . . . At the time I saw Murat in Naples, he was at the peak of his career; he was surrounded by the prestige of glory and royalty; his name was associated with all of the splendors of this marvelous epic and his presence inspired in the troops a driving force and an incredible enthusiasm. Quoted in ibid., 183.

13. Quoted in ibid., 192.
14. Quoted in ibid., 195.
15. Quoted in ibid., 194.
16. Eitner, *Géricault, His Life and Work*, 117.

Strategies of Identification

IDENTITY and alterity are key concepts in the hottest discussions in the humanities today. In the discipline of art history, "self" and "other" are being reflected on in diverging approaches, from historicism to gender studies. These concepts are hard to deal with because they are far from symmetrical in content and epistemological status. Tzvetan Todorov has argued in his *Nous et les Autres* that we-other relations such as nationalism and exoticism are always relativisms.[1] No fixed, concrete content is valorized or defended. Our own or the other culture only gains content in relation to the values of the observer. In the case of exoticism, the other culture is seen as superior to the culture of the observer. In the case of nationalism, the observer's country is seen as superior to the other country or countries. In both cases, the contents of "other" as well as "self" are fundamentally relative, and as such they can only be defined in relation to their other, to what they are not.

Because of this relativism, the concepts fail to be hermeneutically disentangled and substantiated. Any attempt at reading the other remains caught in evocations of utopian or feared self-images. Speaking about the self is not the equivalent of speaking about the other. The other is other because s/he is focalized by the self of the observer. While the self is in the position of subject of focalization, the other is by definition the object. The only way, in fact, to know the other is by letting the other speak about me, by giving the other the position of "I." When "I" speak about the other, I remain caught in the process of defining or demarcating my self-image.

This implies that the concept of alterity does not have the same status as that of identity. While "alterity" is a screen for the imagination, "identity" is the content of that imagination. Alterity and identity are not, cannot be, two signs, mutually differentiating in order to reach meaning; rather, alterity is a code that helps identity to become meaningful, that is, to gain content. Alterity, then, *is* nothing, has no meaning in itself. It is merely a device for producing meaning, and, since it is unacknowledged as such and would be disowned if this proper function of the term were brought to awareness, it cannot be innocently used.[2]

Since the social embeddedness of semiotic practice has, among other consequences, involved the researcher inevitably within his or her critical work, the above problem is acutely relevant to the newer currents in the history of art, of which social history and gender studies, both represented in this volume, are perhaps the most outspoken.[3] Here, as in the less self-reflexive modes of art historical writing, ideology is ultimately decisive in the preference for one interpretation over another. In art history, much effort has been invested in methodological reflection on how, precisely, to avoid such an involvement. For this reason, usually the historical context, social (Clark),[4] political (Crow),[5] or aesthetic (Baxandall)[6] and epistemological (Alpers, in *The Art of Describing*)[7] methodologies are given an almighty function, supposedly to cut off interpretation from the beliefs and interests of the interpreter.

I will explore the consequences and problems of this attitude toward the critic's involvement in her/his critical work as it has been presented in an essay in this volume, the one by Keith Moxey. I focus my examination of the tenets of this paper on (the representation of) otherness in terms of the past. The attitude demonstrated in Moxey's essay shows a tendency to identification that blurs the distinction between self and other so carefully set up. From there, I will move to the essay by Bryson as an example of the problem of alterity in gender-specific analysis. In contrast to Moxey's essay, Bryson's puts identification, not otherness, at the center. The question I will then broach is that of identification as a blindness to otherness, which, I will argue, connects gender to semiosis in a profound way, unnoticed by the author.

In spite of his theoretical statement on the need for semiotic theory in the social history of art—a statement to which I wholeheartedly subscribe—Moxey's interpretation of Bosch's work has an implicit ideological agenda of its own. Although he claims that the social embeddedness of semiotic practice has, among other consequences, that of inevitably involving the researcher in her/his work, Moxey refrains from declaring his own politics. Meanwhile, the historical, social context seems to be the overruling aspect in Moxey's interpretation. This strikes me as paradoxical.

Are we faced with an apparent contradiction between theory and practice, or, on the contrary, is Moxey's practice a case for his theory? I wish to assume that the latter is the case. As a consequence, then, the stress on the social context must itself be, or imply, an ideological gesture, demonstrating the critic's politics. The reading of the connections

between the two lines that I offer suggests the following as Moxey's politics: The localization of meaning in a work of art within the historical, social context of the work is not a matter of objective description of an historical cultural practice but of the ideological interests of the convictions that predominate today in the discipline of art history. But what kind of politics is served by such an historical interpretation of the work of Hieronymus Bosch?

Historical interpretation is based on the recognition that the past is different from the present. This main strength of historical interpretation can, at the same time, have a problematic side effect. An historical interpretation starts by assuming the strangeness or "otherness" of the particular horizon it seeks to understand. A fundamental abyss between the present and the past is claimed even before careful explorations of the past have been attempted. However wholesome such an a priori claim may be in the face of the well-known reluctance to accept otherness in our culture, it may entail just the kind of exclusion it seeks to avoid. And, as I will argue here, this exclusion results from the relativism such a claim inevitably entails. Relativism, as is well known, is a way of setting the other apart, divorcing her from "us" in a way that, although involving acceptance and respect, cuts off dialogue, comparison, and contamination for the benefit of our own uniqueness. In such relativistic distancing, relations with the past in the nature of repetition, similarity, or continuity—to name a few of the alternatives to radical alterity—are almost precluded by endorsing the dogma of the strangeness of the past.

This presupposition is, of course, an important move against the universalistic tendencies of a whole tradition in art and cultural history, of which Kenneth Clark's *Civilization* is perhaps the paradigmatic example. The fear of universals might, however, entice people inclined toward binary opposition to unquestioningly choose its extreme opposite—historicism—which, if practiced naively, might not exclude the kind of ethnocentrism or racism one wants to avoid. The presupposed otherness of the other, the past in this case, allows us, or might even encourage us, to project onto the past values or characteristics "we" do not consider to be part of our present-day self-image. An acute analysis of this particular problem is offered by Todorov's study *Nous et les autres* (1989), whose "*nous*" in the title cannot be taken ironically enough.

This problem has a lot to do with the opposition between the present and the past itself. While the homogeneity of the past seems unproblematic—enough, in any case, to "describe" or "map out" the past as a context for the images—a similar homogeneity of contemporary social

context would be an absurdity. This paradox could be countered by saying that heterogeneity is exactly characteristic for our postmodern era, or by saying that we only experience it as heterogeneous but that, given enough distance from it, we will perceive its homogeneity. These imaginary counterarguments, however, leave the supposed homogeneity of the past undiscussed.

It seems, however, that the homogeneity of the past is not so much a presupposition about what the past was like but an effect produced by the dominant tradition in art history that reads artefacts as determined, caused by its social context. It is the kind of conceptualization of the past, the presupposition of *a network of causal relations*, that leads necessarily to the idea of the homogeneity of the past. The idea of the homogeneity of a past social context is brilliantly criticized by Norman Bryson in his article "Art in Context."[8] He takes as an example Baxandall's chapter on "art historical forensics," which examines the engineer Benjamin Baker's Forth Bridge (1889). Baxandall compiles a list of twenty-four factors acting as the determinant context upon the bridge's construction. Bryson deconstructs Baxandall's argument, however, by showing that the list of determinants can be extended endlessly, something that Baxandall himself, in fact, already begins doing. The notion of determining factors becomes rather meaningless by that sheer possibility, and the homogeneous network of causal relations coming together in its visual manifestation, the work of art, is in its limitlessness reduced to the arbitrariness of heterogeneity.

The infinitude of the list of determining factors seems to be, however, rather theoretical. Moxey puts one important constraint on the endless proliferation of causal determinants by starting at the other side of the work of art. He looks, not at the complex of determining factors that produces the work of art, but at its reception by the original audience. Specifically, Moxey shows how the aristocracy who commissioned and possessed Bosch's paintings had humanist interests, notably concerning the place of painting within the liberal arts. This place influenced, in particular, the extent to which visual art was supposed to be mimetic. The records of their commentaries on the paintings show disenchantingly that the aristocratic patrons were as surprised by the fantastic scenes of Bosch's paintings as the twentieth-century audience is.

But although they failed to understand the specific imaginary, the authors of these records were able to connote the fantastic idiom in the context of humanist art theory. This interpretation has a striking effect on our current view of these paintings. The long tradition of Bosch criti-

cism, which has discovered all kinds of esoteric truths in these paintings, appears suddenly quite ridiculous by not being able to acknowledge the reception of the original audience.

Two questions can be asked now: First, is the authority bestowed upon the original audience in this approach an attempt to remedy the problems of reading the meaning of art in terms of its determining factors, and if so, how successful is that attempt? Second, since the original audience is part of the social context, what is its place therein? In other words, how homogeneous is that original audience? Moxey represents Bosch the artist as part of his audience. His intentions are presumed to be homogeneous with the response of his original audience. This assumption becomes clear when Moxey uses the humanist criticism of Bosch's contemporaries as an indication of how Bosch thought about his own work. He assumes that Bosch shared the values of those who first appreciated his paintings. Bosch is, in fact, his own original audience.

By implying the neat match between artist's and patrons' responses, Moxey seems to suggest that the artist provided his patrons more value for their money than he could be expected to give; the aristocrats ordered not only a painting but a response to it. Moxey thus seems to increase the power of the aristocrats over the artist. But, shrewdly, the latter foresaw what the former would like to get, so that the artist, in the end, gains power over his patrons. What increases in the bargain is, however, the homogeneity of the historical context in which Bosch worked.

Implicit in this analysis is the position of the twentieth-century critic in relation to this closed power system. The main thrust of the interpretation is the acknowledgment of the painting's strangeness. This strangeness, far from being a historical otherness, happens to match perfectly the reception of Bosch's work in the present. The enigmatic quality of these paintings remains the focus of the historical interpretation, just as it is the primary response to Bosch today. How different is that past, then, from the present?

To be sure, the denotation of the paintings—enigma, the failure to refer—may be the same for both present and past, but one can object that the connotation—the motivation for this interest in enigma—differs. The humanist patrons were interested in avoiding mimesis for the sake of promoting painting to the status of a liberal art. Today's amateurs of enigma would probably defend their taste by an appeal to originality, which has been for quite a while now the primary standard by which art is judged. How different are these motivations really?

Ultimately, I am tempted to see in Moxey's interpretation a politics of taste, where he is attracted to a case of the past because it has some sort of overlap with his own preferences or, at least, with a preference of his own time, the present. Far from making the present strange, then, he alleges that Bosch is strange to make it fit into the strangeness we are, today, so fond of. The relationship between Bosch and his patrons resembles that between contemporary artists and the buyers of their works. The artistic values of the emergent humanistic ideology are less strange to us than it might seem from Moxey's account.

Instead of making the past strange, identification with the past is the implicit desire in Moxey's reading of Bosch's paintings. And identification is not an arbitrary psychological process but is political in all its details. Another case from this volume demonstrates this most clearly: Norman Bryson's reading of Géricault and masculinity.

Bryson starts with Laura Mulvey (1979). Although Mulvey's theory of the voyeuristic male gaze has been complicated by many, it is still one of the main contributions to the discussion of the political construction of subjectivity in the visual domain. Her analysis of the gaze as a heterosexual optic in which the man is the bearer of the look and the woman is the image, the object of that look, is today an almost obligatory starting point for almost any critical discussion not only of film but also of other visual objects. Virtually any criticism or elaboration of Mulvey's theory has focused on the role and position of woman in this theory, which many believe to be simplified in Mulvey's model. A confrontation of her model with the issue of male identity—on the one hand, with the practice of the male look and, on the other hand, with the male as the object of that look—is very recent. Kaja Silverman's seminal article "Fassbinder and Lacan" proposes a radical revision of Mulvey's view through a most subtle reconsideration of the Lacanian concepts of the gaze and the screen.

Now, Norman Bryson's article "Géricault and 'Masculinity'" forces us to rethink radically the notion of the male gaze as simply voyeuristic. As he demonstrates, the need for a modification of Mulvey's theory becomes obvious as soon as we decide to deal with the male gaze focused upon another male. In the traditional model, two aspects of looking were analyzed: *voyeurism* is established as the central process and attitude in the male spectator's relation to the image of the female; and *identification* as the central process in the male spectator's positioning toward the image of the female. But what kind of process is at stake if a male spectator watches, say, the images of warriors by Géricault?

This simple question leads to the exploration of a neglected field: the complex negotiations of intermale identifications as a function of the construction of masculinity.

The first thing we need for such an exploration is a theory of identification. Strangely enough, although the concept of identification is absolutely indispensable in the disciplines of art history, film, and literary studies, more than common-sense ideas about identification are not available in these fields. Although Bryson does not present explicitly a theory of identification, his analysis of intermale identification gives us a much more complex image of identification than we usually get. In his article, identification is presented as a source of ambiguity and conflict. Bryson's reading of Genesis 9:20, the story of the drunkenness of Noah, is exemplary in this respect. He reads the problem caused by Ham's seeing his father's nakedness as symptomatic of the double command posed to the male child by the positive Oedipus. Although the boy has to identify with the father to form his sexual identity, he is not allowed to be like the father with respect to his sexual power. Father and son are both comrades and rivals. The latter aspect of their relationship, the interdiction to compete for, or to identify with, the sexually based power of the father, is mobilized in Bryson's interpretation of the story. This interpretation poses two problems, one concerning what is seen, and one concerning the relation between seeing and identification.

There is a taboo on seeing the father's genitals and identifying with the sexual power that according to Bryson, is embodied in his genitals. At the very moment that masculinity is produced by identifying with another male, the male position cannot be fully assumed. It is here that the lack of a sophisticated view of identification makes itself felt, and this is the first problem I have with this interpretation. After all, son-father identification can only be seen as a conflict if one presupposes that identification is something that happens between a person and another person. If it were possible to identify with just an attribute, an attitude, or a position of a person, or with a person without one of his attributes, attitudes, or positions, then identification with the father does not automatically include rivalry for his power. Ham's observance of the nakedness of his father would not put him in danger. He could identify with the position and authority of his father by screening out the genitals and the privileges that are connected to them. He would identify, then, with the father *in certain respects*.

This possibility is acknowledged by the psychoanalyst Laplanche in his differentiation of *kinds of identification* as proposed in his *Life and*

Death in Psychoanalysis (1970). He distinguishes kinds of identification according to the *object* of identification, the *process* of identification, and the *effect* of identification. The object can be a whole or a partial object. If it is a whole, one can identify with the whole as perceived or with the response to the whole. A partial object can be a part of the body, for instance, a face, a breast, or a hairy chest, but it can also be a trait of character or a moment, for instance, a very effective, authoritarian speech-act.

According to Laplanche, the process of identification can assume three forms. It can be a perceptual imprint, an image that the subject, after being impressed by it, cannot forget; or, it can be an introjection, an inward projection, or an identification with the position that the object occupies. The effect, finally, can be either definite—it has a permanent structuring function that determines the subject from a young age on—or temporary—a position through which the subject passes and that he subsequently works to readjust.

In my opinion, Laplanche's distinctions are centrally important to the theory of identification in the disciplines of the arts, hence, also, for any analysis of the complex negotiations of intermale identification in the construction of masculinity. His distinctions allow us to analyze this construction not as a conflict (which would, after all, leave unattended the question of its resolution) but *as negotiations that seek to prevent conflict*. The flexibility and variety of identification make these negotiations succeed in many, but not in all, cases and in a variety of ways, which accounts for the great variety in results. His distinctions also enable us to pay attention to the specific role of the *visual*, not only in the case of Noah's nakedness but also in Bryson's example of the non-nakedness of the officer amidst his naked soldiers. Here we approach the second problem I have with Bryson's interpretation. Why is it taboo to *see* the genitals of men who are in a position of power? I wish to contend that this is not because seeing them is appropriating their power but, rather, because seeing them annihilates and questions that power. This contention involves a central lesson of semiotic theory.

In Bryson's reading, perceiving the father's genitals is forbidden because of what they mean symbolically: sexual privileges and power. The genitals themselves are only a signifier; the object that (still) has to be excluded from the son's construction of masculinity is their signified sexual privilege. Son and soldiers are forbidden to see the genitals because that sight would automatically lead to identification with what the genitals *mean*. Such an identification would further construct their mas-

culinity, which implies the appropriation of the privileges and authority of the father.

In this reading, the visual aspect of the genitals is quickly turned into a general symbolic system. Let us refrain from symbolizing for just a moment and, instead, visualize what Ham in the story of Genesis has seen and what the soldiers probably would have seen if their officer had undressed completely. They would have seen male genitals. There is no reason to appropriate them, because these men already have them. But what else can be interpreted from the sight of the genitals of the father? I would say that, in the case of a showering officer or a father sleeping off his hangover, it is likely that the son will not see a proud penis as a motivated sign of patriarchal privileges, but rather will see a shriveled shrimp—a sign of an altogether different kind. Such a sight would make painfully clear that these privileges are arbitrary, imaginary.

Although father and officer hope—and their cultural position pre-tends—that their phallic power is signified—through iconicity—by their penis, they are afraid that the sight of their penis will show the opposite: the arbitrary, symbolic production of this particularly cru-cial meaning. Sons and soldiers, in the vein of the same ideology, will probably, after seeing the father's genitals, not question the relationship between power and penis but rather start to challenge the power of the father. Thus, the father may well fear that, rather than identifying *too totally* with him, the son will *refuse* to identify altogether with this un-impressive father, thereby undermining the very system through which patriarchal society functions. And this threat involves another threat, a threat to the domain of the visual and the illusions of wholeness *it* promotes. As I wrote earlier, the son can screen off just one part of the father's body and only look at the father, not at his penis. That possibility threatens the dream of wholeness on which the self-image of the male is predicated, even if its security has already been threatened by the visual experience of the little Oedipus seeing his mother. The interpretation of Ham's experience that might apply, and for which he is punished, is the one that follows the mirror-stage, that of the symbolic order where fracturation reigns and wholeness is only a dream-possibility that has to be negotiated time and again. For the father, this "adult" way of look-ing that his son must achieve is just too tricky; the fatherly penis must remain a dream-object so that it can remain a signifier.

In Bryson's reading, the act of perception, assumed to be holistic, is in itself already a coup d'état because it automatically gives access to the symbolic realm of the Phallus. But this reading is predicated upon

the assumption that there is something to see: that the visual somehow *is* iconic. In my reading, the act of perception is not so much a coup d'état, an appropriation within the same system, but a deconstruction, an undermining of the system as a whole, that is, a deconstruction of phallic power into something that is completely arbitrary because its mode of signification is. Thereby the visual image is much more dangerous and worthy of turning into a taboo.

This model changes the nature of identification at stake as well as its place. If identification is at issue in the story of Noah, it is identification with a moment: a moment wherein the naked arbitrariness of power is exposed. Such a moment of (in)sight would transform and reorient the male subject's future view of paternal power, including when he accedes to it himself. Therein lies the threat of this vision. The danger is much greater, much more radical than Bryson suggests. Therefore, that identification is, precisely, plainly, and without conflict, forbidden. What is forbidden is not identification with the father but with the semiotic that produces fathers. But then, the process does not take place between human figures, one real, one represented, but between a subject, the viewer, and an aspect of their culture.

Bryson's article as well as Mulvey's theory seem to presuppose that a certain degree of sameness is a precondition for identification to take place, and this sameness was, I argued, also the desire underlying Moxey's historicism. One must have a certain awareness of self to identify with somebody else, another self who is somehow similar. But how does this overlap of selves account for the excessively central place of the single, tiny body part, the penis, in this construction? The male spectator must know that he is a man in order to occupy the male position of voyeurism. Bryson's examples of the bodybuilder Arnold Schwarzenegger and of the Greek sculpture the *Discophoros* of Polykleitos both suggest, however, that the penis has an uncanny role in the male self-image and, subsequently, in intermale identification.

As the story of Noah shows, men hope that their phallic power and privileges are motivated by their penis. The control that is claimed at the symbolic level is, however, shamefully denied at the level of the male body. The penis, the locus of masculinity, is disturbingly unstable and uncontrollable, especially in visual terms. Its looks do not signify stability and control but instability and lack of control. The uncanny experience of the penis having a life of its own can even raise questions in the male subject about the degree to which he is the subject of his own penis. This male insecurity can be seen as the motivation behind body-

building. The desire to control the penis is displaced onto the body. As Bryson rightly points out, the inflated body becomes a metaphor for the penis. The gain within this rhetorical strategy is the control that the man gains over his body, which he does not have, or only in a limited degree, over his penis. If there is also a class motivation for bodybuilding, especially among lower-class men (which seems plausible—gaining control at the only place where they can get it), then Moxey's identification with Bosch's *aristocratic* patrons is a form of mental bodybuilding.

This issue of control suggests that it is easier to look like an erected penis than to have one. If gaining control is the motivation behind the desire to look like an erected penis, as evidenced by bodybuilding, then the male body in this image is a metonymically motivated metaphor of phallic power rather than a synecdochically motivated metaphor of that power. The penis, because the subject lacks control over it, is denied status as part of the self-image; it becomes alien, other, and is only laterally—metonymically—related to the self.

Bryson's analysis of the Greek sculpture seems to point to a comparable male experience of the penis as alien. One could argue, for instance, about whether the genitals are diminished, as Bryson claims, or not. What is the standard life size of a penis? Even the possibility of having such a discussion demonstrates that the penis is not a very stable signifier of masculinity. The most unstable extremity of the male body signifies, in an ironic reversal, the unmotivatedness of its symbolic potency. But if we decide to qualify the penis as diminished, then something more must be said about the fact that, in the classicist "canon of perfect proportions," the genitals must be diminished. Do diminished genitals make the male body more perfect, or is the perfect male body a displacement of the desired perfect penis, that is, a stable one? The similarities between this sculpture and the more extreme tradition of bodybuilding suggest that we opt for the second answer.

Again, we see that in the construction of masculinity, the penis plays a very uncanny role. The male subject seems to experience a yawning abyss between the qualities of his genitals and the symbolic privileges and power that are embodied in them. These particular problems of the male subject-in-construction are a bit cheerfully glossed over when we assume, as Bryson here and there seems to do, that identification is the definitive establishment of a similarity between two whole selves. With Laplanche, I suggest we endorse the fracturation of identification according to moment, to mode, and to body part so that we can acknowledge and understand (and perhaps question) that conflict is only

too often prevented or at least resolved through negotiation. With semi-
otic theory, I suggest we hold on to de Saussure's penetrating radicality
concerning the arbitrariness of the signifier-signified relation. But with
cultural reality in mind, it makes more sense to see the relation between
motivatedness and arbitrariness as one of tension, illusion, and des-
perate clinging rather than to project power even where—in drunken
fathers or showering officers—it is nowhere to be seen.

NOTES

1. T. Todorov, *Nous et les Autres: La réflexion française sur la diversité
humaine* (Paris, 1989).
2. These thoughts on alterity have been more extensively discussed in my
paper "The Other Within," in *Alterity, Identity, Image: Selves and Others in
Society and Scholarship*, ed. R. Corbey and J. Leerssen (Amsterdam, 1991).
3. I will focus the following analysis on two essays in this volume, to con-
venience the reader by providing a concrete and ready-at-hand example, and
because I find the two essays in question wonderfully illuminating. My critical
remarks on them should be seen as notes in the margins by an admiring and
inspired reader.
4. T. J. Clark, *The Painting of Modern Life: Paris in the Art of Manet and
His Followers* (New Haven and London, 1985).
5. T. Crow, *Painters and Public Life in Eighteenth-Century Paris* (New
Haven and London, 1985).
6. M. Baxandall, *Patterns of Intention: On the Historical Explanation of
Pictures* (New Haven and London, 1985).
7. S. Alpers, *The Art of Describing: Dutch Art in the Seventeenth Century*
(Chicago, 1985).
8. N. Bryson, "Art in Context," in *Studies in Historical Change*, ed. R. Cohen
(Charlottesville, 1992).

Fassbinder and Lacan:

A Reconsideration of Gaze, Look, and Image

I N this essay I will attempt to differentiate the gaze from the look, and hence from masculinity. I will also provide a theoretical articulation of the field of vision within which every subject is necessarily held.[1] Although the paradigm I will advance differs in many respects from that which has dominated film theory over the past fifteen years, my aim is less to displace than to complicate the latter, whose resources are still far from exhausted. Lacan is, of course, central to this double project; however, since the distinctions that I will attempt to draw depend as fully upon the cinema of Rainer Werner Fassbinder as they do upon *Seminar XI*, it is with that cinema and its exemplary refusals that I shall begin.

Although the descriptive phrase "aesthetics of pessimism" derives from Fassbinder himself,[2] it might well have been coined by one of his critics, who have commented in a variety of ways on the negativity that suffuses his texts. Tony Pipolo complains that Fassbinder's films do not "work to dispel that sense of helplessness so pervasive in the present atmosphere," that they generate an "enveloping negativity of affect," and that in them "conditions are generally depicted as virtually unchangeable and characters are denied the personal redemption of classical tragedy."[3] Richard Dyer accuses Fassbinder of left-wing melancholy and worries that "hardly anywhere" in his films "is there a notion of working-class, or women's, or gay, struggle, whether in the form of resistance . . . or revolution."[4] More interestingly, Wilfred Wiegand characterizes Fassbinder's cinema as "post-revolutionary" in that "it no longer steers a course for the naive pre-revolutionary dream of a better world, but . . . has absorbed the fragments of a negative historical experience."[5] And Thomas Elsaesser, as always Fassbinder's most astute reader, writes that identity in his films is "a movement, an unstable structure of vanishing points, encounters, vistas, and absences"— that "it appears negatively, as nostalgia, deprivation, lack of motivation, loss," and that characters "only know they exist by the negative emotion of anxiety."[6]

What all of these accounts point toward, although only Elsaesser manages to theorize it, is Fassbinder's radical refusal to *affirm*, his repudiation of positivity in any shape or form. His aversion to the fictions which make psychic and social existence tolerable is perhaps best dramatized by those films that put such fictions temporarily into play. *The Marriage of Maria Braun* (1978), for example, has been hailed as the story of a "strong and believable" woman who "comes to personify the triumph of the will,"[7] and whose life "stands as a symbol that another kind of life is possible."[8] However, the end of the film detonates this fantasy of the self-made woman, less through the match that Maria lights in her gas-filled kitchen than through the belated revelation of Oswald's arrangement with Hermann, an arrangement that hinges upon the exchange of a woman between two men, that is, that transaction which Luce Irigaray has shown to be at the center of the existing symbolic order.[9] *Jail Bait* (1972) also puts the torch to positivity, this time in the guise of the romantic love that ostensibly binds the adolescent protagonists to each other and motivates the murder of Hanni's father. Encountering Franz outside the courtroom where he is to stand trial for their joint crime, Hanni announces the still-birth of their child and dismisses their relationship as "only physical." *Mother Küsters Goes to Heaven* (1975) enacts a similar collapse of belief in the capacity of the left to deal adequately with an event like the murder by Hermann Kusters of one of his factory bosses and his subsequent suicide, providing in the process a searing portrait of political *méconnaissance* on the part both of the Thalmanns, wealthy members of the Communist Party, and Knab, the anarchist.

Few of Fassbinder's other films deviate even to this degree from an uncompromising negativity, occasionally irradiated but in no way mitigated by an extreme and irrational joy. More is at issue here than a refusal to provide affirmative representations of women, blacks, gays, or the left, although that is already a great deal given the intense preoccupation of Fassbinder's cinema with precisely those sexual, social, and political groupings. What is thus placed at risk is identity itself, which is no longer able to secure an "interior" foothold.

Identity, as psychoanalysis has taught us, necessitates an internalization of a series of things that are in the first instance external. Freud insists upon this principle with respect both to the ego and the superego, defining the former as the psychic mapping of what is initially a bodily image,[10] and the latter as the introjection of parental authority, in the guise, for instance, of the father's voice.[11] Lacan's account of the

mirror stage further elaborates this notion of an exteriority that is taken within the subject, first in the guise of its mirror image, subsequently in the form of parental imagoes, and later yet in the shape of a whole range of cultural representations, the *moi* becoming over time more and more explicitly dependent upon that which might be said to be "alien" or "other." [12] What Lacan designates as the "gaze" also manifests itself initially within a space external to the subject, first through the mother's look as it facilitates the "join" of infant and mirror image, and later through all of the many other actual looks with which it is confused. It is only at a second remove that the subject might be said to assume responsibility for "operating" the gaze by "seeing" itself being seen, even when no pair of eyes are trained upon it—by taking not so much the gaze as its effects within the self. However, consciousness as it is redefined by Lacan hinges not only upon the internalization but upon the elision of the gaze; this "seeing" of oneself being seen is experienced by the subject-of-consciousness—by the subject, that is, who arrogates to itself a certain self-presence or substantiality—as a seeing of itself seeing itself. [13]

What happens within Fassbinder's cinema is that both the gaze and the images that promote identity remain irreducibly exterior, stubbornly removed from the subject who depends upon them for its experience of "self." Elsaesser has touched upon the first of these exteriorizations in "Primary Identification and the Historical Subject: Fassbinder and Germany," although his emphasis falls more fully upon the exhibitionism of Fassbinder's characters than upon the gaze on which they depend:

> Their endless waiting wants to attract someone to play the spectator, who would confirm them as subjects, by displaying the sort of behavior that would conform to the reactions they expect to elicit. The audience is inscribed as voyeurs, but only because the characters are so manifestly exhibitionist. Substantiality is denied to both characters and audience, they derealize each other, as all relations polarize themselves in terms of seeing and being seen. . . . To be, in Fassbinder, is to be perceived, *esse est percipi* (p. 542).

The film through which Elsaesser pursues his thesis—and upon which Judith Mayne also focuses in her account of specularity in Fassbinder [14] —is *Ali: Fear Eats the Soul* (1973), but there are many other texts in that filmmaker's oeuvre where characters display themselves in this way to whomever will look and in which subjectivity is consequently shown to

depend upon a visual agency that remains insistently outside. "We are watched on all sides," the singer, Tripelli (Barbara Valentin) warns in *Effi Briest* (1974), a curse that turns into a lost source of sustenance when the socius finally looks away from Effi. The gaze is similarly omnipresent in *Mother Küsters Goes to Heaven*, represented this time precisely through the camera to which Lacan compares it in *Four Fundamental Concepts*. The passage to which I refer, which insists once again upon the alterity of the gaze, provides the basis for what I have elsewhere theorized as "the photo session,"[15] that is, the clicking of an imaginary camera that photographs the subject and thereby constitutes him or her. "What determines [the subject], at the most profound level, in the visible," remarks Lacan, "is the gaze that is outside. It is through the gaze that [the subject enters] light and it is from the gaze that [he or she receives] its effects. Hence it comes about that the gaze is the instrument through which light is embodied and through which . . . [the subject is] *photo-graphed*."[16]

Among the characters in *Mother Küsters Goes to Heaven*, only Corinna (Ingrid Caven) has reason to celebrate the illumination into which she is thrust, since she alone is able to meet the gaze halfway by offering herself as a spectacle to it. *Mother Küsters Goes to Heaven* thus suggests that some limited power is available to the subject who recognizes her necessary subordination to the gaze but finds potentially transgressive ways of "performing" before it. The title character (Brigitte Mira), on the other hand, repeatedly places herself guilelessly in front of a camera, confident that it will record her "true" essence and feelings, only to be constructed anew and in ways that never cease to appall her.

In a film made a year earlier than *Mother Küsters Goes to Heaven*, *Fox and His Friends* (1974), Fassbinder himself plays a character who is virtually haunted by the gaze, as if to call dramatically into question his own position of apparent visual control. That film begins with a crane shot down from the sky above a circus to the window of a police car waiting near the stage, where Fox the Talking Head (Fassbinder) and a group of female strippers are being introduced to the audience by Klaus (Karl Scheydt), the "ring-master." We thus look initially at Fox from the point of view of the police officers inside the car, whose eyes might be said to "stand in" for the gaze. After Fox wins the lottery, it is Max (Karlheinz Böhm), the antiques dealer, who takes over this function. He is shown conspicuously and at times ceremonially looking on while Fox meets Eugen (Peter Chatel), and Philip (Harry Baer) takes a

mud bath at a man's gym, and breaks up with Eugen. Max's presence is particularly resistant to a naturalistic reading on the last of these occasions; it is, indeed, inexplicable in any terms other than the specular. He silently accompanies Fox and Eugen as they descend the blue, neon-lit escalators of what is presumably a subway station, sometimes following at a distance, sometimes positioning himself in proximity to one of the other two characters, but always a necessary but diegetically redundant witness.

At least two other Fassbinder films suggest that it is no more possible to die without a confirming gaze than it is to assume an identity. Having fallen asleep in one of the empty offices in Saitz's apartment building, the central character of *In a Year of Thirteen Moons* (1978) is awakened by the entrance of a man attaching a rope to the ceiling of the room in order to hang himself. That man invites Erwin (Volker Spengler) to watch him die, and as he falls limply from the rope, the camera holds on Erwin's attentive face, back-lit against a lurid red. Similarly, the "Epilogue" to *Berlin Alexanderplatz* (1980) builds to a crescendo with the crucifixion of Franz Biberkopf (Gunther Lamprecht), an event that assumes the status of a specular extravaganza. Here it is not only the film's protagonist who is "on stage" but the gaze itself, dispersed across the crowd assembled around the cross in a range of historical costumes, their eyes and hands raised theatrically to the dying man.

Elsaesser argues that what is articulated through this constant foregrounding of the look is a subjectivity specific to fascism, whose prototype is "the German petit-bourgeois, identifying himself with the State, and making a public spectacle of his good behavior and conformism" (p. 544). Although I am reluctant to minimize any argument that facilitates an historical understanding of subjectivity, it does seem to me that this curious solicitation of the gaze has less to do with fascism than with Fassbinder's refusal to commute exteriority into interiority—his refusal, that is, to naturalize identity by concealing its external scaffolding.

Fassbinder's cinema does more than exteriorize the gaze; it also separates it from its usual support, the look, a dislocation that has extreme consequences for sexual difference. No character within that cinema, male or female, is ever represented as possessing the gaze, regardless of how central his or her look happens to be to the articulation of the visual field. What films like *Ali: Fear Eats the Soul* and *Fox and His Friends* oblige us to see is that, although the look of a character or a group of characters may masquerade as the gaze for another character, that im-

posture is made possible only through the propping of the look upon the gaze. *Four Fundamental Concepts* stresses not only the otherness of the gaze but its distinctness from what Lacan calls the "eye," or what I have been calling the "look." (The French language does not, of course, sustain my distinction, offering only one word—*le regard*—in place of the two primary English signifiers of vision: look and gaze.)

Although the gaze might be said to be "the presence of others as such," [17] it is by no means coterminous with any individual viewer or group of viewers. It issues "from all sides," whereas the eye "[sees] only from one point." Moreover, its relationship to the eye is sufficiently antinomic that Lacan can describe it as "triumph[ing]" over the look. [18] The gaze is "unapprehensible," [19] that is, impossible to seize or get hold of. The relationship between eye and gaze is thus analogous in certain ways to that which links penis and phallus; the former can stand in for the latter but can never approximate it. Lacan makes this point with particular force when he situates the gaze outside the voyeuristic trans-action, a transaction within which the eye would seem most to aspire to a transcendental status and which has consequently provided the basis, within feminist film theory, for an equation of the male voyeur with the gaze. [20] *Four Fundamental Concepts* suggests, on the contrary, that it is at precisely that moment when the eye is placed to the keyhole that it is most likely to find itself subordinated to the gaze. [21] At this moment, observes Lacan, "a gaze surprises [the subject] in the function of voyeur, disturbs him, overwhelms him and reduces him to shame" (p. 84). The subject who thus "feels himself surprised," Lacan adds, is the subject who is "sustaining himself in a function of desire" (p. 85). What this crucial passage from *Four Fundamental Concepts* suggests is that, if the gaze always exceeds the look, the look might also be said to exceed the gaze—to carry a libidinal supplement that relegates it, in turn, to a scopic subordination. The gaze, in other words, remains outside desire, the look, stubbornly within.

Fassbinder does more than distinguish between the gaze and the char-acters who at times function as its representative. He goes so far at times as to suggest an equation between "look" and "lack," thereby further complicating our understanding of cinema's scopic regime. His films oblige the look to acknowledge itself not only as a carrier of libido but as a signifier of castration. They refuse to cover over the void that is at the core of subjectivity, a void that gives rise not only to anxiety but to desire. In *Ali: Fear Eats the Soul*, for instance, there are characters whose look functions less to confirm or deny another's identity by standing in

for the gaze than to express an erotic yearning. It is in this way that the women stare at Ali in the bar he frequents and that Emmi watches him when he takes a shower in her apartment. Even more striking in this respect are the looks directed toward the figure of Franz (Harry Baer) in *Gods of the Plague* (1969), not only by Johanna (Hanna Schygulla) and Margarethe (Margarethe von Trotta) but by the waitress in the café he visits at the beginning of the film.

As Franz enters the café, the camera adopts a position to the waitress' immediate right, the viewfinder so close to her face that it almost grazes her skin (fig. 1). Franz stands at the counter to her left, using the telephone, behind her in the frame. Although the waitress only turns to look directly at Franz once in this lengthy shot (fig. 2), she is covertly watching him all the time, and the camera insists upon showing what she "sees." Her look is foregrounded again a few shots later as she places the fresh coffee on a table. Franz inserts a few coins in the jukebox, and the affect that has been produced through this foregrounding of the look finds expression with the first bars of "Here We Go Again," to which he and the waitress dance.

Beware of a Holy Whore (1970), which is organized almost entirely around one-way visual transactions, is another film in which the look circulates independently of the usual sexual boundaries and without any power to subordinate. Babs (Margarethe Von Trotta) and the makeup "girl" watch two men absorbed in conversation; Eddie Constantine watches Hanna (Hanna Schygulla); Irm (Magdalena Montezuma) watches Jeff (Lou Castel); Jeff watches Ricky (Marquard Bohm); and Ricky watches an unknown woman (Ingrid Caven) at the bar. The camera meanders from person to person, from group to group, sometimes by means of a cut, at other times through some aleatory movement that parallels the libidinal "drift." However, the syntactic element that most brilliantly evokes the operations of desire also anchors it intimately to the human look. The element to which I refer—a fast zoom in on the face of a watching character at a moment of pleasure, excitement, or shock—constitutes a reversal of one of the conventional signifiers of vision, a zoom in on what is seen. This reversal, which focuses attention upon the look rather than upon its object, brings the look emphatically within spectacle. The turning of the look back upon itself—the mimicry on the part of the camera of a scopic drive made suddenly to go "backward"—also suggests its inability both to reach and to subjugate its object and so inverts the usual scopic paradigm.

Whereas classic cinema equates the exemplary male subject with the

gaze and locates the male eye on the side of authority and the law, even when it is also a carrier of desire, *Beware of a Holy Whore* not only extends desire and the look that expresses it to the female subject but makes the male desiring look synonymous with loss of control, dramatized in the film through hysterical outbursts and the reckless consumption of alcohol. It might thus be said doubly to "feminize" erotic spectatorship, and this despite the fact that the male character who is placed most emphatically on the side of desire is also the director of the film within the film. When, near the conclusion of *Beware of a Holy Whore*, the cameraman comes to the director, Jeff, and asks him for instructions about the next day's "shoot," Jeff shows him by holding an imaginary viewfinder in his fingers. Here is the male eye standing in once again for the gaze, but off-handedly and even irritably, as if asked to perform a role in which it can no longer believe. For most of the film, Jeff is either engaged in histrionic displays worthy of Petra von Kant—displays that locate him decisively on the side of the spectacle—or impotently looking at and brooding upon the one figure who eludes his amorous calculations.

Fassbinder further denaturalizes identity by emphasizing at every conceivable juncture its imaginary bases. He thus never misses an opportunity to point the camera at a character's mirror reflection rather than at the character himself or herself, and he shoots almost compulsively through windows as if to deny any possibility of a direct or immediate access to the object of the camera's scrutiny. In *Despair* (1977) and *Nora Helmer* (1973) the windows are lavishly etched, this ornamentation working against the illusion of depth that represents such an important part of the cinematic *vraisemblance*—against that "impression of reality" to which the classic film aspires. A dazzling series of shots from *Chinese Roulette* (1976) complicates the paradigm further by substituting glass display cases for windows, thus giving glass a three-dimensionality that the characters themselves lack.

As Elsaesser remarks, Fassbinder's characters also "endlessly try to place themselves or arrange others in a configuration that allows them to reexperience the mirror stage" (p. 543). One thinks in this respect not only of Erwin's excitement upon seeing the photograph of himself in the magazine that publishes his interview, a photograph that affords a momentary conviction of identity, but the desperate attempts on the part of Veronika Voss (Rosel Zech) to orchestrate lighting and music in such a way as to create the impression that she "really" is the star that her publicity stills declares her to be. There is also the celebrated moment in

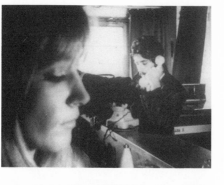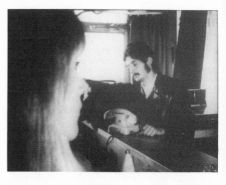

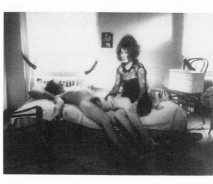

Lili Marlene (1980) when Willi (Hanna Schygulla), lying on the bed in her newly acquired white apartment and basking in the borrowed glory of her stage persona, kisses her own image in the mirror in a euphoric double *méconnaissance*.[22] In a much earlier film, *The American Soldier* (1970), a homosexual gypsy named Tony El Gitano (Ulli Lommel) attempts to seduce Ricky (Karl Scheydt), the Killer, without recourse to the usual lures of touch, smell, or taste. Instead, he undresses in front of a mirror, with his back to Ricky, as if to suggest that he is offering his image in place of his body (fig. 3). Significantly, El Gitano's subsequent death is recorded as precisely the loss of this reflection; as Ricky fires his gun, El Gitano falls to the bed, leaving his fantasmatic murderer in sole "possession" of the mirror.

However, it is *Gods of the Plague* that holds subject and ideal image at the most extreme distance from each other and that, hence, attests most eloquently to the latter's recalcitrant exteriority. Pinned on the wall over Margarethe's bed is an enormous poster of a blonde woman's face, presumably a blown-up advertisement (fig. 4). The face bears a sufficiently close resemblance to Margarethe to make evident even to the casual viewer that the poster represents the mirror in which that character sees herself. However, whenever Margarethe appears in the same frame as the larger than life woman, she is not only dwarfed but diminished by the comparison. This image is also central to the film's libidinal transactions. At a key moment in the film, Gunther (Gunther Kaufmann), Franz, and Margarethe form an intimate group in Margarethe's bedroom prior to having sex and talk about traveling to Greece. "We don't need money," says Franz, and Gunther adds, "because we're in love." As Gunther utters these words, he embraces the poster above the bed, his body held in a spread-eagle position against the female face (fig. 5). This telling gesture suggests that it is not just Margarethe who views herself through that idealizing portrait, but Gunther and Franz as well—that it is the cause and support of love, the terrain across which the two men meet.

Opposite page:

1. Fassbinder, from *Gods of the Plague*. 2. Fassbinder, from *Gods of the Plague*.

3. Fassbinder, from *The American Soldier*. 4. Fassbinder, from *Gods of the Plague*.

5. Fassbinder, from *Gods of the Plague*. 6. Fassbinder, from *Gods of the Plague*.

7. Fassbinder, from *Gods of the Plague*. 8. Fassbinder, from *Gods of the Plague*.

Margarethe is not the only character in *Gods of the Plague* who sustains her identity through constant reference to an external representation. Johanna (Hanna Schygulla), who is a chanteuse in a bar called the Lola Montes, keeps a movie poster in her dressing room that depicts a still photograph of Marlene Dietrich, prototype of all of Fassbinder's torch singers, in what would appear to be *The Devil Is a Woman* (fig. 6). Later in the film, Franz and Margarethe go into a shop to buy a poster that they pin up in the hall of their apartment and that henceforth serves as *his* narcissistic support—a poster, that is, of King Ludwig, an epicene, historical "personality" whom Baer, the actor playing Franz, would subsequently go on to perform in Syberberg's film, *Requiem for a Virgin King* (1972).

The insistent specularization of the male subject in Fassbinder's cinema functions not only to desubstantialize him but to prevent any possibility of mistaking his penis for the phallus, a dislocation that is at the center of Fassbinder's "aesthetics of pessimism." There is ultimately no affirmation more central to our present symbolic order yet, at the same time, more precariously maintained than the fiction that the exemplary male subject is adequate to the paternal function. This affirmation rests upon the negation of the negativity at the heart of all subjectivity— a negation of the lack installed by language and compounded in all sorts of ways by sexuality, class, race, and history. Fassbinder not only refuses to give us male characters who might in any way be eligible for "exemplariness," focusing always upon figures who are erotically, economically, and/or racially marginal, but he obsessively de-phallicizes and at times radically de-idealizes the male body, a project that at least in one film—*In a Year of Thirteen Moons*—leads to a corresponding psychic disintegration expressive of the absolute annihilation of masculinity.

Although an extremely early film, *Gods of the Plague* is, in this respect, fully congruent with Fassbinder's later texts. Franz Walsh, innovatively rendered by Baer, can perhaps best be characterized as a "limp" male subject. He holds himself as though he were literally bereft of "backbone," whether walking on the street or sitting at the dinner table, and at one point he huddles on the floor in an infantile posture for at least three minutes of screen time, listening to a nonsensical children's record. As is so frequently the case in Fassbinder's films, Franz's character is metaphorically reinscribed through an inanimate object, a rag doll that hangs lifelessly from the ceiling of Margarethe's hall (fig. 7).

An important scene near the beginning of the film speaks even more eloquently to Franz's flaccidity. Rescuing him on the street from a group

of angry assailants, Magdalena takes him home with her and attempts to seduce him. Franz remains completely inert, despite Magdalena's best efforts, but eventually she maneuvers him onto the bed, where she struggles with his remaining items of clothing. Two extraordinary shots describe what is, in effect, a sexual pietà: In the first one, Franz sprawls on the bed to the left of Magdalena, his legs on her lap (fig. 8). A reverse shot follows, unmotivated by any diegetic look; in it, the camera takes up a position on the other side of the bed so that Franz's head occupies the right front frame and Magdalena's, the left rear frame (fig. 9). This second shot accentuates the unnatural, almost Mannerist deployment of the male body, which connotes a passivity akin to death. Franz's eyes are turned away from the woman who holds his lower limbs, and, as both shots indicate, his penis is completely detumescent.

Ali: Fear Eats the Soul articulates the marginality of its central male character according to a different logic than does *Gods of the Plague*, focusing upon an Arab *Gastarbeiter* rather than a member of the German underclass. Once again, however, it is the male rather than the female body that constitutes the object of cinematic fascination, and once again that body is stripped of the usual accoutrements of masculinity. *Ali: Fear Eats the Soul* displays both to the diegetic and the extra-diegetic eye a body that is barred, by virtue of its skin pigmentation, from representing the phallus, at least within the film's contemporary German context. However, if that body is the privileged object of the gaze, it has the same status for the look; it is the locus, that is, of libidinal investment as well as a kind of social surveillance. (The same, I should note, could also be said of Franz in *Gods of the Plague*, whose "limpness" paradoxically makes him the cynosure of all female eyes.)

In a crucial scene late in *Ali: Fear Eats the Soul*, the camera takes up residence in the bathroom of Emmi's apartment while Ali (El Hedi Ben Salem) showers. Although we are made visual accessories to that event, we are never permitted to glance directly at Ali; the film shows only the image of his body reflected from the thighs up in an obliquely angled mirror hanging on the wall next to the medicine cabinet (fig. 10). As in *The American Soldier*, *Ali: Fear Eats the Soul* thus suggests that it is not so much the body itself as the representation of the body that constitutes erotic spectacle, and once again, the form that that representation takes is almost classically feminine. This shot of Ali's mirror reflection is repeated four times, with slight variations. After its first citation, which remains unclaimed by any diegetic onlooker, Emmi (Brigitte Mira) enters the room, and what we see is henceforth what she osten-

sibly sees (fig. 11). Her only remark—"You're very handsome"—makes explicit the desire in her look. Ali smiles at her in the mirror, with the modesty of someone whose pleasure in himself is entirely dependent upon the pleasure another takes in him, in a re-enactment of that peculiarly non-narcissistic "narcissism" that Freud associates with the classic female subject. (In one of his metapsychological essays, Freud observes of "such women" that they love themselves "with an intensity comparable to that of the man's love for them."[23])

The second scene that works both to specularize and to sexualize Ali occurs after he and Emmi return from their vacation, and in it the desiring look is complexly imbricated with the gaze. Emmi invites two of her co-workers up to her apartment and introduces them to her husband. The women circle Ali, touching his biceps while murmuring, "Terrific, . . . and such nice, soft skin" (fig. 12). It is not only the attention they lavish on the black man's body that de-phallicizes him—an attention that strays far from the organ to which male identity is pinned, dispersing itself across the entire body in a reprise of female sexuality—but the way they exchange him amongst themselves. If many of Fassbinder's other films abound with scenes over which "Women on the Market" might well be emblazoned, this scene should surely be entitled "Man on the Market."

The film's tone toward all of this is heavily ironic, but the camera itself insists upon Ali's specular status in a closely adjacent scene. Distressed by his treatment at the hands of Emmi and her colleagues, he abruptly leaves home, ending up at the apartment of Barbara (Barbara Valentin), owner of the Arab bar. The first shot inside that apartment shows him, in extreme long-shot, sitting on Barbara's bed, his head downcast (fig. 13). Because the camera is situated in the hallway, outside the doorway of the bedroom, and because the bed is placed in front of orange curtains that frame both it and a wide window, Ali is doubly framed, even—one might say—"on-stage."

In the next shot of the same room, which represents a later point in time, Ali lies on the same bed, face down. As Barbara enters the apartment and goes into the bathroom to wash, Ali stands, undresses, and faces the camera with his arms slightly raised as if offering himself up to the gaze (fig. 14). Barbara enters the frame from the left, turns off the light, walks over to Ali, briefly embraces him, and falls down on the bed with him. Illuminated by a shaft of light, Ali can be seen to lie passively on top of her. The shot continues for approximately sixteen more seconds, during which nothing moves but Barbara's arm.

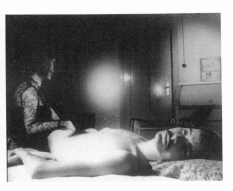

9. Fassbinder, from *Gods of the Plague*.

10. Fassbinder, from *Ali: Fear Eats the Soul*.

11. Fassbinder, from *Ali: Fear Eats the Soul*.

12. Fassbinder, from *Ali: Fear Eats the Soul*.

13. Fassbinder, from *Ali: Fear Eats the Soul*.

14. Fassbinder, from *Ali: Fear Eats the Soul*.

A number of questions pose themselves with a certain insistence at this juncture: What is the relationship of the erotic specularization of Ali to the gaze that both sustains him as subject and appears as the agency of his social oppression? Is it a simple extension of that gaze, or a form of resistance to it? And how are we to read the conclusion of the film, which reunites Emmi to Ali only by confining the second of those characters to a hospital, apart from its obvious reference to the final scene of Douglas Sirk's *All That Heaven Allows* (1955)?

I suggested earlier that, unlike the gaze, the look foregrounds the desiring subjectivity of the figure from whom it issues, a subjectivity that pivots upon lack, whether or not that lack is acknowledged. In the scene involving Emmi's co-workers, the look attempts to deny the void upon which it rests both through a sadistic identification with the gaze and through the projection of insufficiency onto Ali. However, in the scene in Barbara's apartment, the gaze, as inscribed through the elaborately framing shots of a camera that initially insists upon its autonomy from human vision, is redefined through its alignment with Barbara's desiring and accepting look. Although the film specularizes and eroticizes Ali, and in the process further feminizes a character who is already, by virtue of his blackness, estranged from dominant representation, it also directs desire toward him through the agency of the look.

I say "directs desire toward him" rather than referring to Ali as the "object of desire" because that latter rhetorical construction has encouraged what seems to me a gross misunderstanding of how women are represented within dominant cinema, a misunderstanding that I am reluctant to extend to the figure of Ali. If feminist theory has reason to lament that system of representation, it is not because woman so frequently functions as the *object* of desire (we all function simultaneously as subject and object), but because the male look both transfers its own lack to the female subject and attempts to pass itself off as the gaze. The problem, in other words, is not that men direct desire toward women in Hollywood films but that male desire is so consistently and systematically imbricated with projection and control. *Ali: Fear Eats the Soul* begins to make it possible to distinguish between those two things by differentiating, as it at times does, between the look and the gaze.

It is perhaps obvious by now that there is still a missing term in this analysis, a term capable of accounting for the social meaning that is assumed by Ali's body even at moments when there is no diegetic viewer present, such as the hallway shot I discussed a moment ago. The gaze confirms and sustains the subject's identity, but it is not responsible

for the form that identity assumes; it is merely the imaginary apparatus through which light is projected onto the subject, as Lacan suggests when he compares it to a camera. We have yet to account for the agency that determines what the viewer sees when he or she adopts a position behind the "camera," if I may extend Lacan's metaphor—for what makes Ali, for instance, the very "picture" of social and sexual marginality. My search for this missing term always leads me back to the same three diagrams from *Four Fundamental Concepts* (see pp. 91 and 106), diagrams that also further clarify the relation of subject to gaze:

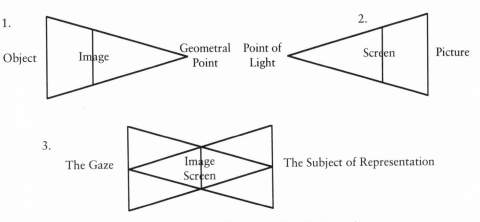

Diagram 1 appears at first to offer a very familiar paradigm, one perfectly in keeping with traditional accounts of geometrical perspective. The site marked "geometral point" would seem to designate the place from which the artist would survey the object to be painted, through the mediating frame of the image. Alberti, whom one can imagine deploying exactly the same diagram, would account for the image as that transparent pane of glass through which the Renaissance artist was to see the object and onto which—the pane of glass turning into a canvas— he was to draw it.[24] This account of geometrical perspective conflates eye and gaze; the artist serenely surveys the world, whose optical laws he commands.

Lacan, however, whose work stands as a monumental challenge to all such notions of mastery and immediacy, clearly wants us to understand both image and geometral point rather differently. Diagram 1, which articulates the field of vision from the point of view of the one-who-looks, situates the looking subject at the site marked "geometral point." In occupying this position, the eye emerges from what Lacan

calls the "function of *seeingness*" (p. 82), which both precedes and ante-dates it and thus always exceeds it. Rather than representing the locus of mastery, the geometral point is only a "partial dimension in the field of the gaze" (p. 88), one constituted by the straight lines along which light moves. Lacan further diminishes the importance of the perspec-tival model by suggesting that it has so little to do with vision that it could be understood by a blind man—that it has less to do with vision than space. He also goes on to stress the irradiating properties of light over those that ostensibly convey the object to the viewer. Finally, as we will see, he shows that the intervening image has nothing in common with Alberti's pane of glass. Consequently, to the degree that the viewer imagines him or herself the agent of vision, he or she is caught within the snares of a scopic Cartesianism, held prey to the belief that "seeing" constitutes "being" (p. 86).

A peculiar feature of geometrical perspective encourages a further deconstruction of the Albertian paradigm, one very much in the spirit of *Four Fundamental Concepts.* That visual system works by inverting the triangle articulated in diagram 1. Whereas the latter fans out from the geometral point, the constitution of depth of field within visual rep-resentation requires that linear planes that are widely separated in the foreground converge at a seemingly distant vanishing point. That van-ishing point might thus be said to reinscribe the geometral point into the "far" reaches of the representation. In so doing, it calls radically into question the possibility of separating vision from the image—of placing the spectator *outside* the spectacle, in a position of detached mastery. The gaze thus gives way to the eye, and the eye, perhaps even more drastically, to the geometral point, for at the juncture where planar lines converge within a perspectival painting, drawing, or photograph, it is precisely the viewer him or herself who might be said to "vanish" or "fade away." All that remains is the inverted inscription of that triangle that pre- and post-dates the subject, what might be called the viewer as function. Lacan's reading of Holbein's *The Ambassadors* thus provides an implicit metacommentary not only on the irreducible alterity of the gaze but on the disappearance of the viewing subject at the perspec-tival vanishing point. Holbein's painting, he explains, "makes visible for us . . . the subject as annihilated in the form . . . of castration. . . . It reflects our own nothingness, in the figure of the death's head" (pp. 88–89, 92).

Lacan does not say whether diagram 1 is to be understood primarily as a mapping of the viewer's visual relation to the object or as a mapping

of his or her relation to the image. However, since it is impossible to see the object except through the image, both are presumably at issue. Diagram 1 would thus seem to constitute a vehicle for articulating the viewer's relation both to "reality" and to that by means of which we apprehend it.

Diagram 2 represents the subject no longer as the viewer standing at the site of the gaze or geometral point but rather as the object of the gaze. (It is crucial to understand that for Lacan it is impossible to occupy the first of these triangles without being imbricated at the same time in the second, which is the chief reason why he superimposes them in diagram 3.) In diagram 2, the gaze is indicated through the radically disembodying and de-anthropomorphizing phrase, "point of light," which conjures up once again the metaphor of the camera. Although the point of light occupies the apex of the second triangle, as does the geometral point in triangle 1, the two are not to be equated. Diagram 2 *inverts* diagram one, situating the subject at the *wide* end of the triangle. In positioning the subject at the site of the "picture," Lacan thus indicates that he is now concerned with that figure as *spectacle* rather than as viewer.

Intervening between gaze or "point of light" and subject or "picture" is something that corresponds spatially to the "image" in diagram 1, but which Lacan dubs the "screen." Although *Four Fundamental Concepts* does not here explicitly invoke Alberti, one of the definitions it offers of the screen opposes it implicitly to the latter's transparent pane of glass. The screen, Lacan insists, is opaque and hence intraversible (p. 96). The subject who occupies the site of the picture thus seemingly has no choice but to assume the shape predetermined by the screen. (As *Seminar XI* puts it, "if [the subject is] anything in the picture, it is always in the form of the screen" [p. 97].) In a later passage, Lacan characterizes the screen, in terms that are directly reminiscent of the mirror stage, as an "imaginary" mapping (p. 107). At the same time, though, *Four Fundamental Concepts* makes clear that more is at issue here than the dyadic relation of the subject to its literal reflection. Diagram 2 is, instead, centrally concerned with the process whereby the subject assumes the form of a representation or—to state the case somewhat differently—*becomes a picture*, a process that involves *three* rather than *two* terms: subject, screen, and gaze.

The screen cannot be understood apart from the closely linked concept of mimicry, which Lacan loosely derives from Roger Caillois. In "Mimicry and Legendary Psychasthenia," Caillois attempts to account theoretically for the process whereby certain insects assume the mor-

phology and coloration of other insects or plant life. Since predators are not deceived by this mimicry, Caillois dispenses quickly with the notion that it serves defensive purposes. He argues instead that it attests to a "disturbance in the perception of space."[25] The "overwhelming tendency to imitate" found in primitive organisms (p. 27) speaks to a *"depersonalization by assimilation to space,"* hence to a "decline in the feeling of personality and life" (p. 30). For the author of "Mimicry and Legendary Psychasthenia," mimicry involves taking a step backward in the chain of being, retreating toward a "reduced existence" (p. 32).

Significantly, Caillois at one point describes mimicry as a photography at the level of the object rather than at that of the image— as "a reproduction in three-dimensional space with solids and voids: sculpture-photography or better *teleplasty*" (p. 23). Although he here omits to indicate the apparatus through which this unusual photography occurs, his account of the process whereby an organism assumes the appearance of something external to itself resonates within *Four Fundamental Concepts*. Lacan at one point illustrates mimicry—and hence the subject-screen relation—through an example that is drawn directly from Caillois:

> Let us take an example chosen almost at random, . . . that of the small crustacean known as *caprella*. . . . When such a crustacean settles in the midst of those animals, . . . what does it imitate? It imitates what, in that quasi-plant animal known as the briozoaires, is a stain—at a particular phase of the briozoaires, an intestinal loop forms a stain, at another phase, there functions something like a colored centre. It is to this stain shape that the crustacean adapts itself. It becomes a stain, it becomes a picture, it is inscribed in the picture. This, strictly speaking, is the origin of mimicry. And, on this basis, the fundamental dimensions of the inscription of the subject in the picture appear infinitely more justified than a more hesitant guess might suggest at first sight. (p. 99)

Finally, Lacan emphasizes, with Caillois, that mimicry serves no inherently protective purpose. As the passage I have just quoted would suggest, however, the uses to which *Four Fundamental Concepts* puts the concept of mimicry exceed Caillois' model.

In the first of the senses in which Lacan uses the word, mimicry signifies not assimilation to space, or the loss of individuation, but rather a *visual articulation*. As diagram 2 indicates, that visual articulation is effected at the moment the subject is "photographed" in the guise of the screen. Lacan says of this kind of mimicry not only that it involves the

reproduction of an image but that, "at bottom, it is, for the subject, to be inserted in a function whose exercise grasps it" (p. 100). He thereby suggests that it hinges less upon parody or deformation than upon the passive duplication of a preexisting image.

Four Fundamental Concepts posits a second kind of mimicry, but one that is presumably fully available only to the subject capable of acknowledging the split between its "being" and its "semblance," or, to put the matter somewhat differently, between its "being" and its specular image. Whereas Lacan extends the first kind of mimicry to the entire animal kingdom, he maintains that the second kind, which he associates with "travesty, camouflage, [and] intimidation" (p. 99), is limited to the human subject: "Only the subject," we are told, "—the human subject, the subject of the desire that is the essence of man—is not, unlike the animal, entirely caught up in this imaginary capture. He maps himself in it. How? In so far as he isolates the function of the screen and plays with it. Man, in effect, knows how to play with the mask as that beyond which there is the gaze. The screen is here the locus of mediation" (p. 107).[26] This passage reiterates the defining and structuring role of the screen, while at the same time implying that it might be possible for a subject who knows his or her necessary specularity to exaggerate and/ or denaturalize the image/screen; to use it for protective coloration; or to transform it into a weapon. *Four Fundamental Concepts* thus provides one of those rare junctures within the Lacanian oeuvre where it becomes possible to impute to the subject some kind of agency, albeit one hedged about with all kinds of qualifications and limitations, not the least of which is the impossibility of that subject ever achieving either self-presence or "authenticity."

Lacan's third diagram explicitly conflates the image in diagram 1 with the screen in diagram 2. The slippage between those two terms suggests to me that by "screen" he in fact means the image or group of images through which identity is constituted. What we are asked to understand by this last diagram is that it is at the level of what is variously called the "image" and the "screen" rather than at that of the gaze that the subject's identity is established. Since the gaze is ultimately no more than what diagram 2 calls a "point of light," it has no power to constitute subjectivity except by projecting the screen onto the object. In other words, just as Lacan's infant can see him or herself only through the intervention of an external image, the gaze can "photograph" the object only through the grid of the screen.

Although *Four Fundamental Concepts* does not do so, it seems cru-

cial that we insist upon the ideological status of the screen by describing it as that culturally generated image or repertoire of images through which subjects are not only constituted but are differentiated by class, race, sexuality, age, and nationality. The possibility of "playing" with these images then assumes a critical importance, opening up an arena for political contestation. Lacan indicates some of the forms that contestation can assume when he defines the screen through one of those proliferating catalogues of nouns of which he is so fond. It is, we learn, "something . . . like a mask, a double, an envelope, a thrown-off skin, thrown off in order to cover the frame of a shield," which "the being *gives of himself*, or *receives from the other* [my emphasis]" (p. 107).[27] *Four Fundamental Concepts* thus suggests once again that the screen can assume the status of a shield or defensive weapon. Alternatively, it can become a "lure" or a tool of seduction in a battle of friendlier persuasion. Elsewhere in the same passage, Lacan maintains that mimicry can even assume the proportions of a "struggle to the death" (p. 107).

It is imperative that we keep in mind when reading *Four Fundamental Concepts* that the subject can only be "photographed" through the frame of culturally intelligible images. Those attempts at a collective self-redefinition that rely upon masquerade, parody, inversion, and bricolage will consequently be more successful than those aimed at the *ex nihilo* creation of new images, since they work upon the existing cultural imaginary. It is presumably for this reason that Lacan speaks of "playing" with the screen rather than replacing it with a new one. In positioning its practitioners so tensely in relation both to dominant representation and the gaze, these strategies also work to maintain a productive distance between the subject and its "self," a distance that is indispensable to further change.

The third diagram goes even further in its deconstruction of the eye than I have so far suggested, necessitating, in the process, a still more drastic reformulation of the paradigms through which we have recently theorized cinema's scopic regime. Lacan speaks at one point in *Four Fundamental Concepts* about the "pulsatile, dazzling and spread out function of the gaze" (p. 89), a function that is implicit in the latter's status as light and that helps to explain why it must be represented not only as the narrow end of one triangle but as the wide end of the other. But more is at issue here than the dispersibility of light. Diagram 3 insists once again upon the non-coincidence of the look and the gaze, not simply by showing the former to be at most a representative of the latter but by situating the one at the opposite pole from the other. Lacan

actually goes so far as to locate the gaze at the site at which the first diagram places the *object* of vision, and the verbal text provides additional confirmation that this is indeed how we are to understand the superimposed triangles of the subsequent diagram. "The phenomenologists have succeeded in articulating with precision, and in the most disconcerting way," remarks Lacan in "Anamorphosis," "that I see *outside*, that perception is not in me, that it is *on the objects that it apprehends* [my emphasis]" (p. 80). Elsewhere, in *Seminar XI*, Lacan makes clear that what is at issue in diagram 3 is the conflation of gaze and spectacle, a conflation that is made on the basis of what might be called the spectacle's "lit up" quality. Through the luminousness that imparts specularity to the object, it in effect looks back at the viewer, much like the sardine can in Lacan's anecdote:

> . . . can we not . . . grasp that which has been eluded, namely, the function of the gaze? I mean, and Maurice Merleau-Ponty points this out, that we are beings who are looked at, in the spectacle of the world. . . .
> The spectacle of the world, in this sense, appears to us as all-seeing. (pp. 74–75) [28]

Lacan goes on a moment later, in a passage of staggering implications for film theory, to compare the gaze not to the male look but to woman-as-spectacle:

> At the level of the phenomenal experience of contemplation, this all-seeing aspect is to be found in the satisfaction of a woman who knows that she is being looked at, on condition that one does not show her that one knows that she knows.
> The world is all-seeing, but it is not exhibitionistic, does not provoke our gaze. When it begins to provoke it, the feeling of strangeness begins too. (p. 75)

What this passage makes clear is that since the gaze always emerges for us within the field of vision, and since we ourselves are always being photographed by it even as we look, all binarizations of spectator and spectacle mystify the scopic relations in which we are held. The subject is generally both, as indicated by the right-hand side of diagram 3. Moreover, although our look can never function as the gaze for ourselves, it can have that metaphoric function for others, even at the moment that we emerge as spectacle. Exhibitionism unsettles because it threatens to expose the duplicity inherent in every subject and every object—

to reveal the subject's dependence for definition upon the image/screen, and his/her capacity for being at the same time within the picture and a representative for the Other of the gaze. It is thus possible to super-impose in an inverted form not only diagram 1 on diagram 2, but my diagram 3 on your diagram 3, which is presumably why Lacan speaks more than once about the immanence of the gaze within the picture ("in the picture, something of the gaze is always manifested" [p. 101]).

Diagram 3 suggests that just as the viewer cannot see the object with-out the intervention of the image/screen, so he or she cannot have a di-rect visual access to the gaze. In both cases, the relationship is mediated by a "mask, double, [or] envelope," and in both instances "misrecog-nition" would seem to be the inevitable outcome. Foucault has made it possible for us to apprehend some of the cultural representations of the gaze that have been put in place since the end of the eighteenth cen-tury, representations that are complexly bound up with the medical and penal institutions.[29] Feminist film theory has foregrounded a number of others through its anatomization of the male look.[30] However, the in-terrogation has not always been pushed far enough. We have at times assumed that dominant cinema's scopic regime could be overturned by "giving" woman the gaze rather than by exposing the impossibility of anyone ever owning that visual agency, or of him or herself escaping specularity.

According to the reading of diagram 3 that I have proposed here, the field of vision puts all three of the Lacanian registers into play. The gaze occupies two domains simultaneously; in its capacity as light and as that which is foreclosed from the subject, it partakes of the real,[31] but in its status as "the presence of others as such," it clearly belongs to the symbolic. The relationship of subject to screen, on the other hand, is articulated within the domain of the imaginary. "Captation" however, can occur only with the complicity of the gaze; the subject can only achieve an invisible join with those images or screens through which the gaze in its capacity as "others-as-such" looks at him or her. That most apparently claustral of all psychic transactions—"self-recognition"—is thus mediated by a third term.

Foucault's account of the gaze does not generally intersect with Lacan's, but it enriches *Four Fundamental Concepts* immeasurably when it suggests that the field of vision may have been variously ar-ticulated at different historical moments. *Discipline and Punish* dis-tinguishes between two "modalities of power" according to their very different scopic regimes. Within the earlier of these modalities, which

was organized around the sovereign and his force, "power was what was seen, what was shown and what was manifested. . . . Those on whom it was exercised could remain in the shade." Privilege, in other words, was concentrated at the site of the spectacle rather than that of the gaze. (Twentieth-century fascism has often deployed spectacle in a similar way, as Elsaesser suggests in his discussion of Fassbinder.) Within the next great power modality, which Foucault associates with discipline, specularity implied subjection; power exercised itself through its invisibility while "at the same time [imposing] on those whom it [subjected] a principle of compulsory visibility" (p. 187).

Although it cannot be immediately reconciled to the Foucauldian paradigm, J. C. Flugel's notion of the Great Masculine Renunciation also encourages us to think in historically specific ways about our present scopic regime. Flugel contends that, prior to the late eighteenth century, masculinity aligned itself with sartorial extravagance—that given the social and economic possibility to do so, it invariably chose to "command" rather than to "lay claim" to the gaze. Since that time, however, phallic "rectitude" has increasingly associated itself with sobriety of dress, and the male subject's specularity and exhibitionism have been projected onto his female counterpart.[32]

These two accounts do more than alert us to the historical vicissitudes of the field of vision. They further denaturalize the alignment of masculinity with the gaze. They also indicate that power can invade spectacle and disinvest from the gaze—that spectacle, in other words, can function phallically. Feminism must consequently demand more than the "return" of specularity and exhibitionism to the male subject. What must be demonstrated over and over again is that all subjects, male or female, rely for their identity upon the repertoire of culturally available images and upon a gaze that, radically exceeding the libidinally vulnerable look, is not theirs to deploy.

I have indicated some of the ways in which Fassbinder's cinema anticipates the political program I have just outlined. Not only does it show subjectivity to be at all points dependent both upon gaze and image/screen, but it demonstrates that the look, male or female, is itself within spectacle. It also works to transform the images or screens through which we see the male subject. This last struggle is conducted very much at the level of corporeal representation, suggesting that although the phallus is not the penis, it nonetheless derives its material support from that organ. We do not remember often enough that in "Subversion of the Subject and Dialectic of Desire" Lacan himself defines the phallus

as "the image of the penis."[33] Fassbinder's films work to ruin or deface that image.

Texts like *Ali: Fear Eats the Soul, Fox and His Friends, In a Year of Thirteen Moons*, and *Berlin Alexanderplatz* consequently make the male body the point at which economic, racial, and sexual oppression are registered. As Wiegand has remarked, Fassbinder—perhaps more than any other filmmaker—"has understood the human body as an arena of social conflict,"[34] and it seems to me that this is precisely how we are to interpret the ulcer that afflicts Ali at the conclusion of the film that bears his name, Hans' heart attack in *The Merchant of Four Seasons* (1971), and the symptoms Fox suffers in *Fox and His Friends*.

Fassbinder's curious response to the racism of contemporary Germany—a response that evacuates the masculinity and insists upon the vulnerability of the *Gastarbeiter*—might seem indicative of that left-wing melancholy of which Dyer has accused him.[35] The crucial point to grasp here, however, is that he refuses to treat the Arab guest worker differently from his white male protagonists, that he refuses to confer upon that figure a positivity that he eschews elsewhere. Fassbinder is unwilling even for a moment to countenance the notion that a black or third world man operates out of an existential plenitude or a self-sufficiency denied to the first world white man, or that such a figure is any less riven by anxiety or desire. Nor is he ever prepared to forego his assault on the phallus, even within a text that is given over as fully as *Ali: Fear Eats the Soul* is to a critique of racism.

Fassbinder's cinema also seems to me exemplary in the particular way in which it approaches the issue of the mediating image/screen. The risk implicit in any politics devoted to what might be described as a "representational contestation" is that it will give fresh life to the notion that what is needed are "positive images" of women, blacks, gays, and other disenfranchised groups, images that all too often work to resubstantialize identity and even, at times, to essentialize it. Fassbinder's films refuse simply to resituate the terms of phallic reference. Instead, they evacuate both those terms and the *moi* that is their imaginary correlate. At its most extreme, Fassbinder's cinema might almost be said to model itself on Holbein's *The Ambassadors*, with its anamorphic death's head—to seek to induce in the viewer a recognition of him or herself as "annihilated in the form . . . of castration."

Since Freud, we have grown accustomed to thinking about lack according to a specular logic or, to state the case rather differently, as the *absence* of a particular visual term. One of the crucial features of Lacan's

redefinition of castration has been to shift it away from this obligatory anatomical referent to the void installed by language. But Lacan might also be said to "visualize" castration, albeit in very different terms from those suggested in "Some Psychical Consequences of the Anatomical Distinction Between the Sexes" or "Female Sexuality." Despite its failure to factor the look into the three diagrams, *Seminar XI* repeatedly locates lack at the level of the eye, defining castration as the alterity of the gaze. Lacan remarks at one point, for instance, that the gaze is "symbolic of what we find on the horizon, . . . namely, the lack that constitutes castration anxiety" (p. 73), and at another that the gaze, *qua objet a*, may come to symbolize this central lack expressed in the phenomenon of castration" (p. 77). *Four Fundamental Concepts* thus extends castration to the male as well as to the female subject, and in an ultimately much more satisfactory way than a text like "The Signification of the Phallus" manages to do. *Seminar XI* also makes it possible for us to understand that, if the gaze exceeds the look, the look introduces a term in excess of the gaze.

It is Fassbinder rather than Lacan, however, who assists us in conceptualizing a look that would acknowledge its lack rather than seek to deny it. Films like *Ali: Fear Eats the Soul*, *Gods of the Plague*, and *Beware of a Holy Whore* work as strenuously to maintain castration at the site of the look as they do to situate it at the level of the male body. As I have already suggested, *Beware of a Holy Whore* even articulates a new formal element—a zoom in on the look rather than on its object— for enacting something that might best be described as the reverse of that visual transaction described by Freud at the beginning of his essay on fetishism,[36] a look that, rather than locating castration definitively elsewhere, becomes itself the locus of insufficiency.

As a result both of their oppression, their specularization, and their forced confrontation with their own lack, Fassbinder's male characters acquire the capacity to become something other than what the male subject has classically been—to slip out from under the phallic sign, away from the paternal function. They may even approach that condition of "beauty" that Fassbinder associates with victimized women.[37] However, his cinema also at times valorizes the suffering that produces these effects, and it is here that his "aesthetics of pessimism" becomes both most politically dangerous and most libidinally complex.

While *Gods of the Plague* presents the viewer with a "limp" male subject and *Ali: Fear Eats the Soul* with one who escapes from the gaze to the look only at the cost of a further feminization, neither violates the

integrity of that corporeal "envelope" that constitutes the male body. In two subsequent films, though, *In a Year of Thirteen Moons* and *Berlin Alexanderplatz*, the assault upon the male body assumes much more aggressive forms. Within the terrifying confines of those two texts, the male body is subjected to sex-change surgery, amputation, torture, and crucifixion, now at the behest of a negativity that is no longer content merely to exteriorize the necessary supports of identity but that demands a much more corporeal eradication. If there were space, I would speak further not only about these two films but about the potential political dangers of Fassbinder's "aesthetics of pessimism." This last issue would lead inevitably into an exploration of the masochism that alone makes Fassbinder's negativity endurable, generating those moments of extreme joy to which I alluded earlier and giving rise to something that can only be described, despite the peculiarity of ending this essay with such a word, as utopia.[38]

NOTES

This essay was originally published in *Camera Obscura* 19.

1. The phrase "field of vision" derives from the title of Jacqueline Rose's book, *Sexuality in the Field of Vision* (London, 1986).

2. Christian Braad Thomsen, "Five Interviews with Fassbinder," in *Fassbinder*, ed. Tony Rayns (London, 1980), 86.

3. Tony Pipolo, "Bewitched by the Holy Whore," *October* 21 (1982): 112, 92.

4. Richard Dyer, "Reading Fassbinder's Sexual Politics," in *Fassbinder*, ed. Rayns, 55, 60.

5. Wilfred Wiegand, "The Doll in the Doll: Observations on Fassbinder's Films," in *Fassbinder*, ed. Ruth McCormick (New York, 1981), 52.

6. Thomas Elsaesser, "Primary Identification and the Historical Subject: Fassbinder and Germany," in *Narrative, Apparatus, Ideology*, ed. Philip Rosen (New York, 1986), 540.

7. Ruth McCormick, "Review [of *The Marriage of Maria Braun*]," in *The Marriage of Maria Braun*, ed. Joyce Rheuban (New Brunswick, 1986), 222.

8. Peter W. Jansen, "*Die Zeit*," in *The Marriage of Maria Braun*, 221.

9. See Luce Irigaray, "Women on the Market," in *This Sex Which Is Not One*, trans. Catherine Porter (Ithaca, 1985), 170–91.

10. Sigmund Freud, *The Ego and the Id*, in *The Standard Edition of the Complete Psychological Works*, trans. James Strachey (London, 1961), 19:27.

11. Freud, *The Ego and the Id*, 34–37. See also Otto Isakower, "On the Exceptional Position of the Auditory Sphere," *International Journal of Psycho-Analysis* 20, nos. 3–4 (1939): 340–48, for a discussion of the super-ego as the internalization of external voices.

12. Jacques Lacan, "The Mirror Stage as Formative of the Function of the I," in *Écrits: A Selection*, trans. Alan Sheridan (New York, 1977), 1–7.

13. In *The Four Fundamental Concepts of Psycho-Analysis*, trans. Alan Sheridan (New York, 1978), 80, Lacan remarks: "*I saw myself seeing myself,* young Parque says somewhere. . . . We are dealing with the philosopher, who apprehends something that is one of the essential correlates of consciousness in its relation to representation, and which is designated as *I see myself seeing myself*. . . . [This formula] remains . . . correlative with that fundamental mode to which we referred in the Cartesian *cogito*. . . ."

14. Judith Mayne, "Fassbinder and Spectatorship," *New German Critique* 12 (1977): 61–74.

15. Kaja Silverman, *The Acoustic Mirror: The Female Voice in Psychoanalysis and Cinema* (Bloomington, 1988), 161–62.

16. Lacan, *Four Fundamental Concepts*, 106. Joan Copjec has recently taken issue with the assumption that implicit in the notion of the gaze is the visibility of the subject. She maintains that the hyphenated form of "photo-graph" in the passage I have just quoted refers to Lacan's graph of desire rather than, as I will argue, with the diagrams included in *Four Fundamental Concepts* (see "The Orthopsychic Subject: Film Theory and the Reception of Lacan," *October* 49 [1989]: 53–71). Indeed, Copjec goes so far as to claim that *Seminar XI* is about semiotics rather than vision and that the gaze refers to the effects of language. While I am in fundamental agreement with her claim that the thrust of *Four Fundamental Concepts* is to show that sense does not found the subject, I see the gaze as a signifier for that which constitutes the subject as lacking *within the field of vision*. As Lacan says in the passage quoted above, the gaze "determines me, at the most profound level, *in the visible*" (my emphasis).

17. Lacan, *Four Fundamental Concepts*, 84.

18. Ibid., 72 and 103.

19. Ibid., 83.

20. See Laura Mulvey, "Visual Pleasure and Narrative Cinema," in *Visual and Other Pleasures* (Bloomington, 1989), 14–26.

21. In his account of the voyeur surprised at the keyhole, Lacan draws on Jean-Paul Sartre, *Being and Nothingness: An Essay on Phenomenological Ontology*, trans. Hazel B. Barnes (London, 1957), 277, which relies upon a similar example. Sartre is less concerned with the voyeur's desire, however, than with the shame induced in him by the gaze.

22. Judith Mayne suggests that this self-embrace "might be situated in rela-

tion to another narcissistic gesture," that in which Fassbinder "literally exhibits himself" in *Germany in Autumn* (1978). See "The Feminist Analogy," *Discourse* 7 (1985): 39.

23. See Sigmund Freud, "On Narcissism: An Introduction," *Standard Edition*, 14:89.

24. Leon Battista Alberti writes that painters "should only seek to present the form of things seen on [the picture] plane as if it were of transparent glass. Thus the visual pyramid could pass through it, placed at a definite distance with definite lights and a definite position of centre in space and in a definite place in respect to the observer" (see *On Painting*, trans. John R. Spencer [London, 1956], 51). For a discussion of Alberti within a cinematic context, see Michael Silverman, "Rossellini and Alberti: The Centering Power of Perspective," *Yale Italian Studies* 1, no. 1 (1977): 128–42; and Stephen Heath, *Questions of Cinema* (Bloomington, 1981), 19–75.

25. Roger Caillois, "Mimicry and Legendary Psychasthenia," trans. John Shepley, *October* 31 (1984): 28.

26. These two forms of Lacanian mimicry are not unlike those presented by Irigaray in *This Sex Which Is Not One*. The first kind of mimicry discussed there follows from the unquestioning acting out of an assigned role. Irigaray calls it "masquerade," and she associates it with traditional femininity. *This Sex* places a much higher premium upon a second form of mimicry, which involves the travesty of woman's assigned role. About it, Irigaray has this to say: "One must assume the feminine role deliberately. Which means already to convert a form of subordination into an affirmation, and thus to begin to thwart it. . . . To play with mimesis is thus, for a woman, to try to recover the place of her exploitation by discourse, without allowing herself to be simply reduced to it. It means to resubmit herself . . . to 'ideas,' in particular to ideas about herself, that are elaborated in/by a masculine logic, but so as to make 'visible,' by an effect of playful repetition, what was supposed to remain invisible: the cover-up of a possible operation of the feminine in language" (p. 76).

27. Sheridan's translation is here less than felicitous, suggesting that the mask or the double may somehow have its derivation in the self. The French text reads rather differently because its grammatical construction is more rigorously parallel; although the subject has no identity without an alienating image, that image may be put in place either by the subject or *by the other* ("l'être donne de lui, ou il reçoit de l'autre"). (See *Les Quatre concepts de la psychanalyse* [Paris, 1973], 98.) The next sentence emphasizes that the screen is no more integral to the subject in the former instance than in the latter; in either case, it is through a "separated form of himself" that the subject is constituted.

28. Maurice Merleau-Ponty clearly exercised an important influence upon Lacan's thinking about the gaze. In *The Visible and the Invisible*, trans. Claude Lefort (Evanston, 1968), the text to which *Four Fundamental Concepts* refers, Merleau-Ponty insists upon the reciprocity of subject and object (hence Lacan's

paradoxical description of the gaze as the "spectacle of the world"): "The vision [which the seer] exercises, he also undergoes from the things, such that, as many painters have said, I feel myself looked at by the things, my activity is equally passivity, . . . so that the seer and the visible reciprocate one another and we no longer know which sees and which is seen" (p. 139).

29. See in particular Michel Foucault, *Discipline and Punish: The Birth of the Prison*, trans. Alan Sheridan (New York, 1978), and *The Birth of the Clinic: An Archaeology of Medical Perception*, trans. Alan Sheridan (New York, 1975).

30. Although Mulvey's "Visual Pleasure and Narrative Cinema" initiated this interrogation, a number of other texts have also contributed to it in important ways. See, for example, Teresa de Lauretis, *Alice Doesn't: Feminism, Semiotics, Cinema* (Bloomington, 1984), 12–36; Stephen Heath, "Difference," *Screen* 19, no. 3 (1978): 51–112; Linda Williams, "Film Body: An Implantation of Perversions," *Ciné-Tracts* 3, no. 4 (1981): 19–35; Jacqueline Rose, *Sexuality and the Field of Vision*, 199–233; Leslie Stern, "Point of View: The Blind Spot," *Film Reader*, no. 4 (Evanston, 1979), 214–36; Sandy Flitterman, "Woman, Desire and the Look: Feminism and the Enunciative Apparatus in Cinema," *Ciné-Tracts* 2, no. 1 (1978): 63–68; Janet Bergstrom, "Enunciation and Sexual Difference," in *Feminism and Film Theory*, ed. Constance Penley (New York, 1988), 159–85; Mary Ann Doane, *The Desire to Desire: The Woman's Film of the 1940s* (Bloomington, 1987), 38–69; and Lucy Fischer, "The Image of Woman as Image: The Optical Politics of *Dames*," in *Genre: The Musical*, ed. Rick Altman (London, 1981), 70–84.

31. Slavoj Žižek accounts for the gaze almost exclusively in terms of the real in his very interesting essay, "Looking Awry," *October* 50 (1989): 31–55.

32. J. C. Flugel, *The Psychology of Clothes* (London, 1930), 117–19. For a feminist discussion of fashion in general, and of this text in particular, see my "Fragments of a Fashionable Discourse," in *Studies in Entertainment: Critical Approaches to Mass Culture*, ed. Tania Modleski (Bloomington, 1986), 139–52.

33. Lacan, *Écrits*, 319.

34. Wiegand, "The Doll in the Doll," 50.

35. Again, I refer the reader to Dyer's essay, "Reading Fassbinder's Sexual Politics."

36. Sigmund Freud, "Fetishism," *Standard Edition*, 21:152–53.

37. In a published conversation with Margit Carstensen, Fassbinder makes the outrageous claim that "Women who let themselves be oppressed often are more beautiful than women who fight back." See "Talking About Oppression with Margit Carstensen," in *West German Filmmakers on Film: Visions and Voices, 1967–1986*, ed. Eric Rentschler (New York, 1988), 168–71.

38. For a discussion of masochism and utopia in Fassbinder's cinema, see Kaja Silverman, *Male Subjectivity at the Margins* (New York, 1992), chap. 6.

Feminism, Psychoanalysis, and the Study of Popular Culture

THIS paper will explore some of the possible relations that can be forged among the three terms in its title, that is, among feminism, psychoanalysis, and the study of popular culture. I propose here at least one way those terms might productively be brought together by describing my involvement in, and study of, a female fandom, called "slash" fandom, that is an intriguing spin-off of the large and lively *Star Trek* fandom. Unlike the other chapters in this book, my remarks will address the making of *amateur* art, that is, modes of production and ideas about creativity that are very different and very distant from the institutional art practices examined so critically and exhaustively in other chapters.

Let me start off with a theoretical polemic. In looking at this particular female fandom, certain issues arose for me in response to a tendency that disturbs me in recent feminist studies of popular culture. The tendency is to dismiss or bypass the work on subjectivity and sexual difference developed over the last fifteen years in feminist film theory. This dismissive or evasive move is typically accompanied by a call to adopt models considered more appropriate to the study of popular forms like the romance, the melodrama, the soap opera, or the sit-com. Almost automatically, it seems, theorists of women and popular culture are turning to Nancy Chodorow's object relations model of female subjectivity to describe how women read, view, and otherwise consume the artifacts of mass-produced culture.[1] They see Chodorow's model as superior, first of all, because she focuses almost exclusively on *female* subjectivity, an emphasis seen to be wanting in the Freudian and Lacanian models that have been so influential in feminist film theory. Her account is also deemed to be better in that her idea of subject formation allows an easier theoretical move from the social to the psychical and vice versa, since her psychoanalytic categories are already quite sociologized (for example, the way she recasts the process of unconscious identification into a kind of more or less conscious role modeling). And finally, Chodorow's ideas are taken up in the belief that she offers a more *optimistic* account of

subjectivity: If the social and the psychical are not so far apart, there remains hope that we can reform the psyche through reforming the social (as seen in her belief, for example, that requiring men to share the work of nurturing children will produce a change in the basic configuration of the Oedipus complex).

But when Chodorow's model of female subjectivity is used to describe how women encounter popular culture, what results, I think, is a reduced account of female viewing, reading, or consuming. The deficiency in the model is caused by the emphasis on *regression* as a specifically feminine mode of identification. For example, in *Reading the Romance: Women, Patriarchy, and Popular Literature*, Janice Radway argues, borrowing from Chodorow, that romance novels "work" to the extent that they successfully induce the reader imaginatively to regress, through identification with the heroine, to a pre-Oedipal moment of being nurtured and absolutely taken care of, a privilege typically denied adult women in this culture because they have the sole responsibility for nurturing.[2] Or, to take another example, Tania Modleski, in *Loving with a Vengeance: Mass-Produced Fantasies for Women*, claims that female viewers form such close identifications with soap opera characters because the shows stimulate the kind of psychological fusion that occurs between mothers and daughters in our culture; the inability to see oneself as separate allows the female viewer to be easily sutured into the soap opera world. In both of these otherwise useful and stimulating studies (and, indeed, Janice Radway's work was the inspiration for my own), female identification apparently occurs by means of a regressive, pre-Oedipal fantasy.[3]

Although I already had my doubts about reducing the account of female fantasy in popular culture to a fantasy of pre-Oedipal regression, it was my work with and on a female fandom that finally convinced me of the limitations of that account. My doubts were based on my understanding of the psychoanalytic idea of *fantasy*, with its ability to describe how the subject participates in and restages a scenario in which crucial questions about desire, knowledge, and identity can be posed and in which the subject can hold a number of identificatory positions.[4] Adopting the Freudian and Lacanian description of fantasy allows one to account for multiple (if contradictory) subject positions; but it also ensures that one give a strict attention to the relation of desire and law, that is, to the subject of the symbolic as well as the imaginary. Only this more complex account of identification and sexual difference in fantasy could help me describe what goes on in the reading and writing of fan

stories, given what seem to be the multiple possibilities of identification and numerous pleasures found there that do not seem to originate in the time and space of the pre-Oedipal.

I will get back to these claims later, but now I will describe the fandom itself and the work that it produces, a unique, hybrid genre of romance, pornography, and utopian science fiction.

In 1988 I was invited to a convention sponsored by a group called WHIPS, which, very disappointingly, only stands for Women of Houston in Publishing. I was invited to the convention because, for two years, I had been ordering through the mail a multitude of fan publications that fall under the rubric "slash lit," which was the subject of the convention. Figure 1 is a copy of a page taken from a publication called *Datazine*, which comes out six times a year and lists most of the currently available amateur fan magazines, or fanzines as they are called (or, more often, just zines). On this page are advertisements for fanzines on *Battlestar Galactica* (BG), *Star Trek* (ST), *Miami Vice* (MV), a general media letter and discussion fanzine called *Comlink* (M [Media]), and three fanzines with the code K/S printed in the left margin. A code designation with a slash in it refers to any fanzine that features stories, poems, or drawings whose theme is an explicitly sexual relationship between two of the main male characters. A K/S zine, then, is a *Star Trek* fan publication, but one in which all the material printed therein concerns a romantic, sexual relationship between Captain James T. Kirk of the *USS Enterprise* and his first officer, Mr. Spock. As you can see from figures 2 and 3, the artwork found in these zines ranges from the romantic to the historically romantic to the very explicit, which should give you an idea of the flavor of the stories and poems. Much of the work is so explicit, in fact, that when ordering any of these zines you are required to accompany your payment with a written statement declaring that you are over eighteen. Other media male relationships have also been slashed in the fanzines, and these you would find listed under other codes, for example, S/S for Simon and Simon, S/H, for Starsky and Hutch, H/Mc for Hardcastle and McCormick, or M/V for *Miami Vice*'s Crockett and Tubbs, although the best recent *Miami Vice* slash story put Crockett and Castillo together to great effect. The first slash zines, though, were K/S (they date from about 1976 or 1977), and they still represent the majority of slash publishing.

What is, however, perhaps most astonishing is that the fandom is almost 100 percent female, although an editorial in a recent issue of the K/S zine *First Time* proudly announced that it included the long-

≡NOW≡IN≡PRINT≡≡≡≡≡12≡

BG THE BATTLE OF MOLUKAI $11.00FC
What led to the devastating battle that destroyed a great empire and annihilated an entire Colonial Fleet?
This novel is the history of the Fifth Colonial Fleet, led by the legendary Commander Cain of the Bat-
tlestar PEGASUS.
All checks must be payable to Joy Harrison.
OSIRIS PUBLICATIONS, 8928 N. Olcott Ave., Morton Grove, IL 60053

ST A BEACH TO WALK ON $16.00
A novella by Dolly Weissberg. A story about how Janice Rand again saw the Captain and Spock and
remembered how long ago she had loved him, and married him, lost him and how their lives progressed
from there. Over 70 pgs., in zine format.
Dolly Weissberg, Riverview Aprt. 7718 High Water G-2, N. Port Richey, FL 34655-2815

MV BERNAY'S CAFE $2.50
A HOT Miami Vice letter zine. If you like Vice come join the crowd that keeps you up on all the latest
things about Miami Vice. Going on Issue #12. Back issues are available for same price.
Noel Silva, 674 Clarinada Ave., Daly City, CA 94015

ST BEYOND THE FARTHEST STAR SEE BELOW
#2-$6.00 PPD. Orion Press' X-rated, "no slash" Star Trek zine returns with a second issue! Includes
"Questions about Maltz" by Endres, "All That Glitters"--a Spock/Christine story by Baker, "Southern
Comfort"--a McCoy story by McInnis, and "Power Failure"--a Kirk tale. Also works by Summers,
Cesari, and more. 70 pgs.
#1-$6.75. Features adult-oriented, erotic, action-adventure ST fiction from mary Cress and Chris
Hamann, Beth Holland, Randall Landers, Linda Marcusky, and Esther Lemay. See Kirk captured because
of his "reputation". See the ship go crazy as revealing pictures of the stalwart commander of the EN-
TERPRISE start popping up everywhere. Also Spock-Christine and Valkris-Torg. Definitely not for
the the weak-hearted. Plenty of explicit, steamy scenes, nudity (art by Rick Endres). Age statement
required (obviously). 70 pgs.
Bill Hupe, 6273 Balfour, Lansing, MI 48911

K/S A COLLECTION OF DREAMS $14.00 US CAN $20.00 OS AIR
Short stories, poetry & art set in the DREAMS OF THE SLEEPERS universe. Includes the short-story
DAYBREAK, which is the prologue to the third DOTS novel (DAYBREAK, DREAM COME TRUE).
Works by: Crouch, Solten, Hood, Tessman, Donovan, Jaeger, Feyrer, Whild, Soto, Dragon, Chiya
Foulard, A.F. Black.
PON FARR PRESS, PO Box 1323, Poway, CA 92064-0014

M COMLINK SEE BELOW
#29, 31, 32 - $2.00 EACH; $7/4 ISSUES FC. The media discussion zine, published 4-5 times per
year. Each issue contains letters on various media subjects (comics, movies, fandom), class-ads, (free
with a current sub), and occasional articles. #32 is current (Oct 87), #31 (8-87) looks at 30 years of
Hanna-Barbera animation.
Checks payable to Allyson M. Dyar.
Allyson M. Dyar, 40-A Cecil Ln., Montgomery, AL 36109-2872

K/S COMMAND DECISION: THE UNEXPECTED BEGINNING $19.25 US $21.50 CAN $28.00 EUR
An explicit ST novel of adventure, intrigue, love, friendship and self-discovery, by C. Smythe; art by
TACS; Poetry by Fine. Nominated for two Surak Awards. (Not an A.U. or Mirror story). 300+ pgs;
offset; spiral bound. SASE for detailed flyer. Age statement required. Published by J.H. Publica-
tions, the LAST few copies of this novel have been turned over to Kaleidos Publications for handling.
Only orders from Kaleidos Publ. can be honored.
KALEIDOS PUBLICATION, 19 Engle St., Tenafly, NJ 07670

K/S CONSORT 2 $16.00 PPD
Consort 2 features material by Barr, Bush, Lansing, Lewis, Poste, Resch, Solten, Laoang, Lovett, TACS,
TSC, and more. 272 pgs; K/S; age statement required.
REPREHENSIBLE PRESS, RFD #2 Box 1250, Lisbon Falls, ME 04252

1. Copy of a page from *Datazine* listing fan publications for sale.

promised story by a male writer. The editor went on to say, "Now be
nice, ladies, send loc's [letters of comment] and let him know what you
think. He can take it!" And, as another exception, at the second slash
convention I attended, in June of 1989 in San Diego, for the first time
two men had a real presence there, two gay men who had been sending

2. K/S Illustration. Reprinted with permission of the artist.

3. K/S Illustration. Reprinted with permission of the artist.

their stories to a *Blake's 7* slash zine edited by women, who were then encouraged and helped by the women to start their own zine. So the almost completely female and heterosexual composition of the fandom may be breaking up slightly in some interesting ways.

The K/S fans write, edit, and publish hundreds of stories and poems in the zines, produce a great deal of artwork, which can sell for hundreds of dollars at slash convention art auctions, and also publish separate novels. It is truly a cottage industry, done mostly in their own homes (or sometimes at work), all made a great deal easier, of course, by the advent of desktop publishing and cheap photocopying. Most of the zines and novels are spiral bound, often with varnished, strikingly illustrated covers, and contain many other graphics and drawings. The level of editorial professionalism is very high. The zines and novels are beautifully produced and skillfully edited by amateurs who have trained themselves and each other.

The slash convention in Houston, the fourth of its kind, was called IDICon IV. All fan conventions are referred to by the fans as "cons" and

given a significant prefix. The IDIC, I-D-I-C, in the name IDICon IV is the acronym for the Vulcan philosophy of Infinite Diversity in Infinite Combination, an idea that has become this fandom's watchword. (In the K/S letterzine *On the Double*, a publication devoted to printing letters of comment on all aspects of the fandom, writers will often sign off with either "Yours in slash" or "Yours in IDIC.") Even before I went to the convention, I had learned a bit about the fandom (other than what I had gleaned from reading the zines and letterzines) through an incisive and informative essay on K/S zines by Patricia Frazer Lamb and Diana Veith. Their essay, entitled "Romantic Myth, Transcendence, and *Star Trek* Zines," appeared in 1986 in the only good collection I have ever seen on science fiction and sexuality, a book called *Erotic Universe*.[5] In addition, I had read the only other substantive article that has been written on the K/S zines, a rave appreciation of them by science fiction writer Joanna Russ that appeared in a 1985 collection of her essays.[6] I thus already knew that this fandom was almost all female, and I had an idea of the extent of the production and the number of fans involved: There are probably not more than five hundred active, core fans, although they publish a tremendous amount, which is disseminated beyond the core group through mail order and convention sales of the zines, borrowing, and even photocopying, although this latter practice is frowned upon if the zine is still "in print," that is, still being sold and circulated.

But many of my questions were still unanswered, and I went to the convention looking for more answers, as well as more zines to add to my ever-growing collection. Among my questions were these: What reasons did the fans give for writing their erotic fantasies across the bodies of two men—and why these particular men? What was the sexual orientation of the fans—straight, lesbian, or some of each? What was their relation to gay politics, given that the focus of their writing was a same sex couple? Did they see themselves as writing renovated romances or more satisfying female pornography? (The Lamb and Veith article claimed that the K/S fans were trying to rewrite the romance along less sexist lines, the Joanna Russ essay insisted that they were attempting to write better pornography than is usually available to women.) How did their slash activity, which clearly consumed many hours and days of their lives in reading, writing, editing, and publishing, fit into their work schedules and domestic lives? Was the fandom as racially mixed as *Star Trek* fandom is? What was their class makeup? Why were female media couples never slashed—for example, why were there no Cagney and Lacey stories in the zines? Given their insistence on their amateur status,

what was their relation to professionalism, especially since they seemed to set such high standards for themselves as writers, editors, and publishers and since so many of them were becoming professional writers, de-slashing and heterosexualizing stories for commercial publication (as, for example, official *Star Trek* novels)? What was their relation to feminism? And finally, what cannot be said in K/S writing; what are its self-imposed or unconscious taboos? But a more personal and ethical question was, Where did I fit into all this? Was I going to the conference as a fan, even perhaps a potential writer of K/S stories, a voyeur of a fascinating subculture, or a feminist academic and critic? I certainly liked the stories well enough. In fact, K/S was the first pornographic writing I had ever really responded to, which made me remember that, as a girl, although I had read and enjoyed Nancy Drew, I had really gotten off on the Hardy Boys, Tom Swift, and Tarzan of the Apes. (However, it never occurred to me as an adolescent reader to put any of these men together in erotic scenarios, although friends have reported doing so, especially Tonto and the Lone Ranger—and this is before reading Leslie Fiedler!) So I was certainly a fan of K/S, but, even while I was enjoying reading the stories, I kept coming across things I just had to take notes on. Given that all of my intellectual and political work has been on women and media, I could not help also responding to the slash phenomenon as one of the most radical and intriguing female appropriations of a popular culture product that I had ever seen. It begged to be analyzed and theorized because so much could be learned from it about how women, and people, resist, negotiate, and adapt to their own desires this overwhelming media environment that we all inhabit. So I decided, finally, that I was all three, a fan, a feminist critic, and perhaps inescapably a voyeur, keeping in mind, however, that voyeurism is an interesting position in itself, since the voyeur is always far more implicated in the scene than the fantasy of observation at a distance acknowledges.

Obviously, I was not able to find answers to all of my questions in the three days and four nights I spent at the convention in Houston, or during the ones I attended in 1989 and 1990 in San Diego. I do not have room here to explain even the answers I did discover, however. What I want to focus on here are some of the issues that came up that offer the greatest *challenge* to a feminist analysis of women and popular culture.

It is important to point out, though, that all my questions, from issues of genre—is K/S romance or pornography?—to the sexual orientation of the K/Sers, to the role of their fan activity in their daily lives, have, in fact, been verbalized and discussed by the fans themselves. It

is a highly self-reflexive and self-critical fandom; their intellectual and political interests and anxieties are apparent in far more than merely symptomatic ways. *They* want to know why they are so drawn to fandom and why they love reading and writing erotic stories about two men together. *They* are curious about the sexual makeup of the fandom; for example, the number of lesbians, in what is admittedly a mostly heterosexual fandom, and the nature of lesbian interest in K/S was debated in two recent issues of *On the Double* by both lesbian and straight fans; and at the last convention in San Diego there was, for the first time, a hugely well-attended panel on gay lifestyles made up of lesbian and gay fan writers and artists. The fans are also asking themselves if the AIDS crisis is having or should have an effect on what they are writing, whether, for example, Kirk and Spock should be shown practicing safer sex. These questions and others like them are made into panel topics at the conventions, along with other more practical panels, of course, like the brainstorming session on how to go about slashing *Star Trek: The Next Generation*, the new television series. I consequently do not feel as if I am *analyzing* the women in this fandom as much as I am thinking along with them. Several fans are also now quite interested in what I am doing (they refer to me as one of the "academic fans," of which there is a handful) and are giving me a great deal of help in my thinking about fan culture. The fans are, of course, wary about having their activity revealed to the outside world—to the "mundanes" as the fans call nonfans. There are very good reasons for this anxiety, with the most immediate and practical one being that we live in a time when "obscenity" and "homoeroticism" have been conflated in the minds of many people, following the urgings of bigots like Jesse Helms, and jobs and lives are on the line. The part of me that is a fan is just as ambivalent as other fans about public, even "academic," scrutiny of our pleasures. I describe the attitude as ambivalence rather than rejection only because I know how rightfully proud the slash fans are of their own creativity as writers, artists, and publishers. Insofar, then, as they want and deserve recognition for their work, this desire conflicts with their wish to remain unknown. Just as there is a strong code of ethics for writing *within* fan culture (which has been discussed in great detail by Henry Jenkins),[7] so, too, there will have to be a complex negotiation around the ethics of writing *about* fan culture, especially slash fandom since it is potentially vulnerable not only to the guardians of morality but to the keepers of copyright.

To give a sense of what slash stories are like, I will briefly describe

a fairly typical one that contains many of the most common motifs. It is called "The Ring of Soshern" and is by a fan writer whose name or even pseudonym I cannot give. Most fans write under pseudonyms, and the choices of pseudonyms (fans often have more than one) reveal an extraordinary sense of play and humor. The pseudonyms cannot be reproduced here, for some of them have become so associated with the real author that it would be like revealing the identity of the author. I thus use only the names or pseudonyms of authors I have been able to contact and who have given me permission.

"The Ring of Soshern" was probably written before 1976, making it one of the earliest K/S stories. Photocopies of the manuscript circulated very privately, and it is a highly revered and imitated story. In recognition of its status as a classic, it was finally published in 1987 in *Alien Brothers*, a new anthology series with very high production values and controversial cash prizes.

In the story, Kirk and Spock beam down to a previously unexplored planet to investigate some mysterious sensor readings. Through a miscalculation, the *Enterprise* gets caught in an ion storm and must leave them behind to flee from it. Kirk and Spock are left deserted on the planet, not knowing when the ship will be able to return for them, for there will be much damage from the ion storm that Scotty will have to fix first. Over the next days, Kirk and Spock have to deal with dangerous plants, dinosaur-like creatures, and even some shaggy humanoids. They each, in turn, get wounded and must be tenderly ministered to by the other. But the real crisis comes when Spock begins to go into *pon farr*. Although Spock is only half Vulcan, he still goes into the heat suffered every seven years by all Vulcan males. He will go into a blood fever, become violent, and finally die if he does not mate. And he cannot mate with just anyone, it must be with someone with whom he is already empathically bonded. (On this point, the author is adhering to previous *Star Trek* lore: perhaps the most famous *Star Trek* episode, "Amok Time," written by Theodore Sturgeon, depicts Spock going into *pon farr* and being returned to Vulcan by Kirk and Dr. McCoy so that he can undergo the mating ritual and save his life.) Kirk realizes that there is a bond of love between him and Spock because of all the years they have worked together, all the times they have saved each other's lives, and their deep respect and affection for one another. Kirk goes to Spock, who at first refuses his offer; but when his blood fever takes him over, he has no choice. Not only does their sexual act save Spock's life, it makes Kirk realize that he does not just love Spock, he is *in* love with

Spock. Spock, too, realizes his love for the captain, and they spend all their remaining days on the planet exploring both the planet and each other's bodies.

Although they are worried about the fate of the *Enterprise* and its crew, they are very perturbed one day to hear Scotty's voice on the long-dead communicator announcing that they can be beamed up immediately. They return to the ship, not knowing what will happen to their new relationship. Surely Dr. McCoy, who has by now realized that it was the infallible Spock who miscalculated the location of the ion storm because he was mentally and physically incapacitated by the onset of *pon farr*, will know that Spock would not be alive now unless *someone* had mated with him. The story ends with Kirk and Spock, each in his own quarters, bleakly contemplating all the obstacles to continuing their erotic relationship; but Spock makes the brave decision to go to Kirk's quarters anyway, and the last line of the story has Spock looking into Kirk's eyes and closing the door behind him.

Although "The Ring of Soshern" has several sex scenes in it, the sex is described fairly abstractly and is a great deal tamer than that found in the thousands of stories that came after. Over the years, several conventions have become established. For example, Spock does want to have sex even when not in the throes of *pon farr*, which allows many more narrative occasions for erotic couplings. Although there were some pretty exotic descriptions of his half-alien genitalia in early stories (in Janet Alyx's novel *The Matchmaker*, for example, Spock's penis is hidden behind a furry mound that becomes tumescent and unfolds like petals, from which his emerald green penis unfurls like a stamen [it sounds like a Judy Chicago Dinner plate with a penis!]), the conventions for describing his penis are fairly settled now: It is green, of course, because of the green Vulcan blood that flows in his veins, is double-ridged, and is somewhat larger than a human one.

Once conventions have become established, the writer has the delightful problem of coming up with variations inside those conventional limits. One conference workshop I attended was entirely devoted to brainstorming new ways to describe Kirk's solid, golden, blond body and the Vulcan's taut, lissome, pale green one. The writers voiced their concern that they might have exhausted all the possible descriptions. As one participant remarked to the appreciative laughter of everyone present, How many ways are there to describe a green cock after you have used up "his green, throbbing member," "his quivering jade tower," and so on?!

One question that is often debated in this fandom is whether Kirk and Spock are, in fact, having homosexual sex, whether they are homosexual. The solution to this, or rather solutions since there are more than one, has a great many implications for issues of genre, identification, and fantasy. One answer to whether they are having homosexual sex or not is a practical one. In Joanna Russ' essay on K/S called "Pornography by Women, for Women, with Love," she points out that, in some of the early stories, the women writers do not seem to be quite sure of the details of gay male sexuality. Some of the betraying details include, she says, characters leaping into anal intercourse with a blithe lack of lubrication, which makes it clear that the authors are thinking of vaginal penetration, both men approaching orgasm with a speeded-up intensity of pelvic thrusting, and multiple orgasms. However, I have found what Russ calls "betraying details" in many recent stories too. Since it would not be difficult to do a minimum amount of research or reading on male physiology and gay male sex (and the fans, in fact, do so, consulting books like *The Joy of Gay Sex* and gay beefcake magazines), this inaccuracy suggests that the women writing the stories do not want Kirk and Spock to be homosexual. Also, some of the authors try to write their stories so that, somehow, the two men are lovers without being homosexual. Here is a good example of this premise in a story called "Homecoming," which also appeared in *Alien Brothers*.

> Until that moment five years ago—almost two years before Spock left for Gol and Kirk accepted the Admiralty—Kirk had never had any inclination toward a same sex relationship. He'd never wanted any man until Spock. Hadn't wanted one after. Perhaps it was exactly what he'd finally concluded: some forms of love defy, transcend all barriers, all differences or similarities.

In such a way, then, the whole issue of object choice or sexual orientation gets resolved in an idea of *cosmic destiny*: The two men are somehow meant for each other, and homosexuality has nothing to do with it.

Russ says that another sure sign that Kirk and Spock are not intended to be homosexual is that, in these stories, one finds no depiction of a gay subculture, no awareness of being derogated, no friends or family, absolutely no gay friends, and no gay politics. I have not done enough reading across the entire range of K/S to be able to speak authoritatively about historical shifts of perspective in this female fan writing,

but I have come across recent stories that do, in contrast to Russ' claim, seem to be trying to incorporate elements of contemporary gay life. For example, one story speaks to the difficulty of coming out to one's parents, as when Spock must tell Amanda, his human mother, and Sarek, his Vulcan father, that he and Jim have bonded forever. Another story, "He Who Loves Last" in the zine *As I Do Thee* no. 11, tells of Kirk's and Spock's troubles when, having temporarily set up housekeeping on the planet Timoran, Spock has an affair with one member of a gay couple who live next door. And there are other such stories, like "Love with the Proper Vulcan" in *Off Duty* no. 1, in which Kirk goes to another human captain who has a male Vulcan lover for advice on how to start a relationship with Spock, while Spock is meanwhile consulting the other Vulcan first officer on how to get things going with Kirk.

Therefore, even though I agree with Russ that there is a tendency in this literature to put these two men together sexually but still, improbably, maintain that they are heterosexual, I do find a kind of political self-consciousness about that scenario emerging and a new willingness to let them be gay.[8] I predict, though, that this slight, recent trend toward homosexualizing Kirk and Spock will not grow substantially, and that the reason is not entirely due to homophobia. Of course, there must be some element of homophobia in the wish to keep them heterosexual, although it would distress the K/S writers a great deal to think that they might be harboring homophobic thoughts. They see their adherence to the philosophy of IDIC, Infinite Diversity in Infinite Combination, as somehow putting them above the crude intolerance, xenophobia, and homophobia they abhor in the society around them. I would argue that the reason Kirk and Spock are heterosexualized in these stories is that it allows another kind of Infinite Diversity in Infinite Combination that the writers and readers seem to desire, and here I am starting to talk about identification and fantasy. Some of the stories, as I have said, do depict Kirk and Spock as homosexual, and clearly the pleasure is in imagining what two men, two gay men, do together sexually. Some of the fans defend this by saying that men, after all, have had their pornography about lesbians all these years; now it is our turn (after saying this, however, they usually acknowledge that it is not simply reversible). But what is served, at the level of *fantasy*, by having them together sexually but not, somehow, being homosexual? I think it allows a much greater range of identification and desire for the women: In the fantasy, one can *be* Kirk or Spock and also still *have* (as sexual objects) either or both of them since, as heterosexuals, they are not *un*available to women. If,

in the psychoanalytic description of fantasy, its two poles are being and having, in the slash universe this binary opposition remains but is not held to be divided along gender lines.

My aim is not to construct this female identification with men or this active adoption of men as sexual objects in fantasy as a privileged or "progressive" position. Rather, I want to show that the range and diversity of identifications and object relations can be much greater than is currently being recognized in feminist studies of women and popular culture. It will then be possible to give a fuller and more complex account of what women *do* with popular culture, how it gives them pleasure, and how it can be consciously and unconsciously reworked to give them *more* pleasure, at both a social and psychical level.

Let me backtrack a bit to explain why women would want to *be* Kirk or Spock. I have no theoretical problem with the idea of women identifying with men in fantasy or in fiction. Such an account of cross-gender identification and the claim that one can, no matter what one's gender, identify with either the man or the woman, with the entire scene itself, or with the fictional place of the one who looks on to the scene, has been made possible through the shift in feminist film theory—a shift from a model based on voyeurism and fetishism, with its often fixed positions that are gendered from the very beginning, to a model based on the psychoanalytic account of fantasy. If we believe that the subject, at the level of the unconscious, is bisexual, then a great variety and range of identifications are possible, even, and above all, across gender boundaries.[9] I am not concerned with arguing that women can identify with men, because I think that has already been proven. My primary inquiry concerns the reasons why these women identify with these fictional men. Why Kirk and Spock? As I mentioned before, although what the fans call "the slash premise"—that the two men are really in love and sexually involved—can be found in other shows, like *Simon and Simon* and *Starsky and Hutch*, for instance, the Kirk/Spock stories came first and still dominate slash writing. We must turn, I think, to the *Star Trek* universe to see what might have spawned such strong identifications.

Although I do not have exact figures, what I have read and heard in the fandom suggests that almost all the K/Sers were originally involved in *Star Trek* fandom, and many still are. Fan testimonials to K/S are repeatedly put this way: "I couldn't believe it when I found K/S; it was as if it was what I'd always been looking for in *Star Trek* fandom but was missing." It is important in trying to describe the possibility of identification with Kirk and Spock to understand the identification

with the entire *Star Trek* universe. To be involved in *Star Trek* fandom, one must have a full working knowledge of what is called "the canon universe," that is, the seventy-eight television episodes (plus the pilot), the five films, and to some extent the *Star Trek* universe as it has been expanded in the official *Star Trek* novels and in the *Star Trek* magazines, both professional and fan. One goes to conventions, where one buys *Star Trek* paraphernalia, meets the actors from both the old TV series and the new one, *Star Trek: The Next Generation*, participates in auctions, trivia contests, and costumed reenactments of favorite scenes. If the fan has a modem, she or he can join in the ongoing *Star Trek* electronic conference. It is a complete world and very often referred to by the fans as a family. And, crucially here, women's involvement in the larger world of science fiction writing and fandom is thought of in terms of Before *Star Trek* and After *Star Trek*. Marion Zimmer Bradley has said that, although Ursula LeGuin's winning both the Hugo and the Nebula for *The Left Hand of Darkness* was important for breaking up what had been an almost totally male field (as was the appearance of Joanna Russ' *The Female Man*), what really changed everything for women's involvement in science fiction was *Star Trek*.[10] It is widely acknowledged that *Star Trek* fandom was really begun and kept alive by women.[11] But as loyal as the women fans of *Star Trek* have been, they have always been vocal about their disappointment with the women characters. There is a great deal of affection for the characters Lt. Uhura, the communications officer, Nurse Chapel, and Yeoman Rand, for example, but there is bitter disappointment that these women of the twenty-third century are still behind the switchboard, at the doctor's side, or in miniskirts serving coffee to the men. And it has not gotten a whole lot better on *Star Trek: The Next Generation*. It was then, in large part the women fans' abiding love for the *Star Trek* fictional universe, which at an important moment in the late sixties made at least a gesture toward sexual equality—there are, after all, women both on the bridge and off who perform important duties—combined with their disappointment—everything they felt was missing from *Star Trek*—that pushed them to begin elaborating on the *Star Trek* universe, to move it imaginatively toward what *they* wanted: a better romance formula and compelling pornography for women. They could only do so, however, through the characters they loved, respected, identified with, and lusted after—the men, not the women, of *Star Trek*.

But as we know, identification in fantasy does not just go through character. The subject can also identify with the entire scene or the narrative itself. One important aspect of this fandom, which I am only just

beginning to understand and can only comment briefly on here, is the love the fans have for the social and political values represented by the *Star Trek* universe. In *Star Trek*, especially the television series, one can see, almost as if frozen in amber, a perfect representation of Kennedy-era liberalism, or, at least, the producer Gene Roddenberry's version of it—the philosophy of IDIC. The militarist adventurism of both the Kennedy era and *Star Trek* does not seem to be an inherent contradiction for the fans. The fans feel as if they are a part of that universe, want it to *be* our universe, and write thousands of stories trying at least to create it on paper and in the mind. Roddenberry's vision is their utopia, with a few modern additions, of course, like a more sustained attention to sexual and racial equality, freedom of sexual preference, and global ecology, often expressed in a New Age-inspired language more suited for describing inner space than outer space.

Now that I have laid out something of the strength and force of the fan investment in the *Star Trek* universe and in these two characters, an investment that manifests itself through both identification and desire, I think it is possible to begin to show how K/S works as romance and as pornography, how it edges toward something that might be characterized as romantic pornography.

The essay by Patricia Lamb and Diana Veith that I have already cited puts forth the most persuasive argument for K/S as renovated romance, a renovation that takes care of what fans and feminist critics have seen as some of the more troubling aspects of the romance formula. Lamb and Veith argue that the characters of Kirk and Spock offer the possibility of a transcendent mystical union based on a relationship of radical equality rather than the usual erotics of dominance and submission found in the typical romance formula, in which dominance and submission are invariably the respective roles of male and female. The two authors even construct a chart to demonstrate that the K/S writers are only mildly extrapolating from the television show's characterizations of Kirk and Spock as equally androgynous. They see Kirk, for example, to be coded as "feminine" in that he is shorter, physically weaker, emotional, intuitive, and sensual, but "masculine" insofar as he, as captain, is undisputed leader, the initiator of action, the sexually promiscuous one, and usually the seducer. Spock, on the other hand, is coded as "feminine" in that he is the "alien" or "other," follows Kirk loyally, and is a virgin before marriage and expects to be absolutely monogamous after marriage. His masculine characteristics include being taller, more powerful, logical, rational, controlled, and reticent about divulging per-

sonal matters. Thus, even though Kirk and Spock have to overcome the usual obstacles of the romance formula—their love is forbidden, it must be kept a secret, neither lover can take the initiative, each constantly mistakes or doubts the reciprocity of the other's desire—when they do get together they do so as a couple in which love and work can be shared. Their passionate, lifetime union is only an extension of the friendship and loyalty they have always felt for each other while working as captain and first officer on the bridge of the *Enterprise*. Lamb and Veith's answer, then, to why the slashers write their romances about two men is that we still live in a partriarchal culture; it is thus still not possible to imagine two women passionately in love with one another who go out and save the galaxy once a week.

I agree with Lamb and Veith's argument, although I think it helps us more to understand the sociological question of "Why Kirk and Spock?" than the perhaps more psychical question of "Why two men?" To grasp why the erotic charge is always depicted as occurring between two men and why it takes place in a scenario in which women can fantasmatically participate but are, finally, radically excluded, we would also have to turn, I think, to descriptions of our culture that emphasize its homosocial organization, along the lines that Eve Sedgwick, among others, has suggested to us.[12]

I would also put more emphasis than Lamb and Veith do on the fans' identification with the whole *Star Trek* universe, not just the characters. But, finally, my main criticism of their work (which I otherwise find invaluable) is that their focus on K/S as romance slights the pornographic force of these stories. Just as K/S re-does romance, so, too, it constructs new versions of female pornography. One ingenious way that it re-does pornography is by attempting to resolve the vexed issue of S & M, an issue that still bitterly divides feminists. There is a lot of S & M in these stories; however, through neatly borrowing a familiar science fiction device, the K/Sers are able to have their S & M by imaginatively stating and firmly siding with those who believe that your fantasy life is fundamentally separate from what you do in daily life. This is how it works: Rarely will a scene of rape, torture, or bondage take place in the regular K/S universe. But, through the science fiction device of the alternate or mirror universe, the evil Spock can find himself working for the Orion slave traders, and a degraded Kirk will be the handsome blond slave brought to him in chains to be put through various sexual initiations before being shipped off to the brothels of Omicron Pi. Afterward, however, a fortuitous time warp occurs that flips the two men back into the

parallel universe where everything is normal. (Again, as with *pon farr* stories, the narrative premise is taken from a *Star Trek* episode, here the Hugo-nominated "Mirror, Mirror.")

Some fans show a strongly psychoanalytic understanding of the relation of the unconscious to everyday life. In several alternate universe stories I have read, the Kirk and Spock of the original time line have flashbacks to, or at least nagging memories of, their evil mirror counterparts, as if to acknowledge that even though fantasy and "reality" are separate, that does not mean that there is *no* relation.

There is clearly much more to be said about the ingenious ways the K/S fans are reshaping both romance and pornography to their own desiring ends. But I need to begin to move toward a conclusion, and I want to do so by mentioning some aspects of the fandom that I find troubling. It has probably been obvious that I am, for the most part, completely ga-ga over this fandom. It indeed represents the most radical and intriguing female appropriation of a mass-produced cultural product that I have ever seen. A friend of mine told me that I wasn't really a fan of *Star Trek*, I was a fan of this fandom, and I think there is a great deal of truth in that.[13]

But here, for example, is one thing that troubles me about the fandom: I cannot tell you how many times during the three slash conventions I have attended that I heard the phrase, "I'm not a feminist, but . . ." The fans, who, from their statements on individual issues—from reproductive rights to equal pay for women—generally ranged from liberal to left libertarian, could not speak of themselves as feminists, could not speak from a feminist position. One reason that immediately springs to mind is that, insofar as the women fans see themselves as readers and writers of pornography, they do not feel accepted by a feminism that is popularly perceived as moralistically antipornography. (I am referring here, of course, to the great success of the Women Against Pornography movement in fostering the now widely held notion that pornography's only function and purpose is to victimize women.)

But beyond that, I think there is also a class issue. Most of the fans are either working class or "subprofessional" (I use the term "subprofessional" to designate the kinds of jobs that, if men held them, would be thought of as professional but, because women hold them and are paid so little, are not quite considered professional). The fans who also work outside the house, either part-time or full time, are secretaries, clerks, librarians, daycare workers, social workers, schoolteachers, and nurses; one of the fans at the most recent convention claimed that 40 percent

of the fans were nurses, mostly in intensive care units. Feminists, on the other hand, seem to be perceived by the fans as middle-class professionals and therefore not like them. It is not that I didn't hear feminist *sentiments* strongly, frequently, and humorously voiced by the fans, but rarely from the position of being a feminist. Instead, the affiliation is to fandom. I discovered participants' occupations and class backgrounds only incidentally; one is not asked, upon being introduced, "What do you do?" but, "How long have you been in fandom?"

A very telling event occurred during a conference workshop I attended devoted to dysfunctional families. The workshop was put together because of the perception that many fans come from so-called dysfunctional families and turn to fandom for the kind of unconditional acceptance one gets (supposedly) only from one's family. The two moderators of the workshop had chosen to focus specifically on the problems of adult children of alcoholics, taking parental alcoholism and the children's response to it as a model for all forms of abuse and victimization. We were asked to read together and comment on the ACOA list of fourteen characteristics that adult "children of alcoholics seem to have in common due to having been brought up in an alcoholic household." They included statements like: "We became isolated and afraid of people and authority figures." "We became approval seekers and lost our identity in the process." "We are frightened by angry people and any personal criticism." "We have an overdeveloped sense of responsibility, and it is easier for us to be concerned with others than ourselves." At about statement number ten, I finally spoke up to ask whether these descriptions did not also apply almost identically to the behavior of women in our culture as a result of their unequal treatment. One of the moderators energetically responded, "Yes," but then immediately offered a disclaimer. "Yes, women are generally devalued, but I don't want to say anything too global." She didn't want to say anything "too global," I think, because she might have been appearing to make a feminist statement.

There are many lessons here for feminism and the study of popular culture. We could look at fandom as an exemplary case of female appropriation of, resistance to, and negotiation with mass-produced culture; and we could embark on a continuing discussion of K/S to help dislodge the still rigid positions in the feminist sexuality debates around fantasy, pornography, and S & M. But if we are to do so, it must be within the recognition that the slashers do not feel they can express their desires for a better, sexually liberated, and more egalitarian world

through feminism; they do not feel they can speak as feminists; they do not feel that feminism speaks for them. Fandom, the various popular ideologies of abuse and self-help, and New Age philosophies are seen as far more relevant to their needs and desires than what they perceive as a middle-class feminism that disdains popular culture and believes that pornography degrades women.

My final question, then, is to contemporary feminism and its work on popular culture: Are we ready, like the slash fans, "to explore strange new worlds, . . . to boldly go where no one has gone before?"

NOTES

This essay is reprinted from L. Grossberg, C. Nelson, and P. Treichler, *Cultural Studies* (London and New York, 1992), by permission of the publishers.

1. N. Chodorow, *The Reproduction of Mothering: Psychoanalysis and the Sociology of Gender* (Berkeley, 1978).

2. J. Radway, *Reading the Romance: Women, Patriarchy, and Popular Literature* (Chapel Hill, 1984).

3. T. Modleski, *Loving with a Vengeance: Mass-Produced Fantasies for Women* (New York, 1984). Another, and more recent, example of this tendency would be J. Byars' "Gazes/Voices/Power: Expanding Psychoanalysis for Feminist Film and Television Theory" in *Female Spectators: Looking at Film and Television*, ed. E. D. Pribram (London, 1988), 110–31. Just as Modleski tries to construct the female spectator's pre-Oedipal regression as *ultimately* positive (from her victimized position, the woman enacts a revenge fantasy in and through the mass-culture text), Byars, after arguing for the pre-Oedipality of the female spectator, also tries to show that this conservative, compensatory position is finally active and positive. She does so by bringing in Carol Gilligan's theories to argue that this *different* spectator (that is, different from the male spectator) is a *better* one: caring, responsive, connected rather than distant, voyeuristic, and sadistic. This conceptual move, which establishes the pre-Oedipal as the origin and the limit of female subjectivity but then attempts to give that position a positive value, ultimately reduces and essentializes the account of female subjectivity, in one case making woman always-already a victim (revenge is the tactic of the victim), and in the other conceiving of woman as having a profoundly different nature from those who manage the world. Such essentializing accounts are not only reductive, they are dangerously disempowering.

4. The now-classic psychoanalytic account of fantasy to which my own description is indebted is found in Jean Laplanche and J.-B. Pontalis, "Fantasy and the Origins of Sexuality," *The International Journal of Psycho-Analysis* 49 (1968). Particularly important for my approach to describing female media fan culture and its artistic products are the following conclusions of Laplanche and Pontalis:

1. Fantasy has nothing to do with an opposition between "reality" and "illusion" but rather interjects a third term—psychical reality—that structures both.

2. Fantasy is not the object of desire but its setting.

3. Fantasy is a story for the subject, a story that attempts to answer certain basic or "primal" questions about the origin of the individual, the origin of sexuality, and the origin of the difference between the sexes (other questions can be posed and "answered" in fantasy, but these are the most basic ones).

4. Sexuality is detached from any natural object; to start existing as sexuality, it must begin in fantasy.

5. Although the subject is always present in the fantasy, she or he may be there in a number of positions or in a desubjectivized form, that is, "in the very syntax" of the fantasy sequence.

6. There is no separation between conscious and unconscious fantasies but rather a profound relationship and continuity between the various fantasy scenarios—"the stage setting of desire"—ranging from the daydream to the fantasies that can be recovered or reconstructed only in an analytic investigation.

7. A psychoanalytic account of fantasy must necessarily show the dialectic relationship between fantasy productions, the underlying structures, and the reality of the scene.

To which must be added the Lacanian emphasis on the nonreciprocity between subject and object, as described in his formula for fantasy: $\mathcal{S} \diamond a$ (the subject is barred from the desire of or for *petit objet a*); in other words, the subject is structured by that which is lacking to it.

5. Patricia Frazer Lamb and Diana Veith, "Romantic Myth, Transcendence, and *Star Trek* Zines," *Erotic Universe: Sexuality and Fantastic Literature*, ed. Donald Palumbo (New York, 1986), 235–56.

6. Joanna Russ, "Pornography for Women, by Women, with Love," in *Magic Mommas, Trembling Sisters, Puritans and Perverts: Feminist Essays* (Trumansburg, N.Y., 1985).

7. See Henry Jenkins, "*Star Trek* Rerun, Reread, Rewritten: Fan Writing as Textual Poaching," in *Close Encounters: Film, Feminism, and Science Fic-*

tion, ed. Constance Penley, Elisabeth Lyon, Lynn Spigel, and Janet Bergstrom (Minneapolis, 1991), 170–203.

8. Fan friends who are involved in *Professionals* fandom (stories based on the lives of the two male leads of a sophisticated, action-oriented, British secret agent show) say that the PROS writers explicitly depict the two men as a gay couple living in homophobic Thatcherist Britain. I have also noticed that the male characters in *Blake's 7* fan fiction seem to be more forthrightly depicted as gay. The differences here—that the characters can be more-or-less or not at all gay—demonstrate that there is not a single, monolithic fantasy of gender or sexual orientation in fan writing but a number of positions and possibilities. These positions can, however, be in conflict; they are not merely multiple and dispersed. For example, most K/S writers never set out to write explicitly gay characters but, rather, men who can share love and work in an egalitarian way (and, indeed, for their project of refashioning heterosexual masculinity—which I argue elsewhere ["Brownian Motion: Women, Tactics and Technology," in *Technoculture*, ed. Constance Penley and Andrew Ross (Minneapolis, 1991)]— they *need* Kirk and Spock not to be gay). Nevertheless, they have in fact written characters who could be reasonably identified as homosexual, and thus eventually they will have to question why they are reluctant to let these two men who are joined erotically and emotionally be gay. This questioning has led, I believe, to the beginnings of a fan debate around homophobia in our culture, its causes and consequences. That this debate should be taking place in what might seem an improbable location—in female media fan culture, many of whose members must maintain an exceptionally conventional demeanor because of their jobs and domestic situations—is heartening during this time of severe backlash against any sexual role or orientation repressively deemed to be "nonstandard."

9. For examples of recent work using the psychoanalytic account of fantasy to account for desire and identification in film, see Elisabeth Lyon, "The Cinema of Lol V. Stein," and Janet Bergstrom, "Enunciation and Sexual Difference, in *Feminism and Film Theory*, ed. Constance Penley (New York and London, 1988); Elizabeth Cowie, "Fantasia," in *The Woman in Question*, ed. Parveen Adams and Elizabeth Cowie (Cambridge, Mass., 1990); "Feminism, Film Theory, and the Bachelor Machines," in Constance Penley, *The Future of an Illusion: Film, Feminism, and Psychoanalysis* (Minneapolis, 1989); and the essays in *Fantasy and the Cinema*, ed. James Donald (London, 1989).

10. Marion Zimmer Bradley, "Responsibilities and Temptations of Women Science Fiction Writers," *Women Worldwalkers: New Dimensions of Science Fiction and Fantasy*, ed Jane B. Weedman (Lubbock, Texas, 1985).

11. See, for example, Bjo Trimble, *On the Good Ship Enterprise: My 15 Years with Star Trek* (Norfolk/Virginia Beach, Va., 1983).

12. Eve Kosofsky Sedgwick, *Between Men: English Literature and Male Homosocial Desire* (New York, 1985).

13. I now know, since attending a slash convention panel on "How did you get into slash [fandom]?" that my position as a fan of the fandom rather than a fan of *Star Trek* is not unusual. Although many of the women fans came to slash after years of involvement in *Star Trek* fandom, many others came to love and appreciate *Star Trek* only through the version of it elaborated in slash fan culture. There are a very few who claim to have little or no interest in *Star Trek* itself, although at least a bit of indulgent affection for it seems to be necessary to the enjoyment of the slash version.

The Ecology of Images

The Target-Rich Environment

AT least two urgent needs emerged from the war in the Gulf. First of all, the United States Congress needs to sit down and draft a constitutional amendment to ensure the separation of Press and State. That action would probably require a much better Congress than any money can buy, but it would do well to protect against the collapse, all too clear from the first hour of Gulf combat, of the distance conventionally observed between the corporate media and the corporate state, respectively engaged in the ratings war over images or the strategic war over oil resources. The technically sweet aesthetics of the TV war, which many people compared to a Nintendo game, was the culmination of what other critics have increasingly come to call the military-industrial-media complex, concentrated in the hands of fewer and fewer conglomerate owners. Consequently, the logic of the TV ratings war became an integral part of many viewers' experience of the minute-by-minute progress of military operations in the Gulf. Everyone seemed to become a media critic. Many even became Baudrillardians without knowing it, repelled by everyone else's (and never their own) fascination with the simulacra of war cooked up by the Pentagon and the networks (a simulated aerial view of Baghdad from an F-111 pilot's perspective—who would not want to see that?). Members of the Institute for Defense Information, a group of disaffected Pentagon ex-employees, confirmed what many suspected; that, in view of a job well done by the networks, the Pentagon decided not to release their own independent footage and propaganda in the United States. To top it all, antiwar protesters (including myself) marched, not to the Pentagon, but to the TV network buildings. Denied access to the corporate workings of military industrialism, intellectuals and activists feel they still have at least one foot in the door of media making; but the "linkage" suggested by the phrase "military-industrial-media complex" was often forgotten in the rush to paint media professionals as craven or warmongering. While the TV anchors drew the heat, the industrialists and the generals were laughing all the way to the bank.

Not that the critiques of the media's role in the war were not justified, especially when they extended to exposés of the TV war's exploitation of popular pleasures, embellished by racism and xenophobia. However, in a war openly fought for control over dwindling oil resources (the model, now, for the twenty-first-century eco-wars for which dystopian science fiction has so long prepared us), we cannot forget that the nightly firework display in the Gulf skies and the spectacle of laser-guided smart bombs homing in on their targets were also an explicitly seductive advertisement for another thirty years of the permanent war economy, sustained by the uninterrupted flow of cheap fossil fuels. Such images, when put alongside the images of burning Kuwaiti oil fields, were part of a story being told about the ecological significance of war politics.

Perhaps the most telling Pentagon images in this respect were those shot by a camera mounted on a GBU-15 glider bomb en route to destroying the al-Ahmadi Sea Island terminal's pumping mechanism, which, we were told, controlled the flow of four hundred million gallons of Kuwaiti oil spilling recklessly into the Gulf. Here, then, in this official Pentagon footage, we were offered the visual perspective of the U.S. Air Force as "Captain Planet," waging war against eco-terrorism in what must surely also rank as the first photo-opportunity for politically correct militarism. The prelude to this bizarre footage was best summed up in the previous day's three-inch-high headlines in the scab edition of the New York *Daily News*: "Saddam Attacks Earth!"—a headline worth an appearance in any bad SF movie. Media treatment of the ecological consequences of the spill itself was no less adventurist and no less fantasmatic, varying dramatically in its assessment of the size of the slick or the flush-out cycle of the Persian Gulf (anything from two years to two hundred years). In the absence of any footage of Iraqi soldiers themselves, the slowly spreading oil slick in the Gulf waters quickly came to embody, for Western audiences, many of the diabolic features attached to the pseudo-biological "Arab threat." The meaning of the slick no longer lay simply within the traditional iconography of corporate oil spill images, incomplete without stock footage of an oil-drenched seabird. Narratives of war, and the new image-arsenal of "eco-terrorism," gave this oil slick layers of additional meaning. When it was not a "military obstacle" or a "logistics problem," in Pentagon parlance, the slick was yet another mess for the West to fix with its wondrous technology. Most pernicious of all, however, the slick came to personify (oily) Arab treachery, whether it signified the dark, inscrutable evil of Saddam Hussein or the sinister, inexorable spread of Islam/Arab nationalism.

If the oil slick became the leading ecological actor during the war itself, the spectacle of the burning Kuwaiti oil wells played the starring role in the media war's denouement. This sooty spectacle very quickly satisfied a number of needs: first, a Western and, I suppose, specifically Christian desire for images of hellfire appropriate to wartime, images that were widespread in the wake of bombing raids on Baghdad and Basra but denied us by military censorship; second, the sense of an ending to the war's narrative, recalling for Western audiences the real oil-related purpose of the war and its economic significance for Bush's New World Order; and third, in the midst of extensive ecological commentary about climatic effects—acid rain, equatorial holes in the ozone layer, and monsoon failure in the Indian subcontinent—a need to believe that there is no life in a desert, and thus there is no desert ecology to devastate. In the year since the war, the withholding of satellite information and weather data on the part of government agencies, no doubt subject to a White House gag order, has made it virtually impossible to tell an accurate story about the ecological consequences of a war in which nine out of ten deaths are estimated to have occurred after the bombing ended. The oil slick and the burning wells were the only images of ecological spoliation the public did get to see, and the ones that the public remembers. Forget the "moonscape" created by B-52 carpetbombing, the targeted bombing of over forty biochemical and nuclear facilities, or the systematic destruction from the air of the water and sewage infrastructure of Iraq. Forget the catastrophic erosion likely to be caused by the breaking of the desert's top surface, held in place by a crust of living microorganisms. Forget the environmental devastation begun with the installation of the two armies—the garbage, sewage, and toxic waste created by two vast alien populations totaling over one million in a desert whose ecosystem is in many ways more delicate than that of the Gulf waters. Those are stories that could not be told, either because of Pentagon censorship or because they require more than a sound-bite analysis and a set of atrocity images. This is not to dispute the disastrous scale and consequences of the oil spill and the burning wells, about which the Pentagon had ample forewarning from their own environmental impact studies, commissioned from the Sandia National Laboratory in Albuquerque (among others). But nothing else could compete, in media terms, with these twin spectacles, which were left to fill out the environmental story by themselves. It is a story in which the United States military, the biggest polluter in its own country, generating a ton of toxic waste every minute in peacetime, was featured

in the Captain Planet role of combating environmental damage. This was one of the more obscene aspects of the war—the bestowing of ecological sanctity upon a military institution that makes a mockery (the Bush administration's wartime decision to exempt military observance of the 1970 National Environmental Policy Act was implemented in only one instance and circumvented in many others, for fear that a general exemption would raise too many questions) of public review of the toxic effects of its weapon testing (especially nuclear) and production of war matériel in the United States, while national environmental laws are nonbinding for overseas activities.

Credible Forms of Lust

If we are to make proper sense of such events and such images, it is high time that we had more of a green cultural criticism, if only to help us see why all wars, and not just this one, are now ecological wars in every sense of the term. After twenty years of the ecology movement, ecological criticism is still, astonishingly, in its infancy in visual studies, despite, for example, the vast amount of attention recently devoted to ecological issues by artists and writers. Theoretical discussion of ecological issues are especially thin in cultural and visual studies, and so my remarks here are largely speculative since there is not much conversation to build on, at least not when compared to the influence of other social movements upon cultural theory. As a beginning, then, I want to recall one of the few related discussions I have found, in Susan Sontag's book *On Photography* (1977), at the end of which she called, somewhat metaphorically, for an "ecology of images":

> Images are more real than anyone could have supposed. And just because they are an unlimited resource, one that cannot be exhausted by consumerist waste, there is all the more reason to apply the conservationist remedy. If there can be a better way for the real world to include the one of images, it will require an ecology not only of real things but of images as well.[1]

A decade earlier, in her book *Against Interpretation* (1966), Sontag had made a similar kind of call for an "erotics of art." This call was answered loudly and clearly in literary and cultural criticism during the subsequent two decades; the kind of criticism that has focused on the libidinal or psychosexual relationship between language and desire, and

images and pleasure. By contrast, there has been precious little in the way of a response to Sontag's call for an "ecology of images." It is unfortunate but perhaps instructive that we may have needed images from war to provide the impetus for belatedly responding to Sontag's call and for seriously debating the consequences, for cultural criticism, of an "ecology of images." At the start of a decade that will play host to a green cultural criticism, redirecting attention to the suppressed (at least, in the last twenty years of cultural theory) "nature" side of the nature/culture equation, nothing seems more important than to debate the ecological role and character of images; not only the use of images to tell ecological stories but also the ecology of the image industry itself, considered in all its aspects of production, distribution, and consumption.

My remarks on this neglected debate will be speculative and exploratory. Whatever ultimate shape this debate will take, I begin here by dividing my comments into two categories of discussion: images of ecology, and the ecology of images. The division will remind some readers of the two schools of thought that used to divide feminist film criticism. On the one hand, there emerged the "images of women" film criticism, the images either seen as positive or negative according to a content analysis. On the other hand, what came to be known as feminist film theory developed, with its more structural focus on the film "apparatus," the film spectator, and the production of gendered divisions within the film narrative. I do not intend this analogy to be hard and fast, but there exists, I think, a minimum of common elements and conditions to make a link between these respective kinds of analysis—the analysis of the meanings of images, and the analysis of narrative and technical logic.

To begin with what looks like the easier category, what are "images of ecology"? Aside from the long history of "images of nature" in the genres of nature and wildlife photography, films, and documentaries, there has appeared over the twenty-year existence of the ecology movement a genre of image in which the "environment" figures quite distinctively as a narrative element, usually endangered and in some advanced state of degradation but also often in a state of repair, reconstruction, or even in pristine good health. In recent years, we have become accustomed to seeing images of a dying planet, variously exhibited in grisly poses of ecological depletion and circulated by all sectors of the image industry, often in spots reserved for the exploitation fare of genocidal atrocities. The clichés of the standard environmental image are well known to us all: on the one hand, belching smokestacks, seabirds

mired in petrochemical sludge, fish floating belly up, traffic jams in Los
Angeles and Mexico City, and clearcut forests; on the other hand, the re-
demptive repertoire of pastoral imagery, crowned by the ultimate global
spectacle—the fragile, vulnerable ball of spaceship earth. These images,
which call attention to the actually existing state of the environment,
are intended to have different meanings from the traditional genres of
images of nature (notwithstanding the obvious caveat that "Nature"
itself has played host, historically, to a whole spectrum of shifting mean-
ings). It is in this respect, then—the conditions under which the ecology
of a depicted environment becomes a narrative agent—that we can
speak of "images of ecology" in recent years, as well as of the critical lan-
guage used to describe these images and narratives as either "positive"
or "negative" images and narratives.

I will have more to say about images of ecology, because we cannot as-
sume an apparent understanding of the power of these images. In other
words, I don't mean to suggest that it is, in a sense, the more *vulgar* of
the discussions I will be pursuing here and that, having briefly pinned it
down, we can move on to higher things. For the time being, however,
I am obliged to devote some time and space to the question of whether
images have an ecology in their own right, if only because it is a less
widely recognized idea in the first place. To do so, we must consider the
social and economic organization of images—the processes by which
images are produced, distributed, and used in modern electronic cul-
ture—and ask if there are ecological arguments to be made about those
processes.

Sontag's discussion of photographic images is a starting point. In *On
Photography*, a book about the "ethics of seeing" the world through
the voracious filter of image consumption, she argues that the world is
consumed and used up by our appetite for images. In Sontag's view, the
world has been reduced to a set of potential photographs; its events are
valued for their photographic interest, and large sectors of its popula-
tion have become "tourists of reality" as a result. Though she sees the act
of the photographer as "essentially an act of non-intervention" (p. 11),
the knowledge that an audience gains through images is always gained
cheaply; it is always knowledge at "bargain prices" (p. 24). Sontag is
careful to avoid reproducing the jeremiac tones of those who, histori-
cally, have lamented the popularity of the image over the reality, but
there is no mistaking the repulsion that wells up beneath her fascina-
tion with modern image-addiction. "Industrial societies," she writes,
"turn their citizens into image-junkies: it is the most irresistible form

of mental pollution" (p. 24). Surely Sontag has in mind here a Judeo-Christian meaning of "pollution," as applied to the *moral* equilibrium of the mind-body and marked by the perversion of that balance. She is clearly invoking the older, moral stigma of spiritual pollution to describe our complicity with the overconsumption of images and the consequent depreciation of the world's reality-resources. But there remains a persistent distaste in her comments. Later in the book, the same charge returns, this time more overtly embellished—in a mode that would come to preoccupy Sontag in her subsequent writing—with the metaphors of sickness:

> The possession of a camera can inspire something akin to lust. And like all credible forms of lust, it cannot be satisfied; first, because the possibilities of photography are infinite, and, second, because the project is finally self-devouring. The attempts by photographers to bolster up a depleted sense of reality contribute to the depletion. Our oppressive sense of the transience of everything is more acute since cameras gave us the means to "fix" the fleeting moment. We consume images at an ever faster rate, and, as Balzac suspected cameras used up layers of the body, images consume reality. Cameras are the antidote and the disease, a means of appropriating reality and a means of making it obsolete. (p. 179)

When Sontag speaks of photography as a "credible form of lust" (just exactly what an "incredible" form of lust might be is left for the reader to toy with), an addictive pleasure for which we will ultimately have to pay the consequences, she seems to convey a strongly moral or religious sense of retribution. I find this appeal disturbing and quite objectionable. If we consider its implications in the context of Sontag's later commentary on the history of "illness as metaphor," we might complain about her own perpetuation of that particular discursive history, exemplified here by the description of visual technologies as both "the antidote and the disease."[2]

For me, Sontag's idealist remarks about image addiction can best be placed in the context of ecological arguments about the historical role of science and technology in the domination of the natural world. In this light, camera technology can be seen as an embodiment of what ecologists have called the rationalist project of mastering, colonizing, and dominating nature; a project whose historical development now threatens the global ecology with an immediacy that is all the more ironically apparent to us through those very "images of ecology" that have become standard media atrocity fare in recent years. My reading

of Sontag's arguments is that they take this ecological thesis one step further, into the realm of the epistemology of images. I would summarize her discussion of the capacity of images to "deplete" reality in the following way: Just as ecologists have spoken of the "carrying capacity" of a bioregional economy, so, too, are we invited to think of the production and consumption of images as a central element in our social habitat, which can only take so much before it reaches its limits. Just as the technological overproduction and overconsumption of raw materials can wastefully exhaust the carrying capacity of a natural economy to sustain itself, so, too, a similar tendency in image production and image consumption diminishes our capacity to sustain a healthy balance of life in the social world of our culture. There comes a point, if you like, when one image too many destroys the global "commons." This way of drawing out a working analogy from Sontag's comments may be rather crude, but I don't think it is unfair; and I have put it in these terms because they highlight more clearly the question that troubles me about this argument.

Can we talk about technologies of cultural production and cultural consumption in terms that so clearly parallel the way in which ecologists have talked about the effect of similar technological processes upon the natural world? To be sure, there are already many common elements on both sides of the analogy, not least of which is the profitable organization of technologies within the film and image industry, and I will have more to say about that topic presently. But the differences are also worth considering. Just as it is important for social ecologists to think about technologies as fully *cultural* processes, not restricted by definition to hardware development and economic growth, so too it is important for us, as cultural critics, to think of the cultural processes we study and talk about as meaningful in ways that are not always technologically determined. The advantage, then, of the analogy that I have sketched above is that it invites us, as cultural critics, to think more about the technological underpinnings of the culture we study. The danger of the analogy is that it also invites us to forget what we think we know about the specificity of the images themselves—how they are received and used for all sorts of purposes, not the least of which, in this particular case, are the ways that images of ecology can actually be used to activate public and popular support for the repair of our local and global ecologies. And it is here that I find Sontag's analysis finally disappointing, because it leaves virtually no room for the kind of green cultural criticism that I think might help make a difference.

In addition, Sontag's remarks are in every respect consistent with the school of thought that rails against image overload in our modern information society. Information glut has become a favored object of attack both from the right and the left. Even on the level of the quantitative argument, I have never been happy with this response since I have always assumed that most people in this world would rather have a surfeit of information (whatever that means) than a scarcity. But information is not the same thing as intelligence or knowledge; its quantity tells us no more about its reception than a quantitative estimate of the number of proliferating TV channels or the number of viewing hours clocked up by the average couch potato can tell us about the uses made of those television images selected by any particular viewer. *That*, after all, is supposed to be the job of cultural studies, which assumes that competent viewers of images have their own, highly organized ways of making sense of the "glut" of images available to them. Even less useful is the response of post-modernist theorists who see the helpless victims of information overload as schizoid or paranoid casualties of forces beyond their control. To my mind, the most useful critiques of information culture are still those that focus on the economic organization of information and its technologies, the ever advancing new and profitable ways of restricting access to information and making it an ever more scarce commodity. Contrary to the image glut school of thought, which leads the moral crusade against the overavailability of information, it is quite clear that getting access to information today is just as uneven and as expensive as ever; this is as true in the tradable global market, where information is a primary commodity, as it is in the home, where it is increasingly difficult, for example, to receive a decent TV signal without paying through the nose for cable. Besides, most of the public commentary that warns us about the dominance of images in our politics and our everyday lives issues from within the "media" itself—media owners, media professionals, media critics—that is, from groups with a vested interest in seeing the image business as all-powerful.

The Anti-Reality Principle

For an ecological analysis of the process of creating image scarcity, one need look no further than the economic organization of the film industry in the age of the megahit. In Hollywood, the medium-priced picture is disappearing fast as the film industry increasingly organizes

itself around two markets: the blockbuster market ($15 to $100 million for production, up to $10 million for wide release, and up to $50 million for global advertising and distribution) and the much cheaper direct-to-video/cable market. In the blockbuster market especially, the familiar industrial process of recycling and recombining images, narratives, and themes has been streamlined with all of the rigor and efficiency available to modern management and marketing techniques. In this context, the principle of recycling is both conservationist and conservative; the industry wants to maximize its gain on tried and true resources—formulae proven to be profitable—but the result runs directly counter to the ecological spirit of preserving and encouraging *diversity*. The result more and more resembles an image monoculture. The ever greater and, some would say, wasteful sums of capital devoted to recycling the old in pursuit of the transnational megahit has the net effect of drastically reducing the chance of cultural diversity in mainstream film production.

The increasingly crucial role of special effects in the megahit business is geared to the industrial principle of obsolescence. The "look" of films made only a few years before is outdated by the technologically advanced effects of today's computerized cameras and postproduction image processing. It is only in the realm of countercultural or subcultural taste where camp nostalgia for the shlocky, low-tech, low-budget look (early stop-motion model effects) of past futures runs high that this industrial principle is displaced if not directly challenged. Yet, with the increasing monopolization of first-run houses and the concomitant extinction of revival houses and venues for screening avant-garde films, the channeling of this redemptive taste culture into the video rental business has itself become a lucrative subsidiary market that does not cut into the mass-release theater circuit and, in many ways, supports its mainstream economy. One of my favorite comments on the ecology of image production comes from the princely parodist of the bad taste circuit, John Waters, ever ready to turn a popular cliché to good use: "At least I've never done anything really decadent, like waste millions of dollars of other people's money, and come up with a movie as dumb as *The Deep* or *1941*. The budgets of my movies could hardly feed the starving children of India."[3]

A more exhaustive account of these tendencies is obviously required if we are to have anything like an ecological analysis of image production. It's my hunch, however, that we are likely to find many economic and technological processes in the image industry that call out for the kind of critiques that ecologists have brought to bear upon other industrial

processes. We are just as likely to find differences, however, for which the application of ecological principles to the field of culture do not have quite the same meaning as they do in the field of technology. The wasteful exploitation of finite resources to manage and control the production of scarcity among general consumer products is an industrial principle that cannot be entirely carried over into an analysis of image production and consumption. Image consumption may not be subject to the same quantifiable processes as those that govern the consumption of other industrial products. If it makes any sense at all to talk about the image "waste stream," then our own position there as consumers is quite different from our position in the material, consumer product waste stream. Images can be used, and reused, in ways that most consumer goods cannot. Proponents of cultural studies, for example, who speak about "consuming" signs and images often forget that "consuming" a Pepsi ad is quite different from consuming a can of Pepsi. So, too, complaints about the "visual pollution" of billboards invite the same kind of second-level critique. That billboard space can be used as a medium for pro-ecological messages further confounds the metaphor.

Cinephiles, archivists, and media critics have long been horrified by the scandalous lack of conservationism within the film and TV industry: the studios' throwaway attitude toward film prints (the meltdown of Erich von Stroheim's *Greed* for thirty cents of silver nitrate is the mythical horror story par excellence), the instant obsolescence of TV film, and the cavalier decisions about use of capital and resources that are made in pursuit of the final cut. There is no question that ecological critiques of the history of the photochemical and photographic industry would expose an even more sordid narrative about the chemical underpinnings of the film economy. You do not need to have lived in Rochester, New York, as I have, to know something about the life-threatening history of the image industry's major supplier, Eastman Kodak, consistently among the worst polluters of major U.S. corporations. The common use of materials like nitrocellulose in film stock and in explosives production has long been an element in film historians' accounts of the image industry, whose film technologies invariably were and are a direct spin-off from military research and development.

In *War and Cinema* (1984), an especially prescient book for the Gulf War, Paul Virilio offered a historical analysis of the importance of film technology to military-industrial interests. In his account of the transformation of the modern battlefield from a Cartesian arena of warring objects to a simulated arena of pictures and sounds, Virilio examines

the crucial role of camera technology in what he calls the "logistics of military perception."[4] This history runs from the emergence of military photography in the American Civil War, through the military use of propaganda film units and Nuremberg-like staged spectacles, to the advent of a planetary war vision with spy satellites and advanced simulation technologies. It is a history in which film technologies are fully and materially embedded in the logic of destruction; in which the video-equipped warheads and electro-optically lit battlefields that we saw in the Gulf War are continuous with earlier strategic uses of aerial photography in World War I, a war during which D. W. Griffith, the only civilian filmmaker authorized to make propaganda films at the front, said that he was "very disappointed with the reality of the battlefield" (soldiers seldom, if ever, actually *saw* the enemy).[5]

The camera's contribution to what Virilio calls the "dematerialization of reality" on the battlefield seems to me a more telling story about the destructive potential of image making technology than that offered by Sontag. Here, the logic of photography—the dematerialization of reality—goes hand in hand with the apparatus of war, devoted to the *destruction* of reality. This is a materialist epistemology, as distinct from Sontag's idealist epistemology, in which images figure as the means of *depleting* reality. In Virilio's history, the camera is a material participant in the apparatus of destruction. Sontag insists that the world today exists only to be mined and ransacked for images, but there is no principle of immediacy at stake in this knowledge because there is no finite limit to the quarrying.

Although I believe that there is an important difference between these kinds of analyses—Virilio's and Sontag's—I am not comfortable with the opposition, nor do I think we can simply appeal to the superiority of the materialist over the idealist critique. Ideas and images are also constitutive of the world in ways that can counter their role as technological recruits in the war against environmental reality. That is why a discussion of the ecology of images—the ecology of image production and image consumption—of the sort I have briefly pursued here must make room for some understanding of the role played by images of ecology; for neither Sontag's nor Virilio's critique takes into account those instances when images (of destruction and/or ecology) are actually used to debate, or even to contest, the consequences that both critics lament—the material disappearance of the real. In short, images of ecology today are also produced, consumed, and used in ways that can help to counteract the destruction of the natural world.

Images of Ecology

In turning back, then, to the question of "images of ecology," we must recognize that any proper account of them covers a broad spectrum. At the most visible, activist end of the spectrum are agitprop images that are directly employed within and by the ecology movement to mobilize sympathy, support, and action for environmental causes; what we could call images of ecology *for* ecology. At the other, more sublimated end of the spectrum are images that have some kind of ecological content and that are incorporated into the everyday fictions of public and popular culture; images of ecology that are not necessarily *about* ecology. This spectrum is not, of course, a flat political spectrum—it does not simply run from left to right—and I will try to show how and why this is so.

Although the ecology movement—on a spectrum from the Sierra Club to Earth First—has made very good use of images of environmental degradation and repair alike, there is no naive faith in their power as political images in their own right. Even though such images speak about the exhaustion of the ideologies of progress that have sustained technological growth and development in the West, the socialist bloc, and, increasingly, the Third World, the images themselves cannot, of course, say very much about such ideologies. The image of spaceship earth is as likely to be found hanging in the office of a nuclear weapons researcher as in a Sierra Club brochure. An image of an oil lake in the Kuwaiti desert can be used to tell a story about the heroism of Western firefighters (the oil well fires were out by the end of the year); alternately, the same image can tell a story about the oil that, though no longer aflame, was still gushing out of the ground and slowly seeping into the desert and the Gulf itself. The story is told by the narrative context in which these images occur, a problem that is profoundly demonstrated by the widespread use of "images of ecology" in advertising by the most environmentally destructive of the major industrial corporations— a practice known as greenwashing. For those and other reasons, environmentalists tend to be suspicious of the use of images as a medium of information. In this respect, we can say that discussion of the images of ecology has already moved beyond the assumption that images in themselves have a fixed political meaning for audiences as either "positive" or "negative" and thus as "good" or "bad." It is not yet clear, however, whether the discussion of this issue has fully addressed the means by which forms of representation—narrative logic and point of view—can bring political meanings to bear upon the nature of the information pro-

vided about ecological matters. In the examples that follow, I will try to show how a focus on narrative logic and point of view can link critiques of the ecology of images and images of ecology.

My first example is from the more activist end of the image spectrum. The ecology movement may be exceptional among new social and political movements in making an overriding appeal to scientific information for proof of the justice of its claims. One of the favored visual forms of organizing eco-statistical information is the cartographic format— maps and graphs are science's privileged genres of imagery—and one of the most commercially successful genre of ecology publications are state-of-the-world atlases. These atlases exploit the fact that the global image is the most stable form of information about a highly unstable environment. Joni Seager's *Atlas Survey of the State of the Earth* is a typical example, a breakdown, from page to page, of the degradation of the world's resources: the state of the rain forests, population increase, energy budgets, acid rain, drinking water, food supplies, sewage, air quality, firewood, petrochemical pollution, coastal erosion, the wildlife trade, genetic diversity, toxic waste, the timber trade, and so on.[6] For the most part, atlases like Seager's, or the *World Wildlife Fund Atlas of the Environment*, or Michael Kidron and Ronald Segal's *New State of the World Atlas*, accept the current organization of global territory according to the sovereignty of nation-states, and their eco-statistics are broken down into the share accorded to national economies (Kidron and Segal's book, at least, seems to be assembled as a cumulative statement against the absurdity of the nation-state system).[7] These maps are not, then, utopian images; they seldom organize the field of representation by bioregion.[8] Nor are they dystopian in the ways that reflect the new global economy or global culture; they do not adequately represent the influence and power of transnational corporations. Nor does the form of the per capita statistics help to differentiate the average citizen's share from the disproportionately destructive contribution of the military, government bureaucracy, or industry within any given nation-state, each citizen in that state sharing differently according to region, color, and class.

Though these images are produced for activist purposes, their form is not an activist one inasmuch as it does not imagine a world organized differently. They accept the current political and economic organization of the world as ostensibly controlled by existing nation-states. Their representational form also accepts the cartographic legacy of imperialism, the very historical perspective that has exploited the privilege of seeing

"the big picture." The eco-atlas may finally be an elite form of repre-
sentation; its point of view is ultimately that of a new elite of planetary
eco-managers. Here, then, is an instance of how the representational
form of the image is a major component of the political meaning of the
information conveyed by the image.[9]

A similar kind of argument could be made about eco-statistics them-
selves, a staple of ecological arguments made in the public sphere. Like
the eco-atlas, which inherits and accepts the imperialist perspective of
military logistics, the persuasive citation of eco-statistics borrows its
shock appeal from the rhetorical stock-in-trade of military statistics.
The arsenal of statistics about eco-atrocities in the global environment
is often used to create a climate of fear in the same way as the mer-
chants of war have profited from the statistics of nuclear kilotonnage,
projected megadeaths, and strategic firepower. The result of this dysto-
pian climate of shock and terror is not necessarily empowering; it feeds
into survivalism, the lowest form of ecological consciousness, especially
when these statistics are simply projected into the darkest of doomsday
futures.

Another privileged genre of images of ecology is the narrative docu-
mentary, with its roots in nature and wildlife film. The noncable context
for this genre in the United States is almost exclusively public television,
with its demographic appeal to the concerns of a predominantly white,
neoliberal, middle-class audience with a median age of 61. (On cable, the
Discovery Channel presents a host of nature and ecological features.) In
the wake of Earthday 1990, the fall schedule of PBS programming was
almost entirely devoted to environmental documentaries, culminating in
the lavish, ten-hour miniseries, "Race to Save the Planet," an attempt to
narrate an ecological history of the development of human cultures in a
form akin to that middlebrow classic of public television programming,
Kenneth Clark's BBC series, "Civilization." Contextualized by liberal,
"quality," Hollywood performers (it is introduced by Meryl Streep and
narrated by Roy Scheider) and characterized by its laboriously pious nar-
ratives and monotonously conscientious tone, "Race to Save the Planet"
was advertised (in slots for PBS's annual fund-raising fall campaign) as
exemplary of "television that lets you take action." The rhetoric of this
appeal to a PBS audience was brilliantly appropriate: not activist TV,
nor TV about activism, but TV that reaffirms its audience's identity as
liberal-minded people who are accustomed to taking for granted their
social identity and position—middle class and predominantly profes-
sional—as already "active" (rather than "activist") in the world.

In considering the use of images about ecology drawn from the more articulate, or even activist, end of my spectrum, I have pointed, all too briefly, to the political importance of representational forms and narratives heavily contextualized by their appeal to particular histories—imperialist, corporate, and professional-managerial—and to particular communities—planetary managers of the eco-elite and high-to-middlebrow taste consumers. Similar considerations are no less evident if we turn to more popular genres.

With the recent revival of ecological concerns in the public mind—thanks to Bhopal, Chernobyl, Exxon *Valdez*, the Gulf War, the greenhouse effect, and the rain forests—narratives about environmental repair have begun to surface in popular genres. The TV networks have been flooded with scripts and proposals for ecologically minded shows and series. TBS launched Ted Turner's personal brainchild, the cartoon show "Captain Planet and the Planeteers," and a host of other children's features—"Widget," "Dark Water," "The Toxic Crusaders"—are either airing or in trial runs for syndication. The 1990 fall TV season also saw the shaky debut of two eco-cop shows, "E.A.R.T.H. Police" and "Super Force," while "Voice of the Planet," TBS's ten-hour, Gaia-inspired New Age adventure series, made a brief initial appearance in February 1991. On a less salutary note, the first cyberpunk film of the 1990–1991 season, Richard Stanley's low-budget *Hardware*, featured a grisly futuristic narrative about overpopulation: "Welcome to the twenty-first century. Guess what's become the planet's most endangered species?" The answer? Fertile women, who are hunted down by military cyborgs.

Hardware's twisted ecological story line is worked through a familiar blend of generic SF formulae. In the last twenty years of popular entertainment, especially in science fiction, the ecological "look" of the future has been governed by a dark dystopian imagination, feeding off the imagery of global degradation. The cultural power of this imagination has long transcended the vestigial influence of images and narratives of progressive futurism that were the standard diet of early science fiction film like *Things to Come* (1936). The historical role of SF film, with its power to "colonize" the temporality and spatiality of the future, is paramount in any discussion of the ecology of film images. From the slew of 1970s SF dystopias—*Colossus: The Forbin Project*, *The Andromeda Strain*, *THX 1138*, *Silent Running*, *Westworld*, *2001*, *Soylent Green*, *Dark Star*, *A Boy and His Dog*, *Logan's Run*, *The Late Great Planet Earth*—which fully absorbed the urgency of ecological concerns about overpopulation and pollution in the wake of the energy crisis, to the

more recent cyberpunk genre—*Escape from New York*, the *Mad Max* trilogy, *Blade Runner*, *The Running Man*, *The Terminator*, *Robocop*, *Cherry 2000*, *Max Headroom*, *Millenium*, *Brazil*—the degraded bio-future has become a dominant landscape in Western cultural imaginary. (The exception, of course, is the temporary revival of the conservative version of progressive futurism in the nostalgic Hollywood theme parks of Lucas-Spielberg).

One might balk at the irony of the film industry persistently devoting vast sums of money to producing images of futureless futures. In most of the cyberpunk films, this dark future is merely a generic backdrop, a convention whose profitability is tried and tested. Different contradictions arise, however, when the genre aims at producing a utopian future. In its action-adventure version of the "race to save the planet" and liberate its population, Paul Verhoeven's 1990 summer SF film, *Total Recall*, offered the best recent example of a blockbuster film that attempts to include a utopian eco narrative. It is not an eco-friendly film, however. The planet in question is Mars, and the population is a federal worker colony, physically mutated by radiation as a result of inadequate working facilities and organized into underground rebel cadres fighting against enslavement by a primitive capitalist exploiter. Air is a commodity whose price is controlled by the capitalist mogul, while the colony's mineral mining production, ruthlessly protected by the imposition of martial law, is used to fund an eco-war on Earth between northern and southern blocs.

Though the film is structurally governed by the promotional requirements of its being a Schwarzenegger vehicle, the ecological components of the narrative are everywhere foregrounded. On Earth, pristine environmental spaces—assumed now to be extinct—are simulated for the purposes of tourism and domestic therapy, while advanced mind technologies, freely used for entertainment and politics alike, are used to manufacture human memories in pursuit of the perfect artificial ecology of the mind. In every respect, *Total Recall* tells a plausibly and explicitly marxist tale about the destructive, alienating conditions of primitive capitalist exploitation and production. Again, one might stop to speculate about the irony of such a film, since its very existence tells an astonishing story about the domestic absorption of marxist critiques of capitalism within mainstream Hollywood film. But this is not my intention here. What concerns me is how the marxist critique is employed to resolve the film's narrative in a way that works against the proto-ecological critique.

With the aid of the resistance forces on Mars, the Schwarzenegger figure succeeds in utilizing ancient Alien technologies to create an Earth-friendly atmosphere for the colony. The capitalist's power is broken, and the shlocky appearance of sunny, blue skies at the end of the film heralds a brave new world for the liberated workers. Here, the Alien technologies are also explicitly marxist; they are "alien" to the monopoly-regulated system of capitalist production because they are employed in the service of all—everyone gets air, and it is free. As technologies, however, they are finally "alien" to the planet's ecology. The process of terraforming the planet is achieved through macroengineering and macroproduction; the vast Alien reactor is employed to melt down the planet's ice core and generate an oxygen-rich atmosphere. In the final sequence of the film, then, the planet's core resources are almost entirely exhausted in three minutes flat in order to create friendly conditions for its liberated human population. Nothing could be more explicitly marxist than this narrative about using macrotechnology to free humankind from servitude to Nature. Nothing could be more explicitly anti-ecological.[10]

At a time when these once-progressive narratives about emancipation through maximized technological production have been challenged to the point of exhaustion, here is a Hollywood film that is at last comfortable with such narratives and that poses them as solutions to an ecological predicament. I present it here as an example of the ways in which ecological concerns are being articulated as images of ecology in popular entertainment—not in any ideal form, but in the impure context of other popular or generic narratives (even marxist ones) that have meanings, often counter-ecological meanings, of their own. In the final analysis, we have to consider, of course, that the dramatic narrative of *Total Recall*, favoring the spectacle of ecological reparation, is itself a product of the eco-logic of industrial cost efficiency, balancing massive and wasteful expenditures against the promise of box office profit.

The Owls Are Not What They Seem: A Postscript

To my mind, this essay would be incomplete if I did not close with some comments about a TV show that monopolized much of the conversation of film-literate audiences in the United States during its brief run from spring 1990 to spring 1991. Almost from the first time I saw the opening credits of "Twin Peaks," I was inclined to watch this show about a

Northwestern logging town as a commentary about environmental and ecological questions. If "Twin Peaks" is one of our first examples of ecological camp ("Greenacres" was a weak, but likely, earlier candidate), as I think it was, then it surely will not be the last.[11] One of the enduring effects of "Twin Peaks" was its influential reshaping and reimagining of the Pacific Northwest at a time when urgent ecological questions are being asked about the timber economy of that region. Recent political debate about these issues has centered on the protection of the northern spotted owl (even though it is only one of the many animal and fish species threatened by the clearcutting of old-growth forests). It is this owl that increasingly got a bad press in "Twin Peaks" since Bob, the mystery killer entity, seemed to be associated with the owls in some way, and since, according to Laura Palmer's diary (the commercially available version), Laura's own psychosexual history was haunted by attacks by owls, imaginary or otherwise. In light of the current ecological challenge to the timber industry, it is hardly surprising that "Twin Peaks" takes place in a lumbertown where the surrounding environment is depicted as harboring threatening, evil forces, likely aliens, for whom the owls may indeed be serving as telepathic communicants, perhaps even the Log Lady's log as well. The owls, we are repeatedly told, "are not what they seem," and, if the show had not been cancelled, may have turned out to be benign agents in the narrative. Nonetheless, the environment is one in which Nature, in Lynch's work generally, is seen as hostile and complicit with the threat to human life in a small town. This is evocatively suggested by the opening credit sequence—the metonymic links among the birds, the brute facticity of industry and its pollution, the inexorable sharpening of the teeth in the sawmill, the shot of a small town beseiged by the shrouded, secretive environment, the sublime violence of the waterfall, and the ominous undertows concealed in the eddies, all reinforced by Angelo Badalamenti's theme music where the strings are a familiar referent from film melodrama and the bass melody is a sinister undertone.

In view of this demonizing of the environment, no sequence was more crucial in the show than the scene in the April 1990 pilot in which the sawmill is shut down for the day by its female owner, Josie, against protests by its female manager, Catherine. Here we saw the spectacle of a conflict over labor, a conflict between two women who, it is significant, are the two people who seem to be in charge of primary economic production in this town. In this scene, both women commit transgressive acts. Josie shuts down the mill, and Catherine gratuitously fires a

worker—the first and only mill worker, as far as I am aware, to appear
in the entire series (you wonder where all these workers are—it's a big
mill in a small town after all). Neither Josie nor Catherine will be for-
given for such transgressions. Alongside the firing of the worker—the
first intimation that all of these workers, eventually, will lose their jobs
after the mill is arsonized—the halt in production at the mill is the first
public sign that there will be a crisis in the community. This crisis is
generated by the death of a woman, Laura Palmer, and publicized in the
pilot by the transgressive acts of these two women. You did not need to
be a feminist film theorist to recognize that these were very bad signs
indeed and did not augur well for the future of women in the series.

In light of the ecology movement's "threat" to the male work force
of the Northwestern logging industry, it is perhaps no surprise to come
across this story about a small town whose lumber economy is thrown
into crisis by actions involving women, both alive and dead, and by mys-
terious environmental forces that involve owls and aliens. Toward the
end of the series run, the environmental subtext became an overt focus
of "Twin Peaks" life when Benjamin Horne launched a campaign to save
the pine weasel as part of his scheming ambition to thwart Catherine's
property development ambitions. Perhaps it is also fitting that it is Josie,
an Asian woman, who has power over the economy and who halts the
mill, since the Northwestern timber industry has been dependent on the
Asian market as its prime export market over the last decade. It is Josie's
face, staring into a mirror as she applies her lipstick, that composes the
very first shot in the pilot—a completely gratuitous shot but one that
suggests an origin for many of the resulting crises in the show: femi-
ninity, foreignness, and dreamy narcissism (dreamy narcissism being
the mold for many of the other female characters in the show, espe-
cially Donna, the willful romantic, and Audrey, the village vixen). With
a figure like Josie in charge of so many of the determinants of the show, it
is no wonder that the masculine revenge in the show would be slow but
sure and perhaps only fully apparent after the fact, rather like Hegel's
Owl of Minerva that spreads its wings only at dusk.

NOTES

1. Susan Sontag, *On Photography* (New York, 1977). Page references are cited hereafter in text.

2. On the other hand, Sontag's remarks about "credible forms of lust" may remind many of us of the debate, within film theory, about psychoanalytical descriptions of the role of sexuality in visual pleasure. As it happens, I don't think this is a productive path to pursue—for the following reason. For Sontag, the visual—the field of vision—is not an element in the *construction* of reality as it is for most film theorists. Images, for her, are fundamentally a *substitute* for reality. In her model, image addiction ultimately determines our diet—our need to "consume" more and more images reduces our tolerance for more nutritious encounters with reality. The result à la Balzac (a man of considerable girth, it should be remembered) is a thinner body of attention to the real world. The operative model of health in this analogy is strictly biological; there is no room for psychosexual or even biocultural determinants. In this respect, there seems to me to be little common ground between feminist film theory's assumption that "perversions" are a normative aspect of our relation to images and Sontag's view that our addiction to images is a fundamentally unhealthy, even immoral perversion.

3. John Waters, *Shock Value* (New York, 1981), 272.

4. Paul Virilio, *War and Cinema: The Logistics of Perception* (London, 1989).

5. Ibid., 15. Griffith's comment reminds us of so many discussions about the lack of any visible enemy sightings in the Gulf war, not only for TV audiences but for combatants themselves. Saudi gravedigging teams were delegated to each Allied unit to dig the mass graves for the Iraqi dead. While this action was officially taken for religious reasons, the result was that Western soldiers were prohibited from seeing the people they had killed.

6. Joni Seager, *Atlas Survey of the State of the Earth* (New York, 1990).

7. Geoffrey Lean, Don Hinrichsen, and Adam Markham, *World Wildlife Fund Atlas of the Environment* (New York, 1990); and Michael Kidron and Ronald Segal, *The New State of the World Atlas* (New York, 1987).

8. For the best bioregional map of the world, see Miklos D. F. Udwardy, *World Biogeographical Provinces Map*, 1975.

9. *Gaia: An Atlas of Planet Management*, produced by the Gaia Project, general editor, Norman Myers (London, 1984), explicitly attempts to avoid the "gloom and doom" ethos that pervades the genre. Presented under the aegis of the Gaia hypothesis—that the planet is a living biosphere with its own global life-support systems and feedback mechanisms—it is a more adventurous and inspiring survey of the state of the earth's ecosystems and resources. The maps use projections either based on Gall's cylindrical projection—to counter the traditionally Eurocentric cartographic perspective—or the more recent Peters

projection, which more accurately represents the true land mass of the continents. But the maps are only one of a host of visual images (tree diagrams, larder diagrams, 3-D globes, and creative low-tech depictions of ecosystems) designed to illustrate statistical information. The polemical overview of the survey, however, is that of planetary management—responsible stewardship of global resources—and therefore meets the gaze of the World Bank and other global organizations created to police the natural economy of the planet according to laissez-faire market principles.

10. Those who know the film will remember that the plot itself doesn't seem to "work," since the Alien reactor can only be activated by a three-fingered Martian fingerprint and not by the human hand of Quaid that Verhoeven utilizes to do the job. Dan O'Bannon, the original scriptwriter, has argued that this inaccuracy is symptomatic of the film's overall failure. In O'Bannon's script, Quaid, who discovers that he is the resurrection of a Martian race in a synthetic human body, uses the Alien technology to totally recall his own identity. The ending chosen by Verhoeven, in spite of its diegetic flaws, seems to me to be more faithful to the film's social ambition. Carl Brandon, "*Total Recall*: Dan O'Bannon on Why It Doesn't Work," *Cinefantastique* 21, no. 5 (April 1991): 36–37.

11. By the time of the fall 1991 season, a "900" number, called the Twin Peaks Sheriff's Office Hotline, was being operated by Lynch-Frost Productions. The phone line recapped the previous night's episode and included new clues and information—a portion of the revenue was to be set aside for "environmental causes." The environmental questions raised by the show cannot, of course, be divorced from the historical psychopathologies of David Lynch himself; his history, for example, as an Eagle Scout from Montana, who fondly recalls camping trips in the Northwestern forests with his father, a research scientist with the United States Forestry Service who wrote his dissertation on the ponderosa pine.

Wölfflin and the Imagining of the Baroque

F O R many years, historians of art seemed to have little trouble with the concept of the "baroque." Their confidence in using this periodic category was in large part a result of the descriptive power of Heinrich Wölfflin's influential text, *Kunstgeschichtliche Grundbegriffe* (*The Principles of Art History: The Problem of the Development of Style in Later Art*), published first in 1915.[1] As most readers are likely aware, that essay postulates a decipherable evolution of pictorial, sculptural, and architectural form from the Quattrocento to the Seicento in terms of opposing categories of visual beholding. Two ways of seeing the world manifest themselves in two distinct styles of art, that of the Renaissance and that of the baroque. Wölfflin's numerous and—once he has called our attention to them—self-evident examples are structured upon contrasting optical modalities: linear versus painterly perception, planar versus recessional spatial articulation, clear versus relatively unclear compositional strategies, and so on. A typical pictorial comparison, say between Leonardo's High Renaissance depiction of *The Last Supper* (fig. 1), an example of the classic plane style, and Tintoretto's early baroque illustration of the same subject (fig. 2) or, better yet, Tiepolo's late baroque interpretation (fig. 3) hinges upon compositional contrasts reiterated throughout the book:

> Every picture has recession, but the recession has a very different effect according to whether the space organises itself into planes or is experienced as a homogeneous recessional movement. . . . The great contrast between linear and painterly style corresponds to radically different interests in the world. In the former case, it is the solid figure, in the latter, the changing appearance; in the former, the enduring form, measurable, finite; in the latter, the movement, the form in function; in the former, the thing in itself; in the latter, the thing in its relations. . . . The former represents things as they are, the latter as they seem to be. . . .[2]

Wölfflin's subject, then, is one of polarity. He finds stylistic contrasts wherever he looks (not only between historical periods, but at times within the same period, and even within the same painting, as we shall see). Never content simply to describe what he sees, his keen character-

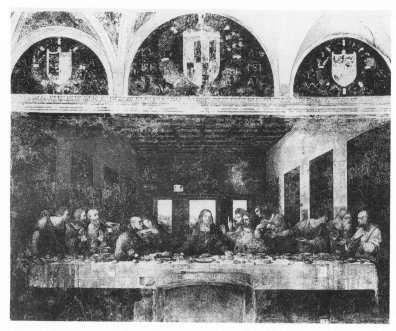

1. Leonardo da Vinci, *The Last Supper*. Milan, Sta. Maria delle Grazie, photo Art Resource/Alinari, New York.

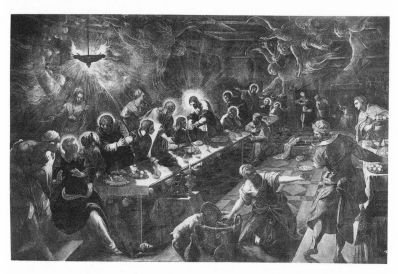

2. Tintoretto, *The Last Supper*. Venice, S. Giorgio Maggiore, photo Art Resource/Alinari, New York.

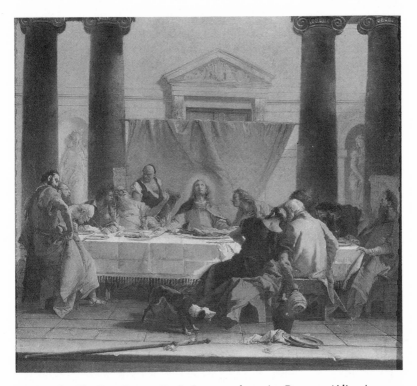

3. Tiepolo, *The Last Supper*. Paris, Louvre, photo Art Resource/Alinari, New York.

izations in the *Principles* are themselves transparently structured upon their own principle of compositional contrast. He is always seeing what something is by what it is not—or what it is about to become.

In this essay, I suggest that Wölfflin's text (quite apart from what he says) could itself be read as an exercise in baroque historiography. It is the way he says what he says that counts. Viewed in this way, the apparent inconsistencies in his philosophy of history, the contrived ambiguities of some of his descriptions, the epistemological conflicts among his texts (which several scholars have previously noted), and, perhaps, even his academic resignation and published retraction of several decades later take on a positive charge.[3] To turn the vocabulary back upon its user, Wölfflin is neither a linear nor a planar thinker. The friction generated by his contrasts reifies his Hegelian sense of history as conflict and process, and the dissonance of his choices, deliberately subverting

as they do the classical symmetries under which they make their appear-
ance, reinscribe the formal composition of the baroque works about
which he speaks, even when he is talking about High Renaissance art.

Before I pursue that line of argument, however, I would like to insert
a tendentious qualification about the often glib use of the word "for-
malism" when characterizing the kind of art history embodied in *The
Principles of Art History*, a text that for generations has been read as a
supreme example of the history of art as the history of style. To restrict
the scope of Wölfflin's inquiries into the nature of visual representa-
tion to the approbation of "formalist" is to ignore the subtle and varied
uses that such commitment to understanding works of art might entail.
Martin Warnke, for example, has recently placed *The Principles* back
into its historical context in order to suggest that the text's formalist
bias constituted a reaction to the appropriation of culture by German
politics during the First World War.[4] By insisting on the "organizational
integrity" of forms of beholding, Wölfflin managed effectively to sepa-
rate art from the pressure of extrinsic historical forces and made claims,
as did contemporary artists, about the autonomy of visual culture. The
"icy pathos" of the text, according to Warnke, constitutes an act of re-
sistance to the hegemony of looking at works of art as always reflecting
the *zeitgeist* of their times.[5] Although Warnke's social history of Wölfflin
offers compelling reasons for the book's challenge to the tradition of
contextualist art history, I would suggest that there is more "behind"
the formalist plot than a singular "contextualist" explanation implies.

I am interested generally in the way works of art might be construed
as syntactical prefigurations of their own historiographic response, and
I think the well-known works of both Wölfflin and Jacob Burckhardt
offer intriguing examples of that process at work.[6] Like Wölfflin's, my
subject is also one of contrasts: not just between Burckhardt's contex-
tualist and Wölfflin's formalist history of art, but also between Renais-
sance and baroque art as each of their stories becomes emplotted in the
confrontation between Renaissance and baroque historiography. This
essay is an inquiry into the possibilities of rhetorical correspondences
between the formal compositions of art works from a stylistic period
and the compositional configurations of the "classic" texts that have
spoken so persuasively about them.

For Wölfflin, it is very nearly irrelevant that Leonardo and Tinto-
retto, or Tiepolo, for example, painted the same subject; the choice of
architecture as the paradigm in his first book, *Renaissance und Barock*
(*Renaissance and Baroque*), is ample testimony to his lack of interest

in iconography.[7] What matters is the evidence for the crystallization on canvas of a particular time-bound, formal apprehension of the world:

> Not everything is possible at all times. Vision itself has its history, and the revelation of these visual strata must be regarded as the primary task of art history. . . . But although men have at all times seen what they wanted to see, that does not exclude the possibility that a law remains operative throughout all change. To determine this law would be a central problem, the central problem of a history of art.[8]

This quotation is from 1915, but he was already worrying about the difficulties of such a project in 1898 when he wrote in *Klassische Kunst* (*Classic Art*), ". . . it is probably an easier task to collect running quicksilver than to catch and fix the different impulses which go to make the concept of a mature and complex style."[9] Even a decade before in 1888 he had asked the question in *Renaissance and Baroque* that would come to shape his life-long inquiries:

> What, first of all, determines the artist's creative attitude to form? It has been said to be the character of the age he lives in; for the Gothic period, for instance, feudalism, scholasticism, the life of the spirit. But, we still have to find the path that leads from the cell of the scholar to the mason's yard.[10]

This earlier quotation immediately situates our discussion in the context of nineteenth-century cultural history, particularly as it is exemplified by Burckhardt, Wölfflin's teacher and predecessor at Basel. Wölfflin's equivocating account of the "double root of style" (his phrase)[11] has much to do with both his acceptance of the persuasive logic of Burckhardt's particular variant of Hegelianism and his rejection of his mentor's synchronic vision. As the elderly Wölfflin would recall, teacher had once told student that " 'as a whole the connection of art with general culture is only to be understood loosely and lightly. Art has its own life and history.' "[12] "It was this conception of the arts as something existing in their own right which Burckhardt never really worked out"[13] and that became the motivating force of Wölfflin's ideas. Given this motivation, the corpus of Wölfflin's work can be read according to the trope of *tessera* coined by Harold Bloom to explain the "anxiety of influence" often "suffered" by poets:

> I take the word not from mosaic-making, where it is still used, but from the ancient mystery cults, where it meant a token of recognition, the fragment

say of a small pot which with the other fragments would reconstitute the vessel. A poet antithetically "completes" his precursor, by so reading the parent-poem as to retain its terms but to mean them in another sense, as though the precursor had failed to go far enough.[14]

My argument, though primarily about the way works of art shape the rhetorical strategies of their own historical accounts, is secondarily about the simultaneous shaping that an earlier historical text performs on one that manifestly follows. The "anxiety of influence," in other words, is an intellectual predicament that itself travels along "double routes." In all three of his texts with which we are here dealing, Wölfflin is concerned—but notably only in prefaces and conclusions—with the theoretical relationship between extrinsic factors (spirits of the age, cultural ideals, social milieux, etc.) and the intrinsic history of form. Contrary to what most of his readers assume, he never made unrelenting claims for an autonomous formal development. He was too much the student of Burckhardt for that. Wölfflin always worried over (as did his incisive critics, including the young Panofsky)[15] what he had to exclude from his purview:

> There is a conception of art-history which sees nothing more in the art than a "translation of Life" . . . into pictorial terms, and which attempts to interpret every style as an expression of the prevailing mood of the age. Who would wish to deny that this is a fruitful way of looking at the matter? Yet it takes us only so far—as far, one might say, as the point at which art begins.[16]

Burckhardt, of course, would be far from sympathetic with this thinly veiled indictment of his work. Were he a late twentieth-century theorist, he could even go so far as to claim a deliberate misreading or "misprision," in Bloom's terms, on the part of his student.[17] The elder scholar's 1855 *Cicerone* is a model of triumphant connoisseurship.[18] In this text, which itself contains some of the first references in art history to the style of the baroque, Burckhardt admiringly describes individual works in terms of their formal composition and highlights the stylistic genius of individual masters. Five years later in the *Die Kultur der Renaissance in Italien* (*The Civilization of the Renaissance in Italy*), however, his approach has altered considerably.[19] Here Burckhardt reads the great masterpieces of Renaissance art as historical documents, symptomatic of fifteenth-century cultural and social attitudes. He spends little time chronicling their formal genius and, perhaps most

significantly (in terms of what Wölfflin would later advocate, despite the synchronic implications of his prefaces and conclusions), does not write of works of art as if there were some kind of historical force or "law" choreographing their transformation over time. Burckhardt characterized the Renaissance as a harmonic, eternally unchanging whole, whose pictures reveal the beauty and virtues of classical stasis. The past is gone forever, the world of the Quattrocento is now framed by time, and it is incumbent upon the historian simply to gesture towards that age rather than to suggest any possibility of renewal. For Burckhardt, the study of history demands arrested time; for his student Wölfflin, it would always be an inquiry into metamorphosis.

Wölfflin's essays on the art of a period are inevitably plotted upon a substructure of change. He yearns for the transformative powers of historical evolution and is never content to let the characterization of one period rest secure in and of itself. The one book that would, by its circumscribed title, seem to imply a static historical "period," *Classic Art,* is itself always watching its own descriptive categories undo themselves, change into something other than they are. For Wölfflin, the Hegelian dialectic provides the template for historical description. One has the sense that he only understands the essence of High Renaissance art—by "classic" he means works produced between 1500 and 1525— by reference to what it is not, that is, not baroque, and vice versa.

In a most insightful essay, Marshall Brown takes this observation to its most radical extension. Though he argues that the compositional principles of the *Principles* are entirely those of classicism—clear and logical presentation, careful discrimination between categories, symmetries that reinforce the argument at every turn, and so on—he is in the end convinced that Wölfflin's "classic" essay is itself a necessary negation of the idea of the classic:

> . . . the difference, between classic and baroque that rationalizes Wölfflin's system and that establishes at once their radical opposition and their total identity is quite simply this: that *the classic does not exist.* It never existed and can never have existed, for when the classic comes into existence or manifests itself, it does so in the form of existence, which is the baroque. The classic is the baroque.[20]

Keeping that paradox intact, we should perhaps heed how Wölfflin himself defined the baroque: "The baroque never offers us perfection and fulfilment, or the static calm of 'being,' only the unrest of change

and the tension of transience."[21] Movement, change, metamorphosis—all readers discern this straightforward impulse towards diachrony in Wölfflin's works as well as in his descriptive words. Of course, we might ask, "What else could an historical study do?" Political histories, social histories, intellectual histories are always intent upon watching their objects and attitudes in the process of alteration as they succumb to or overcome a variety of extrinsic pressures. Yet it also must be acknowledged that to apply a diachronic mode of understanding to the formalist description of framed works of art requires some maneuvering. How could one describe the completeness and autonomy of a "great" work of art, in other words, a "masterpiece"—Burckhardt's manifest project in the *Cicerone*—if at the same time such a connoisseur was aware that the painting was in the process of undoing itself (in current parlance, "deconstructing" before the art historian's very eyes)? What, for example, would happen to the appreciation of a canonical work such as Raphael's *School of Athens*?

Perhaps we are getting ahead of ourselves. This is a study in contrast, as I said, and we will only recognize the shift in historiographic consciousness in Wölfflin—following his strategy—if we morphologically categorize the kind of composition that preceded it. Here is Burckhardt on the *School of Athens* (fig. 4):

> The wonderfully beautiful hall, which forms the background, [is] not merely a picturesque idea, a consciously intended symbol of the harmony between the powers of the soul and the mind. In such a building one could not but feel happy. Raphael has translated the whole thought and learning of antiquity entirely into lively demonstration and earnest listening. . . . We find in the picture a most excellent arrangement of the teachers, listeners, and spectators, easy movement in the space, richness without crowding, complete harmony of the picturesque and dramatic motives.[22]

Harmony, balance, easy movement, symmetry, richness without crowding—these are the virtues of a Renaissance work of art. They are also, by the way, the virtues of Burckhardt's cultural history of the Renaissance. He is not interested in where this world of images came from (he pays little or no attention to the medieval consciousness) and even less in where they are going. What matters is the fixing and framing, in his own composition, of the timeless ideals of harmony and balance that gave birth to the unity of Renaissance culture.

I have argued elsewhere that the narrative composition of his 1860

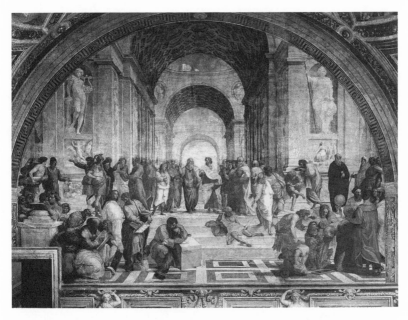

4. Raphael, *The School of Athens*. Rome, Vatican stanze, photo Art Resource/ Bildarchiv Foto Marburg, New York.

Civilization of the Renaissance is derived from Renaissance principles of pictorial composition, specifically those articulated by Leon-Battista Alberti. A connoisseur of Renaissance art, Burckhardt learned from the painters how to look, how to visualize. His text, formally analogous to a painting by Raphael, makes everything appear in proportion, makes everything fit together, leaves nothing out of place. In both cases—that of text and image—the organon through which this panoramic view is systematized, this Albertian graph of space, is above all dependent upon the gaze of a becalmed, external viewer whose directed focus singularly legitimates the arrangement of the rich and abundant details of the optical field. The perspective system originated by Alberti in the middle of the fifteenth century, in this sense, could be construed not just as a painterly device that permits the artist to locate objects spatially in a certain manifest scheme of relationships, but also as a kind of cognitive map for the nineteenth-century cultural historian whose impulse is to relate events, attitudes, and personalities in a coherent, temporal architectonic. It might well be the case that Renaissance paintings pre-

sented Burckhardt with a strategy for representing (re-presenting) the Renaissance; that is, that the works of art of the period compositionally prefigured their own historiographic response.[23]

But back to Wölfflin. Does he speak, as well, of symmetries, harmonies, closed forms, tectonic strength, in his description of *The School of Athens*? Well, of course, he must, for two principal reasons: (1) in order to substantiate my claim that works of art compositionally predict their own histories (!), and (2) because these are the very attributes with which he distinguishes Renaissance sensibilities from those of the baroque. But does he also freeze this world irrevocably in place, or do the Renaissance works upon which he casts his eye frequently suggest the possibility of a spring thaw? And where do we locate his position as an historian? Here is an excerpt from a lengthy passage on Raphael's painting from *Classic Art*. In addition to the many references to change, note also how the use of contrasts is so frequently employed, even if they are posed only to be resolved into harmonies:

> It is clear that Raphael himself had developed and become more inventive, for the situations are more sharply characterised, the gestures more telling, and the figures more easily remembered. . . . The two Princes of Philosophy stand side by side in noble calm; the one with arm outstretched, whose hand, palm down makes a sweeping gesture over the earth is Aristotle, . . . the other, Plato, with uplifted finger points heavenwards. We do not know what inspired Raphael to characterise the opposite qualities of the two personalities in this way. . . . The group around Pythagoras is still more interesting. A man in profile sits writing on a low seat, with one foot on a stool; and behind him are other figures pressing forward and leaning over him—a whole garland of curves. . . . Analysis of the fresco should not stop short at single figures, for Raphael's rendering of movement in individual figures is a lesser achievement than the skill with which he builds up his groups and there is nothing in earlier art which can in any way be compared with this polyphony. . . . It is by figures like these that we must measure Raphael's progress. . . . Around the central figures symmetry reigns, but this is relaxed on one side to allow the upper mass to stream unsymmetrically down the steps and destroy the equilibrium, which is again restored by the asymmetry of the foreground groups. . . . Here the relationship between the figures and the space they occupy is thought of in an entirely new way.[24]

The breathless suggestion here of anticipation, of something that will yet come to be, is undeniable. Terms such as progress, movement, poly-

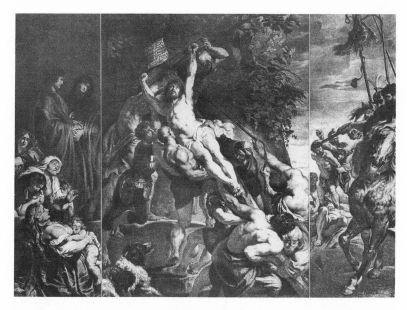

5. Rubens, *The Raising of the Cross*. Antwerp Cathedral, photo Art Resource/
Alinari, New York.

phony, increase, asymmetry, inventiveness, abound. I suggest the inevitable: Wölfflin is reading his images retrospectively. Having abandoned his mandated position as the fixed observer on the other side of a Renaissance perspective painting, Wölfflin has scurried forward, surveyed the course of art history, and then circled round behind to find predicted in the Renaissance the compositional tendencies that are reified in the baroque. In other words, the pre-eminence of the baroque has shaped his recitation of the classic.

The baroque, and here I offer the visual analogue of Rubens' *Raising of the Cross* (fig. 5), "never offers us perfection and fulfilment, or the static calm of 'being,' only the unrest of change and the tension of transience." [25] What views the historian catches are necessarily oblique ones, for the flux of visual experience permits no stasis, no fixed perspective on the subject. The experience of baroque art is designed to overwhelm. With this observation, he interjects, we have hit the "nerve-centre" of the new style (for example, fig. 6, Gaulli's fresco in the Church of the Gesù in Rome):

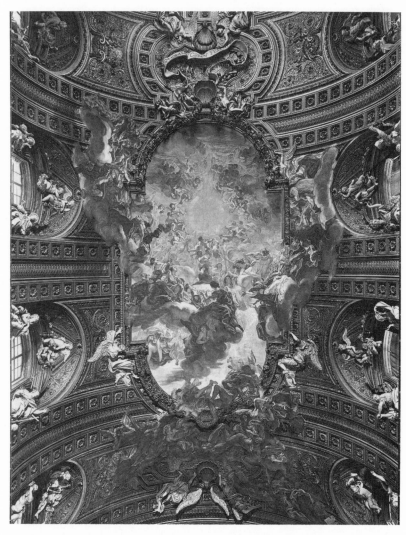

6. Giovanni Battista Gaulli (Baciccio), *Adoration of the Name of Jesus*. Rome, Church of the Gesu, photo Art Resource/Alinari, New York.

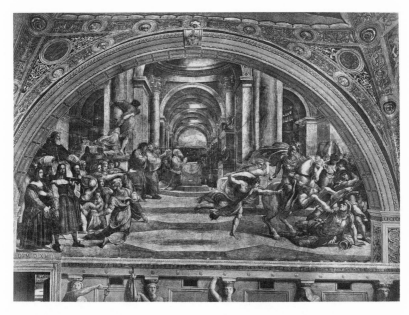

7. Raphael, *The Expulsion of Heliodorus*. Rome, Vatican, photo Art Resource/
Alinari, New York.

> It is . . . in the church alone that it finds full expression. . . . The com-
> prehensible is refused, the imagination demands to be overpowered. It is
> a kind of intoxication with which baroque architecture fills us. . . . We
> are consumed by an all-embracing sensation of heaviness, helpless to grasp
> anything, wishing to yield totally to the infinite.[26]

But that sentiment is just what it should be, for "what is regular is dead,
without movement, unpainterly."[27] Even Raphael, the most "classic"
of painters, is always painting works that generate a creative tension
between what they are and what they might be. "How unlimited and in-
scrutable is the spatial structure of *The Expulsion of Heliodorus* [fig. 7]
compared with the *School of Athens*! [fig. 4]," both, of course, painted
by Raphael:[28]

> For the public of that time, the greatest surprise must have been the way
> in which Raphael disposed his scenes, since no one was accustomed to
> any other arrangement than that of setting the principal action in the cen-
> tre of the picture, yet here there is a great void in the middle, with the

decisive action taking place at the extreme edge. . . . People at that date must really have felt that they were actually watching the sudden miracle taking place.[29]

Once again, we return in this quotation to a perceptual world in flux, to an artistic form in the process of unwinding or unmaking itself. Because the description of Raphael's *Heliodorus*, like the painting itself, is organized according to the mandates of elegantly balanced oppositions, it might be identified as an exercise in a classic mode of apprehension. Again, the structure of Wölfflin's text is patently symmetrical, but with a twist. The symmetries are articulated only to serve as a prelude to the inevitable struggle towards asymmetry. The equipoise between the oppositions, as Wölfflin describes them, is always on the verge of being undermined. Opened up, he claims, is "a great void in the middle." Anticipating the baroque, Raphael has used his oppositions as parenthetical marks enframing a void, an emptiness between. What matters is not so much the contrasts themselves as the active and activating difference that has arisen between them. It is a space of difference—not the space that stable objects occupy, but the unfilled space between things. He has problematized the notion of contrast as well as the notion of an objective historical viewpoint, for he (Raphael, or Wölfflin?) will not let oppositions stabilize themselves. The shifting world of appearances demands that differences, unfilled space, will always be evidence of unresolved conflicts that propel the course of history onwards.

The driving inner factor, Wölfflin implied in the 1933 revision of his ideas, is the regenerative effect of picture upon picture, of form on form.[30] Each form of beholding presupposes a previous one. Oppositions are established only so that the friction between them opens up a space of difference; the possibility of closure is always negated. Such a characterization, of course, makes Wölfflin a distinctly "modern" thinker, in the tradition of Nietzsche, Heidegger, Derrida, all of whom have argued that the Western philosophical project of finding identity— to saying something, that is, that is identical to "Truth"—is to miss the fact that identity is always based on difference; that identity always has difference and absence within it. Even the apparent lawfulness of a high classic painting by Raphael hovers on the edge of unlawfulness as it struggles to cope with "the great void within the middle," as Wölfflin called it.

The language of art and artifice inevitably invades the historical imagination. The fluidity, the emphasis on the shifting perceptual world, the

lack of absolutes that Wölfflin finds so characteristic of the baroque imagination are also characteristic of his imagining of the baroque. Hence, as readers we need not worry excessively about ambiguities or inconsistencies in Wölfflin's own work—for example, the focusing on the temperament and personality of the Renaissance genius at the same time as he claims to be writing an art history without names, or his clearly shifting position on the relationship between inward and outward histories of form. "Just as we can hear all kinds of words into the ringing of bells," he said in 1915, "so we can arrange the visible world in very different ways for ourselves, and nobody can say that one way is truer than the other."[31] Incommensurability is the signature of the baroque historian as surely as it is the hallmark of a baroque work of art.

Bearing this in mind, recall the conclusion of the first passage quoted from Wölfflin, the comparison between the two *Last Suppers*, but this time consider it as though it were a description of the formal contrast between Burckhardt's harmonious vision of the Renaissance and Wölfflin's inevitably baroque point of view. In the case of the Renaissance, he said, "it is the solid figure, in the latter, the changing appearance [that matters]: in the former, the enduring form, measurable, finite; in the latter, the movement, the form in function; in the former, the thing in itself; in the latter, the thing in its relations. . . . The former represents things as they are, the latter as they seem to be. . . ." As Brown says, "On the one side, we have absence, rest, law, silence, death; on the other, presence, movement, freedom, voice, life. It could hardly be clearer that in affective terms Wölfflin's sympathies are entirely with the baroque."[32]

My task here, however, has been to assign primacy to the thought rather than to the thinker. Taking my cue from Wölfflin, I pose the possibility of an "anonymous history of the history of art."[33] My argument is that historical artifacts, particularly visual ones, are themselves always laboring, more or less successfully, to systematize their own historical accounts, as signs producing other signs.

Yet the "double root" of my inquiry has also led to the suggestion that histories of art can and do shape their own historiographic successors, as is the case with Burckhardt and Wölfflin. Clearly, we cannot forsake naming altogether. Historiography, like art, possesses its own inward history. Implicit in Wölfflin's analysis is the claim that the artists of the baroque are always repainting the Renaissance in their own terms. Changes in perception can only be plotted against previous states of affairs. To be faithful to his own "principles," Wölfflin's texts can be read as exercises in baroque historiography only if they are morphologi-

cally posed in opposition to the formal, classical, symmetrical ideology of works that came before. Clearly his life-long preoccupation with resisting or redoing the paradigmatic cultural histories of his predecessor (both as teacher and chair of art history at Basel) has parallels here.[34] In Bloom's terms, Burckhardt's Renaissance provided the *tesserae* for Wölfflin's baroque: "Strong poets make . . . history by misreading one another, so as to clear imaginative space for themselves."[35]

To take this concatenation of rhetorical resonances—between works of art and their histories, between histories and their historiographic successors—to its most extreme extension is also necessarily to call my own analysis into question. The schematic of this essay has itself been compelled to replicate the dialectical movements of Wölfflin's imagining of the baroque. On the one hand, the binary modes of his stylistic contrasts and comparisons between Renaissance and baroque works of art have become transformed here into stylistic contrasts and comparisons between Renaissance and baroque histories in order to emphasize the way in which works of art exert a stylistic grip on their subsequent accounts. On the other hand, Wölfflin's characterization of a "double root of style" (by which he meant intrinsic and extrinsic causes, with an ideological emphasis on the intrinsic) has itself suggested a way of reading the configuration of the *Principles* as not only indebted to the compositional strategies of baroque works of art but also to the rhetoric of his historiographic predecessors, Burckhardt in particular. Wölfflin's imagining of the baroque, in other words, presents such a compelling and enduring historiographic scheme that it is difficult to escape its obsessive lure of always making something become other than what it first appeared to be.

NOTES

An earlier version of this essay appeared in *Kongress-Akten* (Wölfenbuttel, 1991).

1. *Kunstgeschichtliche Grundbegriffe: Das Problem der Stilentwicklung in der neueren Kunst* (Munich, 1915), or *Principles of Art History: The Problem of Style in Later Art*, trans. M. D. Hottinger (1932; reprint, New York, 1950). Future references are to the translation.

2. Ibid., 20, 27, 82, 87–88. Stylistically speaking, Tintoretto's painting is Mannerist. Although Wölfflin compares it to Leonardo's *Last Supper*, he remarks that Tiepolo's interpretation of the same subject yields an even more dramatic comparison.

3. His own tempered revision appeared as "Kunstgeschichtliche Grundbegriffe: Eine Revision," *Logos* 22 (1933): 210–18. Martin Warnke refers to the mystery surrounding his "inexplicable resignation" of his academic chair in Munich in 1924 and his desire to return to Switzerland in "On Heinrich Wölfflin," *Representations* 27 (Summer 1989): 172–87. See also Joseph Gantner, *Heinrich Wölfflin, 1864–1945: Autobiographie, Tagebücher, und Briefe* (Basel and Stuttgart, 1982); Meinhold Lurz, *Heinrich Wölfflin: Biographie einer Kunsttheorie* (Worms, 1981); Joan Hart, "Reinterpreting Wölfflin: NeoKantianism and Hermeneutics," *Art Journal* 42 (Winter 1982): 292–300; Michael Podro, *The Critical Historians of Art* (New Haven, 1982); and Michael Ann Holly, *Panofsky and the Foundations of Art History* (Ithaca and London, 1984).

4. Warnke, "On Heinrich Wölfflin."

5. Ibid., 177, 178.

6. My discussion of "prefigurement" owes much to Hayden White. See, for example, *Metahistory: The Historical Imagination in Nineteenth-Century Europe* (Baltimore, 1974), and *Tropics of Discourse: Essays in Cultural Criticism* (Baltimore, 1978).

7. *Renaissance und Barock* (Munich, 1888), or *Renaissance and Baroque*, trans. K. Simon (Ithaca, 1964). Future references are to the translation.

8. *Principles*, 11, 17.

9. *Die klassische Kunst: Eine Einführung in die italienische Renaissance* (Munich, 1899), or *Classic Art: An Introduction to the Italian Renaissance*, 8th ed., trans. Peter Murray and Linda Murray (Ithaca, 1952), 251. Future references are to the translation.

10. *Renaissance and Baroque*, 76–77.

11. *Classic Art*, 287.

12. *Renaissance and Baroque*, 2. Murray cites this letter in his introduction from Burckhardt's unpublished lecture notes as quoted by Wölfflin in *Gedanken zur Kunstgeschichte* (1941), and remarks that Wölfflin realizes that this advice seems to contradict most of Burckhardt's work. See also "Kunstgeschichtliche Grundbegriffe: Eine Revision."

13. Peter Murray, introduction to *Renaissance and Baroque*, 2.

14. Harold Bloom, *The Anxiety of Influence: A Theory of Poetry* (Oxford, 1973), 14.

15. See Panofsky, "Das Problem des Stils in der bildenden Kunst," *Zeitschrift für Aesthetik und allgemeine Kunstwissenschaft* 10 (1915): 460–67.

16. *Classic Art*, 287.

17. Bloom, *Anxiety of Influence*, 5: "But nothing is got for nothing, and self-appropriation involves the immense anxieties of indebtedness, for what strong maker desires the realization that he has failed to create himself?"

18. Burckhardt, *Der Cicerone: Eine Anleitung zum Genuss der Kunstwerke Italiens* (1855), 4th ed., ed. Wilhelm Bode (Leipzig, 1879); or *The Cicerone: An Art Guide to Painting in Italy for the Use of Travellers and Students*, trans. A. H. Clough (New York, 1908). Future references are to the translation.

19. *The Civilization of the Renaissance in Italy* (1860), 2 vols., ed. Benjamin Nelson and Charles Trinkaus (1929; reprint, New York, 1958).

20. "The Classic Is the Baroque: On the Principle of Wölfflin's Art History," *Critical Inquiry* 9 (December 1982): 397.

21. *Renaissance and Baroque*, 62.

22. *Cicerone*, 151.

23. Holly, "Burckhardt and the Ideology of the Past," *History of Human Sciences* 1 (Summer 1988): 47–73; and "Past Looking," *Critical Inquiry* 16 (Winter 1990): 371–96. The concept of prefigurement is Hayden White's (see footnote 3). See also Peter Gay, *Style in History* (New York, 1974); and Karl Weintraub, *Visions of Culture* (Chicago, 1966).

24. *Classic Art*, 93–96.

25. *Renaissance and Baroque*, 62.

26. Ibid., 86.

27. Ibid., 32.

28. Ibid., 34.

29. *Classic Art*, 101–2.

30. "Kunstgeschichtliche Grundbegriffe: Eine Revision."

31. *Principles*, 29.

32. Brown, *The Classic Is the Baroque*, 394.

33. This phrase comes from the original preface to the 1915 edition of *Principles*.

34. Warnke emphasizes that "everywhere it was common practice to embed art in cultural history, to project an association between art and the reigning will, or reigning conceptual currents," and he cites the influence of Hermann Grimm and Wilhelm Dilthey in particular, "On Heinrich Wölfflin," 176. My focus here has been almost exclusively on Burckhardt.

35. Bloom, *Anxiety of Influence*, 5.

Dead Flesh, or the Smell of Painting

I N one of his paradoxical sketches (fig. 1), Rembrandt represented the central scene of the biblical story of Judges 19, arguably the most horrible story in the entire Hebrew Bible.[1] The sketch is a statement about death, signified by the movement of the dead body. This paradox can be understood as we shift attention from the represented content to the mode of representation. In this paper, I explore the intricate connections, in works by Rembrandt, between modes of representation and the subject of death. Death, I will argue, becomes itself a mode rather than a theme, and the figuration of death in this drawing, as well as in the story it responds to, uses the strongly gendered figures of a mighty man and a victimized female to point to another bond: that between death and femininity.

Svetlana Alpers is one of the few art historians to pay attention to the modes of representation in Rembrandt's works. In her recent book *Rembrandt's Enterprise*, she relates the well-known impasto of Rembrandt's "rough" style to self-reflexivity.[2] She claims that the application of paint in a way that necessitates specific viewing positions, like distance for the "rough" mode, implies a statement on the art of painting. This claim is based on the effect of solidity that the impasto technique highlights. Solidity of paint turns painting into a kind of sculpture, and this sculptural quality is, Alpers argues, a statement on vision. Vision, then, is a subcategory of touch, and paint is a solid object.

Impasto is only one of the devices Rembrandt uses to substantiate his statement on art as sculptural and on vision as continuous with touch. Among the others is, Alpers writes, the representation of *hands* as the crucial organ of the painter. As it happens, the sketch of the central scene in Judges 19 emphasizes hands. It is composed on a diagonal axis, connecting the hand of the killer with one of his victim's hands.[3] The hand is, however, not only the organ of painting but also, in Western painting, the sign that links looking to sexual violence, as in the paradigmatic story of *Susanna and the Elders*. Moreover, the Rembrandt corpus[4] combines the theme of manual sexual assault stimulated by vision with the kind of self-reflexivity Alpers notes, thus suggesting a connection

1. Rembrandt, *The Levite Finds His Wife in the Morning*,
1655–6, drawing, Benesch 997. Berlin, SMPK, courtesy
Kupferstichkabinett.

between visual representation and ideologies of gender. What views of
gender does this corpus promote?

While pondering the attitudes toward women in works ascribed to
"Rembrandt," I have come across cases where women can be read as
represented sympathetically, as in the Berlin *Susanna*, more or less nega-
tively, as in *The Blinding of Samson*, and ambivalently, as in *Bellona*.
And what about the *Wedding of Samson*, modeled upon Leonardo's

Last Supper, where the bride has been given the central and lonely position of Christ? Rather than an affirmative, monolithic ideology of gender, then, I found a plurality of possible positions that the corpus leaves open. But this plurality is built upon a common concern in the gendered works, a concern for the most frightening aspect of life and the most urgent motivation for, yet challenge to, representation: *death*. Death is a challenge to representation, for it is a moment that nobody can describe, an event that nobody can escape, a process that nobody can narrate. As Foucault said: One cannot say, "I am dead."

Death is clearly gendered in the drawing of Judges 19. It represents the moment when the traveling Levite, who has exposed his wife the previous night to gang-rape, finds her the next morning on the threshold of the house. Consistent with the social conflict that informs Judges and is played out in language games, as I have argued elsewhere, the drawing depicts the victim at the entrance of the house, positioning her as a threshold-figure, as the embodiment of transition.[5] The drawing represents the central moment of the intrication of language and violence: the moment where the woman is no longer able to speak. In this moment, her dead flesh is seen, misunderstood, addressed, and already announces the coming moment when, in the end, her husband will dismember her and send the pieces of her flesh to the tribes of Israel, misused in a radical perversion of speech.

At the same time, *vision* plays a crucial role in this horror story. Misseeing and un-seeing the woman is the painful act that this "Rembrandt" represents. Thus the central scene of vision has a special meaning for visual representation. Her death and the story of it are not only violent but also narratively ambiguous. She dies, we might say, several times, or rather, she never stops dying. It is this aspect of her dying that makes this drawing so central to the reflections on death and on representation in "Rembrandt": An event that is punctual and non-narrational is turned into a slow process represented as the climax of narrative and, then, becomes a visual work that challenges the limits of visual representation. Whereas the event is turned from punctual into durative, the representation of this already perverted death in a still medium further explores and undermines the limits of the realm of the speakable. The moment of this endless deferral of death that Rembrandt chose to represent is one in which vision becomes a speech-act. The morning after the gang-rape, the woman's husband opens the door to go on his way, and "*behold*, there was his wife, fallen down, and her hands [were] on the

threshold" (Judges 19:27).[6] Two verbs, then, generate this drawing: to *open* and to *behold*.

According to Umberto Eco, signs are those things that can be used in order to lie.[7] This definition helps to understand the "lies" in the drawing, two oddities easily explained away by technical considerations yet insistently meaningful once we look at the image as a discourse: the movement of a dead woman, signified by the lines under her slightly blurred right hand, and the ghostlike transparency of the living man, signified by the continuous line of the stone on which he is supposed to stand. The lines under the woman's hand appear to be a shadow; yet, from a realistic point of view, this is impossible—the house would stand between the sun and the woman. The line continued through the man's body right above his feet can be seen as a technical imperfection, an earlier draft that should have been erased. Well, it hasn't been, so it isn't. Once we see that non-erasure as meaningful, the man recedes further into irreality. The steps on which the woman lies emphasize the solidity of her body, compared to which his image is singularly flat. From irrelevant and hardly visible imperfections, these two oddities become signs: lies that contradict the "official story." Rephrasing Eco's words in Harold Bloom's terms, Jonathan Culler places the lie with the reader: A sign is everything that can be misunderstood.[8] Misreading is the key to semiosis, just as mis-seeing is the key to opening the woman's body and to representing her death. Misreading is a reading that refuses to read, the attempt to explain away details that don't fit the coherence of the image or the coherence of the reader's ideological commitments. The two details mentioned above, for example, are exemplary signs in this view: They are bound to be misread, and if read, they upset our reading.

In "Rembrandt," then, there are women who are feared and therefore hated who need to be appropriated by violence. These women are potential mates—the bride who must be violated to be *opened*. On the other hand, there are women who are harmless because they have already been violated. These are the victims, women as social figures of marginality with whom the subject "Rembrandt" can identify. With the first class of women, the subject has a relation of contiguity, which implies a continuity he might fear because it endangers him; with the second, he has a metaphoric relation that implies the distance and separation that allows sympathy without entailing danger. Both classes, however, meet in their representation, in death that is: Ultimately, the one must be killed and the other has been killed already. Death becomes an activity, narrativ-

ized and visualized at the same time, that must *take place* (in the double sense of the phrase).

This dynamic aspect of death is readable in the gesture of the woman's hand on the threshold, important in both the text and the drawing. Beyond the dichotomy of literal and figurative-symbolic signs, the detail of the hand becomes a meta-statement on the text's narrativity. Narrativity and display are two conflicting modes of representation that collide and collude in a narrativization of vision. The gesture, as the drawing presents it, is the self-reflexive "lie" that counters the misreading both text and drawing thematize. That misreading is represented in the composition, which we can now read as a meta-statement on the work's theatrical display.

The textual moment picked out for visualization is well chosen. Reading visually, as the introductory exclamation "behold" suggests we might, we see how the man almost steps over the body of his wife—his first misreading of the sight presented to him; then he orders her to stand up—a second misreading, now of his position of power; and when nobody answers, we see him charge her on his donkey to take her home and, in his utter lie, cut her up for semiotic misuse. The drawing foregrounds the confusion about the moment of death rather than helping the viewer domesticate it by adding the short lines under the woman's right hand. In order to represent her death, then, the drawing must let her move.

Opening the body is an emblematic act in other representations of death in "Rembrandt." Taking the Judges drawing as a cue, we can look at these from the perspective of the impossibility to speak death as experience: to say "I am dead." The representation of death will hover between the narrative and the descriptive, breaking down one of the most dogmatic but also most problematic dichotomies of narrative theory. It will also hover between two aspects of its own impossibility: the first person and the present tense.

How, then, can we read "I am dead" rather than "she is dead"? One attempt can be seen in two drawings of the corpse of the executed murderer Elsje Christiaens (figs. 2 and 3).[9] In the profile, the axe is directed inward, and its upper point, like an arrow, functions as an index. It points to the woman's mouth, the silenced organ of speech. In the other drawing, it points outward; also, the woman's head is framed, violently confined, by the beams from which the axe hangs. This confining function is taken over, in the profile, by the central trunk of the gibbet and the

2. Rembrandt, *A Woman Hanging from the Gallows*, 1654–6, drawing, Benesch 1105. New York, courtesy Metropolitan Museum of Art.

3. Rembrandt, *A Woman Hanging from the Gallows*, 1654–6, drawing, Benesch 1106. New York, Dr. A. Hamilton Rice (?).

ropes that hold her body in place. In each work, the confinement of the body is emphasized by the very challenge put to it. The drawings demonstrate the need to hold a body that tends to escape the limits designed by the ropes. And in both cases, the woman's hand is the counterinstrument. The hands of the murdered criminal seem to escape the hold of the very ropes that cause her arms to move upward. This is especially striking in the profile drawing, where a sense of movement seems actually inscribed in the woman's right arm. If the right arm is the one that

has wielded the axe to kill, the left arm is, by comparison, the dead one, contained by the axe that is hung on its side.

In both works, emphasis falls on the woman's womb. The very deadness of the body, its quality of "hangedness," makes the womb protrude and, thereby, at least visually escape the confinement of death. The axe is the instrument of confinement in the drawings. Syntactically, the axes are juxtaposed to the wombs, but as the instruments of confinement, they also subordinate the "clause" of Elsje's body. In the frontal drawing, the axe wards off exterior attempts to bring the body to life by gaining access to it—"she is dead"—while in the profile drawing, it prevents the body from coming to life, from speaking that is, from saying: "I am dead."

These drawings are descriptive and describe the state of death within the ritual of public display as exorcizing guilt. Description is used here as the mode that helps bridge the gap between the evenemential yet inner "I am dying" and the descriptive yet outer "she is dead," thus getting as close as possible to the impossible "I am dead" through the interiorization of guilt. Description, then, serves to portray the inner experience and the outer display as a uniquely self-divided whole.

Through this mediation, the ritual is stripped of its exorcizing effect, which would discharge the identification. By diverting the temporal mode of narrative, which proposes identification as a provisional rite of passage, to descriptive stillness, death becomes the experience of the very ambiguity between state and event. As in melancholia, the guilt-ridden death of the other is turned inward, thus killing, threatening to kill, or at least affecting, the "I."

There are two pairs of paintings on death, one of each belonging among the most famous "Rembrandts": the slaughtered oxen and the "anatomies." The slaughtered oxen (figs. 4 and 5) display the opened body and represent the naked flesh of death.[10] The "personnel" are the same in each work: the gigantic, all-dominating mass of dead flesh, and the woman in the background, apparently a maid. The colors, yellowish and reddish, are those of the pallor of death and of the blood of violence. The direction of the "gibbet" and consequently of the body does not brutally face the viewer. This obliqueness allows us to see the outside and the inside at the same time.

Two major differences between the two paintings are the substance of paint and the distribution of semiotic labor between the members of the "cast." The work in Glasgow is painted in a medium mode of

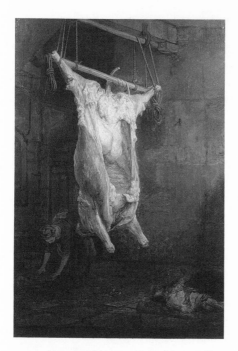

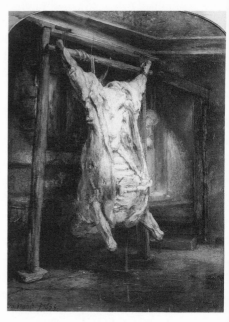

4. Rembrandt, *Slaughtered Ox*, 1643, painting, Bredius 458. Glasgow, courtesy Glasgow Art Gallery and Museum.

5. Rembrandt, *Slaughtered Ox*, 1655, painting, Bredius 457. Paris, Musée du Louvre; photo courtesy Réunion des Musées Nationaux.

paint application, neither extremely "fine" nor extremely "rough." As a consequence, the substance of the paint does not strike the eye, nor does the work draw attention to itself. The painting remains representational, realistic, in the way a "third person" novel without narratorial intrusions is assumed to operate. The deictic traces of the subject of representation, although never really absent, are secondary. The dead body is clearly delimited, and although it is flayed like its sister in Paris, the paint confines it like a skin. We see death as a given, not as a construct. But its very givenness allows us not to see it. Since it goes without saying, as the saying goes, death does not impose itself.

Similarly, the maid is represented at work, turning away from us as well as from the corpse. She seems to just be there, as an effect of the real, as a token of "life" within the scene of death. She becomes the para-

doxical female presence of still-life that, according to Norman Bryson, is repressed yet whose traces are returning in the very subject matter of the genre that is the fruit of her activity, of her life.[11] She has to be in the background to be part of the display. The spatial continuity between her body and the mass of flesh is slightly troubling, especially since she, too, has her head down and her bottom up, but this pose can easily pass unnoticed.

The Louvre painting is much more famous, primarily because of the daring roughness of the handling of the paint, generally considered a feature of the late "Rembrandt." It is particularly striking here, given the relatively small size of the work. In spite of the imposing quality of this paint, it is possible to shy away from its radical implications. For example, it has been interpreted as expressive and evocative, and Alpers rightly points out that this is obviously how Soutine reoriented the motif in his *Flayed Ox* of 1939. This choice implies that Soutine has been blind to the imposing self-referentiality of paint-handling that, as the French say, *crève les yeux*; it "pierces the eye." This piercing obviousness should not surprise us: we know that what pierces the eye blinds. Thus we know from Freud's metaphor of the name of regions on a map and from Lacan's analysis of Poe's "Purloined Letter" that the over-visible can become invisible.[12] The "Rembrandt" drawing of the *Entombment* (fig. 6) similarly foregrounds Jesus' head so much that it becomes invisible.[13]

Soutine, then, despite his strong response to the paint-handling, behaves like Poe's positivist prefect who is too systematic not to be blind. He has treated the impasto as a "third person" narrative mode: By displacing the relation between the work and its subjectivity, he took the work as expressing *something else*; the corpse, rather than itself.

In contrast, a self-referential interpretation raises the question of the relation between this painting-self and the representation of death. It is not enough to claim that the case made for art as work dictated the "rough" mode. The substance of the paint is also the substance of death. And the substance of death is dead, stinking flesh. What we have to deal with—what the work does not spare us—is the effect of the putrifying smell of painting. The medium for overcoming death that painting had become in the age of portraiture becomes here the medium for overcoming the nonrepresentability of death.[14]

The substance of paint as flesh affects every aspect of the dead body. The roughness not only conveys the making of the work; it also loosens the boundaries of the body—its outside—and makes the fusion that is

6. Rembrandt, *Entombment*, ca. 1640, drawing, Benesch 482. Amsterdam, courtesy Rijksprentenkabinet.

inherent to rotting. The flesh represented, therefore, stinks, and its stink contaminates the representation itself. In addition, while the relatively "neutral" brushwork in the Glasgow *Ox* allowed us to differentiate between inside and outside of the body, the Louvre work exposes dead flesh on both sides. The opened body is turned inside out: There is no outside left, all we see is inside. Instead of being in a butchery, we are within a body.

The position of the maid partakes of the same effect. The reassuring distinctness of the maid from the ox in the early work secures boundaries: *She* is alive, *it* is dead. It is meaningful that the butchered body in the earlier work is more filled, less empty than in the later work. As it is also farther from the spectatorial plane, the confrontation with dead flesh is less emphatic and self-imposing. The increase in the substantiality of dead flesh comes with an increase in emptiness, hence, a decrease in *represented* substance. Increase-with-decrease is a dis-play: a display that unplays the fabula of the play.

The emptiness of the body in the Louvre painting is emphasized in yet another way. In the lower part of the body are two pins or nails. These nails are not necessary to fix the body to the stand, for that function is taken care of by the ropes with which it is attached at the top. The

nails' only possible function, then, is to hold the body open. Rather than an effect of the real, they may be assigned an effect of openness. They also entail an effect of violence, bringing the work one step closer to a crucifixion.

The effect of the nails is to emphasize the openness of the body, which is not "really" greater in this work but represented more self-consciously. It is thus that the decrease of represented substance becomes an increase of deadness. The body is here an empty body. The nails display the inside of the body and the nothingness it reveals. And as Gérard Dessons remarks, no body could be more appropriate to represent the nothingness inside the body than the castrated, de-gendered ox.[15]

The maid is not working here as maids do, cleaning up the blood of the butchery. She is looking, or trying to. The intensity of her effort to see is emphatic, but the direction of her look is unclear and her eyes are empty. She bends her head, and thereby narrativizes this work. But her eyes are not quite focused on the dead flesh. She seems to look at the viewer, but not quite clearly. The eyes are intense, yet empty, as if "looking" were a problematic activity. Between state and event, emptiness is narrated here.

There is another lie readable here. The maid's head is fully represented, but her body is unreadable. She seems to be cut off underneath her bosom, at the beginning of her belly.[16] The white apron that makes the top of her belly protrude disappears in the dark background further down. Where her body ends, that of the ox begins. There is contiguity here again, but this time more problematic, less easy to ignore, than in the other painting. The similarity in position between the maid and the ox in the earlier work is replaced here by complementarity. Where the outer representation of her body stops, the gigantic inner body seems to take over. According to this painting's syntax, the opened inside is a replacement of the woman's body. The emptiness of the ox's body becomes the representation of the womb: Only announced, alluded to by the woman's apron, it "pierces the eye" in the dead body. Death is, here, the very stage upon which gender and representation change roles.

"She is dead": It has been stated already in the drawings, but here the staging of death reaches a more disturbing closeness—for the woman looks at the viewer while also, through the emptiness of her eyes, taking on an iconic relationship of signification with the empty body. In other words, she becomes "us" while becoming "it." If the viewer is willing to go along with this effect, the miracle is accomplished, and the painting says: "I am dead." But since this statement requires the violent

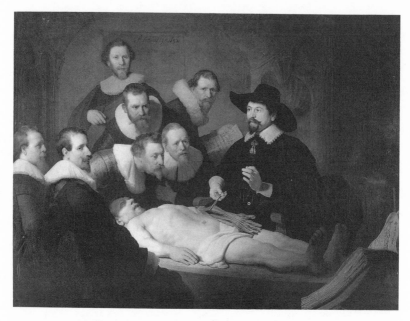

7. Rembrandt, *The Anatomy Lesson of Dr. Nicolaes Tulp*, 1632, painting, Bredius 403. The Hague, courtesy Mauritshuis.

representation of emptiness—through the nails—simultaneously with the radical representation of decay—through the substance-in-fusion of rotting flesh—it can only be said in the grammar of emptiness: in the feminine form.

The Louvre *Ox* leaves, however, one dimension underexplored. The toll decried by this radical statement on death as gendered is an abstraction, albeit concretely necessary, from the social construction of representation. To be sure, such an abstraction is part of the "argument": The secrecy of the empty female body is the necessary condition for its centrality to the challenge of representation.

This work, staged in a liminal, intermediate space, positions death outside of life. The limbo of the dark stable seems far removed from the social theater, and the unreality of the maid in the second work, who is cut in half, contributes to this effect. Just as the husband in the Judges drawing was crossed out by a line so that he became "just lines," a pure representation, so the maid, here, is cut through by the metonymy of the gigantic, blown-up version of her body. But the very aloneness of the

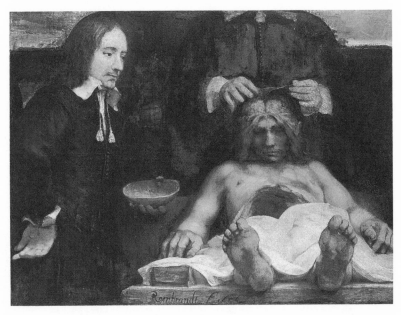

8. Rembrandt, *The Anatomy Lesson of Dr. Jan Deyman*, 1656, painting,
Bredius 414. Amsterdam, courtesy Rijksmuseum.

woman and her "other half" on the stage of death obliterates the radical
contrast between dead flesh and the life of the masterful manipulation
of representation.

The present tense and the first person still leave implicit a third deictic
dimension, the "here" of the social, signified in relation to the second
person whose metonymic extension the subject is and in relation to
whom the subject needs to be defined, demarcated, and confined. This
dimension is central in a final set of two works, in which the dis-play
of death and self-representation are staged on the social theater, where
death produces mastery but where the genderedness so uncannily fore-
grounded in the late *Ox* seems pushed back: the "anatomies" of Drs.
Tulp (1632) and Deyman (1656) (figs. 7 and 8).[17]

The anatomies are about death in an obvious way. Yet the very quali-
ties that defined death in the Louvre *Ox*, genderization and the loosen-
ing of boundaries, seem less obvious here. In neither of the anatomies is
the paint-handling foregrounded, and the social setting, although sug-
gesting a smell of death, does not emphasize the force of the represen-

tation, the smell of painting. These works are also in the two colors of death—pallor and blood—as well as in the shape of death—bodily openness. Unlike the "Oxen," the corpses are human, and, unlike each other, the place, meaning, and function of the open wounds differ.[18]

The anatomies display a conventionalized theatrical event. They are reassuring as well as unsettling paintings. The *Tulp* demonstrates mastery over death and death as a source of knowledge. The surgeon becomes the *other* of the artist, the other artist, or the *you* in relation to whom the subject of painting is positioned; this mastery is *here* yet irretrievably not in *me*. Yet the intense looks of all figures do not confirm this clear place of mastery. The generalized looking focuses and disperses the attention, directed toward a definite object yet away from the corpse as well as from the master. It betokens as well as disperses Tulp's mastery. Fascination is combined with the impossibility of *facing* mastery over death. The surgeon's left hand, making the gesture of understanding, of subtle grasping—the gesture of holding and wielding the painter's brush, the knower's pen, or the surgeon's knife—forms a triangle with two other hands: his right hand, which actually makes the gesture rather than representing or imitating it, and the dissected hand of the corpse. Being about to pull the muscles so as to make them realize—or figure—the gesture, the surgeon is about to move beyond the domain of knowledge: He will make the corpse move. For his left hand to make sense, the corpse must be brought to life. This rivalry with the Divine Maker is also a competition with the artist, who is solely capable, or trying to be, of resolving the paradoxes of representation. No wonder the men are holding their breath.

Dessons' little 1987 book *L'odeur de la peinture*, whose title I borrow for this essay, has been inspired primarily by this painting. This choice of focus is astonishing, for the main theme of the book is the opening of the body. If this painting is of an anatomy, it presents the dead body as remarkably closed. The fleshy belly and thighs have a substance that is as far removed as possible from the Louvre *Ox*. The flesh is not rotting. The skin is intact except for the arm, which is clearly set off from the rest of the body both by color and by disproportioned size. The boundaries between dead corpse and live doctors are clear-cut, so to speak, both in composition and in color.

Strangely, Dessons finds the later *Deyman* less daring. Time and again he verges on the (in)sight of the "indecency" of the *Ox* yet represses the eye-piercing obviousness of its return in the *Deyman*. Thus he speaks of the white and red stuff that fills the "abdominal [and abominable]

cavity" of the *Ox* only. Dessons turns the *Tulp*, and by extension the series of works on the opened body, into a statement on art alone, devoiding it of its disquieting references to the issues at stake in the death works. To open up *his* closing statements into a more complex perspective on the fascination these works exercise, I will, in my turn, wind up my argument in interaction with this text. Speaking of the maid in the Louvre *Ox*, whose deadly, because intransitive, look he has just evoked, he writes of "her indefinite status: she does not have the social authority of the surgeons of Amsterdam, and her ambiguous status: half visible, she is half hidden, inscribing the painting within the violation of a taboo." [19]

Pushing back this guilty violation of clarity that comes with the opening of the body in slaughter, in sex, and in representation, Dessons chooses the *Tulp* as the exemplary discursive representation, as the "model for the discourse on death and on *jouissance*, model . . . for the constitution of a writing of the body, the surgical practice proposes for the painter a model of manipulation, where the right usage of the hand is *figuring, not decomposing* [italics mine]." [20] Figuring, when opposed to decomposing, not only stands for design, for drawing, as opposed to paint-handling—so central for "Rembrandt"—but also (insofar as drawing is so much closer to writing than paint-handling) for writing as opposed to a radically different representational practice. The opposition seems to repress the complementarity of the two, as expressed in Cynthia Chase's title *Decomposing Figures*. Strangely enough, what Dessons is doing here in his essay on the body is trying to get rid of what "Rembrandt" proposes as the *body* of representation in favor of a de-fleshed writing. This move reverts to an old version of the word-image opposition that privileges the word. If we look at the impasto paintings, for example, the *Suicide of Lucretia* in Minneapolis, the anatomies can hardly compete with these in power of representation precisely because of the way decomposing is *done*, not *figured*. Against Dessons, then, I would say: Indeed, decomposing *is* (part of) the right usage of the hand, and if only the social authority of the surgeons could be integrated with the physical authority of the inside of the female body, we would have surmounted the last remnant of resistance that hampered the representation of death because it hampered an understanding of representation beyond the word-image opposition: death's social place as source of knowledge, as the key to reading, and as the model of art.

This integration, then, is accomplished in the *Deyman*. It is often noticed how the opened abdomen demonstrates that this anatomy oc-

curred according to the convention but that the surgeon is not dissecting the body but, rather, the brain.[21] It is also true, however, that this either/or scheme may obscure an important connection between the two body parts, as well as what they stand for. The dark red cavity is symmetrical with the yellowish substance of the brain. Not only are they of the same dimension and form, the latter would nicely *fit inside* the former, thus, again, providing metaphor with a metonymical basis. If we recall the two colors of the substances in the *Ox*, it becomes possible to read this complementarity of form as another token of self-referentiality.

The figuration is a triangle, not a binary opposition. Attentively looking *into the abominable cavity*, the doctor on the left is solemnly holding the basin of the skull. The skull-cup is juxtaposed to the abdomen as its metonymical metaphor, and thus it draws attention to the importance of looking as a rhetorical device of figuration. The eyes of the corpse are shadowed, but the aggressive directness of the pose, the arms, feet, and head turned toward the viewer, suggests that the corpse itself is looking—both at and with the viewer. The body is thus shown in an ambiguous way: alive or dead, male or female, it cannot be told with certainty. The left breast looks quite fleshy, and the immense cavity recalls the emptiness of the *Ox*.

The confrontational pose draws the viewer into the work. It works with the relation I-you within the here. What we have, then, is an integration of womb and brain, of the *Ox* as the experience of death and its intensity (through identification with femininity—"I-she am dead") and the anatomy as the knowledge of death, with its authority placed elsewhere.

Finally, the surgeon has been cut off so that, for the modern viewer, the you has merged into the I. This effect did, of course, not occur when the painting was whole, but maybe it is fortunate that it is not whole now, for its intensity has increased with the decrease in its size. Thus, this work, which Dessons does not see, accomplishes what the author himself writes about toward the end of his essay, apropos the programmatic quality of the *Tulp* but in important ways *mal à propos*: "It was necessary to make a painting where the subject be no more defined as an act of imitation, in allegiance with the order of the sign, but as a conflictual subject, taken in a double relation to the social and the unconscious."[22] What this work, and by extension all death works in "Rembrandt," suggests is precisely this *conflict within* that, in the age of Descartes and the great anatomies, inaugurates modern representa-

tion; this double relation that is not a matter of juxtaposition but that contemporary theory has so much trouble freeing from an opposition. To get out of such a dichotomy, we may take the Louvre *Ox* as a pretext for the *Deyman* and then use it as a comment to read the earlier *Tulp* as a work struggling to stay away from the genderedness of death and of (its) representation; the representation of that which, as this reading of "Rembrandt" suggests, will become the mastery of painting beyond the social mastery of the surgeon.

NOTES

This paper is a revised version of a part of the final chapter of my book *Reading "Rembrandt": Beyond the Word-Image Opposition* (Cambridge, 1991).

1. *The Levite Finds His Wife in the Morning*, drawing, Benesch 997, Berlin, Kupferstichkabinett.

2. Svetlana Alpers, *Rembrandt's Enterprise: The Studio and the Market* (Chicago, 1988).

3. The claim that this man is in fact the murderer of his wife has been argued at length in my book *Death and Dissymmetry: The Politics of Coherence in the Book of Judges* (Chicago, 1988).

4. I consider as part of this corpus all works traditionally ascribed to Rembrandt and therefore part of the cultural construction "Rembrandt," which thus becomes a culturally flexible text rather than an historically validated metonymical figure (where the author receives authority if and only if the existential, "real" contiguity between the person of the artist and the works he produced can be certified to the satisfaction of twentieth-century criteria). In order to mark this use of the corpus, I will henceforward put the name of the alleged artist in quotation marks.

5. See *Death and Dissymmetry*.

6. I translate as "wife" the word *pilegesh*, usually rendered as "concubine," a translation that I believe to be utterly ideological and misogynistic. These women are not "secundary" wives, of poor origin and close to slaves, as is commonly assumed; they are wives according to a different marriage system where after "marriage" the woman stays in the house of her father, her "husband" visiting her intermittently. This system can be called patrilocal. The hypothesis that Judges 19 deals with a violent transition from patrilocal to virilocal marriage explains a great number of oddities in the text. For an extensive argumentation, see *Death and Dissymmetry*.

7. Umberto Eco, *A Theory of Semiotics* (Bloomington, 1976), "Introduction."

8. Jonathan Culler, *On Deconstruction: Theory and Criticism after Structuralism* (Ithaca and London, 1983).

9. *A Woman Hanging from the Gallows*, drawing, 1654–1656, Benesch 1106, private collection; *A Woman Hanging from the Gallows*, drawing, 1654–1656, Benesch 1105, New York, Metropolitan Museum of Art.

10. *Slaughtered Ox*, panel, 73.3 × 51.8 cm, 1643(?), Bredius 458, Glasgow, Art Gallery and Museum; *Slaughtered Ox*, panel, 94 × 69 cm, 1655, Bredius 457, Paris, Musée du Louvre.

11. Norman Bryson, *Looking at the Overlooked: Four Essays on Still Life* (Cambridge, Mass., and Cambridge, U.K., 1990), chap. 4.

12. The debate on Poe's story and Lacan's interpretation has been published in *The Purloined Poe: Lacan, Derrida & Psychoanalytic Reading*, ed. John P. Muller and William J. Richardson (Baltimore, 1988).

13. *Entombment*, drawing, undated, Benesch 482, Amsterdam, Rijksprentenkabinet.

14. On the relation between portraiture as a genre and death, see Ernst van Alphen, *Francis Bacon and the Loss of Self* (Cambridge, Mass., 1992).

15. Gérard Dessons, *L'odeur de la peinture: Essai sur une question posée par Rembrandt à la peinture représentative* (Paris, 1987).

16. As in the Judges drawing, this cut can be explained away quite easily. Realistically speaking, the maid is standing behind a typically Dutch half-door. This kind of realistic explanation shies away from the *effect* of this feature, however—from the cut as sign, that is.

17. *The Anatomical Lesson of Dr. Nicholaes Tulp*, canvas, 169.5 × 216.5 cm., 1632, Bredius 403, The Hague; *The Anatomical Lesson of Dr. Jan Deyman*, canvas, 100 × 134 cm., 1656, Amsterdam, Rijksmuseum. The *Tulp*, considered Rembrandt's first great success, has been studied much more extensively than the *Deyman*. See William Schupbach, *The Paradox of Rembrandt's "Anatomy of Dr. Tulp"* (London, 1982); and William S. Heckscher, *Rembrandt's "Anatomy of Dr. Nicholaas Tulp: An Iconological Study* (New York, 1958).

18. For a different view of the relation between representation and disfiguration, see Michael Fried's *Realism, Writing, Disfiguration: On Thomas Eakins and Stephen Crane* (Chicago, 1987).

19. "Son statut indefini: elle n'a pas l'autorité sociale des chirurgiens d'Amsterdam, et trouble: visible à demi, elle est à demi cachée, inscrit le tableau dans la violation d'un interdit" (Dessons, *L'odeur de la peinture*, 76).

20. "Modèle pour le discours sur la mort et sur la jouissance, modèle . . . pour la constitution d'une écriture du corps, la pratique chirugicale propose au peintre un modèle de la manipulation, où le bon usage de la main, c'est figurer, non triturer" (ibid., 49). I have chosen to translate *triturer* as "decomposing" in order to oppose it to "figuring" in an allusion to Cynthia Chase's masterful

Decomposing Figures: Rhetorical Readings in the Romantic Tradition (Baltimore, 1986).

21. Horst Gerson relates the *Deyman* to the first modern *Anatomical Lesson*, J. J. van Calcar's title page for Andreas Vesalius's *De Humani Corporis Fabrica* of 1543. See his *De schilderijen van Rembrandt* (Alphen aan de Rijn: Icob). Vesalius is represented dissecting the uterus of a woman—considered the site of evil—while *Deyman* dissects the site of the soul (398). It is needless to say how much more relevant this comparison becomes in the present context.

22. "Que le sujet ne soit plus l'exercice de la mimesis, mais bien la peinture elle-même dans sa materialité et sa gestuelle, dans ses rapports pulsionnels avec le sujet peignant. Il fallait un tableau où le sujet se definisse non plus comme acte de copie, allégiance à l'ordre du signe, mais comme instance conflictuelle, prise dans un double rapport au social et à l'inconscient" (Dessons, *L'odeur de la peinture*, 71).

Form and Gender

THIS paper is a slight revision of a lecture written to serve the fairly definite purpose of making the "archaeology of the discipline" of art history, and, more specifically, the "critical history of art" (as Michael Podro has called the foundational German tradition of art history descending in one way or another from Kant and Hegel) discussable and of interest to those participants in the NEH Institute concerned with more recent questions of interpretation. I therefore hope the paper will be read as part of a discussion meant to provide more useful questions than final answers. I should also say at the outset that my familiarity with relevant feminist scholarship is only partial, and I hope those more conversant than I with this rapidly growing literature will be able to add further evidence and arguments.

I should explain that the views presented here are a reflection of a larger project in which I have been involved. I became convinced many years ago that the discipline of art history was in serious difficulty for the simple reason that its working language no longer worked. Progressive art history has centered for the last twenty or twenty-five years upon "contextual" questions, as they came to be called, and from these beginnings, a newly oriented art history has more and more clearly emerged in a kind of dialectical contrast to more "formalist" art history. This new direction has implied more than a change in topics of research. I have argued elsewhere that the modern intellectual discipline of the history of art, insofar as it is distinguishable from other fields of history that make inferences from one or another kind of documentary evidence, is fairly formalist in that it is based upon the idea of form; that is, works of art have been treated by art historical professionals—and to a large extent still *are* treated by art historical professionals—as if they were *essentially* forms or "compositions" of forms.[1] The idea of form thus provided the basis for an internal, self-contained art history, like Wölfflin's or Riegl's, in which forms themselves evolve; and precisely because it is presumed to be essential, form has also provided the basis—has had to provide the basis—for relating art and its history to other kinds of history, to social, political, scientific, and intellectual history, for example. The problem of relation was believed to be solved by the *expressive-*

ness of forms, which in turn meant that the interpretative task of art historians was essentially aesthetic and that, by properly responding to forms, we could see more or less directly into the mind or spirit or world view of artists, places, times, and peoples. We are very familiar with such inferences. The elongated linear forms and nondescriptive colors of Mannerist paintings are to be expected of the paranoid Pontormo or the suicidal Rosso Fiorentino, and such psychological extremities are, in turn, expected of painters working through the sack of Rome, the siege of Florence, and the Reformation; it seems easy to see their anguish and spiritual crisis and the crisis of the age expressed in their fascination with the irrational art of the north and their anticlassical deviance from the sunny, geometricizing, proportional, and generally Apollonian taste of their native Mediterranean culture. But there came a point at which this kind of inference began to seem problematical, and this uneasiness had largely to do with pressure from the emerging contextual art history. Such physiognomic inferences from presumably expressive form were, in fact, hard to connect to other kinds of historical evidence and began to appear circular, to explain too much too quickly; or to explain nothing at all, since they were always vulnerable to fairly uncomplicated and irrefutable charges of subjectivity. It became more and more difficult, in short, to see exactly how physiognomic inference related to context at all. Not only was an old art history fading into the past, however, but the descriptive language used to deal with the unique subject matter of art history—namely art—was becoming more and more irrelevant, a situation that seemed to me would have unhappy long-term consequences for what we all do. If we think of intellectual disciplines as simply what professionals in the discipline do (which we must to some extent), then changes in intellectual style do not matter very much. It is easy to imagine the questions of the discipline endlessly permutating within the walls of university buildings called art history departments. I believe, however, that the survival of an intellectual discipline is dependent upon a conviction that it offers understanding about something in need of being understood, which leads me back to my first point: When practitioners of the history of art found themselves unable to reach any consensus—or even consensuses—about the common object of their concern, the history of art was in trouble. I thus decided to try to devise another analytic language about works of art, a language that would allow us to ask more questions of the kind we now like to ask. This language would replace the old idealist, formal analytic language but would continue to function at a level of generality comparable to it.

Without trying to explain this whole enterprise (to which I shall return briefly at the end of the paper), it is sufficient for the present to say that it has involved the reconsideration of the idea of form itself. I outline some of the implications of that reconsideration in this paper.

The strands of my argument come from various projects and interests and from scattered reading. I began to think about these issues years ago when I read Panofsky's observation in his *Idea* that Michelangelo, the alleged arch-Platonist, never referred to his works, or to thoughts about them, as *ideas*; rather, he called them *concetti*, concepts.[2] *Concetto* is a form of the verb *concepire*, to conceive, from the Latin *concipio*, *concipere*, to lay hold of entirely, to absorb (as liquid), to catch (as a fire), hence to conceive (as a child). A *concetto* is a thing conceived in the mind, and the metaphor may be understood as biological, as if the imagination were a *matrix*, or womb. To extend the metaphor, *concetti*, considered as the progeny of the mind, occupied a lowly position in contrast to ideas. It was not intellect that conceived Michelangelo's new works of art *in potentia* but, rather, the much lower faculty of imagination of fantasy.[3] If the imagination as a womb is at least implicitly feminine, its subordination to reason in the hierarchy of faculties and its close association with sensation should alert us to a distinction significant in terms of gender, one of the two main themes of my paper. As is well known, a very long tradition has regarded intellect as masculine (to use the language of grammar) and lower faculties (the faculties closer to sensation, like imagination, intuition, and memory, the "particular" as opposed to the speculative intellect in general) as at least implicitly feminine.[4] The next step came when I noticed that a late sixteenth-century depiction of Michelangelo showed him in the posture of his own figure of *Night* in the Medici Chapel (figs. 1 and 2). This print, which dates from the 1570s, that is, from the decade after Michelangelo's death, purports by inscription to show him at the age of twenty-three, that is, around 1498, at about the same time he finished the St. Peter's *Pietà*, and so perhaps is based on an earlier image. Certainly the motif is older than the print, dating back at least half a century to the early *maniera* and to late Raphael. In a drawing probably made by Raphael in 1514, a sleeping female figure is labeled (probably by a later hand) as Danae; this figure in turn was reproduced in prints as the vision of St. Helen, serving finally as the model for Veronese's *Vision of St. Helen* (fig. 3).[5] This thematic kinship provides a clue to the meaning of the figure of the young Michelangelo. In the various versions of the vision of St. Helen, the window, left blank in figure 1, frames the actual dream of the saint, and we

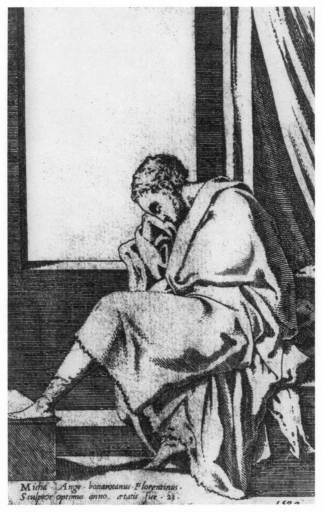

Michä Ange bonarotanus Florentinus.
Sculptor optimus anno ætatis suæ 23.

1. School of Fontainebleau (Master L.D.?), *The Young Michelangelo Asleep at a Window,* from E. Steinmann, *Die Porträtdarstellungen des Michelangelo* (Leipzig, 1913), Tafel 1A.

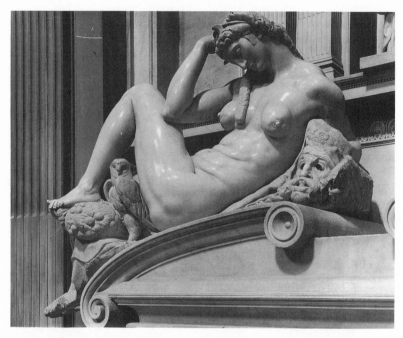

2. Michelangelo, *Night*. Florence, San Lorenzo, New Sacristy, photo courtesy Ralph Lieberman.

may infer that Michelangelo is shown to us not just as a sleeper but as a dreamer, a visionary, perhaps as the object of divine love and grace. His window, unlike that of St. Helen's, contains no vision; but it might be filled with any number of images and thus might be seen as his *fantasia*, his imagination. In this blank, in his dreaming soul, *concetti* develop, that is to say, he gives birth to forms, again as if in a womb. Furthermore, the figure is, like *Night*, a female figure, and in fact the young Michelangelo is the only male figure in this series of images. Night is by tradition feminine, a tradition by no means ended. The philosophical beginnings of this tradition, which are certainly to be found in myth, lie in Aristotle's *Metaphysics*, wherein he considers the opinion of Hesiod, who stated that the world was generated from chaos or night.[6] Aristotle rejects the idea with arguments of a kind that now sound very familiar. Night could not have generated all things, he argues, because there is no principle to explain the generation. The metaphor is partly sexual and reproductive. "Wood," Aristotle says, "will not move itself—car-

3. Paolo Veronese, *Vision of St. Helen*. London, photo courtesy National Gallery.

pentry must act upon it." The word Aristotle uses for "wood" is *hyle*, which meant wood from the forest for building but which Aristotle generalized to mean "matter." This generalization is already under way in the expansion of the example: "Nor will the menses or the earth move themselves—the seeds must act upon the earth, and the semen on the menses." Natural generation is like the making of an artifact, and night or chaos can only be a potential mother. By collecting all these hints together, we can see that, if Michelangelo is shown in the print as his *fantasia*, as a potential womb of forms, he is also shown in a way entirely consistent with another millennial view of the feminine, as waiting, passive. If his imagination is the potential mother, who is the father? An answer to this question is suggested by Michelangelo's repeated use of the classical motif of night, for example, to show one of the loves of Zeus, Leda and the swan (fig. 4). Leda is shown with eyes closed, if not asleep, so that, as Charles de Tolnay observes, the inseminating swan is secondary and seems "a sort of filfillment of her dream wishes." But she is also impregnated by the god, and the children of their union are shown (in one copy) at her feet.[7]

The fact that this figural motif appears so often in Michelangelo's work, and at least in a commentary on his powers of invention in the print in figure 1, suggests that the theme was peculiarly important to him on some level, rather as the *Pietà* has often been argued to be. This conclusion is further supported by the fact that Michelangelo wrote what amounts to a suite of poems on the subject of night. The poems are characteristically complex and antithetical. One of them may be paraphrased as follows:

> He who made time from nothing . . . made two of one, giving the high sun to one, to the other the nearer moon. In that instant, chance, fate and fortune came to each of us; and I was assigned to the dominion of night, even at birth, and in the cradle. And so, imitating my very self, I am as the night, which is all the darker as it grows. . . .[8]

In this poem, Michelangelo's identification with night is an identification with evil, overcome by the light of the sun, his love; in another poem, night is weak, destroyed by any light, even a tiny glowworm.[9] In others, night is strong, the darkness from which all life proceeds. Everything is enclosed by matter, like the sculpture in the stone in his famous sonnet *Non ha l'ottimo artista alcun concetto*, and night is sacred and living; we are sown in shadow, in a similar womb, so that night is

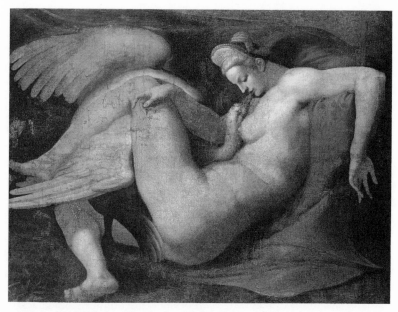

4. Copy after Michelangelo, *Leda and the Swan*. London, photo courtesy National Gallery.

holier than day.[10] Night is also associated with dream and imagination; it takes him, Michelangelo says, where he longs to go,[11] to the source of beauty and the realm of the gods. Night is the matrix of inspiration, which brings us back to the sleeping figure and the blank window in the engraving from which we started.

Unfortunately, I have never written more fully on the notion I have just outlined, and this taste of what a finished paper might contribute to an understanding of Michelangelo's commentary on his own art and to our speculation about the psychosexual roots of his art must now merely serve to introduce certain themes and clusters of themes. Perhaps the most important point for the current purpose is that much of the metaphorical language—perhaps the fundamental metaphorical language—in which we discuss artistic invention is biological and, more specifically, sexual and reproductive in character (at the same time, reproduction is characterized by analogy to art). I have already mentioned *concetto*, but there are other much more familiar examples. Author is from *auctor*, which is from *augere*, to increase, produce, or originate. Only by extension, etymologically speaking, do authors just write texts; they are more

generally progenitors and founders, as Cezanne is (or was) often called "the father of modern painting." Genius is from *gignere*, to grow, and is related to *gens*, race, people. In classical Latin, *creare* means to produce, beget, or bear; it was in medieval theology that creation became a divine prerogative—the creature cannot create, as Augustine wrote [12]— and it was only in modern times that the term, still trailing its theological clouds of glory, came to mean a radical originality of invention, still, in a less grand sense, making something out of nothing. This metaphor had been appropriated by the end of the fifteenth century,[13] but the classical meanings are by no means consigned to the past. We still use this language and are very much within the largely unconscious reach of its implications. Such metaphors are to be found concealed in the everyday language of art history. A "patron," from *pater*, is metaphorically a father, and the notion of genius is merely displaced if it is supposed that the patron rather than the artist gives the essential stimulus to the making of works of art. As art historians, we use "reproductions" of works, and if artists make self-conscious reproductions, then the issues of "authenticity" and "originality" are much more likely to be comparable to questions of paternity than of maternity. But, to come back to the other word in the title of this paper, one of the most important terms is "form."

In what follows, I discuss the history of the ideas of form and matter in very general terms. First, I review what might be called the classical definitions, concentrating on Aristotle. There are other definitions of form and matter in classical thought, but Aristotle's *hylomorphism*, the idea that existing things are unions of form and matter, had a peculiar depth and breadth of influence until modern times. Aristotle posited one underlying matter in order to provide a principle of continuity through change. Matter might thus seem a relatively neutral and necessary hypothesis. Aristotle's definition, however, seems to have developed from and, as we shall see, retained the negative connotations of the "mother and receptacle" in Plato's *Timaeus*,[14] which, to the degree it was thinkable at all, was a principle of non-being in contrast to form. Whatever the relation between the two thinkers' definitions, their ideas of form and matter complemented and reinforced one another in a very long tradition. This hylomorphic notion is still current, although it has been joined by a second, characteristically modern notion of form, which might be called Kantian, according to which "forms" are also those manifold categories within which human consciousness constitutes its world. That Kantian definition, which is fundamental to the original

language of the modern history of art, will be my second topic. In both cases, I shall be concerned not just with form but with the relation between form and matter, which I will argue has, for two and a half millennia and in countless contexts of use, been a deeply gendered distinction. At the end of the paper, I will suggest a correction—I think a correction at the level exposed to view by an archaeology of the discipline—to the constitutive, conceptual posture of the discipline toward form and, therefore, toward gender.

I wish to begin with an observation made by Griselda Pollock in her essay on "Feminist Art Histories and Marxism." She writes as follows:

> We [she and Roszicka Parker] started from the premiss that women had always been involved in the production of art, but that our culture would not admit it. The question to be answered is: Why is this so? Why has it been necessary for art history to create an image of the history of past art as an exclusive record of masculine achievement? We discovered that it was only in the twentieth century, with the establishment of art history as an institutionalized academic discipline, that most art history systematically obliterated women artists from the record.[15]

Her conclusion, which she says was unexpected, is that women and women's art have a "structural" role in the discourse of art history. By "structural," I take her to mean that our understanding of women and our understanding of art are in a dialectical relation to one another, that our idea of art positively excludes the idea of women at the same time that it is absolutely dependent upon the idea of women for its own definition. If that is so, then it is the task of feminist art history to examine and revise this structural defect together with the practices and institutions founded upon it. Pollock's favorite villains in the conceptual structure of art history as it is now practiced and taught are genius and creativity or originality. One may easily agree that these ideas, first, are crude armatures around which to organize a history of art and, second, that they serve fairly obvious (but I would not want to say obviously undesirable) ideological functions in modern bourgeois culture. But form, although conceptually related to them, is a deeper category than either genius or creativity. In the Kantian system to which all three belong, form might be described as the precinct of both genius and creativity and, as I will argue in what detail I can, is the most explicitly gendered category of the three. I will argue that one of the major reasons women are excluded from the history of art and one of the reasons this exclusion coincides with the rise of the modern academic discipline of art

history is that the latter is based on the idea of form. This has simple and important consequences. The conception of art history as the history of genius, as, to use Nietzsche's monumentally silly formulation, giants calling to one another across the waste spaces of time, does not begin to explain how we get from genius to genius. The idea of form, on the other hand, provides a principle of continuity, one form turning into another according to whatever rules until the development is given some new impetus, usually by an artist of genius. That principle of continuity leads us to believe that we are thinking in more gender neutral formalist terms, thinking for example about "art history without names," of Wölfflin's or Riegl's grand developments from Renaissance to baroque, or from haptic to optic. In fact, however, we are thinking in terms both more subtly and more obviously gendered than we are when we think of the history of art as a history of genius or creativity. I will try to explain why I believe this.

Aristotle, who, like everyone else, had some useful ideas and some bad ones, occupies a very unenviable position in the history of Western speculation on the nature of women.[16] In general, as I have described briefly above, Aristotle (and legions after him) believed that things are unions of matter and form. In the case of animals, the four elements in combination (matter) are shaped by form, which governs both the purposeful configuration of things and their growth and is related to soul (in its turn related to *pneuma*, or breath, a principle of life and movement). This fifth higher element, this quintessence, is related to the heavenly bodies, to their light and to their perfect movement. This pneumatic spark of life, Aristotle believed, is carried and transmitted by semen. Men thus represent the immediate contact of heaven and earth. Women are at one remove from that contact. Men are associated with the two higher elements, air, which is closer to the heavens, and fire, which tries to reach the heavens. Women, by contrast, are associated with the lower elements of water and earth. For this reason, women are by nature colder than men, and, because of this coldness, women are unable to convert blood into semen—Aristotle's explanation of menstruation. The monthly failure to convert blood into semen is, according to Aristotle, systematically related to other relative imperfections in female nature—passivity chief among them—and it was thus possible for Aristotle to formulate the idea, which has had a long historical life of its own, that the female is an incomplete or mutilated male. Nature always intends to produce the most perfect human being possible, the most beautiful, the most fiery, and therefore the best able to reproduce;

that is, nature always intends to produce handsome, potent male children, and Aristotle accounted for human variety as deviations from that norm owing to accidental circumstances of conception. Human beings run the gamut from male to monstrous, and the first departure from the male norm is the female. Women are, of course, necessary to nature's larger plan of maintaining the species, so that a certain wavering from the norm is desirable. But still, the specific mode of this necessary division is deviation from the male.

Aristotle did not know about the female ovum (which was not discovered until the seventeenth century) and, to bring us around to our subject, tried to explain what happens in the generation of new human beings in terms of form and matter, which he called *eidos* (or *morphe*) and *hyle* respectively. As I have said, semen is associated with form; it is in fact completed or perfected form, by which Aristotle means that semen is capable of transmitting the life and appearance of the father. The female contribution to generation is prime matter, or *hyle*, the monthly discharge, or *katamenia*, rejected after its unsuccessful conversion to semen.

In making his arguments, Aristotle continually uses the analogy to art. In general, Aristotle believed that all things come into existence through the agency or nature, art or chance. Natural generations contain their own forms. The apple seed contains in some way the apple tree. Things made by art differ from natural things in that they have their formal origin outside themselves. The form of the cup is in the mind of its maker before it is in matter, that is to say, before it is in the cup itself. In both cases, however, matter is given form, and I think that art is clearly the deeper idea, that is, that nature is explained in terms of art and not the other way around. In any case, Aristotle's explanation of human conception can be recognized as a longer version of the one encountered earlier when Aristotle explained why night or chaos could not be the origin of all things. In the first place, Aristotle is constrained by the terms of his argument to separate form from matter altogether and does this by asserting that semen is not material.

> Nothing passes from carpenter into pieces of timber, which are *his* material, and there is no part of the art of carpentry present in the object which is being fashioned: it is the shape and form (*morphe kai eidos*) which pass from the carpenter, and they come into being by means of the movement in the material (*hyle*). It is his soul, wherein is the "form" and his knowledge, which causes his hands (or some other part of his body) to move in a

particular way (different ways for different products) and always the same way for any one product; his hands move the tools, and his tools move the material. In a similar way to this Nature (*physis*) acting in the male of semen-emitting animals uses the semen as a tool, as something that has movement in actuality; just as when objects are being produced by any art the tools are in movement, because the movement which belongs to art is, in a way, situated in them.[17]

This awkward argument means that semen is the bearer of immaterial form, of which it is also the agent or tool, its movement—presumably ejaculation—mechanically initiating the process of human conception. In Aristotle's own causal terms, semen is the efficient cause of the chain of events governed by the formal cause whose activity it enables.

These arguments, which became more or less authoritative, persisted in Western medicine until early modern times, providing a biological basis for the idea (of Aristotle and many others) of the natural inferiority of women. But for our purposes, these ideas were perhaps more important because they were used to illustrate general principles applicable far beyond the bounds of biology. We have already considered Aristotle's version of what might be called cosmic conception in the *Metaphysics*. Here is another example. In his *De anima*, the treatise on the soul, Aristotle defines sensation as a process in which form is apprehended without matter.[18] The terms *eidos* and *hyle* are the same. Aristotle uses the example of a seal ring, which leaves its form but not its matter when it is pressed into wax. Through sensation, which is like the process of conception in reverse, form is separated from matter and subsequent mental operations involve higher and higher levels of abstraction and relations based upon this abstraction. That is, things are regarded as more and more *formal*, and without carrying the analysis further, it is probably clear why reason, like the determination of biological conception, tends to be a male prerogative. Sensation, although in itself the abstraction of form from matter, is closest to matter, which is female, as we have seen; it is also the realm of the unintelligible. Intellect, on the other hand, is the capacity to abstract and manipulate form, *pure* form, meaning form separated from matter. If like is recognized by like, then intellect is like form, not matter, and Aristotle in fact defined intellect as the "form of forms."[19]

In the *Physics*, Aristotle further generalized this principle.[20] Rejecting the theories of earlier philosophers, he argued that what persists through change is a joint cause, with the form, of what comes to be—"a

mother, as it were." "The truth," he concludes, "is that what desires the form is matter, as the female desires the male and the ugly the beautiful. . . ." Matter is both the primary substratum of things and a principle of privation. Aristotle's ideas on this general point are little different from those of Plato in the *Timaeus*. Plato writes,

> It is proper to liken the Recipient to the Mother, the Source to the Father, and what is engendered between these two to the offspring. . . . The substance which is to receive within itself all the kinds should be void of all forms. . . . All who essay to mould figures in any soft material utterly refuse to all any previous figure to remain visible therein, and begin by making it even and as smooth as possible before they execute the work. So likewise it is right that the substance which is to be fitted to receive frequently over its whole extent the copies of all things intelligible and eternal should itself, of its own nature, be void of all forms. Wherefore, let us not speak of her that is Mother and Receptacle of this generated world, which is perceptible by sight and all the senses, by the name of earth or air or fire or water, or any aggregates or constituents thereof; rather, if we describe her as a Kind (*eidos*), invisible and unshaped (*amorphon*), all-receptive, and in some most perplexing and most baffling way partaking of the intelligible [by which Plato means being in some way subject to the intelligible, or connected with it], we shall describe her truly.[21]

This definition of matter and its relation to form, according to which matter is a feminine principle of perfect potentiality and form is a masculine principle of perfect activity, has had a truly millennial career in Western philosophy. Nor has the idea been just philosophical, first because the philosophical definitions passed into currency in all kinds of literature at the same time that they lent external authority to opinions stated in this literature. And it may be supposed that the philosophical ideas arose from attitudes, beliefs, and practices with deeper, less articulated histories. When Cicero translated *hyle* into Latin, he used the word *materia*, which, like *hyle*, means building material, and in doing so he associated matter for the tradition that followed with *mater*, mother. The Aristotelians, he wrote, divided nature into two principles, active and passive, always united in real things. The active principle he called *vis* (or force, related to *vir*, man), and the passive he associated with *materia*.[22]

The ten Pythagorean contraries, again discussed by Aristotle in the *Metaphysics*, are older than either Plato and Aristotle and also give some notion of how ideas may be linked simply by virtue of the scheme

of contrariety to which all belong. The pairs of contraries are: limited and unlimited, odd and even, one and plurality, right and left, male and female, resting and moving, straight and curved, light and dark, good and bad, square and oblong.[23] These categories are pairs, but they are hierarchical rather than symmetrical, the first being superior, just as form and matter are both necessary principles but form is higher. The side to which "male" belongs is coupled with the limited (or definite), oddness (of numbers), unity, right, rest, straight, light, good, and square; the female is associated with the unlimited (or indefinite), even (as in two, four), plurality, left, movement, the curved, dark, bad, and oblong. Any one of these might trigger the idea of the others. We have already seen Aristotle pair matter with the female, with the potential and the passive, with ugliness and darkness (night); and, in a long tradition, matter was also associated with the indefinite, with the divisible and multiple (hence the temporal), and with evil. Clusters of oppositions might thus recur in many forms, any one of which was implicitly or explicitly gendered. Plotinus, standing at the head of the long and vastly influential Neoplatonic systematization of the ideas we have considered so far, conceived of matter as the literal end of emanation from light, good, beauty, and truth, the very end of the great chain of being, dark and formless, the principle of evil and mortality, never truly united to life and form. Here is Plotinus on evil:

> One might be able to arrive at some conception of evil as a kind of measuredness in relation to measure, and unboundedness in relation to limit, and formlessness in relation to formative principle, and perpetual neediness in relation to what is self-sufficient; always undefined, nowhere stable, subject to every sort of influence, insatiate, complete poverty; and all this is not accidental to it but in a sort of way its essence. . . . Everything which participates in it and is made like it becomes evil, though not essential evil. . . . That which underlies figures and forms and shapes and measures and limits, decked out with adornment which belongs to something else, having no good of its own, . . . only a shadow in comparison with the real is the substance of evil.

This substance of evil, Plotinus concludes, is "absolutely deficient—and this is matter—this is essential evil without a share in the good."[24] This stream of metaphysical abuse is not explicitly gendered, but it is heavily gendered implicitly, and when Plotinus turns to metaphor, matter, decked out in false finery, is meretricious, that is, a whore. But to return to our immediate theme, matter for Plotinus, as it would be for

innumerable writers after him, is a principle of resistance to form at the same time that it is apprehended as absolutely subject to form. "For matter masters what is imaged in it and corrupts and destroys it by applying its own nature which is contrary to form, not bringing cold to hot [that is, not simply bringing about change] but putting its own formlessness to the form of heat and its shapelessness to the shape and its excess and defect to that which is measured, till it has made the form belong to matter and no longer to itself. . . ." So we do not simply change, we disintegrate because of matter, to which we return: "When we see an ugly face in matter, because the formative principle in it has not got the better of the matter so as to hide its ugliness, we picture it to ourselves as ugly because it falls short of the form." [25]

This is Aristotle's doctrine of generation, now, however, naturalized at a truly cosmic scale. At this level of generality these ideas have had many applications and a truly myriad history. The intelligible forms, for example, merged easily with Plato's ideas and, in Christian writers, with the ideas in the eternal and unchanging mind of God, which ultimately guaranteed and sanctioned the natural order. In this system, nature and matter were closely related and always both feminine. In medieval allegories, nature was subservient to God, a midwife who translated the ideas of God into material. The ideas were a father, the matter a mother, the generated things children.[26] Perfection existed only in degrees in generated things, and deviation and variety in general were attributed to the resistance of matter, always a negative factor. To take one of any number of examples that might be given, Vincenzio Danti wrote in the midsixteenth century that nature always wishes to realize her intentions, that is, to make a perfect (male?) form, but the resistance of matter prevents her from doing so.[27] Again, this is not a personal opinion but a commonplace, and the distrust of the "material" world and of the simple sensation immediate to it was endemic in medieval and Renaissance thought. The artist must in one way or another correct and perfect nature in order to purify form, to distance it from matter. This idealization, as we might call it now, was the imposition—or re-imposition—of form upon matter and was, furthermore, a victory of the masculine over the feminine principle in the tradition of ideas I am setting forth. Such ideas became the backbone of academic theory. As Bellori wrote, the Greeks devised laws "of a marvelous idea and final beauty which may not be altered without destroying it, there being only one in each species." The one idea for each species is the form of that species, departure from which must be a deformation, a victory of matter and sense

over intellect and always, at least in connotation, a devolution from masculine to feminine.[28]

At this point, I would appeal to the arguments of Martin Heidegger to try to urge upon you how deeply the form-matter polarity has pervaded our apprehension of things—what we take to be natural—how it has become a part of Western common sense. I shall be referring to Heidegger's essay on "The Origin of the Work of Art," a substantial portion of which is given over to an inquiry into the "thingness of the thing." In the Western tradition, Heidegger argues, we think about the thing in three ways. First, as a bearer of traits; second, as a unity of the manifold of sensations; and third, as formed matter.[29] Heidegger believes, in contrast to the broad philosophical tradition that has attempted to construct reality from elements of sensation, that "much closer to us than all sensations are the things themselves," by which I understand him to mean that our apprehension of the presence of things precedes a conception of intuition (sensation—which demands the analysis of that first intuition into its constituent parts). The first two traditional definitions of the thing are both inadequate to this basic phenomenological principle. To say that the thing is the bearer of its traits is, as it were, to keep the thing at arm's length from us. To say that it is the unity of the manifold of sensations, Heidegger says, makes it (the thing) press too physically upon us. In both interpretations, the thing vanishes. More widespread and more apparently self-evident than either of these is the understanding of the thing as formed matter. Here matter (*hyle*) implies form (*morphe*), and, closely paralleling Aristotle's remarks in the *De anima*, Heidegger argues that "this interpretation appeals to the immediate view with which the thing solicits us by its direct appearance (*eidos*)."[30] That is, the visible form, so fundamental to Greek and then Western notions of knowledge, is the principle of existence (which as we have seen, relates it also to generation) in addition to the principle of intelligibility.

The understanding of things as unions of form and matter, Heidegger says, is the conceptual schema that is used "in the greatest variety of ways, quite generally for all art theory and aesthetics." This claim alone would make the notion of central significance for us. But he argues even more portentously that "the metaphysics of the modern period rests on the form-matter structure devised in the medieval period, which itself merely recalls in its words the buried natures of *eidos* and *hyle*. Thus the interpretation of "thing" by means of matter and form, whether it re-

mains medieval or becomes Kantian-transcendental, has become current and self-evident." [31]

Heidegger rejects the notion—which of course he believes to be the almost intractably deep, common sense notion, or better, culturally specific, assumed first principle—that things are formed matter because of the metaphor underlying it. The thing so conceived, he argues, is conceived as equipment, as something made for a purpose and defined by that purpose. To think of things as equipmental is to think of existence as equipmental, which, of course, points to one of Heidegger's major and persistent complaints about the Western tradition taken altogether. This fundamentally wrong-headed view of things is, according to Heidegger, vastly reinforced by Christian theology, which adapted the classical form-matter idea to its version of divine creation. Similarly, the Demiurge is a craftsman in Plato's *Timaeus*, [32] and, according to Aristotle, nature would make houses as the architect does were nature to make a house, [33] and, as we have seen, nature uses semen as a tool to initiate the formation of the child, and the craftsman uses tools to shape functional forms. This metaphor for the coming into existence of things is not only craftsmanly but it is also obviously and inextricably reproductive. God, in whom true forms reside (of which the real forms of nature are more or less adequate images), is "The Father." When the great analogy of the artist to God developed in the Renaissance and the artist began to be called a "creator," the artist was also the one who imposed form upon matter, brought order out of chaos, made something out of nothing. Whatever materials the artist used were absolutely subject to imagination, putty in his hands, so to speak. In short, the materials used became *matter*.

Heidegger does not think in terms of gender (and it is probably just as well that he did not record his thoughts on these matters); but he does discuss the form-matter dyad in relation to some familiar polarities. "If," he writes, "form is correlated with the rational and matter with the irrational; if the rational is taken to be the logical and the irrational the alogical; if in addition the subject-object relation is coupled with the conceptual pair form-matter, then representation has at its command a conceptual machinery that nothing is capable of withstanding." [34] As we have seen, form-rational-logical and matter-irrational-alogical are and always have been strongly gendered distinctions. To understand Heidegger's last conceptual pair—subject-object—in relation to form-matter, however, it is necessary to turn an important corner, to turn from the

classical to the distinctively modern. In making this transition, we shall turn at last to the foundations of modern art history.

In classical philosophy, sight, which shows us forms, was regarded as the most mind-like of the senses, for, by showing us forms, it shows us what is most intelligible about things. That is the principal reason for regarding sight as the highest of the five senses. In early modern times, by which I mean the late Middle Ages and the Renaissance, this classical view began to undergo a change owing first of all to the new optics of Alhazen and his Western followers, who provided an important foundation for early modern science. Alhazen's theory of light allowed a description of how a set of points corresponding to surfaces in light could be transferred to the eye (a theory that enabled the invention of Renaissance one-point perspective to take place), thereby implying that *only* points of light were at issue. Nominalists were quick to see that it was not necessary to suppose that *species*—visible shapes or forms of things—were transmitted in themselves to the eye as more than patterns of light. That is, the same optics that made one-point perspective inventable in its modern form raised the possibility that vision was not so much iconic as indexical. Already in the fourteenth century questions were being asked about whether the images of things really were in the medium between objects and the eye,[35] and Descartes (to take his example) clearly saw the implications of answering such questions in the negative. In his own optics, he wrote that we should not think of vision as the registration of images that are then scanned by the mind's eye; rather we should think of vision as a set of signs interpreted by the mind's eye, like a print in which a few marks and dots suggest a vast amount of visual information.[36] We should think of sensation as giving us signs comparable not to images but rather to words, whose significations are, if not arbitrary, at least not simply resemblant or iconic. Newton, in his *Opticks*, argued similarly that we cannot say that objects are red, we can only say that they cause in us the *sensation* of redness.[37] This principle became part of the modern view of the physical world, according to which we are confronted no longer by a world of *forms* but by a world of *forces* in which "things" are now the unknown center and origin, "things in themselves." "Form" has suddenly become problematical; what is intelligible about things is now, in one sense, only the behavior of the forces underlying them. But where is the principle to account for actual forms, things that exist, that are seen and used? It is perhaps a simplification—but not an *over*simplification—to say that the solution offered is one of the deep principles of the modern intellectual world, as

deep as the physical view of the world it complements. The principle of form is now located in some way in the mind itself; consciousness itself is formative and constitutive.[38] The world is a representation, something we know in the way we know it and not otherwise. This principle is, in a very skeletal telling, Kant's "Copernican revolution." Reflection on conscious experience reveals not the forms of things in their progressive intelligibility, as in the classical view, but rather reveals the mind's own formative faculties and their activities.

This change in the notion of form, which I have characterized as Kantian, Heidegger called "Kantian-transcendental," and we may note again Heidegger's point that when form-matter is linked to representation, that is, when consciousness is thought to give form to apprehensible reality, the result is "a conceptual mechanism that nothing is capable of withstanding." The idea that the mind forms its reality, together with the idea that these formations are historical, provided the basis for the modern history of art by providing the possibility of defining all art in terms of a single principle, a principle presumed to be of a piece with, and "expressive" of, the mind's formation of the world. And, to continue the argument, this idea of formation, although set on different foundations, incorporated and preserved the traditional relation between form and matter.

These ideas still bear simply and closely on the most basic kinds of art historical procedures. As Michael Podro has pointed out, the modern, formal description of art only began to emerge in the nineteenth century.[39] Formal description is based on the idea that what is *essential* about art is that which is non-imitative, because the non-imitative makes visible to us what the mind, to put it simply, has *made* of nature, which acts upon the mind through sensation. According to this view, the character of the elements of representation, rather than what is represented, become primary (even if the opposition by its very definition makes desirable a "unity of form and content"). In analyzing works of art, we are concerned with the expressive qualities of line, color, shape, and materials used, all of which are thought to be primarily significant in ways subject matter is not. Subject matter in this scheme is, after all, subject *matter*, just as for Kant and the idealist philosophers who came after him sensation is the matter subject to form. "Nature" is that which is given significant form by the artist, by the imagination or "vision" of the artist. Kant himself wrote in the *Critique of Judgment* that "the imagination (as a productive faculty of cognition) is very powerful in creating another nature, as it were, out of the material that actual nature

gives it." [40] Kant is writing about the power we all have to form the spatiotemporal world we share.

This radically constructive power was also the paradigm and basis for the much more singular powers of genius (from a discussion of which this quotation is taken), and this formative principle, magnified by the "spirits," "wills," and "drives" of later thinkers, could easily be supposed to be masculine. Schiller, for example, compares man "in perfection" to the Godhead because he is capable of "absolute manifestation of potential." The expression of such absolute possibility requires an absolutely passive partner, provided by sensation, the idealist version of matter. Without *Sinnlichkeit*, man is himself merely potential, but together with it his potential may become "actual power," his personality making "all his activity into something which is inalienably his own." In order not to be mere world—that is, in order not to be like matter *or* sensation or to be included and defined by them—"he must impart form to matter." This process of self-realization is violent; "he is to destroy everything in himself which is mere world, and bring harmony into all his changes. . . . He is to externalize all that is within him, and give form to all that is outside him. . . . These tasks, conceived in their highest fulfillment, lead us back to that concept of Godhead." [41] (To be fair to Schiller, his utopian "aesthetic state"—opposed to the "dynamic" state of rule by will and to the "ethical" state of the subordination of the individual to the general—involves a new level of accommodation in the terms of gender with which I am concerned. Even here, however, "the mind, which would force the patient mass beneath the yoke of its purposes, must here first obtain its assent.") [42]

It would require a study of vast proportions to show how the deep and traditional gender values of the idea of form were adapted to the new conception of form, but there is no doubt that such an adaptation took place on a broad scale. An extreme example is provided by the early twentieth-century *Sex and Character* of Otto Weininger, which, idiosyncratic as it might seem, might also provide a compendium of the ideas I have considered so far. [43] Weininger explicitly associated the feminine with matter, the masculine with mind. It is therefore the man who strives to be the genius, "the man with the most intense, most vivid, most conscious, most continuous and most individual ego. . . . The external world in fact seems to be only a special aspect of his inner life; the universe and the ego have become one in him." To say, as Weininger does, that "women have no existence and no essence; they are not, they are nothing," that the "meaning of woman is to be meaningless," that

"she represents negation, the opposite pole from the Godhead," is to say, among other things, that woman is matter. Halfway between such late popular idealism and its higher philosophical beginnings, we may consider the texts cited by Sandra Gilbert and Susan Gubar when formulating their definition of the "metaphor of literary paternity." Coleridge's romantic concept of the human "imagination or esemplastic power" is a virile, generative force that echoes "the eternal act of creation in the infinite I AM," while Ruskin's "penetrative Imagination" is a "possession-taking faculty" and a "piercing . . . mind's tongue" that seizes, cuts down, and gets at the root of experience in order "to throw up what shoots it will." [44] Certainly such examples might be endlessly multiplied into the twentieth century, if not into the twenty-first.

There is no doubt that what I am talking about is more complex than my argument. As I mentioned before, the imagination, like the lower faculties of the mind in general, was at least implicitly feminine in the earlier tradition, opposed as it was to reason (as we saw at the beginning of this paper in Michelangelo's poems on night). But such unquestionably fruitful complications aside, it is clear that form maintained its millennial generative meanings and connotations into the modern period and up to our own day. The realm of form was defined around new polarities that were, however, adjustments of old ones. Form was identified with spirit, which was opposed to matter. Spirit in German idealism is a realm of freedom again opposed to matter and nature, which are still principles of necessity and resistance. Art as spirit and form is opposed to nature. Originality is the untrammeled play of spirit and freedom. The artist is separate from nature except insofar as the artist is a generative force of nature, a genius, a child of nature herself, which leads us back to the metaphors of generation from which we began.

It is now possible to state our answer to Griselda Pollock's question as a conclusion. Why did the discourse of art history become heavily gendered *after* the formation of the academic intellectual discipline? The answer I am offering (and of course it needn't be the only answer) is that classical art history, the formalist art history of Wölfflin, Riegl and Focillon with which we are all very familiar and upon which our periodizations and narratives of change are still largely based, is, in its turn, based upon the strongly gendered idea of form. When the history of art was primarily biographical or antiquarian, it could be relatively ungendered or sorted out by gender in other ways, for other reasons. But when it became regarded as a history of form, that idea in itself brought

with it a heavy burden of connotation. Form is very far from the neutral taxonomic and developmental category it might be thought to be, and in fact I am suggesting that the history of form had been prepared for millennia to be a genealogy of fathers and sons.

If the idea of form is as central to the discipline of art history as I have argued it is, then its removal from the conceptual structure of the history of art leaves a very large hole there, and not just a hole in the roof. Moreover, to question the idea of form is not only to threaten the institutional foundations of the history of art, it is also to question the broader aesthetic assumptions upon which the discipline has been built. Of course, I cannot solve all these questions in this paper (if I can solve them at all), but as I promised I would at the beginning, I would like to close by offering the outline of a solution to the problem I have raised.

I do not believe it is possible or desirable to eliminate form either as a noun or verb from the language of art history. Form has some fairly straightforward meanings, and it would probably be very difficult to talk about art for very long without recourse to some of these straightforward meanings. It is, however, very possible to criticize and reject the notions of form that descend from nineteenth-century idealism, to which the language of art history is closely related. One of the best ways to do so—and, not incidentally, to attack the persistent classical notion of form as well—is to examine the usefulness of its old dyadic and dialectical partner, its millennial marriage to the idea of prime matter. Matter may or may not be a useful physical idea, but it is not a useful cultural idea or even a useful biological idea. Why should it be supposed, after all, that works of art come into existence in the way that animals were thought twenty-five hundred years ago to come into existence? Or, to ask a related and equally valid question, why should it be supposed that animals come into existence in the way the works of craftspeople were thought to come into existence? What kind of metaphysics is implied (if any) by what we now understand about human generation? Although it is interesting to think about such things, it is probably generally more liberating to suppose that nothing is really like anything else, that all such metaphors should be distrusted. Art just is not biology, nor is biology art.

In the idealist history of art, nature and history, understood as resistant to formal invention, are at least implicitly gendered; they are both passive and resistant to the power, in whose products the art historian is interested. This whole familiar pattern of connotation and inference can

be rejected, however, by simply pointing out that it is, in a simple and obvious sense, unhistorical. The ahistorical, transcendental matter upon which it depends does not exist. That is to say, there is no pure potentiality, no endlessly malleable, infinitely passive stuff out of which the human imagination forms things everywhere at all times in essentially the same way. To think of this issue historically, it is rather necessary to recognize that art is always made of those natural and artificial materials, each with its own meanings and values, that come to hand for culturally specific uses, to be shaped to culturally specific spaces. I will close with the example of the statue of the pharaoh Chephren to which I have referred in another article.

If we think of Chephren as "form," as an "expression of the ancient Egyptian genius or imagination," then the stone out of which it is carved is of little interest except insofar as it again shows us the expressive use the sculptor or sculptors have made of its cubic volume and hardness. But the stone was not just the passive matter such a view implies, a view that, as I have argued, preserves the metaphysical tradition I have been trying to explain. The stone was cut squared from the earth (which is what "quarried" means) and was moved with great expense of labor to the place where it was finished and polished. Certainly part of the meaning and value of the sculpture was the singularity it evidently possessed as a symbol of the power involved in having such stones quarried, transported, and made into images by skilled workers. Seen in this way, the sculpture is much more of a collaborative effort. These observations may be endlessly extended. David Smith did not make his own stainless steel, nor did Helen Frankenthaler make her own acrylics; these materials rest upon the technological foundations of the modern world, and this foundation is evident in the work, even if it is usually invisible in the sense that it is not what is of interest. The same cultural significance is evident in all works, which to that degree are indexes of their own historical situations. I do not mean to imply that women performed all the tasks that we do not usually pay attention to in works of art. In the case of Chephren, they probably did little or nothing, and no doubt the sad and utterly lost human story of the cutting and moving of this stone is a story of male workers. The point I wish to make is that the stone itself implies social organization, in which women also had a part. In other cases, women might have contributed more directly to the making of things, and the history of art would look very different if fibers survived as well as stone and bronze do or if sculpture had not been elevated to the status of a "fine art" in the "modern system of the arts" (at exactly

the same time, it might be noted, that the professional discipline of art history also took shape). But even that is not my point. I do not wish to deny that the history of art has been male dominated for a variety of reasons. It is, however, possible to reconsider the history of art so that it becomes a much more collective history of the making and building of human culture, as well as a record of the preservation of the whole panoply of human possibilities, a history and record in which the contributions of women may be much more visible. My most important point, however, may have to do with the way we think of the past as a prelude to the future, the way the past history of art bears on the future history of art, by which I mean the making of art in the future. This history will be very different if the power and prerogative to shape the world is not presumed to be made in the very language we have professionally naturalized.

NOTES

1. D. Summers, " 'Form,' Nineteenth-Century Metaphysics, and the Problem of Art Historical Description," *Critical Inquiry* 15 (1989): 372–406.

2. E. Panofsky, *Idea. A Concept in Art Theory*, trans. J. J. S. Peake (Columbia, SC, 1968), 119–21.

3. Ibid.; see also D. Summers, *Michelangelo and the Language of Art* (Princeton, 1981), 103–43; and *The Judgment of Sense. Renaissance Naturalism and the Rise of Aesthetics* (Cambridge, 1987), 227–30.

4. See Summers, *Judgment of Sense*, passim, and p. 205 n. 20.

5. K. Oberhuber, "Eine unbekannte Zeichnung Raffaels in den Uffizien," *Mitteilungen des Kunsthistorischen Institutes in Florenz* 12 (1965–1966): 225–44.

6. Aristotle, *Metaphysics*, 1071b–1072a, trans. H. Tredennick (Cambridge-London, 1977), 142–45, with references to Hesiod. On the classical tradition of "Mother Night," see E. Panofsky, *Studies in Iconology. Humanistic Themes in the Art of the Renaissance* (New York-Evanston-London, 1962), 210.

7. C. de Tolnay, *Michelangelo. The Medici Chapel* (Princeton, 1970), 106–107, 190–93.

8. Michelangelo Buonarroti, *Rime*, ed. E. N. Girardi (Bari, 1960), n. 104.

9. Ibid., n. 101. At the beginning of this poem, night is equated with the unlighted earth, "cold and soft" (that is, feminine), in contrast to the radiant embracing sun upon whom her existence depends.

10. Ibid., n. 103.

11. Ibid., n. 102.

12. E. Panofsky, "Artist, Scientist, Genius: Notes on the 'Renaissance-Dämmerung," in *The Renaissance. Six Essays by W. K. Ferguson*, Robert S. Lopez, George Sarton, Roland H. Bainton, Leicester Bradner, and Erwin Panofsky (New York, 1962), 171.

13. Summers, *Michelangelo and the Language of Art*, 473–74, 497–98.

14. As an introduction to the history of the idea of matter, see H. J. Johnson, "Changing Concepts of Matter from Antiquity to Newton," in *Dictionary of the History of Ideas*, ed. P. P. Wiener (New York, 1973), 3:185–96; *The Concept of Matter in Greek and Medieval Philosophy*, ed. E. McMullin (Notre Dame, 1965); and Plato, *Timaeus*, 50Dff., trans. R. G. Bury (Cambridge-London, 1961), 116–25.

15. G. Pollock, *Vision and Difference. Femininity, Feminism and Histories of Art* (London and New York, 1988), 23–24.

16. The following discussion is based upon M. Cline Horowitz, "Aristotle and Woman," *Journal of the History of Biology* 9, no. 2 (1976): 183–213; see G. Lerner, *The Creation of Patriarchy* (New York and Oxford, 1986), 199–211, for remarks on the context of Aristotle's theories. On the tradition of these ideas in the Renaissance, see I. Maclean, *The Renaissance Notion of Woman. A Study of the Fortunes of Scholasticism and Medical Science in European Intellectual Life* (Cambridge, 1980), 1–46 and passim. The misogynist interlocutor in the debate on the excellence of women in Castiglione's *Book of the Courtier* was fluent in Aristotle's ideas, an indication of their broad currency (trans. C. S. Singleton [Garden City, 1959], esp. 212–13 and 217). Also C. Merchant, *The Death of Nature. Women, Ecology and the Scientific Revolution* (San Francisco, 1980).

17. Aristotle, *De generatione animalium*, 730b.

18. Aristotle, *De anima*, 424a17, trans. W. S. Hett (Cambridge-London, 1975), 136–37.

19. Ibid., 432a, pp. 180–81.

20. Aristotle, *Physics*, trans. R. H. Wickstead and F. M. Cornford (Cambridge, Mass., 1980), 192a.

21. Plato, *Timaeus*, 50D–51B.

22. Cicero, *Academica*, trans. H. Rackham (Cambridge-London, 1967), 1:434–35.

23. Aristotle, *Metaphysics*, 986a23ff.

24. Plotinus, *Enneads*, trans. A. H. Armstrong (Cambridge, Mass., 1966), 1:8. See also A. O. Lovejoy, *The Great Chain of Being. A Study of the History of an Idea* (New York, 1960), 59. On familiar art historical ground, the cosmograms in Panofsky's *Studies in Iconology* (135) show the same relationships. *Deus* is at the top; *materia*, both in the human body and the body of the world, is at the bottom, defined as "non being . . . moving only in and by another" (that is, without soul). Again (204) Panofsky cites the typical words of the Florentine

Neoplatonist Cristoforo Landino with regard to the evils springing from one single source: matter (*hyle*). For a historical and critical consideration of the relation between (underlying and essential) form versus (superficial and accidental) detail as a gendered opposition (which implicitly relates detail to sensation, hence to matter in contrast to mind), see N. Schor, *Reading in Detail. Aesthetics and the Feminine* (New York and London, 1987).

25. Plotinus, *Enneads*, 1:8.

26. E. R. Curtius, *European Literature and the Latin Middle Ages*, trans. W. R. Trask (New York, 1953), 106 ff. The midtwelfth-century *De universitate mundi* of Bernardus Silvestris, which began the series of later medieval allegories in which *Natura* figures prominently, begins with the imposition of order upon chaos (matter) and ends with a celebration of the phallus, which staves off death and the return of chaos by reproducing forms.

27. V. Danti, *Trattato delle perfette proporzioni* in *Trattati d'arte del Cinquecento fra manierismo e controriforma*, ed. P. Barocchi (Bari, 1960), 1:264. "All the intentional forms of nature are in themselves most beautiful and proportionate, but matter (*materia*) is not always suitable to receive them perfectly.... Most of the time matter does not receive the perfection of form." It may be that Danti understood nature's intention always to be the making of a perfect male, as Aristotle maintained, which may throw a bit of light on Michelangelo's marked preference for the male body as a model. Also, Aristotle's argument that the fiery nature of the male is evident in the form of the male body must have contributed to the famous notion of the *figura serpentinata*, on which see Summers, *Michelangelo and the Language of Art*.

28. Panofsky, *Idea*, 170. For a nineteenth-century example see B. M. Stafford, *Symbol and Myth. Humbert de Superville's Essay on Absolute Signs in Art*, (London, 1979) 86. Here the place of matter is taken by color, "a natural language properly judged by the sensibility of woman"; line, on the other hand, leaves indeterminate matter and is organized by mental categories. Line is by implication masculine.

29. M. Heidegger, "The Origin of the Work of Art," in *Philosophies of Art and Beauty. Selected Readings in Aesthetics from Plato to Heidegger*, ed. A. Hofstadter and R. Kuhns (New York, 1964), 654 ff.

30. Ibid., 657.

31. Ibid., 660.

32. Plato, *Timaeus*, 29A.

33. Aristotle, *Physics*, 198b10ff.

34. Heidegger, "Origin of the Work of Art," 657–58.

35. On Alhazen, see D. C. Lindberg, *Theories of Vision from Al-kindi to Kepler* (Chicago, 1976), 60–86; and D. Summers, *Judgment of Sense*, 153–57; see also K. Tachau, "The Problem of the *Species in Medio* at Oxford in the Generation after Ockham," *Medieval Studies* 44 (1982): 394–443; and N. L. Maull, "Cartesian Optics and the Geometrization of Nature," *Review of Metaphysics* 32, no. 2 (1978): 253–73.

36. R. Descartes, *Discourse on Method, Optics, Geometry and Meteorology,* ed. P. J. Olscamp (Indianapolis, New York, Kansas City, 1965), 89–90.

37. I. Newton, *Opticks, or a Treatise of the Reflections, Refractions, Inflections and Colours of Light* (New York, 1952), 124–25.

38. I have treated these issues in more detail in an article entitled "Why Did Kant Call Taste a Common Sense?" (forthcoming).

39. D. Summers, " 'Form', Nineteenth-Century Metaphysics," 375.

40. I. Kant, *Critique of Judgment,* trans. J. H. Bernard (New York, 1951), 157.

41. F. Schiller, *On the Aesthetic Education of Man in a Series of Letters,* ed. E. Wilkinson and B. A. Willoughby (Oxford, 1967), 74–75.

42. Ibid., 218–19. See also the observations of T. Eagleton, *The Ideology of the Aesthetic* (Oxford, 1990), 103, 115, 117, and (on Hegel) 144.

43. Weininger's *Geschlecht und Charakter: eine prinzipielle Untersuchung* was first published in Vienna and Leipzig in 1903. Despite the fact that he took his life because of its immediate critical reception, Weininger's book went through some twenty-eight German editions between 1903 and 1947 and was translated into many languages. Weininger is cited and discussed in some detail in the chapter entitled "Mind over Matter" in E. Figes, *Patriarchal Attitudes. Women in Society* (New York, 1986), 111–35, from which these quotations are taken.

44. S. M. Gilbert and S. Gubar, *The Madwoman in the Attic. The Woman Writer and the Nineteenth-Century Literary Imagination* (New Haven and London, 1984), 5.

CONTRIBUTORS

GRISELDA POLLOCK is Professor of Art History at the University of Leeds. She is co-author, with Rozsicka Parker, of *Old Mistresses: Women, Art, and Ideology* (1981) and author of *Vision and Difference: Femininity, Feminism, and the Histories of Art* (1988). She is also co-editor (with Rozsicka Parker) of *Framing Feminism: Art and the Women's Movement 1970–1985* (1987); and (with Richard Kendall) of *Dealing with Degas: Representations of Women and the Politics of Vision* (1991).

LISA TICKNER is Professor of the History of Art at Middlesex University in London and author of *the Spectacle of Women: Imagery of the Suffrage Campaign 1907–1914* (1988).

JOHN TAGG is Professor of Art History at the State University of New York at Binghamton. His books include *The Burden of Representation: Essays of Photographies and Histories* (1988) and *Grounds of Dispute: Art History, Cultural Politics and the Discursive Field* (1992).

KEITH MOXEY is Professor of Art History at Barnard College of Columbia University. He is the author of *Peasants, Warriors and Wives: Popular Imagery in the Reformation* (1989) and *The Practice of Theory: Poststructuralism, Politics and Art History* (1994); and is co-editor (with Norman Bryson and Michael Holly) of *Visual Theory: Painting and Interpretation* (1991).

THOMAS CROW is Professor of the History of Art at the University of Sussex, U.K. He is author of *Painters and Public Life in Eighteenth-Century Paris* (1985), "Modernism and Mass Culture in the Visual Arts," "Versions of Pastoral in Recent American Art," along with other articles on eighteenth-century and contemporary art.

WHITNEY DAVIS is Associate Professor of Art History at Northwestern University. He is the author of *The Canonical Tradition in Ancient Egyptian Art* (1989) and *Masking the Blow: The Scene of Representation in Late Prehistoric Egyptian Art*, as well as a number of essays in art-historical method and theory, archaeology, and psychoanalysis.

WOLFGANG KEMP is Professor of Art History at Phillips-Universität, Marburg, Germany. His latest book publication in English is *The Desire of My Eyes: The Life and Work of John Ruskin* (1990). Forthcoming: *Sermo Corporeus: On the Narratives of Gothic Stained Glass.*

NORMAN BRYSON is Professor of Fine Arts at Harvard University. His most recent book is *Looking at the Overlooked: Four Essays on Still Life Painting* (1990). He is General Editor of the series *Cambridge Studies in Art History and Criticism,* and co-editor (with Michael Holly and Keith Moxey) of *Visual Theory: Painting and Interpretation* (1991).

ERNST VAN ALPHEN teaches Comparative Literature at the University of Leiden. He is interested in post-modernism, especially its relation to art history. He has published widely on ideology, theories of reading, and relations between the arts. His most recent book is *Francis Bacon and the Loss of Self* (1992).

KAJA SILVERMAN is Professor of Film Studies in the Rhetoric Department at the University of California at Berkeley. She is the author of *The Subject of Semiotics* (1983), *The Acoustic Mirror: The Female Voice in Psychoanalysis and Cinema* (1988), and *Male Subjectivity at the Margins* (1992).

CONSTANCE PENLEY is editor of *Feminism and Film Theory* (1988) and author of *The Future of an Illusion: Film, Feminism, and Psychoanalysis* (1989), as well as co-editor of *Camera Obscura: A Journal of Feminism and Film Theory.*

ANDREW ROSS teaches English at Princeton and American Studies at New York University, and is co-editor of the journal *Social Text.* His books include *Strange Weather: Culture, Science and Technology in the Age of Limits* (1991), and *No Respect: Intellectuals and Popular Culture* (1989). He is also the editor of *Universal Abandon?* and co-editor of *Technoculture.*

MICHAEL ANN HOLLY is Professor of Art History and Visual and Cultural Studies at the University of Rochester. She is the author of *Panofsky and the Foundations of Art History* (1984) and of *Icono-*

graphia e Iconologia (1993). She is also co-editor (with Norman Bryson and Keith Moxey) of *Visual Theory: Painting and Interpretation* (1991).

MIEKE BAL is Professor of Comparative Literature and head of Women's Studies at the University of Amsterdam. She is the author of *Narratology: Introduction to the Theory of Literature* (1980), *Lethal Love: Literary-Feminist Readings of Biblical Love Stories* (1987), *Murder and Difference: Gender, Genre and Scholarship of Sisera's Death* (1988), and *Reading Rembrandt: Beyond the Word/Image Opposition* (1991).

DAVID SUMMERS is the William R. Kenan, Jr., Professor of Art History at the University of Virginia. He is the author of *Michelangelo and the Language of Art* (1981) and *The Judgement of Sense: Renaissance Naturalism and the Rise of Aesthetics* (1987). Summers has also published a number of essays on art theory and is currently working on a history of world art.

INDEX

Academic distance, xxvi–xxviii, 261, 309
Académie peinte, 151–55
Adlocutio, 193
Adoration of the Name of Jesus (Gaulli), 358(fig.), 359
Aesthetics, xvi, xviii, xix, 133–34; and Renaissance elite, 111–20
Against Interpretation (Sontag), 328
Alberti, Leon Battista, 287, 300(n24), 355
Alhazen (Ibn al-Haithan), 402
Alien Brothers, 311, 313
Ali: Fear Eats the Soul (Fassbinder), 274, 276, 277–78, 283–86, 285(figs.), 296, 297–98
Allen, Woody, 236
Alpers, Svetlana, 365–66
Alterity: in art history theory, 260, 262; in Fassbinder films, 274–76
Althusser, Louis, 5
Ambassadors, The (Holbein), 288, 296
American Soldier (Fassbinder), 280(fig. 2), 281
Amours de Psyché et Cupidon (Fontaine), 184
Anatomical Lesson of Dr. Jan Deyman, The (Rembrandt), 377–81, 377(fig.), 383(n21)
Anatomical Lesson of Dr. Nicolaes Tulp, The (Rembrandt), 376(fig.), 377–81
Androgyny: and Cupid and Psyche, 184; and Endymion, 154–55; and Enlightenment, 200(n43); and Star Trek characters, 317–18. See also Sexual difference
Apollo and Cyparissus (Dubufe), 200 (n43)
Archetypal World of Henry Moore, The (Neumann), 69
Architecture, 208–14
Arendt, Hannah, 224
Aristocracy: art and upholding values of, 130–31; and Bosch, 107–11, 263–65; and Géricault's images of masculinity, 228. See also Class

Aristotle: and form/matter polarity, 392, 394–97; on night, 388–90; on psychology, 114
Art history: analyzing social (Marxist) theory of, xix, 3–5, 11–12, 83, 95–97; effect of theory on, xiii, xv–xxix, 10–13, 104; language of, xxviii, 384, 406; modernist, 43, 44, 56 (see also Modernism); political approach to, 169–77, 196(n14) (see also Sleep of Endymion, The); psychological approach to, 176–83 (see also Psychoanalysis); semiotic theory and identification in, 260–71; and signification, 106–107, 136(n10) (see also Sign/signification). See also Form/formalism; Historical analysis
Artist(s): identity as, 47–48, 59, 72(n25); status of, 114–17, 133–34; women, 48, 49–50, 60, 65–67, 78(nn 69, 72), 80(n90), 81(n97), 82(n107)
Artist-novel, 46–47, 70(n19)
Artists' Suffrage League, 44
Ashley, Lord, 19
As I Do Thee, 314
Athymia, 193
Atlases, 338–39, 345(n9)
Atlas Survey of the State of the Earth (Seager), 338
Aurora and Cephalus (Guérin), 144(fig. 3), 161
Avant garde: films, 334; use of popular culture by, 132–33

Bailly, Jean Silvain, 225
Bakhtin, Mikhail, 106
Bal, Mieke, xxvii–xxviii
Bara, Joseph, 156
Barbari, Jacopo de, 111, 116–17
"Barberini Faun," 201(n52)
Baroque, 347–62
Barrett, Michèle, 45–46
Bassville, Hugou de, 148
Battle of Aboukir (Gros), 238, 238(fig.)
Baudelaire, Charles, 168

Baxandall, M., 263
Beatis, Antonio de, 108, 111–13
Belgians at Home, The (Holland), 15
Bell, Clive, 60
Bell, Vanessa, 53, 60, 62, 62(fig.), 75(n48), 78(n72)
Belley, Jean-Baptiste, 149
Bellori, Giovanni, 399
Belvedere Apollo, 166(n28)
Berlin Alexanderplatz (Fassbinder), 276, 296, 298
Bernis, Cardinal, 147
Beware of a Holy Whore (Fassbinder), 278–79, 297
Binary. *See* Polarity
Blake's 7, 323(n8)
Bland, Lucy, 34
Blast 2, 51, 65, 66–67, 71(n22), 81(n104)
Bloom, Harold, 351–52
Bloomsbury, 53, 75(n48)
Bomberg, 65
Borrow, George, 57
Bosch, Hieronymus, xx–xxi, 104–35, 136(n4), 263–65; works, 108(fig.), 110(fig.), 125(fig.), 127(fig.), 128(fig.), 131(fig.)
Boullée, Etienne-Louis, 213, 214
Bourgeoisie: and Bosch, 136(n4); representation of proletariat by, 9–10, 17–38, 34(fig.), 40(n31), 41(n43). *See also* Aristocracy; Class
Bowery Boys and Gals, 87
Bradley, Marion Zimmer, 316
Breton, André, 69
Broc, Jean, 161, 189, 197(n15)
Brodzky, Horace, 74(n41)
Brown, Jane, 30–31, 30(figs.)
Brown, Marshall, 353, 361
Bryson, Norman, xxiii, xxv, 107, 221–23, 261, 263, 265, 266–70
Brzeska, Sophie, 53, 74(n45)
Burckhardt, Jacob, 350, 351, 352–56, 361–62
Byars, J., 321(n3)

Caillois, Roger, 289–90
Camden Town Group, 78(n72)
Capitalism, stratification in, 95–97

Caravan at Dusk (John), 57
Carrington (Dora), 52–53
Cart with Wounded Soldiers (Géricault), 249(fig.)
Cassatt, Mary, 44, 86
Castration, 296–97
Cennini, Cennino, 113–14
Cezanne, Paul, 392
Change, 353–54, 356–62
Charging Chasseur (Géricault), 236–39, 237(fig.)
Chephren (sculpture), 407
Chinard, Joseph, 147
Chinese Roulette (Fassbinder), 279
Chodorow, Nancy, 302–303
Christianity: and form/matter polarity, 399, 401
Cicero, Marcus Tullius, 397
Cicerone (Burckhardt), 352
Circle, as symbol, 213–14, 215–16, 224–25
Civilization (Clark), 262
Civilization of the Renaissance in Italy, The (Burckhardt), 352–53, 355
Clark, Kenneth, 262
Class: academic distance and, xxvii; and Bosch's work, 107, 130–31, 136(n4); ecological imagery and, 339; and fandom members, 319–20; modernists and, xxiv–xxv, 64–65; and sexual difference, 17–18, 35–36; in theory, xix–xx, 1–5, 96 (*see also* Marxism)
Classic Art (Wölfflin), 353, 356
Classicism: and Girodet, 141–43, 169–70, 171–75, 176, 177; sexuality in, 180–81, 187–90, 236
Cloots, Anacharsis, 190
Clothing: as defining sexuality, 20–22, 28–29; military, 239, 240(fig.), 242; modernists and bohemian, 55–56, 76(n55)
Coleridge, Samuel, 405
Color: in *Portrait of a Carabinier*, 243; and Rembrandt, 371, 378, 380
Concetti, 386
Condorcet, Marquis de, 223
Contemporary influences, xxvii–xxviii, 106–107

Context, xvii, xxi, 263–64, 337, 350, 385. *See also* Historical analysis; Setting
Copjec, Joan, 299(n16)
Cordeliers, 221, 222(fig. 17)
Cork, Richard, 44
Creativity: and Bosch, 121–35; and popular culture, 302; Renaissance views on, 113–21; in Western philosophy, 392, 393–94, 405
Crow, Thomas, xxi, 132–33, 169–78
Culler, Jonathan, xv
Culture: art history and documenting, 407–408; art in shaping and maintaining, 107, 132–33; capitalism and, 94–95; and images, xvi–xx, 3, 292, 328–33. *See also* Popular culture
Cupid and Psyche (Gérard), 142(fig. 2), 161, 184–85
Cupid and Psyche (Reynolds), 184
Cure of Folly, The (Bosch), 110–11, 110(fig.)

Daily News (New York), 326
Dandyism, 50
Dangerfield, George, 69(n2)
Danti, Vincenzio, 399, 410(n27)
Datazine, 304, 305(fig.)
David, Jacques-Louis: and Drouais, 149–51; and French Revolution, 148; and politics of Girodet, 173–78; student contributions to work, 143–47, 165(n19); and *Tennis Court Oath*, xxi–xxii, 202–208, 204(fig.), 206(figs.), 207(fig.), 215–25; works of, xxiv, 145(fig. 5), 146(fig.), 155–60, 157(figs. 10, 12), 167(n30), 188
Da Vinci, Leonardo, 114, 115(fig. 6), 347, 348(fig. 1)
Davis, Whitney, xxiii–xxiv
De anima (Aristotle), 396
Death: the classicists and Socratic, 190–93, 194, 201(n50); the gaze in confirming, 276; Rembrandt's representations of, 365, 368–81
Death of Bara, The (David), 156–60, 157(fig. 12), 165(n25), 167(n30), 174, 175
Death of Hyacinth (Broc), 161, 189, 197(n15)

Death of Socrates, The (David), 143, 145(fig. 5), 190–92, 193
Decadence: British concerns regarding, 48, 72(n27); and need for social control, 88–89
Defense, masculinity as, 54, 76(n52)
De Lauretis, Teresa, 7–8
Descartes, René, 402
Despair (Fassbinder), 279
Dessons, 378–79, 380
Détournelle, Athanase, 158, 166(n28)
Diagonals, 205, 218–19
Diderot, Denis, 199(n36)
Discipline and Punish (Foucault), 294–95
Discourse: identifying ideology through societal, 4, 5–6; images and narrative, 337–39; and Rembrandt's "death" works, 367–81; representation and social, 14–17; and sexual difference, 33–36, 84–87, 101(n118); social control and institutionalization of, 83, 88–97, 99(n17); the visual in sexuality, 228–30
Dismorr, Jessica, 65, 74(n45), 80(n90), 81(n97)
Documentation: and social regulation, 88–89, 90–91, 93, 99(n17)
Dorelia (John's mistress), 57–59, 77(n61)
Doryphoros (Polykleitos), 233–35, 234(fig.)
Douard, Cecile, 12, 13(fig.), 18(fig.)
Drouais, Jean-Germain, 149–53, 150(fig.), 152(fig.), 163(n9), 174
Duality. *See* Polarity
Dubois-Crancé, Edmond Louis Alexis, 203, 213
Dubufe, Claude-Marie, 200(n43)
Ducat, Ethel, 47
Du Maurier, George, 70(n19)
Duncan, Carol, xx
Dürer, Albrecht, 108, 114–16, 116(fig. 7)
Dyer, Richard, 272
Dying Athlete, The (Drouais), 151–53, 152(fig.)

Early Netherlandish Painting (Panofsky), 104
Eastman Kodak, 335
Easton, Malcolm, 59

Ecology: effects of Gulf war, 327; of images, 328–29, 330–336, 345(n2); images of, 329–30, 337–44

Economy, industrialized, 86–88

Eco-terrorism, 326

Education of Achilles (Régnault), 185–86

Effi Briest (Fassbinder), 275

Eighteenth Brumaire of Louis Bonaparte, The (Marx), 1–2, 5

Electric Lamp, The, 82(n107)

Elsaesser, Thomas, 274, 276, 279

Empiricism, Marxist, 3. *See also* Science

Endymion (Keats), 185

Engelbert II of Nassau, 130

Engendering, 10. *See also* Sexual difference

Entombment (Rembrandt), 373, 374(fig.)

Ephebe ideal, 158

Epstein, Jacob, 46

Eroticism: classicism and homo-, 187–90 (*see also* Homosexuality); and *Endymion*, 179–83; and the look in Fassbinder, 278–79. *See also* Pornography

Erotic Universe, 308

Etchells, Frederick, 62, 65

Etchells, Jessie, 62

Exhibitionism, 293–94

Exoticism, 260. *See also* Alterity

Expulsion of Heliodorus, The (Raphael), 359–60, 359(fig.)

Eye, all-seeing, 216–23, 217(fig.), 218 (fig.), 220(figs. 15, 16), 222(figs.)

Fandom. *See* "Slash" fandom

Fantasy: in Bosch's art and Renaissance, 113–35; bourgeoisie and, 31, 35–36; and identification in fandom, xxv–xxvi, 314–19; Michelangelo and imagination of, 386; in psychoanalytic notions of sexual difference, 46, 303–304, 322(n4)

Fanzines, xxv–xxvi, 304–307, 306(fig.), 307(fig.)

Fassbinder, Rainer Werner, xxiv, 272–73, 274–87, 295–98, 301(n37)

Favre, Abbé de, 180

Female Figures Imprisoned (Saunders), 65, 66(fig.)

Femininity: and death in Rembrandt, 365, 366–71, 372–73, 374, 375–77; and form/matter polarity, 386–91, 396, 397–98; and mimicry, 300(n26); modernist attitudes toward, 47, 52–53, 54–55, 60, 69, 85–87; and proletarian women, 17–18, 20–23; in representations, 45, 59, 60, 66, 77(n66). *See also* Gender; Women

Feminism: in art history, 12–13; and the gaze/look, 294, 295; and modernism, 43–44, 56, 67, 84; and popular culture, 302–303, 319–21, 329; responses to, 48–49; on subjectification and sexual difference, 7–8, 32–33. *See also* Women

Fernandez, Dominique, 185–86

Fetishism, xxvi, 235–36, 242

Film, xxv–xxvi; ecological imagery in, 340–42; and Fassbinder, 272–73, 274–87; the gaze and subjectivity in, 230, 294; industry economics, 333–34, 335, 342; theory and feminism, 302, 315, 329; theory and field of vision, 272

Fitzroy Society, 78(n72)

Flayed Ox (Soutine), 373

Flugel, J. C., 295

Folengo, Teofilo, 113

Form/formalism: in art history, 350, 384–86, 393–94; in Western philosophy, xxviii, 392–407, 409(n24), 410(nn 26, 27)

Foucault, Michel, xix–xx, 3–6, 9–10, 32–38, 106, 294–95

Four Fundamental Concepts (Lacan), 275, 277, 287–94, 297, 299(n16)

Fox and His Friends (Fassbinder), 275–76, 296

Framing the Sign (Culler), xv

France: parliament building for, 208–14, 212(figs.), 213(fig.); Tennis Court Oath, 202–203. *See also* French Revolution; Napoleonic militarism

Frederick and Jessie Etchells Painting in the Studio at Asbeham (Bell), 62(fig.)

French Revolution: and Girodet, xxi–xxii,

147–49, 164(n11); ideals and artists, 158, 166(n29); and idea of permanent revolution, 223–24; symbols of, 219–21
Freud, Sigmund, 284. *See also* Psychoanalysis
Fry, Roger, 42, 59, 60–62, 66
Funeral of Patroclus (David), 188
Futurism, 66, 67, 81(n98), 340–41

Gaia: An Atlas of Planet Management, 345(n9)
Garden of Earthly Delights, The (Bosch), 125(fig.), 127(fig.), 128(fig.), 131(fig.); interpretation, xx–xxi, 105, 108, 124–30, 133, 134–35
Gaudier-Brzeska, Henri, 50, 52, 54(fig.), 63, 71(n22), 74(nn 41, 44)
Gaulli, Giovanni Battista, 358(fig.), 359
Gaze: discourse in legitimizing, 99(n117); as distinguished from the look, 276–77; in Fassbinder films, 274–76, 277–87; and male/female spaces, 85–86, 265; relation to subject of, 287–95, 299(nn 13, 16)
Geldenhauer, Gerrit, 111, 117
Gender: in art history, xix, xx, xxii–xxvi; as cultural construction, 231; instability in *Endymion*, 154–55 (*see also* Androgyny); and Rembrandt "death" works, 366, 380–81; in Western philosophy, 386–408, 410(nn 27, 28). *See also* Femininity; Masculinity; Sexual difference
Genesis 9:20, 232, 266
Genius, 393–94, 404. *See also* Creativity
Gérard, François, 141, 142(fig. 2), 146, 161, 165(n19), 184–85
Géricault, Théodore, xxiii, 228, 236–45, 248–57; works, 237(fig.), 241(figs.), 242(fig.), 249(fig.), 250–52(figs.), 253(fig.), 254(fig.), 255(fig.)
Germany, 296
Germinal (Zola), 17–18
Gestures, meaning of, 193, 201(n54), 378
Gibson, Walter, 124–25, 126
Gilbert, Sandra, 44, 405
Gill, Winifred, 62

Girodet, Anne-Louis, 144(fig. 4), 145 (fig. 6), 157(fig. 11); and David, 143–47, 155–61, 173–75, 201(n48); and Drouais, 150–53; and *Endymion*, xxi, xxiii–xxiv, 141–43, 142(fig. 1), 153–55, 160–62, 162(n1), 168–95, 198(n29); and French Revolution, 147–49, 164(n11); *Nisus and Euryalus*, 189
Gods of the Plague (Fassbinder), 278, 280 (figs. 1, 3, 4, 5, 6, 7, 8), 281–83, 297–98
Goldring, Douglas, 65
Gombrich, Ernst, 108
Goncharova, Natalia, 67
Gossaert, Jan, 108, 111; works, 109(fig.), 112(fig.)
Graham, Freda, 67
Grant, Duncan, 75(n48)
Great Britain: modernism in, 42–69, 69(n2); parliamentary debates, 18–20, 19(fig.), 23–24
Great Seal of the United States, 218–19, 218(fig.)
Greek mythology: Cupid and Psyche stories, 184; Endymion stories, 162(n1), 178–79, 181–83, 197(n17)
Griffith, D. W., 336
Gros, Jean-Antoine, 238, 238(fig.)
Grotesque Ornament (Master of the Die), 119(fig.)
"Grotesques," 117–20
Grounds, Ellen, 26–29, 27(figs.)
Gubar, Susan, 44, 405
Guérin, Pierre-Narcisse, 141, 144(fig. 3), 161, 168
Guillerm, Allain, 188
Gulf war, 325–28, 345(n5)
Gypsies, 56–57
Gypsy Encampment (John), 57

Hall, Stuart, 2
Hamnett, Nina, 52, 62, 78(n72)
Hardware, 340
Haywain Triptych, The (Bosch), 109
Head of Ezra Pound (Gaudier-Brzeska), 52, 54(fig.)
Heath, Stephen, 55
Heidegger, Martin, 400–401, 403

Hennequin, P.-A., 163(n9)

Henry III of Nassau, 108

Hercules and Dejaneira (Gossaert), 109(fig.)

Hermaphrodite, 159, 160(fig.)

Heroism: and Davidian school, 176, 188, 192, 193–94. *See also* Idealization; Martyrdom

"He Who Loves Last," 314

Hippocrates Refusing the Gifts of Artaxerxes (Girodet), 143, 144(fig. 4), 147, 150–51, 175, 201(n48)

Historical analysis: contemporary influences in, xxvii–xxviii, 106–107; and *Endymion*, 161–62, 169 (*see also* Political sphere); and male subjectivity, 257; and semiotic theory, xvii–xx, 261–65; and specularity, 294–95; vertical versus horizontal, 177, 196(n14); Wölfflin and the baroque, 347–62, 364(n34). *See also* Marxism

History of Sexuality (Foucault), 33

Holland, Clive, 15–17, 35

Holly, Michael, xxvii

Holroyd, Michael, 59

Holy Face of Christ (van Eyck), 116(fig. 8)

"Homecoming," 313

Homogeneity: and historical analysis, 262–63, 264

Homophobia, 314, 323(n8)

Homosexuality: as area of research, xxii; and Bloomsbury, 53, 75(n48); eighteenth-century attitudes and representations, 182, 185–90, 197(n15), 198(n36), 199(nn 38, 41), 200(n43); in slash zines, 304–307, 306(fig.), 307(fig.), 310, 311–19, 323(n8). *See also* Androgyny

Housebook Master, 127–29, 129(fig.)

Hudson, W. H., 57

Hulme, T. E., 63, 65, 66, 79(n85)

Humanism, 61, 105, 108–35, 264

Humanities: academic distance in, xxviii; and theory, xvii, 3, 6

Hylomorphism. See Polarity, form/matter

Hynes, Gladys, 62

Hysterization, 33, 101(n18)

Idea (Panofsky), 386

Idealization: in Fassbinder films, 281–83; and masculinity, 234–35, 245–48, 254–56

Identification: and constructing masculinity, 230–36, 244–48, 254, 257–58; fantasy and female, 303, 314–19; semiotic theory and understanding, 261, 265–71

Identity: in art history theory, xxiv–xxv, 260; artists and, 47–48, 59, 72(n25); and difference, 360; discourse in producing, 6, 96; in Fassbinder films, 273, 274–76, 279–82, 296; and the gaze, 286–87, 291, 294, 295, 300(n27); Girodet and distinguishing self-, 175 (*see also* Artist[s], status of); and modernists, 65; sexual (*see* Sexual difference). *See also* Identification

Ideology: bourgeois, 17, 23–24; effect on society of, 4–5, 15; in forming artist identity, 47–48, 72(n25); historicist, 133–34; influence in art history interpretation, 11–12, 261–62; Marxism as reductionist, 96–97; and signification, 106

IDIC. *See* Infinite Diversity in Infinite Combination

Image(s): of ecology, 329–30, 337–44; an ecology of, 328–29, 330–36, 345(n2); in the gaze/look, 287–94. *See also* Representation(s); Visual, the

Imaginary: in art history, xxiv–xxv; the gaze and existing cultural, 292, 294; and masculinity, 234, 248. *See also* Idealization

Impasto technique, 365, 373–74

In a Year of Thirteen Moons (Fassbinder), 276, 282, 296, 298

Infinite Diversity in Infinite Combination (IDIC), 308, 314, 317

Information: attitudes toward proliferating, 333; images as, 337–39. *See also* Knowledge

Institute for Defense Information, 325

Inversion: and Bosch, 124–33; in Renaissance themes, 120–21

Iris and Morpheus (Guérin), 161

Jail Bait (Fassbinder), 273
John, Augustus, xxii–xxiii, 42, 50–51,
 54, 55, 56–59, 76(n56); works, 51(fig.),
 52(fig.), 58(fig. 6)
John, Gwen, 52, 57–59, 58(fig. 5), 77(n61)
Judges 19, 365, 367–69, 381(n6)
Justine (Sade), 188

Kant, Immanuel, 403–404
Keats, John, 185
Kemp, Wolfgang, xxi–xxii
Kidron, Michael, 338
Knowledge: and art history, xvii; relation
 to image overload of, 333; Rembrandt
 and death as, 378; in social regulation,
 xxvii, 88–89, 101(n118)

Labor. *See* Proletariat, representation of
Lacan, Jacques, 273–74, 275, 277, 287–94,
 295–97, 299(n13), 300(n28)
Laclau, Ernesto, 96
La Madeleine, 211
Lamb, Patricia Frazer, 308, 317–18
Language: of art history, xxviii, 3, 384,
 385–86, 391–92, 406, 408; in defending
 post-impressionism, 61; and images of
 ecology, 330, 337
Laplanche, Jean, 266–67, 322(n4)
Last Supper, The (da Vinci), 347, 348
 (fig. 1)
Last Supper, The (Tiepolo), 347, 349(fig.)
Last Supper, The (Tintoretto), 347,
 348(fig. 2), 363(n2)
Lechmere, Kate, 63, 64(fig.), 65, 74(n45),
 79(nn 82, 85)
Leda and the Swan (Michelangelo),
 391(fig.)
Ledoux, Charles Nicolas, 209, 210(figs.),
 213, 216, 217, 217(fig.)
Legrand, Jacques, 211–14, 212(figs.),
 213(fig.)
Lenton, Lilian, 67
Leonidas at Thermopylae (David), 188
Levite Finds His Wife in the Morning, The
 (Rembrandt), 365, 366(fig.), 367–69

Lewis, Wyndham, xxii–xxiii, 50, 51–52,
 53(fig.), 55, 63–68, 73(nn 35, 39), 74(nn
 40, 42, 45), 79(n85), 80(n89)
Liberty or Death (Régnault), 174
Libro dell'arte (Cennini), 113–14
*Lictors Returning to Brutus the Bodies of
 his Sons* (David), 146, 146(fig.), 176
Life and Death in Psychoanalysis
 (Laplanche), 266–67
Light: as democratic symbol, 219; in
 Dying Athlete, 152; in *Endymion*,
 154–55, 182, 201(n52)
Lili Marlene (Fassbinder), 281
Linen (Gallery), 67, 82(n107)
Literature: artist-novel, 46–47, 70(n19);
 feminism and modernism in, 44
L'odeur de la peinture (Dessons), 378–79
Lombroso, Cesare, 72(n25)
Look, the: and Fassbinder films, 277–
 79, 283–87, 295; relation to the gaze,
 276–77. *See also* Gaze
"Love with the Proper Vulcan," 314
*Loving with a Vengeance: Mass-Produced
 Fantasies for Women* (Modleski), 303
Luccione, Eugenie Lemoine, 55
Lynch, David, 346(n11)
Lyric Fantasy (John), 51, 52(fig.)

MacCarthy, Desmond, 61
Magic Flute, The, 82(n111)
Making of the English Working Class, The
 (Thompson), 1
"Manet and the Post-Impressionists,"
 60–61, 78(n73)
"Manifesto of Surrealism" (Breton), 69
Manuscript marginal art: and Bosch,
 120–35; illustrations, 121(fig.), 122–
 23(figs.)
*Man with Delusions of Military Com-
 mand* (Géricault), 255(fig.), 257
Marat at His Last Breath (David), 155–56,
 157(fig. 10)
*Margarita philosophica (The Philosophi-
 cal Pearl)* (Reisch), 114, 115(fig. 5)
Marillier, Clément Pierre, 184
Marinetti, Filippo Tommaso, 63–64, 67,
 76(n52)

Marius at Minturnae (Drouais), 150–51, 150(fig.), 175
Marriage of Maria Braun, The (Fassbinder), 273
Martin, Biddy, 9, 32–33
Martyrdom, 155–58, 166(n29). *See also* Heroism
Marxism: and art history/humanities theory, xix, 1–3, 11–12; and Foucault, 3–5; as reductionist theory, 96–97; and science fiction films, 341, 342. *See also* Historical analysis
Masculinity: in art interpretation, xxii–xxv; and cult of the open road, 57, 76(n57); as cultural construct, 231, 233–36, 243, 244–48, 266, 267–69; and *Endymion*, 176–83, 185, 194; in Fassbinder films, 282–86; and form/matter polarity, 386, 396, 397–98, 404; the gaze and historical, 295; and Géricault, 228, 238–43, 244–45, 248–58; homoeroticism in classicism and neoclassicism, 187–90 (*see also* Homosexuality); modernist attitudes toward, xx, 47, 48–56, 64–65, 71(n22), 76(n52). *See also* Gender; Sexual difference
Master of the Die, 118, 119(fig.)
Matchmaker, The (Alyx), 312
Matter/form polarity, xxviii, 390, 392–93, 394–407, 409(n24), 410(nn 26, 27, 28)
Matuszewski, Boleslaw, 99(n17)
Maud Skillicorne's Penance (Jackson), 55
Media: attitude toward information overload, 333; and Gulf war, 325–28. *See also* Film; Television
Mencia de Mendoza, 109-10, 137(n17)
Merleau-Ponty, Maurice, 300(n28)
Metaphysics (Aristotle), 388
Meunier, Constantin, 11, 12(fig.), 14(fig.)
Miami Vice, 304
Michelangelo: and imagination, 386–91, 387(fig.); and non-mimetic imagery, 118; works, 388(fig.), 391(fig.)
Military: fashion, 239, 240(fig.), 242; and film technology, 335, 336; hierarchy and masculine ideals, 244–48; representations of, 236–43; and war politics,

326, 327–28, 339. *See also* Napoleonic militarism
Mimesis, xviii, 117, 264
Mimicry, 289–91, 300(n26)
Miners (van Gogh), 10–13, 11(fig.)
Modernism: and historicist ideology, 134; rise of, 43–44, 46; Russian, 82(n112); and sexual difference, xx, xxii–xxiii, 42–43, 45, 47, 48–69, 71(n22), 81(n105), 84
Modleski, Tania, 303
Molinos, Jacques, 211–14, 212(figs.), 213(fig.)
Monnet, Charles, 205, 205(fig.)
Moore, Henry, 69
Morality: bourgeoisie and discourses on, 16, 17–20, 23–32; and overconsumption of images, 331. *See also* Social values
Moreau, Charles, 207
Mort, Frank, 34
Mother Küsters Goes to Heaven (Fassbinder), 273, 275
Mouffe, Chantal, 96
Moxey, Keith, xxvii, xx–xxi, 261–62, 263–65, 269
Mulvey, Laura, xxv, 230, 265
Munby, Arthur, 26–32
Murat, Prince, 239, 258(n12)
Murger, Henri, 70(n19)

Napoleonic militarism: collapse of, 236, 243, 248; and masculine ideals, 245–48
National Endowment for the Humanities Summer Institute, xiii
Nationalism, 260
Nature, xxix, 331. *See also* Ecology
Neoclassicism: Girodet's relation to, 168–69; masculinity in, 236
Neptune and Amphitrite (Gossaert), 111, 112(fig.)
Netherlands, 107–11, 132. *See also* Bosch, Hieronymus
Nevinson, C. R. W., 55–56, 63–64, 76(n52), 79(n77)
New English Art Club, 78(n72)

New State of the World Atlas (Kidron and Segal), 338
Newton, Isaac, 402
New York Evening Sun, 42
Night (Michelangelo), 388, 388(fig.)
Nisus and Euryalus (Girodet), 189
Non-mimetic imagery, 117–20
Nora Helmer (Fassbinder), 279
Nous et les Autres (Todorov), 260, 262
Nouvelle Zélis au bain (Pezay), 180–81

Oath of the Horatii, The (Girodet), 143, 145(fig. 6)
Oath of the Horatii (David), 176–77, 193
Off Duty, 314
Omega Workshops, 42, 62–63
On Photography (Sontag), 328, 330–33
On the Double, 308, 310
"Origin of the Work of Art, The" (Heidegger), 400
Otherness. *See* Alterity

Panofsky, Erwin, 104, 106, 386, 409(n24)
Parade, 55–56
Paris, 84–87
Pascal, Jacques–François, 199(n38)
Patriarchy: art in reinforcing, xix–xx, xxiii; bourgeois version of, 24. *See also* Power relations; Sexual difference
Patron: Burgundian nobility of Renaissance, xx–xxi, 107–11, 136(n12), 264–65; metaphorical meaning of, 392; *Tennis Court Oath* and public as, 203
Penis: envy, 236, 244; Fassbinder and dislocating phallus from, 282–84, 295–96; relationship between power and, 268–71 (*see also* Power relations)
Penley, Constance, xxv–xxvi, xxvi–xxvii, 8–9
Perspective: the gaze/look and geometrical, 287–89; and *Tennis Court Oath*, 205–208
Phaedo (Plato), 191
Phallus: Fassbinder and dislocating penis from, 282–84, 295–96; signification, 268–71. *See also* Penis; Power relations
Phillip of Burgundy, 110–11, 117

Photography: and discourse, 90–94; and overconsumption of images, 330–31, 336; promoting power relations through, xix, 20–23, 25–26, 37
Physics (Aristotle), 396–97
Pietà (Girodet), 155, 157(fig. 11)
Pieter Bruegel the Elder, 132
Pipolo, Tony, 272
Plan for a Parliament (Legrand and Molinos), 211–14, 212(figs.), 213(fig.)
Plato, 158, 392, 397
Plotinus, 398–99
Polarity: form/matter, xxviii, 392–407, 409(n24), 410(nn 26, 27, 28); social regulation and, 89; and Wölfflin, 347, 353, 360, 362
Political sphere: effect of *Tennis Court Oath* on, 223–25; effects of particular discourses on, 91, 337–44; and Fassbinder films, 296; and Gulf war, 326; homosexuality as distraction from, 190; interpreting *Endymion* within, 169–77, 193–95; and male psycho-sexual identification, 244–48; as representation of class, 1–3; and *Star Trek* fandom, 317. *See also* Power relations
Pollock, Griselda, xx, 44, 83–84, 85, 86, 87, 393
Polykleitos, 233–35, 234(fig.)
Pontalis, J.-B., 322(n4)
Popular and Republican Society of Arts, 158
Popular culture: and academic distance, xxvii; images of ecology in, xxix, 329–30, 337–44; and models of female subjectivity, 302–304 (*see also* "Slash" fandom); as source of artistic inspiration, 132–33 (*see also* Manuscript marginal art). *See also* Culture
Pornography: bourgeois surveillance as, 10, 23, 35–36; and modernists, 66; "slash" fandom and feminism on, 317, 318, 320. *See also* Eroticism
"Pornography by Women, for Women, with Love" (Russ), 313
Portrait industry, 92

Portrait of a Carabinier (Géricault), 242–43, 242(fig.)

Post-impressionism, 60–63. *See also* Modernism

Post-structuralism, 3

Pound, Ezra, 50, 52, 71(n22), 73(n37)

Power relations: academic distance and maintaining, xxvii; art in upholding, xix–xx, xxiii, 13, 15, 130–31; bourgeois ideology and maintaining class, 17, 24; discourse and institutionalized, 89–97, 99(n17); Foucault and studies on, 9–10, 33, 36–38; and phallic signification, 268–71; and specularity, 295. *See also* Patriarchy; Political sphere

Principles of Art History: The Problem of the Development of Style in Later Art, The (Wölfflin), xxvii, 347–50, 362

Professionals fandom, 323(n8)

Proletariat, representation of, 9–32

Prud'hon, Pierre-Paul, 197(n15)

Psychoanalysis: on fantasy, 303–304, 322(n4); on identity and internalization, 273; Oedipus model and male identification, 232–33, 244–45, 266–69; on sexual difference, 46; and subjectivity models, 4–5, 7, 8–9, 302–304; use in art interpretation, xxiv–xxv; Wolf Man and Davidian painting, 177

Psychology: interpreting *Endymion* through, 176–83; Renaissance and Aristotelian, 114. *See also* Psychoanalysis

Rabinow, Paul, 5

Race of Riderless Horses, The (Géricault), 248–56, 251–52(figs.)

"Race to Save the Planet" (TV miniseries), 339

Racism: and Fassbinder, 296; and Gulf war, 326

Radway, Janice, 303

Raft of the Medusa, The (Géricault), 248, 253(fig.), 256

Raising of the Cross, The (Rubens), 357, 357(fig.)

Raphael, 354, 355(fig.), 356, 359–60, 359(fig.), 386

Rationality: as masculine attribute, 181–

83, 187, 386, 396; and Socratic death, 191–93

Ratter, 147

Raynal, Abbé, 149

Reading the Romance: Women, Patriarchy, and Popular Literature (Radway), 303

Reality: as formed by the mind, 403–405; image and technology in destroying, 337, 345(n2)

Rebel Art Centre, 63, 79(n82)

Régnault, Jean-Baptiste, 174, 185–87

Relativism, 260, 262

Rembrandt, 365–81, 381(n4); works, 366(fig.), 370(figs.), 372(figs.), 374(fig.), 376(fig.), 377(fig.)

Rembrandt's Enterprise (Alpers), 365

Renaissance: historiography of, 347–62; humanist values and Bosch, 108–35

Renaissance and Baroque (Wölfflin), 350–51

Report of the Inter-Departmental Committee on Physical Deterioration, 48

Report of the Royal Commission on the Care and Control of the Feeble-Minded, 48

Representation(s): gender in, 45, 59, 60, 66, 77(n66); and photography, 20–23, 25–26; relation to discourse and social regulation, 84–94; semiotic definition of, xviii–xix, xxix, 14–15; and subjectivity, 6–7, 10–13, 36–38; of women in film, 286. *See also* Image(s)

Resistance: and discourse, 83, 91; and image relations in art, 13, 15, 38; of matter to form, 399, 405, 406–407

Return from Russia, The (Géricault), 250(fig.)

Revolution, permanent, 223–24. *See also* French Revolution

Revolution in Art, 42

Reynolds, Joshua, 184

Rhythm (periodical), 43, 65, 73(n34)

Rice, Anne Estelle, 74(n45)

Rights of Man, The (Lebarbier-Laurent), 220(fig. 16)

"Ring of Soshern, The," 311–12

Riviere, Joan, 54–55

Roberts, William, 63, 65
Robespierre, 221
Rock Driller, The (Saunders), 65
Rodin, François, 77(n61)
Rose, Jacqueline, 7
Ross, Andrew, xxviii–xxix
Rousseau, Jean Jacques, 223–24, 225
Rubens, Peter, 357, 357(fig.)
Ruskin, John, 405
Russ, Joanna, 308, 313
Rutter, Frank, 42

S & M, 318–19
Sade, Marquis de, 188, 199(n41)
St. Bernard of Clairvaux, 120
Sampson, John, 56
Sandia National Laboratory, 327
Satire, 120–21, 129–30
Saunders, Helen, 44, 65, 66(fig.), 80(n90),
 81(nn 97, 105)
Schehl, Carl, 245–46
Schiller, F., 404
School of Athens, The (Raphael), 354,
 355(fig.), 356
Schwarzenegger, Arnold, 229(fig.), 233,
 235–36
Science: atlases as imagery, 338–39; and
 social theory, 3, 88. *See also* Technology
Science fiction, 346(n10); ecological
 imagery in, 340–42. *See also Star Trek*
Screen, 289–94, 300(n27)
Seager, Joni, 338
Seated Hussar Trumpeter (Géricault),
 241–42, 241(fig. 7)
Segal, Ronald, 338
Self. *See* Identity
Self-Portrait (Dürer), 115, 116(fig. 7)
Self Portrait as a Tyro (Lewis), 51, 53(fig.),
 74(n40)
Seminar XI (Lacan), 297, 299(n16)
Semiotic theory, xviii–xix, xxix, 261–71
Setting: and *Tennis Court Oath*, 208,
 214–16. *See also* Context
Severed Heads (Géricault), 254(fig.),
 256–57
Sex and Character (Weininger), 67,
 81(n105), 404–405
Sexual difference: bourgeois notions of,

9–10, 17–36, 34(fig.); concepts of, 45–
 46; *Endymion* and, 183; and fantasy,
 31–32; feminist discourse and, 12–13,
 84–87, 101(n18); the gaze and, 228–31;
 and maintaining class relations, 17–18,
 40(n31); modernists on, 42–43, 45, 47,
 48–69, 81(n105); and photography, 23;
 role in subjectification of, 7–10, 15, 33–
 36; and "slash" fandom, 317–18. *See
 also* Femininity; Masculinity
Sickert, Walter, 78(n72)
Sign/signification: and Bosch, 111–33,
 136(n10); and phallic power, 268–
 71 (*see also* Phallus); and Rembrandt
 "death" works, 365, 368–81; theory
 of, 106–107; vision as, 402. *See also*
 Symbols
Siguenza, Jose de, 113
Silverman, Kaja, xxiv, xxv, 265
"Slash" fandom, xxv–xxvi, 304–21
Slaughtered Ox (Rembrandt), 371–77,
 372(figs.), 379, 382(n16)
Sleeping Faun, 193, 201(n54)
Sleep of Endymion, The (Girodet),
 142(fig. 1); influence on David of,
 156, 158–59, 174; style/interpretation
 of, xxi, xxiii–xxiv, 141–43, 153–55,
 160–62, 162(n11), 168–95, 201(n54)
Smiling Woman, The (John), 58(fig. 6), 59,
 77(n63)
Social Darwinism, 43–44, 48, 72(n28)
Social regulation. *See* Surveillance
Social values: ephebe as embodiment of
 civic virtue, 158; Girodet and Enlight-
 enment, 149; Renaissance humanism
 and Bosch's manifestation of, 105, 130–
 33, 264; and sexuality discourses, 23.
 See also Aesthetics; Morality
Socrates, depictions of, 187
*Socrates Tearing Alcibiades from the
 Bosom of Voluptuousness* (Régnault),
 186–87
Sontag, Susan, 328, 330–33, 336, 345(n2)
Soutine, Chaim, 373
Space: female versus male, 85–86; politics
 as, 170
Spectatorship/specularization: in Fass-
 binder films, 277–79, 282–86; Lacan

and field of vision, 289, 293, 295; and
masculinity, xxiv–xxv; role in art
history of, xxvi
Stansell, Christine, 86–87
Star Trek, 304, 311–19, 324(n13)
Statistics, 339
Sterk, J. J., 111, 117
Stewart, Philip, 180
Structuralism, 3, 4
Student, The (Gwen John), 58(fig. 5), 59
Studio, The (magazine), 70(n18)
Style: change and continuity in Girodet's,
141; and Wölfflin's historiography,
347–62. *See also* Baroque; Classicism
Subjectivity/subjects: Foucault and iden-
tifying, 4–10; the gaze/look and,
228–31, 257–58, 274–98, 299(n16),
300(n27); models of female, 302–304,
321(n3); modernism and, 46–47; pho-
tography and, 89–90, 94; and Western
philosophy, 402
Suffrage Atelier, 44
Suffrage movement, 44, 49, 67, 68,
81(n104)
Summers, David, xxviii
Surveillance: constructing masculinity and
intermale, 231; discourses in, 88–89,
99(n17); eye as symbol of, 221; in Fass-
binder films, 283; nineteenth-century
bourgeois, 9–10, 35–36, 37–38. *See also*
Power relations
Symbols: in Bosch's art, 105–106; French
parliament and democratic, 211–14,
216–23, 217(fig.), 220(figs.), 222(figs.);
genitals as, 267–68, 270 (*see also*
Phallus); night, 388–91, 408(n9); and
United States seal, 218–19, 218(fig.)
Symposium (Plato), 158

Tagg, John, xix–xx, 36–37
Tarr (Lewis), 51, 73(n35)
Technique: paint-handling by Rembrandt,
365, 371–72, 373–74
Technology: atlases as imagery, 338–
39; film, 334, 335–36; role in cultural
processes of, 331–32. *See also* Science
Television: documentary, 339; ecological

imagery on, 340, 342–44, 346(n11); and
economic realities, 335; and Gulf war,
325–28
Tennis Court Oath (David), xxi–xxii,
202–208, 204(fig.), 206(figs.), 207(fig.),
215–25
Tennis Court Oath (Monnet), 205,
205(fig.)
Theater, French, 209–10, 214
Theatre at Besançon, 209, 210(figs.),
211, 216
Theory: and ecological issues, 328; em-
pirical versus philosophical, 3; iden-
tification and semiotic, 260–71; im-
portance in art history of, xiii, xv–xx,
104 (*see also* Art history); signification,
106–107. *See also* Polarity
Things to Come, 340
Thompson, E. P., 1
Three Guineas (Woolf), 55
Tickner, Lisa, xx, xxii–xxiii, xxiv–xxv
Tiepolo, Giovanni, 347, 349(fig.)
Tillyard, Stella, 61
Timaeus (Plato), 392, 397
Timelessness: in *Endymion*, 143, 178
Tintoretto, 347, 348(fig. 2), 363(n2)
To Arms and to Arts!, 158
Todorov, Tzvetan, 260, 262
Total Recall, 341–42, 346(n10)
Tramp, The (magazine), 57, 59, 77(nn
58, 66)
Trompe l'oeil borders, 124
"Twin Peaks" (TV show), 342–44,
346(n11)

Van Alphen, Ernst, xxiii
Vandenbroeck, Paul, 105
Van Eyck, Jan, 116(fig. 8)
Van Gogh, Vincent, 10–12, 11(fig.)
Vanishing point: and field of vision, 288;
and *Tennis Court Oath*, 205–208,
206(fig. 4), 207(fig.), 216
Vatican, 147–49
Veith, Diana, 308, 317–18
Ventricles of the Brain (da Vinci),
115(fig. 6)
Veronese, Paolo, 386, 389(fig.)

Vignettes, French Revolution, 219–21, 221(figs. 14, 15), 222(fig. 18)

Virilio, Paul, 335–36

Vision and Difference, 83

Vision of St. Helen (Veronese), 386, 389(fig.)

Visual, the: and exteriority, 274–76; the gaze/screen and field of, 287–98, 299(n16), 345(n2); and Rembrandt, 365, 367; in semiotic theory, 267–70; and sexuality, 15; and Western philosophical thought, 402

Visual Theory: Painting and Interpretation (Bryson et al.), xiii

Vital English Art (Marinetti and Nevinson), 63–64, 76(n52), 80(n86)

Vitruvius, 111

Vives, Juan Luis, 137(n17)

Volosinov, Valentin, 106

Voltaire, 198(n36)

Vorticism, 63–68, 78(n72), 80(n86). *See also* Modernism

Vorticists at the Restaurant de la Tour Eiffel: Spring 1915, The (Roberts), 65

Votes for Women (Ducat), 47

Voyeurism, xxvi, 36; and analyzing "slash" fandom, 309; and the gaze, 230, 265, 277

Walkowitz, Judith, 87

War and Cinema (Virilio), 335–36

Warnke, Martin, 350, 364(n34)

Waters, John, 334

Wedding of Samson (Rembrandt), 366–67

Weininger, Otto, 67, 81(n105), 404–405, 411(n43)

Westminster Gazette, 61

Whistler, James, 73(n36)

Wicar, J.-B., 163(n9), 166(nn 28, 29)

Wiegand, Wilfred, 272

Wölfflin, Heinrich, xxvii, 347–54, 356–62

Wollen, Peter, 45

Woman Hanging from the Gallows, A (Rembrandt), 369–71, 370(figs.)

Women: Aristotle on, 394–96; art history and recognizing role of, 393, 405–406; as artists, 48, 49–50, 60, 65–67, 78(nn 69, 72), 80(n90), 81(n97), 82(n107); femininity and working, 86–87; and modernism, 43–44, 52–53, 61, 66–67, 69, 74(n45), 75(n46), 80(n89), 81(n103); Renaissance idea of "power of," 125–26, 126(fig.); representation in film/television of, 286, 344; and "slash" fandom, 304–307, 308, 316. *See also* Femininity; Gender; Sexual difference

Women Against Pornography, 319

Women of Houston in Publishing (WHIPS), 304

Women's International Art Club, 49

Woolf, Virginia, 55, 59

World Wildlife Fund Atlas of the Environment, 338

Wounded Cuirassier (Géricault), 239–40, 241(fig. 6)

Zola, Emile, 17–18